Hampton Court

Simon Thurley

HAMPTON COURT

A Social and Architectural History

Published for

THE PAUL MELLON CENTRE
FOR STUDIES IN BRITISH ART

by

YALE UNIVERSITY PRESS

New Haven & London

© 2003 by Simon Thurley

All rights reserved.
This book may not be reproduced, in whole or in part,
in any form (beyond that copying permitted by
Sections 107 and 108 of the U.S. Copyright Law
and except by reviewers for the public press),
without written permission from the publishers.

Designed by Gillian Malpass

Printed in Italy by Conti Tipocolor

Library of Congress Cataloging-in-Publication Data

Thurley, Simon, 1962–
Hampton Court : a social and architectural history / Simon Thurley.
p. cm.
ISBN 0-300-10223-2 (cl : alk. paper)
1. Hampton Court (Richmond upon Thames, London, England)–History.
2. Richmond upon Thames (London, England)–Social life and customs.
3. Architecture–England–London. 4. Palaces–England–London. I. Title.
DA690.H2T48 2003
942.1´95--dc21

2003014023

A catalogue record for this book is available from
The British Library

Endpapers
Detail from a drawing by Leonard Knyff of Hampton Court Palace and its gardens
from the south, with Bushy Park in the distance, c. 1702 (fig. 225).

Page i
Detail from Grinling Gibbons's design for a monument at Clifton upon Teme,
Worcestershire, 1689 (fig. 159).

Frontispiece
Fountain Court looking south east.

Page iii
Detail from Joseph Nash's imaginary reconstruction of 1840 showing Cardinal Wolsey
dining in the Watching Chamber (fig. 60).

Page v
Detail from Grinling Gibbons's designs for limewood carvings for the Presence
Chamber and Bedchamber at Hampton Court, c.1693–4 (fig. 158).

Page vi
Hampton Court from the air, looking west.

*For
Anna,
Clare,
Daphne
and
Esther*

Contents

	Acknowledgements	viii
	Preface	ix
1	A House of the Knights Hospitallers	1
2	Thomas Wolsey's Hampton Court	15
3	Henry VIII and the Completion of the Tudor Palace	43
4	The Later Tudors and the Palace of Pleasure	79
5	The Tudor Pleasure Grounds and the Locality	89
6	Hampton Court and the Invention of a Tudor Style	99
7	The Stuart Ancestral Seat 1603–1640	107
8	The Lord Protector's Country House 1640–1660	119
9	The Restoration: Hampton Court on the Sidelines 1660–1688	129
10	Hampton Court Transformed: The Reign of William and Mary	151
11	Queen Anne and the Decline of the Court	211
12	The Glory of Hampton Court: The Gardens 1603–1714	223
13	Royal Rivalry: The Hampton Court of George I	245
14	Apogee: George II	269
15	Antiquarians and Architecture: The Palace Buildings 1760–1914	287
16	Lodging the Court 1700–1737 and Grace and Favour 1760–1914	325
17	The Parks and Gardens 1714–1914	341
18	The Twentieth Century	357
	Abbreviations	399
	Notes	400
	Photograph Sources and Credits	434
	Index	435

Acknowledgements

THIS BOOK HAS BEEN MADE POSSIBLE by the research I undertook for my MA and my PhD, both funded by the British Academy, and by a Leverhume Fellowship that enabled me to employ a research assistant while I was working full time and unable to visit the necessary libraries and archives. Daphne Ford's illustrations were funded by Historic Royal Palaces, to whom both Daphne and I are grateful. The Mellon Centre for British Art has supported this book; without their help our understanding of Britain's artistic history would be hugely impoverished.

With a book covering such an enormously long time-span, the danger of error is high and I have relied on a group of friends and colleagues who have kindly read chapters for me and offered their advice. Dr Edward Impey and Dr Greg O'Mally kindly commented on the first chapter, Dr Mark Girouard and Dr Maurice Howard read and commented on the Tudor chapters, Dr Andrew Barclay, the Stuart chapters, Dr Gordon Higgott, Professor Robert Bucholz and Tessa Murdoch, the William and Mary chapter, Richard Hewlings and Professor Bucholz, the Georgian sections, Dr Mike Turner and Professor Michael Port, the nineteenth century, and Sir Oliver Millar, John Charlton, Dr Mike Turner, John Thorneycroft and Juliet West, the twentieth century. Anna Keay, Daphne Ford, Esther Godfrey and Clare Murphy read the whole text. Gillian Malpass at Yale University Press has again designed a beautiful book. They all made helpful and incisive suggestions, most of which I have incorporated. At various times I have been helped also by Caroline Catford, Emily Cole, Hannah Godfrey, Susanne Groom, John Harris, Paul Hill, Tim Knox, Alix McAlister, John Schofield, Barney Sloane, Charles Thomas, Pamela Willis and Giles Worsley. My thanks are due to them all.

Finally I must record the enormous debt I owe to my former colleagues, now friends, from Historic Royal Palaces. This book relies on their help, knowledge and expertise to a substantial degree. Daphne Ford, whom I have worked with since 1985, has contributed not only the magnificent drawings but much of the interpretation of the built structure. Her contribution to the understanding of Hampton Court cannot be overestimated. Three other people have made significant contributions too. Anna Keay has been my critic and muse and has shared with me her own research, making this book immeasurably better. Esther Godfrey gave me a year of her time to search the Public Record Office and many other archives and libraries. Her sharp eye, enthusiasm for the task and boundless patience have been enormously appreciated. Clare Murphy has an unrivalled depth of royal topographical knowledge and has found images of the palace all over the world; she also, hawk-eyed, proof-read the finished manuscript. I dedicate this book to the four of them.

Preface

It could be argued that Hampton Court Palace, its parks and gardens, is the foremost secular architectural complex of the early modern period in England. From the late fifteenth century until the early twentieth, with a possible gap of the period 1750–1820, the palace held a central place in England's architectural and garden history. For the earlier period down to 1737 it was a seat of governance of the country too. Since the First World War its importance has been in the development of state-sponsored tourism, the growth of the conservation movement and changing attitudes to the display of England's heritage. However one looks at it, Hampton Court has been continuously a building of national significance for half a millennium.

I was introduced to Hampton Court in 1985 by Michael Green, then an Inspector of Historic Buildings at the Directorate of Ancient Monuments and Historic Buildings of the Department of the Environment. He suggested to me that despite the fame of this royal palace and others, such as Whitehall, there was much to be discovered that no one else was working on. It was the start of a long relationship that has culminated over fifteen years later with this book. In the interim, my Courtauld MA thesis covered the Henrician building history and my PhD the wider Tudor context of the palace. My PhD later found an outlet in *The Royal Palaces of Tudor England*, published by Yale in 1993. I had then intended to move on and write the history of royal palaces in Stuart England, but it quickly became clear that without individual palace histories covering the main residences this would not be possible. Thus in 1998–9 I published three books on Whitehall Palace[1] and the year after began work on a comprehensive history of Hampton Court.

My research into the history and architecture of Hampton Court has run alongside a career that gave me the opportunity to work at the palace for a period of ten years. In 1988 I was appointed Assistant Inspector of Ancient Monuments at English Heritage in the Crown Buildings Advisory Group. My task was to contribute to the work then underway to restore the wing of the palace damaged by fire in 1986. Two years later I was appointed Curator of the Historic Royal Palaces with responsibility for the contents and display of the six palaces in the group including Hampton Court. In 1996 I was to take on the job of Surveyor of the Fabric in addition to my curatorial responsibilities. When I moved to direct the Museum of London in 1997 I left a talented and highly motivated group of colleagues at Historic Royal Palaces from whom I had learnt a great deal. Our everyday discourse was the stuff of royal building and etiquette, of kings, queens and princes. Many of the ideas in this book spring from that collegiate atmosphere.

This book is very different to my earlier work on Whitehall. There it was necessary to establish a coherent building history and set of plans covering the palace's development. These were drawn up from a series of complex excavations and the voluminous building accounts in the Public Record Office. For Hampton Court, a building that largely survives, such a task is not necessary, although at points it has been necessary to establish a fresh chronology. *Hampton Court: A Social and Architectural History* sets out to meld together social, architectural, economic and political history into a synthesis that explains the importance, influence and history of Hampton Court and its locality. The book thus concentrates as much on social and political issues as it does on architectural ones. This is inevitable since for long periods the palace was essentially completed and was the home to court life, to grace and favour residents and latterly tourists rather than to builders and architects. This history is an ambitious project built on a vast array of sources intensively studied over eighteen years. As such I hope it will make a contribution to the methodology of writing architectural history as well as replacing Ernest Law's *A History of Hampton Court Palace*, published just over a hundred years ago, as the standard work of reference.

Finally, it should be noted that, when taking a span of history as long as this, it is difficult to come to any one conclusion. As a consequence, the text is littered with conclusions and observations, each set within its context. As I laid down my pen at the end of chapter 18 and reread nearly 500 years of intensive historical narrative a summation eluded me, except perhaps to observe that people create places for themselves that subsequently exert their own influence over man's affairs. Hampton Court is such a place.

Simon Thurley
London, January 2003

1 Hampton Court from the air, looking east, in 1992.

Chapter 1

A HOUSE OF THE KNIGHTS HOSPITALLERS

STANDING ON HAMPTON COURT BRIDGE on a foggy autumn morning all that can be seen in the impenetrable whiteness is the sluggish silver of the River Thames. The palace and all that surrounds it is obscured and, with a struggle of the mind, one is transported back in time to the very reason for the palace's existence – the river itself. Half a million years ago it was wider and wilder and, as it cut the valley in which it now flows, it laid down the gravel terraces that now form the Thames basin. The royal palace and its parkland sit on the first river terrace in a deep meander created at the end of the last glaciation, 10–13,000 years ago. The land formed was free-draining, easy to clear and fertile, and although the lower floodplain was probably susceptible to flooding, further into the meander the land must have been ideally suited for agricultural purposes. Only a mile away from the meander lay a small island in the river, now Kingston upon Thames (fig. 2). On this has been found Neolithic pottery (dating from 4,000–1,800 BC), the earliest evidence for human occupation in the area.[1]

By the early Bronze Age (2,200–1,200 BC), the landscape of the Thames valley around modern Hampton Court and Kingston had become pretty busy. Attracted by the confluence of the Hogsmill River with the Thames at Kingston and the Mole and the Thames at Hampton Court, settlement and agriculture were fairly dense. The river has yielded up much Bronze Age material, such as the fine late Bronze Age urn with four pierced knobs from the site of the palace's sixteenth-century Water Gallery. Two prestigious early Bronze Age burials have been excavated in the area, one on the south side of the Thames at Hurst Park and the other in Bushy Park at Sandy Lane. These barrows show the prosperity of the inhabitants of the area and are probably indicative of a greater number of currently unexcavated burials. Earthworks in Hampton Court Park near Hampton Wick Gate and at the end of the Long Water may be ancient, possibly also Bronze Age barrows.[2]

Following the Roman conquest, settlement and agriculture in the Hampton Court region seem to have intensified. Roman settlements developed at Kingston and on Kingston Hill, and in the fertile floodplain agriculture probably flourished. John Leland, writing in the 1530s, tells us that in Cardinal Wolsey's time 'was found much Romayne mony of sylver, and plates of silver . . . and chaynes of sylver'; where these finds were made, we are not told.[3] In 1991 at Hurst Park, just over the river from Hampton Court, a Roman corn drier was found and nearby cremated human remains were excavated. This may suggest the existence nearby of a settlement at the centre of a country estate. Roman finds on the north side of the river support the theory that there may have been several prosperous agricultural estates in the Roman period, possibly centring on river fording points at Hampton Court and Kingston.[4]

Yet the name Hampton or *Hamntone* is undoubtedly a Saxon one which probably means settlement (*ton*) in the bend of a stream (*hamm*). In the Saxon period its importance as an agricultural estate was probably reinforced by its proximity to Kingston, which, according to the Anglo-Saxon Chronicle, was the site of the consecration of King Athelstan in 925. It seems as if a number of other West Saxon kings may have also been consecrated there, and this, together with recent archaeological discoveries, paints a picture of a significant royal estate at Kingston from the first half of the ninth century.[5] It is currently unclear how the proximity of Kingston affected the lordship of the manor of Hampton, but the Domesday Book reveals that not long before 1066 it had been held by Aelfgar, earl of Mercia, son of Leofric and the lady Godiva.

Leofric (d.1057) was one of the great earls upon whose advice King Canute relied, and when his son Aelfgar (d.1062) inherited his father's title he was already one of the most powerful men of his age. Despite being banished twice, both times he fought his way back to favour, and he spent his declining years peacefully at the court of King Edward the Confessor. Aelfgar held the largest lay estate in Middlesex, the hundred of Hounslow, which comprised the manors of Hampton and Isleworth containing the villages of Heston, Twickenham, Isleworth and Hampton itself. The extent of the manor and the parish of Hampton coincided exactly, but was smaller than the area is today due to the creation of Hampton Wick in 1831. There is no evidence that either Leofric or Aelfgar ever resided at their Middlesex estate and we know that Leofric died at his manor of Bromley and was buried in Coventry. The Domesday Book implies that, on his death, Aelfgar's lands were not passed on to his son Edwin, and it is likely that in 1066 they were held by King Harold.

It is probably dangerous to read too much significance into the proximity of this powerful Saxon family's landholding to Kingston, or in the fact that the manor fell into royal hands just before the Conquest. Yet it is fair to suggest that as early as the ninth century

2 Map of the Hampton Court region showing the principal rivers, roads, towns and villages and the main administrative units. Medieval and early modern royal residential sites are also shown. Drawing Daphne Ford.

the nature and history of the manor of Hampton were already affected by its closeness to royal estates, and that this factor was, in the long run, to lead to its appropriation by the monarchy.

Domesday and After

Between 1066 and 1087 William the Conqueror forced through a political union with Normandy, driving out the old Saxon landowning nobility and subjecting England to the dominance of the Norman aristocracy. William granted almost half of England to Norman nobles and about a quarter to the Church, whilst retaining a fifth for himself. Generally speaking nobles were granted lands that had formerly belonged to a single Saxon magnate. Thus the former estates of Aelfgar were parcelled up and awarded, as one, to a single Norman lord, Walter St Valery.[6] It was from St Valery's home town in the County of Flanders, Saint-Valery-sur-Somme, that William had sailed in 1066. The two men were not only close companions but were also related – Walter's grandmother was William's aunt. St Valery and his son Bernard demanded, in return for their loyalty and services, 'l'accointance de la plus gente pucelle que là treuverait', and the hundred of Hounslow, granted immediately after the Conquest, must have seemed a valued prize.[7]

The Domesday Book, that great Norman land record compiled in 1086, gives the first real glimpse of the manor of Hampton. In area it comprised thirty-five hides, which is to say about 4,200 acres (a hide is approximately 120 acres). Eighteen hides of this St Valery held himself (the demesne) and the remainder he let. The whole value of the manor was assessed at £39. The demesne, which was about 2,000 acres, used only three ploughs, which suggests that most of it was unploughed sheep pasture. Indeed, Domesday tells us that the hundreds of Isleworth and Spelthorne were the least-wooded part of the whole of Middlesex and that the value of the manor, in 1086, was £9 a year less than it had been before the Conquest. This was probably the result of the Norman army living off the land as it passed through the manor, crossing the Thames at East Molesey.[8] It is likely therefore, that on

being granted the land, St Valery had to rebuild its prosperity himself, and probably introduced the sheep that were to become the basis of Hampton's wealth for the next four hundred years.[9]

Walter was probably never resident in Middlesex. He also held lands in Suffolk and possibly houses in Winchester as well as his estates in Normandy. He granted land and liberties belonging to the churches of Hampton and Isleworth to his supporters and the churches of Heston and Twickenham to the monks of Saint-Valery at an annual rent. In 1096 Walter accompanied Robert II, duke of Normandy (his second cousin), on the First Crusade and he was still in the Holy Land with Bernard in 1097. It is not known when Walter St Valery died but it is known that Bernard succeeded him and was in turn succeeded by his eldest son, Reginald, who also held the Middlesex estates.[10] Reginald, who rose to become Henry II's Steward and Justiciar of all Normandy, was, like his father and grandfather, a crusader. He formed a contract with St Frideswide's, Oxford, to provide one mark a year for his wife while he was away. Reginald had some success in the Middle East, holding the fief and castle of Hârim in the principality of Antioch. Joscelyn III acquired the fiefdom, probably in 1161, and Reginald was back in Normandy from 1162.[11]

The St Valery crusading connections were to be a crucial factor in the history of Hampton. At first, knights returning from the Crusades and wishing to support the military orders in the Holy Land gave lands to the Knights Templar, but after the Second Crusade (1147–9), gifts were more commonly given to the Knights Hospitallers. Reginald, having been a Baron of Jerusalem, would certainly have known the Order of the Knights Hospitallers of St John of Jerusalem well. It was probably due to Reginald St Valery, returning from the Holy Land in the 1160s, that the Hospitallers became established in Hampton. The Order is known to have had a presence there by 1180 as, when the king established the community at Buckland (Somerset) to which all the female members of the Order were transferred, they included a sister (Joan) from 'Hampton in Middlesex'.[12] For the next fifty-five years or so the Order rented the manor at Hampton for its own purposes.

The Knights Hospitallers

The Knights Hospitallers had originally been an Augustinian Order founded to provide accommodation and nursing care for pilgrims to the Holy Land at their great hospital (or hostel) in Jerusalem. In the early twelfth century, in addition to its charitable works, the Order was permitted to undertake military duties. The Hospitallers, financially supported by endowments, were active in countries across Europe, each country administered by a regional priory. Subordinate houses known as preceptories were responsible for producing revenue for the priory that in turn sent its net income to the Grand Master of the Order (after 1309 at its headquarters in Rhodes). From early on successive popes granted special privileges to the Hospitallers. Members of the Order were exempted from the authority of regional churches and were instead exclusively under the papal discipline. As such they were not obliged to pay local tithes and enjoyed exclusive rights of sanctuary.

The precise date of the foundation of the Order in England is unclear, but it is known that a number of important benefactions in the early twelfth century led to the establishment of a priory at Clerkenwell at some time during the reign of King Stephen. It was both the regional headquarters of the Order in England and a preceptory in its own right and therefore combined the residence of the prior with the functions required for the administration of the Order in England. The prior outranked all secular lords in the kingdom, and for this reason, and because of its relative proximity to the royal court at Westminster, the priory was frequently to enjoy a role in national and royal affairs. Preceptories and other manors belonging to the Order could yield substantial revenues if managed well. Apart from the rent of land, mills and waterways, individual manors might be farmed directly or services demanded as payment in kind. The costs of administration to be deducted were theoretically low: building maintenance, rents, tolls and dues and, of course, generous hospitality to the nobility, clergy and wayfarers.

Reginald St Valery died in September 1166, leaving his Middlesex estates to his son Bernard. Bernard was later to be high in the favour of King Richard I, who described him as 'dilecto familiari nostro'. Following family tradition he fought in the Holy Land, and was killed at the siege of Acre in 1190. He had three sons: Reginald and Bernard, who died without issue; and Thomas, who came into the estates in 1189. Thomas St Valery was the last of the line to hold the manor.[13] He had one daughter, Annora, whose first husband held half of the Middlesex estates, the manor of Isleworth, in right of his wife. The other half, Hampton, seems to have been taken into the king's hands, probably on account of Thomas's involvement (or implication) in the rebellion against King John after Magna Carta and the battle of Lincoln in 1217. But before it was confiscated Thomas seems to have given the manor to a rich and prominent city merchant, Henry of St Albans, who was allowed to retain the property by Henry III.[14] Thus for the first time in three centuries the histories of the manors of Hampton and Isleworth were split; and soon afterwards the manor of Hampton was transferred from the hundred of Hounslow to that of Spelthorne to the west.[15]

In 1230 a dispute arose between the Hospitallers and their new lord of the manor, Henry of St Albans, concerning fines allegedly owed by the Order to St Albans. In 1237, following a six-year legal battle, St Albans agreed to sell the manor to the Hospitallers for 1,000 marks (£666 13s 4d).[16] Although the Hospitallers' title to the manor was not challenged, a shadow of doubt hung over this transfer. The royal charters that proved Henry of St Albans's title to the manor had been stolen from him before the sale of the land to the Order, so technically it might have been argued that the lands were still Crown property. To avoid any suggestion of this the Hospitallers entered into a complex legal manoeuvre fifty-five years later to ensure beyond all doubt that they had legal tenure of the manor. This was complicated by the fact that statutes of 1279 and 1288 made it illegal to give or sell lands to immortal religious corporations like the Hospitallers without royal licence. It was therefore necessary to confirm legal title through the courts without a transfer. To do this the Order seems to have persuaded Henry of St Albans's granddaughter, Sabine de Dunolm, to sue them for full possession of the manor, but to drop the case as unjustified when it came to court. To cover her costs the Order paid Sabine 110 marks; and the resulting judgement in the Hospitallers' favour constituted full legal title to the manor. This

negotiation, one commonly used in circumstances of this kind, guaranteed the Order legal title to their lands. With their undisputed ownership they were able to use the manor more creatively. In 1298–9 Joan, the widow of Sir Robert de Grey, granted the Knights Hospitallers the manor of Shobingdon in Buckinghamshire, and either in acknowledgement of this gift, or in return for it, she was granted a life interest in the manor of Hampton.[17]

The nature of Hospitaller activities at Hampton Court in the thirteenth century is obscure. It is known, however, that in 1250 Henry III granted the prior free warren at Hampton Court, a grant confirmed in 1280 by Edward I. This gave the priors the right to take rabbits and other animals not considered beasts of the forest (and therefore royal preserve) in their demesne lands, suggesting the occasional use of the house as a sporting estate. During the fourteenth century the Hospitaller property was augmented by a number of gifts. Walter and Maud de Wyke gave a messuage with 100 acres of arable land, an acre of meadow and 20 shillings annual rent in 1303; and Christine Haywood gave 60 acres of land in Hampton and Hampton Wick.[18] In the early fourteenth century the Order in England went through a financial crisis. This was partially occasioned by the acquisition of its new headquarters in Rhodes in 1310, but can also be put down to maladministration by the enormously fat and incompetent prior, Thomas le Archer (1321–9). In 1328 the Master of the Order sent a representative from Rhodes, Leonard de Tibertis, to investigate. Leonard found the English priory in a state of disarray, and confusion and reforms were set in train. Ten years later, in 1338, a new survey was ordered of all Hospitaller properties in order to monitor progress. This survey or 'extent' is a crucial document and forms the basis of what is known about Hampton in this period.[19] It reveals that the manor was a *camera*. This was an administrative distinction amongst the Hospitaller properties. It denoted a type of holding, of whatever size, the revenues of which were assigned to a particular officer. It was also generally held *in absentia* by the prior rather than directly by a preceptor in residence.[20] In 1338 there were twenty-one *camerae* in England, of which Hampton Court was one.

The Extent of 1338

The extent of 1338 is very significant for it allows the relative importance of Hampton Court compared with other Hospitaller estates to be seen for the first time. The document gives the impression that Hampton Court was one of the largest and best-appointed Hospitaller manors in England. The key to understanding why this was is the fact that the property was located near to the country seat of the Duke of Cornwall.[21] The duchy of Cornwall was created by Edward III in 1337 to provide for the heir to the throne, Edward, the Black Prince. The prince was granted all the lands of the old earldom of Cornwall, as well as extensive lands elsewhere. In addition to his substantial self-contained apartments at Westminster Palace, he owned a house at Kennington on the south bank of the Thames not far from the city, and as a Thames-side country retreat he was given Byfleet house in Surrey.

Byfleet had been acquired by the Crown some time in the early fourteenth century, and after various royal improvements became a favourite with Edward II, who stayed there frequently. After it was transferred to the Black Prince additions and extensions were made to the property, including a new kitchen. These were necessary because it was reported that 'the prince and his brother, the earl of Richmond, plan to stay a great deal at the manor of Byflete, and when he is absent, his household will be there'. In the event the prince's father, Edward III, was a regular visitor too as he had established himself to the east of Hampton Court at Sheen after the death of Queen Isabella.[22] Hampton was seven and a half miles from Byfleet by land and ten miles by water via the River Wey. Lying halfway between Sheen and Byfleet it was a perfect staging post and an ideal satellite to its larger and more important royal neighbours. Its proximity to Byfleet meant that Hampton received a stream of visitors requiring hospitality, and this fundamentally affected its staffing, economy and, inevitably, its size.[23]

As a result of its special status, Hampton was visited by the prior of the Order for three days a year. Most *camerae* were visited for only one day, and many were never visited at all, but Hampton Court was chosen for particular attention. It was also headed by a warden who was a Hospitaller rather than merely by a bailiff as was usual. Hampton did have a bailiff, who was essentially the farm manager, and who was assisted by a steward and a hayward (possibly the shepherd). The warden, Richard de Meriton, however, was the master of the house, and he had a chamberlain to take care of the domestic arrangements, a baker in the kitchen and a gatekeeper to secure the gates. Hampton also had a chapel. The chaplain was not a Hospitaller, but his salary indicated that he was a priest who officiated at services. Thus Hampton was staffed, not only to fulfil its function as a grange, but also as a high-status guest house.

Its use as a guest house also fundamentally affected the economy of the estate. The extent indicates that there were 800 acres of arable land, which seem mainly to have been rented out. Most of this land was in what was to become Bushy Park, but about 100 acres were in what was to become Hampton Court Park, and in both areas the medieval ridge-and-furrow field system can still be seen. The survival of the medieval field system into the twenty-first century is due to the fact that the lands were emparked in 1499 and 1514 and, apart from a short period during the First World War, they were never ploughed (fig. 387). The remainder of Hampton Court Park, about 400 acres towards the river, is likely to have been the area grazed by the Hospitallers' 2,000 sheep. The pasture was probably lush and occasionally flooded. Each year the house consumed 6 tons of wheat and 2½ tons of rye in its bakery. The large proportion of high quality wheat, which made the white bread eaten by the rich, as opposed to rye, which made brown bread for the poor, suggests the maintenance of a high-status diet. A similar deduction can be made from the evidence of ale consumption, since far more of the best ale brewed from barley was drunk than the poorer ale made from drage. Important visitors at the manor were therefore entertained with the best possible produce. In addition it is known that over a year the quantities of food and drink consumed at Hampton Court worked out at 50 pounds of bread, 20 gallons of ale and 3½d worth of meat, fish and spices a day. Whilst a daily average gives little idea of the true pattern of consumption it does illustrate the large scale of annual entertainment.

In addition to its role as guest house Hampton Court provided a place for royal pensioners, the distant predecessors of the nineteenth-century grace and favour residents. The extent lists one corrodian or pensioner, Robert Coltman (or Cultman or

Coleman). His pension guaranteed him board, lodging and pocket money for life at the *camera*. Throughout England the Order provided for eighty corrodians, nineteen of whom were resident at the priory of Clerkenwell. The earliest references to royal pensioners at Hampton Court are found in February and March 1317, when Philip de Radynges and Robert de Gardino were granted positions in place of Lambert de Clay and Lambert le Wayfrer, both of whom had recently died. This would suggest that pensioners had been at the house at least since the early fourteenth century. On Coltman's death in 1342 Edward III sent his old retainer, John le Bakere, to Hampton, and after le Bakere's death in 1357 a series of former royal servants enjoyed the privileges he had had, including one of the King's Farriers and a palfrayman (or stableman).[24]

Hampton Court continued to be used as a grand guest house throughout the remainder of the fourteenth century. The names of some of the Hospitaller commanders and their servants are known from Hospitaller records. In 1307 the commander of the house was one Henry de Loffewyke, and a later incumbent was named William Bishop. At another time there was a marshal called Richard who is described as 'keybearer'.[25] Other than these bald facts only one specific incident is recorded. In March 1353, during a visit by King Edward III and his household to Hampton, the house caught fire and was evidently severely damaged or even destroyed. The king, who appears to have accepted responsibility for this mishap, appointed William Waryn of Kingston and John Sakers to oversee the rebuilding of the 'grangias' or barns and other houses at his expense.[26] Waryn was a leading royal carpenter whose most important recorded work was the reconstruction of the roof of St George's chapel at Windsor Castle in 1352–3. He was also employed to undertake repair work at the queen's manor of Isleworth.[27] About Sakers nothing is known but that he and Waryn recruited the necessary carpenters, sawyers and tilers to complete the work at the king's expense. It is not possible to tell what it was they built at Hampton, but it is certainly possible that the large timber hall, remains of which were excavated beneath the present hall in 1974, was a part of their work.

Hampton's relationship with Byfleet and its role as guest house remained important until, soon after 1414, Byfleet was dismantled by Henry V. After this the significance of the house declined and the Knights Hospitallers probably let the manor. The extent of 1338 indicates that about 10 per cent of their properties were already let for a cash rent, and this percentage grew during the fourteenth and fifteenth centuries, leaving only 20 per cent in direct management by the turn of the fifteenth century. Hampton was almost certainly leased from the early fifteenth century: there is no evidence to suggest that the Hospitallers paid the sort of attention to the property that would have been required if they had retained it. Sadly, the first entries in the earliest surviving lease book date from 1492 and so it is not possible to identify the earliest tenants of Hampton Court.[28]

The Earliest Buildings

So, if the surviving documents suggest that Hampton Court performed a special function during the fourteenth century and until about 1414, one might expect the buildings themselves to be out of the ordinary. In order to consider this proposition it is necessary to turn to what is known in general of the preceptories of the Knights Hospitallers in the fourteenth century. Most of these manors, in common with their secular counterparts, were enclosed within a precinct usually defined by a moat or ditch. These could be very large: the one at Beverley in Yorkshire measures 273 ft by 396 ft; and the one at Chibburn in Northumberland is 327 ft across. Their very size suggests that such enclosures were intended rather to define boundaries than for security, although security was always an issue, particularly at sites that stored agricultural produce. Most of the smaller properties seem essentially to have been granges, comprising barns, brewhouses, dovecotes and minor residential structures with an integral chapel. At larger sites accommodation was more extensive with a timber-framed ground-floor great hall and an adjacent masonry two-storey chamber-block. There were usually also ancillary buildings including a gatehouse and kitchens. Most preceptories were, in terms of planning, more or less identical to episcopal palaces, abbots' lodgings and noble manor houses. Functionally they were neither manor nor monastery, yet they had elements of both.[29]

Bearing these points in mind I now turn to what is known of the early physical appearance of Hampton. The evidence comes from two sources – the extent of 1338 and the evidence of archaeological investigation. In 1338 there was a messuage with a chapel, garden and pigeon house with an annual value of 15s; there was also a large number of staff. These points suggest a house of some size and archaeological evidence bears this out. Evidence of an early moat has been found in five separate archaeological excavations over the last thirty years, and these have permitted an identification of the site and approximate size of the original moated platform upon which the buildings stood (fig. 3).[30] No dating evidence has been found to suggest when the moat was first dug, but some time later (or possibly as part of the original

3 The site of Hampton Court Palace before 1450, showing excavated and extant features in black line and conjectural features in dotted line. Drawing Daphne Ford.

4 Plan and section of the undercroft of the chamber-block of the Knights Templar (later transferred to the Knights Hospitaller) at Strood in Kent published in *Archaeologia Cantiana* in 1897.

5 *(facing page)* The two-storeyed hall and chapel of the Knights Hospitaller at Swingfield in Kent.

conception) a brick revetment wall (buttressed on the south) was added. On the west side was a small enclosure within the revetment that might suggest either a landing stage or the footings of a bridge.[31] The total area enclosed by the moat measures approximately 400ft by 260ft. Traces of a number of other structures have been identified within the moated area. The most substantial of these is part of a stone undercroft now incorporated into the east range of Clock Court, which can be tentatively identified as part of a two-storey masonry chamber-block. Two walls of roughly coursed stone incorporate an inserted fifteenth-century window and are cut, at their upper levels, by Cardinal Wolsey's east range. These walls suggest a stone building 22ft wide and up to 80ft long, dimensions that equate with Hospitaller chamber-blocks elsewhere.[32] The Hampton Court structure can, to some extent at least, be visualised through comparison with these.

At Strood, in Kent (fig. 4), there is a chamber-block dating from about 1250 erected by the Knights Templar, whose lands were transferred to the Hospitallers on the Templars' dissolution in 1314. Documentary evidence reveals that the site had originally also had a hall, chapel, buttery, kitchen and a barn. Today only the chamber-block survives, on an undercroft of three bays with quadripartite vaults of squared chalk blocks with chamfered ribs. It is entered via an external stair and through a richly decorated door with Purbeck shafts. Internally the space was divided in two, the larger of the spaces having arcaded walls. A very similar structure was found at Moor Hall, Harefield, in Middlesex. Approached by an external stair, the first floor had also originally been divided into an inner and a larger outer chamber. At Moor Hall documentary sources reveal that the site was moated and also comprised a timber ground-floor hall.[33]

To the west of the postulated chamber-block at Hampton Court, in the undercroft of the present Great Hall, has been excavated a series of post holes, with fill dated to before 1450 (fig. 63).

Associated with these is a rubble foundation wall on an east–west alignment. The post holes and wall may be related to a timber-framed building forming the north side of a courtyard, and possibly a great hall or barn.[34] Indeed it is possible that this building might be associated with the timber barn or hall constructed by William Waryn and John Sakers after the fire of 1353. In addition to this archaeological evidence there survives an inventory of Hampton taken in 1495 which records the contents of the great hall.[35] If the hall of 1495 is the same as that which was excavated, and the evidence suggests that it was, it contained two fixed tables, probably at its upper end, and two long trestle tables that probably ran its length. There were four forms, or benches, and a close cupboard, and around the central hearth was an iron railing. The only surviving Hospitaller hall is at the preceptory at Temple Balsall in the West Midlands, where there is a three-bay timber-framed hall of before 1250 with aisles added a hundred years later. Also standing are a parlour and chamber cross-wing added by the Hospitallers around 1500 which provide a nice parallel to Hampton.[36] In addition to Hampton's chamber-block and hall a fragmentary wall has been seen beneath the earliest phase of existing kitchens. It may relate to this phase of development. Such a wall could be part of an earlier kitchen or bakehouse to the north of the postulated barn or hall. Certainly the inventory of 1495 suggests a well-equipped kitchen and specifically mentions the buttery, an oven and a boiling cauldron set in a masonry base.

The documents reveal that there was a chapel on the site, and early brick walls beneath the present chapel have been interpreted as the remains of an earlier structure. Most *camerae* had small and unpretentious chapels, many of which were retained by the Order while the remainder of the property was let.[37] If the 1495 inventory lists the contents of the original chapel, it would suggest that it had been retained and not let and that it may have been more lavish than most. In addition to the usual portable ecclesiastical

equipment, there were wooden statues of Christ, the Virgin, St John and St Nicholas, a panel painting of the Cross, a chest and two pews. Of its architectural form there is only one clue: there was a tower with two bells in it, one of which was broken. The sound bell is usually identified with the one that survives in Anne Boleyn's gatehouse. It was cast in Thomas Harry's foundry in 1479 and bears the inscription STELLA + MARIA + MARIS + SUCCVRRE + PIISIMA + NOBIS (Mary most Gracious, Star of the Sea, come to our assistance). The inscription, however, seems more appropriate to a ship than a manor house, and the bell cannot be certainly identified with that listed in the inventory. It is suggested here, then, that the chapel was probably of some substance and splendour. It may have been similar to two stone Hospitaller chapels in Kent that survive more or less in their entirety. The preceptory at Sutton at Hone still has a chapel of 1234 with flint and rubble walls and an oaken roof with tie beams and an octagonal king post. A piscina and aumbry survive at the east end. Not far away, at Swingfield, are the remains of another thirteenth-century flint-and-stone chapel, this one joined to a two-storeyed hall with a porch. The chapel has long lancets in its east end, a shafted piscina and pointed wall cupboard (fig. 5).

Since the Hospitallers employed a gatekeeper it is likely that there was a gatehouse in common with the more important preceptories. A pigeon house is also listed but no trace of it has yet been found. Hospitaller dovecotes survive at Quenington, Gloucestershire, and Garway, Herefordshire.[38] There was also a stable.

The Hampton Court of John Wode

It is not known when this group of buildings was first let by the Order and the first lease of Hampton of which there is any record was to John Wode. There is no date for its grant, merely the information that Wode held a lease of the property on the same terms upon which it was regranted in 1494. Wode was Hampton Court's first important owner, a major Yorkist figure and favoured servant of both Edward IV and Richard III.[39] Born in 1425, he was the son and heir of John Wode the elder, who was probably Clerk of the Estreats in the Exchequer in Henry V's reign. His early life is still obscure but he rose to royal employment in the Treasury by 1444–5, and from 1452 to 1455 he was Under-Treasurer of England. Most importantly he was made Speaker of the House of Commons during Edward IV's last parliament in January 1483 and was knighted on the rising of Parliament the following month. The position of Speaker was crucial to the management of the House of Commons by the Yorkist kings. The role combined the two modern roles of Speaker and Leader of the House, and all Edward IV's Speakers including Wode were prominent royal servants rewarded well for their service. Wode as Speaker was essentially a royal nominee with direct responsibility for guiding the king's business through Parliament. Wode's fortunes rose further still under Richard III, who was a friend and who appointed him Treasurer of England. Richard also made him a vice-admiral in the new Admiralty office. Wode, however, died in August 1484, and was thus spared the inevitable decline in fortunes that would have befallen him with a change of dynasty.[40] Wode was thus a high-flying administrator, sometime royal favourite and man of great local influence and power. He was also very rich. His wages as Under-Treasurer were between 5d and 8d a day plus an annual fee of £40; in addition to this he was rewarded with special payments for undertaking other duties. These included £66 13s 4d for work progressing royal business through Parliament in 1454 and another £100 for his attendance in London, and in 1455 a further £100 for expenses in undertaking his work as Under-Treasurer. However, his real wealth came from selling and exporting royal wool, which grossed him the colossal sum of £3,000 in

the 1450s and triggered a parliamentary investigation into his finances.

Wode also came into considerable lands. He had inherited his own family's estates at West Wittering and elsewhere in Sussex; and marriage to his first wife, Elizabeth Michell, brought him parts of the Michell lands in Hertfordshire, and further lands in Northamptonshire and Cambridgeshire as well as the property of Rivers Hall in Boxstead in north Essex. These were all far from Westminster and the focus of his working life, so he must have been delighted when the death of his mother-in-law brought him a third share of the manor of East Molesey across the Thames from Hampton Court in 1455.[41] Wode's activities were tightly focused on the area around Hampton and Molesey, suggesting that this was his favoured location. He was a justice of the peace for Surrey for virtually the whole period from 1452 until his death in 1484. He was Knight of the Shire for Sussex in 1449–50 and 1472–5 and for Surrey in 1460–61, 1478 and probably 1483. He was also Sheriff of Surrey and Sussex in 1475–6 and 1478–9. In 1462 he was appointed Keeper of Swans on the Thames, and was one of the Commissioners appointed to survey the river in 1476. Little is known of any property that he may have inherited in Molesey, but as he was known as 'of Molesey' he presumably lived there.[42] Likewise late in his life he was known as 'of Hampton Court', which suggests that he had by then moved over the river to the Knights Hospitallers' property. Wode died in August 1484 and, having no issue by either his first or second wife, Margery, who survived until 1526, his estates went to his younger brother, also called John, who died only fourteen months later, also childless.[43]

The lease of 1494 that mentions Wode's tenure of Hampton Court was the same as that which Wode himself was granted, and it makes clear that he had the right to alter and rebuild parts of the house as he thought fit. It is therefore possible that the inventory attached to the lease describes Wode's house including improvements made by him. However, caution must be exercised, because the inventory may equally describe the house as let by the Knights to one of Wode's predecessors. The only structure mentioned in the inventory that might be tentatively attributed to the late fifteenth century is a tower. The inventory of 1494 lists 'A presse in the towre-chambre, a great coffar in oon of the towre chambres; a parclosse [screen] in the towre'. Nothing more is known of this, but it is worth noting that the extension of the residential part of the house (the chamber-block) by a tower lodging would have been entirely consistent with the way in which episcopal and noble houses were developed in the late fourteenth and fifteenth centuries.

The Hampton Court of Lord Daubeney

After an interlude of ten years during which Hampton Court was probably used as a country house by John Kendall, Prior of the Order of the Knights Hospitallers in England, the property was re-leased to Giles Daubeney. Daubeney was born in 1451, the son and heir of William Daubeney (fig. 6). He joined Edward IV's household, accompanied him to France in 1475, and was knighted in 1478. In 1483, after participating in Buckingham's unsuccessful rebellion, he was attainted and fled to Brittany to join the future Henry VII and his court in exile. Later, he fought bravely at the battle of Bosworth and was subsequently rewarded with a series

6 The tomb of Lord Daubeney in the chapel of St Paul at Westminster Abbey. Three of Henry VII's courtiers were honoured with burial in the Abbey; the others were Sir Humphry Stanley and Thomas Ruthall, Bishop of Durham, the king's Secretary.

of high offices. He became Privy Councillor, Master of the Mint, and then in 1486 Lieutenant of Calais; the same year he was made a baron. In 1495 he was made Chamberlain of the Household.[44] In 1497 the Milanese ambassador justly described Daubeney, Sir Thomas Lovell and Sir Reginald Bray as the most powerful men in the kingdom.[45] One of the greatest men of his age, Lord Daubeney was enormously influential and powerful, with constant access to the king. He was highly cosmopolitan, having been in exile in France and served seven years as Lieutenant of Calais; and he had enough assets in lands and fees to make him very rich. It is thus worth considering why he should have been interested in Hampton Court. The first reason is that although Daubeney was reaching the peak of his power and influence in the early 1490s he had no great house near London. His colleagues and equals such as Sir Thomas Lovell, Chancellor of the Exchequer, and from 1502 Treasurer of the Household, had seats near London. Lovell acquired the manor house of Elsynge at Enfield on an important route just outside London near royal hunting grounds. Lovell played host to Henry VII there in 1497 and 1498.[46] Daubeney, it is suggested, must have been looking for a suitable property commensurate with his increasingly elevated status.

In the early 1490s Henry VII began major building work at Richmond, where he intended to establish his principal residence. Works there were nearing completion in 1495 but were seriously set back by a major fire in 1497. Work restarted and was largely complete by 1501, although building was to continue almost to Henry VII's death. The establishment of the court at Richmond soon meant that it was encircled by a band of courtier residences. In 1495 and until his imprisonment in 1504, William, Lord Courtenay and his wife Katherine, sister to Henry VII's queen, had a country house at Kew, later used by Katharine of Aragon. In 1505 Sir Charles Somerset, later Lord Herbert, the King's Captain of the Guard and Vice-Chamberlain of the Household, bought a 19-acre estate at Kew.[47] Richmond was five miles by road and a faster seven miles by barge from Hampton Court (fig. 2) and this fact

more than anything else must have made it an attractive location for the aspiring Lord Daubeney. We do not know how Daubeney got to know of the property. He may have known Wode, or even possibly have visited Wode there, but there is no evidence for a connection between the two men. It is much more likely that Daubeney heard of it through John Kendall, with whom he sat on the Privy Council. Subsequent surviving correspondence would support this theory. At any rate Kendall signed an eighty-year lease on the property with Daubeney on 23 July 1494 at the commandery of Melchborn in Bedfordshire.[48]

The following year Sir William Stanley, the king's Lord Chamberlain, was executed for high treason after Perkin Warbeck's rebellion. Daubeney was appointed Chamberlain in his stead, adding to his many responsibilities the position of Head of the King's Household. Now, with constant attendance at court, Daubeney's new house at Hampton was going to be crucial to him. The eighty-year lease that he had bought seemed restrictive and he started negotiations to acquire the freehold forthwith. In the archives of the Knights Hospitallers in Malta is the registered copy of a letter written to John Kendall dated 1 October 1495. It is a response to a proposal discussed that day by the Council of the Order to exchange Daubeney's manor of Yeldon, worth £50 a year, for the manor of Hampton Court, stated to be worth £40 a year. Kendall was told that the request was to be remitted to the next chapter general in September 1497 pending investigation of the relative values of the properties.[49] This, and further correspondence, shows that only months after his appointment as Lord Chamberlain, Daubeney opened negotiations to acquire the freehold of Hampton Court, enlisting the help of both John Kendall and Henry VII himself to do so. There is no written record of the council's investigations because the relevant registers are now lost, but it must be assumed that they decided against an exchange, for on 15 June 1505 Sir Giles took a new lease on the property.[50] Yet his negotiations had borne fruit, and the new lease gave him a much less encumbered tenure. The lease was longer (ninety-nine years) and he no longer had to find an able priest to 'sing and minister divine service' in the chapel on the Knights' behalf. In practical terms there was now no difference between his tenure of the house and the freehold. Even before he had obtained these concessions he had begun to enlarge the estate. In 1499 he bought six ploughlands containing 300 acres in Hampton and emparked them, displacing twelve tenants.[51] This purchase symbolised Daubeney's determination to enlarge and beautify his property and to transform it into a seat of national importance.

Soon Daubeney, like Sir Thomas Lovell, began to use his house to entertain the royal family. In October 1500 Lovell paid out £300 at Hampton Court on the king's behalf in part payment for 312 butts of malmsey, suggesting that the king was staying and entertaining there. He returned the following July, probably as Daubeney's guest.[52] Sadly nothing is known of Daubeney's household, nor any of the details of these early visits, but it is possible to put some of the later royal visits into a more personal context. The years 1502 and 1503 were dominated by a series of personal disasters for Henry VII, in the midst of which Elizabeth of York often stayed at Daubeney's house. On 28 March 1502, a few days before the death of Arthur, Prince of Wales, she was at Hampton Court. She moved from there to Greenwich, where on 2 April she and the king received news from Ludlow that their eldest son was dead. Two days later one of Elizabeth's gentlewomen, Elyn Brent, was rowed in the queen's barge from Hampton Court to London, and on 12 May the barge was sent again, this time from Richmond to Hampton Court to collect Mrs Brent.[53] These trips suggest that the queen and her household were regular visitors at Hampton Court that year.

In the early summer of the same year Elizabeth became pregnant for a seventh time. Despite the fact that the queen was only in her mid-thirties she had a difficult pregnancy and was seriously ill for much of the summer whilst on an arduous progress to the west. On her return elaborate arrangements were made for her confinement, which was to take place at Richmond. As her time drew near it was decided that the queen should spend some time at Hampton Court, and so on 7 January 1503 she was rowed up river in a 'grete bote' which was moored outside the manor house for the week she stayed there. Her visit ended, Elizabeth and her ladies were rowed back to Richmond, and on 26 January she was rowed on to Westminster. The king and queen intended to celebrate Candlemas at the Tower and so they moved again to what were, in fact, their most modern apartments – a new tower overlooking the Thames in the King's Lodgings probably only completed six weeks earlier. On 2 February the queen gave birth prematurely to a girl christened Catherine, who died a few days later. The queen herself died on 11 February, leaving a grief-stricken husband.[54] The king and other important courtiers visited Lord Daubeney at Hampton Court on and off over the following years. In January 1506 Lovell, who was evidently staying there, gave his servant Lionel Denton an allowance of a shilling a day for his three-day stay. In March 1507 and January 1508 Henry VII came from Richmond to Hampton Court by barge.[55] Four months after this latter visit, on 20 May, Daubeney died. His undated will left the manor, valued at 400 marks, to his wife Elizabeth to hold for forty years, after which it was to pass to his heirs for the remainder of the term. The value of the manor, which had been estimated at £40 a year in 1495, had now increased to over £266. Even allowing for inflation and the purchase of additional land, a 666 per cent growth in value in only thirteen years would confirm that Daubeney had made major additions to the house. It is to these that I now turn.

DAUBENEY'S HOUSE: THE STRUCTURES

Careful analysis of the surviving early Tudor buildings at Hampton Court and several archaeological excavations suggest that the house was extensively rebuilt in the late fifteenth century. A phase of pre-Wolsey building can be identified through the incidence of the use of a unique type of sandy red-brown mortar. Unfortunately there is no decisive dating evidence provided by archaeology or the documents to help us discover who the instigator of this work was or its date. The two principal candidates must be Wode and Daubeney and, in view of the status of Daubeney, and the massive increase in the value of the property during his tenure, the rebuilding can probably be safely attributed to him. It is likely that the principal works were undertaken soon after his purchase of the 1495 lease. The lease made provision for Daubeney to 'take, altre, transpose, breke, chaunge, make and newe bilde at ther propre costes any howses, wallis, motys, dyches, warkis, or other things within or aboute the seid manour'.[56] This clause, although a fairly common one found attached to Hospitaller leases, was by no means universal, and can be understood as an indication of

Daubeney's intention to undertake substantial building work. As outlined above, from about 1500 Hampton Court was used by Daubeney for entertaining the royal family including, in 1503, the sick queen. This suggests strongly that at that period there were suitable lodgings for his royal guests, and that no major building works were underway that would have detracted from their peaceful enjoyment of the house. Thus it is suggested here that Giles Daubeney transformed Hampton Court from a modest country manor into a major courtier house between 1495 and 1500.

In 1495 the main structures, with the possible exception of a tower, were probably early medieval in date. The chapel was probably the medieval chapel of the *camera* with the Knights' chaplain's furnishings. The hall is also likely to have been that of the early medieval house, with its fixed benches and central hearth. The kitchen and buttery, probably to the north of the hall, were equipped with all the basic requirements for feeding a small household. There was evidently a tower with at least one chamber in it, and this is likely to have formed part of the chamber-block on the east side of the inner court. The parlour, which contained a table and a parclose (screen), was probably the ground-floor room in the chamber-block at the upper end of the hall. All except for this latter part was soon to be swept away.

The most important parts of what I shall call Lord Daubeney's house were revealed in a large trench dug across modern Clock Court in 1966–7 and 1973–4 (figs 7, 63). It was found possible to link the excavated features to surviving fifteenth-century elements embedded in early sixteenth-century work, and thanks to these investigations it is now possible to characterise Daubeney's mansion (figs 8, 9). It was of a typical late-medieval plan, ranged around a courtyard with a great hall on the north and an entrance range facing it on the south. Most of the ecclesiastical and courtier houses on the Thames faced the river, and Hampton Court was no exception. It is still unclear what lay between the moat and the river itself, although two massive brick foundations have been found that pre-date Wolsey's buildings and may possibly have formed part of an outer courtyard or forecourt to Daubeney's

8 The site of Hampton Court Palace in the years 1495–1514, showing excavated and extant features in black line and conjectural features in dotted line. In this phase a south-facing courtyard house was established. Drawing Daphne Ford.

7 (*below left*) Air view of the trench in Clock Court revealing Lord Daubeney's new brick-built south range as excavated in 1966–7. This photograph looks towards the Great Hall.

9 A conjectural axonometric visualisation of Lord Daubeney's house around 1513. This is intended to illustrate the scale and accretive appearance of the immediate pre-Wolsey house. The only structures that substantially survive are the kitchens on the north (top right) side. Drawing Daphne Ford.

FIRST FLOOR

GROUND FLOOR

LOCATION PLAN

EXISTING
DEMOLISHED
? CONJECTURAL

RECONSTRUCTED VIEW

10 Plans and reconstructed perspective of the garderobes in the westernmost five-sided turret on Lord Daubeney's south front. The shaded parts of the plans represent extant masonry. Note the aumbrys (wall cupboards) in the first floor garderobe. Drawing Daphne Ford.

house. The south front was a structure of some pretension built upon the earlier revetment wall. The full length of the range is unknown because, although its western corner was excavated, its eastern end now lies beneath later work and remains to be found. Yet since the eastern wall of the east range has been identified, it can be suggested that the entrance front was about 150ft long. It was very shallow, measuring 17½ ft externally and probably only 12–13ft internally. The façade was asymmetrical and the 18ft-wide structure that has been identified as the gatehouse probably lay to one side. The gatehouse was 32ft deep, and projected to both the back and the front of the narrow entrance range. To either side of the postulated gatehouse lay the foundations of three five-sided projections. These contained garderobes at ground- and first-floor level, one of which partially survives, encased in later work of Wolsey's (fig. 10). The garderobe enclosure is fitted with small wall cupboards that were made to contain necessaries and possibly rush lights. The foundations for two large chimney-stacks were also found on the south front; the complete one was 10ft wide. Altogether the south front, with its gatehouse, garderobe turrets and chimney-breasts, must have presented a highly articulated façade and an impressive, if lop-sided, entrance.

Daubeney's great hall, which lay opposite the entrance range immediately beneath the existing hall, was excavated in 1974 (fig. 63). It can be seen that the hall, which was of brick, was on the ground floor and had at its north-east corner a stair tower containing a stone stair built round a central core. This led up from the hall to the principal rooms of the east range. The south wall of the great hall was not seen in excavation, probably because it provided part of the foundation for the south wall of the present Great Hall.[57] If this is the case the hall must have been about 30ft wide internally. It was probably 62ft long. We know this because its east wall survives as the east wall of the present hall, and a substantial cross wall was found in excavation that probably formed its west wall. There is likely to have been a bay window at the

11 The single surviving fifteenth-century roof truss in Lord Daubeney's kitchen. The remainder of the roof is nineteenth century and later.

east end, but this has not been proved archaeologically. Typically the hall would have been entered through a porch directly aligned with the gatehouse, and if the west wall of the hall has been correctly identified the location of the porch can be postulated (fig. 8). The foundations seen in 1974, to the west of the porch and screens passage, would have enclosed the buttery and pantry.

To the north of the great hall lay the kitchens. For many years the earliest phase of kitchen was thought to date from the Wolsey period, but it is now clear that both its extent and alignment were determined by the moat that surrounded Daubeney's house. Indeed, beneath the kitchen is a culvert that originally drained into the early moat and was extended first by Wolsey and then Henry VIII. The early moat was filled by Cardinal Wolsey immediately after 1514 to build the present Base Court, which strongly suggests that the kitchens must pre-date 1514.[58] If this is so they are the largest part of the pre-Wolsey house to survive. The kitchens are in three separate areas: first, the main kitchen, a roughly square building measuring approximately 47ft by 43ft externally, with two dressers (small rooms used for dressing dishes bound for the table) to its south; second, to the east, a serving area with administrative offices; and last, to the west, a large scullery 36ft square (fig. 8).

The scullery was later remodelled by Henry VIII as an extension of the original kitchen, but in 1978 a small trench located its fifteenth-century north-west corner and evidence of a possible cellar area beneath it (fig. 8). Its east wall was pierced by two doors, presumably an 'in and out' arrangement as in any modern kitchen. Spanning both the scullery and the Great Kitchen next door was a single queen-post roof. It was replaced in the nineteenth century but the end truss of the original roof, with a hollow chamfered moulding, survives against the east wall of the great kitchen, as does a series of four pairs of stone corbels that would have supported the trusses. The form of this great truss places it firmly in the late fifteenth century (fig. 11).[59]

The Great Kitchen contained three fireplaces: two massive ones both more than 15ft wide for roasting meats; and a smaller one, presumably for stewing, boiling and making sauces (fig. 12). To the west of the northern fireplace was a boiling cauldron set over a furnace in a masonry base. Its purpose was to boil meat and produce the gallons of stock required for sauces. Such cauldrons

12 Lord Daubeney's Great Kitchen showing the large fireplace on the south wall designed for roasting sides of meat over wood fires.

were essential in a kitchen that catered for large numbers, and Henry VIII replaced this with a bigger one (see below and fig. 46). Another near-contemporary example survives at the major Tudor house of Basing in Hampshire. The east wall of the kitchen has two doors, aligned with those to the scullery, again to facilitate smooth circulation, and two serving hatches. On the south side of the Great Kitchen, towards the Great Hall, are two working houses or dressers. Both have small fireplaces and hatches opening out into the serving area to the east. Across the serving area, large enough to accommodate a battalion of waiters and serving-men, lay a two-storey administrative block. One ground-floor room on the north was reserved as a third dresser, but the remainder would have accommodated the Clerk of the Kitchen and his staff on two floors. Many hundreds of years later this same group of rooms still contains the principal administrative offices of the palace.

In plan, Daubeney's kitchen and hall lay side by side with a large serving place where the waiters were marshalled during great feasts. In this way Hampton Court was organised in the same way as were the great late fifteenth-century mansions like Knole, and royal palaces such as Eltham and Richmond, rather than as in earlier fifteenth-century houses where the hall and kitchen lay on a single axis. This reflected the needs of Daubeney's household and his desire to entertain the king and queen to the very highest standard.[60] It reflected also the fact that Hampton Court was designed with the latest planning fads in mind.

On the east was a range of buildings that must have contained the principal lodgings of the house approached by the stone stair at the north-east corner of the Great Hall. Since this eastern range remained the site of the principal lodgings of the house until 1689, traces of Daubeney's rooms have long since gone. Even the parlour which would have existed immediately to the east of the Great Hall was swept away by Henry VIII's cellar in 1536. However, there is archaeological evidence that the undercroft of the chamber-block was given a new window. More evidence for the extent and nature of Daubeney's rooms lies sealed beneath later alterations, waiting to be uncovered by future generations during repair or maintenance work.

★ ★ ★

13 Oxburgh Hall, Norfolk from the north west. A licence to crenilate was granted in 1482. Despite alterations in the late eighteenth century, Oxburgh remains a close parallel to Hampton Court in around 1513.

Fifteenth-Century Hampton Court in Context

Having characterised Daubeney's new house it is worth pausing for a moment to consider how it compared with the other courtier houses of the age. What seems clear is that John Wode's house was probably fairly modest, despite his wealth. As we have seen, he also owned his wife's house across the river in East Molesey and a country house in Essex. It has not yet been possible to determine the nature of either of these, but Wode, although rich and influential, was not in Daubeney's league, let alone that of the really great contemporary builders like Archbishop Morton. It was Daubeney who was responsible for transforming Hampton Court into a brick-built moated courtyard house in the manner of Oxburgh Hall in Norfolk (built after 1482) (fig. 13), Brigge Court, the Archbishop of York's Thames-side house at Battersea and the house of the first Marquis of Dorset at Bradgate in Leicestershire.[61] As at Oxburgh, but not the great episcopal, archiepiscopal and collegiate buildings of the last quarter of the fifteenth century, the form of Hampton Court was dictated by its moat. Yet within the moat was a house that was architecturally coherent on two, if not three, sides, built of brick with stone dressings following the fashion set at Eton College and disseminated in the Thames valley during the late fifteenth century. Its principal facades were asymmetrical and marked by tall chimney and garderobe shafts as at the slightly earlier castle at Herstmonceux in Sussex, or the later house of Chenies in Buckinghamshire. Closer still in appearance to Hampton Court must have been the recently excavated Brigge (or Bridge) Court in Battersea. Facing the river and brick-built, its facades articulated by turrets, it is a close parallel to Hampton Court. But perhaps the closest parallel at this time was Elsynge at Enfield, the house of Daubeney's close associate, Sir Thomas Lovell. Elsynge has been only partially excavated, yet it too was a brick-built, asymmetrical, moated courtyard mansion built to entertain Henry VII and his family. Both were suburban retreats: not palaces on the scale of Archbishop Morton's houses at Otford, Croydon and Lambeth; but more like the bishop of London's seat at Fulham, houses built by men of substance and power who wanted to be in a few hours' reach of the court.[62]

Lord Daubeney died in 1508, with his heir, Henry, still a fourteen-year-old minor. Hampton Court's future was again uncertain.

Chapter 2

THOMAS WOLSEY'S HAMPTON COURT

FOR MANY, THE SPRAWLING MASS of building that Hampton Court Palace is today is exclusively associated with Thomas, Cardinal Wolsey, and his royal master Henry VIII. A substantial proportion of what remains was built by Wolsey, yet despite this abundance of architectural information virtually nothing is known about Wolsey himself, the man who commissioned, lived in and enjoyed Hampton Court. Although surviving records richly chronicle his professional career, the evidence that could have illuminated the character that drove it and built Hampton Court is sadly lost.

But the bare facts do exist. Wolsey was probably born in Ipswich in 1472, the son of an innkeeper and butcher, and, at the age of about fifteen, went on to Magdalen College, Oxford, possibly as one of the Bishop of Norwich's scholars. After leaving Oxford in 1501 he was briefly chaplain to the Archbishop of Canterbury, and then held a post in the household of Sir Richard Nanfan, the Deputy Governor of Calais. In 1507 he gained a chaplaincy in the household of Henry VII. As royal chaplain his duties were unlikely to have been exclusively spiritual: both his education and his experience in Calais equipped him for use by the king in a whole range of administrative and diplomatic tasks at home and abroad. Wolsey's transfer to the household of Henry VIII in 1509 seems to have been fairly smooth and his promotion thereafter rapid. In February 1513 he was given the deanery of York and later in the year, as a reward for his success organising the French campaign, the bishopric of Tournai. The bishopric of Lincoln followed in February 1514, and in September 1514 the archbishopric of York. On 10 September 1515 he was made cardinal by Pope Leo X, and on Christmas Eve of the same year, Lord Chancellor. Wolsey's preferment did not cease there, for in May 1518 he obtained his first commission as legate *a latere*, a power that was to be subsequently extended and finally granted for life in 1524. In 1518 he also took on the bishopric of Bath and Wells which he exchanged in 1523 for that of Durham, and in 1528–9 for that of Winchester. In addition to this succession of bishoprics he received the premier abbacy of England, that of St Albans, in November 1521.[1]

Like Lord Daubeney before him, Wolsey's need for a magnificent residence was driven by his promotion. As early as 1510 he began to build a mansion for himself on the banks of the River Fleet, just outside of the City of London at Bridewell. This was always a relatively modest construction. The turning point came when, in September 1514, Wolsey was appointed Archbishop of York and acquired the see's two London houses: York Place, Westminster, and Brigge Court in Battersea. He gave up Bridewell and turned his attention instead to these handsome new acquisitions. In addition, just four months later, he signed a ninety-nine-year lease on Hampton Court. Hampton Court was different from any of Wolsey's other properties. He did not hold it through any office, but rather as a personally owned and private residence. Unlike his other great mansions, Hampton Court was chosen by Wolsey. The ambitious, and now fabulously rich cardinal could have chosen any residence in the Thames basin, but alighted on Hampton as the site for his most personal and most extravagant architectural work. It is necessary, for a moment, to consider why.

It is not clear how well Wolsey would have known Daubeney. They both served at Henry VII's court, but only for a year, since Daubeney died in 1508. Yet Wolsey would certainly have been interested in one of the most senior figures at court, and have known of his house at Hampton. Sadly, it is not known when he first visited the place; he may have done so during the lifetime of Lord Daubeney, but this seems unlikely in view of their fleeting acquaintance. At Daubeney's death his son Henry was a minor and in 1510 Henry VIII granted the boy's mother his wardship and marriage.[2] It has not been possible to ascertain what use Daubeney's widow made of her late husband's house in this period. We know that Daubeney died in debt and it is possible that his mansion was let. Henry Daubeney came of age in 1514, and on 19 December he was granted livery of his lands as his father's heir. These lands presumably included Hampton Court, and we know that a month later Hampton was re-leased to Wolsey.[3] No record survives of the financial transactions whereby the lease was given up and transferred to Wolsey, only of the transfer itself. Yet the speed with which it was accomplished suggests that the young Daubeney was eager to rid himself of the house.

The key to the transaction was almost certainly Thomas Docwra, prior of the Knights Hospitallers. Docwra was a trusted and skilled diplomat and advisor to both Henry VII and Henry VIII. Not only did he know Daubeney well but he also worked very closely with Wolsey in the Court of Star Chamber, in the Privy Council, and on foreign policy.[4] Docwra must have seen Wolsey almost daily over the period 1508–14 when the future of

Hampton Court was uncertain, and it was almost certainly he who suggested to Wolsey that the house might be suitable for him. It would also have been Docwra who authorised the transfer of the lease from Henry Daubeney to the cardinal. There was one aspect of the transaction, however, that did not please Wolsey. The property was to be leasehold, and he wanted a freehold. Correspondence survives to demonstrate how Wolsey put pressure on the Order of St John to give him his way. His attempt failed, and it was to be an even more powerful figure, his royal master, who would eventually resolve the issue in 1531.[5]

The Start of Wolsey's Building Work

Wolsey was thrilled with his latest purchase; so much so that he invited the king and queen to come and view it only weeks after its acquisition.[6] By that stage he must have already formulated his plans, for work had just begun. Wolsey, always an efficient and effective administrator, created a construction office centred on Brigge Court in Battersea to oversee the extension of both Hampton Court and York Place.[7] At first this was headed by Robert Cromwell, cousin to the more famous Thomas, but some time after 1516 he was replaced by Lawrence Stubbs. Stubbs, an ordained priest like most of Wolsey's aides, had formerly worked as administrator on the greatest courtier building of the age, the Duke of Buckingham's house at Thornbury outside Bristol. As Wolsey's Receiver General he paid out money for the entire constructional output of Wolsey's works, and it is his name that heads the Hampton Court accounts. Stubbs subsequently became vicar of Kingston and reappears later in the palace's history supplying bricks for Henry VIII's works.[8] Under Stubbs's overall control there were three geographical divisions or offices. One, under Thomas Cromwell, dealt with the two colleges Wolsey had founded and was building at Oxford and Ipswich.[9] The second dealt with The More near Rickmansworth in Hertfordshire and Tyttenhanger near St Albans, both acquired by Wolsey as Abbot of St Albans; and Esher Place, acquired as Bishop of Winchester. These properties were probably under the care of Thomas Heritage. Finally, the largest office, over which Stubbs himself retained control, dealt with Hampton Court and York Place.[10]

It is clear from the surviving building accounts that work on York Place and Hampton Court advanced at the same time. Workmen and materials were moved between the two sites and even the same patterns for stone mouldings were used in both places.[11] Yet the two jobs were entirely different. York Place, smaller than Hampton Court, was focused on the needs of the working cardinal at Westminster. At Hampton Court Wolsey set out to create a country seat that would be used as the setting for great state and royal events, a place to entertain the king and foreign dignitaries. These differing functional requirements were reflected in the development plans. At York Place, for instance, there was a single range of guest rooms; at Hampton Court an entire courtyard. At York Place no rooms were set aside for royal visits; at Hampton Court suites of rooms were provided for the whole royal family.

For the first time in Hampton Court's history a number of fragmentary building accounts survive, and these illuminate the progress of construction. Sadly, they are limited to Wolsey's first phases of building in 1515–16,[12] but they do show that Wolsey began by assembling a crack team of architects and craftsmen to design and execute the work. John Lebons was appointed Master Mason in January 1515. He continued to work at Hampton Court until Henry VIII gained possession of the house fifteen years later, by which time he was also the mason in charge at Cardinal College, later Christ Church, at Oxford. Lebons was a highly skilled designer and craftsman. He is described as being one of the king's Master Masons in 1506, and was one of the three masons who had managed the work on Henry VII's tomb at Westminster Abbey. His contemporaries and colleagues were the great Master Masons Henry Redman and William Vertue who had worked on Eton College, Westminster Palace and Windsor.[13] His deputy was John Forman, the Warden, who possessed a royal warrant to impress masons for the works. Forman later travelled north with Wolsey and became Master Mason at York Minster. Lebons was probably the chief designer for the new house and the accounts record that he was supplied with paper for drawing plans.[14] One of his key associates was the Master Bricklayer, Thomas Abraham. Abraham is a much more shadowy figure, but was probably almost as important as Lebons since he contracted, together with one John Rowe, for all the brickwork for the new outer court, today's Base Court. After Wolsey's death he worked at Hampton Court for Henry VIII in 1532, 1534 and 1536, but not full-time. Clearly Abraham had other commissions of which there is now no record.[15] The Master Carpenter was Richard Russell, one of the greatest carpenters of his day, who had been responsible for masterminding both the complex scaffolding and the centring for the vaults at Westminster Abbey and King's College, Cambridge.[16] He oversaw the works at both York Place and Hampton Court for a wage of £3 6s 8d for eleven months' work. The carpenter who heads the lists at Hampton Court, and thus was presumably the man in charge on site, was Thomas Smeton. Little is known of Smeton,[17] but he continued to work at Hampton Court, after Wolsey's fall, as Warden Carpenter until 1536. The Clerk Comptroller of Works was Nicholas Townley.

The list of those responsible for Wolsey's Hampton Court highlights an important point. These architects and master craftsmen and their circle had been responsible for the greatest late Gothic buildings in England – at Windsor, Eton, Westminster and Cambridge – and would also have known the great aristocratic and episcopal mansions of the age. Yet their work at Hampton Court, although rooted in the fifteenth century, contains a number of important and influential innovations which I shall turn to in due course. Building, which began almost immediately, continued with only short pauses until Wolsey's fall in 1529. During the whole of this period Wolsey continued to use the house not only for his own residence and for the entertainment of the king and queen, but as a setting for great diplomatic occasions. Two of these momentous events divide the main building phases: the first was the visit of the emperor Charles V in June 1522, and the second was the arrival of the French embassy of November 1527. These visits were periods of calm in an otherwise more or less uninterrupted building programme.

★ ★ ★

14 Hampton Court in 1514–22, Thomas Wolsey's first phase of work, showing excavated and extant features in black line and conjectural features in dotted line. Drawing Daphne Ford.

The First Phase of Work to June 1522

The scheme for Hampton Court as devised by Wolsey's designers in 1514 was to extend it to create a double courtyard house similar to the great fifteenth-century mansions of Sudeley Castle, Gloucestershire (for Sir Ralph Boteler, 1441–58); Knole House, Kent (for Archbishop Thomas Bourchier, 1456–c.1470); and Wingfield Manor, Lincolnshire (for Ralph, Lord Cromwell, 1439–50). This type of extension, whereby a new courtyard was added to an older core, was not uncommon and further examples will be discussed below.[18] In addition to the new courtyard the older lodgings were overhauled, modernised and extended, and a large new garden was constructed.

The first major extensions comprised what the building accounts call 'the lodging without the gate' (fig. 14).[19] Other than a suggestion that there may have been buildings to the south of the house outside the moat (as at Henry VIII's much later house at Oatlands), evidence as to where Lord Daubeney had accommodated either his own household or that of the king is very thin.[20] Wolsey desired substantial guest accommodation, and it is clear from his building accounts that part of the first tranche of work was the construction of Base Court (from the French 'basse' – or lower, court). The creation of Base Court to the west of the house rather than to the south was significant. The principal land access to the house was changed from the south to the west, thus breaking with the traditional medieval domestic plan of great hall and gatehouse opposing each other across an entrance court. The change, it can be suggested, was due to Wolsey's desire to create gardens on the southern, sunny side of the house. The work involved filling in the southern and western moat and almost immediately building over the infill. On the south the former gatehouse was probably retained as the principal access from the river. Creating the new court with its great gatehouse to the west set the alignment of the palace for the future.

The courtyard is not especially large by comparison with its contemporaries, measuring 140ft north to south and 166ft east to west internally. The outer court at Thornbury Castle, built at the same time, was about 200ft by 185ft; that at nearby Eton College was 230ft square; and Wolsey's own great quadrangle at Christ Church, Oxford, 276½ft by 271ft.[21] The whole is built of long

15 Emily Rebecca Prinsep's watercolour view of Base Court painted in September 1826. The view shows the courtyard still cobbled and the chimneys before their Victorian re-Tudorisation.

(9½–10¼in.) and thin (2–2½in.) bricks with Wheatley limestone dressings. Internal stone detailing was in the softer, more finely grained Reigate stone.[22] Sadly, all the original external stonework in Base Court is now lost, and has been replaced with restorations of the nineteenth century or later. But enough Reigate survives internally to demonstrate that the mouldings are all of a standard late-gothic type.[23] Much of the original brickwork has also been replaced, especially on the parapets and around windows. Again, there is enough surviving original work to illustrate that the whole exterior was covered in a diamond diaperwork pattern constructed of burnt headers (brick ends). The chimney-stacks that are so famous today are almost all nineteenth century and later, and sixteenth-century views of the palace (figs 17, 92) suggest that many of the original stacks were much plainer. The brickwork was pointed with double-struck mortar (see fig. 36) and some at least painted with red ochre. It is likely that the exposed stone windows, doors, string courses and archways were whitened with limewash.[24] The courtyard itself was originally cobbled rather than laid out to grass as presently: it had to take vast numbers of horses and wagons when its occupant's servants arrived with hangings, furniture and personal effects. Thus when it was first built, Base Court was much harder, sharper and brighter than its mellow grassy appearance today (fig. 15).

The courtyard is entered through the Great Gatehouse, truncated in 1771–3 from five to three storeys (fig. 16). It is a rectangular mass 60ft wide and 38ft deep, quite unlike the slim square collegiate gatehouses being built at the same time at Christ's or St John's College in Cambridge, or that at Eton nearby. The gate-

16 Reconstructed east elevation of the Great Gatehouse, showing it as completed by Thomas Wolsey in 1522. Drawing Daphne Ford.

house is much closer in design to the smaller gatehouse at Esher Place a few miles away, which was built by William Waynflete in about 1475–80; or the more imposing gatehouse built by Archbishop Morton in 1490 at Lambeth Palace (fig. 18).[25] Wolsey adopted this wider style of gatehouse with a low centre and higher sides as it provided superb accommodation. The deep rooms in the gatehouse are lit by tall windows at both sides with views over the house and gardens. The wide gatehouse also, of course, gave a tremendous sense of bulk and silhouette, as is shown in Wyngaerde's views of the palace (fig. 17). There are several unanswered questions about the gatehouse's original appearance. Both the moat bridge and the great doors were replaced by Henry VIII and it is not known what was originally installed in their places. The present vault is nineteenth-century, replacing an earlier fan vault, which was still visible in 1821 but was finally swept away in the restoration of 1882.[26] Wyngaerde shows the turrets surmounted by lead onion domes or 'types' which were probably originally gilded and are likely to have been part of Wolsey's original conception. The terracotta roundels were added much later, but the original intention was almost certainly to adorn the rectangular panels

17 Anthonis van den Wyngaerde's view of Hampton Court from the north (1558–62). It shows the vast bulk of the Great Gatehouse, the middle gate to its left on the east side of Base Court, Henry VIII's Great Hall and to the far left, Henry VIII's Tennis Court. In the foreground is the orchard with a 'herber' or arbour and behind that the gabled elevation of Henry VIII's kitchen range. The buildings on the far right are the Houses of Offices.

18 The gatehouse built by Archbishop Morton at Lambeth Palace in 1490. Wolsey's Hampton Court is the successor to the palaces of the fifteenth-century archbishops of Canterbury.

beneath the windows with terracotta plaques of the story of Hercules (see below). In the event either these were not delivered or they were replaced by Henry VIII in 1530 when he inserted his arms over the gate instead. The inner gatehouse (the so-called 'Anne Boleyn' Gate) on the east side of Base Court is closer in style to the more common needle-like gatehouse of the early sixteenth century (fig. 76). This was never designed to accommodate large numbers of guests; its function was simply to mark the access to the inner court. It too has been altered, but Wyngaerde shows that it also had types before the addition of the cupola in 1707. Its vault was replaced by Henry VIII during the building of the present hall. The royal coat of arms on the west side of this gatehouse was also added in 1530, again probably a substitute for an intended terracotta panel. On the east side of the gate facing the principal lodgings was another plaque, which survives, with putti holding the cardinal's arms. This was later altered to show a crown and the royal arms.

The prototype for Base Court was created by Archbishop Morton of Canterbury and his successors at their palaces at Lambeth (fig. 18), Croydon and Otford. The influence of the Lambeth gatehouse has already been noted, but at Otford and Croydon great outer courts were constructed for the archbishop's household. The courtyard at Otford had twenty-one lodgings ranged along its west side, and at Croydon there were as many as thirty ranged along two sides, facing each other. The immediate precedent for Base Court was certainly Croydon, where between 1450 and 1490 a brick outer court was built decorated with diaperwork containing linked garderobes and chimneys and, crucially, an internal corridor or gallery linking the lodgings (fig. 19).[27] Hampton Court developed this model further. Wolsey's outer court was not designed for his household servants; unlike at the episcopal palaces, Thornbury Castle, or even the universities or monasteries, this new type of courtyard was built principally for guests. Wolsey spent vast sums on providing rich furnishings for Base Court, creating a quality of interior worthy of the international elite. Base Court therefore proclaimed the function of Hampton Court: it was built as a house for entertainment. The lodgings around Base Court were of a revolutionary design (figs 39, 40). The Croydon model still relied on each ground-floor lodging having its own access from the courtyard. At Hampton Court the lodgings were entered from a continuous internal gallery with a single entrance.[28] This enabled guests to circulate within the courtyard whilst keeping dry and warm, and created regular external fenestrated façades. The Hampton Court plan had been anticipated, in a different mode, in the prior's lodgings at Much Wenlock Priory, but rendered into stone and brick in the Thames valley the plan was a breakthrough in domestic comfort. This new method of creating lodgings was soon to be duplicated, at Whitehall Palace first, and then elsewhere.

Structurally, the ranges of Base Court are of brick, and the internal subdivisions for the galleries and lodgings were of timber studwork. The roof structure, which largely survives, was also of timber, and tiled. The timber was cut and moulded at Barwyn Wood together with the timber for York Place, and transported to the site prefabricated ready for assemblage.[29] The bricks themselves were made on site in a kiln only yards from the house by a Greenwich brickmaker called Richard Recolver.[30] In fifteenth-century houses such as Wingfield and Croydon, and even in sophisticated ones of the early sixteenth century like Thornbury, the garderobes of lodgings projected outside the outer walls of the ranges. Later these were combined with chimney-stacks to make a double protrusion on the external walls, as at Chenies in Buckinghamshire.

19 Comparative plans, to scale, of the Great Court of the archbishop's palace at Croydon and Hampton Court Base Court. The Croydon courtyard was the immediate precursor to Base Court, though built for the archiepiscopal household rather than for guests.

At Hampton Court, possibly for the first time, both the garderobes and chimneys were integrated within the footprint of the building, thus avoiding the necessity for external façades interrupted by the regular rhythm of stacks. The garderobes and chimneys divided up the length of the ranges, forming a series of spaces that were approached from the gallery (figs 39, 40). This had the additional benefit of providing soundproofing between each lodging. Although the lodgings enjoyed high-level borrowed lights from the gallery, they gained most of their light from good-sized windows giving out on to what were probably gardens on the north and south.

The lodgings were of two types. The grander ones had two rooms, known as double lodgings (fig. 20). This was not an innovation since many houses, including Croydon, had provided such a luxury for their more important inhabitants since the mid-fifteenth century. But Wolsey's lodgings were larger – 594sq. ft compared with 468sq. ft at Wingfield Manor and 483sq. ft at Thornbury Castle; and there were far more of them – thirty double lodgings, three single lodgings and a large three-room suite over the gatehouse. The floors were of timber finished with a coat of thick strong plaster, giving a smooth clean finish that was originally matted. The timber framework of the partitions was left

20 Reconstruction of one of Thomas Wolsey's double lodgings in Base Court. The bare plaster walls would have either been dressed for guests from Wolsey's tapestry wardrobe, or later hung with tapestries brought to court by household officials and courtiers. Drawing Daphne Ford.

unplastered but limewashed, and would have been covered with wall hangings when the lodgings were in use. The ceilings retained exposed overhead beams with chamfered edges, which were also limewashed. Internal door-frames and doors had four-centred heads and were of oak, the frames moulded with decorated doorstops. The oak-framed borrowed lights also had richly moulded late gothic mullions and both door-frames and borrowed lights were painted with an ochre-coloured paint.

The construction of Base Court transformed the original courtyard of the house into a new inner court approached by the inner gate to the west and the original gatehouse on the south. The rooms in the west range of this court were of a noticeably higher standing than those in Base Court with entirely different planning and fenestration. Even the stone window-mouldings were on a different (and more elegant) type. These rooms adjoined Lord Daubeney's south front and must have been reserved for the most important guests (fig. 40). The principal lodgings were still on the east side of the court and were presumably those built by Wode or, more likely, Daubeney. At first these rooms seem to have been satisfactory, except for the Great Chamber. This was precisely the situation at York Place, where the main lodgings were retained and redecorated and a new Great Chamber built. The accounts for the work at Hampton Court are sadly skimpy but contain a number of references to the Great Chamber with its bay window, fireplace and upper storey.[31] That Wolsey lavished such attention on these two great chambers immediately on acquiring his new houses suggests that the Great Chamber was to be his principal reception room, more important, both at Hampton Court and at York Place, than the house's fifteenth-century hall. At both sites the fifteenth-century reception rooms remained, for the time being. At Hampton Court at least one of these was referred to as the King's Dining Chamber, suggesting that the principal floor rooms were reserved for the king's use right from the start. Beneath these on the ground floor was a series of parlours listed in an inventory of around 1522–3, which culminated in Wolsey's bedchamber. The arrangement of parlours beneath the principal rooms was common and the fact that these were Wolsey's rooms tells us much about his relationship with the king.[32]

The most spectacular and important addition to Hampton Court was a new long gallery (fig. 14). The account for the year 1515–16 states that a glazier was paid for glazing both sides of the gallery, and the only gallery known to have had 'both sides' is the Long Gallery excavated during the repair of the fire damage of 1986.[33] William Roper reports that, in an attempt to change the subject during a difficult conversation with Wolsey, Sir Thomas More said to the cardinal, 'I like this gallery of yours, my lord, much better than your gallery at Hampton Courte.'[34] At the time the two statesmen were standing in the gallery at York Place, which Wolsey had built in the mid-1520s. Perhaps it had benefited from lessons learnt by Wolsey's builders from the construction of the similar building at Hampton Court. Both were part of a group of galleries built during the early sixteenth century, which were attached to a house at one end and ran into the gardens. At each of Wolsey's houses there was such a gallery, and a number of influential courtiers had them too, including George, Earl of Shrewsbury, at Sheffield Manor, and Archbishop Cuthbert Tunstall at Fulham Palace.[35] The first of these galleries may have been that built by Edward IV at Eltham Palace in the 1470s. Wolsey in effect owned Eltham for a short time, and would have known King Edward's gallery well, with its spectacular views over London and the palace gardens. At each of his houses Wolsey set out to build a long gallery on the Eltham model.

The new gallery lay directly beneath today's Cartoon Gallery, an area that in Wolsey's time had yet to be developed, but which lay within the original moated platform of the Knights Hospitallers' property. It is not yet known how the gallery joined the existing east range of the inner court, but a linking structure must have been devised to give access to it (figs 39, 40). The excavated foundations of the new gallery show it to have been built very substantially in brick of an identical type to that used in Base Court. It was about 200ft long and 15–16ft wide internally (fig. 21). From later royal building accounts it is known that it was built upon an open cloister, and from a marginal note made in his copy of Palladio in 1625, Inigo Jones reveals that the covered walk within this was 14ft wide.[36] To the north of the gallery was a knot garden, and to its south, almost certainly, more extensive gardens ran down to the river. Undoubtedly one of the principal functions of these galleries was to provide a grandstand from which to admire the views of gardens and watercourses, although they were also used for business. For instance, the charter for Wolsey's Ipswich College was signed in the Hampton Court gallery in July 1528.[37] Of its internal fittings and decoration nothing is known, but it was probably decorated in a similar manner to the Wolsey rooms described below. Externally, however, the gallery may have been one of the most important and avant-garde structures yet built in England.

21 The foundations of Thomas Wolsey's Long Gallery excavated in the south cloister of Fountain Court during the fire-damage repairs of 1988. This photograph looks east.

22a, b and c Fragments of architectural terracotta recovered during the excavation of the Privy Garden in 1993–4, probably from the exterior of Thomas Wolsey's Long Gallery.
Above left: window mouldings.
Above right: egg-and-tongue cornice; below left, a fragment of fruit-and-flower moulding; right, a corner of a plaque. The scale is in centimetres.
Left: bases and shaft fragments of fluted pilasters. The scale is in centimetres.

This bold claim is based upon the recent discovery of a large number of moulded and decorated architectural fragments made of terracotta. During the restoration of William III's Privy Garden in 1993–5 a large number of these were found discarded in a late seventeenth-century gravel quarry immediately adjacent to the south front. In the pit were found nineteen window-mouldings including a large angled piece which was almost certainly part of a bay window, three pieces of a projecting cornice decorated with an egg-and-tongue motif, and eight pieces of classical orders. Four of the last were fragments of half columns (two fluted); three were fragments of column bases; and one piece was part of a capital of a Corinthian type. In addition there was a large plaque with a cusped trefoil and part of a circular laurel garland (fig. 22).[38] The columns, bases and capitals were parts of pilasters which varied in diameter between 8in. and 11in. and would have formed columns between 5ft 4in. and 7ft 4in. tall. These would have been applied to the face of the building. The other fragments would have been integral parts of its construction – windows, a bay window and a flush plaque with a roundel containing a bust or arms. A number of arguments would tend to suggest that these important terracotta groups can be associated with Wolsey's new gallery. The first is quite simply the proximity of many of the finds to the site of the gallery itself. Wolsey's Long Gallery survived, although extended and converted, until the demolition of the Tudor palace in 1689.

At this date it is clear that Sir Christopher Wren's workmen reused as many of the old materials as possible, including floor joists and stonework. It is equally clear that much material was unsuitable for reuse, particularly irregularly shaped architectural elements such as the terracottas. These, and other rejected materials, were simply discarded in the nearest available pits. Thus when Wolsey's gallery was finally demolished, parts that could not be reused were thrown into the adjacent gravel quarry pit on the south front excavated by Wren's workmen.[39]

Two other arguments would tend to support this view. First, that in the extant buildings at Hampton Court architectural terracotta is entirely absent, and in the fulsome accounts for Henry VIII's extension of the palace there is not the slightest hint of a reference to terracotta elements. This would suggest that the use of terracotta was confined to parts of the building constructed by Wolsey and now entirely demolished, and of these the gallery is the principal example.[40] Second, the use of architectural terracotta of this type in England is confined to a clearly defined period between about 1515 and 1535. Of particular significance is the fact that the Hampton Court examples are stylistically closely related

23 Sutton Place, Surrey, the south front showing the use of terracotta plaques and other decorative panels. Built at the same time as Hampton Court, with some of the window mouldings to identical pattern, Sutton Place is the closest parallel to the Hampton Court Long Gallery despite alterations of the nineteenth century and later.

to the closely datable work at Sutton Place in Surrey of about 1521–30.[41]

The exterior of the gallery was therefore probably enlivened by richly decorated window surrounds, one or more plaques incorporating roundels and a series of applied pilasters.[42] The mix would have been typical of the most fashionable architecture of its day, a subtle mix of late-gothic moulding and decorative forms with a strong Renaissance theme expressed in 'antique' decoration on the mouldings of the windows. Much of this is familiar from other sites of a slightly later date, including Sutton Place, not far away, where terracotta embellishment survives, and on which many of Wolsey's craftsmen almost certainly worked (fig. 23).[43] Yet although Sutton Place can give a flavour of the appearance of Wolsey's Hampton Court, Wolsey's gallery was far more remarkable than the courtier Sir Richard Weston's house. It was one of the first buildings in England, if not the very first, to have classical pilasters on its exterior. Also remarkable in its day was the consignment of eight large terracotta roundels and three large plaques made by the Italian sculptor Giovanni da Maiano. He wrote to Wolsey on 18 June 1521 demanding the balance of payment for eight round images painted, gilded and set in place, at a cost of £2 6s 8d each; and three stories of *Hercules* at the much greater sum of £4 each.[44] Although the plaques, probably intended for the gatehouses, are lost, there are ten terracotta roundels at the palace today, each with the head of a Roman emperor. These are *Tiberius* and *Nero* (on the west side of the Great Gatehouse), *Trajan* and *Hadrian* (on the west side of the inner gate), *Vitellius* and *Augustus* (on the east side of the inner, or Anne Boleyn's Gate) and *Titus*, *Otho*, *Galba* and *Julius* (on the west side of George II's Gate).[45] They are 3ft 4in. in diameter and are not a matching set. *Augustus* is glazed in striking black, white and yellow; the others were originally painted and gilded, which would have hidden the contrasting fabrics of the busts and the roundels that frame them (fig. 24).[46] In addition there is an eleventh roundel in store, possibly of *Cleopatra*, glazed in white, gold and purple. Since it is impossible to tell whether this was one of the eight that Wolsey commissioned, it would be incautious to make too great a claim for it, but it is similar to those used by Francis I at the Château of Madrid some time after 1527.[47]

Since the individual identities of the original consignment of eight heads were not specified, it will never be possible to correlate the extant roundels with Wolsey's 1521 order. Yet we do know that the Victorian Surveyor, Edward Jesse, added *Tiberius* and *Nero* to the west front after finding them in a cottage in Windsor Park. They were probably originally from the Holbein Gate at Whitehall, demolished in 1759, the materials of which were moved to Windsor Great Park by the Duke of Cumberland.[48] The other eight have a securer Hampton Court provenance: during his visit in 1600 Baron Waldstein saw *Trajan* and *Hadrian* on the west side of the inner gate and *Tiberius*, *Julius* and *Vitellius* on the east side.[49] No visitor to the palace mentions roundels on the east side of modern Clock Court, but two can be seen there set into an external chimney-breast in Wyngaerde's view of 1558 (fig. 25). Although the evidence is confusing, two points emerge. Eight of the existing roundels were probably intended for Hampton Court, and, at least from Queen Elizabeth's reign, were used to adorn the inner gatehouse and the east side of Fountain Court. That they were probably there from Wolsey's time may be suggested by the survival of a terracotta plaque with Wolsey's arms on the east side of the inner gate.[50] The plaque is certainly in its original location and proves Wolsey's external use of high-quality terracotta decorative elements.

Debate rages as to whether terracotta decorative elements such as those found at Hampton Court were produced locally, like the palace bricks, or made at some central location (Southwark has been suggested) and brought to the site. The Maiano roundels were imported, but less is known about the architectural elements. In favour of the argument for local manufacture is the fact that there were groups of 'Dutch' immigrants living in Hampton Town in 1523. The 'Dutch' were northern Europeans from Germany and the Netherlands collectively known as *douche*. Many of these were craftsmen, joiners in particular but possibly also brickmakers. However, whilst the 'Dutch' were almost certainly working on Wolsey's buildings, there is no evidence to connect them with terracotta manufacture, and it would have been easy and cheap to bring ready-made elements down river from London to the Hampton Court landing stage.[51]

The building accounts that cover Wolsey's first phase of work also mention expensive and extensive works to the palace surrounds. Most significantly they record the excavation of a new moat.[52] In order to build Base Court it was necessary to fill the

24 Head of the Emperor Augustus by Giovanni da Maiano, 1520–21, on the west face of the Middle Gatehouse, Clock Court. It is unclear whether this is the roundel's original position, although it was probably *in situ* by the Elizabethan period.

25 Anthonis van den Wyngaerde's view of the inner Fountain (now Clock) Court (1558–62). The view shows the courtyard before the Henrician fountain was replaced by Elizabeth I (fig. 88) and before the central range was remodelled by George II (compare fig. 264). Note the original position of Maiano's roundels.

much earlier moat on the west side of the inner court, since the north and south wings of the new building would cross it. It is likely that the moat adjacent to the south range was also filled at this point. Yet a moat was still a desirable feature for the new house, both aesthetically and for reasons of security, and deep excavations on the west front of Base Court enabled the new entrance front to be built on a gently battered moat revetment. The new moat almost certainly now ran from the river due north and round the north of the house to meet with the older western arm (fig. 14). On the north lip a revetment has yet to be found, although there was almost certainly one on the moat's southern lip. On the west Wolsey filled the existing dry ditch and built a massive battered revetment as a foundation for his new west front. The new moat, like its predecessor, was dry rather than being filled with water, and was thus probably more like an eighteenth-century ha-ha than a medieval moat.[53] Whilst the moat was being made diggers were also busy excavating a number of ponds, probably for fish for the cardinal's table. In 1528 Anne Boleyn desired the cardinal to send her freshwater shrimps and carp from his famous ponds, but it is not yet known where these were.[54] Work was also underway on paling (or fencing) the park and creating an orchard. In the early sixteenth century an orchard was not a place where fruit trees grew, although they might be found there. It was a type of less formal garden with herbs, shrubs, trees and banqueting houses for recreation. Eventually two orchards were to be built at the palace, a privy (or private) one and the larger Great Orchard, a more public garden (figs 87, 88). Where Wolsey's orchard was is not known (see chapter 5).[55]

The cost of the work was prodigious. In 1515 the purchase of materials alone cost £1,232 7s 9¼d; expenditure in 1516 seems to have been rather lower at £1,182 19s 11½d, but rose in 1518 to a peak of £2,951 17s 8½d.[56] But these were only the costs of the actual construction. As early as 1515 Wolsey had begun to acquire tapestry for his new houses, and a surviving letter of 1517 illustrates that he was searching the markets of northern France for tapestries of specific sizes for both York Place and Hampton Court.

It is almost certain that a group of tapestries was commissioned then and delivered to Hampton Court and York Place about eighteen months later.[57] A crucial insight into the timing and importance of Wolsey's work at Hampton Court is obtained from his second tapestry commission for the house. In the autumn of 1520 the rich and powerful London merchant Richard Gresham was requested to furnish a whole series of rooms at Hampton Court with tapestry. The rooms in question must have been nearly completed, because Gresham had been to the palace to measure eighteen rooms, listing the details in a book that he presented to Wolsey to approve. Gresham left England for the Netherlands with at least 1,000 marks to spend – this tapestry commission has been described as one of the most ambitious of the early sixteenth century. The new tapestries, which arrived in two batches, in December 1521 and April 1522, comprised 136 large tapestries and 43 window pieces – sufficient to furnish 22 lodgings.[58] Six rooms in the inner court were hung; three parlours on the ground floor of the east range; the 'legate's chamber'; and two chambers on the west side of the inner court above the ewry and the porter's lodge.[59] Another source confirms that Wolsey's own closet was hung with cloth of gold.[60] Next, the whole of the gatehouse to Base Court was furnished, and it is still possible to identify which rooms were hung with which particular sets of hangings. Most of the tapestry supplied in the 1520 order was on a religious, judicial or moral theme.

Tapestry ownership was only for the rich; ownership and display of tapestry on the scale that Wolsey introduced at Hampton Court was only for the super rich. The richer nobility might own fifty tapestries; the very richest a hundred. In 1520 Wolsey already had 600. Of these a high proportion were all silk or silk and gold tapestries, the most valuable type. The wall-hangings ordered for Base Court thus represented a gesture of vast extravagance. It is no coincidence that the first phase of work was completed and the rooms hung with tapestry by April 1522, two months before Wolsey entertained one of Europe's most powerful men, Charles V, Holy Roman Emperor, at his new house. The Bishop of Badajoz

confirms that Wolsey had been planning for the visit since at least December 1521.[61] It was in exactly this period that John Skelton wrote his stinging poems *Colin Clout* and *Why come ye not to Court?* In these the poet targets Wolsey's ostentation as a theme for abuse. In *Colin Clout* he describes Wolsey's work at Hampton Court:

> Building royally
> Their mansions curiously,
> With turrets and with towers,
> With halls and with bowers,
> Stretching to the stars,
> With glass windows and bars;
> Hanging about the walls
> Cloths of gold and palls,
> Arras of rich array,
> Fresh as flowers in May

The next section goes on to describe with great accuracy the set of tapestries known as *Petrarch's Triumphs*, which Wolsey hung at Hampton Court. In his other poem, *Why come ye not to Court?* Skelton goes even further, naming Wolsey's residence and advertising the fact (and fact it was) that Wolsey's court there outshone that of the king.

> *Why come ye not to court?*
> To which court?
> To the king's court,
> Or to Hampton Court?
> *Nay, to the king's court!*
> The king's court
> Should have the excellence,
> But Hampton Court
> Hath the preeminence[62]

So by Charles V's visit in 1522 Wolsey had already established Hampton Court as a house of international importance and stature. It was decorated with some of the best tapestries in the world and adorned externally with a programme of Renaissance decoration of a type not yet seen in England. Wolsey did not, however, act in isolation. As already seen, the king had shown interest in Hampton Court and Wolsey's building project since before 1515. This interest was sustained over the years of construction, with Henry making short visits to see progress in September 1516, March 1518 and October 1520. By the time the first phase was completed in late 1521 or early 1522 Henry was a more regular guest, visiting in both June and December 1521, and March and June 1522. Wolsey was also to entertain the queen to dinner and supper on 18 August 1522.[63] But the work was not finished by 1522. Indeed, between July 1522 and March 1527, except for a brief visit in June 1525, Henry VIII stayed away from the house, suggesting that it was once again the site of major building work.

* * *

From the Visit of the Emperor to 1525

Wolsey's second phase of construction probably began soon after Charles V's visit and continued for five years, with a possible break around mid-1525. For the whole of this period not a single document survives to chronicle what was underway, and we are forced to rely on archaeology to unravel some of the most important years in the building of Hampton Court. Between 1975 and 1995 a complete brick typology survey was undertaken of the entire palace, covering both the extant structures and those archaeologically excavated.[64] This work made it possible, for the first time, to distinguish between a number of phases of Tudor construction. Of particular importance is that it is now possible to separate Wolsey's work from that of Henry VIII, and to identify two distinct phases of work for the Wolsey period. As seen above, Wolsey's first priority was to construct Base Court and the gallery, and to make a number of modifications to the existing courtyard. These structures are built of a single identifiable brick type. A second group of buildings that can be proved to have been constructed by Wolsey are built using brick of a different size and colour, in a different matrix.[65] I shall argue that this change took place some time around 1520–22, and may have been a result of the replacement of Richard Recolver (who had at first provided bricks) with another supplier. What is certain is that the present chapel, cloister and stairs, the Wolsey rooms and the east side of Clock Court are built of a distinctive brick type that appears nowhere else in the building (fig. 31).

One of the principal structures built of this type of brick (Wolsey phase II brick) is the east range of Clock Court, which suggests that after 1522 Wolsey embarked on a rebuilding of his principal lodgings. Wolsey's rooms on the east side of Clock Court remained the backbone of royal accommodation at the palace until the reign of William and Mary, and it was only when the range was in danger of collapsing in 1732 that it was finally dismantled. Indeed the poor condition of Wolsey's former rooms prompted Thomas Fort to undertake a survey of the range for the Office of Works in 1727 (fig. 264). This document is crucial for the understanding of the original configuration of the range, and when combined with the surviving archaeology (fig. 63) provides a full picture of what Wolsey built.

The former east range of the inner court was dismantled to ground-floor level, but the cellars and undercroft of the earlier buildings were retained in the new build. A three-storey range rose on the old site with a rectangular protrusion on its east side (figs 26, 27). In plan this protrusion divided into two squares, containing a staircase rising through the whole structure on the north and a stack of closets on the south. The elevations towards the courtyard were dominated by tall bay windows facing the inner gatehouse. Perhaps the most striking feature of the façade was the fact that the top floor was taller than the two floors beneath it, giving the range a precarious, top-heavy feel (fig. 29). The top floor contained three large rooms, the entrance to which still survives on the top landing of the stairs. The monumental doorway has the royal arms in one spandrel and Wolsey's in the other. Within, more fragments of the original decoration exist, including a massive fireplace with Wolsey's motto and a door leading to a closet to its right (figs 27, 28). The great staircase that once linked the floors is now gone, but its envelope and fenestration can still be clearly seen. In its heyday a large landing at third-floor level

GROUND FLOOR

Hall

Princess's Apartments

Existing or from documentary evidence.
Conjectural.

FIRST FLOOR

Upper Area of Hall

King's Apartments

Existing or from documentary evidence.
Conjectural.

SECOND FLOOR

Lead Flat

Queen's Apartments

Existing or from documentary evidence.
Conjectural.

THIRD FLOOR

Tower Chamber

Upper Area of Queen's Apartments

Existing or from documentary evidence.
Conjectural.

26 East side of the second court of Wolsey's Hampton Court, showing the house's principal lodgings on three floors and a prospect chamber at third-floor level. Drawing Daphne Ford.

27 (*above*) Cross section of the east range of Thomas Wolsey's second court, showing internal architectural features. The original number of room divisions on the first and second floors are unclear. The position of the undercroft of the former Knights Hospitaller house can be clearly seen. Drawing Daphne Ford.

28 (*below*) Chimneypiece at second-floor level in the second court of Wolsey's house. The spandrels contain Wolsey's badges and mottoes. It has lost a shallow projecting overmantel moulding. The chimney is shown on the cross section illustrated in figure 29. This room was probably designed for Katharine of Aragon's use.

must have provided a grandstand view of the palace and its surrounds. Far less survives of the range's first-floor rooms, because their remodelling in 1732 by William Kent for George II swept away almost all the Tudor material, leaving only the great spine wall on the east and the protrusion with the stairs and closets. Yet the evidence shows that there were four State Rooms on this floor, the southernmost joining both Lord Daubeney's south range and the new long gallery (fig. 26). It should not be doubted that these rooms were the most magnificent in the mansion, boasting fireplaces and doors no less splendid than those above.

In 1531 Mario Savorgnano, Count of Belgrade, noted that at Hampton Court 'there is space for the King to inhabit the centre floor, the Queen the one above, and the Princess the ground floor'.[66] On the face of it this neatly explains how the main accommodation at Hampton Court was to be used, but it seems very unlikely that Henry, Katharine and Mary ever stayed at the palace together. Firstly, Mary left for the Welsh Marches in 1525 and essentially remained there for the next two and a half years. On her return she resumed a normal royal itinerary moving between houses but never staying at the same house as her father. In December 1530 she was reported to be 'always apart, at a distance of ten or fifteen miles, with a suitable establishment'. It was, in fact, the establishment that kept father and daughter apart. Her household numbered about 160, a large additional burden even on a house the size of Hampton Court.[67] The queen, who had a household of about 200, was to use the house by herself on a number of occasions, including visits in late November 1528 and in January 1529. The king and queen stayed at Hampton Court at the same time as each other and as Wolsey at least twice: in October 1518, and in June 1525 at the start of that year's progress.[68] On these occasions the house must have been enormously full. Yet despite the fact that the whole royal family never stayed at once the observation about the location of the various lodgings seems to be reliable. Repair accounts from Henry VIII's reign refer to the top-floor rooms as those of the queen, and the principal lodgings of the house would have naturally been assigned to the king.[69] The ground-floor lodgings, in 1520 the parlours and Legate's Chamber, could easily have provided a comfortable lodging for the princess.

Wolsey's new lodgings must have been sensational. In the relatively close confines of Fountain Court his glass-fronted skyscraping lodgings would have completely dominated the field of vision of anyone walking through the inner gatehouse. For this centrepiece there are a number of close parallels built around the same time. One of the first of these was the house begun by Wolsey at Bridewell, which he sold to Henry VIII in 1515. Here a block of stacked lodgings was constructed with upper windows taller than those below. At New Hall (or Beaulieu) in Essex, a house built for Sir Thomas Boleyn, but acquired by Henry VIII in 1516, there was a similar two-storey lodging wing approached by a great stair. At Kenninghall the Duke of Norfolk was to adopt the same arrangement, with the ducal rooms on the second floor above those of the duchess. These houses are lost, but at Thornbury Castle a two-storey range built by the Duke of Buckingham survives with its tall upper windows and low ground floor.[70] The form of the Thornbury windows is very particular; the Hampton Court windows are much closer in design to the slightly later monster bay windows of the Great Gatehouse at Wilton (fig. 30). All these stacked (or vertical) lodgings were influenced by

29 Elevation of the the east face of Clock Court as completed by Thomas Wolsey, c.1528–9, based on the evidence of figures 25 and 264, and of archaeological investigation. Drawing Daphne Ford.

Richmond Palace where the main lodgings were one upon the other in the French manner. Each of these houses had a great processional stair to the upper floors, a feature conspicuously absent from later great buildings.[71]

30 The gatehouse at Wilton House Wiltshire as constructed by William Herbert, first Earl of Pembroke, in the 1540s. The great bay window provides light for rooms on a number of floors as at Hampton Court.

The 'Swap' of 1525 to the Fall of Wolsey

It is not clear when these great new rooms were completed, but certainly in 1525 observations made by a number of foreigners suggest that an important phase in Wolsey's construction works had been reached. In January 1525 it was remarked that, 'The Cardinal is now residing at Hampton Court'; but in June 1525 the king moved from Windsor to Hampton Court and, according to the Spanish ambassador, was presented with the house and its contents where Wolsey would, in future, live 'like any other servant'.[72] It is certainly true to say that in 1525 Henry used the house for a week while Wolsey was at York Place and that soon after (according to Stow) the king licensed Wolsey to use Richmond. In fact, Wolsey spent Christmas of 1525 at Richmond where he entertained with characteristic lavishness. This, and Wolsey's sojourn at Richmond at Christmas 1526, has led many historians to envisage a 'swap' of Hampton Court for Richmond in 1525.[73] In reality the situation was much more complex and subtle. As already seen, as early as 1516 there was a room referred to as the King's Dining Chamber, indicating a formal presence of the king at the house. In December 1521 the Bishop of Badojez informed Charles V that Hampton Court had been given to the king, and as if to confirm it Wolsey wrote to his royal master from 'Your house of Hampton Court' soon after.[74] Despite this, neither man acted as if any change had taken place. Wolsey still stayed in town at York Place during the legal term, only moving to the country after term had ended or if the sweating sickness was raging in Westminster. When Wolsey was at Hampton Court the king was generally at Richmond, and it is noticeable that, on a number of occasions, the moment the law term ended both king and cardinal moved, in unison, westwards. This happened in, for instance, December 1521, Easter 1522 and Easter 1523. After 1525, when the 'swap' is supposed to have taken place, the two men's itineraries did not materially change. It is true to say that Wolsey made extensive use of Richmond during 1526, but he hardly stayed at all in the following two years and in 1528, as in earlier years, the king was at Richmond and Wolsey at Hampton Court. Henry meanwhile failed to pay a single visit to Hampton Court during 1526.[75]

The explanation of the events of 1525 and the so-called swap lies in two factors. The first is that it was very common in the sixteenth century for great magnates and churchmen to provide suites of rooms for the monarch, and to refer to their own houses as the king's. The greatest honour the monarch could do a subject was to stay at his house and use it as his own. Thomas Lovell at his house at Enfield provided a complete set of lodgings for the king and queen separate from his own. At Compton Wynyates Henry VIII's favourite, Sir William Compton, erected the royal arms above the entrance, and in an inscription dedicated his mansion to the king. During the same years that Wolsey wrote to the king from Hampton Court calling it 'Your house', he wrote in identical terms from his other country seat, The More. The likelihood is, therefore, that when Henry came from Windsor in 1525 Wolsey presented him with the new set of lodgings that he had just completed on the east side of the inner court, lodgings to which the king henceforth had unimpeded access and that

31 Hampton Court in 1522–8, Thomas Wolsey's second phase of work, showing excavated and extant features in black line and conjectural features in dotted line. Drawing Daphne Ford.

he used during all future stays. The other factor that may explain the 'swap' is Wolsey's apparent intention of continuing work at Hampton Court in order to build yet more lodgings. Henry took a great deal of interest in the cardinal's house, as remarked above, visiting it before Wolsey acquired it and several times while building work was at its peak.[76] While the new residence was in turmoil in 1516 Henry licensed Wolsey to stay conveniently nearby at his house of Hanworth. Later the king allowed him to use Guildford, ten miles away; and even Bishop Fox helped out, giving Wolsey permission to use his house at Esher whenever he wanted.[77] The king's offer of the use of Richmond was very likely intended to enable Wolsey to continue major works at Hampton Court, which, as shall be seen, he did. Thus after 1525, although Hampton Court was still the property of Wolsey, who continued to embellish and improve it, it was also the subject's house most favoured in the kingdom, at all times at the king's disposal for his pleasure.

In 1526 Wolsey decided to create a new courtyard (the Little Court) to the south of the inner court (figs 31, 39). This was achieved by building a new south range that joined the south-eastern corner of Base Court to the west, and the west end of the long gallery to the east. The former south range was retained, as was the old gatehouse, which became the entrance to the courtyard. The new range protruded out into the gardens to the south and was built over earlier structures seen in excavation in 1976. These had probably been demolished during the construction of Base Court and the filling of the southern moat.[78] The new buildings created a handsome new façade to the south, elegantly unifying Base Court and the Long Gallery. Like the gatehouses of Base Court, the façade was enlivened with octagonal corner turrets containing stairs, closets and garderobes, surmounted by types (figs 92, 104). The new range comprised two elements: a two-storey continuation of the Long Gallery meeting the corner of Base Court; and behind it a discrete three-storey tower-lodging overlooking the gardens and the river.

The projecting tower-lodging had two rooms on each of its three floors; one of the top rooms had a projecting oriel, the remainder had eight-light, south-facing windows. Access was via turret stairs. The ground floor had three rooms: two facing the Little Court and a grander south-facing room (figs 39, 40). On the

32 The ceiling of one of Thomas Wolsey's new rooms, *c.*1526. The battens contain the cardinal's badges. This photograph was taken during reconstruction before the remainder of the ceiling was added in glass fibre.

first floor some of the original decoration survives, showing that, despite the relatively modest Reigate-stone fireplace and door-surrounds, the rooms were designed for high-status use. At least two of the rooms had geometric ribbed ceilings incorporating grotesquework and Wolsey's badges (figs 32, 363, 364). One room at least also had a grotesquework frieze which included putti (fig. 33). A good deal of panelling survives in the rooms as they stand but little of it can be considered to be original to the rooms, or at least *in situ*.[79] At the west end of the lodging a small lobby gave access to a gallery in the west range of the Little and inner courts. The gallery was 16ft wide and 55ft long with a central fireplace, and at its north-east corner another lobby linked it to the old south range (fig. 40). Building accounts from 1534 strongly suggest that the range can be identified as 'my Lorde Cardinalls lodging', containing rooms described as Wolsey's watching and dining chambers.[80] These new rooms were presumably where Wolsey intended to stay while his royal master occupied the rest of the house. Small but still rich, south-facing and elegantly planned with their own discrete courtyard, the Wolsey rooms were the ideal answer to Wolsey's personal accommodation needs.

Despite the fact that after the visit of Charles V in 1522 Wolsey's house became a building site once again, the cardinal continued to use it for the reception of foreign envoys and dignitaries. For instance, the ambassadors of Charles V, on their arrival in England in January 1523, immediately requested an audience with Wolsey at Hampton Court, which they were granted; and in September that year Margaret of Savoy's letters were delivered to Wolsey at Hampton Court by her emissary. Throughout 1524, 1525 and 1526 there was a continuous stream of visitors down river to the cardinal at his new house.[81]

Diplomatic activity reached a peak during 1526–7 with the prospect of a major treaty of perpetual peace between France and England. This had become necessary both to gain French support for Henry VIII's projected divorce and to re-address the balance of power in Europe, which had fallen favourably in Charles V's direction after his victory at the battle of Pavia in 1525. In May 1526 Henry accepted the title of 'Protector' of the League of Cognac, and on 8 August the French envoy Jean-Joachim de Passano signed the Treaty of Hampton Court whereby England and France agreed not to deal individually with Charles V. These events were precursors to the greatest diplomatic encounter between the two nations since the Field of Cloth of Gold in 1520 – the arrival of a major French embassy to sign the perpetual peace treaty. The principal celebration of this event took place at Greenwich with the greatest possible pomp and magnificence, and was immediately followed by Wolsey's own embassy to France where the Treaty of Amiens was signed. Wolsey returned triumphant and announced to a packed Westminster Hall that an enormous congregation of the cream of the French court would come to England in September to celebrate the alliance. The cardinal had resolved that he would welcome this huge entourage at Hampton Court, and it is very likely that he insisted on the completion of the new south front by then.[82]

Anne de Montmorency, Great Master (or Steward) of France, arrived at Hampton Court on 4 November 1527. The Venetian ambassador Marco Antonio Venier wrote that 'Wolsey lately entertained the lord steward for three days hunting at Hampton Court, the palace being sumptuously decorated. He is still there, to see at his leisure the cardinal's sideboards of gold plate', which he went on to describe and value at 300,000 golden ducats.[83] This visit was

33 Fragments of a frieze made of leather *maché* (a compound of brick dust size and leather off cuts) found behind panelling in Wolsey's new rooms of *c*.1526. Leather *maché* was a quick and cheap way of moulding long runs of frieze. Once painted and set above the panelling it was barely distinguishable from stucco.

made famous by the long and detailed description recorded in George Cavendish's *Life and Death of Cardinal Wolsey*. Cavendish was Wolsey's Gentleman Usher and wrote the *Life* thirty years after his master's death as a vindication of him. It is thus untrustworthy on two counts. Yet certainly some of the social material is reliable and can shed light on Wolsey's life at his country house. The French party arrived early at Hampton Court and were redirected to Hanworth a few miles away to hunt until the palace was ready to receive them. When night began to fall they returned to the palace and were shown to the rooms that had been richly furnished for them. They were then ushered into the State Rooms themselves.

> The first waiting chamber was hanged with fine arras, and so was the rest, one better than another, furnished with tall yeomen. There was set tables round the chamber banquet-wise, all covered with fine cloths of diaper. A cupboard of plate of parcel gilt, having also in the same chamber to give them more light, four plates of silver set with lights upon them, a great fire in the chimney.

The second chamber was, we learn, the Chamber of Presence: this too was hung with arras and 'a gorgeous and a precious cloth of estate hanged up'. This room was also lit by silver sconces and was furnished with a vast buffet cordoned off by a rail. Wolsey ate in his Privy Chamber next door and later rejoined the party. While they were at dinner the guest chambers were dressed:

> Every chamber had a basin and a ewer of silver and some clean gilt and some parcel gilt; and some two great pots of silver in like manner, and one pot at the least with wine and beer, a bowl or goblet, and a silver pot to drink beer; a silver candlestick or two, both with white lights and yellow lights of three sizes of wax.

The next morning they rose, heard mass, dined with Wolsey, and departed for Windsor. Wolsey returned to York Place, it still being term time.[84]

One of the greatest misconceptions about the relationship between Wolsey and Henry VIII is that it was, in some way, influenced by rivalry, and by the king's jealousy of Wolsey's wealth. We are often told that Henry took Hampton Court in 1528 because he was envious of it, and it is suggested that Wolsey was unusually acquisitive and dangerously nouveau riche. This view needs to be dispelled, because it distorts the significance of Wolsey's Hampton Court. Wolsey was in no way unique or unusual in his love of conspicuous material display and Skelton's scurrilous attacks on him were at least in part following a convention – the buildings of religious figures were a traditional focus for poetic abuse.[85] Much of the excess of display such as that seen at Hampton Court in 1527 was his due. As Papal Legate he was entitled to all the display and pomp of the pope himself. It is true to say that, unlike his very powerful predecessors, such as John Morton, who was both Archbishop of Canterbury and a cardinal, Wolsey held posts *in commendam*, which is to say that he held posts in conjunction with each other, a practice not seen before in England. Holding an archbishopric, a bishopric and an abbacy simultaneously did two things for Wolsey. First, it put him into the league of churchmen on the Continent, where the practice of holding *in commendam* was commonplace. Wolsey was thus able to act for himself and as a representative of the king on equal terms with representatives of France and Spain like Georges d'Amboise,

34 Comparative block plans of Hampton Court, York Place, St John Clerkenwell, Ely Place, Lambeth Palace and Westminster Palace to scale. Each house adapted the details of its plan to its site, but the relationship of the constituent elements is the same. Drawing Tracey Welman.

the French cardinal (d.1510), or Mercurino de Gattinara, the imperial chancellor (d.1530). Second, it made him very rich: his annual income was probably in excess of £30,000 a year. This wealth, although acquired in the same manner as, say, Morton's, was amassed on a much more efficient and systematic basis, making Wolsey proportionately richer.[86] Thus the celebrations of 1527 were a product of Wolsey's status and wealth in a European context; a status that made him, from the king's point of view, a powerful diplomatic tool.

As an international churchman Wolsey's country house was designed for the specific requirements of a papal legate and archbishop, and as such the planning of Hampton Court cannot easily be paralleled in the houses of the great secular lords. The key to understanding the plan of Hampton Court lies in a consideration of its chapel. The fact that the French attended mass at Hampton Court in 1527 calls into question the timing of the rebuilding of the chapel (fig. 31). It is certain that the body of the chapel and its adjoining cloisters are built in Wolsey phase II brick, but it is not certain when the work began. The only known fact is that it was still being completed when Henry VIII assumed responsibility for the works in September 1529.[87] Thus it may be that work only began on the chapel after the French visit. Yet

it is difficult to imagine that any existing chapel would have been remotely satisfactory to Wolsey. He maintained a very large chapel establishment, taking on embassy to France in 1521 a dean, subdean, ten chaplains, ten gentlemen lay clerks and ten choristers. This was a larger number of singers than at Salisbury, York or St Paul's cathedrals, and certainly the cardinal's chapel contained voices of better quality. In fact, Wolsey's chapel establishment was surpassed in size and quality only by that of the king himself.[88] It is not known whether Wolsey brought his entire chapel establishment to Hampton Court on a regular basis, but for great occasions of state, such as that of 1527, it is hard to believe he did not.

Wolsey's Hampton Court, although in some respects novel, was in fact the last great churchman's residence to be built in England. It belongs to a group of major episcopal, archiepiscopal and conventual buildings constructed between 1450 and 1530 that share a common plan. In its essentials the plan combines chapel, cloister and hall, with residential buildings on an axis. The classic expressions of this arrangement are Lambeth Palace and York Place, the town houses of the archbishops of Canterbury and York respectively, facing each other across the Thames. Ely Place in Holborn in the City of London, the town house of the Bishop of Ely, is similarly arranged, as are several of London's conventual complexes, such as the priory of St John at Clerkenwell (fig. 34). The inhabitant of each of these houses had to meld secular and ecclesiastical processional space in a single coherent structure. In this way these houses were far more akin to the royal residences than to the houses of the great secular lords who had no need for religious processional space. In pre-Reformation royal houses, where royal etiquette was dominated by the monarch's attendance at chapel, the plan of the house reflected the need to express this publicly. Westminster Palace itself was made up of a series of cloisters linked to hall and chapel for just this purpose. Wolsey's Hampton Court fits neatly into this group of buildings, with its chapel, cloister and hall falling into an axis with the principal state lodgings. In adopting this form Hampton Court was quite different from Wolsey's other country house, The More. This house, thought by contemporaries to be nearly as magnificent as Hampton Court, was developed along much more secular lines, suggesting that Hampton Court was to play the primary public role in the cardinal's itinerary.

The new chapel was a substantial building – nearly 100ft long in total, the ante-chapel 50ft wide – but nevertheless it was not as large as some of the fourteenth-century college chapels at Oxford, such as those at Merton, New College and Magdalen, and was only half the size of Eton College chapel. In design, the new chapel was based upon the very particular T-shaped college chapels of Oxford. The origins of this plan can be traced back to the chapel built by William of Wykeham at New College in 1380–87; later followed at All Souls (consecrated 1442) and Magdalen (1474–80). For the New College chapel a choir and crossing were built, but no nave, creating, by default, an ante-chapel filled with side altars. Wolsey was an Oxonian, and knew this arrangement well. Not only was he educated at Oxford but his administrative career began at Magdalen College, where he was bursar in the late 1490s. The Wykhamite plan must have been familiar to him, and he made use of it at Hampton Court.[89]

However, the Wykhamite plan received a number of refinements at Hampton Court. The principal of these was the manner in

35 Reconstructed elevation of the east window of the chapel showing its original configuration. The shaded area represents that exposed during the installation of a lift shaft, allowing access to the original brick and stone face. Drawing Daphne Ford.

36 Early sixteenth-century painted brickwork on the external east wall of the chapel preserved from erosion by a later pentice.

37 Erhard Schön or his workshop, a king and a queen kneeling, and St George and a girl (?princess) kneeling. Vidimuses for Thomas Wolsey's chapel east window, c.1525–6. There were probably two finely finished sets of drawings for the Hampton Court chapel east window. One would have been presented to Wolsey and the other retained by the artist. These drawings are studio copies for the glazier.

which the west end was developed to contain a first-floor pew connected to the body of the chapel via giant twin vice (or spiral) stairs (fig. 40). The inclusion of a domestic first-floor pew was not new; indeed, royal houses had been so arranged since the early Middle Ages. More of an innovation was the provision of twin stairs to provide access to the ante-chapel below. Henry VIII first introduced this feature at his new chapel at Eltham, built in 1519–22. Wolsey himself was almost entirely responsible for the work at Eltham, probably specifying the configuration himself and reserving the design of the chapel ceiling to his own hand.[90] Thus at Hampton Court the cardinal was replicating a design specifically devised for the royal pew at Eltham, which was in this case also intended to facilitate access to the body of the chapel for the king and queen on specific feast days. The cardinal himself would have had no use for two staircases; the new Hampton Court chapel was, like the state lodgings themselves, designed for royal use.

For the original internal appearance of the chapel there is scant evidence. The choir was lit by eight clerestory windows beneath which tapestry would have been hung. The ante-chapel was lit by windows at ground level, but at first-floor level also benefited from

clerestory light. Only the window currently preserved behind the organ is original; the rest are the result of a restoration of 1891. The east window of the chapel is of a unique design. Preserved for hundreds of years behind Grinling Gibbons's reredos and only rediscovered in 1981, the window occupies almost the whole of the east wall. It comprises a pair of six-light windows with four-centred heads linked by a single square-headed light in the centre, the whole surmounted by a single hood-mould (fig. 35). Whilst no specific parallels survive, paired windows separated by niches were not uncommon in the fifteenth century. Yet the importance of the window is not confined to its unusual shape. In the Musées Royaux des Beaux-Arts in Brussels are the original drawings for the individual lights (fig. 37). They show that in the centre was a Crucifixion beneath which, on either side, were supplicants represented by their patron saints: a cardinal with St Thomas of Canterbury, St Peter and St Paul (Wolsey); a king with St George and St Henry (Henry VIII); a queen with St Catherine (Katharine of Aragon); and a girl with St Mary above (Princess Mary). In addition there are six scenes from the *Passion of Christ*. The designs were by the Nuremberg designer and engraver Erhard Schön and were executed by Wolsey's Master Glazier, James Nicholson.[91] The original ceiling was replaced by Henry VIII in 1535–6 and little beyond a few scars remain to show what preceded it. Yet it must have been very shallow, and supported by tie beams above. It may have been similar to the shallow barrel-vaulted ceiling that Wolsey constructed at York Place in 1528, and which was recorded by Sir Christopher Wren in a drawing of 1676.[92]

To this bald architectural information can be added details from Wolsey's own chapel inventory. The chapel contained a great organ, perhaps built into the structure of the chapel, though not in a loft as was to be the case later; and a lesser, portable organ. Both would have been used to play voluntaries at suitable moments – neither would have accompanied voices at this date. There were several paintings on panel, all with religious subjects,

38 One of two heraldic plaques outside the chapel in the lower cloister. Certainly re-set in their current location, probably by Henry VIII. Their original location is unknown. Wolsey's arms have been repainted to show those of Henry VIII (illustrated below) and of Jane Seymour.

39 Reconstructed ground-floor plan of Hampton Court in 1528–9. Drawing Daphne Ford.

FIRST FLOOR. 1528-9.

Confirmed feature in-situ or in excavation.
Inferred from documentary evidence.
Conjectural.

40 Reconstructed first-floor plan of Hampton Court in 1528–9. Drawing Daphne Ford.

some intended for use on the altar including a large triptych. The inventory lists crosses, candlesticks, bells, holy water stoups, censers and incense boats, cruets, chalices, pixes, paxes, corporeals and tabernacle lamps. There were mass books, vestments and altar cloths. Over the main door to the choir was a large crucifix; there were four side altars, probably in the ante-chapel and royal pew, and, finally, there was a pulpit.[93]

On the west the chapel gave on to a two-storeyed cloister which evidence suggests had four sides, although today it is only L-shaped (figs 31, 39, 40).[94] On its north side was a stair constructed with great timber treads ingeniously pegged together by hidden tenons. The ground floor of the cloister linked the body of the chapel with the gardens and with the service areas of the palace. Today the ground-floor chapel door is flanked by two carved and painted stone reliefs sporting Henry VIII's and Queen Jane's arms (fig. 38). Originally these held the cardinal's arms and hat, which were altered and over-painted by Henry VIII after 1530. They were almost certainly located elsewhere in the palace in Wolsey's time.[95] Not only do the panels sit uncomfortably in relation to the brickwork and the door-surround, but it seems unlikely that such lavish carving would flank what was liturgically the least important entrance to the chapel. It is probable that Henry, a king rather than a cleric, thought that angel supporters would be appropriate in or near the chapel, and set the arms in their present location.[96]

As early as the summer of 1527 Henry's desire to be divorced from Katharine of Aragon had caused deep tensions in his relationship with Wolsey, nearly amounting to a rift. These became more marked during the following year, and in August 1528 the king openly argued with the man who had been for fourteen years his chancellor and chief minister, and for eleven years controller of the national Church as papal legate. In September came an event that was, for Hampton Court, a turning point. The king, through the Treasurer of his Household, Sir William Fitzwilliam, ordered Wolsey to vacate the house to enable him to receive the papal legate there for four days.[97] The king had never taken such a brusque or commanding attitude in relation to any of Wolsey's houses before, and from that point onwards Hampton Court was used by the king and queen, whilst Wolsey resided partly at Richmond and partly at Hampton Court. Katharine of Aragon was certainly in residence in November 1528, and in January 1529 both Henry and Katharine stayed; in March Anne Boleyn was in residence too. During this time the Legatine Court was meeting at Blackfriars to determine the matter of the king's divorce. In July 1529 it failed to deliver and the case was revoked to Rome. The French ambassador reported that, 'Wolsey is hidden at Hampton Court, because he knew nowhere else to go. He has fortified his gallery and his garden. Only four or five are allowed to see him.'[98] Despite the deteriorating relationship between king and cardinal, and the increasing enjoyment of Hampton Court by the king, Wolsey continued to build there. Thomas Cromwell's regular supervisory visits went on as usual, and when in March 1530 an inventory was made of the stockpiled materials in the yard over £440 worth was listed, including £120 worth of cut stone, ten tons of squared freestone, 200 loads of lime, 30,000 bricks and 120 loads of timber.[99] It is unclear what works were underway, but clearly a significant part of Wolsey's conception remained incomplete.

Wolsey's fall is sometimes attributed to his overblown architectural ambition. To see the matter in this way is fundamentally to misunderstand Wolsey's place in the history of architecture in England. Before the 1530s churchmen were responsible for constructing most of the country's really significant domestic buildings. Wolsey was, in fact, the last in a long line of English bishop-statesmen who had built on a scale rarely exceeded by their sovereigns. Cardinal John Morton, who was Bishop of Ely from 1479 until 1486 and then Archbishop of Canterbury until his death in 1500, was also Lord Chancellor from 1487 to 1500. He was one of the two or three greatest builders of the fifteenth century in England, leaving monuments at Hatfield, Lambeth and Croydon to name a few. William Warham, Archbishop of Canterbury from 1503 to 1532 and Lord Chancellor during the period 1504 to 1515, was responsible for the construction of Otford house in Kent, a house larger than Wolsey's Hampton Court, which was only a few miles from another of his residences at Knole. Wolsey's Hampton Court sits neatly within this pedigree, except that the house was his personal possession and not his in right of any office that he held. Wolsey reflected, in his buildings, the status conferred upon him by both his monarch and the pope. In an age of conspicuous display it would have been astonishing if he had not.[100]

facing page Emily Rebecca Princep's watercolour view of Base Court painted in September 1826 (detail of fig. 15).

Chapter 3

HENRY VIII
AND THE COMPLETION OF THE TUDOR PALACE

When Henry VIII came to the throne in 1509 he was well served with domestic residences. In Westminster there was the ancient seat of the English monarchy: the large, old-fashioned but conveniently sited Westminster Palace. To the east was the riverside manor of Greenwich, the place of his birth. The house had been embellished and largely rebuilt by his father, and was already one of young Henry's favourite residences. Nearby was Eltham, a much older residence that was soon to fall from favour as Greenwich was redeveloped. To the west was Richmond Palace, only recently rebuilt by Henry VII after a severe fire. Richmond had been Henry VII's favourite residence, but the royal lodgings, which were in the carcass of an earlier building, were unsatisfactory and Henry VIII came to dislike them. Further west was Windsor, consistently enjoyed and embellished by the English monarchy for its comfort, its security and its hunting. It was to become one of Henry VIII's favourite residences too. Further afield there were of course other houses, ranging from Woodstock in the west to Leeds Castle in the south-east, but the core of the English royal itinerary was always to be the group of greater houses in the Thames valley.

Despite the fact that in 1512 the royal domestic quarters at Westminster Palace burnt down and the king was forced to borrow Lambeth Palace across the Thames, Henry showed little interest in architecture in the first twenty years of his reign. Building, like the affairs of state, was left to Wolsey. It was Wolsey who organised the development of newly aquired royal seats such as Beaulieu in Essex and Bridewell in London, as well as the extension of existing houses such as Eltham. In the late 1520s Henry's interest in architecture grew, stimulated partly by the fact that he was no longer participating in sport so actively as he had done, and partly by his growing affection for Anne Boleyn. Whilst the king had always taken an interest in Wolsey's building projects, this interest now took on a new dimension as his use of Hampton Court in particular illuminated the gulf between Greenwich, his most modern house, and what Wolsey had built. By late September 1528 it had probably become clear to Henry that he wanted Hampton Court, and Fitzwilliam's curt letter requisitioning the house was a signal that the king's thoughts had turned to completing the mansion for himself. Some time during the next few weeks the king set 2 January as the date when he would begin work, and in preparation he commissioned a design team to draw up plans.

The Mobilisation of the Royal Workforce

Henry's programme for Hampton Court coincided with a series of important changes in the personnel of the Office of Works. Since the start of the reign the mason-architect Henry Redman had dominated the architectural scene. He had masterminded work at Westminster Abbey where he was Master Mason, as well as designing Wolsey's works at York Place and Cardinal College, Oxford, and working on the design of Eton College. He had also been working for the king at Greenwich, and between 1519 and 1528 he held the post of Surveyor of the King's Works jointly with William Vertue. Redman died in July 1528, prompting expressions of regret from the king, and it was decided that his replacement should be John Moulton, who was a witness to Redman's will and was probably his pupil. Moulton's formal letters patent were issued on 4 February 1529, but he was instructed to start on designs for Hampton Court before that, and he started work there immediately after New Year 1529. He died many years later, but when he listed in his will 'all my portratures, plaates [plans], books paterns, toles and instruments', he was bequeathing the products of one of the greatest designers of his age.[1] He was not working alone. Redman had also been Master Mason at Windsor Castle, and in August 1528 this post was filled by Christopher Dickinson, a mason whose earlier career is obscure, but who also may have been a pupil of Redman's. Dickinson was likewise set to work at Hampton Court and was, as we shall see, responsible for the design of some of the most important works of 1529–30.[2] The designs may have had input from the King's Master Carpenter, Humphrey Coke, or possibly from Wolsey's Master Carpenter, James Nedeham. Neither appears in the documents from 1529, but both had been involved during Wolsey's time, and Nedeham was certainly to be so later.

41 Henry VIII's astronomical clock, with its much-altered dial.

42 Henry VIII's first phase of extension, 1529–30, showing excavated and extant features in black line and conjectural features in dotted line. Drawing Daphne Ford.

Four big projects were devised for Hampton Court in the autumn of 1528, each a consequence of the change in ownership from the cardinal-minister to the king. First was a massive extension of the kitchens, which would now have to feed the entire King's and Queen's Households at once. Second was the addition of a new chamber for the King's Council; third, a new long gallery for the queen; and finally a tower-lodging was to be built for the king containing a suite of private rooms (fig. 42). None of these works differed materially in style from those previously constructed by either Wolsey's or Daubeney's workmen. Perhaps the most striking illustration of this fact is the extension to the Great Kitchen built in 1529–30, which deliberately emulated the work of Lord Daubeney's kitchen built thirty years earlier (fig. 43). Indeed the designers were, as seen above, pupils of Henry Redman, the master and part deviser of what is known as the late-Tudor gothic style. Yet the royal works are easily distinguishable from Wolsey's, since in 1529 there was a change in brickmaker and a change in brick type. From June 1529 to December 1532 John Wilson of Hampton controlled brick production for the King's Works at Hampton Court. He was responsible for introducing a new standard brick type measuring 8¼–9¼in. by 4–4¼in. by 2–2¼in., which was henceforth to be produced by his kilns and those of any other supplier. After Wilson's death in 1532 a much wider group of brickmakers was drawn upon – some as far as forty miles away – but they all conformed to his standard specification. Between 1529 and 1539 about sixteen million bricks were burnt in kilns in Home Park, and a further ten million were brought to the palace from suppliers elsewhere. The standardised Henrician brick remained the staple material of Hampton Court until after 1566, when the bricks became slightly larger. This probably reflected the brick-making statute of 1571 that specified a minimum size of 9 by 4¼ by 2¼in.[3] Thus for the first phase of Henry's works and for his subsequent extensions and alterations brick typology provides a secure analytical tool. To this evidence can be added the 6,500 pages of building accounts that survive in the Public Record Office. In a series of particular books that run uninterrupted from 1529 to 1538, the whole ambition, richness and complexity of Henry's Hampton Court is revealed. These books were kept by two clerks, Henry Burton and Eustace Mascall, under the watchful eyes of Henry Williams, the King's Surveyor, and the

43 The north elevation of the kitchens from Tennis Court Lane showing the chimneys. Lord Daubeney's, Wolsey's and Henry VIII's work is stylistically indistinguishable, although brick typology clearly defines the different phases.

Prior of Newark, his paymaster. In total they record around £46,000 of expenditure.

The First Phase of Royal Work: The Kitchens

In the sixteenth century the household of the king was marvellously self-contained. Within its personnel it not only held the necessary expertise to support the life of the king and his close companions, but also the skills to undertake many of the tasks associated with the governance of the country. Central to this was the capacity of the household for feeding itself and when necessary large numbers of guests or even, in time of war, the army. Feeding the Royal Household was one of the largest expenses that the king faced in peacetime, and was a complex logistical exercise. In winter the court could number up to 800 people, 200 of whom were part of the Lord Steward's department, the section of the household responsible for feeding the whole. In the winter months when the court was itinerant, moving between the greater houses in the Thames valley, the Lord Steward's men would travel ahead in carts, setting up their kitchens in time for the arrival of the rest of the court by boat or horse. Meanwhile the Royal Purveyor would be busy identifying sources of food and drink and organising transport of sufficient quantities to the houses. The kitchens of these large royal residences were therefore substantial and carefully planned complexes, capable of storing large quantities of provisions and providing both workplaces and sleeping quarters for a staff of 200. Staff had to operate efficiently and effectively regardless of which house they were in, and this demanded a degree of standardisation from palace to palace.[4]

Lord Daubeney's kitchens at Hampton Court did not occupy the standard medieval location of such buildings. Usually the great hall would have had a screens passage at its lower end beyond which lay the buttery, pantry and great kitchen. Haddon Hall in Derbyshire is such a house, but many hundreds of other examples once existed. Daubeney's kitchens, however, lay alongside his great hall. Kitchens on this new model, positioned to one side of the great hall with an attached servery, created more space for the increasingly elaborate etiquette of dining, which demanded ever more servants and waiters at table. Soon royal houses relocated their kitchens too; Edward IV rebuilt his kitchen at Eltham along these new lines in 1475. The model for Daubeney's kitchen was almost certainly Richmond Palace, where Henry VII created a new kitchen complex at right angles to the hall from 1498 onwards, about the same time as Daubeney must have been working on Hampton Court. Daubeney's kitchen was therefore already designed for magnificent entertaining with dozens of liveried servants when Wolsey took the house on. Although Wolsey entertained royally at Hampton Court, playing host to numerous embassies and the Holy Roman Emperor, the kitchens must have been extended by temporary structures in order to cope. Henry wanted to have this capacity permanently.

The earlier scullery was modified to allow the Great Kitchen to be extended and a second serving place was built to its south. This instantly doubled the capacity of the kitchens during a great feast, allowing a greater number of serving men to collect dishes more efficiently than before. To the west of the enlarged Great Kitchen was built an entirely new range of kitchens and offices 300ft long. These lay immediately to the north of Base Court and extended more than 80ft west from the west front (fig. 42). This demanded a complex set of foundations and culverts, for the new wing lay over Wolsey's moat at the point where he had constructed a brick bridge giving access to the service yard (fig. 14).[5] When the work was completed the moat flowed beneath the new range and the drains from the kitchens ran under that. The whole was entered through a new gatehouse and comprised three new courts. No trace of any previous building has been found on its site, but it would be surprising if Wolsey had not positioned his temporary workhouses here. Further to the west and detached from the main building were the 'Houses of Offices', a small complex of timber-framed workhouses that included a scalding house, a poultry house, a bakehouse and a rush house, together with a woodyard (figs 44, 45). Sited on the river's edge they were linked to timber landing stages to allow the efficient delivery of provisions from barges. It was very common to detach such offices from the main buildings because each was, in its way, hazardous or noxious. The scalding and poultry houses smelt unpleasant; wood and rushes were inflammable materials; and bakehouses were notorious for burning down. Indeed the Hampton Court bakehouse went up

44 Plan showing the location of the kitchen areas. A: the household kitchens; B: the Houses of Offices; C: the Queen's Privy Kitchen; D: the King's Privy Kitchen; E: from 1536 an additional King's Privy Kitchen. Drawing Edward Impey.

45 The Houses of Offices taken from the south side of the Thames in c.1860–70 while in use as grace and favour apartments. They were demolished in 1878.

46 Reconstruction of the boiling house. The boiling copper has been omitted for clarity. Drawing Daphne Ford.

47 Modern Fish Court (its original name is unknown) looking west from the Great Kitchen door. The court was refaced and embellished in the late nineteenth century. In Henry VIII's time the doors on the left would have led to the larders and boiling house, the door at the end of the court to the pastry house and the doors on the right to the dry larder and speciality kitchens.

in flames in 1605–6, amply justifying the decision to separate it from the palace proper.[6] At Eltham Palace a similar range of buildings still survives, and the Houses of Offices at Hampton Court were only finally demolished in 1879.[7]

Above the gatehouse to the kitchens was sited the Office of the Greencloth, the body responsible for the domestic economy of the court. Beneath the floorboards of the room over the gatehouse has been found a counter and a fragment of paper recording the work of the clerks who organised the complex task of purveying food for the court. Not far from this office on the ground floor was the jewel house, in which was held the coin needed to pay the palace suppliers as they delivered their goods. Other adjoining offices housed activities that did not require close proximity to the Great Kitchen and its vast fireplaces. There was the spicery where herbs and spices from near and far were kept until required. The Officers of the Spicery were responsible also for the supply of fruit, which came partly from royal gardens but mostly from commercial orchards. Nearby was the chandlery where wax for candles and tapers and linen for the table were stored and distributed. Across the courtyard was the coalhouse, storing both charcoal for the kitchen chaffing dishes and luxurious sea-coal for burning in the king's and queen's rooms (figs 77, 78).

The pastry house was in the second court and mainly made pastry coffins (or cases) for the great meat pestles (or pies) served at table. In a windowless outer room flour and other provisions were stored, and in a second room the pastry was made in long wooden kneading troughs. A third room, stifling hot in use, was for the four circular brick ovens with shallow domed roofs, the largest of which was 8ft across. The ovens had deep smoke hoods with wide flues over their mouths, so that smoke from the burning brushwood that heated the interiors of the brick ovens could escape. Above was the confectory where the delicate sweetmeats, marzipans and custards which Tudor courtiers so loved were made. This fine work did not require chimneys, since chaffing dishes provided a heat that was much easier to control. Close by the pastry house was the boiling house, where a copper cauldron with a 75-gallon capacity was set into a vaulted and ventilated alcove with a furnace beneath (fig. 46). The Sergeant of the Boiling House had to ascend four steps to reach the mouth of the caul-

DOMINVS MICHI ADIVTOR * DOMINVS MICHI ADIVTOR * DOMINVS

dron with his heavy buckets of stock. The boiling house was entered by a narrow courtyard that today bears the Victorian name of 'Fish Court' (fig. 47). This was the innermost sanctum of the kitchens, secured by lock and key from pilfering courtiers or ill-intentioned interlopers. The wet, dry and flesh larders were sited in this court. The wet larder stored fish, either packed in barrels of seaweed, or freshly caught and supplied with water by a cistern; live fish were kept in the palace ponds until the cooks were ready for them. The dry larder stored pulses and grains; while the flesh larder held meat butchered, hung and ready to cook. On the north side of the court were two working houses or minor kitchens.

The Great Kitchens built partly by Henry and partly by Lord Daubeney had six great fireplaces and a small boiling house (fig. 77). Spanned by a new roof installed by royal carpenters, the space was made high deliberately to diffuse the tremendous heat of the log fires over which, on spit racks, whole carcasses were roasted. The flagstone floors sloped to sumps for easy cleaning. At either end of the Great Kitchen were the hatches that allowed finished dishes to be passed out to waiting serving-men.

The foundations were dug for the new buildings as soon as the winter frosts had thawed in May 1529; by September 1530 most of the upstairs rooms had floorboards; and a year later the rooms were more or less finished. The kitchens were probably first fully utilised during Henry's three-week stay at Hampton Court in November–December 1531, sheltering from the plague in London. Before the king left on 19 December he granted Sir William Weston, prior of the Knights of St John, the site of a former priory in Essex, St Mary Magdalene of Stanesgate, in exchange for Weston granting the manor of Hampton to the Crown. From that day to this Hampton Court has remained Crown property.[8]

The new kitchen range, although crucial for the smooth working of Hampton Court as a royal house, scarcely affected the comfort of the king and queen. Royal dishes were prepared in a separate kitchen far from the cumbersome household kitchens on the north side of the palace. Indeed the king, like the cardinal before him, had a privy or private kitchen situated beneath his lodgings where his food was prepared by his own cook and other kitchen personnel. This kitchen, which in a much altered state still survives on the ground floor beneath the Wolsey Closet, was used by Henry VIII from 1529 until the construction of a new privy kitchen in 1537 and again by Elizabeth I until 1570 (fig. 78).[9]

★ ★ ★

48 (*facing page*) The so-called Wolsey Closet. This room was formed in the late seventeenth century and now contains an ensemble of Tudor fragments. Parts of the ceiling are the only Tudor elements in their original position. The painted panels are an incomplete series showing Christ's passion painted by a northern European hand almost certainly after engraved sources. They have been cut to fit in their present location. It can be safely suggested that Henry VIII commissioned them and that they must have been similar in function to those supplied by Toto del Nunziata in 1530. The leather *maché* ceiling contains the Prince of Wales feathers and so must date from after the birth of Prince Edward in 1537. New sections in plaster were added in the nineteenth century. It is possible that the lead letters spelling out Wolsey's motto are an antiquarian embellishment.

The First Phase of Royal Work: The Council Chamber and the Royal Lodgings

Neither Hampton Court nor any other residence of Henry VIII was merely a home; it was also the place from which the king ruled, and had to provide all the facilities necessary for the king's Privy Council. To this end a council chamber was built on the north side of the chapel cloister – a two-storey block with an office on the ground floor (figs 77, 78).[10] More important for Henry's comfort was the start of work in April 1529 on a tower-lodging designed to contain a suite of private rooms for the king. The new tower, named at the time the 'Bayne Tower' after the baynes or baths that it contained, was to be sited at the southernmost end of the principal lodgings, between the Royal Bedchamber and the Long Gallery (fig. 42).

That Henry commissioned a suite of privy lodgings so early in his tenure of Hampton Court is hardly surprising. Wolsey, as seen, had built his own south-facing privy tower-lodging and the principal lodgings provided nothing on such an intimate scale for the king. The new tower, which was designed and built by Christopher Dickinson, was to be, like Wolsey's, on three levels. On the ground floor it contained a new office for the Chamber presided over by Sir Brian Tuke, Treasurer of the Chamber, whose responsibility it was to pay the wages of the officers of the Privy Chamber. Next to the Chamber Office was the Wardrobe of the Robes, where the king's clothes were stored, repaired and cleaned. On the first floor was the king's new bedchamber with an en-suite bathroom. The bathroom was served with hot running water from a small boiler heated by a furnace in a room behind it. The bathtub itself was circular and was made by a cooper, so it probably resembled a cut-down barrel. The ceiling of the room was decorated with gilded battens on a white ground. Also on the first floor was the King's Privy Closet, or study. In the decoration of this room Henry took a keen personal interest, directing that murals should be painted on the upper walls by the Italian painter Toto del Nunziata, that wall cupboards should be installed, and new furniture be designed. Toto was also commissioned to produce four large panel paintings: two of the four evangelists; one *pietà*; and a fourth of Christ washing the Apostles' feet (fig. 48). On the top floor was the king's new library and jewel house, rooms destined to contain some of his greatest treasures. The library cases were probably made for Wolsey and brought from another part of the building,[11] and were glazed with lockable doors and curtains to protect the valuable tomes from the sunlight. As in the bathroom below, the ceiling was elaborately decorated with gilded battens and balls. The rooms must have been completed by November 1530 when books were brought down river from York Place and Reading Abbey.[12]

The new privy lodging tower was not conceived in isolation, for as it rose from the ground so work began on linking it to a new second-floor gallery that formed a third storey on top of Wolsey's two-storey structure (fig. 104). Excavations beneath the William III apartments have shown that Wolsey's gallery was built on deep and sturdy foundations, well able to support an additional storey, especially one that was to be timber-framed. Constructing the new gallery involved destroying the ceiling of the old one, so that the two galleries were conceived as a single decorative whole. The walls were panelled and painted, incorporating a number of hidden wall-cupboards or aumbreys; above the panelling was

49 Henry VIII's second phase of building works, 1530–35, showing excavated and extant features in black line and conjectural features in dotted line. Drawing Daphne Ford.

a richly moulded and painted frieze of antique mermaids with the king's motto beneath it, and the whole was topped by a cornice. The ceiling was battened in a geometrical pattern and the battens gilded. Hooks, ribbons and curtains were supplied for paintings that were hung on the walls, and tables and stools were delivered.[13]

The creation of the Bayne Tower and galleries underlined Hampton Court's role as Henry VIII's principal house for entertainment. First and foremost it gave the king some exceptionally fine private space. Yet the Bayne Tower was a very different sort of privy lodging from that created at York Place in Whitehall, another of Wolsey's former residences, at the same time. There the King's Privy Lodgings were arranged along a gallery at first-floor level. While this was partially a product of the wider architectural plan at Whitehall (the gallery there was also the route across the Holbein Gate to the park), there was a functional distinction too. Whitehall was the principal palace, the seat of the king's government, and consequently the Privy Lodgings there were more extensive, incorporating studies and links to the rooms of the Councillors below. The Bayne Tower at Hampton Court, where business was transacted on a far less formal basis, was a truly privy space in medieval style. But the creation of the Bayne Tower had a second effect: the new bedchamber added a fifth room to the sequence of State Rooms in the King's Lodgings (fig. 78). From 1530 there was a guard chamber, a presence chamber, a dining chamber (called the Chamber of Estate), a withdrawing chamber (or Privy Chamber) and a bedchamber in the new tower. This arrangement, with the additional room specially set aside for dining, distinguished Hampton Court from the other greater houses in the Thames valley in which the presence chamber was also the public dining arena. The additional room, directly connected to the Privy Kitchen below, underlined Henry's intention of using Hampton Court as his principal out-of-town house for entertainment. Finally, the insertion of the Bayne Tower between the State Rooms and the long galleries emphasised the fact that the gallery was to be the principal private space in the Privy Lodgings. Henceforth, until the early eighteenth century, at all royal houses, galleries were seen as strictly controlled private space.

★ ★ ★

The Great Hall and Tennis Court

Building work over the course of 1529 and 1530 had rapidly transformed Hampton Court into a residence suitable for the king, and during 1531 Henry used his new residence more than in any previous year. That June he began to devise the next tranche of work. The Milanese ambassador reported that the king was at Hampton Court preparing a scheme that would cost many tens of thousands of crowns.[14] Henry was there again during November and December sheltering from the plague that was then raging in London, but he left the palace on 19 December, and did not spend another night there for eighteen months. During his absence the royal residence was transformed by two of the largest single domestic structures built during his reign: the Great Hall and the Tennis Court (fig. 49).

In January 1532 work began on dismantling Lord Daubeney's great hall, while Christopher Dickinson and James Nedeham retired to their tracing houses to design the new one. Meanwhile the Warden Carpenter, William Clement, rode to local woods to mark out timber for the new roof.[15] Despite suggestions that Nedeham may not have been a designer it is clear from the Hampton Court building accounts that he not only drew plans but provided templates for the construction of the roof. The design he chose was of hammerbeam construction. A hammerbeam is a horizontal timber that projects from the wall at the level of the roof plate and is supported by arched members from a wall post resting on a corbel below (fig. 52). It narrows the span for the timber members above, thus allowing a wider space to be vaulted than would otherwise be possible. The hammerbeam was invented at Westminster Hall to span a building almost 70ft wide and was designed by the brilliant royal carpenter Hugh Herland in 1395. There was no structural necessity for a hammerbeam roof at Hampton Court since at 40ft wide the hall could easily have been spanned by single tie beams. The roof, in fact, also has a second tier of lateral hammerbeams that are purely ornamental projecting from the sides of the hammer posts, which in turn support longitudinal minor arched ribs and pendants (fig. 279). The roof was thus not a structural necessity, but a decorative vehicle conforming to a type. Since the construction by Edward IV of the hammerbeam ceiling of the Great Hall at Eltham Palace in 1475–81, hammerbeam roofs became exclusively associated with the grandest of great halls. The Eltham roof was a consciously nostalgic structure, intended to evoke the chivalric notion of ancient English hospitality as set out in the Royal Household regulations of 1471–2, the *Liber Niger*. Henry VII, in order to emphasise the same point, not only covered his hall at Richmond with a great hammerbeam roof, but decorated it with a series of images of his predecessors from the emperor Brutus onwards.

The English royal great hall, constructed in a medieval style, sits happily in an international context too. Francis I of France built great *salles de bal* at both Fontainebleau and Saint-Germain-en-Laye in the late 1540s. The French royal *salles de bal*, which performed precisely the same function as the Henrician great hall at Hampton Court, were constructed with vaulted ceilings, not with up-to-the-minute boarded, coffered or stucco ceilings as elsewhere in the palaces. For the king of France, as for the king of England, the great ceremonial occasions of the reign were to be conducted, not in rooms of the latest style, but in carefully fabricated ancestral halls.[16]

The Hampton Court hall was built within a tradition of hammerbeaming. For instance, in the first decade of the sixteenth century Sir Nicolas Carew roofed his hall at Beddington with hammerbeams, and Wolsey's own great halls at York Place (1528) and Cardinal College, Oxford (1529), were covered by hammerbeams. Each of these structures – deliberate stylistic anachronisms – emphasised the ancient lineage of the institutions or patrons they represented. The powerful associations suggested by hammerbeam ceilings meant that they continued to be constructed in the grandest institutional and domestic halls until the Civil War.[17] The Hampton Court ceiling was built within this tradition, and the adjoining masonry elements – the new vault beneath the Anne Boleyn Gate and the hall's bay window – were constructed in anachronistic styles to match.[18] Yet the charm of the Hampton Court roof is that it seamlessly melds the most backward-looking, chivalric design formula with fashionable decoration. The spandrels, for instance, are decorated with elaborate applied grotesquework. Much of this decoration, including the heads, pendants, badges and spandrels, was undertaken by Richard Rydge and John Wright, two London carvers who probably designed and applied the embellishments themselves (figs 65, 279).[19] Many of these elements were painted and gilded, and the whole expanse of the internal oak boarding was painted with blue azurite.[20]

Within a few weeks there were twenty bricklayers and twenty-five masons working on the hall, and by the end of the year there were almost sixty carpenters working on the new roof. The internal fitting was undertaken by a more cosmopolitan group, which included the German decorator Robert Shynck. A great crested jewel-piece (or cornice) was installed, studded with royal badges and decorated with antiquework painted in green, blue and gold. The floor was paved with tiles rather than boarded in timber as it is today, and in the centre, supported by a great stone pillar, was a stone hearth. Above this soared a great louvre, richly carved and moulded and painted internally and externally, decorated with a menagerie of lions, dragons and greyhounds carrying gilded and painted vanes, surmounted by a crowned lion carrying a monster vane. At the lower end of the hall was the bold oak screen which remains to this day, but originally it was topped with thirty-two 'lintels' carved with the king's and queen's badges. The screen supported a minstrels' gallery accessed by a stair turret from outside. Externally, the brick and stone elevations were enlivened by more beasts bearing vanes, sixteen in all on the battlements; the gables boasted a lion and a dragon. Beneath the hall at its west end was a new buttery and next to it, occupying most of the space, was a vast new cellar, created by excavating the ground to a depth of about 2ft 6in. (figs 17, 50, 51, 52, 65, 279, 286).

The new hall was on the first floor and so required three new access routes. The old stone stair leading up from the upper end of Daubeney's hall was modified to take a new timber staircase linking the kitchens and the dais end of the new first-floor hall.[21] Then two new sets of stairs were built: one from the north cloister linking the kitchens with the body of the hall, and a processional stair from beneath the inner (Anne Boleyn) gate to the screens passage (figs 77, 78).[22] In order to install the new staircase the northern part of the east side of Base Court had to be substantially remodelled. This included reconstructing the north flank of the Anne Boleyn Gate. Wolsey's original vault was removed and a new fan vault installed bearing the initials of Henry and Anne (fig. 298).[23]

50 John C. Buckler's watercolour view of Clock Court showing the south elevation of the Great Hall and the Middle Gatehouse, 1837.

Hampton Court was the only great hall that Henry VIII was to build. At The More he sub-divided Wolsey's former hall to create a first-floor great chamber, and at Hull Manor and Rochester Priory, both lesser houses, halls were deliberately removed from the building plans. At Nonsuch, the only house that Henry built from scratch, there was no great hall at all.[24] Despite turning away from the great hall at his lesser houses, at Hampton Court the great hall was integral to Henry's conception. By the end of his reign, of the houses he used regularly, only Greenwich, Whitehall, Hampton Court and Woodstock had great halls. These were the houses used for occasions of state and so required the symbolism of a great hall. A symbol was all the hall actually was. Mostly it was an empty shell, which may sometimes have provided a space for the household to dine in. Even this possible use is open to question since it must be seriously doubted whether the central hearth was ever used – in 1924 when minute analysis of the paint on the ceiling was undertaken, no sign of soot was found. The central hearth, like the hammerbeam roof and the fan vaults, was probably part of the chivalric conceit, rather than being a means of warming the royal household.[25] Although there are no descriptions of the Hampton Court hall in use during Henry's reign, accounts from the reign of Edward VI make it plain that the room was only dressed for the most formal of occasions. In his journal Edward specifically singled out visits of the maréchal of France and of the Queen Dowager of Scotland, both in 1551, as being times when the hall was richly hung (see chapter 4).[26] On such great occasions the hall, hung with tapestry, became the great anteroom to the State Apartments. It seems unlikely that specific tapestries were ever commissioned for the hall, although the ten-piece set of the *Story of Abraham*, which was new in 1544, was at Hampton Court at the king's death in 1547 and hung complete could have fitted into no other room there. The *Abraham* tapestries were almost certainly first hung in the Great Hall for the French embassy of 1546 (for which see below).[27]

The new Great Hall and the Privy Lodging Tower, between them, had a major impact on the principal rooms of the house. These rooms were divided into two geographical areas under the supervision of two different departments of the Household. First there were the outward rooms, principally comprising the Great Hall, the Guard (or Great) Chamber and the Presence Chamber. These, the outer rooms of the palace, where courtiers could assemble with relative freedom, were under the control of the Lord Chamberlain. Then there were the inward rooms, comprising the Privy Chamber, Withdrawing Chamber and other private rooms.

51 Philip Hardwick's survey of the bay window in the Great Hall of c.1810. It is possible that the stonework for the window was part of Wolsey's stockpile of materials left at his fall.

52 Philip Hardwick's transverse section of the roof of the Great Hall of c.1810.

These were under the control of the King's Groom of the Stool, the principal official of the Privy Chamber, the part of the Royal Household that took care of the king's personal needs. As remarked, the new Privy Lodging Tower, by providing a new bedchamber and releasing the old bedchamber to be used for another purpose, facilitated the creation of a dining room in addition to the Presence Chamber on the east side of Clock Court. The Great Hall meanwhile could be added, when appropriate, to the outermost rooms, becoming the first of the series of great antechambers sited on the first floor, and so linked to the royal outer rooms in an entirely novel way.

Hunting had been the principal outdoor recreation at Hampton Court since the time of the Hospitallers. But hunting is a seasonal activity, and Hampton Court's owners made provision for other courtly sports, the most important of which was tennis. Today Hampton Court is associated with real or royal tennis through the survival of the Stuart court where the tennis club is based. The present court is the fourth on the site, the first having been constructed some time before 1530 (fig. 31). It is not clear who built the original court (of which we have only documentary evidence) but we do know that Henry VII brought about a revival of interest in the game when he took it up in 1494 at the advanced age of thirty-seven. He went on to build courts at Kenilworth, Richmond, Windsor and Woodstock, amongst other royal residences. Thus it is quite possible that Giles Daubeney was responsible for the construction of this first court on the north side of his house some time around 1500; it is also conceivable that Henry VII played on it during one of his visits. If Daubeney did not build the court, Wolsey's workmen could have erected it after 1514, but the cardinal seems a less likely sponsor for this sporting facility than the house's previous owner. At any rate it is certain that Henry VIII, who was brought up to be an accomplished tennis player, used the old Hampton Court tennis play (the Tudor word for court) at least as early as 1530.[28]

During the first part of his reign Henry VIII was a committed huntsman and jouster, but around 1530, as he entered what was in Tudor times late middle-age, he increasingly turned to indoor sports like tennis and bowls. The outcome of this was a rash of new tennis courts built to serve his main residences, notably at Whitehall but also Hampton Court. At these houses two almost identical tennis plays were constructed during 1531–3. Both were vast chapel-like buildings buttressed, battlemented and fenestrated with towering four-centred three-light windows (figs 53, 99). The Hampton Court play was built on the east front of the palace at

53 Eastern elevation of Chapel Court by John Spyers. This watercolour of c.1780 shows the body of Henry VIII's Tennis Court altered in 1670 for the Duke of York and again in 1717 for the daughters of George, Prince of Wales. The seventeenth-century casements can be seen on the top floor. The sashes are Georgian. The original windows had stone surrounds. To the left are Prince Edward's Lodgings, built in 1537 and burnt down in 1886.

right angles to the chapel, giving the palace two tennis courts – the existing outdoor one and the new indoor one (fig. 49). The earlier outdoor court was probably a so-called Minor or Quarre Court with penthouses along one side and one end wall. The new court was a major or dedans court, with penthouses at either end as well as along one side. The interior of the court was painted black with the play lines in white; the vast windows were covered with wire mesh, painted red. The new court had many other refinements such as a lodging at the north end for its Keeper. The Keeper had an important role, acting as umpire, tennis-ball supplier and chief of maintenance, and his lodging was of some size and comfort. Its first floor incorporated a gallery from which courtiers could look down on the game below. This was essential, because Tudor courtiers were great gamblers and placed bets on the outcome of tennis matches and most other competitive activities. Joining the viewing gallery and lodging and the old court was a gallery, begun in April 1533, which allowed courtiers to keep dry whilst moving from court to court.[29]

★ ★ ★

A Change in Direction: Henry and Anne Boleyn at Hampton Court, 1533–1536

The Great Hall ceiling was the last major structure that James Nedeham was to design at Hampton Court, for in October 1532 he became Surveyor of the King's Works in the place of Thomas Flowre. Nedeham was succeeded as Master Carpenter by John Russell and William Clement, who held the post jointly. Clement was Nedeham's former apprentice and had been involved with Hampton Court from the start, and it seems that it was agreed that he should continue to regard Hampton Court as his sphere of activity. This change in personnel created the design duo that was to be responsible for building Hampton Court between 1532 and 1538, and then designing the extension of Oatlands and the new palace of Nonsuch, both in Surrey. It was Christopher Dickinson, William Clement and their patron, Henry VIII, who were responsible for the finished appearance of the Tudor palace.[30] Although work on converting Wolsey's former houses, York Place,

54 The Great Tennis Court as seen today from the east-front gardens. While the court has been extensively altered, the roofline and surviving stair turret illustrate the original imposing effect.

renamed Whitehall, and Hampton Court progressed in parallel, sometimes producing buildings of almost identical form, there was a crucial difference in inspiration behind the two projects. While Whitehall can be seen as Henry's and Anne Boleyn's joint project, at first Anne seems to have been less involved at Hampton Court. This circumstance is readily explained. York Place, the town house of a celibate archbishop, had no apartments for a queen and thus Katharine of Aragon and Henry could never stay there together. Hampton Court, as seen, was lavishly provided with lodgings for the queen, and Henry and Katharine had formerly been joint guests. Indeed even after June 1527, when Henry told his wife that he intended to divorce her, they stayed together at Hampton Court with an outward show of dignity and decorum. Thus although Anne had rooms at Hampton Court as early as June 1529, she was in no position to influence its development before the divorce from Katharine was finalised.[31] Yet Henry, who envisaged spending more time there and wished to have Anne near him, persuaded Stephen Gardiner, who had been granted the royal manor of Hanworth nearby, to give it up so that he could grant it to Anne. This he did in July 1532, providing her with a base close to Hampton Court. Immediately the Office of Works moved to fit the manor out for Anne at some expense.[32]

It was not until after Anne's coronation in January 1533 that she began to focus on Hampton Court and to play a role in conceiving new buildings, just as she had done at York Place. It cannot be coincidence that in the very month of Anne's coronation royal workmen began to dig foundations for a completely new courtyard to house a new suite of lodgings for the queen (fig. 49). In January 1533 there began a campaign to transform the coherence of the palace: to harmonise and unify disparate parts that had been built over a period of thirty or forty years. The planning of this work must have been underway in late 1532, and Anne was intimately involved. Anne's new lodgings were to be on the east side of a new courtyard formed to the east of the King's Lodgings, overlooking the park. The new rooms were fundamentally different from the old ones above the King's Lodgings because since Henry had begun the conversion of York Place in 1530 the concept of the stacked lodging had been abandoned and a new

55 Ceiling of one of the Wolsey Rooms showing a battened ceiling *in situ*.

56 (*below*) Heraldic roundel from the ceiling of the Great Watching Chamber with moulded work by Robert Shynck, painted by Henry Blankston and gilded by John Hethe 1536.

with grotesquework designs into which was pressed a modelling compound called leather *maché*. This was made by mixing shreds of leather, brick dust and size into a glutinous paste that set with a hard, smooth surface suitable for painting. Panels of decorative leather *maché* could be nailed up as sections of frieze (fig. 33), inserted into ceiling battens as strips of decoration (fig. 55), or fastened as individual decorative motifs within a ceiling or wall design (fig. 56). Shynck could also produce mouldings of lead that were used where finer detail was required, such as for making letters to spell out the king's and queen's mottoes, for oak leaves for the ceiling, or for especially fine grotesquework. Once in place the moulded work was painted by Blankston and Hethe. Henry Blankston was a painter, also from Germany, who acquired denization in 1534 and may have been the partner of the gilder and moulder of antiquework, John Hethe, an Englishman. Sadly the accounts do not specify which type of grotesque decoration was set up in Anne Boleyn's new rooms, only that there were heraldic badges and mottoes.[34]

Externally the new rooms facing the park can be seen on a number of early views (figs 57–59). Built of brick with a diaper pattern, crenellated, turreted and sprinkled with gilded vanes and turned chimneys, they were strangely unimpressive, at least by the time they were recorded in the seventeenth century.[35] The new east front had little of the pretension of Wolsey's soaring lodgings built around 1525. Yet they should not be dismissed as a higgledy-piggledy afterthought. The elements of the east front are carefully grouped, with bay windows, towers and turrets, creating breaks in a façade composed in a deliberately picturesque manner. Purely and relentlessly asymmetrical, the east front set the tone for the Henrician domestic development of the palace. As we shall see, while the west front was made ever more regular and formal, the Royal Lodgings became more romantic and striking in silhouette.

The new gallery on the north side of the new inner court provided the principal public access to the new lodgings from the King's Great Stair and from the chapel, reinforcing the function of the three-storey Long Gallery as the king and queen's private route. The creation of the Queen's Lodgings at the end of the Long Gallery necessitated some modifications to its east end. First it was decided to create a new two-storey extension for the king on the south side, which almost certainly housed a bedchamber at first-floor level. Once again, the accounts for the decoration of the king's new rooms are full, and describe moulded work with a 'border [freize] of antyke wyth nakyd chyldren the antyke all gylte with fyld layde wyth fyne byse [blue]'. The room was directly adjacent to the queen's jewel chamber and her bedchamber, creating interconnecting bedrooms for Henry and Anne. Later, this room, abandoned as a bedchamber and set aside as a cabinet of curiosities, became known as 'paradise'.[36] The second

principle in royal domestic planning introduced. Henceforth the Royal Apartments were to be arranged on a single level facing each other across a courtyard.

The new courtyard had, as its south side, the king's three-storey long gallery overlooking the southern gardens, and this was joined by two other galleries – one on the west and one on the north – forming another two sides of the new quadrangle (fig. 49). The new galleries were harmonised with the old by being raised up on arches, which created a cloistered effect and gave the new enclosed garden its seventeenth-century name 'Cloister Green Court'. On the east were the Queen's New Lodgings, with a watching chamber, presence chamber, private oratory, withdrawing chamber, bedchamber and jewel house, or private closet.[33] The accounts for fitting out these rooms are particularly full and paint a picture of a suite of enormous richness and high fashion. The decorators chosen to undertake the work were Robert Shynck, Henry Blankston and John Hethe. Shynck was a German 'moulder of antiquework'. He used wooden moulds carved

57 Watercolour view of the east front of Hampton Court by Hendrick Danckerts (c.1630–1679), commissioned by Samuel Pepys in January 1669. Pepys had intended to adorn his dining room with views of royal palaces including this view of Hampton Court. In the event Danckerts substituted a painting of Rome, and the watercolour was never painted in oil.

58 View of the east front of Hampton Court by William Schellinks (1623–1678), drawn on 23 April 1662. Schellencks was a Dutch artist and diarist who visited Hampton Court at the Restoration and made this view as part of a series of drawings capturing his travels around England. It shows the appearance of Home Park before the destruction of the Commonwealth period.

modification was the construction of a new 20ft-square stair providing access between the various levels of the gallery and the garden to the south. This allowed the king and queen both to descend from their innermost rooms to enjoy the garden, and to ascend from the riverside after disembarking and gain direct access to their lodgings (figs 77, 78).[37]

On 2 July 1533 the king and his new bride arrived at the palace to inspect work on the foundations and refine their designs. We know that beneath the new lodgings they planned a wardrobe for Anne's clothes, a privy kitchen for her table and, crucially, a nursery for the prince they hoped to conceive. Anne must have stayed in the upper-floor lodging built for her predecessor, and from its upper windows would have seen the work advancing. During the three years it took to create the new courtyard the king and queen visited to see progress and take decisions on building matters. They paid a brief visit in December 1533, preceded by a frenzy of overtime by workmen attempting to finish their tasks to deadline. The pay house even issued candles to carpenters

working on the ceiling of the Great Hall in order to prolong their working day. In the early summer of 1534 Henry and Anne made a number of short visits, and despite the chaotic state of much of the palace they twice entertained in some style ambassadors from the Hanseatic town of Lübeck. During their stay in July a ream of large paper was ordered for plans to be drawn at the king's command, signifying the continuation of design work.[38] The royal couple were there again in spring 1535, and again in mid-March before a progress that took them to the Severn and to Hampshire. Although neither of them knew it at the time, this was to be the last time that Anne would visit the palace. While they were away Anne became pregnant, but she was unable to hold the child and had a miscarriage in January 1536. Just three months later the queen and a group of courtiers including the king's closest friend, his Groom of the Stool, Henry Norris, were arrested on charges of treason. Three weeks later, Anne was dead. At her trial the queen was charged with adultery. Her transgressions were said to have included intimacy with William Brereton at Hampton Court on 8 December 1533. It is very unlikely that the alleged liaison ever took place, although the queen was there at the time supervising work on her new lodgings.[39] Although they were completed in early 1536 Anne did not live to enjoy them.

The construction of the new eastern courtyard was just part of a much larger campaign of modernisation devised by the royal couple, which was underway during 1535–6 (fig. 61). The king's own lodgings were refitted and partially rebuilt to bring them up to the standard of the queen's; the interior of the chapel was remodelled; and the western entrance of the palace re-designed. In early 1534 work began on dismantling the King's Watching Chamber, an obvious starting place for a reconstruction. Created by Wolsey as an enlargement of the previous Great Chamber, the room was too small for Henry's use. Royal etiquette demanded that the watching chamber should be not only the place where the king's bodyguard stood, dressed in red jackets holding long pikes, but also the dining place of courtiers 'above the rank of a baron'. In fact, by the mid-1530s the Watching Chamber had superseded the Great Hall as the room in which almost all the normal intercourse of the court took place. It had, therefore, to be the largest and most convenient outermost room in the palace. Wolsey's watching chamber was lit by clerestory windows and linked to the hall indirectly via a 'hall place' – a waiting and preparation area (fig. 40). The king's work was to enlarge the room, and to give it new windows and improved access. The entire existing structure and Wolsey's cloister to the east of it were dismantled, and foundations laid for a building 4ft wider. This was raised up

59 (*above*) Anonymous view of the east front of Hampton Court, *c*.1656–70 – the so called 'long view'. Neither the artist nor the patron is known. Although apparently confusing, the details of this view are confirmed by later views from the same direction (figs 58, 59, 69).

on a cellar nearly identical in form to that at Whitehall. Next to the cellar, which was destined to be a store for the King's Own Wine, was a drinking house for the Sergeant of the Cellar who looked after it. The much taller new room above was lit by clerestory windows and a great new semicircular bay window, and was approached directly from the Great Hall by a new door.[40] Above the drinking house was a new chamber for the king's pages and on the north side of the room was a garderobe for the king's yeomen of the guard, who slept in the chamber at night.

The Great Watching Chamber, which largely survives, is a very important room (fig. 60, 405, 407). Its later history, its decline and its two restorations will be covered below, but in its present state it broadly reflects its original appearance. The ceiling pendants, turned by Garret Rougg, carved by Richard Rydge, and painted and gilded by Blankston and Hethe; the spandrels of the doorcases carved by John Rogers and the heraldic roundels moulded

60 Joseph Nash's imaginary reconstruction showing Cardinal Wolsey dining in the Watching Chamber, 1840. Wolsey would not have eaten in the Watching Chamber and never knew the room as it now stands. Henry VIII raised the ceiling and moved the east wall to create the present space. Nash's evocation is therefore of the Henrician appearance of the room.

by Robert Shynck (figs 56, 304) all remain.[41] Gone, however, is the door that led south into the Chamber of Estate; this was taken out and blocked up in 1732 when William Kent remodelled all the other outer rooms built by Henry in the 1530s. To envisage these rooms we have to rely on the Office of Works accounts alone. Based on this evidence it seems that not only was the Presence Chamber improved, but the rooms beyond it were almost completely rebuilt. Passing from the Presence Chamber to the Privy Chamber was more than a physical passage: it involved moving from one court arena to another. The Presence Chamber was under the jurisdiction of the Lord Chamberlain, part of the public area of the palace; the Privy Chamber was very definitely part of the Privy Lodgings under the care of the Groom of the Stool. The area between the two chambers was carefully designed to protect the king's privacy. This space contained the King's Privy Closet (or Kneeling Place), a private oratory entered from the Privy Chamber; and next to it a small chapel entered from a passage that ran between the two rooms (fig. 78). This arrange-

61 Henry VIII's building campaign of 1535–6 showing excavated and extant features in black line and conjectural features in dotted line. Drawing Daphne Ford.

ment allowed the priest to say mass without entering the King's Privy Chamber, and the king to hear mass without leaving it.[42]

The king's spiritual devotions in the Privy Closet were supervised by the Clerk of the Closet, who organised both the King's Privy Chaplains and the arrangement of the closet itself. The closet was very richly furnished with carpets and cushions as well as a kneeling desk, an altar and all the necessary liturgical supplies. In this small room the king would hear mass from Monday to Saturday and on all ferial (non-feast) days soon after rising. During the 1540s, when Henry used Hampton Court for summer hunting trips, he rose at six in the morning, heard mass in his privy closet at seven, and then left for the field immediately afterwards. Often the moments in his closet were the only times when the king's ministers could attract his attention, and Henry was known to read letters while he listened to the chaplain next door.[43]

The Privy Chamber had originally been the king's bedchamber, and it was still linked to the oldest surviving part of the house, the original south range built by Lord Daubeney. This meant that the room was rather dark, especially after the Privy Tower containing the new bedroom and bathroom was constructed in 1529–30. The room was therefore given a new bay window and a suspended ceiling decorated by the usual team of Shynck, Blankston and Hethe. But whatever the hopes were for this refit, it failed to improve the room and very soon after it was completed it was decided, without the king seeing it, to scrap the new work and take down the old south range. This was a major decision with a whole series of ramifications. First it entailed an extension and remodelling of the inner courtyard. This was done in 1535–6 when the new area was paved with 907ft of Kent hard stone bought by Christopher Dickinson from quarrymen in Maidstone. At this point it was also decided to surface Base Court with less prestigious seashore cobbles. In order to harmonise the elevations of the new courtyard, the existing crenellations were heightened on the south and west sides, and a low screen wall was built at the south end of the King's Lodgings to regularise the southeast corner of the court. This can be seen clearly on Wyngaerde's Elizabethan view (fig. 63). The patched brickwork was disguised by painting the walls and windows with red ochre and picking out the mortar joints in white.[44] To one side of the foundations of the old range rose a fountain also shown on Wyngaerde's view. Water was supplied to it by a lead pipe, and a brick drain (seen in excavation in 1973–4, fig. 62) took excess water to the Pond Gardens in the south. The superstructure was partially stone but was surmounted by carved and painted wooden beasts by Henry Corant.[45]

The substantial reconstruction of the inner court, renamed Fountain Court after 1536, transformed the appearance of the heart of the palace, but there was more work to be done, especially to the west front. Ever since Henry VIII took the palace from Wolsey it had been a building site, and many of the yards, storehouses and workshops necessary for the progress of the works were sited at the western entrance of the palace. In 1535–6 all these were removed and re-sited away from the western approach, providing the opportunity for creating a suitably dignified and magnificent forecourt. A new gate was erected where Trophy Gate is today, and a wall built stretching from there to the palace along the north side of a new forecourt soon to be known as the 'Outer Green Court' (fig. 80, 88, 92). The western elevation of the palace itself, originally symmetrical, had been made lopsided by the addition of the kitchen gatehouse built in 1529–30. It was only during the works of 1535–6 that a matching wing was built to the south, restoring symmetry to the entrance front (figs 61, 205, 290). It is not now possible to say whether it was originally intended that there should be an answering wing to the kitchen gatehouse, but from a modern point of view it would seem strange if not. On the other hand, a six-year delay between the construction of the two wings seems inexplicable if symmetry was thought to be important. The new wing was designed to contain a number of new lodgings, and the palace's public latrine. This convenience was dignified with a number of euphemisms, such as the Henrician 'common jakes'; the Elizabethan 'great house of easement'; or the 'great withdraught'. It was a cunningly designed garderobe built on a double vault over the moat. The occupants sat on seats (boards with circular holes) arranged on two levels, fourteen to each level (figs 77, 78). The discharge fell into a walled section of the moat close to the river and was flushed out into the Thames with the tide. A sluice prevented sewage being sucked back into the moat at the front of the palace. Since most of the lodgings in Base Court had their own garderobes, these public conveniences must have served the few without them – day visitors, and members of the household whose lodgings were outside the main courtyards. Because the court was principally a male organisation, it is unlikely that there would have been any segregation of the sexes.[46]

While the Great House of Ease rose from the moat so did another major structure – a great stone bridge (fig. 64). Wolsey's western moat was unrevetted and was crossed by what was presumably a timber bridge. The newly magnificent Hampton Court demanded a much more substantial and significant structure, and in September 1535 the foundations for a new bridge were laid. Built of brick with a Headington stone facing, it crossed the 25ft-wide moat in four 8ft spans, and from its cutwaters rose octagonal shafts supporting stone heraldic beasts. There were twelve beasts in all, six carved by Henry Corant and six by Richard Rydge: two greyhounds, two dragons, two unicorns, two lions and two panthers, and a single bull and a fabulous beast with horns and tusks known as a yale. The king's beasts were the Cadwallader dragon, the Beaufort greyhound, the English lion, the Clarence bull and the Beaufort yale. The unicorn and the panther were the beasts of Jane Seymour (fig. 62).[47] The bridge, in common with all the works begun with such enthusiasm after Anne Boleyn's coronation, was in actuality completed in the reign of Queen Jane. Anne's leopard had no sooner replaced the pomegranate of Katharine of Aragon than it was being carefully converted into the panther of Jane Seymour.

62 Fragment of heraldic shield excavated from the moat in 1909-10 showing the arms of Jane Seymour: a gateway, hawthorn tree and golden phoenix.

63 At the heart of the palace, Fountain (now Clock) Court has the most complex archaeology. This phased plan, based on both above- and below-ground archaeology, illustrates the changing face of the inner court and is the base from which the development plans (figs 3, 8, 14, 31, 42 and 49) are drawn.

These changes to the beasts at the west front were typical of the attention paid to heraldic display at Henry VIII's Hampton Court. Not just immediately following the king's acquisition of the house, but throughout nearly ten years of internal remodelling and rebuilding, considerations of heraldic iconography dominated the decorative vocabulary. Externally, heraldic beasts were the palace's chief form of ornamentation, both the royal supporters' and those of Henry's family and his queens. Lions, dragons, leopards, hinds, harts, antelopes and greyhounds, many carrying gilded flags or vanes, adorned gables, pinnacles, crenellations and pillars on the palace and in the gardens. In addition there were set-piece coats of arms, the largest two of which were inserted in panels in the Great and inner gatehouses in 1531. The present panels date from the 1960s, but the originals were brightly painted. Indeed, heraldry was the vehicle for external architectural colour at Hampton Court. Inside heraldry played no less a role. Its presence in the roof of the Great Hall and amongst the moulded-work ceilings and friezes of the royal lodgings has already been noted (figs 56, 65). The principal decorative material for the royal glaziers was also the royal badges and mottoes. Frequent changes of queen would have provided continuous employment for glaziers at Hampton Court even if it had not been for the major building programme. In October 1536, for instance, the great east window of the chapel was re-glazed to remove the figures of St Ann and St Thomas from the composition.[48]

★ ★ ★

64 The palace entrance, showing the Gatehouse and the Moat Bridge today. The beasts on the bridge date from 1950.

65 One of the royal coats of arms in the Great Hall roof with the arms of Henry VIII and Anne Boleyn.

The Chapel

The chapel was the last part of Wolsey's palace to be modernised in the great rebuilding of 1533–6. As seen there is little evidence to illustrate the appearance of its interior in 1529, but it seems to have served the king adequately until work began on transforming it in 1535. Henry left little unchanged. A new green and black chequered tile floor was laid using tiles supplied by Thomas Nortrage of Chertsey; Henry Corant created carved stalls and a new vestry was erected on the south side abutting the gallery to the Queen's Lodgings.[49] But the most important works were the replacement of the ceiling and the complete refitting of the royal pew. The new ceiling remains today as not only the most important Tudor ceiling in England, but one of the most romantic and powerful expressions of the Tudor style (figs 66, 67, 202). The entire structure was prefabricated at Sonning in Berkshire by a team of Hampton Court carvers, first under Edmund More and later under Henry Corant. Sonning was a manor, well stocked with timber, belonging to the bishopric of Salisbury. Indeed its bishop, Cardinal Campeggio, had licensed Wolsey to take timber for Cardinal College, Oxford, and a surviving pay-book lists work done there for a ceiling for the chapel. The king too turned to Sonning, which had fallen into his hands after Campeggio had been deprived of the see in 1534. It has sometimes been suggested that the Hampton Court ceiling was in fact at least in part the one that had been designed and prefabricated for Wolsey's Oxford college, it having remained at Sonning unused, but this seems unlikely. Most of the materials left over from Wolsey's various building works were inventoried at his fall, and large pieces of prefabricated roof would hardly have escaped the view of the King's Commissioners. Moreover, timber and other materials for Cardinal College and Wolsey's other buildings were rapidly used up at York Place and Hampton Court in 1529–31 rather than five years later. At any rate, if parts of another roof were used they must have been fairly insignificant given the scale of the king's nine-month construction period at Sonning. What is most likely is that both king and cardinal found the timber at Sonning good, and its location convenient for prefabrication and subsequent transport along the Thames. As sections of the ceiling were completed they were despatched to Hampton Court by barge. The first section arrived in September 1535, and the remainder in October and December. Erecting the ceiling was a major undertaking that involved dismantling part of the chapel's gable end and protecting the exposed interior with canvas sheeting. In the summer of 1536 the timber sections were finally in place and ready for John Hethe and Henry Blankston to gild, paint and embellish with moulded work at a cost of £457.[50]

Although the immediate models for this triumphant piece of carpentry are the stone vaults of the choir at St George's chapel, Windsor, and those of Henry VII's chapel at Westminster Abbey, the ceiling is in fact a direct descendant of Sir John Crosby's ceiling at Crosby Hall, possibly designed and constructed by Edward IV's Master Carpenter, Edmund Graveley, in 1466–75. Crosby's ceiling was probably the first self-consciously decorative ceiling of its type in England, in which the carpenter's design was liberated from the structural requirements of the vault. Like Crosby's ceiling, and unlike its stone prototypes, the Hampton Court ceiling is entirely decorative, slung beneath a series of large queen-post trusses – built of stone the ceiling would collapse (fig. 66). It is a bizarre cross between a hammerbeam and a fan vault: the hammerbeams terminate in castellated drums containing trumpeting angels, from which spring the ribs of the fan vaults. Along the spine of the ceiling the vaults meet in a matrix of ribs, which centre on a series of pendants terminating in bosses bearing more angels (fig. 67).

There can be little doubt that the chapel ceiling was designed by William Clement, whose name is associated with both the materials and the workforce throughout the design and construction period. The ceiling reveals him as a designer of enormous talent, capable of mastering the highly complex geometry of the vault in three dimensions; it is no wonder that he was later chosen by the king to mastermind the design and construction of Nonsuch, an entirely timber-framed palace. Whilst work on the ceiling progressed at Sonning, the royal pew was refitted. The motivation behind this was not solely an aesthetic one for, as far as we can tell, the original pew had been a single space. The work of 1535–6 was to divide it in two, allowing the king and queen to have their own separate rooms, or Holyday Closets. The term 'Holyday Closet' distinguished the much larger pew in the Chapel Royal only used on Sundays and feast days – 'holy days' – from the small Privy Closet between the Presence and Privy Chambers used by the king on a daily basis. The pew was divided in two by a timber screen which was richly carved, painted and gilded, and filled with stained glass (fig. 78). The two new pews had floor-to-ceiling bay windows with opening casements looking down on the choir of the chapel. These were glazed, gilded and painted en suite. The carving round the bay windows was done by a Frenchman named James Meadew. The ceilings of the two closets, which partially survive, were battened in gold and blue bice, with pendants turned by Garret Rougg.[51]

While the king was at Hampton Court the chapel would be in daily use, with a high mass and a votive Lady mass after it. The most important offices of the day were also performed: matins, lauds, prime, vespers and compline. But except for on feast days, it seems that these devotions were likely to have been performed in private. It was only on Sundays or feast days that the courtiers and the king himself would attend the chapel of the house at

66 Structural survey of the chapel roof and ceiling of 1920 colour coded to show the original structure and subsequent additions and beam deflection. This records the roof structure before the major reconstruction of 1929 but after the work of 1845–7.

which he was staying. On such occasions, if the king was at Hampton Court, the palace was always full, with nobles making a special effort to be present. The great Church feasts drew particularly large attendances and of these Epiphany, the twelfth day of Christmas, was the most important. This was the only feast of the year at which the king would wear his crown and robes and process to the chapel to hear mass. On four other days of the year the king wore his purple robes – All Saints', Christmas, Easter and Whitsun – and on each of these occasions he would also process to the chapel in state. A number of other feasts were celebrated in great splendour: New Year's Day; Candlemas (2 February); St John the Baptist (24 June); the Assumption of the Virgin (15 August); and the Nativity of the Virgin (8 September). These were all feasts in every sense of the word, and the liturgy would be accompanied with banqueting and other entertainment. In addition to these there were some forty other feasts in the liturgical year that saw king and court in the Chapel Royal. For the Household, the great attraction of the king's participation in these holy days was his procession from the Privy Chamber to the chapel. The Presence Chamber, the Chamber of Estate and the Guard Chamber would be bursting with courtiers, visitors and ambassadors; the route was lined by the yeomen of the king's guard. The king's procession, his coming forth from his lodgings, was the cue for the assembled multitude to see their sovereign and to try to catch his eye or his ear.[52]

But although the new chapel at Hampton Court was certainly the most magnificent in any royal domestic residence, it was not the favoured location for the great feasts. In seventeen years Henry spent only five Easters, five Whitsuns, five All Saints' and three Candlemases at Hampton Court. The king preferred to celebrate most of these great feasts at Greenwich. It was only in the 1540s that Henry decided to use Hampton Court for a principal feast. In 1540–41, and then every year from 1541–2 to his death, he spent Christmas and Epiphany there. Despite this relatively light liturgical use for the major feasts, the chapel was the location of a number of important ceremonies in Henry's private life, and in the theatre of ambassadorial etiquette. As we shall see, this was part of the royal policy of using Hampton Court for occasions that required particular magnificence.[53]

★ ★ ★

67 The chapel ceiling today. The present decorative scheme follows the 1847 redecoration.

Henry and Jane Seymour at Hampton Court 1536–1537

The early months of 1536 saw a series of rapid and sometimes astonishing turns in Henry's private life. In January he had a bad fall from his horse, the news of which was the alleged cause of Anne's miscarriage less than a week later on the day of Katharine of Aragon's burial. April saw the investigation into the queen's sexual life, and 19 May her execution. This was fast enough, but the king's subsequent marriage to Jane Seymour on 30 May was indecently rapid. Henry's flirtation with the young, pretty and virtuous Jane had begun in the summer of 1534 and had become a source of material grievance to Anne by the middle of the following year. The king's mind was made up before Anne's untimely death: the day after her execution Henry and Jane were betrothed and ten days later they were man and wife.

All these events took place amidst the great remodelling of Hampton Court planned by Henry and Anne in the previous two years. Jane had been one of Anne's maids and would have known the palace and the works that were afoot there, and the change in consort did nothing to interrupt their progress. Indeed, in the very month of their marriage Henry commissioned more plans to be drawn, and that summer and autumn passed in a frenzy of construction. Over 170 masons, bricklayers and carpenters, and over 200 labourers, toiled on the new works, with vast deliveries of materials each day. The king and his new bride stayed away; indeed between March 1535 and May 1537 Henry did not spend a single night at Hampton Court. But on 8 May 1537, nearly a year after

68 Henry VIII's building campaign of 1537–47 showing excavated and extant features in black line and conjectural features in dotted line. Drawing Daphne Ford.

their marriage, the king and queen arrived at Hampton Court to enjoy the fruits of twenty-five months' work. Their arrival was preceded by a flurry of overtime as finishing touches were put to their new lodgings. Inevitably no record survives to show what they thought of the new work, but it is clear that it did not fully please either of them. That very month Henry ordered the probably bewildered master craftsmen, Dickinson, Clement and Moulton, to embark on a new campaign. Their instructions were to rebuild and extend the barely completed queen's apartments for the new queen; to set up new rooms for Henry; and to create a new suite of lodgings for the prince that the king was confident Jane would bear (fig. 68). Work was to start immediately, and to proceed as rapidly as possible. This building campaign, which lasted barely five months, was the most extraordinary of Henry's whole reign. Not only was work forced ahead at a perilous speed, but the king and queen were in residence through most of it. They were at Hampton Court at the start of May, for the whole of June and for most of September. Life cannot have been very peaceful: in the period between 8 September and 6 October there were more than 450 workmen on site every day. Some 700,000 bricks were burnt in the park and more than twice that number were delivered by barge. As the newly completed Queen's Lodgings were dismantled Jane was forced to stay in the old Upper Lodgings occupied by both of her predecessors. While she and Henry were away from the palace in August the rooms were completely redecorated for her.[54]

The works commissioned by the king and queen in 1537 were to transform the royal lodgings at Hampton Court into their final Tudor and Stuart form, vastly extending the parts of the palace reserved for the king and queen's exclusive use. In particular Hampton Court, in common with the other greater royal houses in the Thames valley, developed a new set of innermost lodgings for the king known as the Secret Lodgings. These rooms had become necessary as the former exclusive preserve of the Privy Lodgings had become too easy of access, and a new private area had become necessary.[55]

Work on the queen's side began with the construction of a new Privy Gallery. This ran northwards 185ft from the north-east corner of the Queen's Lodgings, with eight great windows, one bow window and two bay windows overlooking the park to the east (figs 57, 58, 59, 69, 78). There were no windows in the gallery's west wall; only three large fireplaces and three garderobes. The ceiling was decorated in the usual way with gilded battens by Blankston and Hethe. A number of paintings and drawings of the

69 View of the east front of Hampton Court by Hendrick Danckerts (*c*.1630–1679), probably painted for Charles II in 1665–7 to record the new canal dug on the east front. It clearly shows the Queen's Gallery on the right-hand side.

outside of the gallery confirm that it was built of diapered brickwork with stone dressings, and had a crenellated parapet surmounted by heraldic beasts on pinnacles. They also demonstrate that its two storeys were of equal height, the fine ground-floor rooms providing lodgings for Queen Jane's ladies. These rooms directly overlooked the moat, which lay between the gallery and the park. Unlike the earlier moats this one was flooded, and must have provided a picturesque addition to the east front.[56]

As seen, at Hampton Court and elsewhere the King's Privy Gallery adjoined his bedchamber, making it part of the innermost lodgings of the palace. The Queen's Apartments as more-or-less completed for Anne needed completely remodelling to provide a junction between the new gallery and the queen's bedchamber.

new inner court. Sadly the accounts are not full enough for us to reconstruct the arrangement of the king's new lodgings, although it has been possible to deduce the arrangement of the king's new Secret Lodgings on the east front (fig. 78).[60] The Queen's Bedchamber led into two rooms within her Privy Lodgings, a withdrawing chamber and a privy chamber. Beyond this was another chamber, the name and function of which are not clear, and then there was the 'King's Bedchamber on the Queen's Side'. These rooms were of enormous importance. Set apart from the etiquette that defined life in the King's Privy Lodgings, these inner rooms were as close as Henry VIII came to privacy. In here he dined with Catherine Parr, saw his children and received chosen guests free from the restrictions imposed in his own Privy Lodgings.

70 Anthonis van den Wyngaerde's preliminary sketch of the north side of the palace (1558–62; fig. 17 is the finished version). It shows the Tennis Court and the range that contained Edward VI's lodgings. The range was destroyed by fire in 1886 and very little Tudor fabric remains exposed. In the foreground are the Tiltyard towers.

In order for the north-east corner of Cloister Green Court to accommodate the queen's bedroom it was necessary to build new privy, presence and watching chambers on the north side of the courtyard (fig. 78). Work started on this simultaneously. The former Queen's Gallery leading from the king's rooms was cannibalised and extended, creating a new series of outward rooms for the queen on the north side of the court with a central bow window looking out from her withdrawing room into the courtyard.[57]

As the queen's rooms emerged on the north side of Cloister Green Court, the three-storey south side was also engulfed by reconstruction. The work here comprised two elements: first, filling in the arches of the cloister on the ground floor to create new lodgings for the king, including a new bathroom, a wardrobe and a privy kitchen; and second, the construction of a new privy chamber which projected 40ft from the line of the old gallery into the Privy Garden. This massive new addition with its large bay window overlooking the gardens can be seen on Elizabethan views of the palace from the south (figs 92, 93). This new extension caused extensive alterations to the Long Gallery range,[58] and at this point the king decided to keep the second-floor long gallery as his privy gallery and to subdivide the old first-floor gallery below into a new suite of rooms for his own use. It is quite understandable that Henry wished to retain the second-floor gallery, since it overlooked the sensational gardens, described in chapter 5, which were laid out on the south side of the palace during these years.[59] It was also natural that he should wish to create a new suite of rooms facing the queen's on the opposite side of the

The final element in this three-stage transformation of the palace was the construction of an entirely new suite of lodgings for the hoped-for heir to the throne (fig. 68). These were built on the north side of the palace, partially on the site of the Master of the Tennis Play's Lodging and the gallery between the tennis plays, which had been built in 1533. This new building formed another courtyard enclosing the space north of the chapel and west of the Queen's Gallery (figs 53, 70). A miniature set of lodgings was created, with outward rooms approached by a processional stair, a watching chamber and chamber of presence, and extensive inward rooms including a bedroom, a rocking chamber (for the cradle), a bathroom, a privy kitchen and a garderobe (fig. 78). The innermost rooms lay at the east end of the lodgings, adjoining the north end of the Queen's Long Gallery. Here a tall lodging was built, possibly for the prince's household attendants.[61]

That Hampton Court was chosen for this project is significant. Excluding the construction in the 1530s of St James's Palace, almost certainly designed for Anne Boleyn's progeny, nowhere else were preparations undertaken on such a scale for a royal birth. Henry and Jane had clearly decided that Hampton Court should be their child's home. Yet Greenwich was the king's most favoured country residence by far, so the choice of Hampton Court seems strange. But Greenwich's popularity would itself have been a threat to the king's son. In the sixteenth century, when a minority of children, even royal ones, reached the age of three, it was essential to keep them away from sources of infection and disease. Hampton Court was a good distance away from London, remote from the every-

day activities of the court at Whitehall and Greenwich, and well able to be policed. After the birth of Prince Edward, policed the palace was.

The scheme of May 1537 was undertaken at a fantastic rate, one that rose to a frenzy with news of the queen's pregnancy. Yet no matter how fast the master craftsmen urged their swollen workforce, Hampton Court was not ready for the heavily pregnant queen as she entered her confinement in October. Frantic efforts by the carpenters and painters created a bedchamber for her use, but this was almost certainly not the new room on the east front, but the bedchamber in the second-floor Queen's Lodgings built by Wolsey in the early 1520s. Thus despite the expense and the effort put into the completion of the new rooms, Jane, like her immediate predecessor, never used the lodgings constructed for her pleasure.

The royal confinement was attended by complex etiquette. The bedchamber was furnished with a special new bed screened from the body of the room; new curtains were made for the windows, and an internal porch made for the door. The plague was raging in Kingston, and the king sent most of the court away and himself retired to Esher where he received the news of the birth.[62] The birth of Edward VI in the Queen's Bedchamber on 12 October, St Edward's Day, can be counted as one of the most important events in the palace's history. Not only was it the fulfilment of the king's most fervent wish; it was the fulfilment of his purpose for Hampton Court as conceived during 1537. From the birth of Edward until the end of the reign Hampton Court featured more in the king's itinerary than ever before, and the christening of Prince Edward is the best recorded ceremony of the sixteenth century at Hampton Court (fig. 72). The royal christening robe was preserved and was still on show in the palace in 1600.[63] The event took place in the newly completed chapel, prepared for the occasion by the Office of Works and the Wardrobe.

The baptismal procession assembled at the door of the new prince's lodgings on the north side of Chapel Court, passed through the Council Chamber, and entered the Upper Chapel Cloister. From here it wound its way through the Watching Chamber and Great Hall, down the stairs into Fountain Court, and along the cloister to the chapel door. The procession was led by eighty knights, squires and gentlemen carrying unlit wax tapers. They were followed by the Dean of the Chapel and his chaplains and children, all in vestments; then came the King's Council, followed by the great lords spiritual and temporal. Behind them were the great Household officials; the ambassadors and their suites; and the king's and queen's chamberlains; Cromwell, Lord Privy Seal;

the Lord Chancellor; the Duke of Norfolk and the Archbishop of Canterbury. Then came the small group that was to participate in the ceremony itself, including the Earl of Sussex, the Earl of Wiltshire and the Earl of Essex, each carrying various accoutrements. The four-year-old Princess Elizabeth came next with two

71 Contemporary drawing recording the christening of Edward VI, October 1537. This drawing was made by the royal heralds to record the physical arrangements for future reference. For clarity the font itself, set on seven steps, is artificially lifted out of the surrounding screens.

guardians; and, under a canopy and carried by the Marchioness of Exeter, the baby prince himself. Bringing up the rear was Princess Mary, who was to be godmother, and all the ladies and gentlewomen of the court. The route was lined with men at arms and other household servants bearing torches. The courtyards had been covered with rushes, and barriers and decorations put up alongside. A porch had been erected round the chapel door, covered with arras and floored with the richest rugs. The interior of the chapel had been transformed for the occasion. It was, of course, hung with the finest arras and the altar was piled high with plate, but more importantly in the middle of the choir was the silver-gilt font set on an octagonal base which was raised up on four

72 The christening procession of Edward VI. Part of the record made by the heralds to establish precedent for future occasions. The drawing is a fragment only and shows the Marchioness of Exeter carrying Edward and Princess Mary, whose train is carried by a lady-in-waiting, following the canopy. This is the only document depicting ceremonial at Henry VIII's Hampton Court to survive.

steps. The font itself was hidden from view by a double wall of timber screens with doors (fig. 71). To its south was a screened area for the preparation of the prince heated by a brazier, with perfume burners. The christening over, the prince was immediately confirmed with Charles Brandon, Duke of Suffolk, serving as godfather. After the christening Edward was taken up to the queen's second-floor bedchamber while the heralds and minstrels played fanfares in the Outer Court. In this upper room the king and queen gave their blessing to the child.[64]

Queen Jane never left the bed in which she gave birth, despite early reports that the birth had been easy. On the night of 23 October she fell very ill, and during the night of the 24th she died. We do not know precisely why, but probably attempts to cure her were as much responsible for her death as the illness itself. Thomas Cromwell blamed her attendants who had, he believed, let her catch cold and allowed her to eat 'such thinges that her fantazie in syknes called for'.[65] For her embalming the royal glaziers removed recently installed panes of glass in her bedchamber to allow the air to circulate and soon, in the Upper Presence Chamber, her body was placed in a coffin covered with a great pall and surmounted by a cross. The room was hung with mourning cloth; twenty-four tall tapers were lit around her body; and an altar was erected nearby. For a week requiem masses were said and dirges sung. Her body was then moved to the chapel, and thence to a hearse in Fountain Court. Her effigy in wax was laid on the catafalque, and a funeral procession led by the Princess Mary accompanied her body to St George's chapel at Windsor.[66]

Although his mother was buried and his father was in mourning, the infant prince immediately became part of the political landscape. At the end of February 1538 Eustace Chapuys, the Imperial ambassador, was invited to Hampton Court to see the child, staying in apartments specially prepared for him. The Spanish actually saw Edward at Hanworth, despite being royally entertained by the king at Hampton Court. The French ambassadors were the next to arrive to see the prince, but according to Chapuys they received far less gracious treatment. In May the king was seen at a palace window proudly holding his son, to the 'great comfort of all the people'.[67] In March a household was set up for the prince and he moved from Hampton Court to the royal house of Havering in Essex.

The king was at last the father of a son and there is no doubt that this was a major influence on his attitude towards building in the last ten years of his reign. Nor is there any doubt that his failing health moulded his actions to an equal degree. By June 1537 the king's legs had become so badly ulcerated that he was forced to accept publicly that he had a serious medical condition. The ulcers, which in due course the doctors kept open, probably originated from Henry's fall from his horse in 1536, but were undoubtedly made far worse by his refusal to rest. In 1538 a clot seems to have detached itself from his leg and nearly killed him. He recovered, but only to be hit by terrible bouts of infection and fever in 1540, 1541, 1544 and 1546. None of this was helped by the rapidly expanding waistline that made him increasingly immobile.[68] The king's recognition of his ill health in June 1537 led, only months later, to a new scheme designed to ease his mobility problems.

★ ★ ★

The Setting

In 1538 Henry could rightly be proud of Hampton Court. It was his greatest new building to date: a house acquired by him and developed to his precise specifications; a house furnished to a higher standard than any other apart from Whitehall. It was the most lavish house, the crème de la crème. What of its surroundings? Hampton Court had two large deer parks, but these were merely part of the immediate estate. So in 1539 an Act of Parliament was passed decreeing that 'because the saide manour of Hampton Courte ys thus ... decored and environed with thinges of highe and princely comodities' an honour would be created centred on it.[69] An honour was a group of manors or landholdings held by one lord with a capital seat as its administrative centre. Thus the honour of Hampton Court was a collection of royal property holdings based on and around Hampton Court.[70] Henry had previously created honours centred on New Hall in Essex and Hunsdon in Hertfordshire, two of the major houses built in the first part of his reign. The Acts of Parliament creating these honours explain that the houses had been built at considerable expense by the king and that he intended to spend much time there enjoying himself. The Acts name both houses 'palaces', an important and unusual step in sixteenth-century England. This meant that each was seen as a principal seat, which the king therefore intended to make the centre of what is described as an 'honour royal'. To give Hampton Court its honour, a programme began in 1536 to acquire tens of thousands of acres in Surrey and Middlesex.[71] But this honour was to have a special feature in that the Act of Parliament that created it also set up a chase.

A chase was a private forest. Forests, in their legal sense, had nothing to do with trees, but were geographically defined game reserves protected by forest law, which was enforced by royal bailiffs. The purpose of the Chase, in the words of the Act that created it, was 'for the increase of Venery and Fowle of Warren'. In August or early September 1537, with works at Hampton Court rapidly approaching a conclusion, the queen heavily expectant, and the king coming to terms with his health problems, work started on fencing (or paling) a new hunting ground centred on Hampton Court. This new initiative was a truly gigantic undertaking that involved enclosing four whole parishes, contained within East Molesey and West Molesey, Walton-on-Thames, Weybridge and parts of Esher and Cobham (fig. 73). In 1537–8, £1,473 was spent on paling, ditching and hedging the boundaries of this new ground, which was completely encircled by the time Parliament next met in April 1539 and gave the land the status of a chase.[72] Although Hampton Court Chase was a forest in its legal sense, forests were not fenced and the deer stayed through habit rather than confinement. Thus, in being fenced, Hampton Court Chase was (pedantically) not a forest at all but a gigantic 10,000-acre park controlled by forest law. Not even Henry could have hoped to buy out all the owners over such a large area, despite the fact that about half of it was common land. He therefore revived Norman forest law in a clever device by which he gained the exclusive use of a vast park near Hampton Court. Within the area owners were entitled to fence their own land to protect it from the deer, but were forced to accept forest law outside it.

There is no doubt about the king's motivation for creating the Chase. Henry was an increasingly fanatical and bloodthirsty huntsman. There was nothing he enjoyed more than a vast slaughter of deer, and careful husbandry and land management were required

A HAMPTON COURT PALACE
B OATLANDS PALACE
C NONSUCH PALACE
D RICHMOND PALACE
E WHITEHALL PALACE
F GREENWICH PALACE
G WINDSOR CASTLE

73 Map showing the extent of the Chase of Hampton Court and the approximate extent of the honour. The honour lands are shown as though parishes and manors were co-terminus; in reality few were, and so this map can give only an impression of the extent of the honour.

to keep herds up. The year after the king's death, when the Chase was dismantled, the Privy Council noted that it was 'newly and very lately erected... when hys Highnes waxed hevy with sicknes, age and corpulences of body, and might not travayle so readyly abrode, but was constreyned to seke to have hys game and pleasure ready at hand'.[73] Yet for the ten years that the Chase existed it was heavily used by Henry, who embarked on an endless round of hunting at Hampton Court and the other palaces within the Chase. To administer both the Chase and the honour was spawned a multitude of royal posts. The most important of these was Chief Steward of the Honour and Manor of Hampton Court, an office held concurrently with that of Lieutenant and Keeper of the Chase. The first holder was Sir Anthony Browne who received £10 a year as Lieutenant, £6 13s 4d as Chief Steward and £3 6s 8d for the feodary of the honour. A document drawn up in the reign of Edward VI lists the perquisites that the High Steward enjoyed at Hampton Court: a house and stable with a hay loft; the herbage (cut hay) of the park with an allowance for mowing; three chambers in the palace over the Wardrobe, and a little buttery near the Pond Yard.[74]

The Palace Completed: The Close of the Hampton Court Office

Henry returned to Hampton Court in February and March 1538, and again in early July. For the first time in almost ten years these visits were not spent designing new embellishments for Hampton Court, because his office was now working on the designs for a new palace three miles away – Nonsuch. Work on Nonsuch began on 22 April 1538, the thirtieth anniversary of Henry's accession, and continued until his death. For the next two years, until they both died in the autumn of 1540, the Hampton Court design team of Clement and Dickinson can have done little apart from planning and organising the new work at Nonsuch. They drew heavily on the Hampton Court workforce, the core of which was redirected to Nonsuch and the king's other new palace at Oatlands four miles to the south. A mason who had worked at Hampton Court was arrested as a 'seditious taleteller' for alleging, correctly as it happens, that 'the king hath discharged all his workmen at Hampton Court, his parks and other places', and that the king had 'begun one other work which shall be named none suche'.[75]

This rapid change in direction for the Hampton Court office and workforce was accompanied by administrative change. In 1535 David Marten had been appointed Comptroller of the Royal Works, probably through the patronage of Thomas Cromwell who had used his services at Whitehall. Marten saw it as part of his task to countersign the accounts of the various outstations including that at Hampton Court. But the Hampton Court office under Dickinson and Clement resented this interference, and twice Marten complained to Cromwell that corrupt officials were excluding him from his proper role. Henry Williams, the Surveyor and John Grave, Paymaster at Hampton Court, at first succeeded in keeping Marten at bay, but in September 1538 both lost their jobs. Richard Benese replaced Williams as Surveyor and Robert Lorde became Paymaster. Benese and Lorde presided over a much larger office, covering Hampton Court, Nonsuch and Oatlands. Marten meanwhile finally got his way, countersigning accounts for these three houses.[76] It is unlikely that either Williams or Grave was any more corrupt than any other Tudor official. Not only did the king himself rule that there was no need for a Comptroller where there was a Surveyor and a Paymaster, but the two had presided with care and attention over the single most expensive project undertaken by the Office of Works in the 1530s. Some 6,500 pages of neatly and correctly totalled accounts survive to prove it. But the changes of 1538 were part of a complete reorganisation of the Office to cope with a newly complex workload and expenditure.[77] The closure of the old Hampton Court office coincides with the end of the complete run of building accounts that chronicled the progress of works from 1529 to 1538.

The end of works at Hampton Court must have had a considerable impact on the locality. For more than ten years – nearly twenty if Wolsey's works are included – Hampton had been home to an enormous workforce. At its peak, during the summer of 1535, there were 70 masons, 45 carpenters, 81 bricklayers, 21 joiners and 208 labourers in addition to the suppliers, administrators and royal servants permanently at the palace. Many of these men had been impressed into royal service and their homes were distant, as far as Somerset, Wiltshire and Gloucestershire. These returned to their homes as soon as the building season was over. Others, particularly foreign craftsmen and some of the senior workmen, settled in the area. A 1541 rate assessment for Hampton and Hampton Wick contains an unusually high proportion of foreign names.[78] Whether itinerant or resident the workers needed accommodating, feeding and, on their rare days off, entertaining. Supplying them with food and lodging provided the backbone of the economies of Hampton, Thames Ditton, Kingston and several surrounding towns.

In addition the locality had benefited from the need for building materials. Brick has already been mentioned, but tile was even more important. All the tiles for both roofs and floors were manufactured in Kingston and Chertsey, with a few other towns further afield such as Ruislip contributing. Brick- and tile-making was heavily labour intensive – digging and moulding the clay, building the clamps and then collecting the firewood and stoking the kilns involved many dozens of people. It was also seasonal: the Royal Works virtually closed down between December and March, months during which firing brick was nearly impossible anyway.[79] The river was kept busy too. It was the artery for the delivery of lime, stone, timber, ironwork, lead and glass, as well as specialist materials and workmen from London. A surprising quantity of material was delivered at the palace landing stage prefabricated, including complete windows from the supplier William Johnson of Barrington and fully carved royal beasts from Henry Blankston.[80] Ready-sawn boards were delivered in great quantities from the Baltic, and as a result of the scramble to find suitably seasoned wood big stockpiles were amassed in the palace store yards. After brick and lime, timber was the most important material, and when nearby woods had been denuded of oak, wood was brought by river from as far as Oxfordshire. There was no bridge over the Thames at Hampton, and from as early as 1514 a ferry shuttled workmen, materials and visitors across the river, more or less where the bridge is today. On occasion the river froze, and to keep the Royal Works supplied materials were transported by road. When the river froze in December 1537 almost 500 men were enlisted to move stone from Oxford to the nearest flowing part of the river.[81]

Although Hampton Court was complete by 1539, two further additions were made during Henry's lifetime, both of which are important. In 1540 one of the great icons of the palace today, the astronomical clock, was erected (fig. 41). This was not the first clock at the palace nor, probably, the first in the present position. Wolsey had a great clock, and Henry VIII had paid its keeper in 1530. The earlier clock may have been in the same site as the present one, clearly visible from the principal lodgings of the house across the court.[82] The new clock was probably the fashionable brainchild of Nicholas Kratzer, Astronomer Royal and 'Devisor of the King's Horologes'. Kratzer, born in Munich in 1487, was a mathematician and astronomer and former tutor to Thomas More's children, and was probably the only man in England capable of devising an astronomical clock to match the zodiacal clocks of Europe like that, for instance, enjoyed by the Gonzagas at Mantua. In February 1539 Thomas Cromwell wrote to the king enclosing a book by Kratzer, and this may have been the design for the king's new timepiece. The clock was certainly made by Nicholas Oursian whose initials, and the date 1540, can be found deeply inscribed on a bar in the clock workings. Oursian was French, like most clock-makers in England at that time, and he acquired denization in 1541 – the same year that Henry VIII appointed him Clock-Keeper at Hampton Court on a wage of 4d a day. He retained this post and other royal clock-making appointments until his death in 1590.[83]

The new clock was a highly decorative but extremely practical tool. As it appears today it differs in a number of important respects from the original. The original appearance of the dial is known from accounts for repainting it in 1584–5, 1619–20 and 1664. The main dial showed the hours of the day, the course of the sun and moon, the twelve signs of the zodiac and the characters of the seven planets. These are still represented. Originally it also depicted 'the fower partes of the worlds with shippes saylinge' and 'the buildings on land with hilles and dales'. Around this were royal badges – the fleur-de-lis, a rose, a portcullis and the initials HR – which still survive. In Base Court there was a lesser dial, 8ft in diameter (now lost), which was painted blue and gold. This dial had a frieze above it with grotesquework painted blue and gilded and a thistle and fleur-de-lis and the royal badges, which were repainted according to the monarch.[84] The loss of the lesser dial deprives us of the sense of the hierarchy of the courts; and with the painted ships and territories has been lost the important maritime iconography of a clock, a principal function of

74 Philip Hardwick's drawing of Coombe conduit house, Kingston Hill, c.1810–29. Built in c.1540, it was the most elaborate of the three conduit houses that fed the palace. Coombe conduit was hit by a flying bomb during the Second World War and is now in the care of English Heritage.

which was to tell the tides of the river and seas. It seems that the workings of the clock lasted for just over a hundred years before needing refurbishment by Charles I's clockmaker Richard Nurse.[85]

Today the great dial remains in its original 15ft-square stone frame but without any polychromy. It sits claustrophobically between the two western turrets of the Anne Boleyn Gate and heavily upon a three-light window. The clock portrays the Tudor universe unsullied by the discoveries of Copernicus. The earth stands at the centre of the solar system and the moon, sun and stars circle around it. The clock has three concentric moveable dials, of which the middle one is the solar dial that rotates once each solar day and carries a long pointer bearing a burning sun. The inner dial is the lunar dial that rotates once a lunar month with respect to the solar dial and shows, through a 10in. circular hole, the phases of the moon. The outer dial rotates once over the course of year with respect to the solar dial. This, the sidereal dial, is marked with the days and months of the year, the signs of the zodiac and 360 degrees. The large solar pointer gives the date and the time, while a small red arrow on the solar dial gives the time of the moon's southing (when it crosses the meridian) and thus the time of high tide on the river. High tide at London Bridge occurs, for instance, seventy-five minutes after the southing.[86] Two bells dating from Henry VIII's reign remain in the tower, cast some time between 1530 and 1540 by William Culverden.

Hampton Court had been supplied with water by a conduit system since Wolsey's occupation, and possibly before. Water was conveyed from brick-built conduit heads in Hampton village and in the Upper Park to the palace, but the supply was neither plentiful enough nor the fall from Hampton to the palace great enough to make the system entirely satisfactory.[87] In 1538 Merton Priory was suppressed, with the result that land in upper Kingston, upon which were several fresh springs, fell into the king's hands, and it was decided to build a conduit from Kingston Hill to Hampton Court – a distance of 17,000ft (figs 2, 275). The fall – 129ft – was impressive, enough to supply high-pressure water at second-floor level. The flow was good too, ensuring that the palace cisterns could be kept full, the overflow powering the fountain in the inner court before being conveyed to the ponds on the south front. Three brick conduit heads were constructed, incorporating settling tanks to avoid sediment in the water (figs 74, 75). Lead pipes ran from these heads, via intermediate stopcocks in brick 'tamkins' under the Thames, to the palace. Henry purchased all the land across which the pipes were to run and leased the properties that surrounded the heads with restrictive covenants to protect the supply from pollution. The heads themselves were given thick doors and planted around with brambles to protect against possible attempts at poisoning.[88] The Coombe conduits appear frequently in the palace building and repair accounts from this date onwards and could make a substantial study in themselves. Only one significant Tudor repair was undertaken on the system – in 1600–02 when much of the original work was 'newe cast'.[89]

The Last Years

During Henry's last years, from his marriage to Anne of Cleves to his death in 1547, Hampton Court was at the centre of his personal life, but on the periphery of royal building concerns. There are no particular books to chronicle building expenditure, but a summary statement by Robert Lorde covering the period 1538–47 reveals that a total of £16,686 was spent on the house. This figure, only a third of what had been spent in the previous ten years, still

75 Survey of Coombe conduit house showing the two chambers above ground and the linking subterranean passage. Two settlement tanks removed much of the sediment before water was conveyed downhill.

represents more than mere maintenance. A seven-week statement of expenditure dating from the summer of 1541 indicates that as well as maintenance new works were also underway, including building in the park and garden. The latter will be covered in chapter 5; here it remains to characterise Henry's last years at Hampton Court – years in which the palace was finally used for the purpose for which it had been built.

In October 1539 a treaty was signed at Hampton Court for a marriage between Henry and the sister of the Duke of Cleves, Anne. Less than a year later it was again at Hampton Court, 'in a lofty and ornate chamber', that the king's divorce from her was signed. Anne was given a generous settlement and continued to visit the palace on a number of occasions from her home at Richmond.[90] A great part of the drama that accompanied the disgrace and fall of Henry's fifth wife, Catherine Howard, was also to be played out at Hampton Court. Cranmer had the miserable task of informing the king of the queen's infidelities while he was at mass on All Souls' Day (2 November) in his Privy Closet. After hearing the news Henry left Hampton Court in a modest barge with a small number of attendants, leaving Cranmer and the Council to interrogate the queen and decide what to do.[91] There is no documentary basis for the story of Catherine running down the Upper Chapel Cloister to reach the chapel door where Henry was at mass and being dragged away screaming without having spoken to him. The geography of the Tudor palace would, in any case, have made the incident impossible. We do know that Catherine was confined to her privy lodgings, keeping her privy keys so as to move from room to room. On 14 November the queen and a much reduced household were removed up river to Syon House under armed guard. Just over a week later a proclamation made at Hampton Court announced that the queen had forfeited her honour and would be proceeded against at law. In the following weeks the whole story unravelled. Her alleged and actual lovers were executed in December, while Catherine and Lady Rochford, her confidante, followed them in February 1542.[92]

Catherine's execution plunged Henry into the deepest depression, and the court was a dour and unwelcoming place during the summer and autumn of 1542. But if ladies and revels were unable to dispel the air of gloom, military success could, and news of the Duke of Norfolk's victory against the Scots at Solway Moss in November revived the king's spirits. Henry made preparations to move to Hampton Court for Christmas, and in the absence of a queen Princess Mary was to preside with him. Chapuys reported that work was underway day and night to prepare her lodgings. Building accounts and a lodging list from 1540 demonstrate that Mary had a 'faire double lodging' at Hampton Court from 1537. This would not have been adequate if she was to act as hostess for Christmas, and as she could hardly occupy the queen's side, new lodgings were created for her. These were carved out of a corner of the inner courtyard and a section of the south-east corner of Base Court (figs 76, 78). Ceilings were raised, coves inserted, partitions moved and the external roofline raised; in addition a stair turret and garderobe were built. These changes made the rooms taller and grander and linked them to the main royal lodgings. Mary arrived at Hampton Court triumphant, was met in the park by the king and at the Great Gatehouse by all the court. She moved directly into her new suite. Soon the party was joined by high-born Scots prisoners, with whom the king dealt during the festivities. The king went so far as to order a chapter of the Order of the Garter at Hampton Court on Christmas Eve.[93]

Henry continued to use Hampton Court during the following spring, and on 12 July Stephen Gardiner, the Bishop of Winchester, married Henry and his last wife, Catherine Parr, in the King's Holyday Closet there. Only about twenty people were present, including the two young princesses. At the time of the marriage London was in the grip of an outbreak of plague, and the king issued a proclamation ordering his Household to stay away from the City and moved further out to Oatlands. He returned for Christmas on 23 December, when the queen's brother and uncle were ennobled, as Earl of Essex and Lord Parr of Horton respectively, in the Presence Chamber. Christmas and New Year were celebrated in style and at great expense, with masques and revels.[94] In the summer of 1544 Henry led his army to France for the last time, and while he was away it was declared that the queen would be regent and that she and the royal children should go to Hampton Court. Her expense accounts show that extensive preparations were made for her arrival on or about 21 July. While the queen occupied her lodgings on the east front, the new rooms created for Mary were annexed to Catherine's apartments for her to allocate to the king's children as appropriate. The royal family lived happily together at the palace throughout July and August, the queen frequently writing to the king in France and even sending him a boatload of venison from the park.[95] They left Hampton Court for a mini-progress round the south-east (the plague gripped London) and were reunited with a triumphant Henry on 3 October. The family had not had their fill of Hampton Court, and once again they spent Christmas, New Year, Epiphany and Candlemas there.

If, during the 1530s, Hampton Court had been designed to be the king's most lavish out-of-town residence, the events of September 1546 were to put the palace to the test. After months of closely argued diplomacy England and France had signed a peace treaty in June, kindling a warm glow of friendship between the two countries. Henry stood, by proxy, as godfather to Francis I's grandson, and soon afterwards he invited the Admiral of France, Claude d'Annebaut, to Hampton Court for the ratification of the treaty. Not since Wolsey's celebration of the Treaty of Amiens in 1527 had such a magnificent reception been prepared. In the second week of July work began at Hampton Court on the construction of two banqueting houses in the park; details of these and of some of the revels that took place within them are preserved in three of Sir Thomas Cawarden's account books covering the period June to September 1546. Set amidst an encampment of lesser tents, halls and pavilions, the banqueting houses were substantial structures with boarded sides, and had horn windows lined with painted and waxed canvas and fine fabrics.[96] There is no doubt that the entertainment laid on for the French admiral was at least as lavish and important as the celebration of peace with France at Greenwich nearly twenty years before. On 23 August the admiral and his 200-strong entourage was met three miles from the palace by the ten-year-old Prince Edward surrounded by eighty English lords and gentlemen in golden livery, who escorted him to the palace. His stay there lasted six days and pivoted upon the public signing of the treaty on St Bartholomew's Day in the Chapel Royal. On his departure, accompanied by gifts of plate and hounds, the banqueting houses were dismantled and taken to the nearby royal house at Chobham where Henry intended to re-erect them, but this never happened and eventually they were sold for £26 3s 2d.[97]

That Henry chose Hampton Court for his last great court reception rather than Greenwich confirmed that Hampton Court was henceforth to be the royal house of choice for entertainment. Thus it remained until the monarchy had no more use for it.

76 Elevation of the corner of the west side of Fountain (now Clock) Court showing building phases. The original south range (removed in 1536) can be seen in section, as can the Wolsey Rooms (far left). The heightening of the southern (left-hand) part in 1536 for Princess Mary can be seen. Drawing Daphne Ford.

GROUND FLOOR. c.1547

77 Reconstructed ground-floor plan of Hampton Court in c.1547. Drawing Daphne Ford.

78 Reconstructed first-floor plan of Hampton Court in c.1547. Drawing Daphne Ford.

Chapter 4

THE LATER TUDORS AND THE PALACE OF PLEASURE

WHILE IN THE YEARS 1530 TO 1538 a dozen volumes of bulging works accounts chronicling the extension and embellishment of Hampton Court was produced, for the eighteen years following Henry's death barely a scrap of paper survives from the Office of Works. The fact is, quite simply, that in 1547 Hampton Court was finished. It was one of the very few houses where Henry VIII seems to have achieved what he set out to do. This is why the history of Hampton Court for fifty years after the close of his reign is the story of royal life there rather than one of construction or repair. For the remainder of the Tudor period it was the star royal house. Hampton Court was the place where Tudor monarchs enjoyed themselves and entertained their guests – more of a summer holiday home – whereas Greenwich, which enjoyed equal or greater usage, was the winter working house.

Edward VI

Hampton Court was the favoured residence during Edward VI's reign – the second most visited royal house after Whitehall and the king's usual summer residence.[1] It was at Hampton Court that many of the major scenes of his reign were played out. For these we have the evidence provided by the young king himself who, until November 1552, kept a journal recording them. For him, Hampton Court, the place of his birth, was the closest he had to a home. When taken from the palace to Windsor Castle by Protector Somerset he complained that the castle had no galleries or gardens to walk in, and that it was like a prison.[2] Few improvements were made to Hampton Court during his reign and only a single summary account survives covering the entire period 1547 to 1559. This account shows that during his first two years as king, expenditure of £120 8s 10d and £137 13s 2d was undertaken at the house. Thereafter expenditure fell, in 1550 to £7 0s 5d, the lowest year's expenditure in the whole century. In 1551 there was a slight rise to £51 3s 1½d, and the following year a return to the levels of his first years at £118 12s 10½d. In the few months of 1553 during which he lived, expenditure was £70 9s 9½d.[3] Little more than very basic maintenance can have been undertaken for these small sums. Yet Edward was fond of the palace gardens, and in 1548–9 improvements and alterations were made to the Great Garden and Mount Garden and money laid out on weeding and maintenance. These sums were accounted for separately.[4]

Edward was, of course, too young to rule; his uncle, the Duke of Somerset, known as Protector Somerset, ruled in his place and he and his successor, the Duke of Northumberland, dominate the reign. We know that while Edward was at Hampton Court he lived on the king's side and that Somerset used the queen's side.[5] The palace continued to play an important role in events. The year 1549 was one of crisis, with rebellions in the West and East Anglia sparked by religious change, and a failure of confidence in Somerset's ability to handle these or the complexities of foreign policy. In October his fellow councillors moved to overthrow him. Somerset was with the king at Hampton Court, and for the first time in its history the palace prepared to be attacked. On 5 October the Protector issued a proclamation in the king's name summoning all loyal subjects to Hampton Court to defend Edward and Somerset against conspiracy. The moat was filled, the gates were strengthened, and preparations were made for a siege. Five hundred suits of armour were brought from the palace armoury to equip both the king's guard and the Protector's retainers.[6] The location of the Hampton Court armoury is not known, but the inventory of Henry VIII's goods taken in 1547 lists considerable quantities of arms and armour both for foot soldiers and horsemen. On this basis 500 suits of armour is probably not an exaggeration, or even all the armour held at the palace at the time. Elizabethan accounts prove the continued maintenance of an armoury at the palace throughout the sixteenth century.[7] Fully armed, the household army of Edward VI seems to have mustered in Base Court to be inspected by the Protector and the king. In due course Somerset led the poor young monarch out through the Great Gatehouse to stand before the large crowd of local onlookers assembled in the outer court. The Protectoral speech was met with silence and at ten o'clock that night the royal party moved off to the more easily defensible Windsor.

This remote and isolated incident is important because it illustrates a little-considered function of a royal palace. Hampton

79 *(facing page)* Queen Elizabeth's Privy Kitchen from the north. Although built more than seventy years after Lord Daubeney's kitchens, the 1570 kitchen imitates their external form.

Court was moated, battlemented and secured by high brick walls usually supposed to be entirely decorative. Yet they performed an important security function, preventing theft and other petty crimes. There are several references to robberies at the palace, and physical security was the most effective deterrent against them.[8] The fortification and recourse to the armoury in 1549 shows that palaces like Hampton Court were genuinely ready for civil unrest. In this they were similar to palaces of the French kings such as Saint-Germain-en-Laye or Fontainebleau, which were also moated and, in times of crisis, capable of being defended.

The events of 1549 and the fall of Somerset led to a reorganisation of Edward's private life largely inspired by concerns about physical access to his person. His bodyguard was enlarged, and six attendant lords were appointed to wait on him, two at a time in shifts.[9] Yet despite these changes, in many respects court life went on much as it had under Edward's father. Throughout the reign Hampton Court continued to be the favoured location for the reception of distinguished foreign visitors and royalty. It was possibly due to this heavy usage by delegations of dignitaries that the Privy Council ordered the Surveyor of the King's Works to repair the old stables in 1550.[10] In May 1550 Gaspard de Coligny, seigneur de Châtillon, arrived for the signing of a peace treaty between England and France. He was dined at Greenwich but was treated to hunting at Hampton Court. More importantly, in July 1551 came Jacques d'Albon, marquis de Fronsac, seigneur de St André, knight of the Order of St Michael, made maréchal de France in 1547. D'Albon was in England to confer the order of St Michael on the young king. The original plan seems to have been for this ceremony to have taken place at Whitehall, but the sweating sickness in London, and the deaths of three Gentlemen of the King's Chamber, caused a rapid change in plan and it was eventually performed in the Chapel Royal at Hampton Court on 16 July. With the court in isolation at Hampton Court and the maréchal lodged down river at Richmond, the entertainment was rather meagre, but d'Albon was regularly at the palace – at the king's rising, at supper, hunting and watching Edward shoot and play the lute.

Later in 1551 the French returned under more favourable circumstances for the feast of St Michael. The maréchal St André, who had become resident ambassador, was treated to a reception on a magnificent scale. As in 1546 a banqueting house was constructed in the park, and nearby a new standing for the hunt. The banqueting house was decorated with garlands of flowers, and nosegays and fine herbs were strewn on the floor, having been collected by thirty-three women at a cost of £6 13s 10d. The bill for the two buildings alone was almost £70. After the feasting the maréchal saw the king and his council receive communion in the chapel and later dined with him in the Privy Chamber.[11] In October the same year Edward created two new dukes at Hampton Court in the Presence Chamber: Henry Grey, Marquis of Dorset became Duke of Suffolk, and John Dudley, Earl of Warwick, became Duke of Northumberland.[12] At the end of that month the Queen Dowager of Scotland, Mary of Guise, arrived at Portsmouth, where she was met by a great gathering of the nobility and court. After a slow progress northwards, Lord William Howard met her at Guildford and conducted her to Hampton Court. A mile from the palace she was met by the Marquis of Northampton, the captain of the band of Gentlemen Pensioners, and when she arrived the Marchioness of Northampton and the ladies of the court received her. The next day, surrounded by a flotilla of barges, Mary made her entry into London. For a royal entry to be made via Hampton Court was unusual; normally access for visitors of importance was via Gravesend and Greenwich. A few days later she returned to Hampton Court to admire the house and watch deer coursing.[13]

Queen Mary I and Hampton Court

In early February 1553 Edward caught a feverish cold which developed into bronchopneumonia. In the days before antibiotics this soon developed into a general septicaemia and then a lingering and painful death. On 6 July 1553 he died.[14] Against all odds his oldest sister Mary became queen. She entered London on 3 August, rapidly appointed her Household and Council, and was crowned on 29 September. Less than a year later, on 25 July 1554, she and the future Philip II of Spain were married in Winchester Cathedral. For Mary, the marriage crowned her plans to return England to the Catholic faith, and for Philip's father, the emperor Charles V, it enabled the Hapsburgs to straddle France and dominate Europe. Mary's passion for her new husband was probably matched in almost equal measure by Philip's distaste for his thirty-eight-year-old English wife, but none the less the two made an effective public show of togetherness as they moved, via Windsor and Richmond, to London. On 18 August Mary and Philip made their triumphal entrance into London, where they established themselves at Whitehall. The two weeks following Philip's landing cannot have been easy. Not only was the ceremonial that accompanied the wedding and progress to London punishing, but the two retinues were continually at each other's throats. One of Philip's Household noted that 'The English hate us Spaniards worse than they hate the Devil, and treat us accordingly';[15] the feeling, in fact, was mutual. At Whitehall, Mary longed to retreat from the limelight, and the death of Thomas Howard, third Duke of Norfolk, gave her the perfect excuse to retire to Hampton Court with her husband.

Philip's position was pretty impossible. Although he was often referred to as 'the king', by the terms of the marriage treaty his status was that of uncrowned consort, and since Mary granted him no lands or property he had no means of dispensing patronage or building up an affinity. The court was in turmoil in London and Philip was very unpopular at Hampton Court. A proclamation was issued forbidding anyone to come to court without a paper proving whose service they were in. It was noted that at Hampton Court the 'hall door within the court was continually shut . . . which seemed strange to Englishmen that had not been used thereto'.[16] Yet Philip acted the part of a devoted husband. Ruy Gomez wrote on 24 August, 'The King entertains the Queen excellently and well knows how to pass over what is not attractive in her for the sensibility of the flesh. He keeps her so pleased that verily when they were together the other day alone she almost made love to him and he answered in the same fashion.'[17] Mary believed that it was at Hampton Court, during August, that she conceived a child.

The queen's baby was due on 9 May 1555, and on 3 April Philip, Mary and the court retired to Hampton Court for her confinement. Hampton Court was not Mary's first choice: one Spanish observer believed that she would have preferred to enter her confinement at Windsor, but that she felt it to be too far from London. Sir John Gage, Mary's Lord Chamberlain, ordered

Thomas Cawarden, Keeper of the Wardrobe at Nonsuch, to deliver material to David Vincent, Keeper at Hampton Court, for the queen's sojourn.[18] The 23 April was St George's Day, and the traditional feast of the Garter was held at Hampton Court. The diarist Henry Machyn, a furnisher of funerals and citizen of London, saw 'the King, with other Lords and Knights of the Garter' in procession 'with three crosses, and clerks and priests, and my Lord Chancellor, the chief minister mitred, and all they in copes and cloth of tissue and gold'; the queen watched the procession from her chamber and was seen at her window by the crowds in the courtyards.[19] As the expected birth of a Catholic heir drew closer, in order to avoid unrest in the event of the legitimacy of the child being questioned, Princess Elizabeth was brought from Woodstock in Oxfordshire to Hampton Court where she remained effectively under house arrest. It is not known where she was lodged, but she was perfectly familiar with the palace – in 1537 a lodging had been set up for her large enough to have a guard chamber and a closet.[20] The queen meanwhile showed few signs of giving birth and was seen wandering around the Privy Garden with perfect ease. By 1 June she was feeling some pains and letters were prepared to announce the forthcoming birth to the crowned heads of Europe. Mary remained confined to her chamber, once a day appearing at a window to watch the procession to mass. Preparations at the palace included the delivery of a sumptuous cradle and the employment of rockers. Time moved on and by 10 July the queen was up and about conducting business again, giving rise to questions about the genuineness of her condition. By the beginning of August the situation had become intolerable. The house was full to bursting with the ladies of the nobility and their gentlewomen who were being entertained at royal expense whilst they waited for the birth. The queen was barely seen, surrounded only by her attendants and physicians. Hampton Court was creaking under the strain, the garderobes were full, the kitchens and moat filthy; the court simply had to move. On 3 August the queen and her closest attendants travelled to the nearby royal house of Oatlands, diffusing the tension aroused by the imaginary pregnancy and allowing Hampton Court to be cleaned and repaired. Elizabeth meanwhile left for another lesser royal mansion, at Ashridge in Hertfordshire.[21]

Throughout this time Philip attempted to live the life of a king, receiving ambassadors and emissaries and attending mass accompanied by foreign dignitaries. But life at Hampton Court was very unhappy. The Venetian ambassador reported that 'Since the residence here of the court, there have been many affrays between the Spaniards and the English, several persons on either side having been wounded and killed, the English always getting the worst of it.' Philip was forced to issue a proclamation forbidding the Spaniards to draw their swords at court on pain of losing their right hand.[22] His withdrawal to Oatlands and the final public admission that the queen's pregnancy had been a phantom was a prelude to Philip's departure for the Low Countries. His remaining Household was ordered from Hampton Court to Whitehall in October, and left London to join him in the Low Countries in December. Philip returned to England in March 1557 intent on winning English support for his wars. He remained for a little under four months, staying at Whitehall, but going to Hampton Court to hunt with Mary on 10 June.[23] Less than a month later the queen waved goodbye to her husband at Dover, never to see him again. Mary did not know it, but she had stomach cancer, the cause of her swollen belly. In November 1558 she died, without actively opposing the succession of the young woman whom for twenty-five years she had regarded as a heretic and a bastard. Despite the fact that Hampton Court had seen some of the key events of her reign, the palace was only minimally maintained. No repair accounts survive; only expenditure figures for her last two years exist, showing disbursements of about £100 each year on the house.

Queen Elizabeth I at Hampton Court

By 1558 the twenty-five-year-old Queen Elizabeth had spent most of her life far from court secluded in a succession of country houses. Her experience of the metropolis and of the realities of court life was very limited. She knew London and had used Somerset House as her residence in 1553, 1556 and again in 1558, but she only knew Whitehall as a place of fear before her brief incarceration at the Tower in 1554.[24] It is not clear, therefore, who advised her to take on as her first architectural task the completion of Whitehall, which Henry VIII had left incomplete on his death. Over five years £9,222 was spent on transforming the palace into the queen's principal seat, while expenditure on the other main residences at Greenwich and Hampton Court trailed far behind. In 1558 only £166 18s was spent at Hampton Court, and in 1559 the tiny sum of £49 12d. The following two years saw an increase, but not enough to cover significant works. In 1559–60 the amount spent was £554 20s 9d and in 1560–63 £632 18s 2d. The largest outlay in 1559–60, seems to have been for labourers, possibly suggesting work on the gardens; and in the following three years for brick, tile and glazing. In 1563–4 expenditure again plunged to just over £88.[25]

During the spring of 1559 plans were laid for the queen's first summer progress. It was decided that this should be modest, being confined to Kent and Surrey, and ending in early August at Hampton Court. In preparation for the visit William Paulet, later Marquis of Winchester, went up river to Hampton Court in June 1559. Winchester, Lord Treasurer since 1550 and Tudor administrator extraordinaire, chaired a small subcommittee of the Privy Council responsible for instructing the Surveyor of the Queen's Works on matters concerning the repair and embellishment of the royal houses.[26] He was also an ambitious builder himself, creating a fine Thames-side mansion at Chelsea that was to become a favourite stopping-off place for the queen on her way west. On 22 June Winchester wrote a long letter to William Cecil, the queen's chief Secretary of State, outlining the problems he had found at Hampton Court and proposing solutions. This letter is interesting, and important enough to be printed in full here.

> According to the quenes majesties plesure I have taken with me to hampton courte the surveyor Comptrollers and other the offycers of hir works and there we have surveyed the prevye kichen the lardres and other offyces thereto belonging and we fynde that the same was never well placed because the same standeth under hir privye closette where hir grace dayle dother here srvyce and all noyse made in the same and the saver of all foull waters made in the same all fryenge and broyllinge made also in the same reboundethe uppe into the closette that hir highnes cannot sytt quiet nor wthout ill saver: nor never shall

so longe as yt standethe there: marvelling greatlye that the workemen was so abbused to place yt in that plaice where can never be any helpe for yt.

For remedye whereof yo shall let the quenes matie understand that we have found a newe place for a prevye kichen and all offyces to yt and for the savyng of all evell Waters from yt daylye. wthout truble of any pte of the house: and to bring Condytt water to yt at all howers. and from this to the kychen hir grace shalbe served into all places where yt shall please hir to sytt openlye or pruetlye wthout danger of weate.

And yf yt please hir highnes to have these thinges done she shall have yt done this somer and made verie pleasannt for hir.

And by this doing the troble of tholde prvye kychen and the suers of all evell savers from the same shalbe clerelye taken awaye. And the greate diche next the parke made drye and grene before all the place and as pleasannt a walke as any hir matie shall have about all the howse saving I suffer the thempes [i.e., the Thames] at everye highe tyde to ebb and flowe before the gate. and lykewyse to ebb and flowe under the wall next hooggyn garding and by these two places. I shall cleere the howse of all kynde of waters for doing of harme wch shalbe agreate plesure to the howse and to gyve hir matie occasion to lye often tymes there.

And in searching of the quenes ij lodgings we se cause to repayre and amend them and especiallye the wyndowes: and the ponde garden from the which garden we mynde to take the water cleerlye saving that he shall come to yt by appoyntment And we mynde also to take away all the seight of evye chamber that hathe his leight into the ponde gardens. saving onlye hir own leights and thereby hir majestie shall walke secretlye all howers and tymes wthout looking upon hir owt of any place: except owt of hir own chambers.

And of that grounde wilbe made as many pleasurs as can be well Imagyned uppon Wherein yor self can well advyse the quene as apperethe by yor own garden.

And in doing thereof mr Johnes keep[er] of the quenes howse gave us knowledge of the breking of a greate beame lyeng uppon the chappell Roof that is broken and fallen lyke to have broken the Roof which must be amended withall speed. and so yt shalbe

The barne must be newe made and this I will sett in the grounde where yor self did appoynte. and wth that howse shall stand another howse for the quenes cotches: and for the horse belonging to the same. which wilbe verie well placed and so the surveyor and offycers shall have theyr own Romes with quietnes.

The pryve bridge going to thempes must be amended and the themes fended from the banks. and in doing thereof there must be a bridge made for the barge men to passe. The howse: and so the howse shalbe defended from the bardge men which wth theyr gables dothe hinter the queenes howse dayle. The partyculer declaracon of these things I will leave to the reporte of mr surveyor who will tell the queene or yor self all. And because these things cannot be done wthout the queenes mats plesure knowne and warrnnt. I pray yo signyfye hir highnes pleasure. To me what shalbe done

To Mr Secretarye.

Winchester.[27]

Winchester had set out ten tasks to be undertaken that summer: building a new privy kitchen; filling the eastern moat; mending the queen's south-facing windows; draining part of the Pond Garden; blocking courtier windows overlooking the Pond Gardens; improving other parts of the garden; mending the chapel roof; building a new barn and coach house; repairing the private landing stage or privy bridge. In the event nothing happened that summer – the cost was too great or time was too short. Yet, in the course of the reign all the recommendations were carried out.

Elizabeth's first visit to Hampton Court came and went, and soon after her return to Whitehall she resolved to appoint William, Lord Howard of Effingham, her Lord Chamberlain, as Keeper of the Mansion and Honour of Hampton Court. With this appointment came the duties of Chief Steward, Feodary, Bailiff and Collector of the Honour of Hampton Court, Keeper of the Parks and Gardens, and bailiff and collector of miscellaneous manors nearby.[28] This appointment was another reward for the Marian councillor who had consistently shown himself loyal to Elizabeth under her predecessor. There were financial perks to this clutch of appointments (enumerated in chapter 3), but also real responsibility for a major royal residence. In a document of about 1578 the offices and salaries for Hampton Court were listed as: Keeper of the House – £6 13s 4d; Keeper of the Park – £6 1s 8d; Paler of the Park – £6 1s 8d; Keeper of the Orchard – £10; Gardener – £8 1s 8d; Walker about the Pales of the Chase – £6 1s 8d. In practice deputies carried out all these duties. William was succeeded in his post in 1562 by his son Charles.[29]

In August 1560 careful plans were laid at court for the arrival of King Eric XIV of Sweden, one of Elizabeth's early and most determined suitors. Eric's brother had been in England in the autumn of 1559 preparing the way for a hoped-for union with Europe's most eligible spinster. This was followed, despite the queen's evident lack of enthusiasm, by careful plans for a visit by Eric in person, scheduled for August 1561. Sir William Cecil decided that the king would be entertained at Hampton Court, partly because it was Elizabeth's most magnificent country house and partly because its location, close to Richmond, allowed the king and his retinue to be lodged in a separate palace nearby. This planned visit and the preparations that attended it are important. While it was usual to receive foreign ambassadors at Hampton Court, the reception of a reigning monarch was a unique occurrence and is interesting for what it reveals of royal etiquette. The king was to be brought down river to Richmond where he was lodged for the night. The next day he was to be brought to Hampton Court, probably by road, as the officers of the court were instructed to meet him at the Great Gatehouse. From here he was to proceed to the Great Hall where, at the dais end, the queen herself was to stand. After the two monarchs had greeted each other they were to move to the Presence Chamber and into its bay window for some private discourse. At the state dinner, probably to be held in the Chamber of Estate, there were to be two Cloths of Estate. In anticipation of this royal welcome Eric took to the North Sea in August, only to be turned back by adverse winds; on trying again he damaged his fleet in a storm. The Swedish king never came to Hampton Court, but the etiquette devised for his reception reveals that the Great Hall, not usually used by the monarch herself, was brought into service for a royal reception. Everyone else would be met by the queen in the Presence Chamber; only an equal would Elizabeth receive in the hall.[30]

The queen moved to Hampton Court in mid-September 1562 for what very nearly turned out to be her last visit. On the night of 10 October the queen felt unwell and decided to take a bath. The next morning she felt worse and the royal doctors feared that the cold autumnal air had caused her to catch a chill. What they did not know was that the fever, into which this turned, was the early stage of smallpox, which broke out with great force on 13 October. There is no doubt that Elizabeth was gravely ill: the Council was in panic, the country in a state of alarm and the court began preparations for mourning. It was feared that she would die on the night of the 15th, but, like her father, and unlike her brother and sister, Elizabeth had a constitution of iron, and despite the odds against her, she recovered. The danger was far from over, though. A few days later Sybil Penne, a Lady of her Bedchamber and Edward VI's dry nurse, a long-time Hampton Court resident, caught smallpox and died. This sent the convalescent queen scurrying down river to Somerset House on 11 November.[31] Perhaps not surprisingly this experience turned Elizabeth against Hampton Court and other than a brief visit in 1563 (occasioned by the plague at Whitehall) she did not stay again for nearly five years afterwards, only resuming visits in October 1567.[32] From then on her pattern of residence was fairly consistent. Hampton Court was visited mainly in the autumn and winter, and frequently on the way back to London from Windsor. Sometimes visits to Hampton Court were combined with trips to Windsor or Oatlands, and on a few occasions Nonsuch (after 1592 when the Crown re-acquired it).[33] However, Elizabeth only once came to Hampton Court from Greenwich: like her father she either stayed in the east or the west and seldom combined the two country seats in one itinerary. Taking the reign as a whole Hampton Court became the fourth most visited house after Whitehall, Greenwich and Richmond.[34]

his appointment Tod leased the lands in Bushy Park that his predecessor had held. Four years later he was granted the manor of Fourde in Somerset.[35] The Keeper of the Hampton Court Wardrobe was one of the most important and responsible jobs in the Royal Wardrobe. Hampton Court contained more objets d'art than any other palace apart from Whitehall and the keepership required knowledge of the collections and the absolute trust of the queen.

Elizabeth's visit to Hampton Court in 1568 was dominated by the unfolding drama surrounding Mary, Queen of Scots. On 30 October, at which time Mary was imprisoned at Carlisle, the first important council to discuss her future was convened at Hampton Court. This was followed by audiences with Mary's commissioners on 23 November and 3 December. Then on 7 December 1568 the famous letters incriminating Mary in a plot against the queen were produced in a 'small gilt coffin, of not fully a foot long'. The 'casket letters' were examined by the Council and seven days later Elizabeth, in council, heard the evidence herself. Those present were told of Mary's request for a personal hearing, of Elizabeth's reasons for refusing to see her.[36] The queen probably sat in the Henrician council chamber on the north front of the palace at the end of the Queen's Gallery (fig. 78). This room, which had been home to 226 Council meetings in the reign of Henry, 91 under Edward and 99 under Mary, played host to 243 meetings between 1558 and 1603. Although Hampton Court was a pleasure palace, it was also a place for serious business.

As the result of outbreaks of plague in Westminster and the City in 1569 and 1570 Hampton Court played host to two major court events usually held at other royal houses. In 1569 it seems likely that the queen's accession day, 17 November, was spent at Hampton Court rather than at Whitehall. The accession-day tilts (or tournament) marked the queen's return from her summer

80 View of the north side of Hampton Court taken across the Tiltyard for Cosimo III de Medici during his English tour in 1669. By this date several of the tiltyard towers shown on Wyngaerde's drawing (fig. 70) had been demolished and those that remained were substantially altered from their original form. The tiltyard itself, however, was still kept clear as a piece of waste ground. On the right are Charles II's cavalry barracks of 1662.

In 1565 Hampton Court's longest-serving officer, David Vincent, the Keeper of the Wardrobe, died. Vincent had been appointed by Henry VIII in 1540 and had the task of drawing up the great inventory of the king's possessions at Henry's death seven years later. In 1547, having been Keeper of the Wardrobe at Richmond since 1531, Vincent became Keeper of Richmond Palace and Park too, a sign that Richmond was now firmly a subsidiary guest house to the more important Hampton Court. He was reappointed by Queen Mary in 1553, and by Elizabeth in 1558. His successor was Richard Tod, one of his assistants. A year after

progress, often via Greenwich, Richmond or frequently Hampton Court. Each year, shortly before the 17th, Elizabeth made her entry into London in order to reach Whitehall in time for the great tournament held in the Tiltyard. Thousands of spectators would gather to see the knights mounted on horses or in pageant cars, and their servants clad in fancy dress. The 1569 tilts were almost certainly the first occasion on which Henry VIII's Hampton Court Tiltyard, built in 1537, was used (fig. 80). During his reign the chivalric towers in the Tiltyard had been used as lodgings for courtiers and guests, and Elizabeth continued to use them in a

similar way, often housing ambassadors in them. They were never used for their ostensible purpose in Henry's reign and probably only on this one occasion in Elizabeth's. Sadly, detailed records for the accession-day tilts were kept only from 1581, and so no description of the event survives.[37] Details do survive, though, of the annual feast to celebrate St George's Day for the knights of the Garter held at Hampton Court in 1570. This was the only year when the Garter feast was held at Hampton Court in Elizabeth's time. Early in the reign the feast had been held at Windsor, but after 1566 it was usually held at Greenwich and sometimes Whitehall. This was one of the great public occasions of the year, for which the court was thronged with people straining to see the queen and the knights in procession to the chapel.[38]

The Elizabethan Palace: Use, Improvements and Additions

It was not until the mid-1560s that any substantial building was undertaken at Hampton Court. In 1564 there was a new Surveyor of the Queen's Works, Lewis Stockett; the French War was over and there was a general sense of self-confidence. This was reflected in an outburst of building: the annual receipts of the Surveyor rose from £3,800 a year to over £9,000 before declining, four years later, to slightly below the former level. The years 1564 to 1572 were the most energetic of Elizabeth's reign in terms of royal building at Hampton Court and elsewhere. During this period, and for the whole of Stockett's surveyorship, average yearly expenditure at the palace stood at about £633 a year, falling to £499 in the years 1579–95 and then to only £479 a year for the rest of the reign.[39] The peak of expenditure was in 1567–70, when the only substantial Elizabethan additions were made to Hampton Court at a cost of £3,654 3s 4¾d.[40]

The old Privy Kitchen, built for Cardinal Wolsey, was sited beneath the Queen's Closet. Having been criticised by Winchester in 1559, it was finally replaced in 1570. The site of the new kitchen was the last vacant piece of ground on the north side of the palace between the kitchen offices and the end of the Prince of Wales's lodgings. The new kitchen was built up against a Henrician boundary wall and was consciously designed to blend in with both the previous kitchens (some nearly eighty years older) and with the whole north elevation of the palace. It had two great fireplaces and two serving hatches leading out into a passageway (fig. 79). The kitchen was only two minutes from the old one along the chapel cloister, but its position on the north side of the

81 Queen Elizabeth I building works at Hampton Court, 1547–1603, showing excavated and extant features in black line and conjectural features in dotted line. Drawing Daphne Ford.

82 The royal mews at Hampton Court. The square courtyard stable was built for Henry VIII in 1537, the extension was Queen Elizabeth's coach house of 1570. Drawing Daphne Ford.

palace was far enough away from the royal lodgings to avoid the smell and noise of cooking, and it was larger and easier to service. The completed kitchen was immediately pressed into use and remained the principal royal kitchen until Charles II's reign. The Privy Kitchen remained under the care of the queen's Master Cook, who was paid more than £11 a year and half the beef fat and half the lambskins from the household kitchens.

While the new kitchen addressed a long-standing fault of the Tudor palace, the construction of a new coach house and barn was a reaction to a major change in the nature of royal life. In the 1550s a number of well-travelled aristocrats and diplomats began to import a new type of passenger road vehicle from Germany and the Low Countries. The coach, although not used at Queen Elizabeth's coronation, soon found a patron in the queen and the first royal model was delivered in 1564. In the same year a Dutchman, William Boonen, was appointed the Queen's Coachman and awarded a crimson livery. The year 1564 was the start of a royal revolution in transport that had an enormous impact on the royal houses, their locality and the whole of the south-east of England. First Elizabeth and then the Stuart monarchs gradually moved away from the use of Thames barges and horses towards coach travel, although on ceremonial occasions the river was still used. In 1564, however, the coach was a novelty, and one for which provision had to be made at the royal houses. A coach house was built at the Royal Mews at Charing Cross in 1568, the same year that substantial alterations were undertaken at Greenwich, and in 1570 the coach house and barns were built at Hampton Court.[41]

In 1537 Henry VIII had commissioned from Christopher Dickinson a square courtyard stable building at a cost of £130 (figs 82, 83). It was located on Hampton Court Green and provided stabling for the King's Horse and for those courtiers who were entitled to stabling. Above the stables were hay lofts and tack rooms, and in the attics lodgings for the officers of the stable.[42] In 1570 a new coach house of fourteen bays measuring 16ft by 75ft was constructed adjacent to it. A great central archway gave access for the coaches, and a stone plaque above it reads 'Elizabethe Regina 1570' (fig. 84).[43]

The queen's adoption of land travel began to have an impact on the locality, one that became increasingly marked during the seventeenth century. The bells of Kingston church (and other surrounding towns and villages) were rung each time the queen

83 The entrance archway to Henry VIII's stable quadrangle from Hampton Court Green.

84 Henry VIII's stable (left) and Elizabeth I's coach house (right) from Hampton Court Green.

passed through. From 1570 the Kingston churchwardens' accounts show that she moved by road increasingly. In 1571 the bells were rung eight times, but on only one of these occasions was it the royal barge that carried the queen. The men of Kingston were also burdened with the upkeep of roads for the royal coach. In 1598, for instance, the Chamberlain of Kingston paid 21d to mend the road to smooth the elderly queen's passage from Sir Thomas Cecil's house at Wimbledon to Nonsuch.[44]

During the 1570s Elizabeth was often at Hampton Court, particularly at Christmas, but after 1579 she visited less, usually only in years of plague. These visits, particularly those over Christmas,

85 The Elizabethan bay window on the south front. Rebuilt in the nineteenth century closely following the original pattern and incorporating the original date stone.

were accompanied by regular plays and masques, usually in the 'masking house' – the Great Hall. The Office of Works accounts refer to the construction of new daises beneath the Cloth of Estate in the Great Chamber and elsewhere, and degrees (or staging) made for the ladies of honour and other courtiers to stand on. Elaborate scenery was constructed and installed and wires stretched across the hall from which to hang oil lamps.[45] At Shrovetide 1573 two plays and a masque were held at the palace, and the following year four plays were performed over Christmas. Over Christmas and New Year 1576/7 six plays were acted by the Earl of Warwick's servants, the Lord Howard's servants, the Earl of Leicester's men, the choir boys of St Paul's cathedral, the choir boys of Windsor and the Chapel Royal, and the Lord Chamberlain's men. On New Year's Day 1593 the servants of Lord Straunge were paid for performing several plays, in spite of the fact that Elizabeth was sheltering from the plague and had instructed the bailiffs of Kingston to enforce a *cordon sanitaire* round the palace.[46]

The chance survival of four volumes of household accounts belonging to Elizabeth's favourite, Robert Dudley, Earl of Leicester, throws light on the mechanics (and economics) of a leading courtier's life at Hampton Court.[47] It is unclear where Leicester's lodgings were located, but they must have been extensive and furnished by him each time he visited. On one occasion one of his grooms, Richard Garner, spent two days, with a labourer to assist him, setting up the rooms. In November 1584 when the earl moved his stuff from Hampton Court to St James's eight men spent two days transporting it in nine carts at a cost of 9s 6d. The scale of this operation suggests that the earl brought tapestries, carpets and furniture and not just his personal wardrobe. Whilst in residence more items would be sent up river from either his house in London, Leicester House, or his house at Wanstead. These included items such as his armour, candles, a close stool, leashes and collars for his hounds and a new pair of shoes for a servant. Occasionally food was sent to court too. Wine and partridges feature in the account books, suggesting that the earl had sometimes to feed himself.

The accounts also reveal something of the size of the earl's household while he was at the palace. During the seven weeks that he was at Hampton Court in 1560 he paid for the beds of four gentlemen and nine yeomen, his Surveyor of Stables and three other named servants. It is unclear where they stayed, but their allowances, 12d a week for the gentlemen and 8d for yeomen, presumably bought them lodgings at a nearby inn. While the earl's servants received allowances for their stay, the royal servants received his tips. The Keeper of Bushy Park was tipped after a day's hunting, the stable boys for tending the horses.

Elizabeth used the same lodgings as Henry VIII had done; what use was made of what had been the queen's side is unclear. Over the course of her long reign there must have been some rearrangement of the Privy and Secret Lodgings to suit her requirements. Winchester's recommendation that the window of the queen's bedchamber facing the Privy Garden be mended is probably a case in point. The window in question was the timber oriel on the top floor of Wolsey's 1526 tower-lodging (figs 85, 92). It was replaced with a stone window incorporating a plaque dated 1568. This suggests that the queen favoured a bedroom in that part of the palace – an area her father had not used. Further references to bedchambers do not clarify the situation. The repair accounts mention a 'red' bedchamber and a 'white' bedchamber (which had a stool house and lobby to it), as well as the 'middle' bedchamber. By 1595–6 there was also an 'old' bedchamber which overlooked a 'little court' that had its casements painted in red lead.[48] It is possible that the queen adopted a much more flexible attitude to her lodgings than Henry VIII. A letter written by George, Lord Hunsdon to Secretary Cecil in the summer of 1599 seems to suggest that the queen was content to use makeshift lodgings if Hampton Court was not ready for her:

Her majesty stands stiffly to her determined removing on Monday next [from Nonsuch], and will go more privately than is fitting for the time, or beseeming her estate; yet she will ride through Kingston in state, proportioning very unsuitably her lodging at Hampton Court unto it, making the Lady Scudamore's lodging her presence chamber, Mrs. Radcliffe's her privy chamber, and appointing me to lodge in the chamber I had appointed for you. Make your choice whether to retain your father's lodging, or that which the Lord Chamberlain has always held, until the time shall alter the purposes now con-

ceived, and it shall be seen whether she will be like herself in her own house.[49]

Only once, during the visit of Sir James Melville, the Scottish envoy, in 1564, do we get a glimpse of the Privy Lodgings. Melville visited Hampton Court in order to smooth the tense relationship between Elizabeth and Mary, Queen of Scots. He recorded in a journal the events of the nine days he spent there. Elizabeth was determined to show off her talents to Melville, whom she knew would report them, in detail, to Mary. He was thus treated to the most remarkable staged access to the queen in her Privy Lodgings. His account of what he saw is a unique insight into Elizabeth's private life at Hampton Court. Late one evening, after supper, Elizabeth invited Melville into her bedchamber. They were not alone: in the far corner of the room were Cecil and Robert Dudley, the Earl of Leicester. The queen led Melville to a cabinet in which were several portraits that she kept wrapped in paper with the names of the sitters written in her own hand. By candlelight she showed him first Dudley's portrait, then a portrait of the Queen of Scots. She then showed him a ruby 'gret lyk a racket ball'. Melville asked that Elizabeth send Mary either the painting of Dudley or the ruby as a present. Elizabeth refused both, but gave him a diamond instead. On another occasion, perhaps even more remarkable, one day after dinner with Lord Hunsdon he was taken to a 'quiet gallery' and posted outside a door to one of the queen's rooms to hear her play the virginals. After a time Melville audaciously drew aside the tapestry covering the door and seeing that Elizabeth had her back to him, entered. After a few moments the queen saw him and rose, as Melville thought, to chastise him. In fact she then sat down on a cushion and, calling Lady Stafford from the next room to join them, invited the Scottish lord to do the same. Melville had a series of other encounters with the queen including several in the Privy Garden, a favourite place for early morning audiences. On one occasion the queen was walking in an alley; walking by her was a servant of Robert Dudley with a finely equipped horse, for Melville's use.[50]

Three other areas are of interest from the point of view of their use during Elizabeth's reign. First, the room that Elizabethan visitors to the palace knew as 'Paradise'. Henry VIII created this in 1534 at the end of the King's Long Gallery. The room, described in the accounts as the 'rich chamber', was given a new lavishly painted and gilded ceiling in 1567–70. In the enrolled account describing the work the clerk accidentally wrote 'privy' instead of 'rich', possibly confirming the identification of the room as a type of privy chamber. It was re-matted in 1584–5 and again in 1589–90, suggesting regular usage.[51] Some interesting alterations were also made in the Chapel Royal and the Queen's Closet. In 1566–7 four large turned pillars and twenty-four balusters were made for the Chapel Royal. Painters were paid for 'painting and gilding of fowre grete postes in the chappell with bisse fyne colowrs and Jaspered parcell giylt and 2 large peces of tymber Curved for the heade of the same'. This structure, especially given its lavish decoration, appears to be a baldacchino with an altar rail before it, or at least four riddle posts and a rail. In 1592–3 a great new clerestory window with four lights was inserted into the Queen's Privy Closet between the Presence and Privy Chambers.[52] Finally, in 1584 Henry VIII's fountain in the inner court

86 Pen-and-wash drawing of the Elizabethan fountain in Fountain Court, c.1584, from the Hatfield House collection of drawings.

was replaced. Comparing Wyngaerde's view of Henry's late-gothic extravaganza and the preliminary design for the new classically inspired fountain, it is easy to see why a new one was commissioned (figs 25, 86). It is likely that much of the original fountain was of timber and had severely decayed, but perhaps more pressing was its very old-fashioned appearance. The new fountain, made of marble with a gilt metal figure of *Justice* and a gilded crown, could squirt water at unsuspecting bystanders at the turn of a hidden cock. It cost the enormous sum of £1,000 and was completed only in 1591.[53]

Elizabeth died just before the break of dawn at Richmond Palace on 24 March 1603, leaving Hampton Court a well-maintained relic of her father's reign and the future of England in the hands of her distant cousin, James VI of Scotland.

Chapter 5

THE TUDOR PLEASURE GROUNDS AND THE LOCALITY

THE GARDENS OF HAMPTON COURT were to become, from the reign of Henry VIII onwards, almost more famous and admired than the palace itself. No other Tudor royal residence, except perhaps for Richmond, had gardens that could compete, and no courtier had a garden even half the size.

The surviving fragmentary accounts from Wolsey's period make it clear that his house was set in fine gardens. We know the identity of his head gardener, John Chapman of Kingston, who had responsibility for tending, and probably designing, the gardens both at Hampton Court and York Place.[1] At Hampton Court there was a walled garden and a walled orchard. The orchard is likely to have been to the north of the palace on the site of the later Privy Orchard (figs 31, 88). A knot garden was almost certainly sited between the Long Gallery and the chapel on the site of the present Fountain Court, but when in 1690 William III lowered the courtyard by 18in. any archaeological traces of this that existed would have been removed. Chapman's accounts refer to wooden arbours, herbs, strawberries and primroses. It is possible that the cardinal also planted, or intended to plant, gardens on the southern side of his gallery – the purpose of long galleries was, after all, to admire the view. Likewise William III reduced the level of what became his Privy Garden, making the archaeological recovery of anything he may have planted there impossible.[2]

The Gardens of Henry VIII

The form of the gardens can only be established with any certainty from 1529.[3] As work began on the first phase of Henrician extensions, so plans were laid for the king's new gardens. Indeed, the addition of a second-storey gallery on top of Wolsey's Long Gallery demanded a garden to the south and set its form. The southern gardens were effectively divided into three compartments: a large rectangular apron against the south front of the palace, known as the Privy Garden; a large triangle to its west containing ponds, known as the Pond Yard; and a smaller triangle to the south of the Privy Garden containing a mound or mount, called the Mount Garden (fig. 88). The compartments were defined by tall brick walls against the insides of which were earth banks.[4] The banks, or terraces, provided a raised walk round the edge of the gardens, with fine views both inwards and outwards through shuttered windows to the park. Two towers containing bowers or banqueting houses interrupted the wall dividing the Privy Garden from the park to the east. The foundations of these were excavated in 1993 (fig. 89). Unfortunately seventeenth-century remodelling destroyed evidence that would have shown whether there was a covered way on the terrace linking the palace with the Mount and Thames Gallery built in 1533–6. Likewise, excavations on the south terrace in 2000 were too inconclusive to demonstrate the existence of a gallery on the west. The possibility of there having been an indoor link between the river and the palace must remain conjecture.[5]

The southern gardens, executed over six or seven years, were integrated with the architecture of the palace. The various compartments were like additional courtyards of the complex, each extending the crenellated skyline, gleaming with gilded vanes and types, towards the Thames. The Hampton Court garden was a uniquely English product, quite unlike anything being made in France at the time, where the engravings of Jacques du Cerceau show large areas of knot garden centred on fountains and surrounded by moats (fig. 90). The gardens of Hampton Court were much more closely linked to the brick urban architecture of the Burgundian court, where pageantry, heraldry, architecture and the representation of ducal power were united in the seats of the dukes themselves. The substantial debt owed to Burgundy by Henry VIII's designers at Hampton Court can be appreciated when we look at Sanderus's views of these houses, tapestry designs and medieval miniatures (fig. 91).[6] At least initially, Henry VIII continued to employ Wolsey's gardener, Chapman, as his chief designer, but Edmund Griffith (or Gryffin), who was in charge of creating the Mount Garden, replaced him in 1533. Chapman lived until 1539, so Griffith's new ideas and skills must have superseded his. One of Griffith's assistants, advisers or possibly designers seems to

facing page Detail from Marcus Gheeraerts the Elder's portrait of Queen Elizabeth I, *c*.1580–85, showing a view into a walled garden. The garden is not that at Hampton Court but is certainly a royal garden or an impression of one. This painting (see fig. 94) captures the privacy and intimacy of a Tudor privy garden.

have been the mysterious 'French Priest' who had a key to the king's garden and planted some of the Mount.[7] Yet the gardeners can have played only a partial role in the design. The main palace design team must have designed the architectural framework, and was certainly responsible for accounting for the expenditure through the Paymaster of the Works.

89 One of the banqueting houses on the eastern boundary of Henry VIII's Privy Garden demolished to floor level and incorporated into one of William III's terraces as excavated in 1993. Many of the floor tiles were re-used from dissolved monastic sites.

87 Plan of the Hampton Court estate, 1547. Drawing Daphne Ford.

A Great Orchard
B Privy Orchard
C Tiltyard
D Pond Yard
E Privy Garden
F Mount Garden
G Fish Ponds
H Water Gallery

88 Reconstructed plan of the Hampton Court gardens in 1547, based on Wyngaerde's view (fig. 92), archaeology and seventeenth-century plans (fig. 139). Drawing Daphne Ford.

90 Jacques Androulet du Cerceau's bird's-eye view from the north of the palace of Fontainebleau, 1579. This view contrasts strongly with the contemporary gardens at Hampton Court.

91 A. Sanderus, engraving of the Burgundian ducal palace of Princenhof in Bruges c.1641–4 from *Flanderia Illustrata*. Although made a hundred years after the Hampton Court gardens were set out this view shows the way that Burgundian palace gardens were divided into compartments by brick walls.

92 Anthonis van den Wyngaerde's view of Hampton Court from the south, c.1558–62. This important view shows in detail the gardens and southern aspect of the palace buildings at their Tudor apogee.

The Privy Garden was intended to be experienced both from the palace galleries above, and by walking the paths below. The area, which measured about 300ft by 200ft, was divided up into squares by 180 wooden posts topped with heraldic beasts, 96 stanchions, and 960 yards of rail painted in white and green chevrons by Henry Blankston (figs 92, 93, 99).[8] These sections were, according to an Elizabethan visitor, 'filled with red brick-dust, some with white sand and some with green lawn very much resembling a chess board'.[9] All this could be seen from the long galleries or from the raised banks on the garden's periphery. Once visitors descended into the flat of the garden they could appreciate the twenty brass sundials made by Brise Angustyn of Westminster,[10] and enjoy the planting. This was arranged round the edges of the chessboard and included violets, strawberries, roses, mint, sweet williams, gillyflowers and primroses.[11] Closer to the palace and around the walls were some small trees, including damsons. In September 1532 a payment was made to the Keeper of the new garden, signifying its practical completion.[12]

The Privy Garden was, to all intents and purposes, a functional extension of the monarch's Privy Lodgings. A stair led down to the garden directly from the Long Gallery, and after the ground floor was converted into privy lodgings in 1537 the monarch could step out of the Secret Lodgings straight into the Privy Garden. Just as in the Privy Lodgings, access was restricted to only a very small number of trusted household officials who had keys to the garden gate. A painting of Elizabeth I by Marcus Gheeraerts the Elder shows Queen Elizabeth in front of one of her privy gardens; almost certainly not Hampton Court, yet it clearly shows a yeoman of the guard at the gate ensuring that only those permitted had access (fig. 94).[13]

With the Privy Garden completed, work began in 1533 on creating the Mount Garden to its south. This involved a great deal of building, for as well as the principal banqueting house there were three 'herbers' or arbours in the shape of a quatrefoil, and a fourth circular one, all two storeys high (figs 88, 92).[14] The quatrefoil arbours were very similar in form to one that survives in a ruinous state at Ashby de la Zouche Castle in Leicestershire (fig. 95). It was built in a remarkable sixteenth-century garden probably commissioned by George, the third Lord Hastings, intimate friend and sometime jousting companion of Henry VIII who knew Hampton Court well.[15] Both the Ashby and Hampton Court buildings were probably used for intimate banquets – small-scale after-dinner refreshments of the most succulent sweet delicacies. The Mount was altogether different. Constructed round a tall circular brick building with cellars and a privy kitchen in its subterranean basement, the main room was a lavishly decorated banqueting chamber.[16] This was on a much larger scale than the quatrefoil herbers and was intended for much more formal dining in public. In May 1537, when Henry and Jane arrived at Hampton Court as man and wife, a buffet was set up in the banqueting house to display the king's plate in preparation for formal dining. The entrance to the banqueting house was reached by a spiral path that snaked its way round the Mount, lined by rosemary and sixteen more heraldic beasts on poles.[17] In the adjacent garden were yew, bay and holly trees brought from the Charterhouse at Richmond and cut into shapes. The Duke of Najera, who visited Hampton Court in 1544, saw topiary in the form of 'monsters', which in 1599 were described as being 'all manner of shapes, men and women, half men and half horse, sirens, serving maids with baskets'.[18]

93 Anonymous early seventeenth-century view of the south front of the palace, from Samuel Pepys's collection, showing the Thames-side bowling alley (centre). Prominent on the far right is the Tudor watergate.

94 Marcus Gheeraerts the Elder, *Queen Elizabeth I*, with a view to a walled garden in the background, *c.*1580–85.

In 1536 the Thames or Water Gallery was constructed in the middle of the southern wall of the Mount Garden, at right angles to the wall. Another very substantial structure, over 170ft long, built on deep foundations and piles at the river's edge, the gallery incorporated a landing stage for the king's barge with a pleasure gallery above (figs 92, 93).[19] Part boat house, part disembarking jetty, part recreational riverside grandstand, it completed the Thames-side grouping of arbours, banqueting houses and pleasure gardens – a remarkable and unique chivalric assemblage, a walled fantasy world for the king's private delectation.

As the Thames Gallery rose in the south, work began on the construction of the third part of the southern gardens – the Pond Yard. Here three ponds were excavated and set in a matrix of low walls with stone pillars supporting forty heraldic beasts holding shields (fig. 96). Planted round them were quicksets, white roses, woodbine, hazel, privet and hops.[20] At first the ponds were filled from the Thames with buckets – a very slow process – but soon a well with a mechanical pump was constructed, and water was drawn from there.[21] Although ornamental, the ponds also had a practical purpose as stew ponds – ponds for breeding and storing fish. It is likely that the largest pond was the breeding pond, which would be emptied periodically, the fish ready for eating being moved to the smaller ponds. Fresh flowing water was kept running through the ponds because the overflow from the palace conduit was directed into them from the cisterns, running first through the fountain in Fountain Court. From here sluices could be opened to let the water drain into the Thames.[22]

In 1535, with work on the Mount nearing completion, Henry opened up another area of garden to the north of the palace. This stretch, divided in two by the palace moat, comprised the Great Orchard to the north of the moat, and the Privy Orchard within its circuit (fig. 88). The two orchards were linked by a drawbridge. In the Great Orchard was built the great round arbour or 'herber', a large circular banqueting house with its own kitchen raised up on arches near a pond (or water garden) and surmounted by a dome. To the west of this was at least one other arbour, possibly more. Within the moat were two other smaller arbours, also domed. The whole area was planted out with trees, mainly apples and pears, but also oaks, elms and hollies.[23] The Privy Orchard was also home to a bowling alley built in 1537, joined at its south end to the prince's lodgings (fig. 205). Its windows were salvaged from the suppressed abbey at Rewley. A second bowling alley had been built the previous year on the Thames side, possibly on the site of an earlier, flimsier structure (figs 88, 93). This included a house for a turner to make the king's bowling balls. Whilst having two substantial structures dedicated to this game may now appear to be excessive, bowling was a popular court entertainment on which courtiers bet heavily. Bowling alleys were a feature of many houses; Whitehall also had two.[24]

Another recreational feature enjoyed by most of the greater houses in the Thames valley was a tiltyard. Hampton Court was the last of Henry's houses to be provided with one, long after he had abandoned tournaments for the more stately sports of bowling and tennis. Work began on the Hampton Court Tiltyard soon after William Clement and Christopher Dickinson had been to Greenwich to take the measurement of the tiltyard there in May 1537. The Greenwich tiltyard was 650ft long and 250ft wide, and Clement and Dickinson decided to mark out an area of the Great Orchard at Hampton Court measuring 450ft by 1,000ft (figs 80,

95 Ashby de la Zouche, Leicestershire, banqueting house, c.1530. This structure is very similar to the lost Hampton Court 'herbers' or brick arbours of the Tudor gardens.

88). The width of the yard was probably determined by the desire to incorporate two of the herbers from the orchard, which would be converted into viewing towers. Work started almost immediately on enclosing the area.[25] Although it seems likely that two of the towers were originally herbers, the construction of the other three does not appear in the main run of Hampton Court particular books to 1538 and are known to us only from Wyngaerde's drawing of the palace from the north-west (fig. 17). A lodgings list of 1540 mentions ten lodgings in 'towers without the gate', and a statement of expenditure ending in June 1541 mentions the tiling and furnishing of 'towers', so it seems probable that they were built in 1540–41.[26] What is particularly interesting about these towers, the precise plans of which are not known, is that they seem to have been inspired by the plans of contemporary coastal artillery forts such as Camber in Sussex. With D-shaped protrusions and curviform walls, they blended contemporary military engineering with the chivalric values of the tiltyard.[27] Henry died before the new Tiltyard could be pressed into action and, as has been described, its first use was probably at Elizabeth's accession-day tilts in 1569.

Until 1536 service buildings dominated the area before the west front of the palace, to the south of the Tiltyard. On the riverside were the Houses of Offices, but north of those, on the other side of the palace's main approach, were houses for the officers of the Royal Works. These included the timber-framed houses of the

96 Reconstruction of the Pond Garden as visualised by the Office of Works in the 1920s. This drawing, based on careful and accurate observation of the remaining features of the Tudor Pond Garden and on the building accounts was probably prepared as an idea for restoration.

Palace Keeper, the Surveyor of Works, the pay house, as well as the joiner's shop and the thatched mason's lodge. In 1536 these were all dismantled and moved further west to Hampton Court Green next to the timber yard. In the following years a new mason's lodge was built, and two new houses, one for the Master Carpenter and one for the Master Bricklayer.[28] We know little about these buildings, but when the palace and its environs were surveyed by the Parliamentary Commissioners in 1653 a 'dwelling house' was identified belonging to the Surveyor of the King's Works with a 44ft frontage facing the Green and a depth of 140ft (including the garden). Next to it were the houses, gardens and stables of the Masters Carpenter, Mason and Locksmith and the Clerk of Works. None of these buildings now survives, but some of their successors do and are described in chapters 10 and 16 (fig. 112).[29]

Henry VIII was enormously proud of his gardens, showing the Privy Garden off to visitors soon after its completion in 1534. In summer the garden was regarded as another room of the palace, and all the Tudor monarchs gave audiences to ambassadors and other important guests outdoors. The gardens were also practical, in that they provided fruit and herbs for the royal table. Two little gardens planted beside the Thames were, in 1546, given into the care of one Millicent Alesbury, who had the task of making the king's sweet waters from their plants.[30] In 1561 the post was granted to William Huggins, whose patent also included the charge of 'the stilling houses incident to the same, and the charge of planting there all kinds of wholesome herbs and trees together with the stilling of sweet waters for the queen's use'. In order to do so he had the authority to 'take up throughout all England for the queen's use roses, herbs and flowers for making of sweet waters, glasses for bottling them, and trees like apple trees and wood and coal for distilling them at good prices'.[31]

The Tudor Gardens after the Death of Henry VIII

The story of the Hampton Court gardens between 1547 and 1603 can be briefly told. Briefly, not because little was done, but because we have no record of it. Edward VI was very interested in gardening, and in May 1548 a warrant was issued to Laurence Bradshaw, Surveyor of Works, to undertake £28 18s worth of improvements and alterations in the Great and Mount Gardens. This was in addition to a new programme of weeding and maintenance introduced at the same time.[32] The chance survival of the book of monthly accounts kept by Hugh Braderton, the keeper of Edward VI's and Mary I's gardens at Hampton Court, gives a vivid sense of the effort and expense that went into keeping these high-maintenance gardens in top condition. In October 1552 the hedges were cut and the borders trimmed while five weeders worked for ten days; in November there were six weeders who worked for eighteen days. In December Braderton presented no bill, but in January work began in earnest cleaning the gravel paths

and, in February, digging the beds. In March eighteen days were spent in pruning the hedges and trees before sowing began in April. The accounts for May and June are much busier, showing a great deal of weeding and tidying of beds. In all, his bill for October 1552 to June 1553 amounted to £13 14s 3d.[33]

Elizabeth too was enthusiastic about gardens and in 1583 a French gardener, John Markye, was appointed to review the planting of those at Hampton Court. This he did, with a small team of assistants (including an interpreter), over a period of three years. His bill survives, listing the purchase of timber poles to make arbours, box plants for hedging, several holly trees, a bay tree, a 'musk tree', lavender plants, double primroses and daisies. The bill came to £420 in total. The lack of any topographical evidence means that it is impossible to deduce what improvements Markye made to the Henrician layout. But changes are likely to have been mainly in the planting, possibly including the introduction of more box-hedged knots. Certainly the Office of Works supplied new beasts for the Mount Garden and eight new beasts for the Privy Garden, suggesting that the structure of the gardens remained unchanged.[34]

The Tudor Parks

The immediate environs of the palace – the southern gardens, orchards, Tiltyard and Green – were, of course, set in a much larger matrix of parks. Until Lord Daubeney leased the property from the Knights Hospitallers, there is no evidence that any of the manor's demesne was emparked. In 1500, however, Daubeney enclosed 300 acres of the demesne land in the middle of what is now Bushy Park, creating Hampton Court's first hunting park. Where Daubeney led Wolsey followed, and on a much grander scale. He was almost certainly responsible for enclosing the whole of the present Hampton Court Park with timber paling.[35] Henry VIII, in his turn, gave a substance and a structure to the parks that largely remain to this day. First he walled the road that ran from Kingston bridge to Hampton, now Kingston Road, creating the division between Bushy Park and the Home Park. Bushy was then divided further into three sections: the hare warren to the east and the Upper Park to the west, with the Middle Park lying between them. The park to the south of the Kingston road was meanwhile divided in two by another wall which joined the palace at its eastern moat, where there was a drawbridge. The northern part of the parks was the Course, and the southern, riverside section, the House Park (fig. 87). Each of these divisions was set aside for a different kind of sport.

The Course and House Park were designed to work together. The House Park contained fallow deer transported to Hampton Court from other royal game reserves. In 1653 the herd numbered 199. The Course next door was essentially a racecourse, a mile long and tapering from a half mile in the west to 200 yards in the east. At the finish (the wide end) was a great standing (or grandstand) on a small hillock from which to watch the sport. A new great standing was built on the course in 1601, probably replacing a Henrician original.[36] The race was between two dogs, on which heavy bets would be laid. A deer would be released and allowed to run for a short distance before a slow-running dog was released to chase it. Once the deer, by now racing, reached a post, which was normally 160 yards from the start, the greyhounds were released, and the first dog home would win. Sometimes the dogs would kill the deer at the end of the race; at other times it would be captured in a pen for use on another occasion.[37] The topographer John Norden in 1592 describes 'two parkes, the one of Deare, the other of hares, both invironed with wals of bricke, the south side of the Deare parke, excepted, which is paled and invironed with the Thamise'. This strongly suggests that the hare warren in Bushy Park was also used for coursing, but of hares rather than deer. The important point is that neither park was for hunting. This took place in Hampton Court chase or one of the royal forests nearby. In 1593–4 a new landing stage was made on the Molesey side of the river, allowing Elizabeth to cross over for the purpose of hunting.[38]

In terms of landscape all the parks were planted with oak trees for which acorns were collected and regularly planted. The oaks survived until the Commonwealth, when the timber of the parks was one of the assets stripped by speculators. Only a very small number lasted into the twentieth century – in 1911 an oak tree in Home Park had a girth of 38ft.[39]

Chapter 6

HAMPTON COURT AND THE INVENTION OF A TUDOR STYLE

IN 1529, UNFINISHED AS Wolsey's magnificent conception was, it was still probably the most important and sophisticated domestic building in England and, barring Otford in Kent, the palace of the Archbishop of Canterbury, the largest (fig. 98). It was created by a churchman of international status and wealth, a man who flirted with the latest architectural and decorative fads of northern Europe. Wolsey had himself been across the English Channel, and part of his workforce, some of his building materials and parts of his decorative vocabulary came from overseas. He had made use of the finest architectural talent in England to design his houses and assembled a top team of craftsmen to build them. Above all, Wolsey's personal involvement was crucial. As has already been noted, little survives to throw light on Wolsey's own attitudes, but an important letter sent by William Pawne, Master of Works at Tournai, to Wolsey in 1516 requests detailed instructions regarding work on buildings there, asking 'whether they shall be vaulted with stone or bryk or floored with tymbr and how many loftes shuld bee in evry tour'.[1] This attention to detail was at the heart of Wolsey's architectural achievement.

The size of Wolsey's Hampton Court and of other episcopal, archiepiscopal and royal houses was determined by the dual function of residence and seat of governance. These houses were centres of large and complex administrative functions with commensurate requirements for both residential and office accommodation. It is therefore difficult to compare them directly to the contemporary houses of courtiers. Nevertheless, it is useful to note that not far behind Hampton Court came a small group of courtier houses in a similar style and form. Sir William Sandys, later Lord Sandys, at The Vyne in Hampshire had, like Wolsey, extended a medieval house with a great base court, new lodgings and a free-standing gallery. Completed by about 1526, it provided suites of lodgings for the king and queen that were used by Henry in 1510 and 1513, and by Henry and Anne in 1535. Its plan and decoration – moated, with a series of courtyards, a great hall, royal lodgings and a gallery – was as up-to-date as Hampton Court. Other structures, like Sir Richard Weston's Sutton Place near Guildford in Surrey; or the enormously ambitious but unfinished Layer Marney in Essex, the house of Henry Marney, later the first Baron Marney; or even Suffolk Place in Southwark, the house of Charles Brandon, First Duke of Suffolk and the king's brother-in-law, were in a similar vein. This group of courtiers (Sandys was Lord Chamberlain after 1526, Marney was Lord Privy Seal and Weston Master of Wards) were, like Wolsey, educated at the court of Henry VII. At the twilight of their political careers in the late 1520s, their architectural achievements were soon to be old fashioned.[2] The style of their houses defies description in modern architectural terminology. To call them late gothic ignores the use of Renaissance terracotta and stained glass, internal decorative grotesquework and much more. To call them Renaissance ignores the deep debt they owed to the Middle Ages. Wolsey's Hampton Court, like its contemporaries, was a stylistic mongrel, but it was also a springboard and in many senses a blueprint for royal building in the 1530s.

Chivalric Eclecticism

Henry VIII started where Wolsey had left off, literally in the case of York Place and Hampton Court, but also spiritually in terms of the creation of the Tudor style. It is even more difficult to characterise stylistically the royal houses of the 1530s and '40s than it is to describe Wolsey's because by then a coherent new architectural style had been developed (fig. 99). Indeed, here a new term needs to be adopted – 'chivalric eclecticism'. Chivalry and eclecticism lay at the heart of Henry's palace building. The style was about creating, or possibly in Henry's mind re-creating, a chivalric setting for the human magnificence of the Tudor court. In the iconography of this creation Hercules, Abraham, King Arthur, Julius Caesar and King David all coexisted in a never-never land of chivalric values underpinned by heraldic display. Thus grotesquework and fan vaults, busts of Roman emperors and coats of arms, battlements and Corinthian capitals, hammerbeam ceilings and tapestries designed by Raphael melded into a single stylistic whole. Hampton Court and its gardens were a fantastical, all-enveloping architectural experience where the senses were assaulted by shade and light, mystery and surprise, tiny jewel-like spaces and great expanses of richness and colour. To achieve this

97 (*facing page*) Detail from an anonymous painting of Henry VIII and his family at Whitehall Palace showing a magnificent embroidered throne canopy like that at Hampton Court.

99 (facing page)
Axonometric reconstruction of Henry VIII's Hampton Court in 1547. The detailing on elevations that no longer exist has been taken from historic views. Structures that do not survive and are not shown on historic views are left without detail. Drawing Daphne Ford.

98 Axonometric reconstruction of Wolsey's Hampton Court in 1528–9. The fenestration has been included on surviving elevations. Structures known from buried archaeology are left without doors and windows. Drawing Daphne Ford.

the designers and craftsmen of the Henrician Office of Works acted like magpies, collecting engravings, historic manuscripts, moulds, templates and pattern books. Their sources were international but the combination of elements and its outcome was strictly national. Chivalric eclecticism may have had its roots in the residences of the dukes of Burgundy, but Henry VIII transformed it into a truly national style.[3]

During Henry's lifetime chivalric eclecticism made few inroads into the sphere of courtier building. Indeed, by the end of the reign a group of houses was being built that adopted a more Continental style, one more strictly governed by the rules of classical architecture. Amongst these were the Duke of Somerset's Somerset House on the Strand in London (1548–52), Sir Thomas Smith's Hill Hall in Essex (from 1557) and the courtyard of William Cecil's Burghley House (1561–4).[4] These houses, which imitated restrained classical French forms, were in part a reaction to the extravagance and exhibitionism of Henry's palaces. They were also perhaps a product of a generation that had lived through the religious and economic roller-coaster of Edward VI's and Mary's reigns. But the 1580s saw a change of mood. Against a background of fervent nationalism occasioned by war against Spain, and a Protestantism that set little store in the styles of Italy, a new chivalric spirit pervaded the court. As leading courtiers donned their breastplates, mounted their chargers and read Spenser's *Faerie Queene*, their architects looked once again to the chivalric eclecticism of Henry VIII's court.[5] The generational pendulum of taste swung against the restrained neo-classicism of the 1560s and 1570s as surely as it had moved away from the chivalric eclecticism of the 1530s and 1540s. From the late 1570s until well into the reign of James I, the royal houses of Richmond, and Greenwich, but particularly Hampton Court, again exerted a powerful influence on architects and master craftsmen.[6]

This assessment makes a claim for the significance of Hampton Court in the late Elizabethan period, and it would be as well to examine how justified this is. Just as the royal houses and palaces of the twenty-first century are used for specific purposes by the monarchy, so were the houses of Henry VIII and Elizabeth. Whitehall was the principal seat of the monarchy and, after its acquisition in 1530, the most used Tudor royal house. It was normally occupied in the winter months and its use was closely linked to parliamentary and other state business. In so far as the Tudors had an administrative centre, Whitehall (and the adjacent Westminster) was it. Stylistically Whitehall was more restrained than Hampton Court. Although the park side, containing tennis courts, bowling alleys and the cockpit, had some of the chivalric brio of Hampton Court, the east side, with its black and white theme, was more sober, as befitted a great metropolitan seat. Foreign visitors, however, scoffed at its 'monkish' appearance. Whitehall,

never finished, was an architectural dud.[7] Greenwich was the country house most frequently used by the Tudor monarchs. It was not particularly magnificent, but it was large enough to accommodate the whole winter court, and it was well served with recreational facilities, close to good sport and, crucially, close to the city. In appearance its river façade was imposing but restrained; Greenwich's vivacity was reserved for the tiltyard to the south with its mini-castles and turreted towers (fig. 100). Windsor, the very seat of chivalry, was principally valued for its proximity to good hunting. Although a vast castle, it had few of the luxuries or conveniences of Greenwich, and a fraction of the capacity for household accommodation. Apart from some work in the royal lodgings, neither Henry nor Elizabeth made material alterations to its overall appearance.[8]

The position of Richmond is more complex. Created by Henry VII as the great Tudor dynastic seat, it fell from favour under Henry VIII after 1530, and remained of secondary importance under both Edward and Mary. Elizabeth, however, used it a good deal, perhaps because it was more manageable and compact than Hampton Court – she had less need of Hampton Court's expansive privy lodgings than her father had done. The tight, vertical, stone-built principal lodgings at Richmond were separated from the rest of the house by a moat, and were grouped round a small internal courtyard, another feature that may have been attractive to the queen. Yet by 1600 the main structures were between 100 and 150 years old, having been last modernised by Elizabeth's grandfather. Much of the *joie de vivre* had gone from the Privy Lodgings when the gilded vanes and pennants were dismantled in 1565–7. Although Elizabethan Richmond was the usual western country seat of the monarchy, it was a working house, not a celebratory one.[9]

For Henry, Edward and Mary, Hampton Court was the principal house for entertaining, the place where, after the mid-

100 Anthonis van den Wyngaerde's view of Greenwich Palace from the river, 1558–62.

1530s, all the major court festivals were held. Henry's trips to Hampton Court after 1530 were closely linked to his movements to and from Whitehall. Twenty-one times the king moved from Whitehall to Hampton Court and twenty-four times he left Hampton Court for Whitehall. Only six times did he leave Hampton Court for Greenwich, twice for Richmond, and four times for Windsor. So it seems that Hampton Court was an alternative to Greenwich and Windsor, his other favoured country seats. After 1540 the pattern changed and Hampton Court moved centre stage, replacing Greenwich as the king's favourite country house. The construction of Nonsuch and Oatlands nearby and the creation of the chase marked a decisive westward shift in Henry's itinerary. Whereas in the 1530s all the great religious feasts had been held at Greenwich (apart from in years of plague), in the 1540s the celebration of Christmas and New Year moved to Hampton Court. Elizabeth's attitude to the palace was more ambiguous. She abandoned it for four years following her attack of smallpox in 1562, and although she started visiting again in 1567 it never regained its crown, sharing its place in the queen's western itinerary with the more heavily favoured Richmond. After 1578 Hampton Court was again used for big festivities, but it did not have a monopoly.[10]

Contemporary Opinions of Hampton Court

In terms of function, from 1540 Hampton Court was, with Richmond, one of the two most important royal country houses. But Richmond was a shadow of Hampton Court. At the end of Elizabeth's reign our characterisation of Hampton Court is enormously helped by the diaries of numerous foreign visitors who were shown the palace over a thirty-year period. The earliest of these accounts is the travel diary of Leopold von Wedel, the younger son of a German noble, who came to London in 1584 after extensive travels to locations as far apart as Egypt and Scotland. In 1592 Jacob Rathgeb, secretary to the Duke of Württemberg, kept a travel diary during his master's visit to England, and five years later we have the account of Paul Hentzner, a lawyer from Brandenburg who artfully kept the diary of a young Silesian nobleman. In 1599 the Swiss doctor Thomas Platter wrote an account of his time in England, and the following year an equally full and revealing account was compiled by Baron Waldstein, a young nobleman from Moravia on a three-year grand tour. In 1602 the young Duke of Stettin Pomerania's secretary, Frederic Gerschow, recorded their visit; and in 1606 Thage Thott, who accompanied King Christian IV of Denmark on his travels, left a full account. Three travellers who visited in 1610–14 left shorter accounts which are none the less useful: Justus Zinzerling and the Duke of Saxe-Weimar (both 1610) and Peter Eisenberg (1613).[11] None of these men was in any sense parochial, and many had been travelling for some months if not years before arriving in England; Hampton Court was merely a single stopping-off point in a vast round of visits. Thus their estimations of the palace's status, both within England and within Europe, are of value. Most of these visitors were probably shown the palace by the same guides. These guides came under the care of the Palace Keeper, who was tipped handsomely for the guided tour (the Duke of Württemberg tipped him 2 crowns). Some of the information they were given was clearly apocryphal, some of it merely misleading; but all wrote down what they heard and saw, with varying degrees of accuracy. Any interpretaion of their accounts of Hampton Court has to be approached with care. We can dismiss, for instance, the story told to Stettin Pomerania, Waldstein and Zinzerling: that the ceiling of the Great Hall was made of a special Irish wood which was poisonous to spiders, explaining the complete lack of cobwebs.

The overwhelming impression given by these seasoned travellers is of a house of unsurpassed richness. Jacob Rathgeb tells us that 'This is the most splendid and magnificent royal palace that may be found in England or indeed in any other kingdom', and a similar view was held by Christian IV's diarist, who wrote that 'the castle of Hampton Court is the finest in all England'. This had largely been the view held by travellers since the early 1550s. In August 1554 Pedro de Hoyo, writing from Hampton Court, told his correspondent that it was 'the finest house in the country and some say the world', and in 1559 the castellan of Mantua was informed that the palace was 'stupendous with every convenience'.[12] But the late sixteenth-century travellers give us more detail: Christian IV's diarist continued his account by emphasising that the rooms were all hung with fabulous tapestries which could not 'be equalled anywhere'. Hampton Court's tapestry collection made a particular impact on visitors. Stettin Pomerania remarks that the 'decorations consisted entirely of tapestries . . . not easily will such be found anywhere in such quantities as in this place', and Baron Waldstein tells us that the palace was considered the most splendid residence and the best for tapestry.[13] Soon after James I's accession, the new Venetian ambassador Scaramelli reported on what he had seen of the royal palaces, writing that 'Hampton Court is far larger than the other seven palaces belonging to the crown . . . one thousand eight hundred inhabitable rooms . . . The furnishings of the royal apartments are the richest that the crown possesses.'[14]

These opinions are backed up by the records of the Royal Wardrobe: the palace was indeed the most richly furnished and decorated of all royal houses. At Hampton Court there were, listed Henry VIII's 1547 inventory, over 520 separate pieces of tapestry of all sorts, including window pieces, borders and the like. At Greenwich the number was 210, and at Richmond 179. A very crude calculation based on the number of entries in the inventory for the main out-of-town houses shows that Hampton Court had 606 separately identified household furnishing objects, as opposed to 421 at Greenwich, 314 at Oatlands, 193 at Windsor and 182 at Richmond.[15]

A strong case can be made out for Hampton Court being widely regarded as the most magnificent royal house, with the richest contents – the country house generally set aside for the greatest festivities and the only one preserving in its entirety the chivalric vision of its creator. Sadly the Elizabethans themselves were as silent on the merits and demerits of the royal houses as foreigners were verbose. But it can be suggested that the perfection of Hampton Court was recognised by the Elizabethan surveyors. It is very interesting to note that almost all the works of the late 1560s at Hampton Court bear Elizabeth's insignia or initials, probably on the initiative of Lewis Stockett (fig. 101). These additions would have been worth identifying, since they were essentially embellishments to a completed palace, one already regarded as an icon. The Privy Kitchen, as noted above, was carefully assimilated with the northern elevation of the house, indis-

101 Queen Elizabeth's initials and a crowned Tudor rose on the east face of the Great Gatehouse.

tinguishable from the kitchens of sixty years earlier. The chivalric eclecticism of Hampton Court exercised its power over another generation of builders, and the key components of its main façades, were widely imitated, as were the crucial principles of its plan. The main façade of Burghley House, as remodelled in the 1580s, for instance, combines many elements that can be identified at Hampton Court, including the highly distinctive asymmetrical towers at each end of the façade (figs 92, 102). The Gate of Virtue at Gonville and Caius College, Cambridge (1567), has another, similar, asymmetrical tower. Worksop Manor, built around 1580–85 (fig. 103), in addition to towers, turrets and walls of glass, displays the asymmetry of the Hampton Court south front; and further removed from direct quotation, but deeply indebted to the style is Wollaton Hall, Nottinghamshire (1580–88). While Elizabethan houses were clearly inspired by elements of Hampton Court as the more fantastic expressions of the Jacobean period developed, Hampton Court was a constant presence. It had silhouettes more striking, pinnacles more piercing, more surprises, more variety and greater historic integrity for a society obsessed by the idea of chivalry. As will be seen in the following two chapters, Hampton Court had, in this regard, a special position and character which both the early Stuart monarchs were to cherish.[16]

The Influence of Tudor Hampton Court

Besides the generic influence of the fantasy represented by Hampton Court there are three specific elements of its plan that, it can be argued, had a particular influence. The Great Hall, as we have noted, was the last to be built by an English monarch. Functionally redundant in terms of royal etiquette, it was the chivalric heart of the palace. It was a deliberately backward-looking building – the louvre in the roof was built a generation after such a feature was actually of use. Henry's hall was completed in 1536, and for anyone familiar with the royal court it epitomised a vision of ancient English hospitality: of the great lord presiding over his feudal affinity, the place where master and servant met over the groaning board. The Elizabethan aristocracy had no functional need for a great hall, but halls at Gorhambury (1563) and Theobalds (c.1567) in Hertfordshire, and Copt Hall (c.1564) and Gidea Hall (c.1568) in Essex, were not constructed for use but to emphasise the nature of the bond between the great lord and his tenants. While the hammerbeamed halls of Burghley in

102 The south front of Burghley House, Northamptonshire. The irregularity of the tower terminations imitates Hampton Court.

103 Worksop Manor, Derbyshire (c.1580–85) shares the asymmetry and apparent confusion of the Hampton Court façades and also has the underlying geometry.

104 Reconstructed elevation of the south front of Henry VIII's Hampton Court. The ground and first floors of the Long Gallery were built by Wolsey, and are not clearly seen on any view of the south front. The top floor, the central projection and the gallery 'end' (on the far right) were built by Henry VIII. Drawing Daphne Ford.

Northamptonshire (early 1560s) and Wollaton in Nottinghamshire (1580–88) were imitating a type, they were also looking towards the greatest expression of Henrician chivalry at Hampton Court.

The second feature of Hampton Court that was certainly taken up by the builders of the 1580s was its second-floor Long Gallery. Although long galleries had become an integral part of courtier and even larger gentry houses by the middle of Henry's reign, few, if any, were skied at the top of the house. It was not until the Henrician revival of the 1580s that the full possibilities of such a location were exploited. Robert Smythson was perhaps the principal exponent of the skied gallery, but lesser houses (and architects) had used them earlier, the gallery at Barrington Court, Somerset (late 1550s), being one example. The great age of the upper gallery comes with Hardwick Old Hall, Derbyshire (1580s), and Montacute, Somerset (1590s), and continues into the seventeenth century with houses such as Doddington, Lincolnshire (c.1600), and Chastleton, Oxfordshire (1602). Yet while the royal gallery was a private space enjoyed by the monarch and especially invited (or authorised) guests, the courtier gallery was one of the principal rooms of parade and show after the great chamber. Hampton Court's gallery provided the finest view of its remarkable gardens for a chosen elite, but the galleries of the Elizabethan prodigy houses were an integral part of the theatre of public display.[17]

A third element, the influence of which should be considered, is the stacked lodgings of Fountain Court (fig. 29). These tall, extensively glazed lodgings prefigured some of the great 'more glass than wall' façades of the Elizabethan prodigy houses, such as Holdenby in Northamptonshire (1579). But perhaps more importantly, in placing the principal lodging on the second floor, the Hampton Court range anticipates the late Elizabethan houses such as Hardwick Hall, Derbyshire (1590–7) or Wootton Lodge, Staffordshire (after 1608). The soaring Hampton Court lodgings presented in the confines of Clock Court were the most prominent and dominant of their type and must have exerted a powerful grip on the imaginations of Elizabethan architects such as Robert Smythson.

Hampton Court performed a specific role in terms of royal etiquette. It closely conformed to the functional distribution of spaces existing at Whitehall and Greenwich, the king's most modern houses. It was at Whitehall that Henry first developed the extensive series of closets and privy lodgings in which he was to conduct most of his life. These rooms were governed by the Privy Chamber, a sub-department of the Royal Household, the purpose of which was to attend to the personal needs of the king. By the end of the reign Hampton Court, like Greenwich and Whitehall, had three functional zones (fig. 78). The first of these comprised the outer rooms, under the supervision of the Lord Chamberlain: the Great Hall, Watching Chamber, Chamber of Estate and Presence Chamber. These were essentially public rooms accessible to all the court. Then there were the Privy Lodgings, which started with the King's Privy Chamber, and at Hampton Court probably included some of the south front overlooking the gardens. Access to this zone was restricted to members of the Privy Chamber and Privy Council (around thirty-seven people). The third area consisted of the Secret Places: all that part of the inner court to the south-east and east meeting the Queen's Lodgings on the east front. Indeed the King's Secret Lodgings verged on the queen's rooms, where Henry could completely escape the strictures of etiquette that governed his own lodgings. The Privy Lodgings, accessible to the Tudor political elite, were increasingly part of the business of governing, and although they were in one sense private, they were not where Henry would relax. Hampton Court's extensive Secret Lodgings were a refuge and a pleasure for Henry after 1539, representing one of the few areas where the king could be truly private.[18]

This provision was important to Henry, but perhaps less so to Elizabeth. The architectural consequences of the accession of a woman to the throne are interesting. Henry had developed the Privy Chamber socially, politically and architecturally to serve his needs. The political and social elite of England populated it. Elizabeth pared the Privy Chamber down to its bare essentials, being served privately and attended publicly by her ladies, none of whom wielded political power or patronage in the same way as Henry's Gentlemen of the Privy Chamber. The Privy Chamber, both organisationally and architecturally, lost its prominence, and the extensive rooms of the Privy Chamber at Hampton Court, not to mention the vestigial queen's side, were largely unnecessary for Elizabeth. Richmond, much smaller, with the Queen's Apartments on a separate floor, was much more practical for the Virgin Queen.[19]

★ ★ ★

The European Context

Finally, it is necessary to consider Hampton Court in a European context, since there is little doubt that both Wolsey and Henry VIII saw Hampton Court as a building of European stature – a backdrop for their handling of international diplomacy. It has been argued that Tudor Hampton Court was an emphatically northern European building, its style rooted in the expression of chivalry and in magnificent display. In this sense it can be related to the buildings of the court and courtiers of Louis XII and Francis I. Wolsey's Hampton Court is most often compared to the Château de Gaillon, built for Cardinal Georges d'Amboise from 1501, and the early works of Henry VIII are likened to Francis I's Château de Madrid built in the Bois de Bologne in the 1520s. Whilst these comparisons are helpful in terms of investment in bricks and mortar (and the occasional architectural element such as portrait roundels), in terms of style there is little similarity. For the French, who were militarily heavily engaged in Italy, elements of the Italian Renaissance were quickly grafted on to the residences of princes and prelates, and soon to those of their followers. By the 1540s French buildings were emphatically Italianate in a way that no building in England was during Henry VIII's reign.[20] The flirtation with Italian architecture that produced Protector Somerset's house on the Strand and Sir Thomas Smith's Hill Hall was thus a short-lived fashion in imitation of France. Chivalric eclecticism, on the other hand, was a thoroughly English response to its age. A gulf existed between England and France in details of plan as well as in those of stylistic expression. The French palaces were based on a three-room formula of *salle*, *chambre* and *closet* in the way that Henry VII's houses had been. Even the addition of a gallery to the closet in the early sixteenth century left French royal suites of rooms a fraction of the size of their English counterparts. Yet despite these differences, by the death of Henry VIII Hampton Court could be closely and favourably compared to Fontainebleau and a number of other French royal palaces, both in scale and, broadly, in form and function. Both in England and in France, these sprawling buildings, with moats, galleries, gatehouses, service courts and suites of royal apartments, set in great hunting forests, were performing the same task, as was clearly recognisable to courtiers from both countries.[21]

France, England's immediate Continental neighbour, has been the usual quarry for historians seeking to contrast the architectural achievements of the Tudors with those of Europe at large. Yet it is possible to argue that the philosophy behind England's chivalric eclecticism had more in common with the extraordinarily distinctive architecture of the court of Dom Manuel I of Portugal (1469–1521) than with anything in northern Europe. Under Manuel, Portugal reached the apogee of its strength and wealth, consolidating its web of trading interests across the known world. At home this resulted in the adoption of the so-called Manueline style of architecture, a hungrily eclectic style that absorbed Moorish, Spanish Plateresque, flamboyant gothic (known as 'English') and Italian Renaissance styles. Underpinning the whole was the iconography of Portuguese heraldry. Although the Manueline style succeeded in creating a more coherent architecture than Henry's chivalric eclecticism, it shared the same multinational inspiration and chivalric roots. While England and Portugal, for different reasons, forged their own path, the rest of Europe gradually became dominated by architects and engineers from Italy. For instance, the northern and central European *douche* states, from which many of Wolsey's and Henry's craftsmen had come in the 1510s and 1520s, fell to the Hapsburgs after 1526. The Hapsburgs actively promoted Italian architects in their courts and across their possessions.[22] A fierce royal independence and self-confidence saw the courts of England and Portugal go in a different direction.

Chapter 7

THE STUART ANCESTRAL SEAT
1603–1640

News of Queen Elizabeth's death, which James VI of Scotland had long desired to hear, arrived on the night of 26 March 1603. Ten days later James reached the English border and was greeted by the great cannons of Berwick. The new king was thirty-seven – middle-aged – and his wife Anne, a Danish princess, was twenty-nine. Their children were Henry, the heir apparent, aged nine; his three-year-old brother Charles; and Elizabeth, their only surviving daughter, aged seven.

As the king made his slow and stately progress south, London prepared itself for the impending royal entry and the economic benefits it would bring. A vast influx of visitors, tourists, traders and merchants was drawn to the capital in anticipation. On 5 April, with James still far off, the aldermen of the City were notified that the plague was in Southwark, probably brought by merchants coming from the Low Countries where, in Ostend alone, it was killing 200 people a week. By the time James entered London on 11 May the disease was well established. He avoided the City, moving directly to the Tower, where he stayed for three days before moving down river to Greenwich. There he was mobbed by upwards of ten thousand people wanting access to their new monarch. This was fertile ground for the plague, and deaths by the end of June were running at nearly 160 a week. It was clearly imperative that the multitude should be kept away, so the king withdrew first to Windsor and then Hampton Court, passing Oatlands where it was decided to lodge the royal princes.[1]

Thus it was from Hampton Court that James finally made his entry to Whitehall, access to which by road and river was barred. There, in a week when the plague killed 1,200 citizens of London, he was hastily crowned. Immediately afterwards, James moved away on his first progress to the west, drawing with him a vast crowd that spread infection wherever it went. Usually in October, with the progress over, the court would have settled at Whitehall and Greenwich for the winter, but as Christmas neared it was clear that neither Westminster nor the City could be entered. In the first week of December the plague had certainly passed its peak but was still killing more than 100 people a week. It was therefore decided to spend Christmas at Hampton Court.

★ ★ ★

Christmas 1603–1604 and the Hampton Court Conference

Hampton-on-Thames itself had not been immune from plague: 119 of its 400–500 inhabitants had already been carried away. Yet the perils of rural Hampton must have seemed far fewer than those of the crowded streets of the metropolis.[2] The courtier and diplomat Sir Dudley Carleton wrote to his friend John Chamberlain informing him that they were arriving at Hampton Court 'welcomed with fogs and mists, which make us march blindfold; and we fear we shall now stumble into the sickness which till now we have miraculously scaped... We shall have a merry Christmas at Hampton Court, for both male and female masques are all ready bespoken, whereof the Duke [of Lennox] is *rector chori* of the one side and Lady Bedford of the other. After Christmas, if the sickness cease, we shall come to Whitehall.' Arbella Stuart wrote from Hampton Court to her uncle, Gilbert Talbot, Earl of Shrewsbury, on 18 December telling him that 'The Queene intendeth to make a mask this Christmas to which end my Lady Suffolk and my Lady Walsingham have warrants to take of the late Queen's best apparell out of the Tower at their discretion... It is said that there will be 30 playes.' There were perhaps not as many as thirty, but according to Carleton, there was one in the Great Hall every night. Some were to James's liking but many were not; it seems that the queen and the Prince of Wales had a keener taste for such entertainment, for on several occasions they invited the players to their own lodgings.[3]

Three companies of players came to Hampton Court that Christmas: the King's Men, of which Shakespeare was resident playwright and part owner; the Lord Admiral's Men, owned by Edward Alleyn and Philip Henslowe (who at this time began to be known as the Prince's Men, having passed under the patronage of Prince Henry); and Worcester's Men (who now began to be known as Queen Anne's Men). The first to arrive were the King's Men, who played on 26, 27, 28, 30 December, 1 January (twice) and 2 February. We know that they performed Shakespeare's *A Midsummer Night's Dream*, Ben Jonson's *Sejanus his Fall* and an anonymous play called *The Fair Maid of Bristow*; they also probably performed Shakespeare's *Twelfth Night*, *Troilus and Cressida*, *Henry IV*, *Parts I* and *II*, *Henry V* and *Hamlet*. It has

facing page Detail from an anonymous painting of Hampton Court from the south bank of the Thames, c.1640 (fig. 108).

recently been argued that *Hamlet* was the first play performed the night after Christmas, chosen to flatter the Danish queen and her husband who had actually spent their honeymoon at Elsinore in 1590.[4] The prince's company played on 4, 15, 21 and 22 January and the queen's company played before the prince on 2 and 13 January.[5]

Although the plays were important, it was the masques that formed the backbone of the entertainment. On 1 January the male members of the court performed the *Masque of the Chinese Magician* in the Great Hall. This is described in detail in a letter written by Dudley Carleton:

> There was a heaven built at the lower end of the hall out of which our magician came down, and after he had made a long sleepy speech to the king of the nature of the country from whence he came, comparing it with ours for strength and plenty, he said he had brought in clouds certain Indian and China Knights to see the magnificency of this court; and thereupon a traverse was drawn and the maskers seen sitting in a vaulty place with their torchbearers and other lights which was no unpleasing spectacle. The maskers were brought in by two boys and two musicians, who began with a song, and whilst that went forward they presented themselves to the king. The first gave the king an impresa in shield with a sonnet in a paper to express his device and presented a jewel of £40,000 value which the king is to buy of Peter van Lore. . . . The rest in their order delivered their escutcheons with letters, and there was no great stay at any one of them save only at one who was put to the interpretation of his device.[6]

On 8 January Samuel Daniel's *The Vision of the Twelve Goddesses* was performed in the Great Hall. A great 'paradisical mountain' was constructed at the screen's end; a winding stair led from its top, by which the ladies of the court descended dressed as goddesses in the finery of the dead Queen Elizabeth. Queen Anne herself was Pallas Athena. After speaking a few lines they danced down the hall to the king's Cloth of Estate; they curtsied to James and the ambassadors before dancing in the open area or 'piazza' before the king. Soon the ambassadors joined the dancers, tossing an exhausted and bewildered Prince Henry 'like a tennis ball' from hand to hand. As midnight struck the maskers withdrew, took off their masks, and proceeded with the king and his guests into the Presence Chamber where a banquet was eaten with 'accustomed confusion'.

During the days the court's focus of fun moved to the gardens and parks, as the weather allowed. Several banquets were held in the banqueting houses in the Privy Garden, and a standing was dismantled from the park and re-erected on the east front to allow the queen to see running at the ring. The Tudor open Tennis Court was taken down and 'new altered' to improve it for use.[7]

All the while, the king's new Anglo-Scottish court was bursting with ambassadors craving the king's favour and attention. At least seven European ambassadors were present, including those of Spain, France, Florence and Savoy.[8] This swollen ambassadorial contingent argued incessantly over precedence and much else. Carleton noted that 'the French and the Spanish ambassadors . . . hold hard for the greatest honour, which the Spaniard thinks he carried away by being first feasted . . . and invited to the greatest mask; and the French seem greatly discontented that he was flatly refused to be admitted to the last . . .'.[9]

In anticipation of this influx of dignitaries the Office of Works had rapidly made preparations during November and December, building new daises in both the king's and queen's presence and watching chambers and in the Great Hall. These would be needed to accommodate the ambassadors who sat by the king and queen during the entertainments. A tall cupboard with many stages was built in the Great Chamber to take the royal plate displayed during banquets. The hall itself was fitted out with staging and partitions for masques and plays, and the kitchens overhauled to ensure maximum efficiency. A small house was built (we don't know where) for the king's clocks, and what is now known as Chapel Court was paved.[10]

Amidst the revelry of Christmas and New Year James had a number of more serious concerns. Ostensibly in response to the Millenary Petition, a clerical petition that had called for further reform of the English Church, but also because he wanted to take soundings on the religious state of his inheritance, the king had resolved to convene a meeting of bishops and theologians in the autumn. This meeting or conference was originally planned for 1 November at Whitehall, but the plague made that impossible, and on 24 October a proclamation was made postponing it to mid-January 1604 and convening it at Hampton Court. The protagonists – the bishops, the deans, the Privy Council and the spokesmen for the reformers – assembled on Thursday, 10 January in the Presence Chamber, to be told that the conference would begin on Saturday and would comprise three all-day sessions. A small group of bishops was then invited for a private briefing from the king in the Drawing Room, where he explained the principle of the conference. On Saturday the Privy Council, the bishops and the deans were ushered into the Privy Chamber by the Lord Chamberlain, where the king joined them from the Privy Lodgings. His chair was taken from beneath the canopy of state and placed before the assembled divines, who made their submissions to the king. The following Monday it was the turn of those clergymen whom the king had chosen to present the case for further reform to be heard. They too were summoned into the Privy Chamber where, kneeling, they made their case to the king, who was seated with the young Prince Henry on a stool at his side. On the final day, Wednesday, the king saw both sides together, again in the Privy Chamber, for the final plenary session. At its conclusion the king withdrew to his Privy Lodgings, and the Privy Council withdrew to the Council Chamber to take forward the decisions made.[11] The geography and symbolism of power cannot have been lost on the delegates. The Privy Chamber was open to bishops and deans but certainly not usually to the other, lesser, clerics. The advocates of reform therefore found themselves ushered before the king into the overbearing and intimidating surroundings of the king's inner sanctum and forced to kneel as etiquette demanded. No wonder then that James was disappointed by these spokesmen, whom he thought appeared tame and tractable.[12]

Jacobean Maintenance and Management

James's first long stay at Hampton Court was the focus for a gathering of the greatest and grandest in his kingdom, and for royal pronouncements on the future of religion in the realm. The house was only twice again to be used so intensively, and never again

so prestigiously, in the early seventeenth century. The long and important visit enabled a careful assessment of the accommodation needs of the king's family and closest companions to be made. Robert Stickells, the architect who was later to build the king a banqueting house at Whitehall, was commissioned to draw a plan of the house.[13] The following year saw an overhaul of many of the most important lodgings. The king's and queen's lodgings were largely untouched, apart from some reroofing, and the replastering of floors damaged by the Christmas revels. But the king's children had refurbished kitchens: the Lady Elizabeth was built a new larder and a new boiling place; the Duke of York a pantry and ewry; and the Prince of Wales new roasting ranges, boiling places and a drain. The Elizabethan house simply lacked the facilities for providing five separate households with meat. Both the Prince of Wales and the Duke of York had new furniture, and the duke's lodgings were plastered. Arbella Stuart, the king's cousin, with a royal pedigree as good as that of the king himself, was installed as the second lady of England. Her lodgings were given a new chimney, two partitions, a pair of stairs and new fire hearths. William Knollys, Baron Knollys, Treasurer of the Household was given a new chimney and a floor.[14]

This flurry of work was not to be typical of building activity at Hampton Court during the reign. Despite the fact that after 1603 there was an explosion of court culture and building on a scale that had not been seen since the death of Henry VIII, Hampton Court was not to share in the upsurge. Expenditure on the royal palaces rose from the £4,000 a year of the latter years of Elizabeth's reign to £7,000 in 1603–4 and an enormous £23,000 by 1609–10. James launched major building campaigns at Whitehall, Theobalds and Newmarket for himself, at Somerset House and Greenwich for the queen, and at Richmond and St James's for the Prince of Wales, but nothing at Hampton Court. In fact, during the first twelve years of the reign £48,000 was spent at Whitehall, £39,000 at Somerset House, £10,000 at Richmond and only £8,000 at Hampton Court. This sum, working out at an average of £666 a year, made a figure very similar to the Elizabethan level of expenditure. The yearly average for the following twenty years, the period during which Inigo Jones was Surveyor of the King's Works, was slightly higher at £881 a year. This was broadly comparable to sums being spent at Somerset House (£814 p.a.) and Greenwich (£746 p.a.) but significantly lower than the Whitehall figure of £2,723.[15] The relatively low but consistent expenditure at Hampton Court during the early seventeenth century represented a careful and thorough maintenance programme for the house. The main Tudor structures were repaired when and as necessary: the Great Hall in 1614–15 and 1617–18, and the chapel in 1619–21. The astronomical clock was repainted in 1619–20 and an ongoing programme of work repaired the ceilings in the Paradise Room and the King's Bedchamber. There were few significant additions or alterations – both James and his son Charles left a building that despite minor decorative modification stood much as King Henry had left it.[16]

In the first year of his reign James made the principal appointments affecting the management of the palace, its parks and the honour. In early 1604 William, Lord Howard of Effingham was awarded the grant, in reversion, of the Stewardship of the Manor of Hampton Court; and John Whynyard was confirmed as Keeper of the Privy Lodgings and Wardrobe.[17] The king also established his pattern of residence, visiting in October 1604 while working with the Scottish Commissioners on the proposals for a full Anglo-Scottish union. Henceforth an autumnal visit to Hampton Court was central to the annual pattern of royal life, sometimes augmented by a spring or early summer visit when the plague was bad in Greenwich or the City. The influence of plague on the royal itinerary in the early seventeenth century should not be underestimated, and Hampton Court was regarded as being a safe haven because of its clear air. In October 1607, for instance, it was reported that the king and queen were isolated at Hampton Court for fear of the plague. But not even Hampton Court was completely safe – in 1609 the plague killed two grooms of the Queen's Wardrobe there and went on to infect the king's court which had by then removed to the royal house of Royston in Hertfordshire.[18]

The Queen's Death and Later Jacobean Visits

On 17 July 1606 King Christian IV of Denmark, the queen's brother, arrived at Gravesend on a state visit, to find that James was at Oatlands, hunting. The king rushed to the coast to meet him the following day and the royal pair began a drunken and orgiastic progress round the houses in the Thames valley. At Theobalds the excesses of the royal party reached fever pitch, ending in an evening when the Danish king, smeared in jelly and cream, collapsed in a drunken stupor before being carried to bed. By 7 August the royal roadshow had reached Hampton Court.[19] The palace had been carefully prepared and the Great Hall set up for a great play. In the evening the King's Men arrived and almost certainly performed *Macbeth*, a play that may have been specially written for the occasion.[20]

From about 1617 Queen Anne's health had begun to deteriorate, and it took a turn for the worse during a visit to Hampton Court in December 1618. Her physicians advised her not to move, and the king began to make regular visits upstream to see his ailing wife.[21] We have a very detailed first-hand description of the queen's last days and death at Hampton Court in a letter written by one of her ladies on 27 March. To most observers who saw Anne walking in her drawing room and gallery in the spring of 1619 she seemed to be convalescing, although she was very weak and needed help walking. But only her ladies knew that she could barely eat, and had not been able to for nearly six weeks. On 22 February her attendants realised that she had consumption (tuberculosis). Anne ordered that her favourite bed should be set up in her bedchamber and she collapsed into it exhausted. Her lady reported that

> We stayed all in the chamber next to her bedchamber till she sent a command to us to go to bed, and would not suffer us to watch that night; only the physicians in the night came to her about twelve o'clock: she called for the wench that sat by her, and bid her find some drink to wash her mouth: she brought her a glass of Rhenish wine that she drank out, and said to the woman, now have I deceived the physicians.

A little later Anne asked the maid for some water to wash her eyes; when she returned the queen could not see by the light of the candle. The doctors and Prince Charles were immediately summoned and 'she laid her hand upon the prince his head, and gave him her blessing'. After struggling to sign a will, leaving her

jewels to Charles, the bishop of London prayed, 'And when his speech was gone the bishop called to her, Madam, make a sign that your majesty is one with your God.' After lifting her hands to show her faith she died.[22]

Although the queen may have died in her favourite bed she didn't die in her favourite palace. Her confinements of 1605 for Princess Mary and of 1606 for Sophia had been at Greenwich, and her official residence was Somerset House. Accordingly, a water procession left Hampton Court transporting the embalmed body to Somerset House, where it was to lie in state until 13 May, the day of her burial. During this time James had been at Newmarket, and was also very sick. Indeed, with the king's life in danger, the queen's death was all but unnoticed. James recovered and was well enough to return to Greenwich a few days after the funeral. With the queen dead, her lodgings at Hampton Court and elsewhere were closed up. At Whitehall they were given other uses, but it is likely that her extensive rooms at Hampton Court were simply mothballed, and remained so for six years.

In 1621 the French ambassadors were again at Hampton Court. The regime surrounding their visit was similar to on previous occasions, centring on a masque and endless wrangles over precedence.[23] For the visit of the French ambassador extraordinary in March 1625, a few days before James's death, furnishings were moved from Hampton Court to Suffolk House in Southwark to furnish it for the ambassador. Eight labourers worked for eight days transporting material that must have been considerable.[24]

The Accession of Charles I

James's last visit to Hampton Court was in October 1624. His limbs, wracked with gout and arthritis, were failing him and it was clear that he would not live for long. At Christmas time James was too ill to enjoy his favourite festivities at Whitehall, but he seemed to rally in the New Year. In early March he caught what was described as a 'tertain ague', the seriousness of which his doctors miscalculated, even considering moving him to Hampton Court to convalesce. Thereafter the king's condition rapidly worsened and on 27 March 1625, at the age of fifty-eight, he died. Charles and the Duke of Buckingham had effectively been at the helm for the previous eighteen months and the transition from father to son was seamless. But although the politics were uncomplicated, Charles's accession was accompanied by a rerun of the disastrous events surrounding that of his father in 1603. On 5 April the King's Council pointed out to the justices of Middlesex the dangers of infection that would be faced if a royal funeral, a coronation and the meeting of Parliament in Westminster all took place at one time. In fact the coronation pageants were postponed on account of the increasing plague, and by the summer well over 4,000 were dying each week, while fleeing citizens spread the infection to the surrounding countryside. On 3 July Whitehall became infected and the court evacuated, by river, to Hampton Court. With it came the new French queen, Henrietta Maria, and her train of French attendants including her Roman Catholic priests.[25]

Charles and Henrietta Maria's first few weeks together had not been successful. The king thought his young wife disobedient and unwilling to integrate, while the queen and her French retinue felt insulted and put out by the behaviour of a court that they regarded as impoverished and unstylish. The summer visit to Hampton Court was, as a consequence, very unhappy. The king and queen struggled to balance both their emotional and ceremonial relationship, hindered all the while by the French ambassador, the Duke of Buckingham and the queen's chamberlain Leveneur de Tillières. The Duke of Buckingham insisted that the queen replace her ladies with three English noblewomen – a prelude to the banishment of her French household a year later.[26] Meanwhile, the infection had reached Windsor, where two men lodging in a house with the queen's priests died. The priests were extracted and sent to one of the Tiltyard towers at Hampton Court until it was certain that they were not ill too. The king and queen parted company, Charles moving to the lesser house of Woking while his wife moved to Nonsuch, but the infected rabble followed, and house after house became unsafe until, on 1 August,

105 The east front of Hampton Court drawn by the Dutch traveller Abram Booth in c.1630–40.

the royal couple were reunited at Woodstock. The court spent the summer far from London where tens of thousands were still dying, returning to Windsor in October. Even Windsor was still unsafe, and on the 24th it was reported that plague had been found in 'six or seven' houses there. But the worst was over, and London was beginning to struggle with the disastrous consequences of losing a sixth of its population, and of six months' suspension of trade and business. Charles decided to move to Hampton Court, and arrived on 3 or 4 November; once there he decided that the court should winter at the house.[27] Communication between the court and London was forbidden. Barges were prevented from coming from Kingston, and courtiers who left for London were not allowed to return. In due course a 'pesthouse' was built in a field outside the palace grounds to which members of the household suspected of incubating the plague were sent.[28]

Pastimes of the Caroline Court

The visit of the winter of 1625–6 was one of the two longest of the entire reign, with Charles only finally returning to Whitehall on 7 January. Like his father's first Christmas at Hampton Court, Charles's was marked by masques, plays, banquets and revels.[29] The Office of Works had been instructed to make the house ready while the court was still at Windsor, and carpenters were employed in the Great Hall erecting staging, making a dais for the king and queen and seats for the musicians, and in the chapel, installing pews. The king's and queen's lodgings were re-matted and in the King's Presence Chamber a remarkable relief of Vulcan at his forge framed by pilasters was painted and gilded by John de Critz. In view of the length of time that the court was to be resident special attention was paid to its needs, a thatched ice-house was built (at an unknown location) and the garden was given a magnificent new sundial. Yet undoubtedly the most important work that autumn was the building of a new Tennis Court.[30]

Following the construction of Henry VIII's tennis plays, evidence for their use is sparse. James I was brought up with tennis, a game that he played at several of his Scottish houses including Falkland, where the tennis play still survives. In England he built a new play at his house at Newmarket and another at Theobalds, and at Hampton Court he had had the open court 'boarded' during his first visit and had the Close Court re-paved with tiles in 1606–7. Sadly, we have no evidence that James himself played tennis on either court.[31] But in his treatise on effective kingship, *Basilikon Doron* (1599), he included the game as one that, although unnecessary, was acceptable for his son to play, and both Henry and Charles must have played on the Tudor tennis play at Hampton Court as boys. Charles was taught by John Webb, the Master of the King's Tennis Plays, who was paid £20 a year for his lessons. This early practice led to the game being one of Charles's favourite pastimes. In 1628 Edward Conway complained that he could not get access to the king at Newmarket because he was continually playing tennis.[32]

In 1625 the Hampton Court plays were nearly a hundred years old, and the rules of tennis had changed and the size and features of the tennis play had evolved since Henry VIII's day. Neither Tudor building was suitable for the game now played and it was decided to rebuild the 'boarded' open play in masonry. The building accounts list the play's various features – the black marble 'hazards' and the net – but there is no plan of it. Abram Booth's view of the east front of 1629–30 (fig. 105) shows what were probably its east and north walls with two windows out on to the park. In 1636–7 further improvements were made to the court, including the addition of two turned pyramids or finials for the ridge of the roof. This would suggest that by this date it had been covered over. The same year a covered passage was made from the palace to the court, and a 'causeway' from this to the course, which can be tentatively identified on later views of the east front (figs 57–9).[33] Recreation was a preoccupation of 1636, for it was also in that year that a bowling green was made. Gervase Markham, the agricultural writer and reformer, described three types of bowling in 1613: bowling in alleys, in 'open grounds' and on green swathes. As we have seen, Hampton Court was well served with alleys from Henry's reign onwards, but a warrant for

the construction of the first green was issued in 1628. It was not until eight years later, though, that turf was cut, transported to Hampton Court, and laid in an area cleared of bracken and other weeds. The new green was banked in earth and fenced in with paling and a hawthorn hedge. A small timber arbour was built for shelter, and a stone roller and forty bowling balls were provided.[34]

After the visit of 1625–6, held under exceptional circumstances, and that of 1636, another plague year, Charles's seasonal use of Hampton Court resembled that of his father. He would generally move to the house at the end of his summer progress between 18 and 26 September and remain until mid-, or occasionally late October.[35] During these visits entertainment was often laid on, as in 1627–8 when plays were performed, not in the hall, but in the Great Chamber. The hall was used again in October 1632 for plays and masques. That autumn the queen and her ladies were also busy practising a new pastoral called *The Shepheard's Paradise* on a special stage built in the queen's lodgings. The piece was written by Sir Walter Montagu and lasted an intolerable eight hours. Its main part was taken by the queen, who delivered her lines at its first performance at Whitehall in January 1633.[36]

The Office of Works was busy throughout the reign making preparations, repairs and small alterations for the annual visit. For instance, in 1635 carpenters were paid for 'preparing against the king and the queen coming hither', including setting up a rail round the great buffet in the King's Presence Chamber.[37] The king's and queen's lodgings meanwhile remained much as they were, the only significant exception being the refurbishment of Henrietta Maria's chapel in 1631–2. After the expulsion of her French household in 1626 the queen had been allowed to retain two or three Catholic priests to attend her spiritual needs. This number was increased after the peace treaty with France in 1629 to include eight Capuchin friars. The arrival of the friars not only made the queen's chapel more splendid, it also increased the congregation attending. The private chapel at Hampton Court was enlarged and modified to reflect this by subdividing it horizontally to create a balustraded gallery approached by a stair for the musicians.[38]

In the late 1620s the palace water supply system was overhauled. Substantial repairs were made to the Coombe conduits and a new conduit house was built. The owner of neighbouring land was compensated for damage done by the king's workmen. Almost every year men working from hired barges laid gravel on the pipes that ran under the Thames. The 1530s conduit from Hampton, which supplied the scalding house and bakehouse in the Outer Court, was relaid with new lead pipes. The trench in which the pipes lay was 161 rods long (about half a mile) and crossed a field owned by one John Freeman, whose corn was ruined.[39]

Apart from 1625, 1636 was the worst year for plague during Charles's reign, with over 10,400 deaths in the City and Westminster. As in his first year as king, Charles left Whitehall and removed to Hampton Court, where he prepared to spend Christmas. Lessons had been learnt since the chaos of a decade earlier when the court had scurried from house to house pursued by tradesmen and petitioners who carried the deadly bacteria fresh from London. In 1636 Londoners were forbidden to come within ten miles of the court, and those who commuted to the City from Hampton Court, Oatlands or Nonsuch were evicted from their homes. As in 1626–7, 'Sheds and Hulks' were constructed in the fields outside Hampton Court and Kingston to which the families of plague victims were removed while their houses were cleaned, shut up and marked with red crosses.[40] Yet Charles's fear of disease was not to prevent him from summoning the King's Men to remain close to court and perform for him in the Great Hall. On 1 November they were given an allowance of £20 a week to be on standby for royal performances. In all they performed on fourteen separate days.[41] The performance on Twelfth Night was, as usual, the highlight. That night William Cartwright's new play, *The Royal Slave*, was acted. The king and queen had seen the play in Oxford, performed by the students of Christ Church, and the queen requested that it be brought to Hampton Court. The extravaganza demanded special scenery and props to be made to the value of £100 and a troupe of dancers to be hired for £54. Cartwright himself was paid £40 to attend and to ensure that the actors learnt their lines properly.[42] The Christmas of 1636 was the last long visit paid by the court to the house. It must have been deemed a success: apart from a single death at the palace, the king and the court spent a safe few weeks, returning to London only around 25 January.[43]

The Furnishing of Early Seventeenth-Century Hampton Court

During the seventeenth century the repair accounts for the decoration of the palace become more explicit, and in addition to this information there is the inventory taken of Charles I's goods by Parliament in 1649. These enable us to characterise the appearance of the interiors at the house as the Civil War drew near. In 1640 Hampton Court was still home to by far the largest quantity of tapestries in the royal collection – over 250 are recorded in the Parliamentary inventory. Importantly, most if not all of these can be identified in Henry VIII's inventory of 1547. The most significant examples from this antique collection were the five great late-Henrician sets of *Abraham*, *Joshua*, *Tobias*, *St Paul* and *Julius Caesar*, each with nine or ten pieces to the set. They were extraordinarily valuable: the *Abraham* set was valued at £8,260, *Julius Caesar* at £5,022 and *Tobias* at £3,409. These substantial figures were reached partly because all the tapestries had a high gold content, but their intrinsic worth as works of art lay at the heart of the valuations. At Charles I's death Hampton Court was still prized as the great tapestry show-house, but interestingly only for antique tapestries. Charles had set up a royal tapestry manufactory at Mortlake under Sir Francis Crane in 1619, and by the following year fifty Flemish weavers were at work producing commissions for the royal houses. Hampton Court was not destined to receive any of this new work, which was sent instead to adorn St James's, Denmark House (as Somerset House was now known), Whitehall and Oatlands.

This impression of antique splendour is reinforced by an examination of the other furnishings listed in the 1649 inventory. The greatest of the Henrician canopies of state, valued at £500, remained at Hampton Court. It was of purple velvet embroidered with gold thread, and had the arms of England crowned within a garter. The whole was embroidered with hundreds of pearls laced with two agates, twelve chrysolites, twelve garnets, a gold-mounted sapphire and a large pendant pearl (fig. 97). At least four of the

great beds also dated from Henry's reign. Most had roses, portcullises and fleur-de-lis; and one canopy (or sparver) had a large H embroidered in the middle. The same went for the carpets listed in 1649, most of which can be identified in Henry VIII's inventory. Particularly magnificent was the most valuable carpet in the royal collection – Henry's crimson and purple carpet embroidered with gold and pearls, valued at £500. Some of the seat furniture too was clearly from King Henry's time, including a gold and purple covered chair with the arms of England supported by carved beasts. It is impossible to identify in the Hampton Court inventory large sets of Stuart seat furniture such as were listed at, for instance, Denmark House.[44]

It may seem extraordinary that Charles and James were using Henry VIII's throne canopies and beds, but it is certainly so. The Wardrobe accounts make it quite clear that the Henrician furniture was not only in use but the subject of a very careful repair programme. In 1618 the Venetian ambassador specifically noted that Henry VIII had left at Hampton Court 'no ordinary memorial to himself' and listed tapestries and furniture belonging to the king that he had seen. The antiquity of the throne canopies and beds, semi-sacred pieces of furniture, gave them even greater status. To the French this was anathema. When Henrietta Maria arrived at Somerset House and saw that she had been provided with one of Elizabeth I's beds she was horrified.[45] But Hampton Court was something of a museum to King Henry. In 1635 William Smithsby, Keeper of the King's Privy Lodgings, was authorised to loan to John Tradescant for his museum, the 'Ark' at Lambeth, Henry VIII's cap, hawking bag, spurs and stirrups and Henry VII's gloves and comb case from the Wardrobe at Hampton Court. All had been carefully preserved there since Tudor times as relics of King Hal.[46]

Yet despite the overwhelming quantity of antique furnishing at Hampton Court in 1649, and the striking similarities between its contents and the inventory of Henry VIII taken a century earlier, there was one notable difference. While Henry VIII had fewer than fifty easel paintings at Hampton Court, Charles I had around three hundred and fifty. Charles is remembered as arguably England's greatest royal patron of painting and sculpture. His fame rests on the spectacular collection he amassed, which catapulted the English royal family into the first league of European art collecting, rivalling the Spanish in quality if not quantity. Charles's passion for collecting paintings can probably be traced to the reckless Spanish trip he made with the Duke of Buckingham in 1623, hoping to win the hand of the Infanta Maria. His love of painting had certainly not been inherited from his father. James had added a number of painted portraits to the collections at Hampton Court and elsewhere but had never attempted systematically to build a world-class collection. The Parliamentary inventory lists a number of Stuart portraits, including several of James, Anne and their children that had been commissioned by James I and hung at Hampton Court.[47]

Charles took the display of paintings into a different league. On ascending the throne he set out to attract painters of international stature to his court. He succeeded in luring Orazio Gentileschi and his family to settle in London in 1626, but his biggest catch was Anthony Van Dyck who arrived in the spring of 1632.[48] The king was very much interested in contemporary painting, but he was also eager to build up his collection of old masters, and his celebrated purchase in 1627 of the Gonzaga paintings from Mantua for £15,939 more than any other single act put the English court on the European artistic map. These were added to his earlier purchases, and his collection was to be enlarged over the course of his reign by smaller purchases and gifts. Hampton Court became the repository of many of his greatest old masters such as Raphael's *The Virgin and St Elizabeth with Jesus and the Infant St John the Baptist* (now in the Prado, Madrid) and Titian's *The Entombment of Christ* (now in the Louvre, Paris). These joined some of the major Tudor works still at Hampton Court today, including *The Battle of Pavia* and *The Battle of the Spurs*. Other great English works hanging cheek by jowl with the Italian old masters were a portrait of Richard II (a lost copy of the one in Westminster Abbey), the perspective portrait of Edward VI (now in the National Portrait Gallery, London) and a number of other portraits of Henry VIII, Edward VI and their European contemporaries.[49] A crude breakdown of the subjects of the Hampton Court paintings demonstrates that the vast majority of them were portraits or religious subjects (126 and 112 pictures respectively). Landscapes (41) and scenes from classical history or mythology make up the next most prolific categories (39) and genre scenes (21) and still lifes (10) make up the remainder.

What is striking about the picture hang at Hampton Court is not so much the subject matter of the paintings (conservative though the portraits and religious pictures were), but the notable lack of fine contemporary Continental pictures of any subject. Only one of Orazio Gentileschi's paintings for Charles I was hung at Hampton Court – described as 'a woman's head' in the inventory of 1649, it can be identified with the small-scale painting *A Sybil* still at Hampton Court today.[50] Artemesia Gentileschi was represented by a self-portrait and 'as pictura', and there was one good painting by Fetti. In addition to these there was a small group of Van Dycks. These paintings deserve special consideration because their appearance at Hampton Court in 1649 is not straightforward. There were two portraits of figures prominent in the administration of the Spanish Netherlands; a three-quarter-length painting of Prince Thomas of Savoy (now in the Gemäldegalerie, Berlin), and a version of his portrait of the Cardinal-Infante Ferdinand. In subject matter these fit well with the remainder of the hang, although they were, of course, contemporary. Then there was a small group of paintings listed right at the end of the inventory of Charles and his immediate family. These stand out from the rest of the paintings at the house, being both contemporary and of living members of the English royal family. The paintings were *The Five Eldest Children of Charles I* and the beautiful half-length portrait of Henrietta Maria (both now at Windsor Castle); a copy of the *Greate Peece* (the original now at Buckingham Palace); and the magnificent *Charles I on Horseback* (now in the National Gallery, London).[51] This last group, as we shall see in the next chapter, was probably only brought to the palace during Charles's enforced confinement in 1647. Thus by discounting the largest and most important contemporary paintings it can be seen that the picture hang at Hampton Court in Charles's reign was of a very particular nature. Like the tapestries and furniture, it was predominantly antique. Perhaps this is part of the reason why Abraham Van der Doort, while compiling the great inventory of Charles's paintings in 1637–9, covered Whitehall, Nonsuch and Greenwich but not Hampton Court.[52] The seven-fold increase in easel paintings at Hampton Court by the early Stuart period did not signify a change in the ambience of the residence. Nothing

was there that was remotely avant-garde; the whole ensemble was undiluted royal conservatism.[53]

Information on the pictures is also rich enough to enable us to understand precisely how they were hung. Clearly few if any paintings were to be seen in the Tudor outer chambers which were still hung with tapestry; most were displayed in the galleries and closets of the Privy Lodgings where they could be hung against the panelling. In most cases the Tudor linenfold panelling would not have been altered to take them, but the practice of setting paintings into overmantel and overdoor panels was common. Set into a panel above the chimney in the King's Dressing Room was a *St Jerome* by Titian, and over the door there was another Titian, *Mary Magdalene*. In the middle of the King's Gallery the overmantel was *Venus and Cupid* by Bronzino.[54] In these cases it is possible that the Tudor panelling was altered. The most interesting instance of picture display at Hampton Court is that of Charles I's most spectacular old master purchase, Mantegna's nine canvases of the *Triumphs of Caesar*. The *Triumphs* had formed the core of the Mantuan purchase and were regarded by all as its most important and beautiful paintings. They had originally been installed in the Gonzaga palace of San Sebastiano, where they were set into a great gallery, separated by gilded pilasters. Their architectural role may, in fact, have played a part in Duke Vincenzo II's reluctance to part with them. It is not clear how far Charles was aware of the original setting of the series, but Daniel Nys, the king's agent, would have certainly known of it, and it would have been astonishing if Charles, so passionately interested in his new purchase, had not gleaned this information. Indeed, unlike his other purchases, which came in their frames, the *Triumphs* would have arrived as bare canvases, the pilasters and architectural surrounds remaining in Mantua.[55]

The Gonzaga paintings had been dispatched from Venice by the end of October 1530 and must have arrived in London within a few months. On their arrival Charles was faced with the task of distributing them amongst his residences. The *Triumphs* were chosen for Hampton Court, probably for two reasons. First they perfectly fitted the antique theme of the house, which already contained a sixteenth-century set of tapestries celebrating Julius Caesar. Second, the paintings needed a considerable space in which to be hung, and the Whitehall gallery, already containing the king's finest and most fashionable pieces, would have not been large enough. At Hampton Court the Tudor long gallery on the south front was a room that could be fitted up to take the paintings with ease. Sadly it is not known whether it was decided to fit the paintings into frames set into the panelling, but it seems unlikely since nothing appears in the accounts. We do know, however, that in 1636–7 Matthew Goodwin was paid for painting nine picture frames in 'sad lute colour', and this almost certainly refers to new frames for the major pictures. In 1640 calico curtains were provided to cover them, a fact that demonstrates the value attached to the series.[56]

All this accords with a vision of Hampton Court that was specifically and deliberately antiquarian. Hampton Court preserved in its internal furnishings the trappings of the early Tudor monarchy, virtually unsullied by the contemporary interests of Charles, his two sons and the group of avant-garde collectors and patrons centred round Whitehall. Architecturally, too, the early Stuart period at Hampton Court is ultra-conservative, especially by comparison with the projects that were commissioned by James I and Anne of Denmark at Whitehall, Somerset House and Greenwich, and the plans that Charles I had for Whitehall. Significantly, Inigo Jones did not make a single alteration at Hampton Court. Yet as we have seen, it was still a major residence much used and carefully maintained by both early Stuart kings. Hampton Court represented ancient English hospitality and magnificence, virtues that both James and Charles, in their different ways, wished to emphasise at court.[57] Under James there was a powerful nostalgia for Elizabeth encouraged and nurtured by the king himself, whilst for Charles the virtues of Henry VIII's court were a model. Thus antiquarianism shaped courtly life and ceremony for both the early Stuart kings. Charles's household ordinances were intended to reintroduce order and decorum into court life by re-establishing the etiquette of Henry VIII's time. Tudor regulations that had lapsed under James I were re-introduced by Charles. Communal dining in the Great Hall and in the Presence Chamber became a daily event in the greater houses like Hampton Court, although it was highly unpopular with the king's aristocratic officers. Sundays were further elevated as the principal court day with new regulations governing behaviour at chapel, and the privacy and dignity of Charles's Privy Lodgings was reinforced. Hampton Court was the ideal setting for the extreme formality and ceremony of Charles's court, which must have been awesome to behold.[58] Charles's enthusiasm for the magnificence of Henry VIII's court was one of the main reasons for the popularity of Hampton Court in the early Stuart period.

The Stuart appreciation of Hampton Court can be paralleled in a small number of other English houses. The most interesting of these is Cotehele in Cornwall. In the 1550s the Edgcumbe family built a new seat at Mount Edgcumbe to replace their medieval house at Cotehele. The older house was not abandoned, let or sold but maintained and occasionally used by the family. Then in 1651–2 Colonel Piers Edgcumbe, a Royalist who made a strategic decision to move the family back to Cotehele, undertook a restoration and extension of the old house. He built not in the style of the day, but deliberately to blend in with the medieval façades (fig. 106). He even reused medieval windows to preserve the integrity of the old architecture. This appreciation of

106 Cotehele House, Cornwall, the Edgcumbe family's ancestral seat maintained in a deliberately antiquarian style.

the older house as the ancestral home continued into the later seventeenth and eighteenth century when the family returned to Mount Edgcumbe. A similar division between the new principal seat and the ancestral home preserved in aspic existed for the dukes of Devonshire at Chatsworth (the principal seat) and Hardwick Hall (the ancestral home), and for the earls of Northampton at Castle Ashby (principal seat) and Compton Wynyates (ancestral home). There are other examples too.[59]

Diplomatic Protocol at Hampton Court

Hampton Court's role as an ancestral home in antiquarian taste shaped its early Stuart function as the focus for two types of activity: ambassadorial receptions and hunting. As in so much else, Cardinal Wolsey set the tone for Hampton Court's future in his use of the house for diplomatic activity. Throughout the reigns of Henry, Edward, Mary and Elizabeth this remained a backbone of the palace's function. Admittedly, the nature of the surviving evidence ensures that these events were recorded in greater detail than others, but the pattern of usage is very suggestive. It is not necessary to chronicle here the endless coming and going of emissaries and the little tricks of etiquette employed by the Tudor monarchs either to flatter or to humiliate them. An important feature of ambassadorial visits is that ambassadors were summoned by the monarch to a palace for the day and never stayed the night there. Chapuys, who came to Hampton Court in 1540, was 'lodged at a house plentifully provided with every convenience, and all the necessaries of life'. When the king was ready for him, a mule and a barge were sent from Hampton Court to give him a choice of transport. Sometimes ambassadors would be forced to stay for several days at these outposts waiting for their invitation to see the king. Most of the formal ambassadorial receptions were on Sundays, and ambassadors often saw the king on his way to mass. On 20 May 1543 Chapuys wrote, 'This morning as he [Henry] was going to mass, he again commenced to greet me ... As it was then nearly 11 o'clock, and the king had not yet heard mass, as he had, moreover, to receive the scotch ambassadors, who ... had only arrived in this city a few days before, I would not speak long to him of our political affairs in common.'[60] The pattern of ambassadorial activity barely changed under Elizabeth, but she used Richmond as well as Hampton Court for the Sunday receptions.

The importance of international diplomacy to the courts of seventeenth-century Europe can hardly be over-estimated. Ambassadors were no longer mere negotiators on behalf of their masters; they were now accorded the status of their sovereign abroad. This led to an enormous increase in international diplomatic protocol, and had a significant impact on the daily operation of the royal courts and palaces of Europe. Hampton Court had a crucial role to play in ambassadorial etiquette. It was there that the early Stuart kings' summer progresses usually ended in late September or early October. During the summer months, with the court on progress, most diplomatic activity was in abeyance, but the king's arrival at Hampton Court signalled the start of business again for the autumn and winter months. This time was therefore always characterised by a series of ambassadorial audiences. For instance, on 20 September 1606 Zorzi Giustinian informed the Doge of Venice that the progress was over, the court was at Windsor, and that ambassadors would be admitted when the king arrived at Hampton Court. Very occasionally audiences at the end of a progress would be elsewhere: in September 1611, for instance, they were held at Theobalds, and the king moved on to Hampton Court afterwards. It was also at Hampton Court that the Council first met after the summer recess, to receive both diplomatic and domestic visitors.[61] Although the autumn embassies were of great importance, Hampton Court was also used for the reception of ambassadors on other occasions, particularly when a less formal or more secret meeting was required. Audiences at Whitehall were very public; down river at Hampton Court, as the Venetian ambassador noted, audiences could be held with 'greater secrecy and convenience'.[62]

There were very strict rules of etiquette governing audiences at Hampton Court and elsewhere. Generally ambassadors had to arrive in their own coach, unless they were extraordinary ambassadors, who had the privilege of being transported in the king's own coach. The coach drew up outside the Great Gatehouse where the ambassador would alight. In September 1635 there was a serious breach of etiquette when the French ambassador's coach entered Base Court. This was reported to Sir Henry Vane the elder, Comptroller of the Household, and we learn that

> He instantly called to one of the porters and railed at him for his negligence and, having heard all the excuses he or his fellows could frayme (that the ambassador had entered with so swift as they could not, though they would, hinder it) he charged them, upon penalty of being thrust out of theyr places, not to suffer any coach to enter that court, excepting his majestyes coaches or some such great lords or ladys as should immediately follow them.

Vane proceeded to decree that at all times when the king was in residence the Great Gate was to be kept shut and the wicket gate open.[63] Usually, less audacious ambassadors would alight from their coaches outside the Great Gatehouse to be received by the Master of Ceremonies, and were then escorted through the Outer Court into the Great Hall, through the Guard, Presence and Privy Chambers and into the King's Withdrawing Room. After seeing the king, ambassadors were usually taken on to the queen's lodgings.[64] On occasion the king would not be ready to receive his visitors immediately. In October 1628 Sir John Finet, the master of ceremonies, met the ambassadors extraordinary from the Dutch Republic at their own coach and took them to the Vice-Chamberlain of the Household's lodging. From there they were shown the way up the back stairs into the King's Withdrawing Room. At the same time the Privy Council was receiving the Danish ambassador, probably in the Council Chamber.[65]

The Polish ambassador extraordinary, John Zawadsky, had his first public audience on 7 June 1636 at Hampton Court. The first audience of an extraordinary ambassador in public commanded special ceremony. Zawadsky was taken out to Hampton Court in the king's coach accompanied by eight others containing, amongst other dignitaries, seven or eight Gentlemen of the Privy Chamber and the Lord Chamberlain. At Hampton Court they were publicly received by the king and queen, who were standing under the throne canopy in the King's Presence Chamber. Afterwards Zawadsky saw both the king and queen privately in their respective withdrawing chambers.[66] Although travel by coach had largely superseded river travel for the majority of the most

fashionable and important visitors, ambassadors and others still sometimes arrived by barge. Barges were often used as a particularly ceremonious or privileged means of transport. Zawadsky was invited to take his leave of the king at Hampton Court and was taken to the palace in the king's own twelve-oar barge from Lambeth landing stage. He landed at the Privy Garden stairs and was taken via the long covered walk on the east side of the Privy Garden via the 'back cloyster court', the Presence and Privy Chambers into the Withdrawing Chamber.[67] This was the king's own route to the royal lodgings and was reserved for the highly privileged only.

There are several detailed descriptions of the procedure for audiences at Hampton Court. Early in the reign Giovanni Carlo Scaramelli, the new Venetian ambassador, had an audience with the king and queen:

> I was introduced into the presence amidst a babel of voices, discussing the [Gunpowder] plot. I presented your serenity's letters ... Then I passed into the Queen's apartments ... She was surrounded by a court of ladies, and rose with a bow. I mounted the steps and kissed her hand. She remained standing all grace and fairness of fine height and moderately fine presence.[68]

Antonio Foscarini had an audience with Anne lasting three hours, during which he was taken into her 'very private gallery' where he heard music played and where she spoke to him 'now on foot, now seated'. The queen's position in diplomatic affairs was important. It was reported by the Venetian ambassador that due to the queen's intercession the Danish ambassador had obtained a number of private interviews with James at Hampton Court in October 1611.[69] The conduct of an audience was a sure sign of the degree of favour being extended to the ambassador. The Marquis de Flores Davila, Spanish ambassador extraordinary, had his first audience at Hampton Court in July 1612. It was reportedly an uncomfortable affair. James saw him 'in a gallery, standing up, and without ceremony'; the audience lasted a very short time and according to the Venetian ambassador was 'confined to compliments'. Davila left without an offer of lodgings or a further invitation.[70]

Clearly not all ambassadorial business could be conducted in a day, and frequently ambassadors would be received several days running at Hampton Court. On such occasions, as in Tudor times, ambassadors would not stay at the house but be billeted in Kingston, Sunbury or another nearby village. Neither James nor Charles was prepared to lodge ambassadors at a palace where he was staying. On the occasion that a French ambassador claimed the right to do so an enormous diplomatic row ensued. Ultimately he was accommodated in the Water Gallery, but without being allowed a canopy of estate or an official diet. Neither king was, however, averse to lending a palace to an ambassador when it was appropriate or expedient, providing of course that they were not intending to stay. In 1620, at the height of his enthusiasm for the Spanish match (the projected marriage between Charles and the infanta), James granted Count Gondomar, the Spanish ambassador, the right to lodge in one of the banqueting houses.[71] In a letter from Inigo Jones to the Earl of Arundel dated 17 August the complexities of the arrangement become apparent:

> In my Journey to London I went to Hampton Court, where I heard that the Spanish Ambassador came to Kingston and sent his steward to Hampton Court, who looked on the lodgings intended for the ambassador, which were in Mr. Huggins his rooms; but the steward utterly disliked those rooms, saying that the ambassador would not lie but in the house; besides there was no furniture in those rooms, or bedding or otherwise, neither for the ambassador or his followers. So the Steward returning to his Lord, he resolved to hunt only in the park and so return. But the keeper [of the park] answered, he might not suffer that, he having received no order for it; so the ambassador went back discontented, having had some smart sport in the warren. But since, my Lord of Nottingham hearing of this, sent to the ambassador, to excuse the matter, which the ambassador took very well, and promised to come and lie at Hampton Court before his Majesty's return. But in my opinion, the fault was chiefly in the ambassador, in not sending a day or two before, to see how he was provided for, and give notice what would please him.

The following year James successfully lent Hampton Court to the Polish ambassador for about two months.[72]

Hunting

It is impossible fully to understand Hampton Court or any of the royal houses of the Stuart age without emphasising the importance of hunting.[73] We have seen that Henry VIII made Hampton Court the centre of a great hunting ground that allowed him to chase a stag unimpeded from Hampton Court to Windsor. Under Elizabeth hunting had taken on a more gentle aspect, but James revived it with gusto. From the moment he entered England he made it clear that one of his priorities was to find good health and pleasure at the chase. James opted for the most energetic, testing and arduous form of the sport. A Venetian observer relates that the evening before the hunt the king's gamekeepers would select a large and strong stag for the chase, and that 'on the following morning the hounds rouse him from his lair, pursuing him from natural instinct and never losing the scent, even should he hide himself in a thousand woods'. The king and his lords would follow, mounted, pursuing 'the game over the country and often for the space of eight whole days, until it is quite exhausted and dead, and to effect this without killing the horses, relays are posted in various places'.[74] To hunt in this manner required access to vast tracts of land and James's summer progresses took him out westward, exploring the great royal forests of Woodstock and the New Forest.

Yet the parks of western Thames-side palaces provided good sport too. The autumnal visits to Hampton Court were an opportunity for James to use these. The finest hunting was deemed to be during the 'grease season' (or feeding season) when the deer were fattest and their antlers finest, confining the best sport to the period from mid-June to early September. Thus hunting from Hampton Court and the western palaces was mainly at the end of the season. It was reported in October 1606 that the pregnant queen was alone at Hampton Court waiting for the king to return from a hunting trip. She was too afraid to move by herself as the plague was in the surrounding country, and James was still expected 'in a few days' on 2 November. This was far from being an isolated occasion; the king was devoted to hunting and disliked

the way that in England courtiers followed the monarch in the saddle. According to another Venetian, 'he cursed every one he met, and swore that if they would not let him follow the chase at his pleasure, he would leave England'. This was a cause of concern to some. In September 1605 the king made plans to go to Hampton Court to hunt, against the queen's wishes. She thought it would be dangerous 'in the present time of turbulence and commotion' for James to be out in the country accompanied by very few attendants, in case the king 'as often happens, when lured on by the pleasure of the chase, should stay out late into the evening, thus offering an easy occasion for any who desires to injure him to do so'. James's concerns lay rather with the game itself – an undated warrant probably from around 1624 attempts to prevent it from being destroyed by 'disorderly persons with guns, nets, greyhounds etc'.[75]

The royal preference for hunting from Hampton Court inevitably led to its becoming a focus for equestrian matters. Both Charles and James were served by the Duke of Buckingham as Master of the Horse. Extravagant, enjoying the complete trust of his masters and obsessed with hunting, he did much to improve both the buildings and the bloodstock of the royal stables. Soon after James's accession the Hampton Court stables were repaired, and in 1607 a number of old buildings were demolished in the stable precincts. Thirty years later Inigo Jones was ordered to survey the stables and prepare estimates for their repair.[76] The stables were essentially a temporary home to the King's Travelling Horse that, in addition to those required for the frequent royal removes, included twenty hunters, and others to pull the ponderous four-wheeled deer-van and the hound-van – essential adjuncts to the hunt.[77] In addition to the occasional equestrian presence Hampton Court had a role as a subsidiary stud to the larger and more important stud at Tutbury. In 1620 Buckingham ordered thirteen matings for the king's mares, and in 1623 there were twenty-three mares at the Hampton Court stud. For these Buckingham ordered a new timber-framed stable to be built on the course in 1621–2. The stud remained active until Cromwell closed it down in 1650.[78] Hampton Court was also home to the royal buckhounds and harriers that accompanied the chase. In the Parliamentary inventory of 1649 there were at least ten dog collars in a rainbow of colours.[79]

James effected a number of improvements to the Hampton Court parks. In 1605 the cost of paling round the Middle Park and the lodge was over £108, and in 1611 a new lodge was built in the Great Park. In 1620 James enlarged Hampton Court Park by enclosing a piece of Hampton's glebe land known as court field. By way of compensation he granted the vicar of Hampton a pension of 40 marks in lieu of lost revenue.[80] The practice of restocking royal parks that had been common under Henry VIII was re-established under James and deer were brought to the Hampton Court parks and those round about to improve both coursing and the chase.[81] James's great hunting trips had mainly been to the west of Hampton Court towards Windsor and Kempton; Charles, on the other hand, began to look east. He had resolved to use Richmond as the seat of the Prince of Wales and wished to extend Richmond Park towards Hampton Court, thus joining the two residences by a great hunting ground. This scheme was in some senses a successor to the much more ambitious one undertaken by Henry VIII in the creation of Hampton Court chase, linking Hampton Court and Windsor. Charles's advisers

107 Jacobean wooden stags' heads with antler trophies made for Hampton Court and now hanging in the Great Hall.

were against it. The Lord Treasurer, Bishop Juxon, the Chancellor, Lord Cottington, and Archbishop Laud all thought the scheme not only unnecessarily extravagant but also likely to prove very unpopular. They were right on both counts. The much-reduced scheme finally implemented, which had been budgeted at £20,000, cost at least £5,000 more to achieve, and brought the king the ill will of the local landowners and populace who lost much of their common land. The new park was completed by 1637–8 and linked Richmond with Kingston, allowing the king to hunt between his two great western palaces at will. In 1647, while captive at Hampton Court, Charles hunted in the new park with the Duke of York, moving on to dine at Syon before returning to Hampton Court at night.[82]

In later ages, with the art of taxidermy more fully developed, the hunt left a greater mark on the interiors of royal palaces than it did in the seventeenth century. Yet it was during James's reign that Hampton Court began to be home to sporting trophies, particularly antlers from stags. Sadly, none of the surviving antlers or heads is marked by a plaque proving that they came from a stag killed by James or his courtiers, but we do know that the earliest identified heads of antlers with proven provenance were killed by members of James's court. At Ditchley Park in Oxfordshire, where James and Prince Henry hunted, there remain a number of

heads of deer killed by the king and the prince themselves. It is likely that the carved wooden stags' heads in the Great Hall at Hampton Court date from James's reign, for in 1635–6 a carver, Zachary Taylor, carved three new wooden stags' heads to join five others in the Great Hall, all of which were painted by John DeCritz and John Preston (fig. 107).[83] The palace antler collection grew rapidly in the Stuart era. Although antlers were ignored by the Parliamentary Commissioners compiling the inventory of the late king's goods in 1649, those who compiled the inventory of Hampton Court at Cromwell's death listed 127 pairs in what was described as the 'late prince's gallery'.[84] This was the Queen's Gallery on the east front that became known at the Restoration as the Horn Gallery, after the antler collection amassed by the first two Stuart kings that it contained. Almost all the antlers at Hampton Court today fulfil the Jacobean hunting requirement for a head of at least ten tines (or projecting points) and several have many more demonstrating the quality of the Hampton Court deer. The carved wooden heads further emphasise the symbolic importance of the stag and his antlers to the Jacobean court. Particularly significant is the presence of oak-leaf collars on about half of the Hampton Court carved heads. These are linked with an ancient French hunting legend that so enchanted James that he captured and collared a live stag in 1611 before releasing him.[85]

Chapter 8

THE LORD PROTECTOR'S COUNTRY HOUSE
1640–1660

WHILE THE TWENTY-YEAR PERIOD between 1640 and 1660 is one of the most colourful in the long history of Hampton Court, it is the palest architecturally. For a brief period the house was again at the centre of power and politics. Its geographical location and its status as the great stately home of the monarchy were to make it a focus for many of the extraordinary events of the Civil War and Commonwealth. But the preoccupations of the conflict were not of a sort to be conducive to the embellishment or repair of Hampton Court. For two decades building and maintenance levels were at their lowest for the whole of the seventeenth century.

The summer of 1640 was one of mixed fortune for Charles. The birth of a son to the queen in July helped to offset the disappointment caused by the failure of the Short Parliament earlier that year and the impending renewal of war with the Scottish Covenanters. In celebration of the birth, the king went on a ten-day hunting trip that took him to the New Forest, Oatlands and Hampton Court.[1] Soon after that Charles set off for York at the head of the army to meet the Scots, who had invaded and were occupying much of the north. His trip was not a success and led to a disadvantageous truce being signed at Ripon. On his return to London in November, desperate for cash, Charles summoned the fateful Long Parliament, with the result that he became deeply embroiled in business. Neither that winter nor the following spring did the king move westwards to Hampton Court; there was too much else on his mind. In September 1641 Charles resolved to go to Edinburgh to open the Scottish Parliament, leaving the queen at Oatlands.[2] Henrietta Maria, already the focus of anti-Catholic sentiment, had a hard time there arguing with Parliament over the education of Prince Charles, and faced enormous hostility from the local populace. In the end she decided to move to Hampton Court, where she could be closer to her children (who were at Richmond) and where she would be safer from the ill-wishers at large in Oatlands Park.[3] In preparation for her arrival the queen ordered that her bedchamber be reconfigured. The work involved dismantling a partition and re-erecting it at the other end of the room; enclosing a room and a passage adjoining the bedchamber; and removing a stone door and replacing it with a chimney. Later a rich suite of verdure tapestry hangings was moved to Hampton Court from the Tower to adorn the completed room. Although the precise effect of these alterations cannot be known, the motivation for them is clear. The king was away and the queen as regent was forced to deal with Parliamentary representatives herself. Her bedchamber, the room for the most intimate consultations, had to take on a new character as a backdrop for the role she had to play.[4]

During the king's absence Parliament began to draw up the Grand Remonstrance, recalling everything the king had done that had given offence to his subjects, and by the time Charles left Edinburgh for London on 18 November his presence in the capital was imperative. The king moved south to Hampton Court, via Theobalds where he was reunited with the queen, and made his entry into London on 25 November. His reception was warm, and the Royalist lord mayor banqueted him. But this welcome was deceptive, and it was quite clear to the king and queen that Whitehall was not only dangerous but infested with spies. The royal family therefore moved, almost immediately, to Hampton Court where, it was announced, they would spend Christmas. This news was greeted with despair; the king, despite and indeed because of the festering discontent that filled the metropolis, had to be at Whitehall. A delegation of twenty Londoners, seven of whom were aldermen, arrived at Hampton Court to beg Charles to return; he could not refuse and moved back to Whitehall, where he spent an exceptionally cold and difficult winter.[5] The culmination of Charles's winter of discontent was the attempted arrest of the five Members of Parliament on 3 January. This event led directly to the king's decision to leave Westminster. If Whitehall had been an insecure base in November, after the attempted arrest it was unthinkable that the king and queen should stay in such an exposed location. On the night of 10 January the royal family fled from Whitehall and made for Hampton Court. As with Louis XVI's flight to Varennes a century later a decisive moment had been reached.

Hampton Court was quite unprepared to receive the royal family; it was probably cold and only partially furnished when Charles entered his Privy Lodgings that night. But the king's main concern was not comfort but safety, and Colonel Ludford, who had accompanied the king from London, took several hundred armed men from Hampton Court to Kingston to secure an arsenal

108 Anonymous painting of Hampton Court from the south bank of the Thames showing the approach of the royal barge, possibly containing Charles I and his sons. Painted in about 1640, the topography is not entirely reliable, but it is very interesting that the royal barge and family should be recorded at the palace late in Charles's reign. Note the coach being ferried across the river.

there and raise recruits. Despite this it was clear that Hampton Court was indefensible, and preparations were undertaken at lightning speed for the king and queen to move to Windsor. It was noted that 'things are done in such post-haste that I have never heard of the like for the voyage of persons of so great dignity'. Two days later, secure at the castle, it was decided that the queen and their eldest daughter, Mary, who, aged nine, had just married the twelve-year-old Prince of Orange, should go immediately to Holland to raise funds and armaments for an army. Thus from Windsor they moved to Greenwich, and finally to Dover via Canterbury and Rochester. From there, on 23 February, Charles saw the queen off. She was next to return to Hampton Court twenty years later as a dowager in the reign of her eldest son.[6]

For five years Hampton Court was left empty in the care of the Housekeeper, William Smithsby. Smithsby had been a Groom of the King's Privy Chamber, and had been appointed Keeper of the Wardrobe and Privy Lodgings at Hampton Court in 1634, succeeding John Whynyard. In 1641 he bought the Housekeepership from the Marquis of Hamilton to hold for their joint lives. However, Charles granted it to Smithsby in his sole name the following year. In August 1642 Smithsby was with Charles at Nottingham where the royal standard was raised, and in October he fought at the king's side at the battle of Edgehill. Charles needed Smithsby's services more as housekeeper than as a soldier and ordered him to return to take care of Hampton Court. There, as his bills demonstrate, he was meticulous in safeguarding the royal treasures. Tapestries were sent away for repair and cleaning; furnishings were sent to and received from other palaces; the chimneys in the Privy Lodgings were swept; sheets were washed; a Tudor throne canopy repaired; and 13s 4d was spent twice each year on 'brushes and wipers' for cleaning the king's paintings.[7] Up until this time Hampton Court and the other royal houses were in royal care, but the events of 1643 brought about sweeping changes in their status. First, in July, a case of delinquency was opened against the Surveyor of the King's Works, Inigo Jones, a staunch Royalist and ally of Charles I. This led to his being deprived of his post in favour of Edward Carter, Jones's executive officer at St Paul's cathedral. Then in September Parliament passed an ordinance for the seizure of the king's property, including all his houses. The ordinance gave Parliament power to appoint its own officers to administer the king's estate, and allowed Carter to assume officially the duties of Surveyor.

Carter's surveyorship was undistinguished. Expenditure on the royal houses was low, averaging less than £160 a year at Hampton Court, apart from in 1647–8 when works were undertaken for the accommodation of the king's children.[8] The only work of note was the defacing of the royal chapels: the hated chapel at Somerset House was first to suffer, then those at Windsor and Eton, and in the summer both the chapels at St James's. In the early part of 1644 attention turned to the chapels at Whitehall and eventually in March orders were given for the destruction of superstitious pictures and monuments in the chapels at all the king's houses. In 1637–8 Charles had installed a new choir organ at Hampton Court, similar to those already installed at Whitehall and Greenwich. It was made by John Burward, who also altered the sound-board of the great organ. The cases of both were richly carved and painted and gilded by Edward Norgate. This had been Charles's one contribution to the further beautification of the Hampton Court chapel.[9] In 1645 a Parliamentary tract tells us that on 29 September

> Sir Robert Harlow gave order ... for the pulling down and demolishing of the Popish and superstitious pictures at Hampton Court, where this day the Altar was taken down, and the table brought into the body of the Church, the Rails pulled down, and the steps levelled; and the Popish pictures, and

superstitious Images that were in the Glasse Windows, were also demolished, and Order was given for the new glazing them, with plain glass; And among the rest, there was pulled down the picture of Christ nailed to the cross which was placed right over the Altar, and the pictures of Mary Magdalene and others weeping by the foot of the cross: and some other such Idolatrous pictures.

The new organ was not spared, and in a matter of days the sumptuous Tudor and Stuart chapel had been reduced to a white-painted preaching box over which hovered the Tudor ceiling.[10]

The King's Imprisonment at Hampton Court

In July 1645, after the king's escape from Oxford, his possessions that had remained there were sent to Hampton Court to the care of Smithsby. With them came the remainder of the king's Household, a mixture of domestic servants and hangers-on. Smithsby petitioned Parliament to order them to leave because they were a 'great burden and danger' to the palace, and this Parliament agreed to do.[11] Meanwhile the Duke of York joined his brother, the Duke of Gloucester, and the Princess Elizabeth in captivity at St James's. The princes Rupert and Maurice were banished. The Prince of Wales had, however, escaped by way of the Isles of Scilly, and Jersey, to France where he eventually joined his mother. Charles himself had surrendered to the Scots who took him north to Newcastle before an accommodation could be reached with Parliament. The deal struck in January 1647 allowed for the king to be moved south again, under close guard; first to Holdenby House in Northamptonshire, then on to Royston and Hatfield, and finally to Hampton Court, where he was received by Smithsby. Hampton Court was to be his resting-place from 24 August for about eleven weeks. In many ways it was an ideal location. Close both to Parliament and to the army's headquarters in Putney, the palace was large enough for the king, his attendants and guards. Unlike Richmond or Windsor, it was still luxurious and magnificent and enabled the king to preserve his dignity and his habits. What is usually described as Charles's imprisonment was, in reality, barely house arrest. Not only did the king have free movement about the palace and parks but he was allowed to retain his own attendants, many of whom had been voted delinquents by Parliament. Charles maintained a court in miniature which operated with all the decorum and ceremony of his court in the past, maintained by Parliament's official sanction.

The house was specially refurnished for his arrival and plate was issued from the Jewel House at the Tower for his table. It also seems very likely that Charles requested paintings of his family to be sent from Whitehall. We have seen in the previous chapter that there was a small group of family portraits by Van Dyck recorded at the end of the Parliamentary inventory. These were probably brought down from London with the help of Algernon Percy, Earl of Northumberland, the guardian and gaoler of the royal children, who had free access to the royal houses and who had, in happier times, shared the king's artistic interests. The *Five Eldest Children of Charles I* that had hung in the King's Breakfast Room and the half-length portrait of *Henrietta Maria* from his bedchamber were chosen, as was a copy of the *Greate Peece*, and *Charles I on Horseback*.[12] These were understandable choices given the king's predicament and the absence of his family. In fact, his family, and particularly the children, seem to have been one of his principal concerns. Charles successfully petitioned Parliament for visiting rights and between June and November 1647 his children came twice or even three times a week to Hampton Court, where they talked, hunted and played tennis with their father. It was during one of these visits that the Earl of Northumberland persuaded Charles and his son James to sit for a double portrait by Peter Lely, newly arrived in England (fig. 109).[13] In October Charles asked that they should be allowed to stay overnight at Hampton Court at least once every ten days – a request that was granted. The Office of Works was instructed to repair the palace for 'the king's children' in 1647–8, and Elizabeth came to stay in a bedroom off the Privy Gallery. At her request the king's guards were moved further off at night because she claimed that their noise kept her awake.[14]

Charles's stay at Hampton Court was a happier one than it might have been in such circumstances. It seems as if the army let him use the Prayer Book and have his own chaplains, and he probably even used the much simplified chapel.[15] Clarendon states that 'the citizens of London rode out frequently to Hampton as they had been accustomed to do at the end of a progress'. Lords, ladies, generals and aldermen alike came to the house to pay their respects to the king. Visitors such as John Evelyn and Sir Richard Fanshawe recorded their admittance to kiss his hand.[16] Also came the Parliamentary generals including Oliver Cromwell and Henry Ireton, with whom the king discussed the so-called Heads of Proposals, the draft agreement that was being touted by them as the best constitutional settlement on offer. In reality Charles was playing for time, hoping that the Scots could raise an army and come south and rescue him – a forlorn hope, since the Parliamentary army was becoming more extreme and divided and Parliament less in control. On 9 or 10 November Cromwell wrote to Colonel Edward Whalley, Charles's supervisor, warning him that the army might try to assassinate the king. Whalley showed the letter to Charles. On the night of the 11th, under cover of darkness, the king escaped. The escape had been crafted in the preceding days by Sir John Berkeley and John Ashburnham, who had both been active in mediating between the king and Cromwell and Ireton, and by a Gentleman of the Bedchamber, Sir William Legge. They had met together on a number of occasions to make the necessary arrangements and had joined the king in his long gallery to outline the plan.[17]

Each Monday and Thursday the king wrote letters in his bedchamber until about five or six in the evening, at which time he went to prayers and then finally on to supper. The king's supper was usually brief, and when he retired to bed Colonel Whalley would set guards around his bedchamber for the night. On the night of his escape the king retired to write letters as usual, and the colonel arrived at his bedchamber door at five o'clock to accompany the king to chapel. He was told that Charles was still at his desk, and he was happy to return at six. When, on his return, he found that the king had still not emerged concern began to mount. At seven o'clock the colonel demanded that the king's servants let him look through the keyhole and knock loudly on the door in case the king was ill. Finally at eight o'clock the colonel's patience snapped. He demanded that Smithsby let him in to see for himself. Since the door was bolted from the inside Smithsby was forced to take the colonel out into the gardens and to the Privy Stairs. From here Smithsby and the colonel were able to

109 Peter Lely, *Charles with James, Duke of York*. The first important, securely dated work by Lely in England was this double portrait of 1647 described by the Cavalier poet Richard Lovelace as 'that excellent picture of his Majesty and the Duke of Yorke, drawne . . . at Hampton Court'.

pass through the Privy Lodgings in reverse until they came to the King's Dressing Room where they saw his cloak lying on the floor. At this point the nerves of both Colonel Whalley and the king's servants failed them. To enter the King's Bedchamber without invitation was a serious matter, but the colonel persuaded them that the king's silence was serious enough. On entering the bedchamber from the Privy Lodgings, and searching both it and the King's Closet, the king's guardians knew that he had gone.

Charles had almost certainly left his Privy Lodgings the way that Whalley and Smithsby had entered them. Accompanied by a Groom of the Bedchamber he had probably reached the waterside, where a boat was waiting for him, and crossed the Thames to a waiting horse. Charles had almost five hours' head start of the Parliamentary troops that were sent out at the dead of night in pursuit. He arrived safely on the Isle of Wight on Sunday, 14 November. Meanwhile Cromwell, who was lodging at the army headquarters in Putney, was informed of the king's flight and hastened to Hampton Court to hear for himself what had happened. At midnight he wrote to the speaker of the House enclosing three letters that had been found on the king's writing table and briefly stating the facts of the matter. It has been suggested that Cromwell may have had a hand in the affair, since the king's escape enabled Cromwell to re-unite the rapidly disintegrating army. Both Whalley and the governor of the Isle of Wight, Robert Hammond, were his cousins, and it was a letter from Cromwell that triggered the king's flight. Whether this was the case or not, escape from the house cannot have been hard since both its architecture and royal etiquette were designed to lubricate clandestine

110 *The Kings Escape from Hampton Court 11 Nov. 1641*[sic]. One of a series of eighteenth-century prints recording the fall of Charles I in 1647.

movements. As Charles's boat pushed off from the Water Gallery that night, he left Hampton Court for the last time. It would be twelve years before the next Stuart would enter its gates.[18]

Hampton Court Abandoned and Sold

Amidst the chaos surrounding the discovery of the king's escape, Smithsby's wife removed from the King's Closet a group of jewels and miniatures, which she and her husband hid. They would eventually be presented to Charles II by the Smithsbys in 1660. Astonishingly, one of the three letters found on the king's escape, addressed to Colonel Whalley, was almost solely concerned with his works of art. In it he requested that four paintings in his possession, which were not his own, should be returned to their owners. These were Henrietta Maria's portrait in blue (there is a copy now in Denver of the lost original), which was to be sent to Anne Killigrew, Mrs Kirke, dresser to the queen; a copy of a portrait of Princess Mary, the Princess Royal, by Jan van Belcamp, which was to be sent to the Countess of Anglesey, Buckingham's sister; Lady Stanhope's picture was to be sent to Carew Raleigh in Holland; and a second portrait of Princess Mary to be sent to Lady d'Aubigny, the widow of Lord George Stuart who was killed at Edgehill in 1642.[19] This concern for his collections and possessions continued while he was in captivity at Carisbrooke. In November 1647 the King's Privy Lodgings at Hampton Court were opened in the presence of several MPs, and items requested by Charles were removed and sent to the Isle of Wight.[20] That

same month the king's remaining household at Hampton Court was dissolved and the house once more rested under the watchful care of William Smithsby.[21] The Civil War itself largely passed Hampton Court by. Only once was it nearly drawn into the conflict, when the Earl of Holland, the Duke of Buckingham and Buckingham's younger brother, Lord Francis Villiers, chose Kingston upon Thames as the focus of a rising, the ultimate aim of which was to relieve Colchester, under siege by General Fairfax. Parliamentary intelligence suggested that part of the plot might be to seize Oatlands, Hampton Court, Richmond and Nonsuch, and one Colonel Pretty was sent out to Hampton Court, where he rendezvoused with 600 cavalry in the hare warren. Pretty took control of Hampton Court and Kingston the following day and put the Hampton ferry under curfew, and established a night-time guard to prevent the Royalists crossing into Middlesex.[22]

Five months after the king's death it was decided to liquidate the assets of the former monarch, and on 4 July 1649 the 'Act for the sale of the goods and personal estate of the late King, Queen and Prince' passed through Parliament. A little under a fortnight later another Act made provision for selling royal lands and buildings, including a number of royal houses. The important houses in the Thames valley were exempted from the Bill including Whitehall, St James's, Somerset House, Greenwich, the Tower, Windsor Castle and Hampton Court. The motivation behind this act was principally financial. Not only did the king die heavily in debt but the Government itself was chronically short of cash, and it was realised that unless the former royal assets were disposed of officially they would soon be squandered and stolen by those who had care of them.[23] The matter of the sale of the royal houses and particularly of Hampton Court was surprisingly controversial. The palace was the subject of a brief survey in 1649 to ascertain the extent and value of the estate, but neither the Council of State nor Parliament itself had any clear idea at this stage what the former royal houses might be used for. Yet special mention was made of reserving the 'furnished rooms' at Hampton Court, and in both August 1649 and April 1650 the Council of State chose to convene there.[24]

In the meantime the question of how much land should be reserved with the house at Hampton Court was referred to the Committee of Obstructions. The conclusion of their deliberations was that the hare warren, at the very least, could be sold, and by November 1652 a buyer had been found. Unfortunately for Thomas Hammond, the former lieutenant-general of the Ordnance, when his offer of purchase was put to the vote in the House it was turned down. This was probably because a Bill was then in preparation that was designed to end the stalemate by selling Hampton Court and the other properties reserved in 1649 as complete estates. This Bill was defeated by a large margin (nineteen votes to thirty-four) and a committee was instructed to consider how the palaces could be mortgaged to raise ready cash instead. Attempts to raise money against the palaces came to nothing, and finally a Bill was passed in the last days of 1652 authorising the sale of Hampton Court and the other palaces. The final decision to sell led to a much fuller survey of Hampton Court being commissioned from the Surveyor-General for Land Sales, Sir William Webb. This was completed and laid before the House on 5 April 1653.[25]

The survey was not only a full and accurate land survey and valuation, it was also a detailed proposal showing how to realise the highest price for the property. The presumption was that the main building would be demolished except for the south-east wing containing the Great House of Ease and the rooms next to it. This part, together with a triangle of the Outer Court and the Pond Gardens, was to be turned into a separate mansion and gardens worth £20 a year. The demolished materials were estimated to fetch £7,777 13s 5d, and the rental value of the site was put at £36 a year. Most of the detached buildings, including the Thames Gallery, were also to be pulled down for their materials, and the land was to be sold. The only outbuildings to be kept were the bakehouse, scalding house and poultry house in the Outer Court, judged to be worth £11 a year. The houses for the Office of Works and the stables on the Green were to fare better: the lodging known later as the Toye Inn was worth £7 a year, the Surveyor of the Works's house was worth £6 a year, and the other houses used by the officers of the Works were worth £15 a year. The royal stables were to be kept and let for £26 a year, and the Elizabethan stable, known as the Great Barn, was worth £28 a year. The parks and other immediate lands were also valued. In all, the gross value of land and materials was estimated at £10,765 19s 9d, and the annual rental value at £120 4d.[26]

On 15 April, less than two weeks after the survey had been tabled, a resolution was passed exempting Hampton Court from sale until Parliament gave further order. This time Hampton Court had been singled out for special attention, almost certainly because of the extreme nature of the proposals for the sale of the site and its materials. That Hampton Court should be chosen for preservation is significant. It suggests that Parliament itself had fallen for the antiquarian myth so carefully fabricated and nurtured by the Stuarts. This certainly was the view of the Venetian ambassador, who wrote that Hampton Court had been chosen as 'a relic of departed greatness'.[27] Thus even within the Long Parliament there was a hard core of members who regarded the palace as part of the ancient heritage of England and did not wish to see it demolished. Instead it was suggested that the parks around Hampton Court should be let. Yet the financial pressures on the new regime were enormous, and the prospect of foregoing more than £10,000 in the cause of sentimentality was not to be borne. On 23 August Colonel West, the chairman of the Committee for Raising Monies, succeeded in persuading the Commons to lift the ban and Hampton Court was once again put on the market.[28]

As the Commissioners and Trustees for the former royal estate started their work again, the arguments surrounding the disposal of Hampton Court suddenly changed direction. On 20 September Sir Anthony Ashley Cooper tabled a resolution that Cromwell should be offered Hampton Court in exchange for New Hall in Essex. New Hall, a large country house of Henry VIII's, had been sold to Cromwell by Parliament for only 5 shillings, when its true value had been over £1,000. Cromwell moved quickly to disassociate himself from this proposal, but despite this a resolution was passed once again reserving Hampton Court with its Home Park and gardens from sale. This was a decisive moment marking the recognition that whoever was to be in charge would need a country seat, and that for this Hampton Court would be the natural choice. Whilst the house and its immediate surroundings were saved again for possible reuse, the sale of the lands was not blocked, and on 3 November Bushy Park was sold to a goldsmith, Edmund Blackwell, the Middle Park to Colonel Norton, and the title of the manor and honour to John Phelps.[29]

The Protectoral Palace

In December 1653 it was decreed that Oliver Cromwell, captain-general of the forces, should be 'The Lord Protector of the Commonwealth', effectively installing Cromwell as king. It was rapidly resolved by the new protector's council, and equally rapidly ratified by his first Parliament, that the former royal residences of St James's, Whitehall, Somerset House, Greenwich, York Manor, Windsor Castle and the manor and honour of Hampton Court should be put at his disposal for 'the maintenance of his state and dignity'.[30] At Hampton Court there was a problem. Although the sale of the Middle Park had not yet gone through, Bushy Park and the manor and honour were now in private ownership. In February 1654, therefore, three members of the Council of State, Walter Strickland, and the colonels Philip Jones and William Sydenham, were asked to come to terms with Edmund Blackwell and John Phelps. Blackwell had moved quickly to profit from his purchase, breaking up the parks and selling them off in small parcels to his friends and relations. Twenty-three acres of the new park were leased to a Mr Caswell of Hampton for £407 10s, a £53 profit; the meadows to his brother for £1,550 (a profit of £308) and old Bushy Park to a Mr Woolmer for £1,528 (a profit of £100). The hare warren was meanwhile sold to a Mr Inwood for £1,170. Since Blackwell had made considerable gains from the lands that he had already sold, he was not prepared to let the remainder be re-purchased by the State without similar profits. The Council was forced to accept this condition and on 10 March 1654 agreed to pay £6,210 19s for the lands, giving Blackwell a profit of £1,100. This was galling enough for the Government, but to add insult to injury those to whom Blackwell had sold also demanded their potential profits be recognised if their lands were to be repurchased. Blackwell's brother insisted on a profit of £450, Woolmer wanted £400, and Brice and Inwood £200 and £20 for expenses. Finally, in May 1654 Phelps sold back the manor and honour for £750.[31]

While Parliament struggled with the sale of the royal estates a similar and parallel process was underway with regard to the former royal furnishings.[32] A board of trustees was appointed in the summer of 1649 to oversee the sale of the goods, and in due course they were given lodgings in Somerset House to serve as their office and saleroom. Their task was to seek out and identify the king's moveable estate, inventory it and present the inventories to the Council of State. The Council then had fourteen days to reserve any goods it thought fit for the use of the State; the rest the trustees could sell at home or abroad for the best price. The trustees' work was slow, and they were ordered by Parliament to finish their work at Hampton Court by 25 September so that the Council could make its selection of reserved goods. The trustees were probably already at Hampton Court at that time, struggling with the mass of royal possessions they found. There is no record of the progress of their work, but their identity is known. Jan van Belcamp, who was the Keeper of the King's Pictures, was certainly there and was possibly the only person who was capable of identifying many of the easel paintings. He signed that part of the Hampton Court inventory. Anthony Mildmay was probably also present. He had been a Gentleman of the Bedchamber to Charles I, and despite accompanying his dead body to Windsor had not liked his royal master. He knew his way round the closets and backstairs of the palaces like few others. One other was probably present too: Ralph Grafton, a prosperous draper and upholsterer valued for his expertise in textiles. He was not officially a trustee but had been co-opted to help with the vast royal textile collections. On 5 October the trustees delivered their complete inventory to the Council of State, but deprived them of the chance to make a full choice because quite a number of items had already been carted to Somerset House, displayed and sold. On 28 November the committee convened to consider which goods would be reserved for the use of the Commonwealth and three weeks later issued instructions that nothing be removed from the house until they had completed their deliberations.[33]

In January 1650 the Council of State lifted the block on selling the Cloth of State at Hampton Court – a symbolic disposal of a redundant item – but at the same time other furnishings were of increasing interest. Following at least two meetings at Hampton Court, the Council requested that a large number of hangings should be set aside, and that the *Triumphs of Caesar* should not be sold without the bid being disclosed to the Council. Soon afterwards the *Triumphs* were sent away to be copied to enable a set of tapestries to be made; they were returned to Hampton Court in June 1659.[34] The whole process was further complicated by the indecision of the Council of State and the passing of another Act of Parliament in July 1651 that reserved an additional £10,000 worth of goods for the State. In 1653 the Council ordered an investigation into the activities of the trustees who claimed that their five-year labour had been obstructed by the Council itself. It is certainly true that Cromwell himself reportedly ordered more goods to be reserved for his own use. Ultimately the value of reserved items reached about £53,000, more than five times the original sum. Unfortunately the copy of the Hampton Court inventory seems to be a summary and is not nearly as full of detail as that of, for instance, Somerset House.

Throughout the protracted negotiations over the future of Hampton Court and its contents, William Smithsby and his son Thomas, the Under-Housekeeper, took care of the house, submitting bills to Parliament for its upkeep and for their wages. Smithsby was in an ambiguous position. He had been sequestered for delinquency in March 1648, but since he was related to Cromwell by marriage, had received sympathetic treatment. Yet Cromwell wished to replace him with someone whose loyalty was untainted by former royal connections. A transaction worth £500 seems to have transferred the Housekeepership from Smithsby to Major Hezekiah Haynes, the Deputy Major-General for East Anglia. Meanwhile Smithsby's Keepership of the Privy Lodgings and Wardrobe was revoked. The Smithsbys were dismissed in August 1654 and instructed to leave within a month. William Smithsby had stuck by Hampton Court through thick and thin and did not intend to move easily. Eight months later he was summoned before Council to explain why he had not yet left.[35] But eventually he did go and was replaced by a former officer of the Removing Wardrobe, one of the most successful contractors for the sale of the king's goods, Clement Kinnersley. He was appointed Wardrobe Keeper to the Protector, with his son John as assistant; they, in effect, took over day-to-day control of the palace.[36]

Just as there were changes in the personnel of the protectorial Wardrobe, so were there changes in the Office of Works. Two weeks before Cromwell took possession of Hampton Court Edward Carter's responsibility for State buildings was terminated and he was succeeded by the former sergeant plumber, John

Embree. Embree was a sharp operator and had not only bought a range of handsome goods at the royal furnishing sales but had also managed to acquire former royal land at Whitehall. On appointment as Surveyor to the Works he rapidly aggrandised his position further by claiming almost £12,000 worth of back-pay and unpaid bills. Much of this was, in due course, paid to him. Despite his talent for feathering his own nest, the royal palaces were not neglected, and during 1654 he succeeded in obtaining warrants for substantial sums to repair the former royal estate, including Hampton Court. This level of expenditure rapidly became a matter of concern to the Council of State, which resolved to relieve him of responsibility for repairs at the Protector's main residences of Whitehall and Hampton Court and of responsibility for the mews at Charing Cross. A committee was, in the mean time, to consider how these buildings should best be maintained, but whilst it deliberated a further £1,000 was delivered to Embree for pressing repairs at Whitehall and Hampton Court. In December 1654 Cromwell and his successors were granted Hampton Court and the core of the London houses in perpetuity, and it was resolved that the Protector himself would assume responsibility for the maintenance of Whitehall and Hampton Court out of his quarterly allowance of £12,000. This was a sensible solution for relieving the State of uncontrolled building costs and giving personal responsibility to Cromwell. Unfortunately it failed. The costs of maintaining the two palaces were far higher than anyone imagined. In 1656 Embree was paid £12,000 to cover urgent works and the following year almost £10,000. In 1657 it was finally agreed that Cromwell's allowance for household expenses would be doubled, on the condition that they should cover the costs of his residences, but the boost came too late because Cromwell died before it became effective.[37]

Orders were issued to prepare Hampton Court for Cromwell on 16 March 1654. Squatters had begun to occupy parts of the park and unauthorised people were lodging in the palace – they all had to be ejected. The task fell to Embree and Smithsby and the latter spent £70 13s 2d for his part in the preparations.[38] Accounts for Embree's surveyorship do not survive and so nothing is known of what he undertook before Cromwell's arrival on 15 April or for the five years following. It is known, however, that plate, textiles, paintings and all kinds of furnishing to the value of £35,497 16s 6d were provided from the king's goods for the adornment of Whitehall and Hampton Court.[39]

Oliver Cromwell at Hampton Court

The Protector settled on Whitehall as his principal residence. For him, as for the king before him, Whitehall was both a residence and a seat of government containing many of the offices of state necessary for the governance of the realm. Seventeenth-century rulers, like those of today, required more than a seat of power – they required a country retreat, and Cromwell decided to make Hampton Court his. The reasons for his choice were never made explicit. He could have chosen Greenwich or Windsor, but Hampton Court was still probably the most lavishly furnished and most beautiful of the royal residences. Cromwell spent most weekends at Hampton Court, uprooting his family, court and officials each Friday and moving as discreetly as possible in a heavily guarded barge or coach to the country. The same procedure was undertaken in reverse each Monday. The weekly trip to Hampton Court and back provided the opportunity for a number of assassination attempts, several of which were foiled by Cromwell's tactic of varying his route each weekend. It was perhaps for security reasons that the highway between the house and Hampton Wick was barricaded by a wooden fence.[40]

In November 1657 the marriage of Cromwell's two youngest daughters, Mary and Frances, took place. Frances married first, at Whitehall on 11 November. A week later her sister Mary married Thomas Belasyse, Lord Fauconberg at Hampton Court. It is likely that neither wedding was performed in a royal chapel. Under Cromwell the Hampton Court chapel had been stripped of all but its Tudor ceiling and contained, at the time of the 1659 inventory (see below), only a pulpit standing on a deal table and twelve long forms. In any case the 1653 Marriage and Registration Act had secularised the wedding ceremony, replacing an ordained priest with a justice of the peace. Mary and her lord were probably married publicly in one of the great State Rooms of the palace, although it was claimed that later that day they were married privately by a minister. The Hampton Court wedding was less lavish than the Whitehall event, but was none the less a magnificent occasion. In celebration Andrew Marvell, Cromwell's Latin secretary and unofficial poet laureate, composed *Two Songs at the Marriage of the Lord Fauconberg and the Lady Mary Cromwell*. These 'songs', in reality sub-masques, involved Cromwell and his family in speaking parts, with the Gentlemen of His Highness's Music accompanying the chorus. The similarities (and perhaps the slim differences) between this performance and the many royal masques that had been held in the Great Hall cannot have been lost to many of the participants, but may have been to Cromwell and his family who had never seen a royal masque performed.[41]

During the summer of 1658 Cromwell's second eldest and favourite daughter, Betty Claypole, wife of his Master of the Horse, John Claypole, fell ill at Hampton Court. Cromwell decided that the Council should meet in London on Tuesdays and at Hampton Court on Thursdays, giving him more time with his ailing daughter. On 6 August she died, and a few days later her body was transported down river amidst a flotilla of barges to Westminster. Cromwell was devastated and refused to leave Hampton Court or even attend the funeral; it was publicised that he had 'gout and other distempers contracted by the long sickness of my Lady Elizabeth'. For eleven days the business of government stagnated as the Protector mourned; he re-appeared in public only on 17 August.[42] That day he decided to ride in the park for an hour and was accosted by George Fox, the founder of the Society of Friends (the Quakers). Fox had set out from Kingston to lobby Cromwell on behalf of the Friends, and he wrote:

> I came at him as he was riding in ye head of his life guard and I saw and felt a waft of death go forth against him that he looked like a deade man . . . he bid me come to his house and so I went to Kingston and ye next day went up to Hampton Courte: and then he was very sick and Harvey told me (which was one of his men that waited upon him) that ye doctors was not willing I should come in to speak with him. So I passed away and never saw him more.[43]

Cromwell was an ill man, suffering certainly from gout, but also from stones and malaria. He was moved to Whitehall, where after a fatal relapse he died on 3 September.

Cromwell's death posed another threat to the survival of Hampton Court. Richard, Cromwell's son, left the palace and went to the Cockpit lodgings at Whitehall while Parliament deliberated what to do. Orders were given that special care should be taken at Hampton Court where there was a continuing danger of its contents being stolen, and the deer in the park killed. It was decided that Clement Kinnersley should be named officially as Housekeeper and that he should be given a Wardrobe Keeper, two porters and two gardeners to help him until the future of the house could be determined.[44] The fate of Hampton Court lay in the hands of a few, and ultimately in those of General George Monck, who was pondering the future governance of the country at St James's. Hampton Court had apparently no further use, and since the financial situation remained as desperate as ever it was resolved to sell it, with several other remaining royal properties, to pay the navy. But once again the palace seems to have had a champion, this time in the form of Colonel Edmund Ludlow. Ludlow claims to have argued in July 1659 that whoever was to rule the country would need a magnificent house, and that if Hampton Court were sold, the people would be forced to pay for the construction of a new residence. His arguments may have delayed a decision, but still a proposal was passed in October that the palace should be sold.[45] However, nothing happened before February 1660, when the excluded MPs were readmitted to the Long Parliament and promptly offered Monck £1,000 secured on the sale of Hampton Court. He refused the offer but took £20,000 from the Treasury instead. Nevertheless Monck was granted the custody of the manor and park for life, an office that was confirmed after the Restoration.[46]

That Hampton Court survived the Commonwealth relatively unscathed was undoubtedly owing to the interest that Cromwell took in it. His choice of Hampton Court as his country residence, bypassing Richmond and, notably, Greenwich, ensured its survival while the other two suffered fatal neglect. Hampton Court was clearly strategically convenient, and much safer than Greenwich, which was close to the city and vulnerable to attack by sea. It was also well served by a royal road and not far from the castle of Windsor. Yet there may have been genuine affection for the location itself, and the inventory taken on Cromwell's death suggests that he and his family were concerned with the appearance and comforts of the house. The inventory is particularly illuminating because its compilers, John Embree and a C. Denely (possibly a clerk), made a distinction between those goods belonging to the State (in other words former 'reserved' royal goods) and goods belonging personally to Cromwell. It shows that Cromwell in five short years amassed a considerable wardrobe of fine furnishings and works of art at Hampton Court.[47]

In the 'Rich Bedchamber', Cromwell's State Bedchamber, the trappings of the Stuart monarchy were still in place, but Cromwell slept in his own sheets and refurnished the room with fashionable new furniture. A pier table and pier glass flanked by torchères (or stands) stood between the windows, a combination that was subsequently to dominate the late Stuart interiors. Although the state bed was ex-royal, the Wardrobe contained two great new standing beds with lavish hangings, one hung with newly imported Indian silk. Another great bed was in the Prince of Wales's former bedchamber – this one was covered in embroidery and had been brought by Cromwell from Scotland. In the Great Hall was a large organ, and also a choir organ brought from Magdalen College, Oxford, valued together at about £300, the only items valued in the inventory. It is interesting to note that most of the seat furniture was bought by Cromwell, including a large number of chairs, some covered in gilt leather. Hampton Court was still, however, home to the cream of the royal tapestry collection: the *Esther* series hung in Cromwell's Presence Chamber, the *Old and New Law* in the Privy Chamber, the fabulous set of *Tobias* in the Withdrawing Room, and the *Triumphs of the Gods* in the State Bedroom. The set depicting the *Morians* hung in his supping room, and in his private bedchamber were tapestries of *Vulcan* and *Venus*. The Tudor Paradise Room was still maintained and richly hung, and in the Long Gallery remained the *Triumphs of Caesar*. No sculpture of note had appeared at Hampton Court in Charles I's inventory, but Cromwell reserved and repurchased royal sculpture and moved it there. As will be explained in chapter 12, he installed figures of *Arethusa*, *Cleopatra*, *Venus*, *Adonis* and *Apollo* in the gardens. Cromwell and his circle particularly admired classical works of art; the spectacular *Triumphs of the Gods* tapestries were cherished and, as we have seen, a tapestry series from the Mantegna *Triumphs* was contemplated.[48] Yet we should not suppose that Hampton Court was anything like as impressive during the Commonwealth as it had been in King Charles's time. Vast quantities of furniture had been removed and many of the rooms must have seemed very empty. This was certainly the view of young Lodewijck Hugens when he visited the house in May 1652. Like many before him he admired its size (he was told that there were 2,000 rooms) but thought it 'neither well built nor well furnished inside'; he noted that 'the furniture had all been removed, except for the tapestries which had been behind the good ones to protect them from the damp of the walls'. His guide told him that in the king's time better tapestries had been hung.[49]

Several of the protectoral officers occupied the same rooms as their royal predecessors. Cromwell's son-in-law John Claypole was assigned the same lodgings as Charles I's Master of the Horse, the Duke of Hamilton, had had. These were almost certainly the present 'Wolsey Rooms' on the south front. Claypole's children had as their nursery part of the Archbishop of Canterbury's former lodging, which possibly lay below. The Comptroller of Cromwell's Household, Colonel Philip Jones, was assigned the Lord Chamberlain's lodgings and his own kitchen, and the cofferer, John Maidstone, was granted the lodgings of the Captain of the Guard, the Earl of Holland's rooms. As at Whitehall, Cromwell converted many of the most important former royal rooms into state offices – a deliberate choice. The chapel vestry was converted into a servants' dining room; the king's oratory was set aside as a lodging for one of Cromwell's ministers (or court preachers), and the queen's made into a lodging for a Mrs Blowfield. Mr How, another minister, was lodged in the former rooms of Sir Francis Windebank, Charles I's Secretary of State.

The 1659 inventory also tells us much about the use of Hampton Court under Cromwell. The Protector took a clear decision not to use Charles I's State Rooms or Privy Lodgings himself, and they were left virtually empty as offices. The King's Dressing Room, empty of furniture, was set aside for the Commonwealth's Lord President, John Bradshaw, and the closet next door set up as a bedroom for a servant; Charles's bedchamber itself was left empty and its closet became the bedroom of another menial servant. Instead, Cromwell moved into the Queen's Lodgings and the east front Privy Lodgings. The inventory starts in the Queen's Guard

A Grt. Presence Chamber
B Privy Chamber
C Supping or Withdrawing Chamber
D Balcony Room
E Closet
F Rich Bed Chamber
G Study
H Bed Chamber
I Dressing Room
J Paradise Room

111 Conjectural first-floor plan of Oliver Cromwell's lodgings at Hampton Court in 1659, based on the inventory taken at his death. Drawing Daphne Ford.

Chamber on the north side of Cloister Green Court (fig. 111). This room was Cromwell's outer chamber, his 'Great Presence Chamber'; the next room, the queen's former presence chamber, was Cromwell's Privy Chamber; and the queen's old privy chamber became Cromwell's Supping or Withdrawing Chamber. Then came the Balcony Room, the queen's former withdrawing room which had a balcony looking out into the courtyard. This room contained a couch and elbow chairs and so was presumably the functional drawing room. Beyond this came a closet, and then the Queen's Great Bedchamber overlooking the course. This room was Cromwell's 'Rich Bedchamber' or State Bedchamber, presumably used on more formal occasions, and it led into the former Queen's Dressing Room, Cromwell's study, which contained a single elbow chair and a 'fine Counterfeit Ebbony Table'. Next door was Cromwell's Little Bedchamber, with his dressing room beyond.

It is very interesting that, in preference to the King's Lodgings, Cromwell adopted the more compact and homely Queen's Lodgings, which were closer in scale and layout to the rooms of a major courtier house such as John Webb's Wilton. We cannot be sure of how his sleeping arrangements related to those of his wife. The inventory does not suggest any discernible separate suite for her use, and we must assume that they lived together in a single set of rooms, another surprising departure from royal etiquette. Neither did Cromwell's suite contain any discernible Privy Lodgings other than the study, Little Bedchamber and dressing room. Most interestingly, a clear distinction is made between the 'Rich Bedchamber' – a public room with a great state bed – and Cromwell's own smaller bedchamber on the east front. This suggests that Cromwell may have used his bedchamber in the manner of Charles II in other words, that the Rich Bedchamber was a room for reception of visitors in a formalised setting in the French mode. As we have seen, it was this bedchamber that had been altered in 1641 by Charles I's French queen while she acted as regent. It was suggested above that this alteration was undertaken to facilitate the bedchamber's use in the reception of guests. Did Cromwell use the same room for the same purpose? Sadly no evidence has yet come to light to show how the room was used. Yet we do know that Cromwell preferred not to use Hampton Court for business. When Charles X of Sweden's ambassador Christer Bonde let Cromwell know that he 'should not be averse to visiting him at Hampton Court when he went out there' so that he 'might be able to use the opportunity to get upon more familiar terms with him' he was surprised to be issued with an invitation. Indeed he wrote to Charles X explaining that 'It has never before happened that a public minister has been able to visit him in the country.' Although this was not strictly correct (visits by at least two others are recorded), it was certainly very unusual. When he got there he found a very relaxed atmosphere. In his diary Bonde recorded that he 'heard music; walked in the park, killed a stag; then to bowling green and played bowls; then kissed the hand of Cromwell's wife, and his daughter's cheek; then drank a glass of Spanish wine, and returned to London'. These privileges were rarely granted and a Royalist observer reported that Cromwell was 'exceedingly intimate' with Bonde. The visit was thus atypical, but the description of one of Bonde's entourage, Johan Ekeblad, suggests that the presentation to Mrs Cromwell and her daughter may have been in a formalised setting.[50]

Another interesting sidelight is Cromwell's use of the chapel. The inventory lists its furnishings, which, as we have seen, consisted only of a pulpit and forms. There is no clue to whether the holyday closets were furnished or not. On Sundays Cromwell had prayers and preaching in the chapel, and on one occasion he may have wished he had not. In August 1655 James Thompson, the minister of Hampton, preached a sermon before Cromwell attacking him and his regime. But where Cromwell sat to hear the sermon is unclear. At Whitehall it seems that he used the royal pew in the manner of Charles I, so perhaps this was the arrangement at Hampton Court too.[51]

In all, the picture given of Hampton Court during the Commonwealth is not as bleak as the popular imagination might like to paint it. Apart from enjoying the organ in the Great Hall and hunting in the park Cromwell was clearly happy to play bowls on Charles I's green (the inventory of his goods includes benches, rollers and what was probably a scoreboard). His own rooms were magnificently furnished and were clearly used for state and family business. But Cromwell's use of the Queen's Apartments was more than a matter of avoiding dead men's shoes. The simpler Queen's Lodgings may have suited his form of etiquette better, and he may have preferred Henrietta Maria's bedroom too. Until more emerges about protocol at the protectorate court these questions remain unanswered, but it is sure that Cromwell's use of Hampton Court is important for the illumination of the inner workings of his regime.

Chapter 9

THE RESTORATION:
HAMPTON COURT ON THE SIDELINES 1660–1688

THE PROCLAMATION OF THE Restoration on 8 May 1660 was the signal for three weeks of frantic activity. The royal residences, barges, carriages and ships had to be prepared for Charles's arrival and rapidly purged of their associations with Cromwell. While in the East End of London carpenters and painters tore down or painted over the arms of the Commonwealth on the fleet, strenuous efforts were being made in Westminster to refurnish Whitehall for the king's reception. On 9 May the House of Lords resolved that 'A Committee might be appointed, to consider and receive information where any of the king's Goods, Jewels, or Pictures are; and to advise of some course how the same may be restored to His Majesty.'[1] This was the start of a process that saw the vast majority of the former royal collection remaining in England reassembled, first at Whitehall, and ultimately at Hampton Court. Clement Kinnersley received items back into the Royal Wardrobe and John Webb, better known as architect than interior decorator, refurnished the royal rooms at Whitehall with them. By the middle of 1661 over 1,000 paintings had been returned to their rightful places in royal houses.[2]

It must have been recognised by Webb, and others involved in preparations for the Restoration, that other than Whitehall only Hampton Court would be suitable for the reception of the king. Greenwich was still standing but had been wrecked internally; Richmond was partially demolished; and St James's and Windsor had been used as prisons and garrison headquarters. Somerset House was in better condition because it had lodged foreign guests, but it too had housed a garrison and needed considerable repairs. Ten days after his arrival at Whitehall on 29 May, Charles made the twenty-mile trip westwards to revisit Hampton Court, which he had last seen as a teenager fifteen years before. On his way he had a fall from his horse, but this did not deter him from playing a game of tennis before returning to Whitehall for dinner.[3] Soon after his visit Charles began rapidly to fill key posts there. The Duke of Albemarle was appointed Lieutenant, Keeper, Ranger and Steward of the house and its parks. William Smithsby, former Keeper of the Standing Wardrobe and Privy Lodgings, despite strong claims from others, was given back his old job but died the same year and was succeeded by Richard Marriott.[4] It was Marriott who showed Pepys round the Privy Lodgings in May 1662 a few days before the reception of Catherine of Braganza, and subsequently entertained him at his own lodging for a refreshing drink. His son James succeeded him in December 1664. The Marriotts' duties and rewards were very similar to Smithby's and included keeping the keys, cleaning paintings and medals; they received old royal furnishings as part of their fee. In 1672 for another fee Marriott gave up his lodgings to house a Dutch delegation.[5] In June 1660 Tobias Rustat was appointed as Under-Housekeeper. Rustat had served Charles I and had been a loyal servant to Charles II in exile. At the Restoration he also had become Yeoman of the Wardrobe which gave him considerable status, access to the king, and a number of residences including lodgings at the Tower, Windsor and Whitehall. In addition to his wages as Under-Housekeeper he was awarded a livery and a new bed every three years.[6] Simon Basill was appointed Clerk of Works at Hampton Court. He had been a clerk at Greenwich and Eltham and was the son of Simon Basill the Elder, a former Surveyor of the King's Works. When he died in 1663 Henry Cooper replaced him. Basill, Sir John Denham, the Surveyor of the Works, and his three colleagues, the Comptroller, Master Mason and Master Carpenter each had substantial lodgings at Hampton Court. Situated on Hampton Court Green, these underwent considerable improvement at the Restoration (fig. 112). Whilst the houses of the master craftsmen were repaired through structural necessity, the Surveyor's House was practically rebuilt in 1663 due to his wife's position at court. Margaret Brooke, Lady Denham, was beautiful, vivacious and just a third of her distinguished husband's age. She was also the Duke of York's mistress. To house her in comfort the Surveyor's residence became a small palace in its own right, with cellars, a balcony room, a marbled parlour, a landing stage, and a parterre in its riverside garden.[7]

While Charles filled the posts that were to mould Restoration Hampton Court the Royal Wardrobe was busy refurnishing it. A massive order for new furniture was placed in January 1661 to replace anything that remained from the previous regime. This included a new state bed hung with velvet and fringed with gold; thirty large window curtains; six velvet-covered chairs of state with twelve matching high stools and six matching footstools; three cloths of state with the king's arms; four close stools; twenty Turkey

129

112 Houses belonging to the Office of Works and the Royal Household on Hampton Court Green in 1783. This drawing was prepared in response to a plan to dispose of surplus property at Hampton Court. It is an office copy dated 1796.

carpets, ten Persian carpets and forty smaller carpets; six pairs of andirons with shovels and tongs (for the Privy and Presence Chambers); and six long forms upholstered with green cloth and gilt nails (for the Privy Chambers and Withdrawing Rooms). Additionally six suites of tapestries were prepared for the great outer rooms and twenty pallet beds ordered for the Gentlemen and Grooms of the Bedchamber. In the following months more was ordered, including sconces for the Privy Gallery and Privy Lodgings; and the 'carnation' bed suite (presented to Charles by the States of Holland) was brought from Whitehall.[8]

A New Tennis Court

Charles enjoyed his newly refurnished country house in a series of day trips in late 1660 and early 1661, during which his principal concern was playing tennis and planning the construction of a new tennis court.[9] During his exile he had spent many of his extended leisure hours in the tennis courts of Europe. Foremost amongst these was the court at Saint-Germain-en-Laye, the nursery house of the French royal family where Henrietta Maria had been brought up and where she held court in exile. Life at Saint-Germain was uneventful, and Charles and his brother, James, spent a good deal of time playing tennis. The court was the third that had been constructed there since the sixteenth century. Built in 1623–4 it sported a steeply pitched roof, deep eaves and external galleries to provide access to the windows. Charles's experience of the tennis court at Saint-Germain was to influence directly the construction of a new building at Hampton Court[10] on the site of his father's tennis court, on which Charles had played as a boy (fig. 116). The building was considerably more substantial and was closely based on the court at Saint-Germain as interpreted by the king's tennis marker (or umpire), Robert Long. Only three of its outer walls were new – its eastern wall, which was heavily buttressed to take the additional weight, was still the Tudor wall of 1537. The court was, like its French model, given panoramic clerestory windows on the east and west with external balconies to facilitate maintenance, and a vast new roof with deep eaves. Its interior still retains some features of Charles's time, including the long penthouse with its turned balusters, but much more is lost. The original floor was paved in tile inset with the play lines in black marble; the walls were plastered and painted black. A tambour and grill were erected, and the enormous casement windows were furnished with nets to prevent their being broken and curtain rods and black curtains to stop the glare of the sun.[11]

In addition to a survey of about 1718 by Thomas Fort (fig. 113), four views of the court show its original form: the Pepys view (fig. 57), the so-called Long View (fig. 59), the Schellinks view of 1662 (fig. 58), and a painting of about 1680 (fig. 114).[12] It was 130ft long by 45ft wide and had a play area measuring 32ft by 98ft. The width of the court was identical to that at Saint-Germain but the English version was slightly longer (Saint-Germain was 104ft long by 45ft wide and 54ft high). Its lower part was of brick, but the upper part (as at Saint-Germain) was almost entirely of timber, with ten windows. At the north end of the court was a new lodging for the Master of the Tennis Court, a post occupied by Thomas Cook from at least 1675 until his death in 1697.[13] From his lodging a first-floor gallery at the north end of the court could

113 Plan and cross section of the Tennis Court, c.1718, by Thomas Fort, Clerk of Works at Hampton Court 1715–45.

114 Anonymous painting of the east front of Hampton Court palace, c.1680. This is the only record of the king's new building 'Next Paradise' and the last view of the east front before its demolition in 1689. For whom it was painted and why are unknown.

be entered. This had a plaster 'compass ceiling' and was furnished with a 7ft-long bench covered with crimson velvet and studded with gilt nails, and a number of other velvet-covered stools and chairs. From here courtiers and the king himself could watch the game and lay bets on the outcome.[14] At the south end was another 'house' with a deeply gabled roof like that on the main court. Here the king had a dressing room, in which two cupboards were made to keep the rackets and balls. A gallery approached the whole complex with deep eaves built up against the Tudor wall on the east.[15] Less than a year after the court was finished Charles decided to build a new court at Whitehall and to use the court at Hampton Court as his model. In November 1662 Robert Long visited Hampton Court twice to take careful measurements of the court to inform the workmen at Whitehall.[16]

Preparations for Charles II's Honeymoon at Hampton Court

From the summer of 1661 the emphasis of work was redirected towards the interiors. This can be simply explained. In May the king's marriage to Catherine of Braganza was agreed and, other than Whitehall, the only residence fit to play a role in her reception was Hampton Court. The Office of Works thus began an overhaul of the interiors in preparation for the eventual reception of the king and queen. Most of the work was for the Queen's Lodgings where careful thought was given to re-hanging the rooms with tapestry; the Wardrobe was supplied with a large wooden horse 22ft long for the purpose of supporting the tapestry while it was cleaned. A Tudor mantelpiece was taken out of the Queen's Bedchamber and a new marble one worth £60 brought from Whitehall to replace it; the old window mullions were also removed and two large casements inserted with square panes rather than diamond ones. Soon after, the lodgings were entirely redecorated, Catherine's closet marbled in white paint and the new casements, lead cames and iron curtain pole in her bedchamber gilded.[17]

A setback was the bad weather of January 1662, when torrential rain and heavy winds not only prevented Catherine's sailing from Lisbon, but wrought havoc on the crumbling structure of Hampton Court. Chimneys over the King's Presence Chamber fell through the roof destroying the ceiling inside, others fell on to the Long Gallery and bakehouse; and stones from the gable end of the hall fell into Base Court.[18] Yet work pressed on and began to focus on reinstating the lost trappings of monarchy. New daises were made for the King's and Queen's Presence Chambers, each measuring 16ft by 10ft. The king's was 12in. high and the queen's a lesser 6in. Preparations were also made for the hanging of a throne canopy in the Balcony Room. The 'carveing aboute the queenes bedd' was mended and regilded and a dais was made for it measuring 16ft by 11ft. This was enlarged in May when a gilded rail was installed across it. It is possible that another balustrade, brought from Greenwich in August/September 1662, was intended for the King's Bedchamber. Rails covered in scarlet baize were also made for the King's and Queen's Presence Chambers, which were intended to divide the rooms for public dining. In the Queen's Presence Chamber staging was erected for her musicians to play on during dinner.[19]

Some of the most interesting work of 1662 took place in the chapel. The plain white preaching box created by Cromwell was rapidly transformed into a Chapel Royal. Boards were erected beneath the windows to hang tapestries from, and a timber platform for the altar measuring 20ft by 14ft was constructed with an altar rail 20ft long and 12ft wide. On the platform, on a step 8in. high, was placed a wooden altar measuring 8ft by 4ft. In the choir two forms were made for the singing boys with reading desks 8ft long and 5ft high. The pulpit was taken down and re-set lower.[20] A new organ loft was built with steps up to it, and part of Cromwell's organ casing from the Great Hall was reused to make its frontal, while a crimson taffeta curtain was bought to hang in front of the organist's seat. The royal pews or Privy Closets were refurbished. On the queen's side a large cupboard was removed, and desks were made for both her pew and the king's. The king's was provided with a chair, stool, benches and traverse curtain,[21] all of crimson velvet fringed with gold and silver. Large orders for lesser furnishings were placed including thirty hassocks, a bible and service book. In June 1662 after the king's and queen's arrival further small improvements were made to perfect the chapel: desks were adjusted, the sub-dean's pew raised, and a bible and service book beautifully bound in gilt-tooled leather was ordered, presumably for the king's use. Wear and tear on the chapel's benches meant that the seats were re-matted and additional prayer books and surplices were ordered.[22]

In addition to refurnishing the Chapel Royal, a private oratory was set up for the Roman Catholic Catherine of Braganza with a dais, two desks, a table, and an elbow chair, stools and benches covered with purple velvet fringed with gold and silver, with wall hangings to match. John Hingston was paid £150 for an organ and a harpsichord for the Chapel Royal, and an organ for the queen's chapel. Meanwhile the children of the Chapel were re-established under the tutelage of Captain Henry Cooke as Master. They returned to their pre-Civil War home in the old Tudor bowling alley where their lodging and classroom were refitted.[23] Charles thus reinstated the entire panoply of Anglican royal worship at Hampton Court and added to it the setting for the queen's Catholic devotions in her own chapel. It is noticeable that until this had been achieved Charles did not stay the night at Hampton Court, suggesting the high importance he attached to a proper setting for court worship.

In March 1662 work began on hanging pictures and mirrors, and ordering benches and stools, carpets, sconces, bed linen and fire furniture for the Queen's Lodgings. New mats were laid and the hearths of a dozen royal rooms were replaced in either black or white marble.[24] A room was prepared at the Queen's Backstairs for her Portuguese ladies and others were repaired and decorated before being assigned to courtiers. Amongst those awarded lodgings were the countess of Suffolk (First Lady of the Bedchamber to the Queen), the Duchess of Buckingham, Prince Rupert, the Earl of Lauderdale and of course the Duke and Duchess of York and the king's mistress, the Countess of Castlemaine. It is not clear where all these lodgings were. The Duke of York certainly utilised the Prince's Lodgings on the north side of Chapel Court, and the duchess must have been nearby because a timber shed was made near the old Tudor Tennis Court for her maids of honour to dine in.[25] Provision was also made for the king's Privy Council and for his guard. For the latter, two new barracks were constructed, both timber-framed and 25ft wide. One, for cavalry, was 70ft long, and was by the Tiltyard. The other, 59ft long, was for foot soldiers, by the Tennis Court. A view of 1669 shows what was probably the Tiltyard Barracks (fig. 80), but those by the Tennis Court survived only until July 1679 when they were dismantled without record.[26]

The fairly intensive work of 1660–62 aimed to recreate the infrastructure necessary to re-establish the court etiquette of Charles I's time. This included Charles II's desire to reintroduce the traditional domestic arrangements whereby the monarch fed and clothed his household at his own expense. As far as Hampton Court was concerned, this meant that the kitchens should be ready to feed the entire court twice a day in the great rooms of the house. For this reason, as much as for any other, the organ from the Great Hall was dismantled and sent back to Oxford and the organ loft dismantled. The hall was then whitewashed above the hangings and in November 1662 the open lantern in the roof was boarded over, presumably to keep out the cold.[27] Royal diets show that dining in the Hampton Court hall was re-established as it had been 150 years previously. This was incredibly ambitious given Charles's financial situation. Although the Restoration financial settlement had provided for the restoration of court diets, it (and Charles) had grossly underestimated the cost, and by the end of September 1661 there was a deficit of well over £50,000. But these financial concerns were pushed aside when the queen landed at Portsmouth on 13 May 1662.[28]

The Arrival of Catherine of Braganza

Eleven days later the Dutch painter and poet William Schellinks arrived in Kingston and made his way to Hampton Court to see the preparations for the reception of the queen. Access to the king's innermost lodgings seems to have been easily granted and there, in the bedchamber, Schellinks saw the great bed of green velvet hung with magnificently embroidered gold and silver borders, fringes and tassels, its posts surmounted by fine plumes. He also gained access to the Long Gallery where the great royal collection of Italian old masters had been reassembled. He was a regular visitor at the palace over the following days and saw tennis being played in the new court, examined the carriage in which the queen was to arrive and watched the delivery of the Duke of York's luggage on heavily laden wagons. Eventually came the luggage train of the queen and her entourage accompanied by a number of Portuguese ladies and gentlemen. They expected to find lodgings prepared for them, but were to be disappointed. The gentlemen ushers had not only assigned all the lodgings in the house and gardens long ago, but had requisitioned all the decent accommodation in the surrounding area. The disgruntled Portuguese were forced to move on to Kingston, where they had the utmost difficulty in finding a bed for the night.

A cordon had been placed around the house to prevent unauthorised persons having access before the king and queen arrived on 29 May. A great encampment of tents and wagons sprang up, some full of undelivered luggage, others belonging to stall-holders and costermongers selling souvenirs, snacks and other goods for the crowds that were assembling. An air of chaos reigned – in one tent lay the body of one of the king's choristers who had been run over and killed by a cart; in another was one of the king's cooks who had drowned while swimming in the Thames. John Evelyn was one of those who managed to get a ringside view of the royal arrival. He had travelled down to Hampton Court on the 25th where his friend, the king's Vice-Chamberlain, Sir George Carteret, had offered to put him and his wife up. Evelyn was able to visit the queen's newly decorated bedchamber and examine her bed, a gift from the States of Holland. It was hung with crimson velvet hangings embroidered with silver. Some of the furniture in the Queen's Apartments was the queen's own and Evelyn especially noted the 'Indian cabinets' and lacquer trunks, novelties in England.[29]

The 29th had been chosen for the queen's arrival, since it was the day on which Charles celebrated both his birthday and his restoration to the throne. Early that morning the Duke of York arrived at the waterside by barge and was immediately joined by the great nobility in the newly refurbished chapel where a long and tedious sermon was preached on King David and the exile and restoration of Charles.[30] Meanwhile, outside, huge crowds gathered awaiting the arrival of the queen. The king and queen had left Portsmouth on the 27th and after a night at Windsor, where they prepared themselves, they set off in the late afternoon for Hampton Court. A contemporary print shows the vast carriage procession, with Charles and his new bride at the centre, arriving at the house (fig. 115). In reality, as the procession did not arrive until about nine o'clock at night, the assembled crowds saw little. The royal carriage drove through the outer court in a cloud of dust between massed ranks of guards. The king and queen alighted in the inner court with the Duke of York at their side. From here the queen processed to her bedchamber, passing through her lodgings, where in each of her chambers were stationed, according to rank, all the nobility of England. Finally an exhausted Catherine retired to her bedchamber to rest.

The following morning the queen resumed her round of introductions, receiving the Duchess of Ormond, Lady Cavendish and Lady Fanshaw immediately after her levee in the presence of the king. Then came the formal reception of the king's Privy Council and the great officers of the realm and Household. The Lord Chamberlain had gathered them together in the Council Chamber whence they processed to the Queen's Privy Chamber to be received by Catherine. Later came a delegation of lords introduced by the Lord Chancellor, followed by the Speaker of the House of Commons. That afternoon the king and queen dined in public behind the crimson-covered rail in the King's Presence Chamber. The room was packed and the summer heat made the occasion intolerable. Eventually the flustered queen withdrew to dine in private, her make-up running down her face. In the evening the king and Prince Rupert led the dignitaries to the bowling alley, whilst the Duke of York took his leave and returned to Whitehall. Over the following days the queen received other delegations, including the Lord Mayor and Aldermen of the city who presented her with a bag of gold.[31]

On 1 August Henrietta Maria came to Hampton Court from Greenwich and dined with the king and queen, and the Duke and Duchess of York. Sadly there is no record of her emotions as she returned to her former country home after fifteen years. She arrived by carriage and alighted in the inner court where she was met by the king. He took her by the hand and presented her to the queen who was waiting at the top of the stairs to her lodgings. A week or so later the queen was received by Henrietta Maria at the Queen's House at Greenwich, her first state visit.[32] Catherine could not end her residence at Hampton Court until the preparations for her reception in Westminster were complete, which they were towards the end of August, and the 23rd was appointed for her entry. In readiness for the ceremonies at the waterside the old Tudor Water Gallery had been modernised and redecorated. A gilded wrought-iron balcony 10ft wide and 5ft deep had been inserted in the window above the landing stage, and the great room that opened on to it was refurbished.[33] The river-banks round about were crowded with soldiers and spectators as the king and queen, the Duke and Duchess of York, Prince Rupert, his brother Prince Edward, and the Countess of Suffolk, and hundreds of Household officials and courtiers, embarked for Whitehall.

115 *The Comming of y͑ King's Ma^tie and y͑ Queenes from Portsmouth to Hampton court.* One of a series of six prints by Dirk Stoop illustrating the passage of Catherine of Braganza from Lisbon to London, 1662.

Household Reforms and their Effects

The financial crisis facing Charles's Household was not only temporarily forgotten during the reception of the queen, it was thrown into a new and more desperate phase. The queen and her Household brought further expenditure and even greater commitments. It was clear that something had to be done and on 1 December 1662 it was. A new Household establishment was issued that reduced the number of the king's servants below stairs who received diets, and ensured that all the senior members of the queen's establishment were provided for. This reduced costs (to a degree) and it was made clear that henceforth only the senior members of the king's and queen's households would be fed at royal expense. Yet the new establishment failed to attack the core of Charles's financial problem, which was chronic overstaffing, and so a further set of reforms was pushed through on 1 October 1664. This had a drastic effect on the Household, amalgamating a whole series of offices and reducing staff from 225 to 147.[34] The counting house and spicery were merged, as were the pantry and ewry, cellar and buttery, pitcher house and almnery, poultry and scalding house and woodyard and scullery. The boiling house and accatry were abolished, and the staffs of the bakehouse, chandry, larder and pastry were substantially reduced. Meanwhile, the Queen's Household servants were amalgamated with those of the king, meaning that the queen no longer had a separate kitchen establishment.[35]

Since each of the Household offices were assigned both a work house and lodgings above, these economies had a major impact on the usage of space at Hampton Court. But because there were no immediate redundancies and the various offices were only slowly vacated, their rooms only gradually fell vacant. As they did, throughout the late 1660s, '70s and '80s, the whole of the north side of Hampton Court gradually changed its character. Many of the former offices were converted into smaller kitchens for courtiers such as the Duke of Buckingham, Lord Newport, and the Earl of Manchester. In December 1670 orders were given for the Great Kitchen itself to be partitioned to form a kitchen for the Duchess of Cleveland (the former Countess of Castlemaine).[36] Other offices were converted into lodgings, such as the spicery, which was granted to Sir Stephen Fox, and others still into new types of working house. The boiling house, for instance, was converted into the Lord Chamberlain's laundry. Possibly as a result of abandoning the hall for dining, the louvre in the Great Hall was removed and the roof leaded over in September 1663.[37]

The effects of the Household reforms stretched wider than the confines of the palace walls. In May 1662 the bailiffs and freemen of Kingston upon Thames, seeing the vast scale of entertainment at Hampton Court, and believing that it would continue, petitioned the king for a second weekly market to improve supply to court. One of Charles's early preoccupations had been to secure the loyalty and support of local town government, the boroughs and corporations. Kingston seems to have been regarded as loyal and supportive of royal power, as well it might standing, to gain so much by its proximity to Hampton Court. It could even be argued that a special relationship existed between Kingston and Hampton Court, since from the 1630s the palace Wardrobe Keeper had been authorised to lend Kingston tapestry for their courthouse during the yearly assizes — a tradition that continued into the Restoration. The bell-ringers of Kingston who had not rung their bells for a royal passage since 1640 (but did so for the proclamation of the Protector) rang heartily for the Restoration and resumed their regular ringing for the king and queen as they passed by.[38] Perhaps as an acknowledgement of the loyalty of the bailiffs and freemen of Kingston, Charles acceded to their request, granting them a Wednesday market in 1662.[39] The 'Tory reaction' of the final years of Charles's reign saw new charters being granted to most of the borough corporations of England. Loyal or canny boroughs had the foresight to make voluntary surrenders to the Crown in the knowledge that delay would only result in legal proceedings which would force them to do so anyway. Since the Government was using the new charters to extend its powers, it made sense for corporations to cooperate in the hope that their new charter would not unduly restrict their privileges. Kingston was in the vanguard of this, making two such surrenders in 1685, one in January and the other in June. The bailiffs of Kingston went to Whitehall to discuss details of the first surrender with the Lord Chamberlain, Henry Bennet, Earl of Arlington, who had been made High Steward of Kingston in 1683. A great dinner was thrown to celebrate the delivery of the charter at which Lord Hunsdon and the gentry of the county were present. The surrender, although sealed by the bailiffs and freemen, was never enrolled because Charles's death intervened and James II restored Kingston's previous rights following the second surrender.[40]

But however much Kingston curried royal favour, it was in fact to be grievously disappointed, since not only were the needs of the court enormously scaled down by household reforms, but Hampton Court was not as favoured by Charles II as it had been by his father and grandfather.[41] One example of the hardship this caused was the case of Andrew Snape, whose petition of December 1672 was accepted. He had been granted a sole licence for supplying wine at Hampton Court at a rent of £50 a year, but due to the reduction in court diets and infrequent visits had sold very little and had fallen £87 10s into arrears. He received a rent rebate and a new licence on much reduced terms.[42] But the impact of the Restoration court on the locality was not only negative: in 1677 Charles contributed £350 towards the rebuilding of the tower and steeple of the parish church of Hampton-on-Thames. This was in recognition of the fact that many of his servants, including James Marriott, were parishioners. While the work was underway Charles granted the congregation use of Hampton Court's Chapel Royal.[43]

The Great Plague

By fortune the Restoration of 1660 had not been accompanied by outbreaks of plague such as the catastrophic episodes of 1603 and 1626. In fact, Europe was, as a whole, free of the disease in the Restoration year. But in 1661 a severe outbreak occurred in Turkey and from there the plague probably came to the Low Countries in 1663–4. In London the Privy Council responded by controlling the entry of ships from Amsterdam into the port of London and was successful at keeping the infection at bay. But this was only a stay of execution, for by the spring of 1665 there were ominous signs that the deadly bacteria was at work and by mid-June there were more than a hundred deaths a week in the City. This was enough to prompt those who had money or sense to act and it was reported on 13 June that most of the gentry and

aristocracy had left and that the court was preparing to do likewise. Despite this no particular alarm was felt and the Privy Council confined its efforts to isolating the worst-affected parishes by posting wardens at the boundaries to prevent the unnecessary passage of people. As the month progressed it was clear that this was not working and on 29 June deaths close to Whitehall caused a general remove of the court in 148 carriages, which travelled first to Syon and then on to Hampton Court.[44] The court arrived on 9 July and was joined by the king who had been in the south. In preparation the Office of Works had made extensive repairs, especially in the lodgings of courtiers and Household officials, where the mat-layers and glaziers were kept very busy. Orders had been given to restrict access to Hampton Court and only those with certificates guaranteeing that they had not come from an affected area were permitted to come near.[45] Pepys made a number of visits to the court and Council during their stay and on Sunday the 23rd he followed the king to chapel. Because no one invited him to dinner afterwards he went to James Marriott's, where other lesser court figures, including the painter Peter Lely, were dining. Afterwards he attended a Council meeting, leaving late in the evening.

As in 1625, Hampton-on-Thames and the surrounding villages soon became infected; at the end of July one of the king's guard died and the French ambassador passed a dead man lying on a nearby road. It was decided to remove to Salisbury but, as we learn from a French observer, 'there is again great bustle and precipitation, and great difficulties in providing carts and coaches. Cartmen want forty francs each for seven leauges.' Nevertheless, the court and the French embassy left Hampton Court for the west, where they arrived in early August.[46] The plague reached its peak in October with 4,327 recorded deaths, but thereafter the infection declined until Christmas. Unlike previous outbreaks it did not, however, disappear and in the spring of 1666 there was a resurgence. Under these circumstances it was impossible for the court to go back to London, and after spending Christmas at Oxford the king returned to Hampton Court on 27 January. By this time his presence in London was imperative and with the plague abating he returned in early February to Whitehall where he received the Lord Mayor to express his gratitude for his efforts on behalf of the City. Hampton Court played a minor role in the next catastrophe to engulf London, the Great Fire. In 1666 the palace was used to evacuate works of art and furniture from Whitehall when it was thought that the fire might reach Westminster.[47]

New Lodgings

Apart from Charles and Catherine's honeymoon in 1662 the first decade of the Restoration was a quiet period for Hampton Court. The king did not visit at all in 1663 and 1667 and only once in 1668 and 1669.[48] In 1670 the palace entered a new phase with the start of work on two major construction projects worth over £6,000, one for the king and the other for the Duke and Duchess of York (fig. 116). That these projects should have been embarked on at this time might seem difficult to explain in the light of royal indifference to the house during the 1660s, but it is likely that Charles intended the building work at Hampton Court to form part of a larger scheme to accommodate royal needs. In the years around 1670 Charles purchased the house of Audley End in Essex, rebuilt the early Stuart royal house at Newmarket and commissioned new work at Hampton Court. This flurry of expenditure, at a time when royal finances were far from flush, has to be explained in terms of Charles's perception of his future needs. Newmarket was already a favoured destination, and Audley End was probably chosen as a large ready-made mansion equidistant from there and London.[49] When Hampton Court was used in the 1660s it was invariably as the king moved back and forth from the west, particularly Portsmouth, where he took great interest in the fleet. Hampton Court was thus probably seen as a western stopping-off point, as was Audley End in the east. As such the house required suitable accommodation for the king and queen and the duke and duchess on their way to and from Whitehall.

During the 1660s James normally lodged on the north side of Chapel Court in the old Prince's Lodgings, the traditional residence of the heir to the throne, although during 1664–5 he seems to have stayed on the top floor of the range between Clock and Cloister Courts – Katharine of Aragon's lodgings.[50] The duchess seems to have used a number of other lodgings including, on one occasion, the queen's own. In 1669 it was decided to build new lodgings in the carcass of the old Tudor Tennis Court. There was an excellent precedent for this at Whitehall where, in 1663, the Henrician tennis play, nearly identical to that at Hampton Court, was converted into a residence for the Duke of Monmouth. Monmouth's lodgings were soon to become the largest and most lavish at Whitehall, rivalling the Duke of York's own.[51] The Tudor play at Hampton Court had remained undivided and probably in occasional use until its internal fittings were removed in 1670. Contracts were let to the carpenter and plasterer in May, the plumber in June and the joiner in September.[52] The conversion involved removing the ten great sixteenth-century windows and filling the remaining voids with large casements (fig. 53). The smaller ground-floor windows were also removed and replaced, and one of these remains today (fig. 117). Doors and fine stone door-cases were inserted in the centre of each façade (fig. 118). Bricklayers then cut back the inner face of the thick Tudor eastern wall by 11in. up to ceiling height at first-floor level, and inserted timber beams to support the brickwork of the top floor. This time-consuming and structurally precarious work was to make space for the insertion of four pairs of slim, low, two-room lodgings, stacked on top of each other and linked vertically by two small winding stairs, one to either side of the central doors (figs 118, 239). They were all wainscotted and grained to look like walnut.

The principal rooms, five to a floor on three floors, were formed by inserting two massive cross walls containing flues and decorated with new marble chimney-pieces, their cheeks lined with white tiles. Each room was given a deep cornice, and was to be hung with tapestry. Frames were made for overdoor and overmantel paintings. As the interiors of the new building were being installed, the old Prince's Lodgings were refurbished to match. The names of the rooms and their distribution are difficult to ascertain, but the accounts mention presence chambers, bedrooms and closets, so the duke and duchess probably had a truncated set of royal apartments. It seems likely that the duchess's rooms were in the old Tennis Court with her ladies occupying the mezzanine rooms on the east. These were probably approached by a stair at the east end of the chapel. The duke's lodgings were mainly in

116 Charles II's building campaign of 1660–89, showing excavated and extant features in black line and conjectural features in dotted line. Drawing Daphne Ford.

the north range, the old Prince's Lodgings.[53] When the duke and duchess came to stay with the king and queen in August 1670 they lodged in the Lord Chamberlain's lodgings, their own not being ready. The duchess died in March 1671 and it is unlikely that she ever stayed in the new building. The duke married Mary of Modena in September 1673, but neither of them can have used the lodgings much given the sparse use they made of Hampton Court. At any rate, in January 1684 Charles granted the duke's lodgings to his former passion Frances Stuart, Duchess of Richmond.[54]

The king's new building 'Next Paradise' was a clever solution to the problem of the royal lodgings at Hampton Court, although it must be doubted that it was ever conceived as a definitive one. Charles clearly wished to replace the rooms of his bedchamber with a more modern and convenient suite. The lodging thus had to interconnect with the king's innermost rooms and have a pleasant external aspect. Charles had also modernised his bedchamber at Whitehall, where the Volery lodgings were built for him in a similar style in 1666.[55] At first-floor level the new block directly adjoined three rooms: the King's Dressing Room, the end of the Long Gallery and Paradise itself. On the ground floor it adjoined Lady Scrope's lodgings and the Queen's Eating Room. Decorative elements from the rooms were removed and stored; the outer walls taken down and the old building boarded up. While deep foundations were dug to create cellars for the new wing a watch was put upon the building site to protect the vulnerable royal interiors.

The building that rose in rubbed red brick with white lime tuck-pointing and stone dressings comprised two storeys and an attic over a sub-basement approached from the cloisters (figs 114, 116, 119). The windows were large casements. The park elevation was very plain, of six bays with the central two protruding, but the southern elevation, of which there is no visual record, had four cartouches of Portland stone, each 5½ft long, and a pediment with the royal arms and four Ionic capitals. On the west side where the new façade joined Paradise, four piers with pilasters, capitals and bases supported a balcony 5ft deep and 21½ft wide with a very elaborate blue and gold wrought-iron balustrade (fig. 140). The privy storey (or first floor) was essentially a continuation of the royal lodgings, although the interface with the Tudor

117 The east side of Chapel Court showing the archaeological evidence for the alteration of the Tudor windows in 1670, and an original 1670 window *in situ*.

118 Stone doorcase, possibly by Hugh May, in Chapel Court going in to the Duke of York's Lodgings, 1670.

building was unhappy; the ceiling and floor of Paradise were raised by 4ft; and the floor at the end of the Long Gallery also had to be raised.

The panelled interiors were given deep wooden cornices and overdoors and overmantels in moulded picture frames. The most important rooms had richly carved chimney-pieces by Henry Phillips – these were the 'room at the backstairs', the King's Closet and the King's Bedchamber. Each had two cornucopias linked by a festoon above the chimney-piece. The room 'north of the bedchamber' was simpler with fruit and flowers over the chimney. The fireplaces themselves were of marble with Dutch iron firebacks and white-tiled cheeks. The withdrawing room had a 'fret' ceiling and the ante-room was described as being 'arched'. In the centre of the building was a great staircase of black and white marble with thirty-nine carved balusters and a fretted ceiling lit by a lantern intricately carved by Henry Phillips. At its head there was a room for the waiters. There was also a top-lit back staircase. Other rooms included a Privy Kitchen in the sub-basement, a stool room and a new room for Mr Chiffinch, the Keeper of the King's Backstairs Under Paradise.[56] To the east of the new building the moat was filled and a gravelled forecourt was created which was sectioned off from the park by a wooden palisade painted white and stone colour; the ground on the Privy Garden side was levelled and re-planted.

The boards that divided the old and the new work were finally dismantled in May 1675, and Charles certainly used the new lodging during one of his four visits for Council meetings that summer. To an extent the king's intentions for this new building remain a mystery. Charles visited the building under construction in August 1670 to view progress, but showed little enthusiasm for staying there afterwards. Although it was reported in April 1681 that there was a plan to remove the whole court there for the summer, Charles spent fewer than half a dozen nights at Hampton Court between 1669 and his death in 1685.[57] Yet it is clear that great care was given to furnishing the rooms there, especially the King's Bedchamber. In February 1670 a new bed was brought to

119 Reconstructed eastern elevation of the king's new building 'Next Paradise', 1670. Based on the building accounts and on figures 114 and 140. Drawing Daphne Ford.

121 The main façade of Sir Stephen Fox's house at Chiswick from Lyson's *The Environs of London* (1792–6).

120 Ground plan of the Duke and Duchess of Monmouth's house at Moor Park in an anonymous hand of 1687. This plan is part of a volume collected by the antiquarian Richard Rawlinson that includes many Office of Works papers.

Hampton Court for the king, but remained in its specially made trunk until September 1673 when it was erected in preparation for a night's stay in October. It was probably this bed that was dismantled two years later, cleaned and altered into a 'new fashion' for the king. It is unlikely that Charles continued to use his former bedroom for any purpose. The accounts call it the 'old bedchamber'.[58]

Together with the new Tennis Court, the king's new building and the lodgings for the Duke and Duchess of York were Charles II's most significant additions to Hampton Court, and it is worth considering who might have been responsible for their design. It was normally the Surveyor himself who had the presiding influence over any new work ordered. At the Restoration the surveyorship had gone, not to an architect of note, but to a fiercely loyal Royalist with little or no aptitude for architecture. Sir John Denham, who was Surveyor from 1660 for eight-and-a-half years, was forced to rely on his assistants in the Office of Works for architectural advice and design. Amongst these were John Webb, who undertook design work at Whitehall and, in particular, Greenwich and Somerset House, and Hugh May, the Paymaster, who was to emerge as one of the leading architects of the post-Restoration.[59] In the years until 1669, when Sir Christopher Wren was appointed Surveyor, the supervision of work at Hampton Court was almost certainly the responsibility of May, which raises the possibility that he designed all three buildings.

Wren had been appointed Surveyor of the Works in March 1669 amidst the most testing period of design for St Paul's and with designs on the drawing board for Whitehall Palace, the new custom house and a number of smaller buildings. As some of the first domestic work done for the king under Wren's surveyorship, the Hampton Court buildings would certainly have come to his notice, but it must be seriously doubted whether they featured high on his list of priorities. It should be noted that during the very busy and productive 1670s both Webb and May retained some of the most important royal projects, which progressed under Wren's ultimate control but without his design input. Since May knew Hampton Court well and spent much time there, and since the works were limited in extent, Wren may have delegated them to his Paymaster. That May's riding charges (travelling expenses)

were particularly high (and higher than Wren's) in April and May 1669 might also suggest that he was spending more time at Hampton Court.[60] A closer look at the two buildings themselves reinforces the suggestion that they were designed by May.

The Duke of York's Lodgings had no external aspect but required a clever planning solution to meet royal requirements. This was, as we have seen, the provision of mezzanine lodgings linked by a pair of small symmetrical service stairs. The provision of pairs of symmetrically placed service stairs is very similar to the layout adopted at Frogmore House in Windsor Great Park, work that has been attributed to May. The king's new building likewise bears a close affinity to other houses certainly designed by May. Although its precise plan is not recorded, what we know of its layout is strikingly similar to May's Eltham Lodge with its top-lit stairwell, but more importantly to that of the Duke of Monmouth's 1679 house at Moor Park, also by May (fig. 120). Even more significant is the strong resemblance borne by the elevations of the new building to Frogmore, Moor Park, and particularly May's house for Sir Stephen Fox in Chiswick, now lost (fig. 121). Perhaps most significant of all is the fact that the contract for Thomas Kinward, the Master Joiner, states that the quality of the doors and shutters should be of 'workemanshipp at least equall to the lower apartement of the Lord berckeleys house'. Berkeley House, Piccadilly, was designed by May for the first Lord Berkeley of Stratton in 1665, and in his specification for other houses May uses his own earlier work as a blueprint.[61] Thus the balance of probability is that May was responsible for two if not all three of Charles's buildings at Hampton Court.

During 1670 Charles also ordered the construction of a new bowling green. The green that had been constructed by Charles I and enjoyed by Cromwell was evidently not considered adequate, although Charles had appointed a keeper for it, Tobias Yeates, soon after the Restoration. Its 'rayls and posts' were lifted and moved to a new location by the Thames, which was reached by a new bridge over the moat (fig. 210). The same year, and possibly for his new green, Charles drew up a new set of rules for the game. The Count of Grammont describes bowling at Charles's court: 'it is only in use during the fair and dry part of the season, and the places where it is practised are charming delicious walks, called bowling greens, which are little square grass-plots, where the turf is almost as smooth and level as the cloth of a billiard table. As soon as the heat of the day is over, the company assemble there: they play deep: and spectators are at liberty to make what bets they please.'[62]

Barbara Villiers at Hampton Court

Although Charles's visits to Hampton Court were infrequent after 1669,[63] the house was far from deserted. The queen, who frequently moved independently from the king, stayed by herself on a number of occasions during the 1670s, when she entertained and hunted in the parks. These visits kept the otherwise quiet Office of Works and Wardrobe busy in the royal lodgings.[64] From 1662 the queen's Lady of the Bedchamber and the king's mistress, Barbara Villiers, Countess of Castlemaine, had lodgings there on the south front in and under the King's Long Gallery. Improvements and alterations continued to be made to these throughout the reign, and by 1674 she also had a number of rooms that had belonged to the queen, and a lodging in the Water Gallery (for which see chapter 10).[65] By 1670 her favour had entirely gone. Yet the Duchess of Cleveland, as she now was, was the acknowledged mother of five of Charles's children: Anne (later Countess of Sussex), born in 1661; Charles, Duke of Southampton, born in 1662; Henry, Duke of Grafton, born in 1663; Charlotte (later Countess of Lichfield), born in 1664; and George, Duke of Northumberland, born in 1665. This fact alone made it necessary that she should be maintained in some style.

Around 1670 Barbara was in receipt of two grants. First she was given Nonsuch Palace, the former Tudor pleasure house at Ewell. She seems not to have liked it, or perhaps she found it too expensive to renovate. She never stayed there and in 1682 sold it for its building materials.[66] More significantly, she was also granted the Keepership of the Hampton Court Parks and Hare Warren and the office of Keeper and Chief Steward of the Mansion and Honour of Hampton Court. Although the honour had been much depleted since its Tudor heyday through grants made by subsequent monarchs and disposals during the Commonwealth, its stewardship was still a significant grant covering a dozen or so manors, including several former royal houses such as Oatlands and Richmond.[67] Yet as a financial unit the honour of Hampton Court was losing money. The rents from the honour no longer covered the salaries of its officers and the other payments and pensions the honour had accrued since the sixteenth century. Indeed, the Treasury expressed considerable concern at the fact that the estate ran at an annual deficit of about £300, underwritten in 1672–3 by rents from the dean and chapter of Westminster. These problems were not the concern of the duchess, who benefited from salaries of nearly £250 a year and rents of £60. The appointments she held also brought real responsibilities that Barbara exercised personally at first – her signature appears on individual bills soon after her appointment. However, in March 1677 the custody of the house was granted to William Young for the life of the duchess, relieving her of day-to-day duties.[68]

The duchess was therefore using Hampton Court as her country house, and her children were probably brought up there during the late 1660s and early '70s. This premise seems to be confirmed by the fact that in August 1674 her thirteen-year-old daughter, Lady Anne Fitzroy, married Thomas Lennard, Earl of Sussex, at Hampton Court.[69] This was not only the wedding of the year, it was the last great ceremonial of Charles's reign held at Hampton Court. From April the Office of Works was busy repairing lodgings for courtiers, particularly those of the great officers of the Household, and also painting passages and staircases and repairing glazing – in July alone over £203 was spent in sprucing up the palace. Since this was the first time a substantial part of the court was to be accommodated at Hampton Court since the king's honeymoon more than ten years previously, lodgings had to be distributed to those who would be attending the marriage. This was the responsibility of the Lord Chamberlain and Vice-Chamberlain, who allocated lodgings by warrant to the Gentlemen Ushers Daily Waiters who had the task of delivering them to the occupants. Before the wedding of 1674 lodgings were occupied on an infrequent basis and only by a few privileged senior courtiers who might have business at Hampton Court. These included the Treasurer of the Household, the Vice-Chamberlain and the royal medical staff. Most of the lodgings remained empty.[70] The imminent arrival of the court triggered a survey of the lodg-

ings by Thomas Duppa, the Assistant Gentleman Usher Daily Waiter; Richard Coling, the Lord Chamberlain's secretary; Tobias Rustat, the Under-Housekeeper; Mr Yeates, the Palace Gardener; and one Mr Simpson, an old man who looked after the palace keys. The survey undertaken one week before the wedding is a valuable document showing, for the first time, the geography of the court in residence (figs 122, 123). One remarkable feature it reveals is that many of the great officers were allocated the same suites of rooms held by their predecessors under Charles I.

Charles arrived at Hampton Court from Windsor shortly after noon on 11 August and made straight for the duchess's lodgings, which were sited at the east end of the King's Long Gallery adjacent to his new lodgings. From here the royal family formed a procession with the king and his daughter at its head, followed by the bridegroom, the Duke of York, the Duchess of Cleveland and Prince Rupert. Ashmole tells us that 'they proceeded through the gallery at the upper end whereof, in the antecamera to the king's bedchamber, they were married by Dr. Crew the Bishop of Oxford'. The 'antecamera' was clearly a sizeable room, since the wedding was witnessed by the Spanish ambassador; the earls of Suffolk and Arlington; the Lord Keeper, Heneage Finch, and Lord Treasurer, the Earl of Danby; and the bridegroom's family. For this reason and because the procession passed through the Long Gallery from the east it is likely that the 'antecamera' was the Privy Chamber next to the king's old bedchamber overlooking Clock Court. Certainly the dinner that took place afterwards was in the King's Presence Chamber next door, which was provided with a rail to allow spectators to watch the wedding party dine. Beyond that in the Chamber of Estate the Duke of York was host to the remainder of the nobility. A parallel for the king's use of the old bedchamber for large formal receptions can be found in his use of the old bedchamber at Whitehall.[71]

Long after her children had grown up Barbara continued to live at Hampton Court, and in 1686 a dispute arose between the duchess on the one hand and the palace Housekeeper and Lord Chamberlain on the other over her occupation of a number of rooms. She claimed that when the king was absent she had absolute right to dispose of lodgings. James and the Lord Chamberlain thought differently, and although the particular rooms in question were granted to her on a temporary basis to defuse the situation, it was made clear that the king alone, through the Lord Chamberlain, had right to assign lodgings.[72]

Charles's Later Visits

A new phase in the history of Hampton Court began in or around 1680, although to many at the time it might not have seemed so. In May 1674 Charles took the court to Windsor, where it remained until August. This was the longest stay the court had spent at Windsor during the reign and was deemed a great success – plays were performed and a great mock battle staged at the foot of the north terrace. The visit convinced Charles that Windsor was henceforth to be his summer residence, and orders were given to reconstruct first the King's and Queen's Lodgings, and later the great outer rooms, St George's Hall and the chapel. The first phase was complete in late 1678, allowing the king to stay in comfort in his new lodgings, but work continued until the end of the reign on the hall and chapel. This meant that from 1680 Charles made Windsor a regular summer residence, moving the court there first in May 1680, and then every April until his death.[73] This shift in interest to Windsor had a profound effect on the use of Hampton Court which, for the first time in its history, became a satellite house to a more important residence, rather than being the principal focus of royal interest.

Hampton Court's satellite role was an unusual one, since it became the regular early summer meeting place of the king's Privy Council, meeting there thirty-four times between 1689 and the end of the reign. As early as May 1671 it was decided that the king should continue at Windsor, while the Council and Lords of the Treasury remain at Whitehall. So that they could meet in between at Hampton Court, orders were given to furnish the Council Chamber and the adjoining room for the clerks 'as hath been formerly accustomed'. The Council Chamber, and the room within it for the clerks, were probably those listed in the survey of lodgings taken in 1674, lying on the ground floor between Fountain Court and Cloister Court. This room replaced the earlier chamber on the north side of the palace at the end of the Queen's Gallery. In June 1679 Marriott and the Office of Works were ordered to fit up a new room elsewhere. Preparations were thorough: a gallon of ink, two hundred pens and six pounds of Indian sand were delivered, as were two close stools and six pewter chamber pots for the use of Council members.[74] The State Papers show that between 1681 and 1683 the Council met regularly at Hampton Court, on Thursdays, from the end of March until July. On occasions there were also meetings on Saturdays, but this was generally due to the king's ill health or a special crisis.[75] During the 1680s improvements continued to be made to the Council's accommodation. In 1681 the Office of Works made a new table and a 'high side table' for the Council Chamber; additional chamber pots and two close stools were ordered the following year. In 1683 sash windows were installed in the Council Chamber, and it was re-hung with a set of *Cleopatra* tapestries.[76]

In March 1681, due to the vast number of ordinary people drawn to Hampton Court by the Council, an order was made to restrict access to the Long Gallery, and five years later the gallery was re-matted in preparation for the meetings. This suggests that the Council Chamber was directly adjacent to the Long Gallery on the south front, and may have been located in the king's new building of 1670, which was approached by the gallery. We know that the Council first assembled in an outer room, the councillors entering and bowing to the king; when everyone had arrived the party moved into the Council Chamber and took their seats. At first the lords of the Council were given dinner at Hampton Court after the meeting, but the retrenchment of 1679 stopped this, much to the anger of those concerned. The king, however, continued to dine after the meeting and would normally return to Windsor immediately afterwards.[77] Sometimes more informal arrangements were adopted. In July 1674 Thomas More and the sons of George Fox went to Hampton Court to address the king in Council about their father's imprisonment. Arriving early in the morning, they found the king in his bedchamber at a meeting of his Cabinet Council. This bedchamber was certainly in the new building and probably explains the expense of fitting up a bedchamber, which was never used to sleep in. In May 1681 Sir John Reresby was presented by Lord Halifax to the king in his closet, probably also in the new building.[78] Indeed, these instances suggest

122 (*facing page*) Survey of Hampton Court lodgings taken in 1674 plotted on to a reconstructed ground-floor plan of the palace. Drawing Daphne Ford.

'In the first Court on ye Right hand ye Gate' (West Gatehouse, south side)
1 The Groom Porter
2 The Queen's Gentlemen Ushers
3 Mr. Marriott, Wardrobe Keeper
4 Queen's Gentlemen Ushers Daily Waiters
5 Queen's Gentlemen Ushers of the Privy Chamber
6 Captain of the Yeomen of the Guard
7 Queen's Gentlemen Ushers' Privy Chamber
8 Captain of the Pensioners
9 Maids of Honour

'Under ye Gate' (West Gatehouse)
10 Treasury Chamber Office
11 Porter's Lodge

'On ye left side of ye Gate' (West Gatehouse, north side)
12 Serjeant Porter
13 Dean of the Chapel
14 Mistress Laundress to the King
15 The Duke's Wardrobe

'North Side ye Court' (Base Court)
16 Standing Wardrobe
17 Removing Wardrobe

'Under the two Arches on the left hand the Inner Gate' (north-east corner of Base Court)
18 Great and Privy Buttery
19 Room belonging to the Great Buttery
20 Room belonging to the Privy Buttery
21 Pantry where the bread is delivered

'Entering in att ye Back Gate called the Greenecloth Yard' (Lord Chamberlain's Court)
22 Jewel House
23 Comptroller's Cellar
24 King's Coal House
25 Sir Stephen Fox
26 Spicery Office
27 Wax Chandlery

'Under the Passage into the Pastry Yard' (Master Carpenter's Court)
28 Bottle House
29 Clerk Comptroller

'Pastry Yard' (Master Carpenter's Court)
30 Fish Larder
31 Pastry Office

'The Paved Passage' (Fish Court)
32 The Boiling House
33 The Wet Larder
34 Larder
35 Dry Larder
36 Comptroller's Kitchen
37 Master of the Horse's Kitchen
38 Livery Kitchen

'Paved Passage at the Bottom of Ye Hall Staires' (West Serving Place and North Cloister)
39 Saucery
40 Hall Kitchen and Lord's Side Kitchen
41 Silver Scullery and Pewter Scullery
42 The Almonry

'The Court on the right hand back-side the Hall' (Hall Courtyard)
43 Scullery to Lord Arlington, Secretary of State

'In the Passage' (North Cloister)
44 Great Wine Cellar
45 Serjeant of the Wine Cellar
46 Lord Chamberlain's Scullery
47 First Clerk of the Kitchen
48 Lord's Side Kitchen, now The Duke's
49 Lord Chamberlain's Kitchen
50 First Clerk of the Kitchen
51 Gentlemen of the Wine Cellar to the King
52 King's Privy Kitchen
53 Master Cooke
54 Offices for the Queen's Master of the Horse

'In the Prince's Court' (Chapel Court)
55 The Queen's Chirurgeon
56 The Queen's Apothecary
57 Mr Chace, the King's Apothecary
58 The Duke's Offices
59 'a long room for the Musick to practice, and the Children of the Chapel at the further end' (the former bowling alley)
60 The Duke of York

'The Paved Court' (Clock Court)
61 Lord Treasurer
62 Master of the Horse
63 Bottle House
64 The King's Robes
65 Plumber
66 Lord Privy Seal

'The passage to the Cloyster Court' (Fountain Court)
67 The Council Chamber

'The passage leading out of the Paved Court to the Chapel'
68 Queen's Sweet Coffers
69 Grooms of the Privy Chamber to the King

'In the Court called Chappell Court' (Round Kitchen Court)
70 'A new building': 1st door Pantry and Cellar to the King's Lord Chamberlain; 2nd door Vice Chamberlain to the King; 3rd door Groom of the Stool to the Queen

'Next the Greate Staires'
71 The Queen's Privy Kitchen

'In the passage out of the Chappell Cloyster to the Cloyster Court' (East Cloister)
72 Yeoman of the Mouth to the Queen
73 Queen's Bottle House
74 Under Housekeeper

'In the Cloister Court' (Fountain Court)
75 The Queen's Robes
76 Groom of the Stool to the Queen
77 Countess of Penalva
78 Lodgings of the Groom of the Stool to the Queen
79 The Lord Steward's Lodgings
80 Duchess of Cleveland
81 Laundress and Starcher to the Queen
82 Duchess of Cleveland
83 The Queen's Confectionery
84 Groom of the Stool to the Queen
85 Countess of Penalva
86 Pages of the Backstairs to the Queen

'In the Court between the Chappell and Horne Gallery' (former Queen's Great Gallery)
87 Serjeant of the Vestry to the King
88 The Duke's Lodgings
89 The Queen's Priests
90 Lady Killigrew, the Queen's Dresser
91 Secretary to the Queen
92 Lord Chamberlain to the Queen

that the king's new building was heavily used during the 1680s as the regular meeting place of the Council, either in its own chamber or in the king's bedroom. It would have also been the place where the king dined afterwards, supplied from the Privy Kitchen below.

James II at Hampton Court

James II's pattern of usage at Hampton Court differed little from that of his brother. The court spent the summers of 1686 and 1687 at Windsor, and like Charles before him, James made regular trips to Council meetings at Hampton Court, staying for dinner and returning to Windsor to sleep. It seems probable that he made a number of other brief visits in the early summer of 1687, possibly in conjunction with inspections of his army which was encamped on Hounslow Heath. The only suggestion of his having stayed the night is intensive Wardrobe activity recorded for 21 April 1688. Before his day-visits flurries of maintenance work can be detected in the accounts, but otherwise work concentrated on the palace's permanent inhabitants, the Duchesses of Cleveland and Richmond, former rivals in Charles II's affections.[79]

A more important resident joined Charles's old mistresses in 1687. James ordered that his younger daughter Anne, then thirty-two years old and recently married to George, Prince of Denmark, should take up residence at Hampton Court. She was to have James's old lodgings in the Tudor Tennis Court, and lodgings elsewhere were to be vacated and prepared for her household, which included a governess for her child. The Office of Works made extensive repairs and alterations in preparation for her residence,

10 0 50 100 150
Feet

10 0 50
Metres

123 (*facing page*) Survey of Hampton Court lodgings taken in 1674 plotted on to a reconstructed first-floor plan of the palace. Drawing Daphne Ford.

'Over the Gallery up staires next ye Gate' (West Gatehouse, south side)
1 Secretary Coventry
2 Gentleman Usher Daily Waiter to the King, Mr Duppa
3 Another of the King's Gentlemen Ushers
4 Sir Edward Carteret, Gentleman Usher to the King
5 Signet Office
6 Lord Chancellor Keeper
7 Sir Alexander Frazier, the King's First Physician
8 The Secretary of Scotland

'Up Staires on ye left hand ye Gate' (West Gatehouse North Side)
9 Gentleman Usher of the Privy Chamber to the King: Mr Darcy
10 Gentleman Usher of the Privy Chamber to the King: Sir Paul Neale
11 Gentlemen of the Privy Chamber
12 Queen's Gentlemen Ushers Quarter Wayters
13 King's Barbers
14 Esquires of the Body
15 Lord Arlington, Secretary of State

'Entering in att ye Back Gate called the Greenecloth Yard' (Ld Chamberlain's Court)
16 Comptroller's Lodgings
17 The Compting House
18 Mr Cofferer
19 Mr Regner
20 Clerke Comptroller

'Pastry Yard' (Master Carpenter's Court)
21 Clerke of the Kitchen
22 Office of the Scullery
23 Clerke of the Robes
24 Confectionery
25 Officers of the Pastry

'In the Paved Passage' (Fish Court)
26 Officers of the Boiling House
27 Clerke of the Kitchen
28 Officers of the Larder
29 Chirurgeon of the Household
30 Serjeant Chirurgeon

'In the Paved Passage at the Bottom of ye Hall Staires' (North Cloister)
31 Officers of the Scullery

'The Greate Space' (the Serving Place)
32 The Avenor
33 Sir William Borman Second Clerke of the Greencloth
34 Master of the Household
35 Second Clerke Comptroller

'In the Court behind' (now in Tennis Court Lane)
36 Mr Chace, the King's Apothecary

'The Paved Court' (Clock Court)
37 Vice Chamberlain to the King
38 Lord Archbishop of Canterbury
39 Master of the Horse

'In the Gallery coming from ye King's Guard Chamber to the Chappell'
40 Groom of the Stool to the King
41 The Grooms of the Chamber in the Screen in the Great Hall
42 The Kings Waiters dine in a room within the King's Guard Chamber
43 The Queens Waiters dine in a room within the Queen's Guard Chamber
44 The Duke of York's Lodgings

Rooms of State and Royal Lodgings in 1674 (compiled from various sources)

A King's Guard Chamber
B King's Presence Chamber
C King's Privy Chamber
D The Dark Drawing Room
E King's Privy Lodgings and Privy Gallery
F Privy Garden Stairs
G Paradise
H King's New Building next Paradise
I King's former Dressing Room
J King's former Private Bedchamber
K Queen's Rich Bedchamber
L Queen's Dressing Room?
M The Balcony Room
N Queen's Withdrawing Room
O Queen's Closet
P Queen's Privy Chamber
Q Queen's Presence Chamber
R Queen's Guard Chamber
S The Queen's Gallery
T The Horn Gallery

and new furniture was provided; tapestries were sent from Windsor and altar cloths from Whitehall.[80] The chapel was brought back into use for the royal couple – the pulpit was mended and seven forms, six dozen round hassocks and ten kneeling mats were purchased. The upper pew was re-matted for Anne and new locks were placed on the door. Anne and George certainly used Hampton Court during 1687–8 and, as we shall see, Anne gave birth to a son, William, there the following year.[81]

Stylistic Changes and Furnishings

We have seen that Hampton Court had been immune from the stylistic revolution attempted by the early Stuarts at Greenwich, Whitehall, St James's and Somerset House. Cromwell's tenure of the house was also notable for being architecturally uneventful. Thus in 1662, when the house hosted the reception of Catherine of Braganza it was still essentially Henry VIII's palace of 1547. Sir Christopher Hatton said of his visit in 1689, 'The outside is very meane. How it is furnished within I cannot tell . . . I was so disgusted to see ye front and back side, I admire how anyone can fancy it.' Yet apart from a small number of hostile observers, Hampton Court was still admired for its gothic architecture. Evelyn thought it 'as noble and uniform pile and as capacious as any gothic architecture can have made it'; his views were echoed by Count Magalotti, the attendant of Cosimo III, Grand Duke of Tuscany, who admired the splendour of its gothic style, opining that 'although the more elegant orders of architecture are not to be found in it, so as to make it a regular structure according to the rules of art, yet it is, on the whole, a beautiful object to the eye'. The count thought the palace's towers and turrets were 'a most striking ornament whether viewed near or at a distance'. Even the Portuguese who attended Catherine in 1662 found the palace grand, richly furnished and comfortable. However, the gothic features admired by some were the very elements that rendered the house displeasing to Monsieur de Monconys, one of the French king's councillors:

> The front of the house is regular, but behind the façade nothing but a mass of towers, tourrillos and other baubles, which make up a not unpleasant confusion, and make the place seem something more than it is. For there is no architecture nor sculpture, nor height. The whole is of brick, without ornament . . . for the most part it is nothing but a hole.'[82]

The palace's gothic appearance cannot have been pleasing to Charles. The architectural story of his reign was dominated by attempts to build a modern, uniform palace in a contemporary style, and as we have seen Hampton Court played no part in this.[83] Hampton Court was ultimately a convenient place lying between Whitehall and Windsor where the Council could meet, and a retirement home for mistresses of whom the king had tired.

124 John Greenhill, *Henry Harris as Cardinal Wolsey*, 1664. Harris had a long theatrical career, from 1661 to 1699. His is one of the earliest-known representations of an English actor in costume. The painting suggests that Hampton Court was closely associated with Wolsey and Henry VIII in the 1660s and reflects an antiquarian affection for it.

Yet to allow the house to perform these roles Charles and his surveyors embarked on a wholesale modernisation. Clearly the king's new building represented an entirely fresh contribution to the palace, but in May 1676 the palace's first sash windows were introduced, into Paradise, and seven years later they were put in the Council Chamber. This modification not only represents the first step in a process that was to see all the Tudor stone casements replaced, but it identifies the two rooms in which the king most wished to show his modern taste.[84] Internally, almost all the principal rooms were repanelled, with new dados, cornices and overdoor and overmantel picture frames. In September 1674 two massive paintings were installed in the Queen's Presence and Withdrawing Chambers. A large hole was cut in the roof to 'draw up the pictures' before they were fixed by Mr Norris, the Royal Picture Framer. These were probably the two large paintings by Romanelli sent as a gift by Cardinal Barberini. The Presence Chamber was also hung with a vast canvas on the wall; in 1684 the window it hung in front of was finally blocked up.[85]

Most of the Tudor fireplaces in the State Apartments were replaced with new marble ones. The new rooms next to Paradise and in the Tennis Court were panelled throughout, and fashionable carvers were commissioned to produce overmantels. Externally some of the exuberance of the Tudor elevations was stripped away. In March 1666 twenty-four pinnacles were dismantled in Cloister Court and eight more were taken down round Fountain Court.[86] Yet despite the modernising fervour there is some evidence to suggest that the Tudor work was appreciated and respected. Tantalisingly, the keeper of the house was reimbursed for several 'prospect pictures' by Hendrick Danckerts in June 1675. These may have included a view of Hampton Court from the east that still hangs at the palace today (fig. 69). It shows the glorious Tudor east front and the new canal (see chapter 12) but not the king's new building, a possible indication of the affection with which Charles regarded the antiquarian aspect of the house.[87] A revival of Shakespeare's play *Henry VIII* with Henry Harris as Cardinal Wolsey led to Harris's being depicted at Hampton Court by John Greenhill, possibly an indication of a wider antiquarian affection for Hampton Court (fig. 124). Some of the Tudor parts were carefully repaired – the dial of the astronomical clock was repainted by Robert Streeter in October 1664 and the north-west tower of the Great Gatehouse was rebuilt between August 1666 and May 1667.[88] The gatehouse had given trouble in Elizabeth's reign when three of the turrets were rebuilt, probably due to subsidence. The two turrets in Base Court retain stone plaques, one with the date 1566. The Caroline repairs are remarkable for the care that was taken to make work blend in with the Tudor fabric. Much of the north-west part of the gatehouse, including the porter's lodge, was dismantled in order to repair the turret and its type, replace the stone surround of the Great Gate, overhaul the window and arms above, and insert a lesser pedestrian gate to one side (fig. 290). Old bricks were used in order to avoid the new work's being obvious. The brickwork bridge was also altered and repaired.[89]

Our understanding of the interiors of Charles II's Hampton Court is aided by the existence of an inventory of the paintings, probably made some time in the first ten years after the Restoration and possibly compiled by William Chiffinch.[90] It makes clear the fact that Hampton Court was still the great repository of antique tapestry, for no paintings are listed in any of the outer rooms apart from the Great Hall. The hall, used as a dining room until the Household reforms of the early 1660s, was hung with a 56ft-long painting of a whale and a painting of the nine muses. The room was not to be hung with tapestry again until the 1840s.[91] The Queen's Gallery on the east front contained twenty-seven paintings, which were mostly portraits of British monarchs and foreign dignitaries but included Huysmans's fine portrait of Catherine of Braganza. Interspersed with these was the remarkable collection of antlers that caused the gallery to become known as 'the Horn Gallery'. Evelyn was impressed by the display, noting 'vast beames of stags, elks, antelopes etc.'. Amongst these were the fossilised horns of a giant Irish elk, found 10ft-deep in a bog in County Clare, and presented to Charles II by the Duke of Ormonde in 1684.[92] The King's Gallery, a much larger room, held seventy-nine works of wide subject matter and by a variety of artists. The backbone of the hang was Mantegna's *Triumphs of Caesar*, not hung in order, nor even in a line, but interspersed with other paintings. Compared with the Privy Gallery at Whitehall (and setting aside the *Triumphs*) the hang was a ragbag of second-class paintings nearly half of which were portraits and most of the remainder either classical history or religious paintings. Other than the two great galleries only a few rooms contained easel paintings. Paradise had thirty-one, again dominated by portraits and

religious subjects, and the King's Dressing Room had twenty-seven, fifteen of which were religious subjects including three images of St Sebastian (who was seen as a protector against the plague). In the king's and queen's bedchambers and adjoining rooms, where textile wall hangings dominated, there were only architecturally framed paintings.

Charles was certainly interested in easel painting: even before the details of the Restoration were finalised he agreed to buy a group of seventy-two paintings from a Dutch art dealer and former protégé of the Earl of Arundel, William Frizell. Frizell was instructed to keep the paintings in Breda until Charles sent for them. They came to England in two batches and the second, smaller group was sent for by Charles while at Hampton Court in June 1662.[93] At least eighteen of these paintings remained at Hampton Court, most in the King's Dressing Room on the east front next to Paradise. The whole collection mainly comprised Italian High Renaissance pictures but a third of them were northern European and many of these found their way to Hampton Court where they joined other Dutch and Flemish paintings. Thus Charles II's rooms at Hampton Court held a much higher proportion of northern paintings, and a far greater preponderance of religious subjects than had his father's. Yet Charles maintained the antiquarian feel with portraits dominating, and he did not move any of the really great paintings from Whitehall to his country seat.

Such a small amount of information survives regarding James II's use of Hampton Court that it is difficult to characterise his attitude to the palace. Yet an inventory of paintings survives from 1688 which suggests that even in his short reign James made some interesting changes to the picture hang.[94] The portraits considered appropriate in the Queen's Gallery changed. Out went the Duke of Buckingham, the Duke of Lennox and the portrait of Charles and Henrietta Maria with Princess Mary. They were replaced by William Dobson's two unfinished paintings of Charles I and James II as Duke of York painted during the Civil War and in store in Charles II's time. Van Dyck's great equestrian portrait of *Charles I on Horseback with M. de St Antoine* was also relocated to the gallery. The changes in the King's Dressing Room were a similar tale of in and out. Out to the Backstairs Room went Charles and Henrietta Maria at Greenwich and in came the portrait of James I as a child holding a hawk. Mary, Queen of Scots remained as the only other portrait in the room. The James II inventory provides much fuller information about the Queen's Apartments. The picture hang in these rooms remained much the same as it had been for Catherine of Braganza, other than the addition of a full-length portrait of the Infanta of Spain in the Queen's Bedchamber. The remainder of the rooms were hung with old masters of classical subjects. In the Queen's Chapel hung two religious pieces.

Hunting and the Hampton Court Parks

Charles, unlike his grandfather, was not excessively fond of hunting and preferred racing at Newmarket and Winchester to hours in the saddle. However, he hunted occasionally, but rarely from Hampton Court. At any rate the Commonwealth years had decimated the royal parks and forests, and curbs were put on any form of hunting for the first four years of his reign. Hampton Court was gradually restocked and especial care was taken to maintain deer for coursing in the park. Charles rarely enjoyed sport there, but visitors were often sent with senior courtiers to spend a day. One such visit was that of Cosimo III, Grand Duke of Tuscany, who went to Hampton Court in the company of Lord Phillip Howard and Lord Anthony Ashley Cooper, where

> After the usual compliments, his highness went forward, Prince Rupert remaining in the place appointed for him under the shade of a tree, on a stage a little raised from the ground, which is the same where the king stands to see this amusement. When the huntsmen had stretched out their nets, after the German manner, enclosing with them a considerable space of land, they let the dogs loose upon four deer which were confined there, who, as soon as they saw them took fright; but as they had not the power of going which way they pleased, they ran round the nets, endeavouring, by various cunning leaps to save themselves from being stopped by the dogs.

The deer remained trapped like this until everyone had seen their fill, when the deer were released into the park.[95] The park was also used by selected courtiers for hawking. The Earl of Bedford was at Hampton Court in January 1669–70 for five days hawking, and his accounts survive to illustrate the costs of his residence. First he had to pay boardwages for his two grooms (15s); then provide hay and corn for his horses (£2), food for his own diet at the palace (£1), and for the falconers and their horses (£2 20s); and for transporting pigeons for the hawks (8d), and for pigs' hearts to feed the hawks (8d).[96]

In equestrian matters Charles II's reign was a quiet one. It would appear that Cromwell had maintained a stud on a limited basis at Hampton Court after 1654, and at the Restoration Charles resolved to make this the kernel of a new royal stud, gathering together what bloodstock he could find. Rather than run a stud directly, the king contracted the work out to James D'Arcy, Master of the Stud, for £1,000 a year. In 1681–2 works were undertaken in the 'hunting stable', 'guard stable' and king's stable, but most of the time the stables were under-used.[97] The principal development in this area was the increasing use of the carriage. By the early years of the Restoration the carriage's supremacy was secure. A pamphlet published in 1672 entitled *The Grand Concern of England Explained in Several Proposals offered to the Consideration of Parliament* called for the great multitude of carriages to be suppressed because they destroyed the livelihood of watermen and led to fewer people breeding and keeping horses. By that date every town within twenty-five miles of the capital could be reached by coach, and the royal family led the fashion. It was in the windows of the Duke of York's coach in 1665 that glass first appeared, and paintings of Hampton Court in Charles's reign prominently show the splendid royal carriages (figs 115, 125, 126). In 1684 the revetment wall at the Great Gatehouse was heightened to prevent horses and carriages falling into the moat. Coach travel was still not fast by modern standards: a good coach on a well-maintained road only travelled at six miles an hour if the occupants were not to end up bruised and travel-sick. For this reason the network of special royal roads developed, particularly in the west towards Richmond, Hampton Court and Windsor. The royal roads were jointly managed by the Surveyor of the King's Roads who was paid an annual fee of £95 by the Exchequer, and Andrew Laurence, Surveyor of the Highways, who worked for the Master of the Horse receiving a salary of £82 and a repair allowance for the

125 (*above*) East front view of Hampton Court attributed to the traveller and topographical artist Jacob Esselens, 1660–65. The prominence given to the carriage suggests that this is a depiction of Charles II leaving the palace.

126 A view, possibly with Hampton Court in the distance, attributed to Jacob Esselens. Once again the prominence of the carriage suggests that it is the royal coach.

'private wayes' of £270. The Office of Works would sometimes also be ordered to make road repairs to smooth the royal path to Hampton Court. The bailiffs of Kingston entertained the surveyors as they came to make their inspections. Licences to use the royal roads, far less pitted than the public ones, were much sought after.[98]

The only occasions on which Charles and his court now used the river were ceremonial and recreational ones. Other than the great water procession to Whitehall of 1662, record survives of one such event. The Countess D'Aulnoy records an excursion to Hampton Court to honour the Prince of Neuburg in 1675: 'Barges were waiting, dressed with flags both striped and embroidered, & hung with brocaded tapestries of rose colour & silver, their decks spread with Persian carpets, with a gold ground. When all the court had taken its place an advance was made up the grand river Thames... The air resounded with agreeable symphonies.' On reaching the palace the party disembarked and the entertainment began.[99]

Chapter 10

HAMPTON COURT TRANSFORMED: THE REIGN OF WILLIAM AND MARY

WILLIAM AND MARY SAVED Hampton Court from a long decline that would have almost certainly ended in abandonment and probably demolition. For the first time since Charles I the palace had royal admirers and, for the first time since Henry VIII, owners who wished to make an architectural impact on it. It is largely thanks to William that Hampton Court is today the place it is.

In 1688 William Henri, Prince of Orange, was thirty-eight, and had lived most of his life in increasing expectation of ascending the English throne. His relationships with his uncles Charles II and James II (who was also his father-in-law) had been strained at best, hostile at worst; yet he had visited them in England on a number of occasions on family and diplomatic business. William himself was above all a soldier and a diplomat, but he was also a great artistic patron who spent time away from the battlefield buying paintings and visiting great houses.[1] His wife, Mary, had been born in 1662 at St James's Palace. She was one of the two surviving children of the Duke of York, the future James II, and his first wife Anne Hyde. Charles II, still without an heir, had removed the two girls, Mary and Anne, from the Roman Catholic influences of their father's household and oversaw their education himself. He influenced the determined, artistic and (to a degree) hedonistic girl whom William was eventually to come to love. The choice of husband for both Mary and Anne was crucial, and Charles wished to see them both marry into Protestant royal houses. His wish was fulfilled for Mary in 1677 when she, aged fifteen, was married to Prince William of Orange, Stadtholder of the United Provinces (the Netherlands).

There is little need to rehearse the events of the Glorious Revolution of 1688 that led to the flight of James II and the arrival of William III and his Dutch troops on English soil. William made his way to London where Mary joined him on 12 February 1689. The following day she and William were declared Queen and King, and on the 14th the Privy Council met at Whitehall for the first time. Before this William had lodged at St James's, since it was unthinkable that he should reside at Whitehall as prince, but as soon as the official announcement was made William and Mary were expected to move into Whitehall. The king, however, had no intention of doing this. He had never liked its vast size, its accessibility or its dirt, but most important was the fact that all the dense smog caused by London's tens of thousands of coal fires brought on terrible asthma.[2] Only nine days into their reign William and Mary moved west and arrived at Hampton Court, where they stayed for three nights. William had probably never been there before; the excursions he had made during his visit of 1670 had been to Oxford, Cambridge and Audley End, and in 1681 he had visited Windsor. In 1677 his marriage to Mary had taken place at St James's and they had not left London. Mary, of course, knew the palace from her childhood at Twickenham and Richmond and would have stayed in the converted Tennis Court Lodgings with her parents.[3] But her memories, if they had been fond, were deceptive: she wrote to Agnes van Wassenaer-Obdam in 1689, 'At the moment I am in the country in a place which has been badly neglected, it is about four miles from London but lacks many of the commodities of Dieren [her Dutch house] (although the house has four or five hundred rooms).'[4] William's reactions are not known, but they can have hardly been more enthusiastic. His houses in Holland, particularly Het Loo, his summer residence, were small, clean and brand new; Hampton Court, which had not been a regular residence of the Crown since before the Civil War, must have seemed unbelievably old-fashioned, confusing and dirty. Yet for the royal couple it held potential, and two large consignments of their goods were sent down river from Whitehall on 1 and 2 March. The king and queen followed on the 2nd. It was soon reported that they 'found the air of Hampton Court agreed so well with him [William], that he resolved to live the greatest part of the year there; but that palace was so very old built and so irregular, that a design was formed of raising new buildings there for the king's and queen's apartments'. The bed of state which had been at Windsor, the official summer residence of Charles and James, was moved to Hampton Court, and it was widely known that 'Sir Christopher Wren hath received orders to beautify and add some new buildings to that fabric, their majesties taking much delight in it for its present situation'.[5]

The king, melancholic, homesick and ill, was eager to move in as quickly as possible to avoid the choking London smog. On 12 March orders were given to make preparations for the court's general remove to Hampton Court and the harbingers sent out to reserve accommodation. Nine days later a long list of furniture was ordered and on the 23rd nineteen loads of stuff moved up

127 Fountain Court.

river from Whitehall, the king and queen arriving the following day. William and Mary remained at Hampton Court until 16 October, only leaving for day-trips to Council meetings or other essential business at Whitehall or Portsmouth. This was far from being a popular decision. The Earl of Portland's secretary complained that 'the Kings inaccessibleness and living soe at Hampton Court altogether, at soe active a time ruined all business', alleging that it took ministers five hours to get there. The visit was so 'inconvenient for those that were there' that William 'began to think about the Earl of Nottingham's house at Kensington which was situated one or two miles from the centre of London, and where the air was good, as somewhere to stay regularly'. William had found the solution to his inability to reside at Whitehall. Hampton Court and Kensington were henceforth to be part of a single master plan. Kensington was in walking distance from Whitehall but the air there was clean; it was designed to be simply a residence with no provision for entertainment, receptions or business. Hampton Court meanwhile would become his principal seat, his weekend home and his summer residence.[6]

The New Palace is Designed

The astonishing point about William and Mary's long residence at Hampton Court of 1689 is that whilst William was under great political pressure to establish himself as king there was intensive discussion about the design of new buildings, modifications to the old ones and major demolition work. The warrant books of the Lord Chamberlain record extensive refurnishing of interiors for the king and queen and the supply of fashionable fabrics, trimmings and furniture. Sadly, it is not clear which rooms were decorated for them, but they are likely to have been the old Tudor lodgings in Fountain Court. Meanwhile lodgings throughout the palace were refurbished for courtiers.[7]

In April, only a month after Wren had received his orders, the Office of Works opened an extraordinary account in preparation for the new building – the royal patrons were clearly in a hurry.[8] Wren's instructions represented a tremendous coup for a man who only weeks before had feared the worst. Nothing would have been more natural than for William to replace the fifty-six-year-old Tory Surveyor of the Royal Works with a Dutch architect, or to use his power of patronage to reward a nominee of the Whigs to whom he owed so much. In the event he did neither and Wren was retained, almost certainly due to the wishes of Mary. The queen had rapidly forged an alliance with the Anglican Church, becoming a supporter of the completion of St Paul's cathedral and a champion of the Surveyor. Wren, as we shall see, developed a happy relationship with the enthusiastic twenty-six-year-old queen, one that enabled him to retain his post.[9] William's accession did, however, see one change to the Board of the Office of Works: the appointment of William Talman to the post of Comptroller, vacant since the death of Hugh May in 1684. Talman owed his success first to the patronage of the Earl of Devonshire at Chatsworth and then to the favour of the Earl of Portland, Hans Willem Bentinck, William's lifelong friend and confidant. Talman and Wren were, as we shall see, frequently at loggerheads until Talman's departure from the Board in 1702, and it is not clear what influence he had over the fevered design work in the Office in the spring of 1689. This is a question that is addressed below.[10]

The process of designing the new palace took place over an incredibly intense period between the first week of March and mid-April. By then Wren probably had approval for the final design, since his cost estimate for the building work was presented to William at Hampton Court on 4 May and foundations were being dug for it in June.[11] It is crucial to realise that Hampton Court was far from being Wren's only task at the time. Just as he was commissioned to design Hampton Court, Wren also received orders to convert the Earl of Nottingham's former house at Kensington. The Kensington design work was undertaken simultaneously, with the major contracts being let in July 1689. The moment the building season started in April work also began on roofing the choir and transepts of St Paul's, a major and complex undertaking; a couple of months later work restarted on four of the City churches after a hiatus caused by the revolution. Finally, Wren was still overseeing important work at Whitehall where the Queen's New Privy Lodgings, begun for Mary of Modena, were being fitted up for Mary II. Wren must have been desperately overstretched. Significantly, he failed to attend the meeting of the St Paul's commissioners on 28 March, one of only three meetings he had missed since February 1685; he was almost certainly at Hampton Court with the king and queen. From that time on the record of Wren's travelling expenses (or 'riding charges') shows that there was never a month when he failed to visit the palace before mid-1692.[12] What is certain is that throughout the six-week design phase Wren relied heavily on his drawing office in Scotland Yard. Our understanding of the workings of Wren's office has enormously increased in recent years.[13] Undoubtedly a vital factor in the Hampton Court works at the Office in 1688-9 was Nicholas Hawksmoor. He had been Wren's personal clerk since the age of eighteen and his principal draughtsman since about 1686. From 1689 until the death of Mary five years later he received a daily wage as Wren's clerk at Hampton Court in addition to his formal post as Clerk of Works at Kensington. The whole burden of drawing the Hampton Court schemes rested on his shoulders, and in due course his influence on the ultimate realisation of the project will be explored.

First, Wren's own position should be considered. For his entire career, Wren had been waiting for an order to rebuild one of the major royal residences. Despite work at Whitehall and Winchester, he had never completed a major royal palace, and William's enthusiasm for a new Hampton Court must have seemed like his best chance yet. Charles II had first spotted Wren, as the architect who could fulfil his dream of a great metropolitan palace, at Whitehall. As early as 1664 the two had worked on ideas for rebuilding the ancient seat and in July 1665 Wren travelled to Paris at Charles's command to glean ideas for the project. The timing of his trip was crucial. All Europe knew that the sixty-seven-year-old Gianlorenzo Bernini had gone from Rome to Paris to see the Louvre for himself and meet his royal patron, Louis XIV. While in Paris Wren met Bernini, saw all that was best and most modern in French architecture and studied at the Louvre. He returned to London with his luggage full of engravings and books, the kernel of an architectural library that was to grow into a major reference tool. Over the following decades, a period deluged by architectural publications, he bought more and even acquired, through the king, original drawings, such as those for Les Invalides.[14]

Although it will be demonstrated that such engraved sources played a vital role in the design development of the new work at

Hampton Court, other factors were at work too. The most potent of these were the requirements of English court etiquette. Charles I, in a small way, and then Charles II and James II had introduced elements of French royal planning into the English state and private lodgings. Indeed a terminological change from 'lodging', the English word used to describe a suite of royal rooms, to the French term 'apartment' reflected the aspiration. One of the crucial changes was in the form of the bedchamber. Since the Restoration Charles II had transformed the once private English royal bedchamber into the principal reception room of the palace. At Whitehall the new royal bedchamber complete with a French-style bed alcove was reserved for the public ceremonies of the king's levee and the coucher. The king actually slept in a second bedchamber elsewhere. Another important innovation was the creation of a specific dining room for dining in public. Originating in France, such planning ideas as these were transmitted via Whitehall, Somerset House and Windsor and came to influence courtier houses. From the early 1670s courtiers such as the Earl of Lauderdale at Ham near Petersham, the Duke of Newcastle at Nottingham Castle and the fourth Lord Brooke at Warwick Castle introduced mini state apartments in their houses. With the accession of William and Mary and an increasing admiration for French design, further development of the state apartment towards the French model could be expected. Yet, as we shall see, the very different requirements of English court etiquette limited the degree of cross-Channel imitation that was possible. Ultimately the French-inspired ideas of William, Mary and Wren were constrained by the Lord Chamberlain's regulations inherited from Charles II.

THE EVOLUTION OF THE DESIGN

Essentially the design of Hampton Court went through three stages, identified here as schemes I–III. Later secondary sources suggest that the very first idea under consideration was the abandonment of the present site and the construction of a completely new palace at the west end of Hampton.[15] But if this was the case, the plan must have been dropped very quickly; at any rate no drawings survive to show that it was considered at length. The earliest group of drawings, scheme I, is for a rebuilding of the palace on its previous site using key fixed points in the existing landscape. The main axes of the new building were to be a new avenue in Bushy Park, Charles II's canal and its radiating avenues, and the centre line of the Privy Garden (fig. 128). These first drawings show that the crucial factor in designing Hampton Court as the new summer residence was its landscape setting. William was determined to maximise the effect of the mature elements of the park and gardens in the new design. This reason, above all others, must have been the motivation for keeping the palace where it stood. The importance afforded to the setting of the new building was emphasised by the appointment, in early 1689, of William, Earl of Portland as Superintendent of the King's Gardens with the power to 'oversee and direct any plantations and works therein'. Portland was himself a great gardener and had advised William on the creation of his magnificent gardens at Honselaarsdijk and Het Loo. He had also created his own remarkable garden at Zorgvliet. He was to be assisted in his work by a team of four: the leading English country house gardener and landscape contractor George London who was officially Deputy Superintendent, William Talman as Comptroller, Caspar Frederick Henning as Paymaster and William Deeplove as Clerk of Works. Of these Talman was undoubtedly the most important influence and was in effect Portland's right-hand man.[16]

In addition to the key landscape features retained from earlier reigns, Wren's first scheme allowed for the retention of Henry VIII's Great Hall as a centrepiece. This calls for some remark. It has been noted that during the seventeenth century Hampton Court acquired a reputation as the 'ancestral' country home of the Crown, and that there was a strong sense of antiquarianism about its preservation. Charles II decisively broke with this tradition, modernising many interiors and building the first major new structures since Henry VIII. William perhaps regarded the ancient roots of the palace with respect, as a legitimising factor for the new building. Wren, who had cared for Hampton Court and the other Tudor palaces for twenty years, perhaps recognised its architectural importance too. For both, possibly for all, the Great Hall was Henry VIII's finest work and to demolish it would be a blow at the ancient dignity of the monarchy itself.[17]

Scheme I exists in two versions – I (i) and I (ii). In both, the hall was the point of entrance from a *cour d'honneur* aligned on a new avenue and flanked by what were presumably to be offices and stables. And in both variants of the scheme the service buildings were linked to the main block by quadrant colonnades. This was an innovation for England. Wren's design for Winchester, which had a similar receding forecourt, was based on the inner end of Versailles and Le Vau's Collège des Quatre Nations in Paris. The quadrant colonnades at Hampton Court, though, could have been inspired by François Mansart's unbuilt scheme for Gaston d'Orléans at the château of Blois, an early use of the semicircular colonnade in France. It is unclear, however, whether the Office of Works knew this design. It is more likely that one of the published Louvre schemes by Bernini or Claude Perrault, both of whom used quadrants, was the inspiration.[18]

For scheme I (i) there exists a detailed plan of the first floor of the State Apartments quadrangle in the hand of Hawksmoor (fig. 129).[19] The quadrangle would have measured 233ft by 340ft, compared with the courtyard finally built which measures 310ft by 360ft. The plan shows a processional stair leading off from the Great Hall and two suites of lodgings meeting at the south-east corner. In this plan Wren replicated the precise layout of the old Tudor lodgings, more or less on the original site. Yet a fundamental change was its orientation. The Tudor house had been designed for easy access by the monarch from the river, whereas the new buildings were designed for access by road from the north. Unlike the Tudor closed courtyards, both the entrance court and the Grand Court were open-ended with ironwork screens providing security. The new Hampton Court would show itself to the world. Related to this plan is an elevation of the south front of the State Apartments (fig. 130).[20] The elevation clearly owes a debt to the south front of Versailles, having a rusticated ground floor with round-headed openings, a *piano nobile* with Ionic pilasters and a balustraded attic with statuary. This first scheme, although still owing much to the Tudor palace, was the closest Hampton Court came to Versailles. The drawings, and certainly the elevation, which is highly finished, were fine enough to be shown to the king and queen, and indeed probably were. But they were rejected and a second version of the scheme, with a plan and four related elevations, was prepared.[21]

128 Nicholas Hawksmoor, site plan of scheme 1 (i) of the early summer of 1689. Pen with some pencil under drawing. This is the earliest and most important drawing of the whole scheme for a rebuilding as first conceived.

129 Nicholas Hawksmoor, first-floor plan of the State Apartments quadrangle for scheme 1 (i) of the early summer of 1689. Note the bed positions.

130 Nicholas Hawksmoor, south elevation of the State Apartments, possibly a presentation drawing, highly finished in brown ink of the early summer of 1689. The scale is 20ft to 1in.

131 Nicholas Hawksmoor, site plan for scheme 1 (ii) of the early summer of 1689. Brownish ink with some pencil under drawing. Note that the position of the Long Water is included to position the new buildings in the landscape.

With scheme 1 (ii) the State Apartments decisively broke away from the Tudor disposition (figs 131, 133–6).[22] The plan adopted was entirely symmetrical, a novelty in English palace planning, since normally the size and extent of the royal apartments varied according to the relative status of monarch and consort. Now there was a joint monarchy and this scheme, like that ultimately built, recognised the equality of William and Mary spatially.[23] The entrance court led into the Great Court via archways on either side of the Great Hall, and from here the 'grand front' could be seen with its giant order and central entranceway surmounted by an equestrian figure of William and crowned by a dome (fig. 133). To either side of the central block lay two lower side wings containing the Great Stairs which led up to the King's and Queen's Apartments. Wren had already experimented in this manner at Winchester, where the dominant central portico surmounted by a dome contained stairs to the *piano nobile*. But the Hampton Court composition was infinitely more sophisticated, and larger. The staircases led to two identical suites of apartments on the north, south and east of the courtyard. Each was approached by a guard chamber in a corner pavilion, which led to an ante-room, presence chamber and privy chamber; in the eastern corner pavilions were the King's and Queen's Drawing Rooms. On the east front, joining in a gallery in the centre, were the rooms belonging to the Bedchamber (fig. 132).

The elevations show taller central and end blocks with attics, and lower, linking, intermediate sections without attics. In the corners of the courtyard are stair towers with pinched pepper-pot cupolas (fig. 134). The inspiration for this scheme is still French but more eclectic. The whole has moved on from Versailles and borrows elements such as the corner stair turrets from Bernini's third design for the Louvre engraved by Jean Marot (fig. 146). Both Louis Le Vau and François Mansart had used a pedimented portico surmounted by a dome and flanked by lower wings in their designs for the Louvre (fig. 137), and the Collège des Quatre Nations, which Wren admired when it was under construction, has the same device. Marot engraved Le Vau's schemes for the

A King's Great Stairs.
B King's Guard Chamber.
C King's Ante Chamber.
D King's Presence Chamber.
E King's Privy Chamber.
F King's Drawing Room.
G Ante Room.
H King's Great Bedchamber.
I King's Dressing Room.
J King's Little Bedchamber.
K King's Closet.
L King's Closet.
M King's Backstair.
N King's Private Stair into the Privy Garden.

a Queen's Great Stairs.
b Queen's Guard Chamber.
c Queen's Ante Chamber.
d Queen's Presence Chamber.
e Queen's Privy Chamber.
f Queen's Drawing Room.
g Ante Room.
h Queen's Great Bedchamber.
i Queen's Dressing Room.
j Queen's Little Bedchamber.
k Queen's Closet.
l Queen's Closet.
m Queen's Backstair.
n Queen's Private Stair into the Garden

O Chapel newly built.
P Tudor Great Hall retained.
Q Council Chamber.
R Ante Room to the Council.
S Closet to the Council.
T Drawing Room to the Council.
U Stool Room to the Council.

132 The first floor of the Royal Apartments as proposed in scheme 1 (ii) in the early summer of 1689. Drawing Daphne Ford.

133 Nicholas Hawksmoor, west elevation of the State Apartments quadrangle for scheme I (ii) of the early summer of 1689. Pencil with pen annotations. Note the human figure added for scale (which is 20ft to 1in).

134 Nicholas Hawksmoor, west elevation of the State Apartments courtyard for scheme I (ii) of the early summer of 1689. Pencil with pen annotations.

135 Nicholas Hawksmoor, south elevation of the State Apartments quadrangle for scheme I (ii) of the early summer of 1689. Pencil with pen annotations.

136 Nicholas Hawksmoor, east elevation of the State Apartments quadrangle for scheme I (ii) of the early summer of 1689. Pencil with pen annotations.

137 Louis Le Vau, design for the south façade of the Louvre, 1660–63, engraved by Jean Marot and published in 1676.

138 Nicholas Hawksmoor, elevation of the north side of the kitchen at Castle Howard 1700–01. Over ten years after the completion of the Hampton Court drawings Hawksmoor was using precisely the same technique for illustrating proposals for Castle Howard.

139 Nicholas Hawksmoor, site plan and survey of the Tudor palace for scheme II, from the early summer of 1689. Pencil with the outline of the Tudor palace pricked through for transfer. Note the setting-out lines for the Chestnut Avenue in Bushy Park. This drawing is the only survey of the Tudor palace and is thus a unique piece of evidence tying together the views of Wyngaerde and archaeological evidence.

140 Nicholas Hawksmoor, site plan and survey of the Tudor palace showing proposals for replacing the eastern quadrangle (scheme II). Note the close integration of the design of the gardens and the new façades. In this drawing the gardens have already achieved a layout close to that which was actually built in 1689–94.

Louvre, and Israel Silvestre engraved the completed Collège in 1670. The four elevations should be closely compared with Hawksmoor's later elevations for Castle Howard, where the same technique of providing an elevation with functional identifications was used (fig. 138). The draughtsmanship and handwriting are the same and it is clear that Hawksmoor also drew the second scheme. It will never be possible to disentangle the respective contributions of Wren and Hawksmoor to this design, yet a number of observations can be made that may help.[24] The first is that amongst the Hampton Court design drawings not a single sketch survives in the hand of Wren. This is strange, since if he conceived the scheme we should expect some drawn evidence to have survived. Pencil alterations and proposals on a number of Hawksmoor's finished drawings may indeed have been made by Wren, or possibly another senior figure in the office such as Talman. These include an enlargement of the north-west pavilion in the Grand Court on the ground plan for scheme I (i) (fig. 131). Alternatively, the Surveyor's preliminary sketches may have been regarded as rubbish once the final design was completed. One such sketch on the reverse of an uncompleted letter to the Lords of the Treasury survives for the Queen's Privy Lodgings at Whitehall. This chance survival may provide a clue to the genesis of the Hampton Court drawings, which were perhaps sketched in rough by Wren before being drawn by Hawksmoor. Yet scheme I (ii) is very sketchy, and looks itself like a preliminary idea. It is also very different in style from Wren's previous buildings, notably those most comparable in disposition, Chelsea Hospital and Winchester Palace. The likelihood is that the conception of these early schemes was Hawksmoor's own.

Whether William and Mary preferred the second variant to the first is unknown, but it is clear that they liked the concept of the great northern *cour d'honneur* because Portland instructed London to start on the planting of the northern avenue (now the Chestnut Avenue) immediately.[25] Before more than a dozen trees were planted, however, there was a change of direction. Everyone involved saw that either of these variants would take many years to complete, and, as we have seen, William felt it imperative that he should have a suitable alternative to Whitehall. Wren was thus instructed to start work on a second scheme that would see the retention of parts of the Tudor palace at least in the short term. Architecturally scheme II was a much more complex problem. Suddenly Wren's office had to take into account the Tudor palace and design the new buildings in relation to it. A survey was rapidly undertaken of the existing buildings. Three versions survive: two surveys showing the Tudor palace dotted and the proposed outline of the new royal apartments added in hard line (fig. 139), and a third finished plan, presumably for presentation, showing how the new apartments would fit with the Tudor palace and the surrounding landscape (fig. 140). All three, once again, are in the hand of Hawksmoor.[26]

No elevational information survives relating to these surveys, but we do have plans and elevations of the south and east fronts that relate to them (figs 142, 143).[27] On the south front the Tudor buildings to the west are shown in their final configuration and what appears to be a gallery linking the apartments with the rest of the palace is shown. There are five State Rooms, not six as in previous plans, and to the east of the Great Bedchamber are the King's Closets and Backstairs. These adjoined the Queen's Closets and Backstairs in the south-east corner pavilion. The east front contained four State Rooms (fig. 144). The elevations owe a clear debt to the east front of the Louvre as designed by Claude Perrault in 1668 and engraved by Jean Marot in 1676, an engraving to which Wren's office would certainly have had access (fig. 141).[28] Perrault's pavilions with their segmental attics were never built, and in Wren's design for the south front they are subsumed into the façade and support balconies. The central feature on the east

141 Design for the east façade of the Louvre by Claude Perrault, engraved by Jean Marot in 1676.

front echoes Perrault's central entrance (minus the uncomfortable porte cochère) with an order on the principal floor. The desire to create a dome is expressed in a concave drum. The second scheme is less successful than the first. The lack of height in the corner pavilions and the interruption of the balustrade by the segmental bays produce an uncomfortable effect, and the plan is confused and over-elaborate. Again the finished result is remarkably unlike Wren's previous buildings and may suggest the mind of Hawksmoor working independently.

THE FINAL SCHEME

The third and final scheme survives only as a set of presentation drawings. A preliminary design for the south front more closely modelled on the first scheme and the south front of Versailles prepares the way, but no plan accompanies it.[29] Any developmental sketches that may have been made have unfortunately been lost. This scheme (fig. 145) is closely modelled on the south elevation of Bernini's third design for the Louvre as engraved by Marot (fig. 146). All the elements of the Hampton Court design can be found there: the centrepiece raised on a rusticated plinth with a giant order, the mezzanine windows, the horizontal emphasis, and the statues on the parapet. The original effect of both the Hampton Court and the Louvre elevations has been marred by the nineteenth-century fashion for painting the window frames and glazing bars white. This leads to a dominance by the windows that were, in their original varnished oaken state, visually recessive and more akin to the drawings.[30] Writers on the design of these elevations often quote both *Parentalia*, Wren's biography written by his son, and John Macky's *Journey through England and Wales* to explain the low ground floor. In *Parentalia* it is stated that William excused his Surveyor for 'not raising the Cloysters under the apartments, higher; which were executed in that manner, according to *his* expres Orders'. John Macky adds that the lowness of the

142 Nicholas Hawksmoor, elevation of the south front of the King's Apartments for scheme II. These elevations are at 20ft to 1in.

143 Nicholas Hawksmoor, elevation of the east front of the Queen's Apartments for scheme II.

A King's Guard Chamber.
B King's Ante Room.
C King's Presence Chamber.
D King's Drawing Room.
E King's Great Bedchamber.
F King's Backstairs.
G Council Chamber?
H King's Gallery.
I Queen's Bathroom?
J Queen's Closet.
K Queen's Closet
L Queen's Little Bedchamber.
M Queen's Great Bedchamber.
N Queen's Drawing Room.
O Queen's Privy Chamber.
P Queen's Presence Chamber.
Q Queen's Gallery.

144 The first floor of the Royal Apartments as proposed in scheme II in the early summer of 1689. Drawing Daphne Ford.

145 (*above*) Nicholas Hawksmoor, presentation drawing showing the eastern elevation to the new quadrangle as built, 1689.

146 Bernini's third design for the Louvre, engraved by Jean Marot in 1676.

cloister was 'done for the conveniency of the king, whose constitution did not allow him to mount stairs'.[31] This trite explanation deserves closer examination, since it must be doubted that the asthmatic William would have altered the proportion of the façades of his palace in order to avoid an extra few steps. His asthmatic problems certainly did not seem to affect the design of any of his other residences, including the contemporary Kensington where the ground floor was at a higher level. The first scheme in both its forms has a ground-floor height of 16ft, which was reduced in the second and third schemes to 12ft 6in. The reason for this change is straightforward. Once the decision had been taken to retain the Tudor palace it was essential that the floor levels ran through from the chapel, hall and Tennis Court Lodgings. Thus the height of the ground floor was determined by its relationship to the Tudor building and not by William's health. The deleterious effect of the lower ground floor can best be seen in Fountain Court where the arches of the cloister conceal a lower arched vault within.[32]

The Tudor palace also affected the setting out of Fountain Court. The courtyard as finally built exists in relation neither to the external elevations nor to the landscape axes so crucial to the design process (figs 140, 225). This was undoubtedly another result of the need to harmonise the plan of the new buildings and the old, in particular to preserve the spinal axis through the Tudor gatehouses with the north walk of the cloister. Since Charles II's canal bore no relation to this earlier axis, the entrance to the east front was built off-centre to the courtyard. To disguise this Wren created two apses, one leading to the entrance vestibule in the east and a second adjacent one blind (fig. 253). In answer to criticisms that the internal elevations of the courtyard are overcrowded Kerry Downes has pointed out that the dense fenestration was probably a matter of deliberate choice rather than force of circumstance. The closely spaced windows produce an exciting and baroque external aspect and the Great Rooms (particularly the Cartoon Gallery) are as a result much lighter interiors than a small courtyard would usually allow.

It should, of course, be noted that none of the elevations bears much relation to the internal layout either in plan or section. A certain amount of trickery was employed to maintain the basic design unit – the *œil-de-bœuf* windows on the south front are blank, the central group painted with images of the *Four Seasons* by Louis Laguerre. In the courtyard another set of blank roundels were painted with the *Labours of Hercules*.[33] The plan of the rooms on the south front (fig. 175) was much more carefully formulated than in the previous two schemes. The king's and queen's apartments still met at the south-east corner, but their layout was determined by the placing of the King's Privy Chamber and Queen's Drawing Room centrally on each façade. Other than this the precise layout of the queen's side is not clear. On the king's side, however, Wren introduced a new element in English palace planning. The King's Privy Chamber was to open directly into the King's Gallery, where the doorway would be flanked by two fireplaces, thus bringing the gallery into the public domain. This was contrary to both English and French sixteenth-century practice, which had always restricted access into galleries, but in keeping with French late seventeenth-century plans in which they were rooms of parade. Wren had intended to build such a gallery for Charles II at Winchester, where the drawing room was to have led to a gallery and ante-room before the Great Bedchamber. Although Winchester was never completed, this arrangement clearly demonstrated Charles's intention of using the Great Bedchamber as his principal reception room with the Gallery and Ante-Chamber as rooms of assembly preceding it. The Hampton Court arrangement was directly based on the gallery at Versailles, which was approached from the king's *antechambre*, and signified Wren's intention of developing the innovations of Winchester.

The internal hierarchy was expressed externally through a stone frontispiece on the south front delineating the Privy Chamber. Stone embellishment also dignifies the two lesser entrances to the Orangery with rusticated entrances and carved achievements over the window pediments rather than more blank roundels. On the east front the central stone-clad centrepiece bears no relation to the size of the rooms within, but rather attempts to create a suitably impressive principal entrance to compensate for the loss of the northern *cour d'honneur*. The lowness of the entrance, additionally hampered by a decision to drop the sills of the window to allow for a balcony for the queen, fails to create a convincing entrance, although the pillared vestibule beyond makes a fair attempt at rescuing an unimpressive introduction to the palace. More distinguished by far is the stone masonry of the east front. The great tympanum carved by Caius Gabriel Cibber for £400, and the frieze linking the Corinthian capitals by Edward Pearce, show the vast improvement in English craftsmanship that had been stimulated by the Great Fire. Never before had an English royal palace enjoyed such superb stonemasonry.

DESIGN CONSIDERATIONS

The supply of Portland stone had, in fact, been a significant consideration in the design of the new building. At the outbreak of war, work at St Paul's had ground to a halt, since the shipmasters of the stone ships were either too frightened to sail from Portland or had had their crews decimated by press-gangs. In January 1690, with the help of the queen, Wren managed to obtain an exemption from the Admiralty to protect the crews of stone ships. Despite this and improved management procedures, supplies of stone remained extremely disrupted throughout 1690 and into late 1691.[34] Wren knew, as the design of Hampton Court progressed, that the more Portland stone was required the longer the building would take. This certainly ruled out many of the earlier stone-reliant proposals such as that illustrated by figure 133, and almost certainly affected the final design in the abandonment of the giant order on the east front and the minimal use of stone dressings. It also stimulated Wren to look elsewhere for stone supplies and the swags on the south front were ultimately made of Headington stone from Oxfordshire. Salvaged stone played an important role too. During the fire damage repair work of 1986–92 the parapets in the quadrangle were found to incorporate much reused Tudor stone, and some of the pilaster facings in Fountain Court were seen to be of reworked Tudor Reigate stone.[35]

Having considered influences from France, and the constraints imposed by the old palace and by the availability of materials, we should certainly examine whether William's extensive architectural works in the Netherlands had any effect on the design of Hampton Court. William and Mary had eight palaces in Holland. In The Hague William had four houses: the Stadtholder's Quarter in the Binnenhof (his official residence), the Oude Hof at Noordeinde, Honselaarsdijk and Huis Ter Nieuwburg. All of these had been built or rebuilt by William's grandparents, Frederik Hendrik and Amalia. In Gelderland William had inherited Huis te Dieren from his father. William himself had bought the estate of Soestdijk in Utrecht, had acquired the right to use Huis ten Bosch, and had built a new hunting lodge at Het Loo. Of these there is no doubt that Het Loo, the only palace built entirely by William and Mary, begun in 1685 and continued until 1702, is the most significant. Yet we look in vain to find many similarities between William's work at Het Loo and Hampton Court. Het Loo was started as a hunting lodge belonging to the Prince of Orange. Hampton Court was the palace of the king of three kingdoms, the home of 'His Majesty' rather than his 'His Royal Highness'. This distinction is crucial even after the remodelling of Het Loo when he became king. The two buildings were built for different purposes in different circumstances, and the parallels between them are few.[36]

On a lower level and a wider canvas, the architecture of the Low Countries had exerted an influence in England for as long as France had done.[37] After 1688 this was intensified, and the construction of Hampton Court was affected by such innovations as the introduction of Swedish limestone flags in the cloisters and elsewhere. This stone, very popular in Holland, was imported into England in Dutch ships and used for the first time in the late 1680s.[38] Yet little was brought to Hampton Court by the personal preference of William apart from the employment of Daniel Marot. Marot's influence will be considered below, but in December 1700 the King's Master Joiner, Charles Hopson, made a wooden model of the great staircase at Het Loo and delivered it to William at Hampton Court. This was presumably intended for Marot's use as he prepared designs for the great mural scheme there. Thus we can be sure that the designs for Het Loo and Hampton Court co-existed in William's mind.[39]

A consideration of whether there was a particular style belonging to the Office of Works may prove more fruitful in the search for influences on the Hampton Court design. Any discussion of this must take into account the effect of Wren's deputy, William Talman. He was involved in the building of two houses that prefigured the block-like silhouette of Hampton Court: Thoresby Hall, Nottinghamshire, and Chatsworth in Derbyshire. The genesis of the design of Thoresby is still an architectural conundrum. It was probably commissioned by William, Fourth Earl of Kingston, in 1683, and was largely completed by 1689. Soon afterwards a fire caused some damage to the original design and the building was reconstructed. Yet views of the house (fig. 147) clearly show similarities to the completed Hampton Court, especially in the use of a flat stone centrepiece on the principal front and the horizontal division of the façades with low attic windows. Both Hawksmoor and Talman contributed to the design, and amongst

147 Late seventeenth-century sketch of Thoresby Hall, Nottinghamshire.

the drawings from the Office of Works at All Souls, Oxford, is one for a new attic storey. The drawing is in Hawksmoor's hand and its existence proves a link between Thoresby and the Office of Works.[40] Another house with undoubted links with Scotland Yard is Petworth in Sussex, rebuilt by the sixth Duke of Somerset and completed around 1693. It too exhibits the horizontal emphasis of Hampton Court and was built mainly by workmen whose principal employment was with the Office of Works. The contract of the Joiner even specifies that the panelling should be modelled on the King's Gallery at Whitehall. Wren's measuring clerk at Hampton Court and elsewhere, John Scarborough, is recorded as having worked for the duke, and Hawksmoor's name appears in his correspondence. Petworth is too late to have influenced the design of Hampton Court, but its design may have emanated from the same stable. The south front of Chatsworth, an independent work by Talman, bears a less striking resemblance to Hampton Court, but exhibits similar principles in its roof line and fenestration.[41]

Thus it could be argued that Hampton Court sprang from a native school of design, apart from the undoubted influence of Bernini's third design for the Louvre, and that the final elevations were rooted as much in the country house practice of Wren, Talman and Hawksmoor as in the *Grand Marot*. Indeed, the sudden appearance of the final Hampton Court design in finished drawings, and so different in style from the previous schemes, suggests a radical change in stylistic direction between the first two attempts and the accepted third. We shall probably never know whether this change of direction reflected a change in the balance of influence within the Office of Works or the intervention of William and Mary. Yet the final design for Hampton Court, although credited to Wren, was drawn by Hawksmoor and bears a resemblance to the country house work of Talman and the Office of Works. The evidence does not (yet) allow us to attribute Hampton Court to Hawksmoor, but the finger points increasingly in his direction.

During the weeks that the Office of Works took to reach its final design, William and Mary were in residence at Hampton Court, living first in Charles II's Building Next to Paradise and later in the Tudor State Apartments overlooking Fountain Court. On Easter Day, 31 March 1689, they received communion from the Archbishop of York in the chapel, and the following day held their first council meeting at the palace. Although the design of the new building was important, war was uppermost in William's mind. Above all else William was a soldier, and he was motivated by a consuming desire to make war on Louis XIV who had inflicted a series of military humiliations on him. By the early spring of 1689, 100,000 Germans and Dutch were in arms along the Rhine and William was negotiating for England to join the Grand Alliance against France. In fact, war was declared on France after a Privy Council meeting at Hampton Court on 6 May. This was henceforth to be William's overriding concern. A close second came the unwanted demands of English politics that rapidly engulfed his attention. The diary of William's secretary, Constantijn Huygens, shows the king to have been frustrated, longing to return to The Hague to avoid the English and get on with war.[42] In these circumstances it was Mary who gave more attention to Wren, and *Parentalia* makes it clear that she examined the drawings and discussed the works with the Surveyor while William only 'occasionally' delivered his opinion. This is not to suggest that William had no interest in building – he accompanied Wren to Winchester in March 1694 to consider whether he should complete Charles II's palace there, and on returning from campaign always went to see the progress of his works. Yet, it is clear that Mary was the driving force behind Hampton Court.[43]

The Start of Work

When work started on the new building in June the pace was uncompromising and relentless. The quadrangle was constructed in stages, one side at a time, starting on the south. This range was built fastest, and was followed by that on the east overlooking the park, which rose more slowly but was still in place by the end of 1691. As the lead was laid on the roof of the east range so foundations for the range on the north were excavated, but work on constructing the north side only began in 1692 and was not complete until the middle of the following year. The demolitions followed a similar pattern, each area being cleared immediately prior to work starting. In preparation the Privy Garden was fenced and turned into a vast builders' yard with work houses and saw pits for the carpenters, a shop for the masons, a forge for the smiths, a rubbing house where the bricklayers were to fashion the fine brickwork, and a 'closet' for Wren (or more likely, Hawksmoor) equipped with a table.[44] The demolished and dismantled materials were carefully sorted and whatever could be reused was retained. The rest was either tipped into the moat, used to build up the wharf, fill ditches in the park, level and repair local roads and the Thames-side barge walk, fill old cellars, or build up Wren's private garden against flooding. The quantities of rubble were so great that even after the new foundations had been packed with the excess, hundreds of barge loads left the wharf to be dumped elsewhere. During repair work after the fire of 1986 lumps of Tudor stone and terracotta were found used as core-work in the walls and embedded in foundations. Excavations in the Privy Garden in 1993–4 revealed more.

Managing and supplying the materials was a massive task in itself. Old timber was sorted and stored in the Tennis Court, the Great Hall or in the horse guards' stables. Stockpiled boards were also brought from the unfinished palace at Winchester. Much was simply recut and put straight into the new building. Some of the joists in the Cartoon Gallery, for instance, came from the Tudor palace. Locating suitable timber for the roof sections was more difficult, because the war had led to the Admiralty using all the longest sections of good oak. Work at St Paul's was being delayed for the lack of good oak and Hampton Court could have suffered the same delays, particularly since the span of the south-front rooms required beams over 35ft long. The tie-beams of the trusses were eventually made of imported Baltic redwood, and oak was used only for the short upper members.[45] Bricks were not made on site but bought from suppliers in Twickenham and Vauxhall at a cost of between 17s and 20s a thousand. These and most other materials were brought to the site by barges which were pulled by horses on the barge walk from Kingston. Gravel, which was dug out on Hampton Court Green, was simply delivered in cartloads. Much of the Green was taken over for more workshops. At least ten buildings, some as large as 50ft by 70ft, accommodated blacksmiths, locksmiths, wheelwrights, paviours and carpenters.

148 Cross-section across the south range of the new quadrangle (the King's Apartments) showing the structural system. Other than the roof trusses and girder beams the timber structure is omitted. Drawing Daphne Ford.

One shed was used as a house of refreshment and doubled as a brewery and distillery; another was the home of the accounts office. Stockpiled materials and the enormous numbers of workmen encamped in and around Hampton attracted vagabonds, petty criminals and other 'vicious and idle people'. Wren was forced to order the demolition of booths set up opportunistically to provide drink in May 1690, and Hampton parish petitioned the king for help with meeting its Poor Law obligations. In 1694 the Crown granted the parish an annual sum of £50 to help it support the swollen numbers of sick and destitute drawn by the construction work. Neighbouring parishes too were affected by the works, especially East Molesey on the south side of the river. From here a ferry transported labourers to the Hampton Court landing stage for an annual fee of £2.[46]

Our knowledge of Wren's constructional techniques derives largely from the analysis of the south range after the disastrous fire of 1986.[47] A great central spine wall containing chimney-flues and stacks divided the range into two unequal parts. The State Apartments on the south were 34ft deep and were roofed by substantial queen-post trusses, with 37ft 6in. tie-beams set into the south elevation and the spine wall in lead-lined pockets (fig. 148). The rafters were braced by the use of Swedish wrought-iron brackets fixed by massive iron bolts. The 28ft 2in. wide king-post trusses were constructed in a similar way. In both cases the tie-beams were secured to the outer walls by wrought-iron cramps, and through the central spine wall to each other or to a metal plate. Wren decided that the queen-post trusses could also be utilised to support the floor below, and so wrought-iron rods 14ft 8in. long were fixed through straining beams spanning two trusses and bolted through the principal girder beams supporting the third floor (fig. 149). These were concealed within stud partitions at third-floor level. The rods brace the third floor, preventing the deflection or 'bounce' that such a wide span might have created. The floor structure of the third-floor rooms was constructed to provide sound insulation by creating a boarded compartment in the thickness of the floor to contain a 3–4in. depth of cockle-shell 'pugging' immediately beneath the floorboards (fig. 150). To prevent contamination of the pugging by debris dropping through the gaps of the boards, fillets were inserted beneath them. This method of construction was extended to the first and second floors of the palace too. In the State Apartments the floors were deeper with a greater allowance for pugging over kitchens and other service areas.

A stair that rose through the building, bypassing the State Apartments, serviced the courtier lodgings on the third floor (fig. 175). Wren was particularly anxious that it should not interrupt the plan of the royal apartments on the principal floor. He therefore located it in the line of the spine wall and reduced its width to a minimum

149 Diagram showing the method of supporting the third floor via metal rods supported by the roof trusses, concealed in partitions and fixed through the floor girder beams. Drawing Daphne Ford.

150 Cut away diagrams showing the two types of floor construction at principal floor level. The left-hand diagram shows the standard floor construction, and the right-hand one shows the alternative, deeper, structure allowing greater sound and fire insulation above service areas. Drawings Daphne Ford.

by framing it with giant vertical softwood posts. The framework was infilled with a very thin brick skin that held the cantilevered stone treads in place. The stair was lit at roof level by three lanterns. On the principal floor the rooms of state on the south front were divided by masonry stud walls carrying fireplaces and flues which were joined only to the central spine wall. Since the stud walls only spanned half the distance to the south elevation, wrought-iron tie-rods encased in timber stud partitions completed the span (fig. 148). This technique was employed, partly to save on time and unnecessary brickwork, but also to create small closets between four of the rooms in the thickness of the walls.

In constructing the new apartments Wren drew mainly on the established engineering knowledge of the Office of Works. It has long been known that Wren followed the example of Inigo Jones and John Webb in his use of king-post roof trusses braced with wrought-iron straps and shoes. In the King Charles block at Greenwich, Webb had used identical roofing techniques. Wren's use of the queen-post truss was more innovative and was born of his need to construct Hampton Court quickly. He had first experimented with the queen-post at the Sheldonian Theatre in Oxford in order to create a roof with steep slopes at the sides and a flat top. This idea was subsequently developed in several of the City churches. At Hampton Court the detail of the truss was developed further, allowing prefabrication to be dispensed with and allowing the truss to be made *in situ* (fig. 148).[48] Just how innovative was his use of transverse iron ties elsewhere in the building is open to question, since no other comparable structure has been dismantled in the way Hampton Court was in 1986–92. Yet it is known that he had the opportunity to examine the constructional techniques used by French engineers at the Louvre and some of their ideas find a reflection in Wren's work at Hampton Court. So it can be suggested that the systems were new, being designed to speed up the construction process. Hampton Court may thus have a place in the history of the development of building construction.[49]

★ ★ ★

The Collapse

The year 1689 ended disastrously for Wren. First, in early November, a section of roof at Kensington fell, bringing down with it walls and floors. One workman was killed and several more injured. To make matters worse, the queen had been there only a short time before. A greater calamity was to follow. On 11 December a much larger part of the south range of Hampton Court also collapsed, killing two carpenters and injuring eleven others. Understandably, Wren was upset and very 'troubled'.[50] On 30 December Wren told the Treasury that he was preparing a written report on the Hampton Court incident. The news was greeted with irritation and the complaint that they should have had one ten days before, since the king was now worried that the whole structure was unsound. Wren was reassuring on the last point, explaining that the building as it now stood was stable. As far as a report was concerned, he was determined to use a commission of retired master craftsmen to give an independent view, and told the Treasury Board that his report would be submitted on 6 January. On the 10th the reports of both Wren and the Comptroller, William Talman, were read to Lords Godolphin and Delamer of the Treasury in the presence of the king. Once they had been heard, Wren was called for, and he managed to persuade William that all was well. Cautious as ever, William gave the order to recommence works, subject to the Lords of the Treasury being satisfied that Talman's concerns had been fully addressed. Talman's concerns had not. Neither his report nor Wren's survives, but a verbatim transcription taken by the Treasury clerk tells us of the argument held in the Treasury chambers before Delamer and Godolphin, Sir Henry Capell and Mr Hampden on 13 January 1690.

On one side stood Talman with his expert witnesses, who had been well chosen to present Wren in a poor light. The first two were Jasper Latham, a distinguished monumental mason, and the great sculptor Edward Pearce, both of whom were working at St Paul's. Both Latham and Pearce were known to be arrogant and difficult craftsmen, and both were in dispute with Wren, who had complained to the Commissioners for the rebuilding of the cathedral about their performances. Then there was John Thompson, the City of London's largest mason contractor, also at work at St Paul's, who was probably motivated, with Latham and Pearce, by jealousy arising from the fact that the Hampton Court masonry contract had been awarded to a rival, another St Paul's contractor, Thomas Hill.[51] On Wren's side stood the chief officers of the Works, Matthew Banckes, the Master Carpenter, and John Oliver, Master Mason. The argument turned on whether the use of structural ironwork in the piers of the south front was part of the design or a later bodge, and whether the cracks there were hairline or material. Wren made the good point that since the building had withstood a great hurricane of the night of 11 January, which had felled houses and trees and killed dozens of people, it could hardly be in immediate danger.[52] Talman replied that the new structure was in the lea of the old palace and so was not affected by the winds. Ultimately the Treasury lords decided that the matter could be resolved by determining whether the piers were dangerously cracked or not and appointed their own committee to decide. Philip Ryley, Surveyor-General of Woods and Forests South of the Trent; Sir Samuel Moreland, the hydraulic engineer; and John Fitch, a well-known master bricklayer, made their way to Hampton Court. Their deliberations are lost to us, but Wren's point of view prevailed and work re-started.[53]

Research after the fire of 1986 also enabled a study to be undertaken of the reasons for the collapse and the precise area affected (fig. 151).[54] It is clear that by November 1689 the south range was structurally complete and that the roof had probably been leaded; only the third-floor internal partitions remained to be built. The Tudor east front was largely demolished and foundation trenches had been dug in preparation for construction of the walls. On 11

151 The south range of the new quadrangle (the King's Apartments) showing the area of brickwork that collapsed and the areas of brickwork that were built back. Drawing Daphne Ford.

December a 39ft section of the central spine wall collapsed down to first-floor level, bringing down seven chimney-stacks, twelve roof trusses, the roof and the third floor. The spine wall was structurally the key to the building, so its collapse would have been fatal. The cause was inadequately mixed mortar which, in the sub-zero temperatures of the coldest winter in memory, had not set. When work started on repairing the damage a mortar richer in lime was used for the 33 rods of brickwork that had collapsed, and 88 rods of brickwork that were still standing but were dismantled and rebuilt as a safety precaution. It is likely that excessive speed was the root cause of the accident. The mortar had probably been inadequately prepared and the lime not properly ground. The queen recognised that she therefore bore some responsibility and recorded in her journal,

> I was so unsettled at Holland House I could not do as I would. This made me go often to Kensington to hasten the workmen and I was too impatient to be at that place, imagining to find more ease there. This I often reproved myself for and at last it pleased God to shew me the uncertainty of all things below; for part of the house which was new built fell down. The same accident happened at Hampton Court. All this, as much as it was the fault of the workmen, humanly speaking, yet shewed me plainly the hand of God was in it, and I was truly humbled.

After the collapse, work continued at a slower pace, partly because of the disaster, certainly, but also due to difficulties with cash flow.[55]

The Water Gallery

While work continued on the main building Mary's attention was focused on the creation of a pleasure house for herself at the riverside. She chose the large and well-built Tudor watergate built in 1529–36 and used by successive monarchs as a riverside retreat (figs 92, 93, 99). Its last occupant had been the Duchess of Cleveland, who had created, in the 1670s, a dairy and bathing room there. The bathing room was probably contemporary with that built beside the Thames at Somerset House in 1674 by Catherine of Braganza; the dairy, however, was probably the first of its kind in England and was a direct imitation of the *grande laiterie* built near the royal menagerie in the gardens of Versailles in 1663. The *laiterie*, or dairy, was created by Louis XIV for his mistress Louise de la Vallière, and the duchess's imitation of it at Hampton Court is startling. Work must have been undertaken at her own expense because no accounts for its conversion survive, but since it appears in the Office of Works repair accounts from 1676 it must have been constructed after she had fallen from Charles's favour in about 1670. Thus her imitation of Louis XIV's work at Versailles in creating the Water Gallery can be seen as part of her continued campaign to be seen as the king's mistress-in-chief.[56]

The Water Gallery is of singular importance in William and Mary's time, being the only building completed at Hampton Court before Mary's death. It therefore not only provides a crucial insight into her taste, but also into her unrealised intentions for the main palace. The building was far enough removed from the chaos of the main site to provide a retreat for the queen. Only with hindsight can it be seen as having been a temporary measure – its eventual design was integrated into that of the gardens, and in 1690 it was certainly regarded as a permanent part of the palace. Work started straight away on a conversion that would transform its appearance. Although the core of the Tudor structure was maintained, all the windows were replaced with sashes, and a 17ft-high octagonal lantern was constructed at the south end. The battlements were removed and a terrace formed on the roof. The Tudor types were carefully restored, and towards the private garden two new niches, each 6ft high and 2ft wide, were made. The French sculptor and plaster-worker Nadauld was paid the large sum of £50 for moulded plasterwork in the Queen's Closet in the gallery, and sheds were made for him to burn his plaster in. This suggests considerable work to the internal ceilings. Nadauld later moved to work for Talman at Chatsworth, where his superb plasterwork friezes survive in the west sub-vestibule.[57]

On the ground floor what had been the duchess's bathroom was given a new boiler that allowed the queen to have hot running water. The bathroom had five massive sash windows 9ft 8in. high and 8ft 9in. broad, and so must have been a considerable size. 'Paper windows' were provided for the windows to give the queen some privacy and umbrellas (external awnings) provided to keep out the sun. The bricklayer made three niches in the room and there were three fireplaces with tiled breasts. Next door was a bedroom and a withdrawing room approached by an ante-room; all had new marble chimney-pieces. Nearby was a stool room. Also on the ground floor was the Queen's Dairy, newly tiled with delft tiles (fig. 152) and supplied with running water. One turret off the dairy was made into a grotto. The rooms were floored with flags relocated from the Building Next to Paradise. Not far away 'against the garden wall' was a kitchen with an oven and chimneys. On the first floor was a long gallery that ran between the turrets – this was given 524ft of Ionic cornice and sash windows. At the north end was a room overlooking the Privy Garden with new windows and the balcony removed from Charles II's New Building Next to Paradise. Above, on the leads, approached by a new stair and railed by an iron balustrade, was a viewing platform that allowed Mary to watch progress on the palace and garden to the north. To the south of the gallery was the great room next to the Thames with the balcony overlooking the river erected for the reception of Catherine of Braganza, which was dismantled, given new carved supports, and re-erected with a white marble platform. Additionally there was an ante-room and 'middle room'. The 'great room' over the Thames had two chimney-pieces with great picture frames above, and four closets in the corner towers, as well as a lantern on the roof. One of these was altered to a hexagon in December 1691.

The theme of the interiors was blue and white with some gold and gilded wood. The upstairs rooms were supplied with four large couches with seats and backs upholstered in leather with fringed covers of sky blue calico. There were also twenty-five cane chairs and four round stools with frames japanned in blue and white to match. A large cane table with a blue and white japanned frame was supplied, and another of 'middle size' with drawers in it for flowers. Blue and white curtains with deep blue and white tufted-crêpe fringe were supplied for all the rooms. A number of large framed mirrors were hung on the walls, and delftware sconces hung from blue and white silk cord with matching tassels lit the rooms at night. Both the Office of Works and specialist furniture suppliers delivered stands for china made in the form of 'halfe boys and foliage'. In the bedroom on the ground floor was a half-tester (or angel) bed with dolphin feet, decorated with rich silver laces and a crowned silver cipher. There were armchairs and stools to match. The cushions and pillows were of calico.[58] In the gallery hung a series of paintings commissioned by Mary from Godfrey Kneller, who was promoted by William and Mary to Principal Painter and Gentleman of the Privy Chamber, and was knighted in 1692. The commission was almost certainly in imitation of Mary's mother, Anne Hyde, for whom Sir Peter Lely painted the ten most beautiful ladies at court in 1662–5. Mary may have remembered them being painted and would have seen them at Whitehall before James moved them to Windsor, where they hung in 1690. In the Water Gallery Kneller's paintings were framed by blue and white painted picture frames.[59] Further paintings by the still-life and flower painter Jacob Bogdani were supplied in 1693–4 when a marble closet and a mirrored closet were created. Gerrit Jensen supplied glasses for the glass closet and delftware closet and for the bedchamber next to the bathing room. About the same time the queen created a print room with the 'finest prints' hung in neat black frames.[60]

Two descriptions of the gallery have come down to us. The first, written by Daniel Defoe in 1722–3 when in his sixties, recalls the Water Gallery in its heyday.

> The Queen had here her gallery of beauties, being the pictures, at full length, of the principal ladies attending upon her majesty . . . with a set of lodgings, for her private retreat only, but most exquisitely furnished; particularly a fine chintz bed, then a great curiosity; . . . and here was also her majesty's fine collection of Delft ware; . . . and here was also a vast stock of fine china ware,

the like whereof was not then to be seen in England; the long gallery, as above, was filled with this china, and every other place, where it could be placed, with advantage.

The travel diarist Celia Fiennes described the gallery as being

> decked with china and fine pictures of court ladies . . . beyond this came several rooms and one was pretty large [the gallery], at the four corners were little rooms like closets or drawing rooms one panell'd all with Jappan another with Looking Glass and two with fine work under panells of Glass.

Mary certainly used the gallery for dining during the last two years of her life, but rarely stayed the night. While the queen dined in the gallery itself the lords and ladies in attendance dined in the Bathing Lodgings, where two oval tables were erected, one for eight people and the other for twelve.[61]

Central to the decoration of the gallery was the extensive use of porcelain, lacquerwork, mirrors and delftware.[62] Daniel Defoe credited Mary with the fashion for calicoes, china and lacquer. However, we have already seen that Catherine of Braganza first brought lacquerware to Hampton Court and it is worth noting that the first Duke of Devonshire was constructing a mirrored and japanned closet at Chatsworth at exactly the same time.[63] Porcelain was no stranger to the royal palaces either; large quantities appear in Charles I's inventory and Charles II acquired and imported more. Defoe was incorrect to attribute this fashion to Mary, but was right to note the way in which it was integrated with the design of interiors as a principal decorative element – a subject of importance that requires closer scrutiny.

Daniel Marot

Long before William and Mary ascended the British throne the collection and display of porcelain and delftware had been a craze in the Netherlands.[64] William's grandmother Princess Amalia (d.1675) had a collection of 1,185 pieces, many of which were displayed in her 'gallery' and 'closet'. These displays were integrated with panels of lacquerwork imported by the Dutch East India Company, and of delftware made by factories in the Dutch Republic. When William and Mary began to create their new residence at Het Loo, the Dutch project of theirs about which we know most, such displays became a major feature of the interiors. They were co-ordinated and designed by Daniel Marot (1661–1752), a French Huguenot who had come to the Netherlands in 1685–6. He was the son of Jean Marot whose architectural publications loomed large on the bookshelves of Wren, Hawksmoor and Talman at Whitehall. Marot, a skilled draughtsman and designer, was fully conversant with the very latest fashions in French architecture, gardening, cabinet-making and interior design. He was to use his considerable skills in designing the interiors of Het Loo from at least 1692. Two rooms are particularly significant. The first is the room now known as the library but originally an 'Indian room' decorated with lacquered panels, piled high with porcelain and roofed with mirrors (fig. 153). The second is the 'little cellar' – a small vaulted room linked to a grotto and a private exit to the gardens. The cellar was created as a workroom where the queen could pursue ladylike activities such as the preparation of preserves and milk or the arranging of flowers. Such

152 Blue-and-white Delft tin-glazed earthenware tiles, probably from Hampton Court, designed by Daniel Marot. They were manufactured at Delft in the Netherlands at the 'Greek A' factory and marked with the monogram of its proprietor from 1686 to 1701, Adrianus Kocx.

153 William III's library (originally Mary's porcelain closet) at Het Loo, the Netherlands, etching by Daniel Marot, c.1712.

rooms were lined with Delft tiles for ease of cleaning, hygiene and decoration, and were filled with porcelain and delftware vessels. Rooms the decoration of which revolved around the use of delft, porcelain, mirrors and lacquerware, were also created at Honselaarsdijk, where a further refinement was developed. In a wing of the stable building Marot created for Mary a bathing quarter comprising a stoking room, a bath, a bedchamber and a closet. The interior was decorated in the Chinese style and doubled on occasion as a dairy.[65] Thus, Mary's development of the Duchess of Cleveland's Water Gallery into a pleasure pavilion rolled all the

imprint (figs 152).⁶⁷ In the 1990s a blue and white japanned table was discovered in a film studio in America, which can almost certainly be traced to both the Water Gallery and to the design of Marot (fig. 154). Compared with French furniture of the period, such as that provided by the Pelletier brothers (see below), it is very crude. But its crudity gives it a greater claim to authenticity, since it was almost certainly made by a London furniture-maker to a drawing by Marot. Indeed, a warrant to one Mr White for a 'pattern chair painted in imitation of china for our service at Hampton Court' is probably evidence that furniture was being made to unfamiliar designs. White is likely to have been Henry White, a 'cane chairmaker' of St Paul's Churchyard and Thames Street, and it is plausible that an established English craftsman should have been asked to supply a model of a chair to Marot's design for the queen. English ignorance of the techniques needed for the vocabulary of Marot's interiors was combated by his fellow Huguenots, who probably included the carver and plasterer Nadauld and the other furniture-makers and upholsterers who eventually furnished the King's Apartments.⁶⁸

More concrete evidence of Marot's involvement can be found in a drawing attributed to him for a ceiling – perhaps the only drawing to survive for the queen's Water Gallery (fig. 155). It shows a room with a fireplace on its short wall and a richly painted ceiling with a centrally crowned oval, presumably intended for a portrait. Its proportions do not accord with any room at Hampton

154 Table attributed to Daniel Marot, almost certainly from the Water Gallery at Hampton Court.

155 Daniel Marot, design for a ceiling, pen and ink with colour washes, c.1692–4. This drawing is likely to have been for one of the lost rooms of the Water Gallery.

elements from Het Loo and Honselaarsdijk into one. For Mary, as for the duchess, the inspiration was from France. Mary, and certainly Marot, looked to the Trianon de Porcelain built by Louis XIV for his mistress Madame de Montespan at Versailles in 1670 where, just as in the Water Gallery, anything that was not actually porcelain was painted blue and white to resemble it.⁶⁶

It is not known when Marot first came to England, but it can be argued that he followed his royal patrons soon after their arrival. The first documentation of his residence in London dates from October 1694, but it suggests that he had been in London for some time before. Marot held no official position in England, but until the queen's death he formed part of her private household and was remunerated from her privy purse. Given the work he had done for Mary in the Netherlands, it would seem that Marot must have been behind the interiors of the Water Gallery. No English designer had the experience to create such a series of rooms for the queen. Additionally, a number of delftware tiles and tulip vases associated with the gallery bear his unmistakable

156 Daniel Marot, design for grotesque ornament, pen and ink and black chalk on paper, c.1690.

157 (*right*) Embroidered panels possibly executed by Queen Mary II and her ladies to the design of Daniel Marot, c.1690.

Court, nor with any surviving interior at Kensington Palace. The most likely of the possible lost interior for which it may have been intended is the Water Gallery.[69] If we are to accept that Marot had a hand in the decoration of the Water Gallery it seems likely that he would also have been asked to provide designs for the main palace. A second design for a decorative panel in the grotesque style also attributed to Marot suggests that he did so. The drawing is closely associated with a set of embroidered panels now hanging in the room known as Queen Mary's Closet at Hampton Court. These panels were almost certainly embroidered by Mary II and her ladies to Marot's design (figs 156, 157). As early as 1690 Mary had had a room set aside at Whitehall next to her closet for her embroiderers to work in; it was probably there that the Hampton Court needlework was made.[70] After Mary's death William hung the embroideries in the corner closet where around 1702 they were seen by Celia Fiennes, who described them as being 'all of satten stitch done in worsteads, beasts, birds images and fruites all wrought very finely by Queen Mary and her Maids of Honour'.[71]

Grinling Gibbons and Nicholas Hawksmoor

By 1692–3 the question of the design of the interiors of the new building would have been raised, and in Sir John Soane's Museum there is an album of drawings, usually attributed to Grinling Gibbons, said to be for William and Mary's Hampton Court. Both these traditional assumptions should be looked at closely. The album contains twenty-seven drawings of chimney-pieces, the elevations of a small room, some designs for friezes and a few other miscellaneous interior designs (figs 158, 160, 162–6). Albums of engravings of chimney-pieces and wall elevations were common in France from the 1650s onwards, but in England this group of drawings is unique.[72] That the drawings are connected to Hampton Court is certain because the room elevations have the dimensions of Queen Mary's Closet; one of the frieze designs matches the frieze in the King's Great Bedchamber; and two designs for overmantels exhibit a very close likeness to executed work in the State Rooms. That they were done before Mary's death in 1694 is certain too, because several designs bear the W&M monogram. In all, there is little reason to doubt that these drawings were designed for Hampton Court some time before 1694.[73] Their attribution to Gibbons requires closer scrutiny. The outlines of his career are well known and so they will only be briefly repeated here.[74] Although he was the son of a London draper, Gibbons was brought up in the Netherlands and trained in the rich seventeenth-century tradition of boxwood carving of which Albert Jansz Vinckenbrinck was the leading exponent. He was discovered by John Evelyn at work in a cottage in Deptford in 1671 and introduced by him to Charles II, Wren and Hugh May. Gibbons's success was not instant. In fact, Wren continued to rely

158 Grinling Gibbons, designs for limewood carvings for the Presence Chamber and Bedchamber at Hampton Court, c.1693–4.

159 Grinling Gibbons, design for a monument at Clifton upon Teme, Worcestershire, 1689. One of the few authenticated drawings by Gibbons.

on a group of tried and tested carvers and craftsmen until after Hugh May had used Gibbons at Windsor Castle in 1678–9. By this time Gibbons was an established carver with two apprentices, a country house practice and a house in the fashionable artists' quarter of Covent Garden.

In November 1693, as Mary's attention turned to the design of the interiors of Hampton Court, William appointed Gibbons Master Carver in place of Henry Phillips. In doing so he overlooked the most obvious candidate, William Emmett, who had, until that point, had the lion's share of the carving work at Hampton Court, Kensington and Whitehall.[75] That Gibbons should have scooped the top job from under Emmett's nose is astonishing. Although Gibbons was given no part in the decoration of the Water Gallery, Mary's most important Hampton Court work, he had been one of the team of carvers working for her at Kensington in 1691 with Emmett and Nicholas Alcock. In 1691 in the Queen's Bedchamber Emmett carved an overmantel with the 'king's armes and supporters with the garter and imperial crown'. In the Queen's Gallery Alcock carved a piece incorporating the king's arms, the garter and imperial crown, with two boys holding trumpets at the top and a lion and unicorn crouching below. Both sound remarkably like the Hampton Court designs and quite unlike anything Gibbons had produced. Gibbons had been responsible for carving the surviving overmantels in the Queen's Gallery at Kensington, a similar one for her closet and one 'on a gold ground' for her dressing room. He had also made two marble chimney-pieces (now lost) for the queen's private apartments at Whitehall incorporating figures, a relief panel and cornucopias.[76]

It was perhaps Gibbons's experience of working for the queen that won him the post as leading carver at court. But it is likely that a combination of other factors was relevant – William liked the fact that he had trained in the Netherlands and spoke Dutch; he continued to have powerful supporters at court – but most important must have been his talent. That the Hampton Court Album should be attributed to a carver is perhaps surprising, especially since the drawings in it bear little resemblance to any of his known work. The chimney in the King's Closet at Hampton Court with carvings by Gibbons, and the chimney by John Nost now in the Queen's Gallery there, are the only decorative elements of William's fitting-up of the interiors of 1699–1700 that bear any resemblance to the 1693 designs. Indeed, the only surviving carved works of the period in England similar to the Hampton Court drawings are the screen to the Morning Chapel at St Paul's cathedral, executed by Jonathan Maine in 1699, and the overdoors to the Chapel Gallery at Chatsworth by Samuel Watson. Yet we know that Gibbons could draw – there are about a dozen drawings that can be safely attributed to his hand. The safest are the three that have his handwriting: two for overmantels at Hampton Court (fig. 158), and one for a monument at Clifton upon Teme, Worcestershire (fig. 159).[77] We should also feel confident about the large-scale woodwork drawings for the choir stalls at St Paul's. In addition to these Gibbons is known to have produced full-size rod drawings for his team of carvers.[78] The central question concerning the Hampton Court Album is therefore not whether Gibbons was capable of drawing the sculptural elements, but rather whether he had the ability to draw the architectural ones. If it were possible to attribute to Gibbons the entirety of the drawing, a substantial case could be made for his having designed the whole of the interiors of the apartments at Hampton Court and more. In addressing this question a small group of drawings are pivotal. First, the two designs for overmantels in the Bedchamber and Presence Chamber (fig. 158) – the only two drawings for Hampton Court that we can be certain are entirely by Gibbons. These have conspicuously sketchy and basic architectural elements – just enough to size the carvings. This lack of architectural context is significant when they are considered next to one of the elevations for the Queen's Closet (fig. 160). This drawing is largely by Hawksmoor – it bears his handwriting and the architectural elements are recognisably in his style, yet the drawing of the carving appears to be in the style of Gibbons. This division of design responsibility is familiar from the St Paul's cathedral drawings in which, in precisely the same years, Gibbons embellished Hawksmoor's drawings of the architectural framework with sculptural elements (fig. 161).[79] With this in mind a closer

160 Nicholas Hawksmoor with possible additions by Grinling Gibbons, design for the north elevation of the Queen's Closet. Pen and wash with pencil annotations and alterations. The drawing bears Hawksmoor's handwriting and distinctive penmanship – note especially the scroll on the left-hand side of the upper part of the chimney-piece.

look at the chimney-piece elevations in the Hampton Court Album reveals that the technique for showing the architectural elements can be very closely paralleled in the work of Hawksmoor – particularly his use of wash to give three-dimensionality to the elevations. In noting this we should also remember that Hawksmoor was quite capable of drawing the sculptural elements himself. Drawings for the tympanum on the east front show the same fluidity of composition as the Hampton Court Album drawings (fig. 145). Indeed, a drawing such as folio 57 (fig. 162), inscribed by Hawksmoor 'Inside of ye king's bedchamber', raises the question whether many of the carved elements in the album might not be drawn by him too.

That Hawksmoor and Gibbons may have been working together on a series of designs for Hampton Court should not surprise us. Once in post as Master Carver, and with the Hampton Court works nearing fitting-out, Gibbons would have had to work closely with the Office of Works team. We have already seen that this team, although led by Wren, relied entirely on Hawksmoor for draughtsmanship and probably for much authorship too. Drawings dating from 1693–4 for Hampton Court are all in Hawksmoor's hand. What could be more likely, therefore, than that Hawksmoor and Gibbons should have collaborated, as at St Paul's, on the designs for the internal woodwork? The results of this postulated collaboration, although beautiful drawings, were largely a group of unsatisfactory and cluttered interior designs. A small number are balanced architectural compositions, but most display an uneasy relationship between the carving and the architectural framework. Folio 26 (fig. 163) succeeds in creating a heroic, if

161 (*above*) Nicholas Hawksmoor and Grinling Gibbons, elevation of a small organ case under an arch for St Paul's cathedral. Pen and ink and wash, *c*.1693–4.

162 Nicholas Hawksmoor design for a doorcase for the King's Bedchamber, *c*.1693–4. Pen and ink and wash.

slightly top-heavy composition; folio 47 (fig. 164) is more typical in combining a standard Office of Works chimney-breast and chimney-piece with an over-scaled and impractical urn. In folio 23 (fig. 165) upholstery and porcelain engulf the overmantel, oppressing a modest fireplace. Perhaps the only room that was really successful was the design for the Queen's Closet (fig. 166), where Hawksmoor and Gibbons succeeded in producing a design of harmony and beauty, seamlessly combining the internal oak framework with limewood carving and lacquered panels. The ambition of the drawings should not, however, be underestimated. The use of colour and texturing indicate that many of the designs incorporate elements other than limewood, including blanc-de-chine and blue and white porcelain and lacquerwork. Upholsterers' work may be indicated too, including both tight-hung and swagged damask, some with fringes and tassels. This is very much in the manner of Marot's engravings (fig. 167), and other published French fireplace designs such as Jean Le Pautre's *Cheminées à la moderne* of 1661 (fig. 168), where the technique of splitting the drawing to show alternatives is also adopted. The iconography is interesting too. Elements include medallions of St George; the Garter star; the joint crowns and initials of William and Mary; the crowned Garter; a crowned St George in a garter; the *Judgement of Solomon* with a Garter and a crowned medallion of Charles I; and in one case a bust of Charles I.

★ ★ ★

163 (*above left*) Nicholas Hawksmoor and Grinling Gibbons, design for a triumphal chimney-piece, *c.*1693–4. Pen and ink and pink and gold wash.

164 (*above right*) Nicholas Hawksmoor and Grinling Gibbons, design for a chimney-piece with a monumental urn, *c.*1693–4. Pen and ink and coloured washes.

165 (*left*) Nicholas Hawksmoor and Grinling Gibbons, design for a chimney-piece with porcelain and upholstery work, *c.*1693–4. Pen and ink and coloured washes.

166 (*facing page top*) Nicholas Hawksmoor and Grinling Gibbons, design for the elevation of the north wall of the Queen's Closet,, *c.*1693–4. This beautiful drawing shows more clearly than any other the respective contributions of Hawksmoor and Gibbons.

167 (*facing page bottom left*) Daniel Marot, design for a chimney-piece from *Nouvelle cheminées faittes en plusiers en droits de la Hollande et autres provinces*. On the title page of the book Marot describes himself as 'Architecte des apartements de sa Majesté Britannique', and the fireback in the design displays the royal arms of England.

168 (*facing page bottom right*) Jean Le Pautre, design for a chimney-piece from *Cheminées à la moderne*, 1661.

Progress of Work to 1694

While work pressed on, William and Mary continued to occupy the Tudor part of the palace where the heavily pregnant Princess Anne joined them in July 1689. Anne had hoped to be granted Richmond Palace, but was forced by William to come to Hampton Court for the birth. In the Princess's Lodgings, far from the demolition of the south front, she gave birth to a son on 24 July, surrounded by the ladies of the court and waited upon by a large number of 'persons of quality'. The child, named William after his uncle, was immediately made Duke of Gloucester and was christened in the chapel on the 28th with the king as godfather. Amidst the celebrations accompanying the birth of a Protestant heir came news of a Catholic plot against William. Orders were given to double the number of guards, and several companies of infantry and cavalry were posted round the house. Six sentry boxes were also provided and stationed at the principal entrances to the palace. In fact, William travelled nowhere without a substantial bodyguard: the Household Guard of regular soldiers was made up of nearly 2,500 men comprising two regiments of foot guards and three troops of horse guards. One of William's first actions at Hampton Court was the construction of purpose-built guardhouses for the foot- and horse-guard troops on duty. Foundations for these were dug in May 1689; by August the roofs were lifted and the two buildings were completed by the end of the year (figs 196, 261). In May 1700 a three-bay sutlery was built linking the two barracks.[80] Although the original intention was probably to use the guardhouses only during court visits, soon the idea for a permanent guard at Hampton Court grew. James II had formed the Corps of Invalids in response to William's threatened invasion. One company of fifty privates plus officers and NCOs had been sent to Hampton Court in 1688, but were disbanded when William arrived. The idea was too good to be abandoned in time of war, and so in 1692 William formed a company of 168 Pensioners, 46 of them from Chelsea Hospital, and sent them to Windsor to be on permanent duty there. This was a good way of making more space for the numbers of invalids swelled by William's wars, as well as providing a guard for the castle. In 1694 it was decided to create three more companies, one of which was to be sent to Hampton Court on a permanent basis. In 1698, following the peace of Ryswick, the size of the Hampton Court company was increased by an influx of 'maimed and decrepit' soldiers to equal the number of the company at Windsor. At the end of the reign the corps was made up of a hundred and fifty private soldiers, two drummers, six corporals, six sergeants, an ensign and two lieutenants, under a captain.[81]

Although no threat materialised in 1689, William's popularity, even with the Protestant majority, was not high, and his work at Hampton Court was frowned upon. For many it demonstrated not only a desire to live away from the heartbeat of Westminster, but also insensitive and hasty extravagance on the part of a newcomer who was also requesting funds for war.[82] At the end of September, in an attempt to recapture his initial popularity, William spent a few days at Newmarket where he held open house. He enjoyed both the racing and the clear air, and made a favourable impression on his subjects, but was soon drawn back to Hampton Court, where preparations for the court's return to the metropolis was underway. On 7 October packing began, and on the 16th the king and queen moved with their remaining goods to Holland House (which they had borrowed until Kensington should be ready) to spend the winter.[83]

William and Mary did not return to Hampton Court until 31 May 1690, just before William left for Ireland to meet his father-in-law in battle at the Boyne.[84] The king was away for three months during which the twenty-eight-year-old queen faced Jacobite risings, the threat of French invasion, an incompetent navy and an empty Treasury. No wonder she wrote to her friend Agnes van Wassenaer-Obdam, 'you have to know that during the absence of the King I have not had time to take care of the building here at Hampton Court'. Yet she managed to visit on 12 July, observing to William in a letter that 'things go on there very slowly, want of money and Portland Stone are ye hindrances . . . especially since the French are in the Channel, and at present between Portland and us, from whence the stone must come'. A little under a month later the queen paid a second visit, fearing that work would not be much advanced.[85]

William returned triumphant on 10 September and went straight to Hampton Court where Mary joined him for an emotional reunion. They visited the buildings at least seven more times that year. The pattern in 1691 was similar, with William leaving to campaign in Flanders. He returned briefly on 15 April and only two days later the royal couple went to Hampton Court to inspect progress. William then left for the Netherlands, where he remained till mid-October. The queen meanwhile paid short visits all summer and took the king down only five days after his return. Carpenters twice made special walkways to allow the pair to inspect the work. In the following year there was little change to this routine with William away in the Netherlands between early March and October. While he was away the queen again went out to Hampton Court to watch the work and enjoy the Water Gallery. She wrote to a friend in November after William's return, 'I have made little excursions to show him the building at Hampton Court.'[86]

Once again in 1693 the king was abroad between March and October. The burdens of government rested particularly heavily on Mary's shoulders that summer, with the French capturing a valuable merchant convoy and the queen facing the consequences of cabinet incompetence. For her health, as much as anything else, Mary went to Hampton Court on 17 February, 20 May and 27 May. In June she wrote from Whitehall to a correspondent that 'the king has began a great building and large gardens, 'tis at so convenient a distance from this place, I go to it with ease in two hours time'; ten days after the king's return he went down to Hampton Court for a morning to see what had been done.[87] Sadly, the fulsome accounts preserved in the Public Record Office only survive until March 1692, and from then on the progress of work has to be deduced from other sources. The most important of these is an estimate almost certainly belonging to December 1693, setting out what remained to be done. A fair amount of external work was still outstanding on the queen's side, especially carpentry, plastering and glazing. But the largest tasks were the construction of the gallery that was to link the king's and queen's sides on the west side of Fountain Court, known as the Communication Gallery, and the great stairs to the two suites. Internally there was still £3,900 to be spent on the king's state apartments, £5,900 on the queen's, £1,800 on Prince George's, and £1,400 on the Orangery and its grotto. This did not include the seventy-two smaller rooms for courtiers on the third floor and

mezzanines that would cost a further £2,880. Nor did it include miscellaneous external works in the courtyards worth another £4,685. In all another £35,315 was required.[88]

Work pressed on into 1694, and on 17 March, when the king was hunting, the queen went to Hampton Court to inspect the works. She visited again on the 31st. At the beginning of May William left for the Netherlands and only returned in November. During his absence Mary visited twice, on 2 June and again on 18 August. This exhaustive chronicle of royal movements serves to demonstrate two facts. The first is that when William was in England he took a great interest in the work; but more important is that he was always away for the building season, and that the supervision of works rested heavily on Mary's shoulders. What is quite clear is that up till her death Mary was actively involved in devising improvements for the palace. She had certainly begun to order the soft furnishings in late 1694 – the upholsterer Richard Bealing, for instance, was paid for three journeys to Hampton Court to take orders from her.[89] Three drawings by Hawksmoor dated September 1694 show that she was eager to create a bridge from her closet to the terraces of the Privy Garden to give her direct access from the first floor to her beloved gardens (fig. 169). Another drawing of this time, again probably in Hawksmoor's hand, is for a grotto in the Orangery. This was partly inspired by her grottoes in Holland, and was modelled on Louis Le Vau's grotto of Tethys at Versailles which had been engraved and published by Le Pautre in 1676.[90]

While the royal apartments progressed at speed Wren and the design team addressed the problems of harmonising the Tudor parts of the palace with the new. In 1691 a great new portal 11ft high and 6ft wide had been erected to create a satisfactory passage between the two courtyards, surmounted by a trophy and the words GVILIMIVS ET MARIA R. ET R (fig. 195). Soon afterwards Wren proposed a solution to the unpromising entrance to the King's Stair from Fountain Court. The lowest and least impressive of the Tudor buildings lay on the south side of the courtyard at just the point where important visitors would enter the new apartments. Being stuck with the Tudor range, Wren proposed a high screen-wall fronted by an Ionic colonnade, and topped with more trophies carved by Cibber (fig. 170).[91] Wren had longed to use a giant order in his preliminary Hampton Court schemes. As we have

169 Nicholas Hawksmoor, plan and elevation for the Queen's Terrace, 1694. Pen and ink and coloured washes. This design would have linked the Queen's Closet with the Privy Garden.

170 Nicholas Hawksmoor, drawing for the Ionic colonnade in Fountain Court.

seen, part of the reason for their failure to be realised was the extreme problem that Wren was having with obtaining Portland stone. Yet for the colonnade, the main entrance to the palace, the materials simply had to be found. Again the inspiration was France. Mansart had used coupled Corinthian columns in several of his Louvre projects. Here, however, Wren was looking to Versailles and Mansart's open Ionic colonnade at the Grand Trianon at Versailles completed in 1687 (fig. 171).

In December 1694 the queen contracted smallpox, the infection that had so nearly killed William and his companion Portland, and had killed both of William's parents. To William's intense grief Mary died at Kensington on the 28th. The whole nation was immediately plunged into deep mourning led by

171 The garden front of the Grand Trianon, Versailles.

William and the court. On 13 January orders were given for the Household to drape their coaches in black and dress their servants in black livery. At Hampton Court the pulpit, altar, altar cushion, bibles and prayer books were covered in black cloth, and black coats of mourning made for the bell ringers.[92] Work there almost immediately ground to a halt, partly because of William's grief, partly through the lack of Mary's supervisory skills but also through a lack of finance. That Hampton Court should have been built at all is remarkable given the financial climate of the early 1690s, and Mary had admitted as much to William in a letter of July 1690.[93] In 1689 the king and queen had been granted approximately £940,000 a year for four years. This was at least half a million short of what was required to run the Household, and did not make provision for the £200,000 required annually to service the war debt. On this inadequate sum William restored 1,300 household places, swelling the size of the court to double that of James II and vastly increasing its costs. At the same time, as we have seen, William purchased Kensington House for 18,000 guineas and launched the rebuilding of Hampton Court. By the queen's death £131,000 had been spent there and £92,000 at Kensington, not including a further £83,000 on gardens. William and Mary were spending twice what Charles II had done at his most extravagant. By 1695 the salaries of servants below stairs were sixteen months in arrears, and the staff were in a desperate state. Stopping work at Hampton Court was thus as much a financial necessity as an emotional response to the queen's death.[94]

Work Restarts

THE CARTOON GALLERY

For three years after Mary's death work at Hampton Court was frozen. When William went to the country for hunting it was to Windsor that he turned. Work had begun on major improvements in the parks and gardens there, and the famous French gardener André le Nôtre was invited to submit designs. Meanwhile at Hampton Court James Marriott, the Housekeeper, kept a close watch on the interiors, letting visitors such as Celia Fiennes see the empty barn-like spaces maintained by the Office of Works at minimum cost. But from the summer of 1697 a wind of change began to blow. William attempted to negotiate a European peace that finally broke out after the signing the treaty of Ryswick in September. The ending of the war eased William's financial situation, and Parliament finally granted him a permanent, unencumbered civil-list revenue of £700,000 per anum. William, now able to focus on his Household, began to prune its size, determining to remove at least fifty posts, including one of the two Wardrobe keepers at Hampton Court.[95] William's thoughts now turned to building, and orders were given to restart work at Hampton Court. Indeed, even before the treaty was signed, scaffolders were at work on the king's and queen's stairs. As orders were given to start, the Clerk of Works, Henry Simmons, died and was replaced by John Ball, the son of the former clerk at Windsor. He had been ejected from his official house by William's building works there, and was given the clerkship at Hampton Court in compensation.[96] Apart from this change, as the building season arrived in spring 1698, Wren recommenced work with the same team as he had had four years earlier. There are no detailed accounts for the first

184

172 The Cartoon Gallery: 'A draught of the famous gallery at Hampton Court describing the order in which the seven cartoons are placed', S. Gribelin, 1720.

year's work, but we know that over £7,500 was spent. Of this £5,000 was laid out on stockpiling materials, and more than £1,600 on task-work. Of this the largest part must have been the work on the King's Gallery.

The most pressing task, it seems, was to make a decision about the decoration of the gallery, and the winter of 1697 was devoted to considering how to incorporate Raphael's cartoons, the *Acts of the Apostles*. In 1623 Charles I had acquired the cartoons, which had been painted on paper in 1516 as designs for tapestries for Pope Leo X's Sistine Chapel. Since that time they had been stored in strips at Whitehall and only occasionally viewed.[97] In March 1689 William ordered that the large case containing them be delivered to the Removing Wardrobe, and not long after he had them unrolled at the Banqueting House. Huygens was delighted when he first saw them laid out on the floor, calling them 'admirably fine, far excelling the prints after them of the best masters'. William and Mary immediately decided to take them to Hampton Court for the new building. On 4 May 1691 Huygens reported that Parry Walton, the Picture Restorer, had 'been ordered by the Queen to have the patterns of tapestries by Raphael appropriated to be hung in the gallery ... with sarcenet curtains in front of them which could be raised and lowered'.[98] It is not obvious in which gallery it was intended to hang them, since at that point both the King's and the Queen's Galleries were too small.

The cartoons were glued together into large sheets and put on stretchers sometime between 1691 and 1693 at Hampton Court, and were erected in the shell of the King's Gallery in June 1697. In November of that year Christopher Hatton reported that he

173 First floor of the new quadrangle as completed in 1702. Drawing Daphne Ford.

A: King's Great Stair
B: King's Guard Chamber
C: King's Presence Chamber
D: King's Eating Room
E: King's Privy Chamber
F: King's Withdrawing Room
G: King's Great Bedchamber
H: King's Little Bedchamber
J: closet
K: closet ('Queen Mary's')
L: King's Back Stair
M: King's Gentlemen of the Bedchamber.

Rooms left unfinished since Queen Mary's death in December 1694.

had 'this day ... been at Hampton Court, but ye sight that best pleased me was ye cartoons by Raphael wch were far beyond all ye paintings I ever saw. They are brought from ye Tower and hung up ther and are copying for my Lord Sunderland.' While the painter Charles Jervas copied them, John Norris, the King's Picture Framer, was measuring the gallery for panelling and framing. Jervaise completed his work and took his drawings to Paris, where they were to be engraved by Gérard Audran. Meanwhile, the doors of the gallery were enlarged to allow the cartoons, now on wooden stretchers, to be removed to the chapel, where they were stored until the gallery should be ready for them.[99] The gallery, in fact, needed considerable remodelling, indicating that the original intention had been to hang them elsewhere. In the summer of 1699 the barrel-vaulted plaster ceiling inserted in 1691–2 was demolished and a new coved ceiling put up. The springing point of the new cove was 4ft 2in. higher than the original ceiling, creating enough space for the cartoons (fig. 172). The central doorway to the Privy Chamber was bricked up and a new low fireplace put in its place. A new door was made through the spine wall to the King's Bedchamber. The whole room was then fitted with panelling and carving. The gaps for the paintings were wainscotted before the cartoons were put in place. Even then the great sheets needed easing and trimming. Each one had a green silk curtain hung from a gilded rod to protect it from the light. Work on the gallery had a significant impact on the Privy Chamber on the south front. This now required remodelling with a single central fireplace on its north wall. These changes radically altered the circulation arrangements of the King's Apartments. The Cartoon Gallery, previously a room of display along the lines of Versailles, was now a private space only approached from the King's Bedchamber in the Tudor manner, whilst the Privy Chamber was now part of the axial enfilade to the bedchamber without access to the gallery (figs 173, 175).

APARTMENTS FOR THE KING'S HOUSEHOLD

In addition to the consideration of what became the 'Cartoon Gallery', work was almost certainly underway on fitting-out the upper rooms in Fountain Court for the courtiers. This was a pressing need since in January 1698 Whitehall was engulfed by a massive fire that destroyed not only the King's Apartments but also the lodgings of all the courtiers and officers of the household. Only Scotland Yard survived unscathed. None of the later detailed accounts covering the period 1699–1702 shows expenditure for fitting-out the upper rooms in Fountain Court. It therefore seems likely that with a crisis of accommodation in the royal household the work would have been completed by March 1699, and included in the lump sums in the enrolled accounts of 1689–9. Work during 1699, for which detailed accounts do survive, concentrated on repairing and improving lodgings in the Tudor palace. The Lord Chamberlain, Shrewsbury, and his secretary Sir John Stanley, began to concentrate on the distribution of lodgings in late 1699. In December Wren had all the old lodgings in the palace surveyed and started on a plan for the new ones. Stanley meanwhile set about producing a draft accommodation strategy, assigning rooms to those attendants the king wished to lodge.

174 William III's building campaign of 1689–1714, showing excavated and extant features in black line. Drawing Daphne Ford.

Shrewsbury was ill and in the country, and decided to give Stanley the authority to distribute the lodgings himself. The king clearly took an active interest in the final distribution, ordering, for instance, that Lord Rochfort should have ground-floor rooms since he was lame, and that Dr Ratcliffe should have two rooms. Inevitably, Stanley's job was a thankless one and his efforts aroused as much discontent as satisfaction. Sir John Lowther, Lord Privy Seal, surprisingly disliked the lodgings assigned to him in the new quadrangle, finding the rooms too high, and Lord Lexington complained that his were too small. William kept changing his mind too, in April giving the rooms first assigned for the Daily Waiters and Scottish Secretary to Dr Ratcliffe. In the end Stanley wrote to the Lord Chamberlain in despair: 'I have so much the spleen that it would have been a great ease to have had one quarter of an hour's talk . . . for to have friends and acquaintances unreasonably jealous, and the king at the same time angry, is what I know not how to bear; nor do I know how to behave myself.'[100]

175 The first floor of the King's Apartments as constructed in 1689–94, deduced from archaeological evidence. Drawing Daphne Ford.

WILLIAM TALMAN AND A *TRIANON*

William's attention was increasingly taken up by the completion of his palace. He certainly would have viewed the trial hang of the cartoons in the King's Gallery, and he decided to stay at Hampton Court for dinner on 22 April for the first time in four years. The visit resulted in orders to Wren for an estimate for the completion of the interiors. Wren turned to his designs 'long since' prepared, and submitted an estimate on 28 April for £6,800. What happened next is surprising to say the least. On 12 May Talman's

alternative estimate for the works was read before the Lords of the Treasury, and the decision was made to go ahead with his proposals for the Great Stair, Guard Chamber, Communication Gallery and 'four rooms beyond to the King's Great Bedchamber' at a cost of £5,500. Talman was charged to complete the rooms by Michaelmas.[101]

Wren's sudden loss of the Hampton Court work can be attributed to three factors. The first of these was, quite simply, cost. Talman's undercutting of Wren was a winning move. The Office of Works still had crippling financial problems and enormous outstanding debts. By the end of the reign it would owe £57,910 to various craftsmen, many for work done for Hampton Court. Second, Wren was still very deeply involved in the work at St Paul's, and the king and the Lords of the Treasury probably rightly doubted that he could give the work sufficient time.[102] Talman, on the other hand, had promised a deadline. Thirdly, Talman had extremely good credentials for completing the work. Since his appointment as Comptroller of Works, he had built up a busy and successful architectural practice. Despite a difficult and litigious manner, he was still the leading country-house architect of his time and had created the two most lavish and prestigious suites of state apartments in England at Chatsworth and Burghley. Perhaps even more significantly he was, together with Portland, working on both the king's new garden and a project to design a *trianon* for Hampton Court.

During 1698 Portland had been made ambassador to France to consolidate the peace of Ryswick, and on his recall Louis XIV had gone out of his way to show him gratitude and favour, personally guiding him round his gardens, parks and pavilions. These included the *trianon* and Marly, both of which left a deep impression on Portland. All the while his thoughts were on what could be achieved in a similar vein at Windsor and Hampton Court, and on his return to England he formulated plans for both.[103] At Hampton Court the intention was to build a pavilion or *trianon* to replace the Water Gallery, which was to be demolished to make way for the extension of the Privy Garden. In early 1699 Portland wrote to Matthew Prior, secretary to the English embassy in Paris, asking him to forward copies of J. H. Mansart's designs for Versailles, Trianon and Marly. Louis himself had presumably promised these to Portland while he was still in France – we know that Louis had also arranged for Portland to be shown round Marly by Mansart himself, a rare privilege. Through the agency of

176 William Talman plan showing the proposed location of a *trianon* at Thames Ditton, the proposed avenues linking it to those of Home Park and the farm land that would have to be purchased to make the scheme a reality, 1699.

177 William Talman, cross-section through one of the interiors in the proposed pavilion at the *trianon* at Thames Ditton, 1699.

the duc de Villeroy, one of the king's closest confidants, who had accompanied Portland to Marly, Louis ensured that the very latest plans were sent and personally approved the final selection. The designs were finally in Portland's hands by April, or early May at the latest.[104]

A few years earlier, some time between 1695 and 1697, William Talman had purchased a property in Long Ditton called Borough Farm.[105] It is not clear what he intended to do with this at first, although he may simply have intended to build a country retreat near the palace as so many senior Hampton Court officials did. But during 1699, almost certainly in collaboration with Portland, the idea was formed that the new *trianon* might be positioned on his land. The plan was an ambitious one that would have required the purchase of a strip of ground linking the Home Park and Talman's farm. Across this a new avenue would be planted, extending the south-eastern avenue of the park to the proposed *trianon*, which would be set in its own gardens (fig. 176). The evolution of the *trianon* designs, which have been examined in detail elsewhere, culminated in a bound set of presentation drawings. Externally the final result bears little direct resemblance to either the Grand Trianon or Marly, and although certainly French in appearance the design only arrived in France via Italy. Talman's *trianon* is essentially a Palladian villa influenced by his large collection of drawings by Inigo Jones and by Palladio himself. The interiors, however (fig. 177), have a strong affinity with both the interiors at Het Loo and those of the King's Pavilion at Marly. While Talman's immediate inspiration for these probably came from the Mansart designs sent to Portland, Daniel Marot had already introduced the style to England.[106]

Although the interiors of the *trianon* look like the work of Marot, it is unlikely that he was involved despite the fact that Talman and Marot had probably already collaborated on the queen's Water Gallery and the east-front gardens (for the latter see chapter 12). Talman was responsible for the gardens and garden buildings at Hampton Court, so the Water Gallery and the *trianon* proposal fell to him to design rather than Wren. The Water Gallery had required considerable architectural input and it was probably Talman who provided it. Moreover, Talman was more adept in the use of Marotesque designs than any other architect of his age. Both Dyrham and Chatsworth have delftware vases similar to those at Hampton Court and, as has been noted, elements of Marot's design can be detected at Petworth, another house connected closely with the Office of Works.

TALMAN, HAWKSMOOR AND THE BOWLING GREEN

Talman's beautifully drawn and presented scheme with its readily available site was rejected. This must have been principally on grounds of cost, but also of time – the land acquisitions alone would have taken years to organise. It may have also been due to Portland's resignation in May 1699 and his retirement from court. In his stead William appointed Richard Jones, Earl of Ranelagh,

178 William Talman, presentation plan and elevation for a pavilion for the bowling green at Hampton Court, 1700.

In his design for Witham Park, Somerset, Talman displays an interest in open loggias, the principal feature of the Hampton Court scheme, and the windows of Dyrham in Gloucestershire and Welbeck Abbey in Nottinghamshire find echoes in those of the pavilion. The roofline is topped with Talman's characteristic urns.[107]

On receiving the cost estimate William ordered the demolition of the Water Gallery and start of work on the terrace and new pavilion. The Water Gallery had been carefully maintained and repaired during 1697–9 until the decision was finally taken to build the pavilion and bowling green. But the moment it was, the gallery began to be dismantled. The delft tiles were removed, the lead was taken off the roof, and 365 loads of 'boards, wainscot, stone, tiles, glass, china and girders' were taken from the gallery to be stored in the Great Hall and store yard. Six bales of hay were used to pack away the plate glass and delftware from the gallery and more prevented damage to a marble chimney. All the stone and brickwork from the old structure was used for the new terrace, which was 1,900ft long, and for the foundations of the pavilion. Work continued on the scheme all summer, and when William returned from Holland on 28 October 1700 much of the terrace was complete and the foundations laid.

Yet the design process was clearly incomplete. A second design seems to have been sent to the king at Het Loo, and on his return significant changes were made. A drawing, again probably in the hand of Talman, showing an alternative layout for the bowling green with a circular temple-like pavilion set in a semicircular screen wall, demonstrates that thought was being given to the scheme. But by far the most interesting drawing is in the hand of Hawksmoor, and introduces an entirely different concept (fig. 179). Hawksmoor proposed four buildings, rather than one, each being heavily rusticated in the manner of St Mary Woolnoth and crowned by domes like those at Castle Howard. The green is still an oval, and the pavilions stand on the axis of the avenue at each side. The strength of Hawksmoor's individual style comes through these as in no other previous drawing of his for Hampton Court, suggesting that he was designing on his own and not on the instructions of the Surveyor.[108] Hawksmoor's pavilions owed little to the *trianon* but were closely modelled on Louis XIV's other country retreat, Marly, for which Portland had received drawings (fig. 180). Marly was remarkable for its integration of gardens and architecture, with a royal pavilion and twelve lesser satellites. At Marly, Louis became 'The First Gentleman of France', consciously relaxing the rule of etiquette. The pavilions, each of which contained two three-room apartments, housed his guests, who were able to promenade with him informally or play pall-mall. The pavilions at Hampton Court were presumably intended to serve a similar purpose. Hawksmoor's drawing suggests that Portland's package of French designs was available to the Office of Works, and that amongst the designers and draughtsmen at Scotland Yard there was scope for competition for the design of the work.[109]

But if it was Hawksmoor's idea to create the bowling green pavilions, it was not he who executed them. Hawksmoor's hour had not yet come – he was not a courtier like his master Wren or like Talman, also the holder of a prestigious court post. Yet his design seems to have found favour either directly with the king, or more likely with Talman, for the scheme as built was for four pavilions designed not by Hawksmoor but by William Talman.

Paymaster of the Army and a connoisseur of architecture and gardening. His remit was wider than Portland's, for he was also responsible for the control of building works, thus becoming for two short years chief minister for building. Before William's departure for Holland in the summer of 1700, Ranelagh presented a set of designs for 'a building to be erected at the end of the new terrace walk' to him for approval. This he obtained, and he passed the scheme over to Wren on 16 July for a cost estimate. A set of coloured presentation drawings exist, almost certainly those handed to Wren on 16 July 1700. They show a pavilion, a much smaller building than the *trianon*, with a through loggia at the end of a raised terrace. Beyond lies an oval walled bowling green, surrounded by a raised gravelled path, a replacement of Charles II's riverside bowling green (fig. 178). The drawings are in the hand of neither Wren nor Hawksmoor, and even setting aside Talman's responsibility for garden buildings at Hampton Court the buildings are clearly in his style. The orangery at Dyrham Park shares with the pavilion's principal façade a Doric order with an uncomfortably heavy entablature topped by two parapets, and a loggia in Kensington Gardens attributed to Talman follows a similar pattern.

190

179 Nicholas Hawksmoor, design for a bowling green and four pavilions at Hampton Court, 1700.

Talman's pavilions were quite different from Hawksmoor's (figs 181, 182). Each was two bays wide by three deep, and of two storeys plus a semi-basement. The two upper floors, like those at Marly, had three rooms each. Externally they were of brick with stone dressings and had hipped roofs topped with urns. The blank panels above the windows, the windows themselves and the urns are typical of Talman's work and quite unlike Hawksmoor's. John Nost carved timber models for the rooftop urns, which were then cast in 'hard metal' by Richard Osgood and painted stone colour, with pineapples gilded by Thomas Highmore. Although the accounts make it clear that elements from the interiors of the Water Gallery were reused in the pavilions, the interiors seem to have been far plainer – much more akin to the closets in the palace today. Grinling Gibbons was paid for carving cornice, door and window surrounds, and frames for mirrors in the 'king's pavilion', where some of the panelling was highlighted with gold leaf.[110]

* * *

THE BANQUETING HOUSE AND AVIARY

Concurrently with the pavilions Talman was at work on more French-inspired garden buildings – the Banqueting House and aviary. Banqueting houses and other garden pavilions had been a feature of royal gardens and particularly Hampton Court since the sixteenth century, but despite this the Banqueting House is in some respects Talman's most important and original surviving work at Hampton Court. Here he was able to achieve something of the interior decoration he had intended for his first *trianon* design. Indeed it is the only interior at Hampton Court today that could possibly be called Marotesque.

Orders were given for the construction of the Banqueting House at the same time as for the pavilions.[111] It was to be built on the riverside, on the foundations of a far more utilitarian structure – the Tudor mill-house (figs 88, 92). Parts of the basement of the present building are of Tudor brick, and a Tudor door is incorporated. Work pressed ahead and by September 1700 the building was being roofed. The Banqueting House is a single-storey build-

180 Cross-section and elevation of 'the first pavilion on the right' at Marly. The external decoration of the pavilion was in *trompe-l'oeil*, but the quoins, urns and balustrade were rendered in stone.

181 J. Tinney after Anthony Highmore, 'The Pavillions belonging to the Bowling Green, at the End of the Terras Walk, at Hampton Court', c.1744.

182 Reconstructed plan of the pavilions and Bowling Green in c.1702. Drawing Daphne Ford.

ing with a semi-basement approached from a raised terrace in the Glass Case Garden. It is entirely of brick with a single stone string course, and a stone door-case with a bronze head of *Flora* erected in October 1701. Talman chose to crown the building with battlements, a surprising choice given the extremely fashionable interiors. It therefore looked far more like the old Water Gallery than like the new pavilions and echoed the Tudor aspect of the parts of the palace it adjoined. There were three rooms on the *piano nobile* entered through an 'outward roome' panelled in oak with carved enrichments by Gibbons. The principal room was the 'Painted' Room and the third a closet. Gibbons gave both the closet and the Painted Room richly carved mouldings while the floors were paved in dressed Purbeck marble slabs. The closet was hung with a sensational crimson and gold damask supplied by the mercer John Johnson and woven by the Spitalfields silk weaver known only by the initials S.C. It had William's Nassau motto, *Je. Main. Tien. Dray.*, with military trophies and crossed cannons, probably celebrating his victory at Namur. The chair and stools were covered en suite with the wall panels and curtains, and there was a corner fireplace for the display of delft. A small stool room adjoins the closet.[112]

The painted interior, although usually attributed to Antonio Verrio, must have been a collaboration (fig. 183). It is quite unlike his previous work and only the ceiling and the two panels to either side of the fireplace seem to be his. For the ceiling an oil *modello* survives, presumably used for presentation to William before work commenced.[113] The rest of the room looks much more like the interiors proposed by Talman for his *trianon* with illusionistic caryatids, medallions, cartouches and panels of grotesquework. Set within this were mirrors with gilded frames carved by Gibbons, and green damask festoon curtains. Four giltwood benches were ordered to stand between the windows, with an armchair to match. The furniture was covered in green damask and fringed with gold. A particular feature of the room was the extensive use of gilding added by Peter Cousen in May 1701. The beautiful and realistic swags of flowers were painted either by Jakob Bogdani, who had embellished the Queen's Closet in the Water Gallery, or more probably by Jean-Baptiste Monnoyer, who had worked for Le Brun at Marly and Versailles and then for the Duke of Montagu at Montagu House. Indeed it may have been Monnoyer who created the illusionistic architectural elements and

183 The principal room in the Banqueting House. The pier glass is a post-Second World War addition.

grotesquework. It is also possible that Verrio, Monnoyer and Cousen were working to a scheme drawn by Talman or even Daniel Marot.[114]

The Banqueting House was only part of a larger conception based on Louis Le Vau's menagerie in the gardens of Versailles, where a miniature château was surrounded by the cages and pens of exotic creatures. In England the official Royal Menagerie was at the Tower of London, and royal residences had had collections of exotic birds since Tudor times. But for William III, Talman and Henry Wise created an exquisite combination of garden, banqueting house and aviary as a distinct quarter of the gardens. Walled gardens lay to the east and west of the Banqueting House and in the eastern compartment lay the aviary (figs 204, 225, 226). It could be enjoyed from the terrace in the Glass Case Garden through windows in the wall, but could be entered only from the Banqueting House. The birdcages were of oak with glazed windows, some of which opened and had nets behind them. They were covered by a boarded roof and lined three sides of the garden with an apsidal end surrounding a circular fountain. Some 222ft of timber was provided to make perches for the fowls, and 378ft for little ramps to provide access to the eighteen nesting boxes. A seed room and a lodging for the Aviary Keeper were provided. The aviary was maintained while the court continued to visit the palace, but it was dismantled in 1746.[115]

THE COMPLETION OF THE KING'S APARTMENTS

It can be seen that during 1699–1700 Talman was high in royal favour. With so much activity in hand at Hampton Court he was the natural choice for designing the palace interiors. But if Marot's influence can be detected through Talman's work on the *trianon* project and the Banqueting House, it is difficult to see how it

could have possibly had any influence over the completed interiors of the King's Apartments. Talman's room for manoeuvre was, in any case, extremely restricted. The tapestry hang had been decided in the queen's lifetime, and this dictated the basic wall divisions. The Cartoon Gallery was already designed (but not built), the cartoons had been prepared and Mantegna's *Triumphs of Caesar* were probably already destined for the Queen's Gallery. The king had chosen, or was in the process of choosing, the overdoor and overmantel paintings, and Lord Montagu, as Master of the Great Wardrobe, was William's leading adviser on the internal fittings. In addition, Talman had a mere £5,500 to spend – a tight budget compared with contemporary architectural expenditure at Chatsworth, Burghley or Petworth.

Although Wren had been a favourite of Mary's, there is no particular evidence to suggest that William admired him; indeed the collapse of 1689 was a matter of great concern to the king. Talman on the other hand, through his friendship with Portland, was on close terms with William, and it is not surprising that the day after Talman's appointment William met him at Hampton Court to discuss the interiors.[116] After one more brief visit William left for the Netherlands on 4 July 1699, not intending to return until October. During his absence Talman (also, of course, engaged on the garden buildings) drove structural works forward as fast as he could, since William had expressed a desire to move in immediately on his return. On 12 September he wrote to William in Holland claiming that the five main rooms on the south front were nearly complete, that the King's Stair had been constructed, and that the cartoons in the gallery would be hung the following week. The bedchamber and two closets, he explained, were less far advanced because they were involving more work than he had expected.[117]

On his return William was said to be 'extremely well pleased with the buildings', so much so that arrangements were made for him to spend a night there for the first time in over a decade. On 28 October 1699 Robert Jennings wrote to Thomas Coke, later Vice-Chamberlain to Queen Anne, 'The King went on Tuesday to Hampton Court . . . The King's apartment is finished, and I fancy 'twill be made the prettiest place in the world. The king will give us all country apartments; we shall be much there, for he likes the place extremely.'[118] The palace was, in fact, not completely finished, but William decided to abandon his original plan to stay at Windsor until the work was completed and instead reside at Hampton Court and supervise the work personally. To make things more comfortable furniture was brought to the palace from Hounslow in November, and the Lord Chamberlain laid down a skeleton household list showing who should accompany the king on his visits. Between October 1699 and April 1700 William stayed at the palace at least thirty times, issuing a stream of instructions for the completion of the rooms on the south front and the gardens.[119]

After the false start of 1693 Grinling Gibbons finally estimated for carving almost all the principal work in the apartments on 15 December 1699. In the end he supplied enriched architectural mouldings for all the new rooms, and in addition he supplied limewood drop festoons to frame the overdoor paintings in the Presence and Privy Chambers, and the Eating and Drawing Rooms, four to each room, at a cost of £28. In the Privy Chamber, and the Eating and Drawing Rooms, Gibbons also supplied surrounds for overmantel pictures at £25, £28 and £30 respectively. The overmantel carving in the Presence Chamber was performed (for £28) by John Le Sage. Gibbons also supplied overdoor carving for the Great Bedchamber, and carvings for the Cartoon Gallery chimney-breast. The one item that cannot be accounted for is the frieze in the King's Bedchamber. Since a drawing for this exists in the Hampton Court Album it must have been executed in 1693–4 for another part of the palace, and relocated in the bedchamber in 1699.[120]

Warrants in November ordered changes in hangings for the great bed, and new furniture for the downstairs closet. The following month, while Gibbons, in his makeshift workshop in the queen's empty apartments, finished overmantel carvings for the drawing room, furniture was ordered for the Cartoon Gallery. In January John Nost installed the magnificent carved chimney-piece in the Great Bedchamber. It was not deemed a success and was almost immediately dismantled and boxed up. The following month the Lords of the Treasury obtained an estimate for what was still to be done, since the works of the previous summer had already totalled £5,240 11s 11d. This was despite the fact that in December William had ordered a series of economies including the omission of carving in the Communication Gallery. For the remaining work, which still included the bedroom and closets, the Communication Gallery, the Backstairs and a number of other rooms, more than £1,800 was required.[121]

In January and February work began on setting up a downstairs dining room with a sideboard at a cost of nearly £70 (fig. 184). This was an important development because the king was increasingly dining with only a few close friends and hugely over-indulging in both food and drink. Strong wine and ale transformed these dinners into drunken orgies, during one of which William hit a guest in the face with a glass, covering him in wine. The room chosen was at the west end of the ground-floor orangery, and adjoined two oak-panelled closets to the east and the stone hallway to the Privy Garden to the west. This location, far away from the State Apartments, gave privacy and the stone hall provided access to the garden. The king could enter his rooms here from the hunt and immediately move to a 'debauch'.[122] The principal feature was a sideboard or alcove separated from the rest of the room by a rail and closed off, when not required, by a sliding vertical shutter. The sideboard was marbled and contained a marble cistern that was fed with running water. Within was a marble-topped table designed for the display of plate. The alcove was the place from which wine was served, and to which the dirty plates would be removed. After dinner the shutter could be dropped and the king and his companions left in peace. The room was furnished with a large oval table with chairs, and a pier glass and table, and the walls were hung with the Kneller *Beauties*, now relocated from the Water Gallery.[123] A private dining room of this sort was not unusual in royal houses in either England or Holland. In fact, Het Loo was equipped with a very similar room. Yet the form of the sideboard was new for a royal house and derived from French engraved sources easily available to the Office of Works. That William should commission such a room owed more to his Dutch background than English tradition.

William's general over-indulgence was symptomatic of his deep unhappiness in England. His popularity was at an all-time low with the general populace, with his ministers and Parliament. Partly to compensate he began to entertain, in a modest way, at Kensington, holding drawing rooms there in late 1699. But he

184 The King's Private Dining Room. After a hundred years of use by grace and favour residents as a theatre (known as the Oak Room), the King's Private Dining Room was reconstructed in 1991–2 as it was in 1702.

clearly intended to move his social centre to Hampton Court, and in December he began stripping the queen's rooms at Kensington, carrying off silver and paintings to Hampton Court. His general mood was not made better by his health, which had been deteriorating since 1698. Although only forty-nine, he was physically like a man twenty years older. His legs were frequently grotesquely swollen, on occasion making it impossible to walk. Colds, bronchitis and constipation added to his discomforts. Hunting at Hampton Court was a relief, and Holland was ever a lure. It was a discontented, depressed and unwell king who oversaw the furnishing of Hampton Court.[124]

Furnishing the New Rooms

The Lord Chamberlain had overall responsibility for the furnishing of the royal apartments, but in practice Ralph, Earl and later first Duke of Montagu, William III's Master of the Great Wardrobe, was in charge. His active leadership is proved by the frequency with which he is mentioned in the bills. Montagu had been Charles II's ambassador to France between 1669 and 1672, and again between 1676 and 1678, and he had brought back a team of French artists to decorate his London home, Montagu House. It has been suggested that he used his position to create an Anglo-French decorative school in which Marot and Charles le Fosse were set up to rival their French counterparts Le Brun and Berain. If this was so it had little effect on the royal palaces, the only discernible change there being the promotion of Huguenot craftsmen and suppliers over the French Catholic ones who had dominated the Great Wardrobe under Charles II. This probably owed more to Montagu's sympathies with the plight of the Huguenot exiles than to any stylistic differences between French Catholics and Protestants. As we shall see Montagu's taste, like that of his royal master, was solidly French.[125] In January 1700 Montagu was summoned before the Treasury and ordered to furnish the King's State Apartments as cheaply as possible; his estimate for doing this is dated 12 February 1700 and is for £3,386 5s 11¾d. The vast majority of the items ordered were

185 The King's Privy Chamber, south wall. The tables and curtains were added in 1992.

readily available or could be made quickly, for on 14 March the Lord Chamberlain's secretary reported that the furniture was being sent down that week.[126]

There is no doubt that the principal decorative element in the new rooms was tapestry. This was partly due to the revival of interest in tapestry caused by Louis XIV's creation of the Gobelins workshop under Charles Le Brun, which produced tapestries exclusively for royal building projects. But it was also because the core of Henry VIII's sensational collection of about 900 pieces remained the backbone of the royal art collection. Montagu's enthusiasm for tapestry was also important – he had acquired the Mortlake tapestry manufactory in 1674 and had filled his own houses with its products.[127] Not all of the Tudor pieces found favour with William and Mary, but the large figure sets of Brussels tapestries bought by Henry VIII in the 1530s and '40s and Charles I's Mortlake series of the 1620s and '30s became favourites. Just before the building collapse of 1689 Robert Streeter had painted the king's drawing room and redroom with 'pattern' of panelling and cornices to enable the proportions of the rooms to be settled and decisions taken on tapestry. As a result in 1692 the *Abraham* tapestries were repaired, cleaned, relined and given new blue and grey borders. The following year with work moving rapidly forward orders were given for the further repair of the *Abrahams* and a complete overhaul of the *Joshua* set. These were two of the three very finest sets in royal possession; they were only hung on special occasions and in the 1690s were still in near-perfect condition. In September 1699 the order was given to hang these and a number of other great antique tapestries, and 6,000 hooks and tacks were supplied for the task.[128]

Thus the upholders (upholsterers) who executed the final decorative scheme did not concern themselves with the walls of any of the principal state rooms. The curtains in the Presence, Eating, Privy and Withdrawing Rooms were made of white 'flowered' damask, 530 yards of which was ordered at a cost of almost £400. The curtains were 'draw up' or festoons, with carved cornice boxes containing pulleys made by Thomas Roberts. None of these sur-

186 Table frame of carved and gilded pine with a slate top, supplied by Jean Pelletier for the King's Apartments, 1699. It is now at Windsor Castle.

vives, but they were probably similar to a cornice from another part of the palace that survives in archive and was used for the restoration of 1990–2 (fig. 185). The Great and Little Bedchambers had festoons too, but by 1702 the king's closets and his gallery were provided with draw curtains, in crimson and green respectively. This difference partly reflects the practical need to draw the curtains in the private rooms for warmth, and partly the impracticality of draw curtains for the incredibly tall windows in public rooms. The festoon curtains of unlined silk can have only been for effect, helping to show off Gibbons's richly carved window architraves.[129]

The rooms were sparsely furnished, leaving the largest space possible for the assembly of the court. The Presence and Privy Chambers had tall crimson damask canopies with embroidered coats of arms (fig. 190). Beneath these were armchairs, high stools and cushions, set on a carpet-covered dais. The carpets themselves lay on finely woven rush mats. The only other seat furniture in the rooms took the form of upholstered benches. The Eating Room was provided with armchairs and a fire-screen, and a table would have been brought in when required. The Drawing Room, without a canopy or dais, was provided with an armchair, high stools and cushions just like the Presence and Privy Chambers; there was also a rug. The Great Bedchamber had two elbow chairs and back chairs as well as stools and a fire-screen.[130] Montagu was instrumental in obtaining for Jean Pelletier the important commission for the giltwood furniture for the new rooms, which was worth over £600. The furniture was supplied between 1699 and 1702, and Pelletier made four trips to the palace to supervise its unpacking and to make good minor damages that had occurred in transit. The Eating Room, Privy Chamber and Withdrawing Room were to have pier tables flanked by candlestands and surmounted by pier glasses. The piers in each room were of slightly differing widths and so Pelletier ensured that each table varied proportionately to fit. The tall candlestands were designed en suite. While the stands still adorn the rooms the tables are at Windsor Castle (fig. 186), the current tables being reproductions of a dif-

197

187 J. Stephanoff, 'Cartoon Gallery', from W. H. Pyne, *Royal Residences*, 1817–20.

ferent pattern made in 1991 (fig. 185). Pelletier based his design on pier tables at Versailles as engraved by Pierre le Pautre. Two further tables of a larger size and also in a French style were made to stand at either end of the Cartoon Gallery (fig. 187).[131] Above the tables were pier mirrors supplied by Gerrit Jensen, cabinet-maker and glass-seller in ordinary to the king. Those in the king's two closets were enlarged on William's specific orders, presumably because they played a crucial role in providing more light. The one in the Great Bedchamber was 13ft high and incorporated slips of blue glass forming a monogram and crest secured by clear glass studs (fig. 188). The mirror in the dressing room is very similar to one published by Daniel Marot as one of his works for the king, which suggests that he may have had a hand in the design of the mirrors.[132]

The decoration of the Guard Chamber is the one surviving work of John Harris of Eton, William III's Gunsmith and Decorator Extraordinary. The fashion for elaborate displays of weapons upon the upper walls of the royal guard chambers began at Windsor in Prince Rupert's lodgings in the Round Tower. The first displays were erected by Ordnance officers at his command in the late 1660s and were developed ten years later in Charles II's new apartments in the Upper Ward. John Harris was almost certainly involved in the creation of these displays, but his first solo commission was the redecoration of the guard chamber at Whitehall in 1687 for James II. Following this success he went on to create new displays at Windsor and St James's, and the extraordinary fantasy in the Small Armoury at the Tower of London. He held no place in the Royal Household and worked for the Board of Ordnance. Hampton Court was his last major work, for which the Board paid him £58 10s 2d. The present arrangement of 2,800 or so arms has certainly been modified since the display was completed in 1699 (fig. 189). Quite apart from anything else, most of the muskets, carbines, pistols and swords date from the late eighteenth century. Yet the pikes (which are cut down to make pilasters), drums (one of which is dated 1691), armour and bandoliers date from King William's time. So do the circular and oval 'targets' around which the arms are arrayed. These were carved by Gibbons and although now stripped were originally brightly painted.

Harris was given the post of Furbisher of Small Arms at Hampton Court in November 1699, thus acquiring responsibility for maintaining the display. Each year after that the arms were taken down and cleaned, a practice that continued until 1870. Since the original arms were still in service they were probably removed for use on a regular basis, thus explaining the date of the current selection. The panelling of the Guard Chamber was painted by Robert Streeter in 1699 and remained painted until 1866. It was the only painted room on the principal floor. This may have been because the room was expected to receive hard wear and tear from the yeomen of the guard who were still expected to sleep in the room. In order to accommodate them a 'pissing cestorn' was plumbed in in October 1700, and a door was made from the Guard Chamber to the Wolsey Rooms which were used as a 'smoking room'.[133]

There is no doubt that William was thrilled with the quality of the art collections he found at Whitehall and Hampton Court in 1688. Not only were there the great Tudor and Stuart portrait collections, but the bulk of Charles I's collection of Italian old masters

188 The King's Great Bedchamber, pier mirror on the south wall supplied by Gerrit Jensen in 1699.

was intact and had been embellished by Charles II's acquisitions. The diary of Huygens records admiring the paintings in the galleries of Whitehall at close quarters during a visit made with William on the day that William was proclaimed king. During their stay at Windsor in September 1689 William and Mary found yet more paintings to their liking. Hampton Court was still hung mainly with English and European royal portraits (84 out of 190 paintings) and religious subjects (52 paintings). There were far fewer classical and mythological subjects, or still lifes and landscapes (24 of each). With perhaps fewer than ten exceptions (such as Van Dyck's equestrian portrait of Charles I, which was in the Queen's Gallery, and the *Triumphs of Caesar*) there were no masterpieces. These were all recorded in an inventory drawn up by Huygens in early October 1689 intended to act as a basis for a redistribution of the royal art collection.[134] With this to hand it was decided that the finest paintings were to be hung at Kensington in the gallery, and by January 1690 many of the best paintings from Whitehall and elsewhere were hung at Kensington. After Mary's death Huygens was instructed to collect the cream of the paintings from the Water Gallery at Hampton Court and the Queen's Apartments at Whitehall. These went to Kensington for a new hang in the gallery installed at the end of 1695.[135]

Thus Hampton Court, in keeping with the policy of previous monarchs, was not intended by William to contain the great pictures of the royal collection. The important point about the picture hang in the State Apartments is its continuity with the early Stuart period. Hampton Court was recast by William as the great dynastic seat, filled with portraits of the royal family past and present, and leavened with the two great series, the *Triumphs of Caesar* and the Raphael cartoons. In the State Apartments hung *Christian IV of Denmark*, *Elizabeth of Bohemia*, *Charles I*, and *Anne Hyde as Duchess of York* – a series of Stuart dynastic portraits emphasising continuity. In his private rooms downstairs William hung a group of smaller paintings with a different flavour. Some were Dutch and probably bought by him for the collection. But even here something of the dynastic theme was maintained, with the pictures including Van Dyck's *modello* for the equestrian portrait of Charles I. In all only 110 paintings hung at William's Hampton Court, with a large number in store, presumably awaiting the completion of the Queen's Apartments.[136]

As in Charles I's time it is noticeable how few of the paintings were contemporary. William commissioned a number of overdoor paintings from Jacques Rousseau of a type almost identical to those painted for the gallery at the Hôtel Lambert in Paris. These have the effect of elongating the door openings in the French manner, and must have been part of Talman's plan. Jean-Baptiste Monnoyer also provided overdoors for the King's Little Bedchamber (fig. 193). Flower paintings were an integral part of the interior decoration of Dutch houses, so it is a matter of little surprise that William chose these to hang in his innermost rooms. A group of flower painters followed William and Mary to London in 1689, including Simon Verelst, Maria van Oosterwijk and Jakob Bogdani himself. Bogdani was to be employed at Hampton Court, where he copied the French model of placing the flowers in a great silver or gold vase, something that William, Huygens and Bogdani had observed and admired at Montagu House.[137] All these were essentially architectural and decorative commissions. The only major new painting commissioned for the new rooms was Sir Godfrey Kneller's equestrian portrait of William (fig. 191).

The original impact of this vast portrait was even greater than it is now, since in its present state it has lost about 3½ft in height and about a foot in width. It was completed and then stretched and framed *in situ* by John Norris, and was nearly 15ft square. The commission is significant, because previously William had confined images of himself in his residences to a small portrait over the chimney in the Council Chamber at Kensington. The introduction of such a prominent and heroic image of William in the Presence Chamber, and Verrio's subsequent depiction of him on the Great Staircase (fig. 197), marked a clear and deliberate decision to use his own image as a leading device in the iconography of power. In doing this he was following the successful example of both Charles I with Van Dyck's equestrian portrait and, of course, Louis XIV's image-making at Versailles and elsewhere. The change can probably be dated to the signing of the peace of Ryswick in 1697 after which William wished to be depicted as victor and pacifier. An oil maquette (now lost) was made soon after the portrait was commissioned in April 1700 and from this the painting was executed. The key to understanding its symbolism is the scroll held by one of the putti which contains a quotation from Virgil, an approximate translation of which is: 'And he reigns over the pacified world with the virtues of his ancestors.' The link with Virgil's fourth eclogue presents Kneller's William as a sovereign of ancient Trojan and British lineage who has fulfilled ancient prophecies by bringing peace, justice and prosperity under the aegis of victorious Britain, the true heir of ancient Rome.[138]

★ ★ ★

189 J. Stephanoff, *The King's Guard Chamber, Hampton Court*, original watercolour prepared for W. H. Pyne, *Royal Residences*, 1817–20.

The Arrival of the Court

William wanted a grand opening for the finished rooms and in April 1700 there was a general remove of the entire court to the palace for the first time since 1689. It had been William's intention to spend some months there from April and, as will be seen in chapter 16, orders had been given to prepare the courtier apartments in anticipation in November 1699. In the week before the king's arrival the Great Bedchamber was set up with a green damask bed that had formerly been at Windsor, and the walls were hung in green damask to match. The first formal residence of the court lasted over ten weeks between April and July, after which William left again for Holland. From this date until his death a new pattern was established whereby during the king's visit improvements were devised for the palace and immediately on his departure the new schemes were executed. One of the problems thrown up by the king's first residence had been how to provide for the Privy Council. Early designs for the new palace had provided for a large and well-appointed council chamber (fig. 132), but the final design made no specific provisions and the Council continued to meet in the Tudor range between Clock and Fountain Courts. It is not clear why Wren's final scheme made no provision for the council, especially since when William finally settled at Hampton Court in 1700, councillors had neither lodgings nor a place to meet. William decided to convene meetings in the Cartoon Gallery, which was conveniently linked to the Great Bedchamber by a jib door (fig. 173). The room was provided with twelve armchairs and two great couches covered in green and trimmed with gold, and the table was covered in a large Turkey carpet. Clearly this decision had a major impact on the gallery, which of course held some of the most famous works of art in the royal collection. Thanks largely to increased public access to the cartoons throughout the latter part of the reign, painters petitioned the king to copy them. The earlier copies by Henry Cooke were removed by William to Het Loo but both Louis Laguerre and Verrio made copies too.[139]

The use of the Cartoon Gallery as the public council chamber and occasional studio meant that William lost his private gallery, and towards the end of his first visit he decided to use what had been intended as the queen's gallery instead. A warrant was issued

190 (*facing page*) The King's Privy Chamber showing the original throne canopy and rock crystal chandelier. Both were restored after the fire of 1986.

191 Sir Godfrey Kneller, *William III on Horseback*. During the fire-damage repair of 1986–92 this enormous painting remained in the Presence Chamber in a reinforced box.

holding court office by the reimposition of the Test Acts in 1689. He therefore moved on to paint for a succession of private clients, most importantly for the Earl of Exeter at Burghley. It was probably the brilliance of his work for Exeter that led to a blind eye being turned to his religion and his re-engagement by the Crown in 1699. His first work at Hampton Court was the collaboration on the Banqueting House discussed above, but in the summer of 1701 William invited him to start work on the ceilings of the state apartments. It is possible that William intended to paint a few each summer, starting in his bedchambers and moving westwards towards the outer rooms. In the event Verrio only completed two rooms in William's lifetime. During the king's Dutch visit in the summer of 1701 work began on the ceilings of the Great and Little Bedchambers.

In the autumn of 1700 William had decided to re-hang his Little Bedchamber in yellow 'Indian' damask fringed with silver lace, with wall hangings, portière curtains and furniture all to match (fig. 193). While he was in London attending the parliamentary session the furnishings were installed by the furniture-maker Thomas Roberts and upholsterer Richard Bealing. In addition to the magnificent bed, the room contained four square stools, an armchair with a large yellow velvet foot-cushion, and an ebonised fire-screen.[141] In July 1701 all this was dismantled together with the furnishings in the Great Bedchamber next door; matting was

192 The Queen's Gallery. Fire surround carved by John Nost. The piece was originally intended for the King's Great Bedchamber, but was installed in the Queen's Gallery in 1700.

for the completion of the 'east' gallery and the room was floored. Grinling Gibbons provided carved mouldings for the cornice, overdoors and overmantel, and the fireplace rejected from the King's Great Bedchamber was installed (fig. 192). The room was then hung in watered green mohair (a rich, ribbed silk-and-wool textile), and back-chairs with gilt frames covered in matching green were provided. Here, in William's private inner gallery, Mantegna's *Triumphs of Caesar* were hung. This series was thus even more highly revered than the cartoons. The *Triumphs* had always been part of the plan for the new apartments and in May 1689 Huygens was ordered to ascertain whether Parry Walton, the curator, painter and restorer, was capable of restoring them. The answer was seemingly in the affirmative and the paintings were moved to Windsor, where they could be worked on without danger from construction activities. By June 1693 three had been restored and relined and Walton was paid £60. Either his work was not judged to be adequate, or Walton declined to undertake more, because Louis Laguerre was appointed to complete the task. It seems that he only completed it after the building work recommenced, since he was paid £300 in 1701–2 for a complete restoration of the canvases. They were finally installed in the gallery in January 1702.[140]

William had almost certainly always intended to have the ceilings of the state rooms on the south front painted. Other than the Guard Chamber they all had deep, gently curving coves, like the ceilings that Antonio Verrio had painted so successfully for Charles II at Windsor. For his efforts there Charles had appointed him 'first and chief painter', a post that he continued to enjoy under James II. Verrio was a Roman Catholic and had been barred from

193 *(facing page)* The King's Little Bedchamber looking west. The yellow hangings were installed in 1992.

laid to protect the floors, and scaffolding was erected. On the ceiling of the Great Bedchamber Verrio painted Endymion, the beautiful youth who fell into an eternal sleep, in the arms of Morpheus, the god of dreams. The cove was painted with gilded scroll-work and medallions showing scenes from the story of Diana. In the Little Bedchamber William chose Mars, the god of war, sleeping in the arms of Venus, with whom he had fallen in love – surely an expression of the idea that William's warlike spirit had finally been tamed. The Little Bedchamber may be a collaboration given the use of gilded vases with orange trees and roses, not usually associated with Verrio.[142]

On the completion of the Great Bedchamber it was hung with a tapestry of the *History of Joshua*. Joshua, Moses's successor, led the Israelites to victory, conquering the promised land, a subject certainly chosen by William as symbolising his own achievements. A red velvet state bed was bought from William's Lord Chamberlain, Edward Villiers, Earl of Jersey. It was altered, given case curtains and matching window curtains by Richard Bealing, who also upholstered armchairs and stools en suite (fig. 194). That William should have had a 'second hand' bed in his Great Bedchamber has often been a cause for remark. It is not known where Jersey obtained the bed, but since he was ambassador to Louis XIV's court in Paris in 1698–9 it is likely that it was a diplomatic gift. Thus the bed was far from being 'second hand', but rather was a modern bed, straight from Paris and in the latest style. It is certainly of a French form, very rectilinear and quite unlike the Anglo-Dutch baroque beds of Marot such as the sumptuous Melville bed made for William's secretary of state for Scotland. It can hardly have escaped the notice of either William or Jersey that in 1701 Louis XIV enlarged his bedchamber at Versailles, sweeping away the bed alcove, throwing two rooms together and placing a new rail across the room. This moved the *chambre du roi* to an even more central position both architecturally and in terms of etiquette. William III's bedchamber at Hampton Court with its French furniture and bed was modelled on the French royal bedchamber rather than his bedchambers as stadtholder in the Netherlands.

Behind the Great Bedchamber lay a room for the Gentlemen of the Bedchamber, and beyond that the backstairs (fig. 173). The Gentlemen's room was hung with gilt leather studded with brass nails, and contained a marble hand-basin in one corner. Ostensibly this was where the Groom of the Stool and other Gentlemen slept while on duty, but it had another function too. Frequently the king would wish to meet with people privately in his closet, without the visitor having to parade through the outer rooms of the palace. On these occasions visitors could be introduced via the backstairs where they would present themselves to the Groom of the Stool or Gentlemen of the Bedchamber in the room behind the Great Bedchamber. When first built the route from the Backstairs Room to the King's Closet led directly into the Great Bedchamber, but in January 1702 it was decided to brick up the door to the Great Bedchamber and open a new jib into the Little Bedchamber (figs 173, 175). This demonstrates William's intention of reserving the use of the Great Bedchamber for public occasions, and routeing his backstairs visitors privately through the Little Bedchamber. In the Great Bedchamber two rails were provided for the bed. First an 'old raile for his majesties bed of state' was repaired and delivered to Hampton Court. This is very likely to have been the giltwood panelled rail, originally made for Charles II, that is still at Hampton Court. The rail has been altered a number of times but it is likely that in 1700 it went round three sides of the bed rather than across the room (fig. 194). In addition to this stately piece of furniture a ten-leaf cedar screen (or rail) with gilt wire was provided. This was a more flexible rail that could be moved about the room as occasion required.[143]

That the Little Bedchamber was on the backstairs route to the King's Closet calls into question whether William used it at night. The building accounts reveal that the king had a bedroom on the ground floor immediately beneath his closet. It was hung with night scenes and linked directly to a stool room (which the Little Bedchamber was not) (fig. 253). Most importantly, it was furnished with special locks without door handles on the outside, making it the only room in the palace that could only be entered by a key alone. All this suggests that William actually slept on the ground floor in a much smaller, more intimate and domestic room. The rooms adjacent to this bedchamber were interspersed with those of Arnold Joost van Keppel, the Earl of Albemarle, who had usurped Portland's position as William's principal favourite. Albemarle had been appointed Master of Robes in 1695 and as such his proximity to the king was at least logical. He was granted an enormous suite of rooms covering almost the whole of the ground floor of the east range south of the vestibule to the gardens, and seven more rooms on the second floor above the King's Private Gallery and closets. The stair linking them was the King's Own Backstair, and his domestic servants and secretary lodged in adjacent rooms. Some of the king's closets, we know, were hung with damask wall hangings and curtains salvaged from rejected schemes upstairs. Others were oak panelled with carved overmantels in oak.[144]

Upstairs, beyond the Little Bedchamber, were two closets and a garderobe. The King's Closet next to his bedchamber – the most important, and public, of the rooms of the Bedchamber – was hung in crimson damask fringed with gold lace. An armchair, two back-chairs and a fire-screen were provided to match. This was where William would receive visitors on business. The other upstairs closet, now known as Queen Mary's, underwent several decorative schemes, including a blue damask one with striped velvet hangings (this was dismantled and moved downstairs), and a gold and green striped scheme. The furniture in the second closet differed from that of the other state rooms. Two heavily carved 'easy chairs' with back-stools to match and large walnut 'cane' elbow-chairs with oval backs suggest that this was a room designed for informality and greater comfort.[145] The rooms were lit with silver sconces, many originally made for Kensington. In the drawing room was a set of six depicting the *Judgement of Solomon* made by R. Smythier for Charles II and embellished with William's monogram in 1689–94. For the Great Bedchamber a new set of six was ordered at a cost of £534 12s. The rock crystal chandelier hung in the Privy Chamber was a very great rarity and possibly the first to be hung in England – a serge cover was provided to cover it when not in use. On the jambs of the chimneys were branches of silver and glass, which also had serge covers.[146]

When in July 1700 William visited Holland again he was virtually crippled. He only walked with the greatest difficulty, and gout in his left hand made it almost impossible to hold the reigns of his horse. Yet his extraordinary constitution withstood several days hard hunting at Het Loo that summer. The crossing back to Margate almost killed him, and he lay prostrate at Greenwich

194 The King's Great Bedchamber. The crimson case curtain was replaced in 1992. The bed is shown surrounded by the bed rail made for Charles II and altered for George II. The rail has been at Hampton Court since William III's time and was erected for one evening only in 1997 in order to work out its original position.

before being taken to Hampton Court to recover on 5 November. The news of James II's death and Louis XIV's acknowledgement of James's son-in-law as king of England restored some of William's popularity, causing him to rally. At Kensington he received delegations and even dined in public and held modest drawing rooms. But Hampton Court was still not truly completed; indeed at his death the King's Apartments were still being painted and furnished. Thus it was only for a short time, if at all, that Hampton Court was used 'normally' by William, which makes it difficult to describe everyday court life there. William's intentions can, however, be deduced. When he left for Holland in June 1699 he announced that in future all foreign ambassadors were to have their audiences at Hampton Court. This may have partly been in response to the destruction of Whitehall where, in the Banqueting House, the first formal public reception of envoys had traditionally taken place. On his return there was certainly a noticeable rise in diplomatic activity at Hampton Court. In April 1700, for instance, the king received envoys from Spain and France, and in May from the Grand Duke of Tuscany. But Hampton Court did not have a monopoly of diplomatic activity, because William used Kensington for receptions too. As had been the case with his predecessors, ambassadors were never lodged in the palace but in

houses nearby. We have no description of an audience, though it is likely that they took place in the Great Bedchamber in line with the practice of Charles II. More intimate consultations, such as the terse meeting William had with the Count de Tallard, took place in the King's Closet.[147]

Wren's new Hampton Court, like its Tudor predecessor, was supplied with both a Presence Chamber and a room for dining in public. This room, called the Eating Room, was serviced, tortuously, from a staircase at the south end of the Communication Gallery (fig. 173). There is no record of William dining in public in the Eating Room at Hampton Court, although it is known that in the last years of his life he did occasionally dine publicly at Kensington. Yet the Royal Household was ordered to keep open tables 'with abundance of persons of honour'.[148] It is not clear where the Household tables were kept during 1699–1702, but the Tudor kitchens continued, subdivided and modernised, to provide food for them. New tastes and techniques in cookery were catered for by the addition of coal-burning grates and hobs to many old fireplaces, and the construction of an ice house in the park. Smaller up-to-the-minute kitchens on the ground floor of the new building served William and his closest companions (fig. 253). The trend of allocating the Tudor working houses to courtiers which had begun in 1663 continued with, for instance, the Closet Keeper being assigned the former bakehouse lodgings.[149]

While public dining seems not to have been a focus of court life at Hampton Court during William's last summers there, assemblies, or 'drawing rooms', seem to have been. Although there is no record of card playing of the sort that took place in the Kensington gallery in the winter, contemporary newspapers mention the hand-kissing that was a principal part of the court drawing room. Expanded drawing rooms were also held at Hampton Court before the king departed for Holland, and to welcome him home.[150] Given the small size of the King's Drawing Room these were most likely to have taken place in the Privy Chamber with William seated beneath the throne canopy. In the English tradition, since the early Stuart period, the Privy Chamber had become the principal reception room in the palace. It was for this reason that Wren positioned it in the centre of the south front, defined externally by a Portland stone frontispiece. But by 1700, and indeed for almost forty years previously, the Great Bedchamber had taken on many of the most formal functions of the Privy Chamber. Charles II had, from 1660, received ambassadors and other supplicants in the great ceremonial bedchamber at Whitehall rather than in the Privy Chamber. This movement towards the French custom was not reflected by Wren in any of the Hampton Court schemes, and was barely recognised in the Household regulations, which clung to the etiquette of the early Stuart court. Indeed, in 1689, while thought was being given to the arrangement of the new royal apartments, a warrant was issued 'To require you to make all the lodgings and offices in Hampton Court on the Kings side as they were formerly and according to an antient survey, a coppy wherof is herewith a[ppended] and that noe rooms bee changed or given but by my warrant.' William's Hampton Court was thus to be planned along the most traditional lines. Yet it is difficult for us today to interpret his intended use of the newly completed apartments. There is no record of his using the Great Bedchamber for receptions, nor is there any reason to believe that he had a levée or couchée as did James II. There is little evidence to show how either the Drawing Room or Privy Chamber functioned. The largest two state rooms were on the queen's side and in their unfinished state remained unused by William. Etiquette at the court of William III remains something of a mystery, and with it the king's use of his new apartments.[151]

The Chapel and Tennis Court

In many senses the Glorious Revolution of 1688 was a religious one, and within days of its achievement steps were being taken to expunge traces of the religion that had been practised at court by James. William reappointed Charles II's dean, Henry Compton, Bishop of London, as Dean of the Chapel Royal and he immediately issued orders forbidding music other than organ music, and singing other than anthems and the Gloria, in the Chapel Royal. As expected, William appointed his fiercely loyal friend and religious and political adviser Gilbert Burnet as Clerk of the Closet, and after his elevation to the bishopric of Salisbury John Tillotson took his place. Tillotson, who became Archbishop of Canterbury in 1691, was, like Burnet, known for his attacks on popery. Therefore within the Royal Household both private royal devotions and public displays of piety were rapidly reformed. During her first stay at Hampton Court, in February 1689, Mary ordered that the altar in her private chapel be removed, the scar in the floor repaired, and a communion table provided. That Easter William and Mary were at Hampton Court and experienced the full ceremonialism of the Caroline court. The queen recorded in her journal that they received the sacrament together alone in the chapel, a 'foolish formality' in her view. By Christmas time chapel etiquette had been reformed, and when they received communion at Whitehall members of the court accompanied them.[152]

The Hampton Court household chapel was destined to become William and Mary's principal royal chapel and the secular ceremonial that accompanied attendance at it was revived. On 3 March 1689, as the queen came from chapel, people were presented to her and kissed her hand just as in the days of her father and uncle. A series of very detailed warrants, indicating personal attention by the queen, specified the provision of two very beautifully bound bibles and three prayer books with 72 yards of blue ribbon fringing. In August 1689 pews were set up in the body of the chapel for William and Mary to take the sacrament, and that winter satin-lined bearskins were supplied to put round their feet in chapel. In April 1693 a permanent clerk, Richard Cawthorne, was appointed to read prayers and officiate at Hampton Court, and a small basin, two small flagons, a cup and cover and a chalice were provided for his use when the king and queen were absent.[153]

This was a prelude to the refitting of the royal closets that began in March 1690. The Tudor closets were removed and a new floor inserted 2ft 7in. lower than the previous one, supported on eight columns with responding half columns against the walls. Three compartments were made at first-floor level overlooking the chapel. Behind them were three ante-rooms lit by clerestory windows; the central one had a new 9ft-high door providing access to the chapel gallery. After 1699 the northernmost compartment overlooking the chapel had its ceiling lowered to create a cosier winter closet with a fireplace. In August 1690 a new organ was ordered from Bernard Smith, the Royal Organ Maker, and the organ loft was enclosed in preparation for its arrival.[154] Smith worked fast, and since it was clear that the dust created by build-

ing at Hampton Court would quickly ruin his new instrument, he delivered it to Whitehall pending the completion of the new palace. With Mary's death it remained there, and was burnt in the fire of 1698.[155]

No drawings survive for the conversion of the closets in 1689–93, but evidently Wren was also asked to consider the introduction of an altarpiece. William and Mary had decided to convert James II's Roman Catholic chapel at Whitehall into a library. The massive marble altarpiece by Gibbons and Arnold Quellin was dismantled and shipped up river to Hampton Court, where it was put in store pending erection in the chapel. At 40ft tall the reredos would have just fitted, but it is unlikely that William, Compton, Burnet or Tillotson really thought it appropriate. Made of white and coloured marbles and smothered in large figurative carving, it would have clearly been a popish intrusion. In the event it remained packed up until 1706 when Queen Anne finally decided to commission a timber one (see below). At this point the Whitehall altarpiece made its journey back down river to Westminster Abbey, where it was finally re-erected.[156]

In 1699, when work started up again, William half-heartedly moved to finish the chapel but failed to complete the scheme before his death. Grinling Gibbons managed to complete the woodwork of the royal pew, but the black and white marble for a new floor remained stacked up in the ante-chapel. The decorated Tudor ceiling of the chapel gallery was taken down and the ceiling was plastered, modernising the entrance, and 66ft of 'Italian moulding' and 20ft of 'compass moulding' were fixed round the openings of the three closets looking into the chapel. At this point William called a halt to work, and the Lord Chamberlain's secretary was able to report on 18 January 1700 that the chapel was nearly completed and that the dean should specify what furnishings were required. The dean's requirements were modest, and in October 1701 a new pulpit with stairs leading up to it was installed. William's sudden truncation of the scheme in 1700 was certainly due to his desire to move the court to Hampton Court as soon as possible; for with the chapel given over to building work the obligatory daily morning service and twice-daily prayers could not have been held.[157]

During William and Mary's reign there was a significant reduction in ceremonial in the household chapel, and the king's private religion assumed a more Protestant aspect. Since Henry VIII's time a closet sited between the Presence and Privy Chamber had been the king's private oratory. In May 1689, while William and Mary were using the old palace, orders were given to make the closet over to the Lord Sydney, signifying the king's abandonment of the old ways. This change in personal religious habit was reflected in the plans drawn up by the Office of Works in 1689. None of them made obvious provision for personal sacramental space. The King's Apartments as built were the first since the Middle Ages not to have a private chapel. It is possible that the room subsequently used as an oratory in the north-east corner of Fountain Court was always intended as such, but even so it would have been a single room for the king and queen, and a room with a fireplace, not an altar, on the east wall.[158]

In November 1689 William III granted the office of Master of the Tennis Courts to Henry Villiers, and Robert Long secured the appointment of his son (also Robert) as Marker. In December 1697 Horatio Moore succeeded as master and received orders from William for substantial works at Hampton Court.[159] Although as

195 Nicholas Hawksmoor's design for the Great Portal from Clock Court to Fountain Court. The handwriting on this drawing is Hawksmoor's. The portal can be seen in Knyff's view of the palace (fig. 205).

stadtholder William had enjoyed playing tennis, there is little evidence of his interest in the game as king. Thus it is rather surprising that in 1699 he embarked upon a remodelling of Charles II's court. There were two elements to the work: first a series of improvements to the court itself, including a new stone floor that Moore believed would enable the ball to 'give a true bound'; and then a remodelling of the Tennis Court Lodgings and access gallery. An important part of this was rebuilding the wall of the gallery to match the remainder of the east front walls when seen from the Great Garden. In view of the fact that a wire cage was made to place before William's seat in the refurbished court, his role was probably as spectator rather than player. In February 1702 Henry Wise planted the garden to the west of the court with cherry, peach, plum, pear and apricot trees.[160]

The Final Months of William's Life

In the last months of the reign work began on creating a playhouse or theatre in the Great Hall. This must have been at least partially as a replacement for the Whitehall theatre lost in the fire of 1698. Although William was not as avid a playgoer as Charles II, both he and Mary enjoyed theatre at court, particularly on special occasions such as royal birthdays. The conversion of the Great Hall created a permanent setting for plays in an arena that had been used for drama for a hundred years. It also sat within a European tradition. Louis XIV had transformed the Great Hall (or *salle de bal*) at Saint-Germain-en-Laye into a theatre in the 1660s, and by 1682 over 140 performances had been enacted there. Soon afterwards the new *salle de comédie* was completed at Versailles. At Hampton Court the building materials stored in the hall were removed and order was given in February 1702 for reflooring the

196 Plan of the guard houses and Houses of Offices on the west front, after May 1700, when a sutlery was built to join the two original barracks.

Tudor Great Watching Chamber and wainscotting it to the top with plain panelling without mouldings. A doorway was to be made from the Watching Chamber into the Great Hall and a theatre constructed there. To facilitate this, work began on stripping out the remaining Tudor features, including the heavy cornice from which tapestries had hung. Timber partitioning, stairs, banisters and balustrades, scaffolding and flooring were prefabricated, but never installed. Nor was the Watching Chamber panelled in William's lifetime, though it was soon after his death, as an office for the Board of the Greencloth.[161]

On 20 February 1702 William decided to try a new horse, Sorrel, in Bushy Park. He later told his trusted physician Dr Bidloo: 'I was urging the horse into a gallop when she fell on her knees. I tried to pull her up by the reigns, but she fell first forward and then sideways, and I fell on my right shoulder on the ground.' The king thought this odd since he was a superb horseman and the ground was level. The horse had, however, stumbled into a mole hole throwing William to the ground and breaking his collarbone. That afternoon, in the King's Bedchamber at Hampton Court, Dr Ronjat set the broken bone and soon afterwards William, claiming to feel fine, unwisely set off for Kensington. Inevitably a bumpy trip in the royal carriage dislodged the fracture and Bidloo had to reset it when the king arrived at Kensington. Over the next few days William's health rapidly deteriorated, and after taking to his bed he died on 8 March at eight o'clock in the evening.

We should certainly not imagine that had William lived he would have swept away the rest of the Tudor palace and replaced it with something more modern – as late as December 1699 a plan to replace all the Tudor stone windows with sashes was abandoned on cost grounds.[162] So Hampton Court was definitively unfinished, both internally and in the wider concept. Attempting to characterise the style of what was completed is difficult. At times there seem to have been two teams working with very different results: the Talman–Marot team probably designing the Water Gallery and certainly the pavilions, the Banqueting House and gardens, and in 1698–1700 the interiors; and the Wren–Hawksmoor team on the main building and the interiors until 1698. It is likely that William himself was a much stronger influence on Hampton Court than has been previously thought. The fundamental change in design in 1689 from the home-grown baroque of scheme II to the uncompromising French style of scheme III is surely down to the patron's wishes. William's intense rivalry with Louis XIV led to an aping of his style, not only in the final design of the exterior of the building but also in the French-inspired furnishings, many copied directly from Versailles. Talman's victory over Wren was probably as much due to his greater sensitivity to French currents of decoration as to his budgetary promises. But what Talman created at Hampton Court was as far removed from Versailles as it was from the great courtier houses in England. Talman's interiors belonged to a style that he had created outside the Office of Works. The interiors at Burghley and Chatsworth had been his experimentation ground. All the elements of the Hampton Court rooms had already been executed at these houses, and often to much higher standards of quality and richness. Even setting aside the fact that Verrio and Laguerre completed the decoration of the ceilings at Chatsworth, whereas most remained plain at Hampton Court, the State Apartments there are significantly more expensively fitted-out. Samuel Watson's carvings are more lavish and ambitious than Gibbons's, the panelling configuration is more vigorous, the window seats are of Derbyshire marble, the overmantel panels are inlaid with parquetry and several of the floors were originally of walnut and cedar parquet. The main stairs leading to the State Apartments, rising in two parts to the second floor, were lined with alabaster and blue marble.[163]

Contemporaries gave Hampton Court mixed reviews. Edmund Gibson in his second edition of Camden's *Britannia* of 1695 thought 'the Additions made to it by *King William and Queen Mary* do so far excel what it was before, that they evidently show what vast Advancements, Architecture has Receiv'd since that time'. But a more discerning critic, Roger North, found the whole new building lacking,

> It is towards ye garden and park, of a square forme, pink't full of holes, some round, and some oblong, others square: that were it not for ye angles, which hinders the Rotundity of view, one would take it rather for an ampitheatre, than a habitation. And ye order of round windows . . . seem portholes in a Royal Cittadell, and would give one a conceipt as if gunns peept out there. But that which is worst of all, there is nothing rising at ye Angles, as pavilions, or Ayering chambers above ye common Rang of ye Roof, nor no larg rising frontoon with a grand order in ye Midle, but a small one, having short columnes, like ye midle door within of an old fashioned cabinett. And the whole line of ye roof flatt and strait, but Balustred, which looks like ye teeth of a comb and doth in no sort answer the Grandeur of a Royall palace.[164]

North's criticisms still ring true today.

Hampton Court was built on a tight budget and its interior, as much as the exterior, was a compromise. Though French design was the governing obsession, with the possible exception of the king's bed all the furnishings were home grown. As William's correspondence with Portland reveals, there was not much that could be bought in Paris that Huguenot craftsmen and their English colleagues could not make in London. Much of the damask supplied

to Hampton Court was made in Spitalfields and bought through London merchants; the glass plates for the mirrors came from Vauxhall; and the giltwood furniture was made in the parish of St Martin-in-the-Fields. Indeed, by 1715 Elizabeth Charlotte of Orléans wrote that 'one can no longer send fashions' from France to England 'because the English have their own, which are followed here now'.[165] But it was not the preoccupation with French culture and court etiquette that was the enduring legacy of William's reign. At Hampton Court he had developed a way of living far more private than that of Charles II or James II. It was domestic considerations that drove the great building activities rather than a desire for a magnificent public life. This set the tone for British royal life at Hampton Court and elsewhere until the present day. Ultimately, William's Hampton Court has become a footnote in British architectural history. It was a building outside the mainstream of the development of classical architecture; a building with few, if any, contemporary imitators; and soon after its completion it was to become (as will be seen) the archetype of what was wrong with architecture in Britain.[166]

Chapter 11

QUEEN ANNE AND THE DECLINE OF THE COURT

THE REIGN OF QUEEN ANNE marks a significant change in the history of Hampton Court. Where once the court had been a major instrument of power and influence and the royal palaces an expression of the monarch's personal preference, the court was now increasingly peripheral, with royal artistic patronage being influenced by the emerging political networks of the Whigs and Tories. The root of this change lay in the exclusion crisis that led to the emergence of two distinct groups in Parliament between 1679 and 1681. Originally the Whigs and Tories had been divided by their views regarding the monarch's right to rule, the Tories believing in divine right and the Whigs in the right of Parliament to choose. Yet as time moved on the divisions were essentially over religion and the relative merits of religious toleration (the Whigs) and support for the conservative element of the Anglican Church (Tories). The Tories were in the ascendancy under Queen Anne, the legitimate daughter of James II, but after the accession of the Hanoverians in 1714 the Whigs became the natural party of power and government for the rest of the century. The main link between the Crown and the two Houses of Parliament now became the cabinet, which gradually superseded the large and unwieldy Privy Council as the primary instrument of executive power.

These changes were of importance to the history of Hampton Court for two reasons. First, in comparison with Charles II's court, that of Queen Anne was largely on the periphery of the real forums of power and patronage, and access to the person of the monarch was not the prize it had been. Ambitious, clever and power-hungry individuals now looked towards Parliament, the government bureaucracy, the armed forces and trade rather than the court.[1] At first glance, from the perspective of the court itself, it is difficult to perceive this shift. The round of receptions, dining, progresses, hunting, meetings, repair, redecoration, refurnishing, christenings, coronations and funerals continued without apparent change. Yet the power was vanishing from what were increasingly ceremonial rather than executive events. This began to have a significant impact on the use and pattern of occupation of Hampton Court in the reigns of Anne and the first two Georges. Second, major decisions about acts of public artistic patronage became central concerns of the political elite. This was partly because great public works like Blenheim Palace or St Paul's cathedral were paid for out of the public purse, but equally because specific styles in painting and architecture were increasingly associated with the beliefs and principles of the opposing Whig and Tory views.[2] A manifestation of this was the alteration in patronage networks. The history of Hampton Court, its architects, craftsmen, clerks and offices, had always been political in the loosest sense of the word. Appointments were made by the monarch based on preferences, and possibly membership of certain court factions. From 1701 the political parties began to exercise far greater influence on patronage than did the monarch's isolated whims, resulting in the politicisation of official artistic commissions at court. No longer did the personal preferences of the monarch determine the form of the royal residences; the political and artistic alignment of those who created, maintained, designed and ran Hampton Court was set by the political elite.

At the heart of Anne's reign was a chronic financial problem. Although the queen had been granted £700,000 a year by Parliament at her accession, this was dependent on unsecured revenue, and by 1710 receipts had fallen short by a total of £868,335. On her death in 1714 she owed her household servants over £150,000.[3] The financial situation at the Office of Works was little better. In 1702 Wren was seventy and still, after nearly fifty years, Surveyor of the Royal Works. Throughout Anne's reign it was the tried and tested team of Wren as Surveyor and John Bull as Clerk that held sway at Hampton Court. But the final years of their partnership were dogged by severe financial problems and at Anne's death the Office of Works had debts of £80,000 and one of the worst credit ratings in its history.[4] Given these facts it was fortunate that William III had left the royal houses in such good condition. Hampton Court, although barely finished, was largely brand new and theoretically in need of little maintenance. But Anne preferred Windsor to Hampton Court. She had owned a residence there in the town since the late 1690s and was drawn back each summer to hunt and enjoy herself there. For her, as for Charles II, Hampton Court was a convenient place for the Privy Council to meet, equidistant between St James's and Windsor. Likewise Anne preferred the newer and more private metropolitan palace at Kensington to the 'official' seat of power at St James's.[5] In short, St James's and Hampton Court were for business; Kensington and Windsor for pleasure. As with all generalisa-

197 R. Cattermole, *The King's Staircase, Hampton Court* (detail), original watercolour prepared for W. H. Pyne, *Royal Residences*, 1817–20.

198 Antonio Verrio's oil modello for the ceiling of the King's Staircase for presentation to William III, c.1702.

tions this picture can, in fact, be refined. For Hampton Court, Anne's reign can be divided into two distinct periods. The first, before the death of her husband, Prince George, in October 1708, is one of retrenchment and neglect, the queen only staying three nights. The second, after Anne's twenty-four-month period of mourning, begins in 1710, after which for four years Hampton Court was a focus for attention and a place of occasional residence.[6]

Antonio Verrio and the King's Stair

On her accession Anne found a number of important works still underway at Hampton Court. The most important of these was Verrio's mural for the King's Stair (fig. 197). This was under scaffolding during the whole of the first half of 1704, and was only finally cleared in August.[7] William must have approved the overall scheme before his death, from oil sketches prepared by Verrio, several of which survive (fig. 198). The lower, panelled, part of the stair is painted with grisaille panels of arms in a marbled and gilded framework. The gilding work was commissioned separately from Peter Cousin. The events of the main composition take place around an open *trompe-l'oeil* courtyard with a giant Composite order and a rich entablature. The courtyard itself is open to the sky, where around a circular golden table sit the chief gods of Olympus and their emblems. The framework of the design is a development of that first employed by Verrio in the king's chapel at Windsor, completed before the death of Charles II. The iconography, an allegory that glorifies William III as Alexander the Great, is based on the *Satire of the Caesars* written in AD 361 by the emperor Julian the Apostate. The satire tells of the triumph of Alexander over the Caesars and represents the Protestant William's (i.e. Alexander's) triumph over James II and the Catholics (i.e. the Romans). The *Satire* was well known in the seventeenth century and frequently used by Protestant pamphleteers; it would thus have been nearly as pleasing to Anne and the design seems not to have been altered after William's death.[8]

Historians have not been kind to Verrio's great work. Horace Walpole thought he painted it 'as ill as if he had spoiled it out of principle'. Edward Jesse, the early nineteenth-century historian of the palace, thought it 'wanted elegance'; and the mid-twentieth-century art historian Edward Croft-Murray called it 'one of the most unpleasant daubs ever produced by the baroque age', while Ellis Waterhouse observed that Verrio counted as perhaps 'the most heavily remunerated painter in Britain up to the time of Sir John Millais . . . [and] also one of the worst'.[9] I am inclined to be more sympathetic. The first reason for this is that the paintings have not fared well and only twenty years after their completion were being restored. In 1722 Sir James Thornhill was paid for repairing detached plaster, and in 1750 a major restoration costing £590 was undertaken by the Master Carpenter and Clerk of Works. This latter work was presumably again concerned with plaster adhesion rather than touching up. Two more eighteenth-century restorations are recorded: one in 1775–9, which seems to have concentrated on the grisaille panels at low level, and the other in 1781 when the staircase was again in 'very great decay'. During the

nineteenth century over-painting was seen as the solution to the mural's poor condition (see chapter 15), but even during its first hundred years the stair suffered from continual restoration.[10] This has led to the crudity of some of the figure painting. Yet the architectural framework and Verrio's use of *trompe l'oeil* succeeds in creating a dynamic and exciting space, and the brightness makes the staircase the most colourful and exciting eighteenth-century interior at Hampton Court. The Stair cannot claim to live up to the best baroque painted interiors in England, such as the staircase at Chatsworth, the Saloon at Blenheim, or even Laguerre's staircase at Petworth (which owes a great deal to Verrio's Hampton Court stair), but it provides a fitting and magnificent entrance to the King's Apartments. Finally it is worth noting that the overall effect of the space is now much diminished, for Tijou's wrought-iron balustrade was originally painted a steely blue and gilded, and hanging in the centre of the ceiling was a great glass lantern on a gilt chain with sixteen nozzles and a gold crown.[11]

The Drawing Room

The queen's next and final commission for Verrio followed hard upon his completion of the Stair. In late 1703 he started work in what was to be the Queen's Drawing Room. It is unclear why Anne commissioned this expensive project given both her financial distress and her disinclination to use Hampton Court. The room itself and those to either side were unfinished, not even having floorboards, and the Wardrobe had removed a bed described as 'the queens' and taken it to Kensington, which strongly suggests that Anne did not expect to reside at Hampton Court.[12] In March 1704 the queen ordered that a green damask bed and matching seat furniture should be carefully measured, repaired and taken from Hampton Court to Windsor, to be replaced by a bed and matching wall hangings in satin with Indian embroidery brought from Windsor. The care with which the green bed was measured for Windsor and then repaired would suggest that it was the best bed that was being moved there, and that the Indian bed was a substitute for the less favoured residence. Yet despite this, work was also underway to redecorate the queen's dressing room with new crimson damask curtains and wall hangings, and quantities of new bedding and beds were provided for the Queen's Bedchamber staff.[13]

Anne's intentions for Hampton Court in 1703–4 are difficult to ascertain and may not have been clear in her mind either. Work went ahead on painting the Drawing Room, probably simply through the momentum of having Verrio on site. The financial records show that painting the room was never a priority, and money did not flow easily into Verrio's pocket. He continually petitioned to have payments kept up, until on 19 June 1705 he claimed that it had been four months since he finished the room, and that he wished to be paid and given instructions for his next task. The queen told him 'there was no haste of any more painting', awarded him a £200 pension, and sent him into retirement.[14]

No sketches survive of the scheme, which is an allegory of the queen's reign and British naval power. Unlike Verrio's earlier work, which had been framed by architectural orders, the Drawing Room is painted as a great marble hall hung with faux tapestries bordered with fruits and flowers with gold medallions at the corners. On the west wall, directly on an axis with Charles II's Long Water, is Britannia enthroned, receiving homage from the four corners of the globe. On the north wall Prince George, in the uniform of Lord High Admiral, stands reviewing the British fleet, the crown of Denmark lying on a table beside him. Facing him, the fleet appears again, but in the foreground a podgy George reclines naked on the back of a sea creature while cupids frolic in the surf. Above, Neptune and Britannia crown Anne as Justice (fig. 199).

The imagery was clearly a celebration of British naval power, but significantly it gave a leading role to George, an otherwise faceless consort.[15] The Queen's Drawing Room, Verrio's last work, has been widely judged his least successful, yet for the history of Hampton Court and of decorative painting in England it is also the most interesting. Verrio was sixty-four in 1703 and had begun to suffer from what his contemporaries called *gutta serena* (cataract). In order to complete the work he relied heavily on a number of assistants who, according to Horace Walpole, included Gerard Lanscroon, Nicholas Scheffers and Giovanni Battista Catenaro. It is likely that they were engaged in painting the finely observed and accurate ships in the background. Edward Croft-Murray has pointed out that the evidence of the sketch-book of James Thornhill in the British Museum strongly suggests that he too was amongst the assistants. Thornhill had been born in 1675 in Dorset and was sent to London at the age of fourteen to be apprenticed to his uncle, the sergeant painter, Thomas Highmore. Highmore's work, as far as it is known, did not embrace large-scale mural painting, or indeed, figurative painting at all. His work at Hampton Court, which included painting statues and painting and gilding Tijou's ironwork, is typical of his output, and Thornhill was probably introduced to Hampton Court working on similar tasks. His sketch-book shows that while engaged on these more mundane matters he had time to observe Verrio at work and made a sketch and notes of Verrio's design for the King's Bedchamber. When Verrio started work on the Drawing Room it is likely that Thornhill was one of his assistants, for in his sketch-book there are two drawings showing designs for the feigned tapestries on the north and south walls. Indeed it has been possible to detect the softness of Thornhill's hand in some of the figurework.[16] Thornhill left Highmore and Hampton Court to paint at Chatsworth, Greenwich and St Paul's, returning in 1712 to paint the chapel as a great muralist in his own right.

Anne and Prince George at Hampton Court

On 19 April 1706 Anne and George dined at Hampton Court. The prince liked it so much and was so pleased with the improvements, that he persuaded Anne to stay for two nights. This was the first time she had stayed as queen and the bells of Hampton church were rung to celebrate the fact. George seems to have harboured some affection for the palace, as we shall see, and according to John Macky, writing in 1732, the east front apartments were set up specifically for him. This is, in fact, very likely and would explain Verrio's iconography. The following year Anne and George visited again and it was suggested that because of the fine air the court should spend the summer there. Yet nothing seems to have come of these plans, and Anne and George never stayed at the palace together again.[17]

200 View of the cascade in Lord Halifax's garden at Upper Lodge, Bushy Park, by an unknown hand, c.1715.

In the years immediately after these visits a number of important changes took place in the staffing of Hampton Court. Until the death of the Duchess of Cleveland in 1709, the titles and offices of the honour of Hampton Court were held on her behalf by William Young, the Keepership of the House and Gardens by Jasper English, the Keepership of the Middle Park and Hare Warren by Edward Progers, and the Keepership of Bushy Park by her son the Duke of Grafton. Long before her death the titles and offices had been eyed up by Charles Montagu, first Earl of Halifax, a veteran statesman and former Chancellor of the Exchequer under William III. He held the Rangership of Bushy Park for the lives of Cleveland and her son, the Duke of Northumberland, and obtained permission, in 1706, to rebuild the Ranger's House to his requirements. In May 1709 Halifax bought the reversion of the Hampton Court offices, which he came into the following year and then held until his death in 1715, when the titles passed to his nephew George.[18] Halifax's most important contribution to the history of Hampton Court was his rebuilding of the old timber-framed lodge as the fine mansion now known as Upper Lodge. It was surrounded by baroque water gardens that were recorded in a number of paintings (fig. 200).[19]

William Young coincidentally also died in 1709, as did another long-standing servant of the palace, James Marriott. Marriott was replaced by his son Richard as Keeper of the Privy Lodgings and Standing Wardrobe.[20] On 15 June 1707, Verrio died at his house at Hampton Court, and Henry Wise was paid to defray his funeral expenses and pay his debts. Verrio was one of a number of leading craftsmen and designers who settled at Hampton Court after a long association with the palace. Henry Wise built himself a house against the wall of Bushy Park opposite his official residence (Wilderness House) in 1705.[21] The following year Sir Christopher Wren renounced his claim to over £300 of salary arrears in exchange for a fifty-year lease on the Surveyor's House on Hampton Court Green, where he intended to retire. The house was in poor condition and was virtually rebuilt in 1706–7.[22]

Only one work of any significance was undertaken to the exterior of the palace before the death of Prince George. In August 1707 Wren reported that, because of the action of the bells, the turret on Anne Boleyn's Gate was about to collapse. It was decided to remodel the top of the gatehouse, centralising the bell-house and redesigning it as a leaded cupola at a cost of £700. Not long afterwards it was decided that the clock movement too was in need of repair. In 1702 a watchmaker, Thomas Herbery, had been paid for renewing the 'watch part' of the great clock, but this work seems not to have righted the ancient timepiece and in 1710 the manufacture of a completely new movement was deemed to be the only solution. The clockmaker chosen was Langley Bradley of Fenchurch Street, who had made the great clock for St Paul's cathedral and was well known to Wren. It was he who decided to keep the single bar with the letters 'N.O.' the signature of his illustrious predecessor (see chapter 3). Bradley's new movement caused a storm of protest, as his appointment rode over the estab-

199 The Queen's Drawing Room looking west. On the west wall is a representation of Britannia receiving the homage of the Four Continents and, on the ceiling, of the apotheosis of Queen Anne.

lished rights of Mansell Bennet, the Royal Clockmaker, who felt he had been pushed aside.[23]

On the death of George of Denmark in October 1708 Anne withdrew from public life and entered intense private mourning for almost two years. The ending of mourning at Christmas 1710 ushered in a new phase for Hampton Court. For four years she made efforts to revive the social life of the court and spent three periods of residence at Hampton Court, in October–November 1710, October–November 1711, and August 1713.[24] Although, famously, Sarah, Duchess of Malborough, said of Anne that 'she was never expensive, nor made any foolish buildings', it was in this period that Anne made her architectural contribution to Hampton Court and briefly enjoyed its delights.[25]

Queen Anne at Hampton Court

During her visits Anne occupied the former King's Apartments used by William III, as was the form for a female monarch (Queen Elizabeth had used Henry VIII's apartments). The State Rooms remained much as before, but the queen's inner rooms were redecorated and re-configured. Anne spent much of her time confined to the precincts of her bedchamber due to her shyness and ill health, and this meant that the backstairs were heavily used to convey important visitors to her presence, something that greatly worried the Lord Chamberlain, the Earl of Shrewsbury. After the attempted assassination of Robert Harley in 1711 he wrote to Harley arguing, 'I think a particular consideration should be had in what manner to propose to her Majesty not to be so exposed to attempts, as she certainly is . . . by her back stairs everywhere in all her houses being made the common way to come to her as well for strangers as her nearest domestics.'[26] In short, Anne used the backstairs for ordinary access rather than secret communication. The resulting influx of visitors led to a rearrangement of her closets. In 1711 William's former closet was converted into a dressing room for the queen; Grinling Gibbons provided carving and it was re-hung with seven pieces of green damask and two matching festoon curtains. En-suite furniture, provided at the same time, included three stools, a 'great' armchair and a fire-screen.[27] The following year three festoon curtains of blue lutestring and more carvings were provided for the queen's closet. This closet, with three windows, was the corner closet now known as 'Queen Mary's', which suggests that the queen had moved her principal business room, inserting the dressing room as an ante-room between it and the backstairs. We also learn of two curtains of yellow lutestring for the 'waiting room', the Ladies of the Bedchamber's backstairs room. This was filled with a quantity of new furniture for the Ladies of the Bedchamber and the queen's waiting visitors (fig. 173).[28]

In these innermost rooms the queen lived a life less public than her immediate predecessor, but still following the broad formalities of royal etiquette. John Arbuthnot described the duties of her dresser or Bedchamber-woman. She

> came into waiting before the queen's prayers, which was before her majesty was dressed. The queen often shifted in a morning: if her majesty shifted at noon, the bedchamber-lady being by, the bedchamber-woman gave the shift to the lady without any ceremony, and the lady put it on [the queen]. Sometimes, likewise, the bedchamber-woman gave the fan to the lady in the same manner; and this was all that the bedchamber-lady did about the queen at her dressing.

William III had probably followed a more complex and public ceremony in his bedchamber. Yet Anne did undertake a small number of formal receptions in her bedchamber; in November 1711, for instance, she gave the Russian ambassador his first private reception there.[29]

In the public rooms Anne held a number of drawing rooms, which were formal early evening assemblies in the queen's presence. These took place in the Drawing Room and the Privy Chamber on the south front, and in 1710 six dozen cane-bottomed chairs were provided for them.[30] Anne's drawing rooms at Hampton Court were thinly attended. On 2 October 1710 Jonathan Swift went to a drawing room at Hampton Court before dining with Lord Halifax. He 'expected to see *nobody*' but met enough people to entertain him. He then writes that 'I walked in the gardens, saw the cartoons of Raphael, and other things' before visiting Halifax's house in Bushy Park and returning to London by carriage.[31] In *The Rape of the Lock* Alexander Pope, another literary visitor to Anne's court, described the 'various Talk' in which the court passed its hours at such assemblies at Hampton Court:

> Who gave the *Ball*, or paid the *Visit* last:
> One speaks the Glory of the *British Queen*,
> And one describes a charming *Indian Screen*;
> A third interprets Motions, Looks, and Eyes;
> At ev'ry Word a Reputation dies.[32]

These occasions were probably a sad echo of William's reign, but nevertheless they required the full household to be in residence. All the court lodgings in the new quadrangle were granted out and were enjoyed by courtiers and court officials. In 1711, when the queen was laid up at Hampton Court with severe gout, a new suite was furnished for one of her physicians, Dr Hanns.[33] The Household Below Stairs was also present, and after dining at the greencloth table at Hampton Court in 1711, Swift claimed that while the court was there or at Windsor the table provided the best hospitality in England. This is perhaps why in June 1712 the household kitchen was equipped with an enormous new set of 'kitchen goods' including three dozen saucepans, two dozen large spits for the range, two dozen trivets and six dozen patty pans.[34] But most importantly Hampton Court was again the meeting place of the Council. It was this use of the palace that inspired Alexander Pope to write of Hampton Court as a place of political significance:

> Close by those Meads for ever crown'd with Flow'rs,
> Where *Thames* with Pride surveys his rising Tow'rs,
> There stands a Structure of Majestick Frame,
> Which from the neighb'ring *Hampton* takes its Name.
> Here *Britain*'s Statesmen oft the Fall foredoom
> Of Foreign Tyrants, and of Nymphs at home;
> Here Thou, Great *Anna*! Whom three Realms obey,
> Dost sometimes Counsel take – and sometimes *Tea*.[35]

Anne was a highly conscientious monarch who attended long Cabinet meetings twice a week and received a constant stream of ambassadors and petitioners, and papers to sign. Although Parliament had a decisive power in affairs of state, the formulation of

foreign policy, the appointments and dismissal of ministers, and the distribution of patronage were central concerns of the monarch. Anne's Council met for the first time at Hampton Court in October 1710 in the Cartoon Gallery. Nothing is known of the physical arrangements made for this but, as is explained below, more is known about its Hanoverian use and it should be assumed that the furnishing arrangements were similar. The gallery was not only the largest state room at Hampton Court but it was unquestionably the most famous. Jonathan Swift went especially to see it, but it was also visited by numerous tourists including Celia Fiennes, and George Bickham who called it the 'Great Council-Chamber'.[36] The great attraction was, of course, the Raphael cartoons, which as early as 1703 had been celebrated in an anonymous *Hymn to the Light of the World*, beginning 'Stay, Stranger, here, in this Apartment stand, / And view the Wonders of great *Raphael's* Hand'. In 1711 Sir Richard Steele was able to note with pleasure that 'These invaluable pieces are very justly in the Hands of the greatest and most pious Soveraign [sic] in the World', but he also commented that they 'cannot be the frequent Object of every one at his own Leisure'.[37] For this reason, as has been noted, copies were made soon after their installation, but this did not satisfy the demand. In June 1702 Louis Laguerre was petitioning for payment of £260 owing him from an agreement made with William III for copying them, and in 1708 a Mr Brackyn was copying one of the cartoons (and Kneller's picture of William III on horseback). In 1707 Simon Gribelin drew and engraved a set with a frontispiece dedicated to Queen Anne (fig. 172). Four years later the queen commissioned the French engraver Dorigny to make a set of engravings, and he was given lodgings, firewood and a bottle of wine a day to enable him to do so. Others followed in the space of a very few years, including Sir James Thornhill who 'during three unremunerated years' after 1729 made several sets of copies in different sizes. Both Dorigny's and Gribelin's copies were important expressions of royal cultural prestige, and Dorigny's were originally intended to be used by the queen as diplomatic gifts. More than anything else it was Raphael's cartoons that gave Hampton Court an international profile.[38]

The Chapel

Anne's most significant contribution to Hampton Court was the work she commissioned in the chapel. William III had remodelled the royal pew, but the body of the chapel remained much as Charles II had left it. This was not deemed satisfactory for Anne. The first reason for this was that Anne was fervently committed to upholding the Anglican faith and had been even during her father's reign. While James was king she and Prince George had been assigned the Whitehall chapel whilst her mother and father used the new Catholic structure. Immediately on her accession she made plans to enlarge the chapel at St James's, in order to give it, according to Narcissus Luttrell, 'the form of a cathedral'.[39] While this intended work did not take place, Anne insisted that the one part of her otherwise frugal and sombre household that should maintain the standards of Charles II's court was to be the Chapel Royal. The queen's musicians and chaplains were kept busy the whole year round – so much so that the Gentlemen of the Chapel begged, and were granted, an increase in their travelling allowance. As princess and then as queen Anne championed the musicians and composers of the chapel, reversing the orders of Queen Mary that had diminished the musical content of royal worship. There was a second reason for the refurbishment of the Hampton Court chapel. Because of her persistent ill health and the absence of a daily levee, the queen's attendance at chapel was a crucial part of the day at court, being the only opportunity for Anne to show herself publicly. As had been the case in Henry VIII's time, the monarch's visit to the chapel was the main public event of the daily round.[40]

On 5 December 1710 Wren presented to the queen a drawing in the hand of Hawksmoor giving two variations of a design for a new altarpiece (fig. 201). The design belongs to a family of altarpieces originating with John Webb's design for the Queen's Chapel at Somerset House in 1660–62, modified for several City churches and refined for the royal chapel at Whitehall. Central to the design are giant columns on high bases supporting a segmental pediment. Doors, niches or blind windows flank the central structure.[41] Of the alternatives the queen chose that with coupled columns and a more vigorous segmental pediment (fig. 202). In January 1710 the order was given to build the altarpiece and make other improvements at a cost of £2,735 9s 4d.[42] Unfortunately, the par-

201 Drawing by Nicholas Hawksmoor showing alternative designs for the altarpiece for the Chapel Royal, Hampton Court, dated 5 December 1710.

202 T. Sutherland after Charles Wild, 'The Chapel Royal looking East', from W. H. Pyne, *Royal Residences*, 1817–20.

ticular books for work do not survive and we only have the summaries of the audited accounts. Thomas Hopson was paid for 'bolection work' about the chapel, ante-chapel and stairs. This must refer to the panelling of the walls, the ante-chapel and the new staircase linking the royal pew with the ante-chapel. This was inserted into the south-west compartment of the pew, replacing the Tudor spiral. The Tudor ceiling was retained and survives today as one of the few in the palace.[43] New box pews were constructed and a new pulpit was integrated into their design. These can be seen on a plan of about 1732-42 as first installed (fig. 253).[44] We know that Thomas Highmore painted the vault of the ceiling (but not the ribs) in white lead (fig. 202). He also painted the walls white, and repainted and gilded the 'ornament painting over the tribune in the ceiling of the chapel' and the two Tudor panels to either side of the west door; for this he was paid £194. James Thornhill painted the ceiling of the central part of the closet created by William III which had previously been left blank.[45] John Smout laid the black and white marble squares, which had been in store since King William's time, on a bed of Portland stone in the choir. The Portland stone alone served as the floor in the ante-chapel. Since William and Mary's new organ had been burned in the Whitehall fire of 1698, Christopher Schreider was paid £500 for building another organ according to a design approved by the queen.[46]

Grinling Gibbons was paid £422 for unspecified work, presumably the carved cresting and drops of fruit and flowers with cherubs' heads shown on Wren's alternative for the altarpiece. The design as executed is very similar to the altarpiece designed in 1667 for Whitehall, also burnt in 1698. Just as at Somerset House and Whitehall, the principal entablature above the panelling divided the reredos vertically. At Hampton Court this lower area was used for liturgical hangings such as that shown in Charles Wild's view of about 1817 (fig. 202). Above was a roundel that was later filled with a painting of *St Michael the Archangel*, but which was initially empty. The background was decorated with monochrome marquetry similar both to the overmantels in the state rooms at Chatsworth (1689–94), and to the altarpieces at Trinity College, Oxford (1691–5), and the Royal Hospital, Chelsea (1682–3).

Wild's view shows that by 1814 the Tudor tracery had been removed from the windows and casements installed instead (fig. 202). This work was almost certainly undertaken for Queen Anne, since behind the altarpiece and to the east of the organ loft Tudor tracery survives behind the work of 1711. The audited accounts also show that the large sum of £110 was spent on glazing.[47] That casements were chosen as replacements rather than more fashionable sashes was probably due to the Tudor four-centred heads. The removal of the windows must have caused considerable disruption to the chapel walls, and a careful examination of the ceiling reveals that its lower parts were altered and embellished to conceal this. To support the principal ribs new console brackets were fashioned with great straps and cherubs' heads. New hood mouldings over the windows were also introduced, consisting of deep moulding with a trail of acanthus. The work is very successful and, painted gold and blue, is barely distinguishable from the original despite its stylistic divergence. As well as refashioning the ceiling, care was taken to harmonise the walls. An oil sketch by Thornhill shows his intentions for the space above the altarpiece (fig. 203), including *trompe-l'oeil* vaults and windows with coffered reveals. The high-level painting was executed as shown, and the coffered decoration was extended to the true reveals. The window piers were also painted. In September 1711 Richard Marriott supplied a crimson pulpit cloth, a large order of bibles and prayer books of varying sizes and grandeur, curtains for the organ loft, and two surplices for the minister. The following year furniture for the Queen's Closet was delivered, including an armchair with a footstool, a Persian rug for them to stand on, an altar cloth and other furnishing for the sanctuary.[48]

In the early part of Anne's reign Hampton Court continued to be an outstation for the Royal Hospital at Chelsea. But when, in June 1704, arrangements were made for supplying coal and candles to the guard room, it was noted that 'the company is reduced and the guards fewer than heretofore'. This was partly due to the infrequent usage of Hampton Court, and partly to a natural decline in recruits. A Jacobite scare caused the Hampton Court Invalids amongst others to be deployed in 1708 under the captainship of a one-legged man called Bettesworth. This ensured their continued survival, and they were reinforced in 1709–10. The Invalids continued at Hampton Court until 1713, when it was decided to convert more of the old Royal Savoy hospital off the Strand in Westminster into barracks. While this work was underway six companies of Coldstream Guards (378 men in all) were re-located to Hampton Court and the Invalids ejected. In preparation for their arrival a number of minor modifications were made. By the end of the reign there were once again two companies of Invalids at the palace, some of whom were deployed against the Jacobite rising of 1715–16. Under George I the corps was developed further, being converted into a regiment in 1719.[49]

Depicting the Palace: Leonard Knyff

Four images, dating from the start of Anne's reign, record the entire Hampton Court estate, including the parks, the gardens and the Green. These are a large painting from the east (fig. 204), an engraving from the east, a drawing from the south (fig. 225) and an engraving from the west (fig. 205). These were all, in one way or another, the product of the pencil and brush of the Dutch landscape painter Leonard Knyff. The engraving from the west (fig. 205) was taken from one of a series of eighty drawings of royal palaces and country houses, originally part of a project of a hundred views for a great book. Subscribers were sought in the *Post Boy* in mid-1701, so many of the views must have been completed before then. The book, engraved by John Kip, was published in 1707 as *Britannia Illustrata* and sold by the bookseller and publisher David Mortier. The drawing from the south (fig. 225) probably comes from a different source. In January 1703 Knyff told Mr Rhodes, Lord Irwin's steward, that he had drawn 'a great many' prospects of Hampton Court and Windsor for Prince George of Denmark which he had not engraved. This drawing, containing notes as to colours, was clearly not destined for engraving and may have been part of George's original commission. Lord Coningsby of Hampton Court House in Herefordshire commissioned Knyff's painting from the east. For him Knyff painted at least three and possibly four bird's-eye views: two of his Herefordshire seat, one of his house's royal namesake and possibly one of Windsor Castle. These hung together in Herefordshire until the collection was dispersed and the view of Hampton Court Palace acquired by George VI. The engraving from the east, although from the same vantage point as the painting, comes from a different source. David Mortier gathered together a vast mass of engravings and drawings by Knyff, Kip and others and published them as *Nouveau Théâtre de la Grande Bretagne* between 1715 and

203 Sir James Thornhill's oil sketch for the east wall above the altarpiece in the Chapel Royal, Hampton Court.

204 Leonard Knyff, *Hampton Court from the East* (detail), *c.*1712–13.

1716. The view of Hampton Court from the east was one of these, and was engraved from a lost drawing by Knyff distinct in substance and many details from the painting. The view was dedicated to Charles Spencer, Earl of Sunderland, whom George I made Secretary of State in April 1717.[50]

Between them these views represent the most comprehensive survey of the palace since the series by Wyngaerde in Elizabeth's reign. But their influence was much wider. Wyngaerde's commission remained a private project and the views were virtually unknown until the late nineteenth century, whilst *Britannia Illustrata* and *Nouveau Théâtre* reached a very wide audience. The first plates in *Britannia Illustrata* were arranged on the basis of precedence. First came the official seat of the monarch, St James's; then the near-redundant royal houses of Somerset House and the Tower of London; Hampton Court came next, and then Windsor; and finally, before the great country seats of England, was Lambeth Palace. Of these Hampton Court stood out as the only seat worthy of comparison to what came after. It is noticeable that it sits happily in the company of the great courtier houses, set in parkland with gardens by London and Wise. These views not only captured the splendour of the Williamite building boom, but the end of an era. These great houses set in formal gardens with their new baroque wings influenced by the architecture of Paris and Rome were about to be swept from fashion by the rise of a new style in architecture and gardening. These two books should be compared with a third, *Vitruvius Britannicus*, the first volume of which was published only seven years later in 1715. It too was arranged according to precedence, but in this case the works of Inigo Jones and John Webb were placed first, and next came the works of the book's compiler, the architect Colen Campbell. Unlike *Britannia Illustrata* it contained an introduction in which Campbell attacked foreign styles of architecture and praised English architects (by which he meant Jones, Webb and himself). Needless to say Hampton Court was not included in volume one nor in either of Campbell's two successive volumes. Thus Knyff captured Hampton Court as it fell out of fashion, and his images were to become a symbol of what architects wished to avoid rather than to emulate.[51]

205 Leonard Knyff, 'Hampton Court from the West', from *Britannia Illustrata*, 1707. Note the portal on the east side of Clock Court and the clear view of the Tudor bowling alley on the north side.

Yet their value lies in the record they provide of the parks and gardens, always more ephemeral than the bricks and mortar of the palace itself. The parks at Hampton Court were a major attraction for Anne, who followed the hunt in a two-wheeled chaise along specially cut rides in both Home and Bushy Parks. After 1710, when Anne began to show an interest in Hampton Court, a major overhaul of the park was undertaken to improve the hunting. Twenty miles of new ridings were cut, in imitation of the improvements undertaken successfully for the queen at Windsor, where Anne and George had hunted from 1689 to 1694 and again after 1702. The Office of Works was ordered to start 'taking off hills, filling up holes, digging ditches & water courses to carry off the water where wanted, digging and getting out the fern, nettles and other weeds that annoy them, making all passable and sowing hayseed where wanted'. In addition two new bridges were built over the canal in the House Park to improve access.[52] Swift, who saw Anne hunting on a rainy day at Hampton Court in 1711, describes the scene: 'The queen was abroad to-day in order to hunt, but finding it disposed to rain, she kept in her coach; she hunts in a chaise with one horse, which she drives herself, and drives furiously, like Jehu, and is a mighty hunter, like Nimrod.'[53]

The queen's interest in the hunt ensured that deer stocks were maintained by Henry Wise; the lodges in the park were assigned to the Deer Keeper, and other gamekeepers were maintained. Prince George was a pheasant fancier and gamekeepers were delegated to breed birds for his inspection.[54] But a more important result of the queen's love of the parks was the improvement of the Royal Stud. Early in Anne's reign a number of meadows adjoining the stud, which had previously been let, were reclaimed and a new stable 40ft long and 12ft wide was constructed.[55] In Knyff's painting (fig. 204) horses can be seen in the Home Park on the river side, but in reality the stud was further east against the Barge Walk and separated from it by a fence and a hedge. There was a lodge for the Stud Master which was repaired in the first year of Anne's reign. The Mastership of the Stud was actually vacant for the first six years of the reign, only to be filled in 1708 by Richard Marshall. The following year his lodge was rebuilt in brick at a cost of £230.[56] Under George I the importance of the Stud was further increased. In 1716 two new stables (43ft by 17ft) and paddocks were built to house his 'cream horses', milky white albinos with Roman noses and little red eyes, the breed that pulled state coaches until the 1920s. The park walls were also repaired and the fencing to the Thames mended to prevent deer drowning in it.[57]

Anne was the last Stuart monarch to enjoy Hampton Court Palace. On her death in August 1714 the throne passed to George Ludwig, Prince of Hanover, the heir to the Protestant succession through his grandmother Elizabeth of Bohemia, James I's daughter. As George I of England he ushered in a new age for the palace.

Chapter 12

THE GLORY OF HAMPTON COURT: THE GARDENS 1603–1714

The story of the Hampton Court gardens from the death of Elizabeth to the accession of George I is one of the most remarkable and surprising parts of the whole history of the palace. Not only did the period culminate in the completion of the largest formal landscape ever created in England, but also it reveals a surprising interest in gardening by the patrons of the work. That William and Mary should take most of the credit is no surprise, but the supporting cast is remarkable. It includes such diverse figures as Oliver Cromwell, who had a new privy garden designed; Lady Castlemaine, who had the Wilderness planted; and Queen Anne, who ordered the maze.

From the death of Elizabeth to the Glorious Revolution the cultivated gardens at Hampton Court were essentially the southern gardens centred on the Privy Garden, Mount Garden and Pond Yard. Minor works were undertaken in the parks, but of these no trace survives. During James I's reign the structure and much of the planting of the Tudor gardens was carefully maintained and embellished, and in July 1618 they could still be described as the finest royal gardens in England. New fountains were constructed for the Privy Garden – in 1607–8 two were made of black and white marble with pyramids, and in 1615–16 two more with leopards' heads. However, during the second half of James's reign major changes in garden design began to take effect, inspired by the gardens of Italy. As these changes gathered pace in the 1620s and '30s they began to amount to a revolution in design, sweeping away the gardens of the Tudor age. Despite the fact that gardens in the new style were being laid out by courtiers, such as Sir John Danvers at his house in Chelsea, the structure of the Hampton Court gardens remained much the same until James's death. Yet in the last year of his reign James may have moved towards the new style. He commissioned George Hopton to replant the knots in the Privy and Mount Gardens, and this was probably in the French manner in box with embroidery-like scrolls. Five new knots, or parterres, were made in the Privy Garden, and two in the Mount Garden.[1]

★ ★ ★

Charles I and the Longford River

Charles I and his family were more interested in gardening than James had been. Henrietta Maria was particularly fascinated, and her interest opened up a conduit between England and France. Importantly, she brought to England the French gardener André Mollet, the youngest member of a dynasty of famous French gardeners. He redesigned the royal gardens at St James's (1629–33) and Wimbledon House (1642). Meanwhile, Henrietta built new gardens at Greenwich and Somerset House, where she commissioned a monumental fountain topped by a figure of *Arethusa* by Hubert Le Sueur. In some senses these gardens were small-scale and old-fashioned, belonging to a tradition that was being superseded in France. There the use of water was increasingly becoming the essential ingredient in a fashionable layout. At houses like Rueil and Liancourt there were cascades, fountains, grottoes and lakes – features notably absent at Wimbledon and St James's. There is evidence that Henry, the Prince of Wales, wanted to introduce waterworks into his gardens at Richmond before his death. He brought together a group of experts under Inigo Jones to do this. Prominent amongst them was the Huguenot hydraulic engineer Salomon de Caus, who had already designed the jets for the queen's new fountains at Somerset House and Greenwich. But plans remained on the drawing board at his death.[2]

Charles, however, appears to have wanted to transform the Hampton Court gardens along these lines, and he launched a project to construct a hugely expensive and complex water-supply system. The conduit, or river, was to take water from the river Colne over Hounslow Heath to the Hampton Court parks, a distance of eleven miles. The existing Colne channel covered a large part of the route, but this required widening and the installation of sluices and watergates. The Longford River, as it became known, cost over £4,000 and was constructed between October 1638 and July 1639. Its designer was the talented land surveyor Nicholas Lane who had previously worked for Charles on a major survey project to extend Richmond Park.[3] It is very unlikely that the river was ever intended to provide water for domestic use – the Coombe conduits still provided an ample flow of clear filtered water from Kingston Hill. At any rate the Longford River did not

206 (facing page) Leonard Knyff, *Hampton Court from the East*, c.1712–13 (detail of fig. 204).

207 The Hampton Court gardens in 1689. Drawing Daphne Ford.

have the pressure or the settlement tanks necessary for domestic supply. It did, however, have a 13ft head from Bushy Park to the palace, quite enough to power garden waterworks. This is probably what Charles intended.[4] While these plans remained unfulfilled, a number of improvements were effected elsewhere.

In the Privy Garden two new sundials, one of remarkable sophistication (and complication), were installed. In 1625 a 'Horozontal dyall' on a great pillar of Portland stone was made and furnished with fourteen engraved brass gnomons by Elias Allen. Then in 1631–2 John Marr, the mathematician, was paid the vast sum of £100 for his work designing (and probably constructing) nine large hemispherical dials and seven large plain dials for the Portland stone base. Marr later published a 'description and use' of the instrument dedicated to the king.[5] In March 1639 James, Marquis of Hamilton, who was Steward of the Manor as well as Master of the Horse, was instructed to construct a bowling alley for the French game of pall-mall, a cross between Tudor bowling (in an alley) and modern croquet. It is not clear where this was made.[6]

The Commonwealth

Although Oliver Cromwell made no lasting contribution to the palace buildings, his work in the garden deserves closer attention. Soon after he resolved to make Hampton Court his country retreat orders were given to corral there all the best classical sculpture for the Privy Garden. At first a large statue by Fanelli was transported from Somerset House. Then Hubert Le Sueur's *Arethusa* fountain, brass figures of *Venus* and *Cleopatra* and marble figures of *Venus and Adonis* were delivered and installed. It is very likely that they were set in a new layout in what was called at the time the 'Italian style'. This was a form of parterre with a four-square arrangement of paths dividing grass plots, with statues in the centre of each plot, and a central fountain (fig. 207). The garden was described by Count Lorenzo Magalotti at the Restoration and was, he wrote, 'divided into very large, level, and well-kept walks, which, separating the ground into different compartments, form artificial parterres of grass . . . This beauty is further augmented by fountains'.[7] In creating this garden Cromwell was replacing the old-fashioned Jacobean layout that probably still existed at Hampton Court with the new fashion. The fashion was not particularly associated with the Commonwealth regime, but was rather the prevailing new way of the late 1630s and '40s. At Whitehall too, in 1650–51, Cromwell was responsible for the creation of a similar garden, again with grass plots, each with a statue in the centre. Certainly, it could be argued that there was a negative aspect to this. The Jacobean gardens had grown out of the heraldic gardens of the Tudor monarchs and were, in some respects, uniquely royal creations. Cromwell may have wished to turn his back on these. However, what was perhaps more particularly connected with Cromwell and other members of the Puritan regime such as John Milton and Bulstrode Whitelocke was an admiration for classical sculpture. Milton even wrote a short tract in its praise with a section advising on the purchase and transport of pieces. Inevitably, figures such as the one of *Cleopatra* were seen by some as having no place in a godly garden. One Mrs Nethaway was so shocked by the nakedness of the Hampton Court statues that she wrote to Cromwell, 'This one thing I desire of you, to demolish these monsters that are set up as ornaments in the Privy garden.'[8]

The Restoration Gardens

The story of the Hampton Court gardens in the reigns of Charles II and James II is a surprising one.[9] Neither monarch, as we have seen, had a particular affection or use for the palace nor, apart from Charles II's honeymoon, was there a period of major residence there. Yet between 1660 and 1688 two significant changes were made to the gardens that were to set their form for the future, and which endure today. In 1660 Charles gave an important commission to André Mollet and his brother Gabriel. They were ordered to create a new layout in St James's Park to dignify the west side of Whitehall Palace. After working for Henrietta Maria, André had moved in 1633 to the Netherlands, where Prince Fredrick Henry of Orange employed him at Honselaarsdijk (fig. 208), but at the Restoration the pair were back in England awaiting royal commands. These came quickly. In 1660 Charles commissioned them to create a canal lined by double avenues in St James's Park, aligned on the park stairs of Whitehall Palace, and cutting through a semicircle of trees that framed the west side of the palace. The canal flanked by avenues with a semicircular termination was Mollet's trademark design, already set out for Prince Fredrick Henry at Honselaarsdijk, which was one of Europe's most fashionable gardens. Charles was delighted with the new layout and appointed the Mollets the 'King's gardeners'; a few months later he put them under a Surveyor of Gardens, to which post he appointed Adrian May, the brother of Hugh, who was to succeed him as Surveyor in 1670.

208 Balthazar Florentius a' berckerode, *The Stadholder's Garden at Honselaarsdijk, the Netherlands*, c.1640. This shows the garden as it was made in the 1620s but with the addition of André Mollet's parterres either side of the house.

May's first task as Surveyor was to supervise the next park to be redesigned, which was at Hampton Court. As the Mollet brothers arrived at Hampton Court the Office of Works was busy rushing through a refurbishment for the arrival of Catherine of Braganza. The palace surrounds, like the buildings themselves, were looking old-fashioned and run-down and the first priority had to be to eliminate derelict eyesores. Since Henry VIII's reign the Tiltyard towers had been used as lodgings. In 1628, for instance, Inigo Jones had been instructed to prepare five towers against the king's arrival for his physicians, apothecaries and laundresses. Later, one was converted into a pigeon loft. Although the Parliamentary survey of Hampton Court refers to the towers as being in good condition in 1649, Cromwell's inventory omits them and they seem to have been in a dilapidated state by 1660. One was dismantled in 1661 as was the pigeon loft, and after another partially collapsed it too was demolished in March 1682.[10] A new bowling green 60 yards square had been made in the park near the Privy Garden in 1628. Despite Cromwell's surprising affection for bowling, by 1660 it was surrounded by a decaying fence. This was replaced in 1660 and in 1669–70 the Green itself was relocated closer to the palace.[11]

But something far more important was afoot. The park had been badly treated during the Commonwealth and had lost

many of its trees (fig. 58), and anyway a hunting park adjacent to the palace was not what Charles now desired. So André Mollet designed for the king another of his great avenue-lined canals, this one 105ft wide by about 3,800ft long (fig. 209). It was longer than the canal at St James's (2,560ft) and longer than that at Fontainebleau (3,475ft). Seven hundred and fifty-eight Dutch limes were purchased for both the long avenue and those along the semicircular canal at the east front.[12] The canal and avenues were aligned on the room that now became the Queen's Drawing Room, formerly Oliver Cromwell's private bedchamber. The avenues were set out by one Philip More, and the massive task of earth moving and pit digging was contracted to Edward Maybank. As in the case of the St James's canal, the sides were not revetted with brick but shored with timber. The Longford River meanwhile was given a substantial overhaul to supply water to the canal. John Evelyn saw the new arrangements in June 1662, and described 'The park formerly a flat naked piece of Ground, now planted with sweete rows of lime-trees, and the canale for water now neere perfected'. The same summer the Dutch traveller William Schellinks saw the 'straight and circular avenues' and noted that thanks to the canal 'one can go by water with the barges right up to the gardens'.[13] In 1669 stone pavements or landing stages were made at either end of the canal to replace the original timber revetments. Further work 'planking and piling' was undertaken in 1670, and another 319ft of Purbeck paving laid four years later. By 1675–6 the Longford River was badly silted up and the canal water was low; £60 was spent on rectifying this.[14]

The Privy Garden, loved by the Cromwell family, seems to have been in better shape. Although the banqueting houses were repaired and redecorated, little new work was undertaken in 1660–62. During the remainder of the reign small improvements were made to the southern gardens, some as a result of the king's new building and others a result of the use of the palace by Lady Castlemaine. A development that was to have long-term importance was the planting of a vineyard in the Pond Garden in 1672.[15] It was the first English royal vineyard since medieval times, and was probably planted by John Rose, whom Charles had appointed gardener under the Mollets in 1660. Rose, who later assumed André Mollet's position, had written in 1666 *The English Vineyard Vindicated*, and was something of an expert on vines. It is likely that the present Hampton Court vine is a successor of the Caroline ones. The Privy Garden underwent modification after the construction of the king's new building Next to Paradise, a new garden or compartment being created on its southern side. In 1676 a great brick 'neeche' was built adjacent to the new building to provide shelter and a seat for looking out into the park. Parts of this were excavated in 1994.[16]

The Planting of the Wilderness

By 1685 the officers with responsibility for the royal gardens had all been replaced. James II's royal gardener was none other than the painter Antonio Verrio, and under him at Hampton Court was Henry Peacock, the 'Keeper of the Garden and Bowling Green at Hampton Court'. Verrio's position was no sinecure and the surviving documents make it clear that he took an active role in the running of the gardens. Given James's extensive work at Whitehall the focus of this activity was the garden there and St James's

210 Detail of William Talman's plan of the Hampton Court gardens (fig. 176). This is an important plan as it is the only one that shows the gardens as they were between 1694 and 1698. Notable features are the Charles II bowling green by the Thames and the lack of the maze and semi-circular canals, both built later.

Park. Yet it seems certain that during James's reign a major new garden was completed at Hampton Court. An estimate for repairs to the royal parks in 1686 includes £60 for 'rayleing & payling the new Plantation in the Old Orchard, formerly ordered by his late Majesty'.[17] This demonstrates that in Charles II's reign a new garden was planted to the north of the palace where the Wilderness is now. While the garden may have been started in the final years of Charles's reign it must have been completed around 1685–6. There is little doubt, in fact, that the Wilderness as shown on Talman's plan (fig. 210) and Bridgeman's survey of 1711 (fig. 231) was commissioned and started under Charles II and completed under James II. The fulsome accounts for William's reign do not record its construction and the early schemes for rebuilding the palace contemplate its eradication for the great new northern forecourt.

The term 'wilderness' comes from the verb 'to wilder' (lose one's way) rather than being directly linked to any sense of wildness. Thus the Wilderness was a geometrical matrix of paths lined by high clipped hedges of hornbeam forming boxes in the French manner of a *bosquet*. This type of plantation was introduced into England in the 1650s but reached the peak of its popularity around 1680.[18] The Hampton Court Wilderness was approximately square

209 The Long Water and avenues looking east, 2003.

211 Plan of Hampton Court and its gardens by an unknown hand in the Office of Works, c.1714. It is not known for what purpose this comprehensive and detailed presentation plan was made. The emphasis on the gardens which includes the earliest depiction of the maze might suggest that it was a proposal for the new garden regime under Queen Anne.

(fig. 211). It was divided into compartments or boxes containing lime trees by paths in the shape of a cross and a diamond. Where the diamond met the sides of the square on the east and west were semicircular paths and these were linked on the north and south by sinuous paths crossing the geometrical ones. In the centre was a lone pine in a circle (figs 339, 345). Next to the Wilderness was a woodland grove with high clipped hedges and more elms. It has been suggested that the design of the Hampton Court wilderness was the work of one Guillaume Beaumont. Beaumont seems to have been living in Richmond in the 1680s, and he was named in the will of one William Groome as one of four executors together with Henry Peacock who, as has been noted, was the gardener at Hampton Court. His name does not appear in the Hampton Court accounts but he is described, in an inscription on his portrait at Levens Hall in Cumbria, as having 'laid out the gardens at Hampton Court Palace and Levens Hall'. At Levens Beaumont was responsible for creating a wilderness similar in form to that at Hampton Court, and in 1709 he was commissioned to create another at Greystoke Castle. Thus it is possible that Beaumont was asked to design a wilderness at Hampton Court.[19]

Whether designed by Beaumont, Peacock or even Verrio, it is a matter of surprise that Charles should have contemplated such an extensive work at what can be described as only a secondary residence. The answer is probably that he didn't. The work was almost certainly commissioned by the king's former mistress Lady Castlemaine, a long-term resident and the Keeper and Chief Steward of the Mansion and Honour of Hampton Court. Work done for her in the Privy Garden has already been mentioned, and a declaration of expenditure by William Young, her deputy, makes it quite clear that she was very interested in the gardens.[20] The lack of any royal financial records suggests that she paid for the work herself, just as she paid for the French-inspired dairy in the Water Gallery. After Charles's death responsibility for the garden reverted to the Crown.

William and Mary 1688–1694

Long before they began work on the gardens of Hampton Court, William and Mary were already the great gardeners of Europe, having created and embellished important gardens at Honselaarsdijk, Dierien and Het Loo.[21] When William was not at war his chief recreations were hunting and gardening; Mary meanwhile was obsessed with botany and horticulture. It can have been no surprise that William and Mary immediately commissioned gardens in England, and during Mary's lifetime expenditure on the gardens was running at about £12,000 a year.

William appointed the Earl of Portland Superintendent of the Royal Gardens in June 1689.[22] He was an obvious choice because he shared William's passion for gardening, having built one of the most remarkable gardens in Holland at his house at Zorgvliet. He had also been William's principal adviser for the construction of his Dutch gardens. Portland appointed George London, a former pupil (and kinsman) of John Rose and the leading English gardener, as his deputy; William Talman as Comptroller; and as Paymaster Caspar Frederick Henning. Talman's position as Comptroller of both William III's gardens and buildings put him in an interesting and powerful position, one that certainly strengthened the synergy in design between the palace and gardens at Hampton Court. On a lesser level too there was a change in garden personnel, since William and Mary brought their Dutch gardeners with them to England. Hendrick Quellingburgh was put in charge of the Privy Garden, Samuel van Staden oversaw the Wilderness, and Casper Gamperle and Hendrick Floris shared responsibility for the queen's collection of exotic plants.[23]

Once William and Mary had settled upon Hampton Court as their principal residence the design and construction of the gardens progressed in parallel with work on the palace. Sir Christopher Wren's first proposals, drawn by Hawksmoor (fig. 128), included a schematic design for the gardens in the south and east as well as the great avenue to the north. It has been noted that Charles II's canal was a dominant factor in the layout of the new palace, and all the principal design drawings included at least its western end to show its relation to the proposed buildings (fig. 131). In these early schemes the Wilderness and Tiltyard Gardens were to be swept away for the northern forecourt, and in anticipation of this change planting began in Bushy Park for a quadruple northern avenue of limes and chestnuts, which was to be punctuated by a circular basin of water (fig. 128). This avenue was, like the Long Water avenues, in the strong French tradition of André le Nôtre, but in its scale and ambition, unprecedented.

The early plans for the palace show that it had always been William's intention to fill the area between the semicircular canal and the palace with a gigantic parterre, perhaps the largest built in the seventeenth century (figs 128, 140). Long before the east front of the new palace was completed, and before the details of the parterre had been resolved, work started on its construction under Mary's supervision and to the design of Daniel Marot who had already designed gardens for William and Mary at Het Loo. A payment from Casper Henning in March 1698 gave Marot £236 11s 11d for his efforts.[24] The king and queen clearly wanted to get the garden established as soon as possible in anticipation of the completion of the palace. Marot's perspective drawing for the parterre survives (dated August 1689; fig. 212)[25] and was later published by him, with modifications to reflect the executed design (fig. 213). The geometry of the garden was determined by the Long Water and park avenues and turned on thirteen basins. Within the compartments there were two treatments. In the inner semicircle nearest to the palace was a *parterre de broderie* with box hedges and gravel much in the tradition of André Mollet, whilst encircling this was a band of *gazon coupé* (grass cut into shapes with the gaps filled with coloured gravels). At key points in the design evergreens were planted – 304 yews and 24 hollies in all (fig. 225). The Longford River finally realised its potential by powering the fountains in the basins. Over 3,000ft of new elm pipe was laid from Bushy Park, and an extensive system of lead pipes installed in the parterre itself. The whole garden was fenced off from the east front of the palace by an elaborate wrought-iron screen (or palisade) by the Huguenot smith Jean Tijou (fig. 214).[26] The palisade was at first intended to keep the workforce out of the new garden while the palace was being constructed, but eventually it was to reserve the garden for royal use.

Progress was harder to achieve in the Privy Garden, since much of the area was absorbed by the huts and workshops of the Office of Works. By the summer of 1690 most of the building clutter had been removed, and work had begun on demolishing and levelling the Mount and dismantling the Tudor garden towers. A new terrace was built on the west side of the parterre, with a wych

212 (*above*) Daniel Marot perspective drawing for the Great Parterre at Hampton Court, inscribed 'Marot fecit aoust 1689'.

213 Daniel Marot's engraved version of the Great Parterre design. It differs from his perspective view in a number of respects. That it was published in 1703 in his *Oeuvres* confirms his authorship of the design.

214 (*below*) Jean Tijou, 'Design for Iron Gates at Hampton Court', from his *New Booke of Drawings* (London, 1693).

ing the Pond Garden to the west, and of realigning the whole Privy Garden to the dimensions of the new south front. A new wall was built to the east too. Less high, this created a walk on top of the terrace from which the Great Parterre and the park could be admired. The parterre itself was relaid with *gazon coupé*. A fountain basin was dug and the statue of Arethusa, brought by Cromwell from Somerset House, was installed as a fountain on a new stone base. The southern boundary was marked by a trellis (figs 215, 216). Meanwhile Wren's plans for the ground floor of the new building included a greenhouse or orangery with flues for

elm bower planted against a high wall. The bower, in the form of a long tunnel with a single window looking out on the parterre, was supported by a massive oak frame with a coat of arms at its northern end. The bower and wall had the effect both of screen-

stoves and tall doors opening out directly into the new garden. In its centre there was to be a grotto. Remarkably, the orangery was to be separated from the king's bedroom by only one other room, giving William direct access to the gardens should he require it

(fig. 253). A seamless transition between house and garden was thus achieved. Perched high above the orangery doors were four giant lead statues painted to look like stone (fig. 216).

This principal greenhouse or orangery (known as the Upper Orangery) was for orange trees shipped from Holland. Some of these survived until 1892 when they were taken to Windsor. Next to the Privy Garden, in the former Pond Yard, three more greenhouses were built to take Mary's collection of exotic plants, in what was known as the Glass Case Garden. These greenhouses were of a remarkable Dutch design probably by the carpenter Hendrick Floris; each was 55ft long with south-facing sloping windows and furnace rooms behind (figs 210, 218). Into these were introduced Mary's world-famous east Indian collection of rare plants, catalogued by Cornelius Van Vliet in 1690 as *Stirpium . . . quibus hoc anno 1690 Horti Regii Hamptoniensis Ilbernacula sunt ornata*. Mary expanded her collections in the four years before her death, gathering plants from Barbados and Virginia. In 1691 the queen appointed Dr Leonard Plukenet as curator of the botanical collections at a salary of £200 a year. Under Plukenet's care the collection grew and expanded. Areas were set aside for the germination of seeds (the melon ground immediately to the north of the palace)[27] and for the cultivation of flowers for use in the palace (the auricula quarter and the flower garden) (fig. 226). After Mary's death the botanical fervour subsided and William decided to replace the greenhouses with a second orangery. The accounts for the construction of this are missing, but what is now known as the Lower Orangery appears on Knyff's view of 1707 (fig. 205).

215 The King's Privy Garden as completed in 1695, based on historic plans and views and archaeological investigation. Drawing Daphne Ford.

216 (*below*) Engraved view by Sutton Nichols of the King's Privy Garden from the south as completed in 1695.

231

217 Engraved view by John King of the Great Parterre and east front, c.1700.

Like the other garden buildings it was almost certainly designed by William Talman. Its windows are very similar to those in the pavilions, with rubbed brick staff moulds and blank panels beneath the sills (fig. 219).

Meanwhile attention turned to the House Park, where Charles II's great avenue was locked into a wider matrix of vistas by the addition of diagonal and cross avenues of lime. The Kingston avenue, more or less 30° from the Long Water, was aligned upon the spire of Kingston church, and the Ditton avenue aligned in symmetry with it (fig. 231). The Ditton avenue terminated in a semicircle; the Kingston avenue just stopped in its tracks in order to preserve the view of the church spire. The planting of these avenues locked the geometry of the park into the east front parterre and the park itself into the wider landscape. Like the Bushy Park avenues, those in Home Park were in the French tradition and echoed the royal landscape at Greenwich where already in Charles II's reign matrices of avenues had been planted. The park fencing was repaired and new deer pens were built in all three parks to increase stocks.[28]

The moat at the west front was finally filled in and a turn-around (or sweep) constructed for the use of coaches (fig. 205). This was essentially a square-headed ragstone (cobbled) circle protected by stone bollards in front of the gatehouse that allowed coaches to turn easily. Throughout Charles II's reign the west front was clogged by Hackney coaches waiting for a fare from courtiers attending Privy Council meetings, and in 1701 coaches were provided at state expense for the Lords of the Treasury when they met at the palace. A turnaround was a new invention probably imported from Holland where there had been one at Honselaarsdijk since the 1660s; its introduction at Hampton Court finally modernised access to the palace, setting the seal on the dominance of the carriage (figs 205, 226).[29]

On Mary's death much had been achieved, the Great Parterre was already a maturing garden five years old, the Glass Case Garden was a world-class centre of botany, and the Privy Garden a handsome complement to the new south façade and the Water Gallery. The appearance and extent of the gardens at this juncture are preserved in two engravings (figs 216, 217), and a plan made by Talman (fig. 210). In March 1696 it was decided to let a maintenance contract to oversee the upkeep of the cultivated estate. Portland was to receive £4,800 annually to maintain the gardens at all the palaces, of which the lion's share, £1,623 4s, was for Hampton Court. The gardens department was huge. Under a head gardener there were eighty staff in four sub-departments: the Fountain Garden, the Privy Garden, the Wilderness and the Hothouses.[30]

* * *

218 Thomas Fort's survey of the glass houses in the Pond Garden, c.1718. Two types are shown, the top one in elevation and section with a plan showing air circulation. The bottom one showing a simpler type in section, elevation and plan.

219 The Lower Orangery, probably designed by William Talman, c.1700.

William's Gardens 1698–1702

In 1715 the gardener Stephen Switzer wrote that 'upon the death of that illustrious princess [Queen Mary], Gard'ning and all other pleasures were under an eclipse with that prince and the beloved Hampton Court lay for some time unregarded: But that sorrow being dispelled, his Majesty reassumed his further pursuit of gardening, in altering and making considerable improvement to the gardens'.[31] In 1698 William was determined to complete the gardens with all possible speed. William Talman and George London retained overall control but to the team was added London's partner in the Brompton Park nurseries since 1689, Henry Wise. Wise first worked at Hampton Court in May 1699 and was to be a significant figure in the subsequent development of the gardens under Queen Anne.[32] Wise turned to Bushy Park where in August 1699 more limes and chestnuts were added to the Great Avenue, and a 60ft-wide roadway was built down its centre. Soon after, a 400ft-wide basin was finally constructed in the centre of the chestnut circle (figs 220, 231). These works cost just over £4,100 in all. That work was concentrated first on the essentially redundant northern avenues may suggest that William was once again considering the creation of a great northern forecourt. In the event, the most remarkable avenue at Hampton Court still leads nowhere. In Home Park new avenues were also created to integrate the bowling green and pavilions into the existing matrix, and work started on a new wilderness to be sited at the east end of the Long Water.[33] To this were transplanted all the plants and trees from the former Mount Garden. A drawing from Henry Wise's office, probably in the hand of an Office of Works draughtsman (fig. 232), shows the scheme for the Lower Wilderness to have been very similar to Wise's Maestricht garden at Windsor made for Queen Anne in 1710–13.[34] Two symmetrical parterres lay to either side of an extension to the Long Water, terminating in an octagonal basin. Each parterre had a central basin flanked by two smaller oval ones containing fountains.

Talman also submitted an estimate for what remained to be done in the gardens totalling (after revision) £8,933. In the event it was the estimate of Henry Wise that was accepted and he went ahead to create the Broad Walk along the east front, terminating in the north at the Flower Pot Gate, which gave access to the palace from the Kingston road. Other works included laying out and planting plots with evergreens on the northern and southern flanks of the east front. In Fountain Court Wise planted more evergreens and erected four stone pillars with vast brass lanterns on their tops.[35]

In the summer of 1700 the pace quickened. Portland had resigned the Superintendence of the Gardens and the Earl of Ranelagh took his place. Ranelagh and the king wanted to press forward with the extension of the Privy Garden down to the river as shown on Wren's original designs. Work on detail started immediately, and two drawings in an Office of Works hand show proposals for the basic layout of the plots, paths and terraces (fig.

221).³⁶ These led, in March, to the construction of a number of models for the king's inspection by Charles Hopson the joiner, showing the Glass Case Garden and Privy Garden. Once agreed, orders were given for the demolition of the Water Gallery and the reuse of the materials to build a bowling green and four pavilions. Soon afterwards the vast bulk of soil from the Mount was carted away.

Work cracked on at speed to extend the garden; the great urns were removed from the terrace and placed in the Great Parterre (fig. 222); the east and west walls of the Privy Garden were extended to the river; and a wrought-iron fence was made in front of the Upper Orangery to give the king privacy and security in his private rooms. The incredibly fulsome documentation for this period shows William, in his gardens, acting just as he did in the palace – continually experimenting and changing his mind in order to get the perfect result. His absences saw periods of intense construction, and his spells of residence frenzied design work. The most radical change of mind came on 16 June 1701. Between May and June William had been shuttling between Kensington and Hampton Court. The Privy Garden was nearing completion; in February the southern half had been lowered by almost 8ft in order to create a gentle slope from the south front to the Thames. A new fountain had been made, terraces raised and boundary walls and fences constructed. A new pattern of *gazon coupé* had been laid, many of the evergreens and shrubs planted, and the stone bases for the statues installed. William had ordered that Tijou's wrought-iron screens, taken down from the east front the previous year, be considered for erection at the end of the garden, and painted sticks representing them were erected for royal approval. On 13 June William returned to the palace to review progress, and to his dismay found that all this work had still not resulted in a view of the river from the first-floor royal apartments, something he intensely desired. The garden was simply still too high. Three days later he made a decision to scrap a year's work and ordered

220 (*facing page*) The Hampton Court estate and Bushy Park photographed from the air by the RAF in August 1944. The depleted state of the avenues can be clearly seen. Also visible in Bushy Park are the areas still under wartime food cultivation, and in the centre right Camp Griffiss, the military headquarters from where the D-Day invasions were planned.

221 Proposal for principal layout of the extended Privy Garden, 1700, by an unidentified hand in the Office of Works, possibly working for William Talman.

the whole garden to be lowered again. Almost 10,000 cubic metres of soil had to be removed and with it all the beds, plants, terraces, watercourses and the new fountain. The southern end of the garden was to be 5ft lower than before, and overall a 3ft depth of soil was to be removed from the five-acre garden. Having delivered this bombshell to London, Wise and Talman, William left for Het Loo. Wise moved all the plants, in wicker baskets, to the melon ground; John Nost removed his statues; and others dismantled the water pipes and culverts. By hand and by barrow the garden was lowered again; the cost was to be £1,426 4s 4d.[37]

William returned to the palace on 5 November. In one sense the garden was the same – Wise had returned all the elements to their former places – but in another it was very different. A series of adjustments had accommodated the drop in levels and the river was clearly visible at the southern end of the parterre. With William's approval, the garden was ready for the finishing touches. Sundials and stone-colour-painted lead urns were set upon the terrace and steps, and eventually five statues – *Bacchus*, *Venus*, *Apollo*, *Vulcan and Pan*, and *Orpheus* – were set on their pedestals.[38] Tijou's screens were not erected in William's lifetime. Nor was the issue of the triangle of land at the south-east corner of the Privy Garden resolved. Knyff's drawing (fig. 225) shows one proposal, but as late as 1713 it was a 'piece of waste ground'. The total cost of the new gardens from 1699 to William's death had been at least £28,000 and the costs of the bowling green, Glass Case Garden and statuary another £12,000. Thus the cost of works on the garden was broadly comparable to the £43,155 spent on fitting-up the interiors in the same years. For the gardens a grand total for the cost of the first phase, the works after 1698, and maintenance must have reached about £115,000.

Trying to unravel the respective responsibility for the design of the southern gardens is an impossible task. William clearly had a decisive impact and he must have discussed the garden with Portland, despite his retirement from his official post. Talman,

222 Drawing, c.1819, by Philip Hardwick of one of the urns by Caius Gabriel Cibber originally intended for the Privy Garden terrace but moved by William III to the east front of Hampton Court from where they were removed to Windsor by George IV. They have now been returned to the east front.

223 Chatsworth House, Derbyshire, from Kip and Knyff's *Britannia Illustrata*, 1707. The parterre to the south of the house bears a striking similarity to that at Hampton Court.

224 A garden design by Daniel Marot, from his *Oeuvres*, 1703, showing a clear resemblance to the Privy Garden.

London and Wise had an enormous influence too and a glimpse at their work elsewhere, particularly at Chatsworth (fig. 223), reveals the strong similarity the Privy Garden bore to their projects for William's courtiers. In 1700 a letter from Talman to William Blathwayt in the Netherlands suggests that the king might like to consider some ideas (probably for the east front) put forward by 'severall noble Lords the wee here call the critiques', suggesting that the design of the gardens was widely discussed in Talman's circle. It is not impossible that Daniel Marot also had an influence, at a distance. Several of his published garden designs (fig. 224) bear a distinct likeness to the Hampton Court parterre, and William must have had close contact with him in the Netherlands.

An important element in the consideration of design responsibility is the authorship of the surviving drawings for the gardens. It is clear that in 1689 Hawksmoor's plans showed proposals for the gardens just as they did for the new palace; the most detailed surviving plan of the northern chestnut avenue is in his hand.[39]

225 Drawing by Leonard Knyff of the gardens at Hampton Court from the south, with Bushy Park in the distance, c.1702. Knyff's notation in Dutch on this drawing suggests that it was originally intended to be a sketch for an oil painting.

This may have simply been because the gardeners lacked the skills to put their schemes on paper. A small number of tolerably good drawings survive in George London's hand, but nothing can be proved to be in the hand of Henry Wise.[40] Yet John Evelyn makes it clear that the London and Wise partnership had a significant drawing capability: 'They have a numerous collection of the best designs, and I perceive are able of themselves to draw and contrive others applicable to the places, when busie works and parterres of imbroidery for the coronary and flower gardens are proper or desired.' Indeed, we know that by 1713 Wise had taken on 'one Man constantly in pay and sometimes more' for 'the making several surveys and Draughts of her Majesty's Palaces, gardens parks and Plantations'.[41] From about 1708 this was Charles Bridgeman, whose superb survey of the Hampton Court estate captures its full brilliance in Queen Anne's reign (fig. 231). During the construction of the Privy Garden it is not clear who took on the task of draughtsmanship.[42] It can, however, be plausibly suggested that such drawings as we have (figs 227, 228) are in the hand of an Office of Works draughtsman working for Talman, London and Wise.[43] This reflects the close collaboration that, as we have seen, created the palace designs. Underpinning this was certainly William's personal vision, driven through with a determination to make the perfect setting for his new palace.

The Gardens under Queen Anne

On William's death the administration of the Royal Gardens came under close scrutiny; not only was there a change in personnel but Queen Anne announced that she intended to 'restrain the expense of the gardens'. Only George London survived the resultant purge, and he expected to be given the lucrative maintenance contract for what were, after all, the largest formal gardens in England. He was to be disappointed, because his estimate of £4,800 a year was drastically undercut by a rival bid for £1,600 submitted by Henry Wise.[44] With effect from 1 August 1702, Wise became royal gardener with responsibility for new works as well as maintenance. In the short term the queen stuck to her resolve to reduce costs. The statues for the Privy Garden were sent back to their supplier, Mr Ball at Turnham Green; Tijou was sent away empty handed and his magnificent screens left in store; and half a dozen other craftsmen and suppliers had their bills unpaid.[45]

226 Reconstructed plan of the Hampton Court gardens in 1702. Drawing Daphne Ford.

Despite Anne's penny-pinching attitude to the Hampton Court gardens, the estate flourished during her reign, especially in the period after 1710 when she used Hampton Court as a regular residence. The Privy and Glass Case Gardens were well maintained and the Tijou screens were finally erected. The planting required continual attention; flower pots, tubs and stone rollers had to be purchased; and sheds, fences and melon frames required repair and painting. The queen was keen to develop Hampton Court for the supply of her table. William had already turned the eight-acre tiltyard into a kitchen garden, dividing it into six quarters separated by high walls planted with espaliered fruit trees (fig. 226).[46] In 1703 Wise planted 770 more fruit trees, including apples, peaches, plums, figs and quinces in the kitchen garden, melon ground and fruit garden. In the summer the fruit was taken over to the queen at Windsor. Improvements of a more subtle nature were instituted too. An apron of Swedish limestone was laid along the east front to allow the placing of tubs of orange trees there in the summer.[47] Anne was determined to enjoy the two parks and after she started using the palace in 1710 ordered 'Chaise Ridings fitt for her majesties passage with more ease and safety in her chaise or coach in both her parks (as hath sometime since been performed in Windsor parks) to be made 20 miles in compas, by taking off the hills, filling ye holes' etc. A plan shows the remarkable racecourse-like ridings made from the palace through Home Park over the road at Kingston bridge and into Bushy Park. They were constructed at a cost of £250.[48]

The most important work of the reign was the complete remodelling of the Great Parterre and the east-front Gardens. This major project was certainly partly due to the cost of keeping the topiary and box in order, but it was also for aesthetic and practical reasons. According to Daniel Defoe, the queen disliked the smell of box and it was for this reason that the Great Parterre was laid to *gazon coupé*, but others, including Stephen Switzer, didn't mention the smell and simply admired the 'plain and noble design'. The truth probably lay in the fact that Daniel Marot's fussy box *broderie* was in William's French taste, which was expensive to

228 Alterations to the gardens, 1710–11, by an unidentified Office of Works hand working for Henry Wise. The drawing includes proposals for new beds in Fountain Court.

227 (*left*) Proposals for altering the Fountain Garden, 1703, by an unidentified Office of Works hand working for Henry Wise. At this stage statues were proposed to replace several of the fountains in the semicircular garden and a single figure proposed at the south end of the Broad Walk.

maintain and disliked by the queen. It is likely that the clinching factor was not expense, smell or fashion, but the continued problem of the fountains. The fountains had never worked properly despite a major overhaul in 1700. Early in the reign a proposal was sent to the queen by one Thomas Savery who proposed to build a pump in the reservoir in Bushy Park that would move 300 tons of water to a cistern on the roof of the palace in twelve hours. From there the fountains could be powered and water stored in case of fire. The whole contraption was to cost £1,000 and Savery was prepared to maintain it at a charge of £250 a year. This would have been fine if it were not for the fact that in addition to the problems of supply the fountains had to be cleaned every day as scum built up, blocking the overflows and causing them to flood.[49] In the spring of 1703 orders were given for the remodelling of the garden, and a drawing by Henry Wise's draughtsman shows a proposal for simplifying the Great Parterre by removing all but five fountains, rationalising the paths and

229 The *Arethusa* fountain in Bushy Park.

230 David Cox Junior, *The Lion Gate from the North in Georgian Times*, c.1850. This gate was Queen Anne's solution to the unresolved northern approach.

sweeping away the *broderie* (fig. 227). These ideas were executed in 1703 by Wise, who provided an estimate for 'sinking, new making and altering' the Fountain Garden, which was done at a cost of £1,500.[50] In all this the Office of Works took an active interest, producing the drawing and reducing Wise's estimate. The design bears a similarity to the much more straightforward proposals drawn by Hawksmoor in 1689 (fig. 140) and reflects a return to a simpler taste. Changes in the Fountain Garden did not stop there. Even the five fountains and the three hundred or so remaining evergreen trees proved too much and in a second phase in 1707 all the pipe work was removed and the Longford River water diverted to irrigate the Wilderness. The Fountain Garden was returfed and gravelled at the substantial cost of £1,141 and the numbers of topiary hollies and yews reduced from 328 to 240 and placed in rectangular beds edged with box.[51] The redesigns of 1703 and 1707 had vastly simplified the Fountain Garden and brought it much more into line with what Vanbrugh, for instance, was creating at Blenheim.

In 1710–11, when she had returned to using Hampton Court more regularly, a final phase of garden redesign completed Queen Anne's vision and established the east front much as it is today. Her aim was to increase the area of ornamental water by digging a semicircular canal on the park side of the semicircular avenues, and extending transverse arms northwards and southwards. Tijou's railings were then to be moved to the park side of the canal, set on a low plinth, thus separating the park and gardens by a fence.[52] Two drawings from Wise's office for this final phase (fig. 228) seem to suggest that thought was also being given to the simplification and redesign of the southern end of the Privy Garden, including building a substantial wall between the end of the Privy Garden and the Barge Walk.[53]

In the last year of her reign Anne embarked on a series of projects on the north side of the palace which were eventually completed by George I. The Bushy Park avenue was completed by the addition of the *Arethusa* fountain (fig. 229) and the construction of a grandiloquent gateway to the Wilderness on axis with it. The Lion Gates, as they are known, are of an unusual design which has affinities with the style of Vanbrugh – the use of the Doric order, military trophies and inverted scrolls all find parallels in his contemporary work at Blenheim and elsewhere (fig. 230). They were finally finished in George's reign. Henry Wise, meanwhile, completed the planting in the park and planted 'figure hedge work of large evergreen plants' at Lion Gate.[54] The 'figure hedge work' was the famous maze, which does not appear on early plans of the Wilderness (figs. 210, 231) but is shown on a plan of about 1714 (fig. 211). Mazes had been unfashionable in late seventeenth-century English gardens – Switzer thought them 'calculated for an inferior class of people' – but after the publication of John James's translation of Dézallier d'Argenville's *Theory and Practice of Gardening* in 1712 contemporary French designs became more fashionable. Henry Wise's maze design for Queen Anne, and almost certainly the lesser 'troy town' maze, too, led the fashion for a revival in England.[55] The substantial amount spent on the palace's northern approach suggests that Anne wished to resolve the contradictions implicit in an avenue that led nowhere. The Wilderness was revitalised with new places for people to go, and a gateway to Bushy Park beyond.

A snapshot of the Hampton Court estate at the end of Queen Anne's reign is provided by Charles Bridgeman's map (fig. 231).

231 Charles Bridgeman, *A General Plan of Hampton Court Palace Gardens and Parks*, 1711. As well as showing the Hampton Court estate in its final eighteenth-century form, this important survey depicts Hampton Court Green, with the houses for the Officers of Works, and the relationship between Kingston (top), Hampton (bottom) and the Thames. North is to the left.

232 Drawing, probably by Henry Wise, showing the parterres in the Lower Wilderness as built, c.1700. The canal was not extended nor the oval basin made.

Bridgeman had prepared his first great estate survey at Blenheim for Henry Wise in 1709 and as a result was probably asked to survey the Hampton Court estate in early 1711. The survey survives in several versions but was made into a very fair presentation copy showing the effects of Queen Anne's work, and that by 1711 the broad form of the gardens as we know them today was set.[56] It also demonstrates their enormous size. William and Anne expanded the cultivated area of garden from a mere 27 acres in 1689 to 58 acres by 1710, making Hampton Court by far the largest garden in Britain. Kensington gardens covered, by comparison, a compact 17 acres. Although the Hampton Court gardens were famous by this date, they had a remarkably minor impact on the development of garden design in England. Quite apart from the fact that Anne swept William's fussy French *broderie* from the east front, denying it a chance to have a significant impact, the walled matrix of the gardens was unique to the site. The Tudor compartments dominated the form of the estate, each garden being enclosed within its own tall walls. While this gave the garden a special character it made it hard to imitate elsewhere. The social division of the spaces too set Hampton Court apart. The Privy Garden was, like the Privy Lodgings, a space reserved for the king and his closest friends. It was separated from the rest of the garden by tall locked gates. The east front was the more public garden, but it too was fenced off denying access to those who were not entitled to enter. The Broad Walk was the most accessible part, giving courtiers a mile-long walk each way across the east front. Thus in simple terms of access the gardens were hard to appreciate. Most of all, however, it was not long before the formality of the Hampton Court estate was derided and mocked as gardening turned to a more informal style. The late Stuart gardens of Hampton Court were on the crest of a wave, one that was soon to break.

233 *(facing page)* Detail from the drawing by Leonard Knyff of the gardens at Hampton Court from the south (fig. 225).

234 Sir James Thornhill's oil maquette for the ceiling of Princess Caroline's bedchamber, early 1715.

Chapter 13

ROYAL RIVALRY:
THE HAMPTON COURT OF GEORGE I

GEORGE I ARRIVED AT St James's Palace from Hanover on the evening of 20 September 1714. He came without his queen, Sophia Dorothea, whom he had divorced in 1694 and confined to the small country house of Ahlden. At his side was his son George Augustus, Prince of Wales and future George II. They settled at St James's with the prince's wife, Caroline of Ansbach, and their three young daughters Anne (b.1709), Amelia (b.1711) and Caroline (b.1713). Their seven-year-old son Frederick, heir to the electorate of Hanover and also the throne of England, remained in Hanover both for his education and as a figurehead. George, like William III, was aware that he would not be permanently resident in England and in thirteen years of rule spent six summers in Hanover, eventually dying overseas. Yet England was officially his home and within only two months of his arrival George was making plans for the completion of Hampton Court. Despite his reputation for being a philistine, George was most interested in architecture, keenly visiting the houses of noblemen, admiring the fine furniture at Lord Orkney's house at Cliveden near Windsor and on his first arrival making a surprise visit to Kensington to look at it. His patronage of Vanbrugh, although ultimately futile, was fuelled by a genuine determination to remodel his palaces. He had a particular interest in paintings and was a great admirer of Mantegna's *Triumphs of Caesar*. In fact, George ordered a restoration of them in 1717 from the French painter Joseph Goupy who was finally paid £170 in 1726. After they had been repaired they were reframed with handsome new gilded frames.[1]

The Georgian dramatis personae

Just as James I and William III had brought their foreign companions and cronies to the English court, so did George. Barons Kielmansegge (whose wife, Sophie Charlotte, was widely regarded as a mistress of the king's, becoming Countess of Darlington after her husband's death) and Robethon joined Barons Bothmer and Bernstorff as the king's leading Hanoverian advisers in London. His other mistress – Melusine von der Schulenberg – who in due course (with special Parliamentary dispensation) assumed the title of the Duchess of Kendal, also took her place at court. Other more menial servants did likewise.[2] With the new dynasty, and its Hanoverian attendants, came an entirely new political world dominated by the Whigs and led by figures who were to have an important impact on Hampton Court. These included the Secretaries of State, Charles, Second Viscount Townshend, and James Stanhope, after 1717 First Lord of the Treasury and after 1718 First Earl Stanhope; Charles Montagu, First Earl of Halifax and holder of the great offices of Hampton Court; and Robert Walpole, then the influential Paymaster-General. At the same time came a number of influential changes at the Office of Works. Despite Wren's continued tenure of office during Anne's reign, the dominant force on the Board had been John Vanbrugh, former East India Company factor, ex-soldier, playwright and the most fashionable and successful architect in England. Vanbrugh's career was closely linked to the fortunes of his Whig patrons. After losing the Comptrollership of Works in 1713 under a Tory Government, he won a knighthood and his old job back after 1714 with George's accession and the return of the Whigs. Vanbrugh's resumption of the Comptrollership came amidst a tide of reform. The offices of Master Mason and Master Carpenter, and all the other master craftsmen that have dominated this history, were abolished, and a new matrix of responsibility was created documented by a secretary in a series of minute books, a valuable source of information for the history of the palace.[3] The first Secretary was Nicholas Hawksmoor. At the same time John Ball was dismissed and Thomas Fort, a master joiner turned architect, was appointed as Clerk of Works. Fort retained the post until his death in 1745, becoming a dominant force at the palace. The houses on Hampton Court Green occupied by the Master Mason and Carpenter were assigned to the Surveyor General of the Crown Lands (Hugh Cholmley) and the Surveyor General of the Woods and Forests (Thomas Hewett).[4] Thus during the early years of George's reign, as William III's quadrangle was at long last completed, it was Vanbrugh and Fort, assisted by Hawksmoor, rather than Wren and Ball who were the presiding influences.

While these personalities were undeniably those that shaped Hampton Court in George's reign, the mainspring behind the palace's history was the chemistry between the Prince of Wales and the king. The relationship between the two began to deteri-

245

orate soon after the king's accession and was most manifest in their differing approaches to public display. In the words of Lord Hervey 'the pageantry and splendour, the badges and trappings of royalty, were as pleasing to the son as they were irksome to the father'.[5] George was unimpressive and disappointing in both stature and behaviour, and was virtually invisible for the first two years of his reign. In contrast the prince and princess were not only willing but keen to follow the formalities of English court life. The story of Hampton Court during the reign of George I is the use of the palace by father and son to gain social and political advantage over each other.

The Completion of the Queen's Side

George I first came to Hampton Court on the morning of 8 November 1714, staying for dinner and returning to St James's for supper. It was during this visit, in the company of the prince, that he made the decision to restart work on the east front to accommodate his son and daughter-in-law. It was the obvious course of action. With no queen and an adult married heir, the consort's apartments were the only suitable accommodation for them at the palace. Consequently the following month orders were given for the 'finishing', in four months, of the three rooms at the end of the Green Gallery (the present Queen's Gallery) 'to be in all respects as well done as the best rooms that are already finished there'. The three were to be the Bedchamber, the Drawing Room or 'Painted Room' and the Privy Chamber. Four drawings, possibly in the hand of Thomas Fort, show the layout of the rooms and the intended joinery work and locations of the fireplaces (figs 235, 236). A very full cost-estimate covers the work necessary.[6] The plan and panelling layouts do not agree with each other or with what was actually built, with the exception of the bedchamber, which was panelled as shown. The principal area of uncertainty seems to have been whether to have two fireplaces in the Privy Chamber and place the canopy on the west wall or to preserve the traditional English linear arrangement whereby the canopy faced visitors entering the room. Several German palaces including the residences at Munich and Ansbach adopted the former arrangement in their *audienzzimmers* and this may have been why proposals were made to break with English form. In the end it was decided to go ahead with the traditional arrangement.[7]

The most important of the rooms, the bedchamber, was to have a painted ceiling. Choosing a painter for this was controversial in terms of politics, style and nationality. The Tory Lord Chamberlain, the Duke of Shrewsbury, wished the ceiling to be done by Sebastiano Ricci and he was duly commissioned to produce a design. Ricci was painting the staircase at Burlington House, Piccadilly, for Richard Boyle, Third Earl of Burlington, which was celebrated as a magnificent example of Roman decoration produced by a leading Venetian painter. Ricci worked in the high baroque tradition of Verrio and would have represented continuity at Hampton Court.[8] Shrewsbury met with a violent objection from Lord Halifax, a Whig and First Lord of the Treasury, who insisted that the commission should be given to James Thornhill and added that he would not pay Ricci if he undertook the work. Halifax's objection, according to George Vertue, was on grounds of nationality. William Aglionby had complained in 1685 that 'we never had, as yet, any of Note, that was an *English Man*, that pre-

235 Plan of the apartments of the prince and princess of Wales on the east front at Hampton Court, possibly in the hand of Thomas Fort, winter 1714.

236 Proposed elevations (not as executed) for Princess Caroline's Privy Chamber, possibly in the hand of Thomas Fort, winter 1714.

tended to *History-Painting*'[9] and the history of Hampton Court had borne this out. But by 1714 Thornhill was recognised as the greatest living English painter, having created the sensational mural cycle at the Royal Hospital at Greenwich for Queen Anne. He was also the choice of the Whigs who swept into power in 1715 and promptly awarded him the task of painting the interior of the

dome at St Paul's. Halifax won the day and Thornhill was commissioned to produce an oil maquette for the ceiling (fig. 234) that was duly agreed.[10] The politicisation of decision-making for the bedchamber ceiling prefigured the political struggle that led to the destruction of the baroque of Wren and the Tories and the triumph of the Palladians largely under Whig patronage, a theme that will be followed throughout this chapter.

The subject of Thornhill's ceiling is Leucothoë restraining Apollo from entering his chariot (daybreak restrained). In the cove are fine portraits of the king, the Prince and Princess of Wales and their eldest son Frederick. The task was completed by June 1715 at cost of £457 10s and was universally admired.[11] The Board of the Office of Works, including Wren, thought Verrio's recent work 'not so well executed' and more expensive. The king also liked it and made Thornhill History Painter in Ordinary in 1718. The following year George took him to Hanover and the year after, on the death of Thomas Highmore, appointed him Sergeant Painter. In 1720, after the completion of the dome of St Paul's, he was knighted, the first native painter to be so honoured.[12]

The Bedchamber was furnished for the prince and princess immediately afterwards (fig. 237). A new crimson damask bed was installed with two armchairs, eight stools and a fire-screen upholstered en suite. Two crimson festoon window curtains were supplied and the Removing Wardrobe delivered two pieces of tapestry from the *Joshua* series for its north and west walls. The cabinetmakers John Gumley and James Moore supplied a gilded pier glass, pier table and two torchères for the window wall.[13] A rock crystal and silver chandelier was supplied for the ceiling. The overmantel painting was a portrait of George's maternal great-grandfather, James I, by Paul van Somer; to its right was van Somer's portrait of Anne of Denmark at Oatlands and to the left hung their daughter Elizabeth, George's grandmother and queen of Bohemia, painted by Daniel Mytens. Over the door to the Privy Chamber was a full-length portrait of Henry, Prince of Wales, by Van Dyck.[14] The Bedchamber was thus a great dynastic chamber, linking the present (in the ceiling) with the historic roots of the dynasty (hung on the walls). As such it continued the tradition begun by Charles II and elaborated by William III of presenting it as the most important ceremonial room in the palace. George and Caroline, both as Prince and Princess of Wales and as king and queen, were to use it as such.

The Drawing Room, a shell apart from Verrio's mural, was fitted with an oak dado, three pairs of crimson damask festoon window curtains, thirty walnut stools and two armchairs covered in the same damask with case covers of taffeta. Gumley and Moore supplied a pier glass almost 12ft high, a table and two stands.[15] Next door, in the Privy Chamber, after the options for locating the fireplace had been considered, it was decided to retain the axial approach to the room and place it on the north wall. This left the way open for a large crimson canopy of state to be erected on the south wall. Festoon window curtains from the same damask pattern with matching pelmets were installed on the east front. Beneath the canopy, upon a fine Persian carpet, two large state chairs were supplied with footstools and fourteen square stools for the perimeter of the room. Gumley and Moore again supplied a mirror, pier table and stands for the window wall. The south and east walls were hung with three more tapestries from the *Joshua* set. The paintings were again chosen for their dynastic links and were dominated by a group of portraits of Anne of Denmark's cousins, the Brunswick dukes. There were more Stuart portraits too, including Mary, Queen of Scots and Lady Margaret Douglas, Countess of Lennox (fig. 238).[16] Since the work of 1715 did not provide for fitting-out the rooms on the north side of Fountain Court, the room now known as the Public Dining Room, but originally called the Music Room, was set up to be a temporary Guard Chamber. It seems likely that a number of the tapestries prepared in 1714 and sent to Hampton Court were hung in here. They probably included *Tobias and the Angel* and one of the *Joshua* series, hung against bare plastered walls. Access to the temporary Guard Chamber was via the Caithness Staircase (a modern name) and through the present Oratory (figs 235, 239).

While these rooms were being fitted-out, work was also underway on a small number of private rooms for the prince and princess. These were sited in the north-east corner of the State Apartments, the prince's on the ground floor and the princess's above.[17] Of particular concern seem to have been a bedroom, bathroom, dressing room and stool room fitted-out by Thomas Fort in August 1715. The bathroom was divided by a 6ft-high screen 'of oak beadwork' and was provided with a marble cistern fed by pipes with a brass tap. The Dressing Room, for which two pairs of window curtains were supplied, had an overdoor carved by Grinling Gibbons. Gumley and Moore provided the Private Dining Room, the Private Bedchamber and the Dressing Room with large looking-glasses in gilt frames, and giltwood tables and

237 Havell after R. Cattermole, 'Queen Mary's State Bed-chamber, Hampton Court', from W. H. Pyne, *Royal Residences*, 1817–20. This view shows the room much as it was before 1737 but with the addition of paintings over the tapestries on the north wall. The bed still retains its case curtains.

238 The Queen's Privy Chamber in the 1980s, but showing an arrangement adopted in the 1970s.

stands. The dining room additionally had 'two arm chairs and 16 back stools covered with morocco leather and trimd with gilt nails'.[18]

The rooms were furnished in part by the £4,934 worth of furniture delivered for the prince and princess and probably included a number of tapestries ordered from the Great Wardrobe. As well as the tapestries provided for the state rooms, three pieces of a set called the *The Battle of Solebay* were mended, cleaned and re-lined. These were later hung in the new private apartments in Fountain Court.[19] Whilst this work was underway some minor refurnishing was undertaken for the king. His Great Bedchamber was given new curtains and new mats were supplied to place beneath his bed and beneath the canopy in the Privy Chamber. The king's private apartments on the ground floor, which had been partly occupied by the Duke of Albemarle in William's reign, were examined by Fort in September 1715 and on his advice were re-absorbed into the king's domain and a partition dismantled. The principal rooms either side of the Upper Orangery were used by George throughout the reign and remained much as William had left them.[20]

★ ★ ★

The Prince of Wales at Hampton Court in 1716

George paid a short visit to Hampton Court in early June 1715 to inspect the improvements, but the following year, for the first time since his accession, returned to Hanover. His trip opened up a major controversy, in that the Prince of Wales was to be left as 'guardian and lieutenant of the realm', but not regent, in his absence. The prince was furious and humiliated, all the more so after his Groom of the Stole and chief adviser, the Duke of Argyll, was removed from his offices by the king to prevent him and the prince intriguing during George's absence. With the king away, the prince and princess and their daughters removed from St James's on 25 July to spend the summer at Hampton Court in their new apartments. They remained continuously until 24 September, when the prince left for a few days, and then until 28 October when the whole family left by barge for St James's. That summer both the most fashionable people from London and ordinary country people from surrounding Surrey and Middlesex flocked to Hampton Court. Dudley Ryder recorded in his diary that 'The Prince and Princess dine every day in public at Hampton Court and all sorts of people have free admission to see them even of the lowest sort and rank.'[21] But while the prince and princess won wide popularity during their stay there was a much deeper and more cynical motivation. The Prince of Wales had set out to create his own supporters in Parliament by wooing the Tory opponents of the king's ministry. Walpole wrote in a state of agitation to Hanover where Stanhope was with the king informing him that the great Tory lords and their wives were constantly in attendance at Hampton Court:

> They generally choose to come on the private days; but their reception gives offence to all well wishers [of the king's], and I assure you, does not a little animate the tories, who generally . . . resort to court, and meet all possible encouragement to do so. I cannot but say, the prince is civil to us, but that is all that I can say, which is now so well known and understood, that the tories take great pains to publish it; that the prince hates us.

In mid-August Walpole decided to go to Hampton Court to see for himself the prince's court and reported to Stanhope what he saw. His greatest concern was that Argyll, stripped of his offices by the king, was in constant attendance; 'they have begun to have little private balls', Walpole explained, at which the duke and his friends were alone with the prince, princess and their attendants. 'You can easily conjecture what must be the consequences of these appearances,' he told Stanhope. 'They have such an effect already, as draws the tories from all parts of the neighbourhood, gives such a disgust to the Whigs as before michaelmas I may venture to prophecy, the company here will be two to one of the king's enemies.'[22] Amongst all this, as guardian of the kingdom, the Prince of Wales continued the business of government. A continuous stream of visitors arrived at Hampton Court. Amongst them were the Sub-Governor of the South Sea Company, the Governor of New Jersey and New York, the High Sheriff of Oxfordshire and his delegation, an ambassador from Venice, envoys from Modena, the King of Sicily and the Vice-Chancellor of Cambridge University.[23]

Whilst a pointed political motivation lay behind the long visit of summer 1716, neither the prince and princess nor their guests neglected to enjoy themselves. Lady Cowper, one of the princess's

248

239 Plan of Princess Caroline's apartments, possibly in the hand of William Dickinson, 1714–15. The plan shows A: the Green Gallery; B: the Princess's Bedchamber; C: the Princess's Drawing Room; D: the Princess's Privy Chamber; E: lobby (later the Oratory); F: Guard Chamber; G, H, I: the princess's private rooms (the prince's rooms were located below). The small stair in the room to the south of the bedchamber (B) led to a mezzanine sleeping platform for the Ladies of the Bedchamber. The canopy of state can be seen in the Privy Chamber. The area with darker walls to the north (top) are the rooms proposed to be modernised for the young princesses. This plan also conveniently shows the first-floor arrangement of the lodgings as laid out for James, Duke of York in 1670.

240 Charles Robert Leslie, *The Queen's Private Bedchamber*, c.1840.

ladies, kept a diary describing Caroline's life at Hampton Court that summer: 'The Prince and Princess dined in public every day in the Princess's Apartment. The Lady at Waiting served at Table ... In the afternoon the Princess saw company, or read or writ till the Evening, and then walked in the garden, sometimes two or three hours together, and then went into the Pavilion, at the end of the Bowling Green, and played there.' One evening on their way back from the Pavilion in the dark and rain the enormously fat Lady Buckenburgh dislocated an ankle; after that the evening entertainment was relocated to the Queen's Gallery, taking place between nine o'clock and half past ten.[24]

The day before the prince and princess arrived at Hampton Court, the joiner John Hopson was ordered to make plans of the six rooms and the Little Oratory 'that are next to be finished on the Prince and Princesses side'. These rooms were to replace their private rooms that had been temporarily sited in the north-east corner of the State Apartments the year before. The 'Draughts and Designes' were completed by October and the work, valued at £6,600, started in early December and continued, in one way or another, until summer 1718.[25] As we shall see the prince and princess used these rooms during the summer of 1717 and then not again until they became king and queen. Moreover, it appears that with a few exceptions (noted in the next chapter) the rooms as decorated and furnished in 1716 were barely altered in 1728–37 when they were reoccupied as the Queen's Private Apartments. From south to north they comprised the Private Chamber (with a water closet), the Private Bedchamber, the Dressing Room and Bathroom, the Closet and water closet, the Private Dining Room, the Sideboard Room and the Oratory (fig. 239). They were fitted-out with oak panelling with enriched cornices and carved over-doors and overmantels. The carving in each room reflects its importance. The cavetto moulding in the Dining Room has great sweeps of acanthus leaves garlanded with primroses, the Bathroom and Dressing Room similar, but without the primroses, and the bedchamber has acanthus, primroses and flat scallop shells. Some rooms had specially fitted features such as the two sideboard alcoves in the Private Chamber and the linen cupboards in the Closet. The Bedchamber was singled out for special attention and Gibbons provided a circular limewood garland to surround the carved circular overmantel panel. Below, either side of the fire-

241 Marble cistern in the Sideboard Room in the Queen's Apartments installed for Princess Caroline in 1717. The cistern was plumbed with running water supplied by a tap with a bronze grotesque mask.

242 Queen Caroline's Bathroom as arranged in 1995, based on careful research into its appearance in 1737. It shows the bathing cistern and to its right the door to the backstairs from where hot water was delivered.

place, against the oak jambs, were gessoed and gilded strapwork drops similar to those designed but not executed for Queen Mary in the 1690s (fig. 240, and compare fig. 165). In the centre of each was a chimney branch. The room still retains its original brass night-lock system that allowed the prince or princess to remain in bed whilst controlling access to the doors by means of a system of wires and weighted bolts.

Two rooms had running water. The Sideboard Room, used for serving the dining room, had a marble cistern for rinsing glasses (fig. 241) and the bathroom had another, presumably for ablutions. The bathroom, like the temporary one fitted-up in 1715, was divided by a low screen providing privacy and allowing the part of the room facing Fountain Court to be used as a dressing room (fig. 242). This was a feature that was commonly used in high class bathrooms – Talman provided such an arrangement at Chatsworth, for instance. The bath itself would have been a wooden tub filled by buckets of hot water brought up the adjacent backstairs.[26] Architecturally most surprising is the treatment of the Oratory (fig. 243). William and Mary's intention for this room is not known but since it sits at the corner of the quadrangle the room must have always been intended to be top lit. Drawings from 1717 show that the room already had an octagonal lantern (or one was proposed) but it is unclear what form it took. Since the room was used as an ante-room to the temporary Guard Chamber it may have been of relatively low status. By 1719, however, with the Guard and Presence Chambers completed, it was decided finally to resolve the design of the ceiling. It is clear that by 1719 a ceiling was in store that was destined for the room, and in December Fort was ordered to have it delivered to Hampton Court to prevent more being spent on warehousing. The ceiling is octagonal, each side defined by a rib of carved foliage surmounted by a carved cherub's head. The sides contain three panels each, the topmost enriched by swirling foliage leading to a lantern with swags. The whole is made of carved wood painted white and not plaster, as it appears, and was almost certainly created by Grinling Gibbons. Stylistically it is old-fashioned, more similar to the dome of St Stephen's Walbrook in the City, which was completed by 1677, than the nearly contemporary ceilings at Blenheim Palace or the slightly later ceilings at Ditchley Park, Oxfordshire. That it was kept in store raises the possibility that it was salvaged from an earlier abandoned scheme for another of the palaces, or even that it may have been destined for Whitehall before the fire of 1698. After the ceiling's installation the palace was barely used and the room was only finally furnished as an oratory in 1731.[27] Yet the completion of this room in 1719 was an important development in royal life at Hampton Court. Under William, Anne and George I, there had been no private confessional space for the royal family, as there had been in the old building. The construction of the Oratory was the first step in re-establishing private royal devotions in the Privy Apartments.

Some of the furniture for the new suite was repaired and recovered and moved from Kensington and St James's and a minority was specially made but most was simply transferred from the apartments set up the previous year.[28] Only the Private Chamber and the Bedchamber had soft wall-hangings. The former was hung with damask and the latter with three of the *Solebay* tapestries. The remainder of the suite was hung with paintings. The centrepiece was the Private Dining Room, double-hung with eight seascapes by Willem van de Velde – part of a set of twelve commissioned by James II (fig. 244). The Hanoverians believed them to depict the defeat of the Spanish Armada, but in reality they show a series of now forgotten Anglo–Dutch naval engagements. Over the fireplace hung a putative portrait of Charles Howard, Lord Effingham, the Elizabethan high admiral who defeated the Spanish. This choice together with the *Solebay* tapestries and Verrio's drawing-room mural made several of the most important rooms at Hampton Court shrines to British naval power. This choice was deliberate and reinforced by George, who ordered that the set of portraits of British admirals painted for George of Denmark and hung at Kensington be rehung at Hampton Court. The series of fifteen admirals, by Sir Godfrey Kneller and Michael Dahl, were hung in the Communication Gallery, which was immediately renamed 'the Admiral's Gallery'.[29]

There are a number of features of the private apartments that call for attention. The first is that their integration into the plan and function of the east-front rooms was completely harmonious, which suggests that their eventual use thirty years after they were designed was not far from what William and Mary had first envisaged. The bathroom gave on to a service stair, and the dining room communicated with the drawing room, allowing the prince to withdraw from an assembly and have supper. The serving room adjacent to the dining room was also approached from a backstair to allow food to be conveniently delivered. The only access route that appears to have been a later compromise is the small backstairs room between the prince's bedchamber, the Green Gallery and the Private Chamber. This room had to serve both as the room for the backstairs servants and as a route for the prince between the gallery and his private chamber. The solution was the insertion of a mezzanine floor and a small staircase, allowing the royal family to pass through the room and the royal body servants to reside above (fig. 239).[30]

While work was underway on fitting up the new apartments in Fountain Court consideration was given to housing the young princesses in the former Tudor Tennis Court converted for James, Duke of York and subsequently briefly occupied by Princess Anne. Only minor works were undertaken at this stage, but nineteen pieces of tapestry were delivered and two doorways made out of windows to allow the princesses access to the east-front gardens.[31] Two drawings in the Royal Library at Windsor show the alterations made for the princesses and their governess, Jane, the Dowager Countess of Portland, second wife and widow of the first earl, Hans Willem Bentinck (fig. 245).[32] She oversaw the daily life and education of the girls during their summer visits to Hampton Court and coordinated the French, music and drawing teachers who accompanied them. One room was specially set aside for their dancing lessons.[33] Plans were subsequently drawn up to link these new rooms with the princesses' temporary guard chamber (the present Public Dining Room).[34] These would have

244 The Private Dining Room as arranged in 1995, based on careful research into its appearance in 1737. It includes many of the original paintings by Willem van de Velde.

given the three princesses bedrooms on the first floor approached by an ante-room and drawing room off the Guard Chamber (fig. 245). Solving problems of access for the king's grandchildren was not, however, seen as a priority and this work was held over until 1717.

What is clear from all this is that though the prince and princess's stay was accompanied by a full and magnificent court life, it must have been fairly inconvenient, with many of the rooms full of builders and upholsterers. Indeed, when there was a suggestion that the new rooms might be used for the princess's lying-in, the Lord Chamberlain thought it impossible, the 'inconveniences attending it being so many and so great'. Many of the inconveniences, according to the Lord Chamberlain, were due to George's and Caroline's continually changing brief for the rooms. He wrote to the Vice-Chamberlain, Thomas Coke, explaining

> I had given all the necessary orders for finishing the Prince and Princess' apartment, and the young Princesses, as last night, which I find was done . . . As to the alteration of the rooms as he [the Prince] designs them, he will do that as he pleases to his own servant, I having by his Majesty's command (as you know) given over that part of the House to his Royal Highness's service: so that I reckon that neither you nor I have any more to do with that.

Financial accounts show a steady stream of additions, such as the walnut stand for a clock ordered for the dressing room, and a walnut writing table. In July 1716 iron balconies were added to the windows of the withdrawing room, and in December seventeen cane sashes (the eighteenth-century equivalent of net curtains) were fitted in the prince's and king's rooms.[35]

★ ★ ★

243 The private oratory. The ceiling was installed in 1719 and was possibly originally intended for Whitehall Palace. The room was arranged in 1995 to reflect its usage in 1737.

245 Plan of the principal floor showing the apartments of the prince, princess and their children. One of a pair showing the rooms at first- and ground-floor level prepared by an unidentified hand in the Office of Works in late 1716.

The King at Hampton Court in 1717

On the king's return from Hanover it was clear that the prince and his wife had set their hearts on a course opposed to the policies and wishes of George. The winter of 1716 and the following spring saw no improvement in their relationship and it was clear that despite the king's wish to return to Hanover in the summer, the trip would be highly inadvisable politically. Stanhope's ministry was still under pressure, and both he and Sunderland probably persuaded the king to stay in England, drop his reclusive and reticent image, and launch a summer of lavish entertainment at Hampton Court to help win support. The model that they intended to follow was that set by the prince and princess at Hampton Court the previous year, and careful plans were quickly laid to ensure success. Fort had made a survey of the palace in May to ascertain what needed doing for the planned royal extravaganza and on 10 June the king came down to see progress.[36] On 19 July George and the Prince and Princess of Wales removed there for the summer. The king remained continuously until 2 October, when he paid a short visit to Newmarket returning on the 8th, and finally made his way back to St James's for the winter on 13 November. A few days after the king's arrival the Bishop of Lichfield wrote to a friend that London 'is now very empty since the Royal family went to Hampton Court, where the public manner in which the king lives, makes it the rendezvous not only of the Ministers and great men but of the people of all ranks and conditions'.[37]

During the king's stay Sundays and Thursdays were appointed as 'public days' and became the best attended. Sundays were by tradition one of the great court days centred on the king's atten-

dance at chapel, and George processed weekly to the chapel in sombre formality preceded by the great sword of state. The chapel was restocked with a huge number of prayer books and bibles for household servants and courtiers plus two surplices for the minister and a diaper for the communion table. A canopy was made for the dean. The choir was moved from St James's and accommodated in lodgings in Kingston. Thursdays were Cabinet days when the ministers would arrive from London for their weekly meeting and were characterised by the king's public dining and entertainment of varying elaboration.[38] Thomas Burnet was with the court throughout its stay and wrote to his friend George Duckett after the court had returned to London at the end of November 1717. He boasted that no one could paint a picture of what had passed so well as he. His description is worth quoting in full:

> In the Evening then about ten a Clock the King used to come out to the Drawing Room with a constant serenity in his Countenance and universal affability to all about him, that charms every body; he enterd into the Diversions of the Room, by looking on, sometimes on those that were playing at Billiards, sometimes on the Ombre players, &c. Between twelve and one he generally withdrew, and then every body went to Supper, either with a select company at some of the Taverns, or else to some of the Tables kept in the Court. By this means bedtime was seldom so early as three. About eleven in the morning either you had some of the Ministers to levy, or some friend that you drank tea withall. And about one you were to be up in the AnteChamber at Court, where sometimes you had only an opportunity of making your Court to the *Great*, sometimes of paying your Duty to his Majesty. From hence at three a Clock all the world went to Dinner, as they were invited: some to the King's own table, which consisted of fifteen, some to Baron Berensdorf's which seldom consisted of more than five or six, some to the Earl of Sunderland's, or Count Bothmar's, each a table for a dozen, some to the dukes of Kent or Newcastle, which was about as large as the others, and lastly those who were not invited to any of these places, for every body took their Turns, were asked to dine at the Green Cloth, which was generally made up of 20 or 30 persons, and I have seen 36 there at once. At these tables you eat and drank plentifully till about six or seven a Clock, at which time you were at liberty either to visit the Ladys of the Court or to go to an Assembly which the Lord of the Bed Chamber in waiting kept in his apartment. And then about nine or ten all the world was assembled in the drawing Room to see his Majesty. Where sometimes there was a Ball and sometimes a Musicall Entertainment, but always games of all sorts going on.[39]

The balls or dancing often took place in the Cartoon Gallery where on 25 October there were country dances. On one occasion, before it got cold, an assembly was even held in the Tennis Court, where a billiard table was set up. As the summer progressed more drawing rooms and balls were held until by the end of August there was one almost every day apart from Sundays.[40] The Wardrobe supplied large quantities of additional furniture including 120 cane chairs of the 'strong sort' for assemblies and 18 new chairs for the Royal Dining Room. As well as the ordinary days there were a number of special celebrations. On 2 August was the anniversary of the king's accession. After chapel there was a reception in the Cartoon Gallery and in the evening the company moved to the pavilions at the end of the terrace for dancing and card tables. Similar celebrations were held to celebrate the king's coronation on 20 October and the Prince of Wales's birthday on 29 October. In between public events George settled into a relaxed and happy way of life, walking in the gardens and supping with his mistresses whose apartments were specially fitted-up for the summer. Madame Kielmansegge's bedroom and dressing room were redecorated with new hangings and a sky blue bed, while Madame Schulenberg was provided with a grass green field bed and twelve walnut chairs. The following year she was built a sideboard with a marble floor and two marble cisterns complete with plumbing and drains.[41]

There were two particularly notable factors about the round of court life. First is its relative informality compared with that of William III or Charles II. George never held a levee and so even the residual, erratic and informal dressing that Queen Anne had maintained completely ended. Rather than being surrounded by English Bedchamber staff, George much preferred to be attended by his two Turkish Pages of the Bedchamber, Mehemet and Mustapha, who had served him in Hanover for more than a decade. The informality of the Bedchamber extended to public occasions. During his residence George dined 'in company but not in *state*', thus enabling him to entertain up to fourteen at his own table. Each day the lord in waiting invited a specific group to dine with the king, which won him considerable popularity.[42] This was the first time George had allowed this to happen and it was very unusual for an English monarch, emphasising the king's determination to make a friendly impression.

The second notable feature was that although George treated Caroline as his consort, including her in many of the assemblies and walking with her in the gardens, the prince was snubbed, being denied access to the king's table and impressed with a sense of his inferiority. Whilst neither father nor son was happy with this situation, the prince did his best to maintain his own dignity, maintaining a more formal lifestyle than his father. Each day there was a formal levee and couchee and dining in public behind a rail.[43] This involved a much fuller use of the new quadrangle by the prince and princess – a fact that was anticipated long before the court arrived. In February and March orders were given to complete the Guard and Presence Chambers on the north side and to provide a suite of private (or lesser) rooms for the prince's exclusive use.

This commission is of considerable interest architecturally, for the six rooms fitted out in 1717 were designed by the Comptroller of the Office of Works, John Vanbrugh. Vanbrugh had been closely connected with work at Hampton Court since early 1716. He told the Duchess of Marlborough that he was 'engaged almost every minute' on the 'Princes removing to Hampton Court' and that on 14 July he attended the prince at the palace and received orders for completing the works. Vanbrugh was still dashing between Hampton Court and St James's attempting to meet the prince's wishes in August.[44]

The two great state rooms, the Guard and Presence Chambers, make one wish that Vanbrugh had had responsibility for the east-front rooms too. They are the only state rooms at the palace that succeed in breaking out of the austere panelled boxes created by Talman. They were created out of a large void by inserting a timber partition with a small closet in its thickness containing

garderobes for the Yeomen of the Guard, lit by a borrowed light from a small lobby between the rooms (fig. 258). This solution was only adopted after Vanbrugh had flirted with providing two doors between the rooms (fig. 239), an idea that was probably quashed by the requirements of court etiquette to restrict access to the Presence Chamber. A blind door was, however, inserted on the west wall of the room for effect. The Guard Chamber has a plain rectangular ceiling defined by deep mouldings supported by plaster vaults resting on console brackets and embracing high level *oeil-de-boeuf* windows looking south on to Fountain Court (fig. 246).

246 R. Reeve after R. Cattermole, 'Banqueting Hall, Hampton Court', from W. H. Pyne, *Royal Residences*, 1817–20. The engraving in fact shows the Queen's Guard Chamber.

Robert Wetherill, a plasterer closely associated with Vanbrugh who had worked at Blenheim, and to whom Vanbrugh made a payment of £50 in October 1718, constructed it. The ceiling is similar to the exactly contemporary ceiling in Vanbrugh's new kitchen at St James's and finds echoes in Hawksmoor's fitting-out of Blenheim, particularly in the south dome of the Long Library, where the vaults rest on very similar brackets. The ceiling in the Presence Chamber next door was also made by Wetherill. Here the vaults were supported on great carved wooden brackets with volutes and shells originally painted white and highlighted in gold leaf. Above was a moulded cornice and plain flat ceiling painted white.[45]

The chimney-pieces are also considerably more striking than those in the King's Apartments. In the Guard Chamber Vanbrugh wittily transformed two terms or caryatids into yeomen of the guard to make the jambs of the fireplace. The idea was not, in fact, new for Hampton Court, since Hawksmoor had proposed similar fireplaces on a smaller scale for Queen Mary in the early 1690s (fig. 163). Vanbrugh had subsequently used caryatids on the west bow window at Blenheim, and in 1719–20 he repeated the Hampton Court idea at Seaton Delaval. The fireplace in the Presence Chamber is a vast sculptural piece in the vein of fireplaces produced in his country-house practice – but larger (fig. 247). Payments to Grinling Gibbons strongly suggest that he executed both pieces.

The Guard Chamber is plain boarded above a panelled dado with an enriched dado rail. The wall above is articulated by gently projecting and receding planes, the movements of which are respected by the cornice. On each projecting panel is a pair of vast straps with scrolled tops supposedly supporting the projecting cornice. Talman had used a similar device, more modestly, in the Great Chamber at Chatsworth in the 1690s. The walls were painted in imitation of stone to match both the fireplace and the massive stone doorcases, with broken pediments supported on overblown consoles. The room would thus have been reminiscent of the stone halls of Blenheim and Seaton Delaval.[46] It was furnished with beds, a 'guard table' and forms for the yeomen of the guard, but it was only in 1729 that Benjamin Goodison finally provided a large brass chandelier with a gilt chain, carved crown and gilt rose for the ceiling. A canopy was erected in the Presence Chamber by Richard Roberts – it was not new, but came in one of several batches of furniture moved from Kensington, St James's and Somerset House in late 1717. This was presumably thought to be acceptable since the canopy in the Presence Chamber was symbolic and would never be used.[47] Vanbrugh wrote to the Lord Chamberlain, the first Duke of Newcastle, in early 1724 that he had just returned from Hampton Court 'where every thing in the Princes Rooms will be done as I promis'd, except some little matters in the chimney, which signify nothing, not being in the upholsterers way'.[48]

In April 1717 Fort was instructed to estimate for 'taking downe the great room' or Music Room that had been used as a temporary guard chamber, and to partition its west end to make a private way between the Princess of Wales's apartments and the young princesses' rooms to the north (fig. 258). This necessitated a complete refitting of the former music room; the Master Plasterer, David Lance, installed a new ceiling, and the walls were panelled.[49] The room retained its title 'Music Room' or 'Dancing Room' and was probably used for balls. Part of the orders of February 1717 was the finishing of the three rooms in the north-east corner of the quadrangle 'at the same level of expenditure as the Bedroom, drawing room and privy chamber'. The creation of the passageway across the end of the Music Room made it clear that the new rooms facing Fountain Court were to be the princess's, while the three new rooms were intended to serve the prince. Indeed this had probably always been the intention, since the rooms are marked on a plan of 1714 (fig. 235). David Lance undertook the plastering, Thomas Hopson the joinery and Gibbons provided the carving work. Vanbrugh once again must have been responsible, and certainly designed the fireplaces, which bear a close resemblance both to those at Seaton Delaval and to three designs in the so-called *Kings Weston Book of Drawings*.[50]

While little expense was spared in fitting-up the new rooms for the prince and princess, a less lavish refurbishment was proposed for their daughters in the former Duke of York's lodgings. The panelling of 1670 was deemed to be either too old-fashioned or in too bad a state of repair to be preserved, and Fort was ordered to have the rooms 'wainscoted, no higher than the sills of the windows, without panels over the doors windows or between the windows but barely fitted up for hangings with a small cornice'. The panelling was painted and a large number of hangings provided to hang above the dados.[51]

The summer of 1717, like that of the previous year, was, for the prince and princess, a mix of the magnificence of court assem-

247 The fireplace in the Queen's Presence Chamber designed by Sir John Vanbrugh and probably executed by Grinling Gibbons.

blies and the chaos of a building site, a fact that cannot have added to the ease of relations between father and son. The cold war of the summer broke into open warfare that winter. The trigger was a quarrel over the christening of the prince and princess's son born at St James's in November. George, furious at supposed insults and insubordination, banished the prince and princess from court. They moved from St James's to Leicester House nearby, which became their town house for the remainder of the reign. Banishment had the opposite of the intended effect. Suddenly there really was an alternative court and the prince manipulated his friends in

248 Proposal for remodelling the entrance court of Hampton Court Palace, by an unknown draughtsman working for Sir John Vanbrugh, winter 1717. The new work, including the two vast new assembly rooms, are shown in yellow.

249 Survey of the principal floor of Hampton Court with pencil proposals for a great 70ft square hall by an unknown draughtsman working for Sir John Vanbrugh, winter 1717.

Parliament to bring a number of strategic defeats on the ministry in the next session. George banned court society from Leicester House and was faced with an even greater need to entertain than he had had the previous summer.[52] The king now needed a big gesture, a great statement that would draw attention to his own court and cause. His eye fell on Hampton Court.

Vanbrugh's Plan for Rebuilding Hampton Court

The summer of 1717 had been a success in the king's terms; he may have even enjoyed his life there. Yet there were clearly problems with the palace if he were to extend and improve the quality of court life. There were insufficient large spaces for assemblies; the kitchens were old-fashioned and inadequate; there were no modern lavatories; and at least half of the building was two hundred years old. These problems were probably put to Wren and Vanbrugh in September 1717 with a list of requests, and it was Vanbrugh who took up the challenge of solving the king's problem.[53] Vanbrugh had long wanted to undertake a major royal commission as the pinnacle of a career during which he had become the leading country-house designer of his generation. In 1712 he had a false start after presenting a scheme to Queen Anne showing St James's as it was and two alternative schemes for its reconstruction. The scheme was later revived for George I, again in two versions, but came to nothing. In 1717 his chances came thick and fast: in September he was asked to produce a scheme for Hampton Court, and in December a scheme for rebuilding Kensington.[54] Seven drawings for the Hampton Court scheme survive (figs 248, 249).[55] The hand is rather crude and the drawings look unassured and hesitant. It is not currently possible to identify the draughtsman with certainty but at least two possibilities exist. The first is that they were undertaken for Vanbrugh by Henry Joynes, his former clerk at Blenheim and after 1715 Clerk of Works at Kensington. He is known to have been a competent draughtsman, although no examples of his draughtsmanship survive. A less likely candidate is the draughtsman simply known as Arthur, a servant of Vanbrugh's who worked for him from 1716. This possibility is weakened by the fact that the Hampton Court drawings are in the same hand as the 1712 drawings for St James's,

four years before Arthur is known to have been working. Several of the Hampton Court drawings are, however, similar to a group of drawings in the Elton Hall Album at the Victoria and Albert Museum, which are attributed to Arthur.[56] How this mystery draughtsman related to the various officers of the Works is unclear, but what is certain is that Vanbrugh had not the inclination, or more likely the skill, to create drawings on this scale himself.[57]

Essentially the drawings comprise a new survey of the palace at ground level and a careful survey of the parts that would abut the new work (fig. 249). Wren's quadrangle would remain and the old Tudor east range of Clock Court would be dismantled to create two vast new reception rooms – solving George's need for more entertainment space. These would be linked, as in Wren's original conception, to the Great Hall. Base Court would survive as a service court to the west, but most of the Tudor kitchen range would have been obliterated by a new forecourt flanked by long arcaded entrance ranges containing lodgings. The scheme is very similar to Vanbrugh's designs for Eastbury, near Blandford in Dorset, a house he started in 1718 and published in *Vitruvius Britannicus* in two versions (fig. 250).[58] The concept is noticeably different from Wren's original idea for a grand northern approach of

251 Thomas Fort's perspective view of Vanbrugh's proposed new entrance front. This drawing is on one leaf of an album prepared by Fort and is a copy of a lost drawing once held in the Office of Works.

250 Ground-floor plan of Eastbury House, Dorset, from *Vitruvius Britannicus*.

March 1689 (fig. 128). Arcades screening courtier lodgings and terminating in square pavilions form Vanbrugh's wings and his forecourt leads directly to the Great Hall without adopting a series of progressively widening ranges as at Versailles or later at Blenheim. This scheme must have been discussed in the Office of Works, since Thomas Fort made a perspective view of the Grand Court (fig. 251). Although the fenestration does not accord with the plan and the arcades are omitted, the general appearance must be correct. At the south end lies the Great Hall recast in a Vanbrughian gothic and flanked by great trophies of war. But perhaps most remarkable is a pencil sketch on one of the surveys (fig. 249) which shows Vanbrugh's idea for a great assembly hall on the south front. This is a hall of perfect Palladian proportions, 70ft square with 3ft 6in. columns which, if Corinthian, would be 35ft high – half as high as the hall was wide. Vanburgh had proposed a similar pillared hall for the entrance at St James's in 1712, showing his interest in and understanding of such Palladian forms.

The Reign of William Benson

How George received the scheme is unclear. One thing is certain, the idea was dead and buried by April 1718 when Wren's long dominance of the Office of Works finally ended and William Benson was appointed Surveyor in his place. Benson was an amateur architect and engineer who had met the future George I in Hanover and had provided advice on the fountains in his garden at Herrenhausen. He was also a Whig and had been elected MP for Shaftesbury. As a Whig, a Hanoverian favourite and an architect Benson was perfectly poised to topple the aged Wren.[59] Immediately on appointment Benson set out to overturn the orders of 1715, which in four months he succeeded in doing, assuming all the powers that Wren had enjoyed previously. Importantly a number of Wren's and Vanbrugh's men including Hawksmoor were ejected and replaced by his own kinsmen and friends. Prominent amongst these was a young Scottish lawyer, Colen Campbell, whom he appointed his deputy. Vanbrugh survived the initial purge despite a plethora of accusations culminating in a formal accusation of mismanagement against the former regime laid before the Treasury in 1719.[60]

Knowledge of the schemes for Hampton Court and Kensington may have been an important element in Benson's coup. He and Campbell were filled with an evangelical zeal to transform public architecture in England. Campbell had published his first volume of *Vitruvius Britannicus; or, the British Architect* in 1715, with plates illustrating all the most important recent buildings and a short introduction attacking contemporary Italian architecture, and by implication condemning British architects that copied it. Campbell was not alone; an unpublished tract, *A Letter Concerning the Art or Science of Design*, written in early 1712 by the Third Earl of Shaftesbury, had already expressed the concern felt by sections of the Whig artistic intellegensia about the state of British architecture. He complained that Wren's dominance of the Office of Works had seen the 'noblest publick Buildings perish' and noted that two great commissions remained – Whitehall Palace and the Houses of Parliament. 'Hardly,' he wrote, 'as the Publick now stands, shou'd we bear to see a *Whitehall* treated like a *Hampton-Court*, or even a new Cathedral like St Paul's.' It is not impossible

that knowledge of George's enthusiasm for rebuilding Kensington and Hampton Court and the Whig determination to see it realised in what we would call today a Palladian style triggered Benson's coup.[61] Ultimately financial problems ended any possibility of a royal scheme, and Benson and Campbell began to focus on rebuilding the Houses of Parliament as a more realistic target. Their botched attempt to persuade their lordships that their chamber was on the verge of collapse brought Benson's reign to an unhappy end.

With the abandonment of the great rebuilding scheme and with the king's continued need to make a big impact at Hampton Court, 1718 was a very busy year. The problems of lack of space and facilities remained, and Benson, with Fort (who had managed to survive the purge), worked hard to solve them. We are hampered in understanding this important phase because Benson's incompetent administration of the Office of Works deprives history of the documentation. But the months up to George's arrival on 13 August must have been frantic. George's residence lasted until 25 October and was characterised by festivities that put the previous summer's show in the shade. The king held nightly assemblies, twice-weekly balls in the prince and princess's former music room and dined in public every day.[62] The Prince of Wales meanwhile had moved to set up a summer retreat at Richmond to rival the king's entertainment at Hampton Court. Through the Earl of Grantham, and despite threats from the king, the prince acquired Richmond Lodge in the summer of 1718 and immediately moved in. What made the situation worse for George was that, against his specific orders, the comedian William Penkethman opened a theatre for the prince and princess nearby which they patronised during the season.[63] The king, spurred on by these acts of defiance, ordered the Lord Chamberlain to look into the practicality of making permanent the previous summer's use of the Tennis Court as a location for very large assemblies. An insight into the deliberations of his office is given in a letter written by Sir John Stanley, his secretary, to Coke, the Vice-Chamberlain

> As to the Tennis Court I dare give no directions, till the King is apprised of the charge; for the putting up of sails as you propose will cost at least 200l. The boarding it up will cost as much more, and I am sure will not be done in two months; nor the room be lighted under 10l. a night, which I believe the King will think too great a charge, to turn a good tennis court into a bad barn, that will endanger the lives of everybody that sits in it. I therefore desire that you will represent this to his Majesty for his commands; for without it will not be fit for me to send a letter to my Lord Chamberlain to sign for what may be thought a great and unnecessary expense. In the meantime, if his Majesty will not please that his Presence and Privy Chamber be lighted up for that use, which will be more handsome and less expense, I can't but think the Old Guard Chamber, which is hung for the Green Cloth, but not used by them at night, or the Communication Gallery between the two Great Apartments, or even the Old Hall, will be more convenient, more warm, and a less charge, for the company to play cards than in the Tennis Court. But this is all submitted for the King's pleasure.[64]

Despite the objections, the king directed that the Tennis Court be converted and work started immediately on fixing up painted sailcloth over the windows, painting the interior white and making a gallery at the north end for the musicians.[65]

Why Stanley's suggestion of using the State Apartments was not taken up is not known, but the reason for not using the Tudor hall and Guard Chamber was that they too had been allocated a new function. Undoubtedly inspired by the prince's patronage of Penkethman's players at Richmond, George ordered in September that William III's unfinished theatre in the Great Hall should be completed with all possible haste. It is unclear what needed to be done but bricklayers were paid almost £400 suggesting quite substantial works. Thomas Highmore was paid £26 for painting the theatre and Thornhill over £100 for scenery. The actor, dramatist and theatre manager Colley Cibber, writing in 1740, tells us that plays were intended twice a week, 'But before the Theatre could be finish'd, above half the month of September being elapsed, there were but seven plays acted before the court returned to London.' The seven plays were acted by Sir Richard Steele's Company of Comedians from Drury Lane, who were paid £374 for their efforts. They opened with *Hamlet*, which had probably first been performed in the hall over a hundred years earlier, and Shakespeare's *Henry VIII*.[66] A plan of the Great Hall set up as a theatre in the hand of Thomas Fort shows the eventual layout (fig. 252). It is impossible to distinguish the work of 1702 and that of 1718 but it is certain that Benson oversaw the works as the (lost) bill books were in his name; it is less certain, however, that he designed it himself. More likely it was left to Vanbrugh who, after all, was a playwright, the owner and architect of a theatre on Haymarket, and had included a large theatre as a centrepiece of his design for rebuilding St James's Palace.[67] The Wardrobe was responsible for providing the fittings for the theatre, and supplied twenty-five pieces of crimson serge and six pieces of green serge for hangings for the boxes and seat coverings, a pair of very large curtains for the great east window, and another pair for the stage. Other items delivered included candlesticks, thirty-six cane chairs and a harpsichord.[68] George's work finally brought Hampton Court into line with the palaces of Europe, where even secondary houses had integral theatres, especially in Germany.

Another of the estimates to be provided in 1717 was for 'an additional kitchen or side kitchen to be built' with a new cellar, and this work also fell to Benson to execute.[69] Here at last was a new building at Hampton Court, not the mere refitting of an old shell for a new purpose. The site chosen was on the north side of the palace, facing the Tudor kitchens across the northern service road now known as Tennis Court Lane (fig. 253). Benson's precise brief is lost but it is clear that George needed a modern kitchen to provide for the extensive entertaining he was hosting at the palace that summer. But who should design it? Clearly Benson could not give the first new commission of his Surveyorship to Vanbrugh, whose architecture he despised and whom he had tried to sack. The obvious choice was Colen Campbell, who was working on the other major current commission, the new state rooms at Kensington. The building as constructed is the first and only fruit of the Benson–Campbell revolution at the Office of Works – a severe grey-red brick rectangle five bays by seven, and two storeys high, with an attic and cellars. Although in reality a kitchen, it is in form England's first neo-Palladian villa (fig. 254). Campbell had experimented with this form of building before. His first house was Shawfield, for Daniel Campbell, a wealthy Glaswegian sugar merchant (fig. 256). This house was square with

252 Thomas Fort's survey plan of the theatre erected in the Great Hall at Hampton Court, c.1718. The stage is at the hall screen and Minstrel's Gallery end (left); the squares and rectangles are trapdoors.

a symmetrical arrangement of rooms and its front and rear elevations divided into three, the centre part surmounted with a pediment, and consciously imitated Chevening, believed to be by Inigo Jones, particularly in its plan. The new Hampton Court kitchen follows this precisely, with a tripartite façade, pediment and symmetrical plan.[70] Inside was a small rectangular serving lobby lit by two windows leading to the kitchen proper. Here were five great fireplaces in a double-height space lit from the north by windows on two storeys. Four rooms set aside for sculleries, pantries or larders were ranged either side of the central space (fig. 257). Beneath were vaults designed to take the king's cellar, and above, rooms for the king's cooks. Campbell was to build a similar kitchen just under ten years later for Walpole at Houghton House in Norfolk, again disguised as a villa.[71]

In 1715 George had brought with him his entire kitchen establishment – thirty-one servants including a kitchen master, a clerk, three master cooks and an under cook. After his trip to Hanover in 1716 the number of Germans was reduced to ten. For the first two years of his reign the centuries-old distinction between the household and the privy kitchen was temporarily set aside and George, his mistresses and his closest companions fed from the new German-staffed kitchen. In 1717, when the king moved to Hampton Court and Kensington, the traditional distinction was re-established and English servants were admitted. Yet the king and his friends continued to use German staff, and thus the household kitchen became known as the 'English Kitchen'; the new kitchen or 'side kitchen' was for the king's table and was effectively the 'German Kitchen'. The English Kitchen was still within the old Tudor service range and fed the thirty or so servants who still had tables at court. At Hampton Court more servants were entitled to dine than when the court was at Kensington or St James's, since there were so few alternative places to eat nearby. To facilitate this the old Tudor presence chamber was partitioned off to make dining rooms for the Women of the Bedchamber and Pages of Backstairs to the Prince.[72]

The process of converting the old Tudor kitchen range for other uses continued under George. For instance, the former fish larder and the rooms above were converted into a kitchen for Count

253 Ground-floor survey of Hampton Court, possibly by Thomas Fort, c.1732–42. Together with figure 211, this is the earliest ground plan of the palace to have survived. Fort's survey is very detailed and accurate, showing even the layout of the pews in the chapel. The drawing is unfinished as it shows the king's new side kitchen pencilled in.

254 The 'Georgian house', George II's side or 'German' kitchen.

Bothmer. But a more important change was that most of the kitchen offices at Hampton Court had gradually become private enterprises trading with suppliers and the Royal Household and using accommodation in the royal houses to pursue their trade. Hampton Court was always a little more difficult to supply than the metropolitan houses. For instance, fresh meat could not easily be transported from Smithfield, so a new slaughterhouse was built at the palace to the design of the Clerks of the Kitchen. Yet the local suppliers of Kingston and round about enjoyed a brisk business in the summers of 1716 and 1718. The Lord Steward's papers contain minute details of the foodstuff supplied for the royal family at Hampton Court during the reign. The Board of the Greencloth used the old Tudor guard chamber as their meeting place and obtained permission to have the floor there repaired and raised, because its condition and dampness was 'prejudicial to the books and papers'.[73] They presided over a huge restocking of the kitchens and the purchase of a large amount of plate and cutlery.[74]

As well as the side kitchen Benson built one other building for George in 1718 – a public lavatory. In September 1717 it was ordered that 'a necessary house for persons of Fashion' should be built and it too was to be sited on the north side of the palace.[75] This appears on plan (fig. 253) and on a single view of around 1780 (fig. 255). It was a plain building of no architectural preten-

255 Watercolour of *c.*1780 by John Spyers, showing the north side of the palace looking west, with (right) George II's new side kitchen and (centre) the new communal lavatory. On the left is an eighteenth-century addition to the Tudor kitchens.

256 Plans and elevation of Shawfield House in Glasgow designed by Colen Campbell, from *Vitruvius Britannicus*.

257 Ground-floor plan and section of the 'Georgian house' as originally built. Drawing Daphne Ford.

sion. The construction of both the side kitchen and the 'necessary house' began the development of a new part of the palace precincts. Plans of the palace of 1710–13 (fig. 231) show the north side still enclosed in the Melon Ground (see chapter 12). The new kitchen and lavatories were built in an area of former garden, and by the mid-1720s what is now Tennis Court Lane had been developed (fig. 253).

Benson's reign was short. The enormous number of enemies he had made in a short time turned on him and exposed his financial and contractual plans for the Office as being corrupt. The final straw was an attempt to declare the House of Lords unsafe and thereby gain the commission to rebuild it. Benson was dismissed, leaving the Office of Works in chaos in July 1719. This disorder was matched by even deeper chaos in the king's finances. George I was the first English monarch to have a fixed income guaranteed by Parliament. This should have been good news, but the provision made soon proved to be inadequate. In 1714 he was granted £700,000 a year, but by 1718 the debt on the civil list had grown to such a level that the Treasury was forced to take action. A significant area of expenditure not under proper control was the furnishing and embellishment of the apartments of Madame Schulenberg, Madame Kielmansegge and the prince and princess. Both the Office of Works and the Wardrobe had, as we have seen, paid out lavishly on their collective behalf since 1714. In 1717 the prince and princess's expenditure and in the following years the mistresses' expenditure came under control. The two ladies accepted fixed sums and money in lieu of furniture from the Great Wardrobe. At the same time expenditure by the Great Wardrobe and the Office of Works was fixed at £13,000 and £14,400 a year respectively. This retrenchment and the fact that the summers of 1719 and 1720 were spent in Hanover account for a great reluctance to spend on Hampton Court, and expenditure on the house plunged for two years.[76]

The decline in expenditure and activity was matched by the disillusionment of the new Surveyor of Works. Sir Thomas Hewett was the last architect Surveyor and, after Benson, the second placeman to hold the post. Hewett was, of course, a strong Whig, and had made a reputation as Surveyor of the Woods North and South of the Trent. He, like Benson before him, was eager to be involved in a major scheme to create a new palace or public building, but he was to be disappointed. His tenure of the office, which lasted until 1726, made little or no impact on Hampton Court. George himself never visited the house again, despite a reconciliation with the Prince of Wales in 1720 and a summer spent in England in

258 Plan of the principal floor of the State Apartments, probably by Thomas Fort, 1724.

1721. Preparations were made in 1722 for a visit, but it never took place.[77] Despite this, royal interest in Hampton Court continued and in April 1724 Fort was ordered to make a series of plans of the palace. A plan of the second-floor rooms over Fountain Court, plans of the whole of the palace showing room dimensions, and a plan showing the names of the rooms in the palace survive. Fort's first-floor plan (fig. 248) shows the palace after the works of George I's reign were completed.[78]

The Palace Environs

Both George I and George II travelled to and from Hampton Court exclusively by coach. Anne had made a better road through the Home Park so that the royal family could arrive privately at the east front, and the first Georges put increased emphasis on the maintenance of the private royal road from Westminster through Fulham towards Hampton Court, Richmond and Kew. For a monarch who is known for his retiring ways, George I made the trip in some style with the bells of the churches along the route rung for him in time-honoured fashion. On these occasions keeping the road free from interlopers was a particular concern and there were frequent complaints that 'the coaches of several Ministers of State, and other Persons of Quality and Distinction were stopt and crowded into the Ditches by carts Drays Stage and hackney Coaches etc'. The quality of the road was not improved by the massive logistics of royal removes. Indeed, in 1717 twenty new wagons were delivered for the king's visits to the palace, which rutted and damaged the road still further. While George was interested in Hampton Court the roads were well kept and in 1717 responsibility for them was transferred to the Office of Works. But after the palace was abandoned in the 1720s complaints were lodged about their state by the inhabitants of Hampton and surrounding towns.[79]

The emphasis on road travel and a continued interest in hunting at Hampton Court ensured that the stables were cared for. The royal stables kept about a hundred horses with a staff of eighty or more who cared for the carriages, the bloodstock and the real estate. A surveyor was appointed to look over the Hampton Court stables: from 1714 Sir Richard Steele, who wrote to a friend claiming 'I have nothing to do but to give an estimate in case they want being repaired.' This he must have done, because in 1716 the

stables and paddocks were overhauled at some expense. Yet they were in a very poor state again by 1723 when Colonel Negus, the Commissioner of the Horse, inspected them. Another major overhaul took place that year.[80] Hampton Court retained its stud under Georges I and II, controlled by its master Richard Marshall. Talman's plan of 1699 (fig. 176), Bridgeman's plan of 1711 (fig. 231) and Fort's plan of 1742 (fig. 275) show the stud and its enclosures, which seem to have been walled.[81] George I and his son both used Hampton Court as a base for field sports. They only rode to hounds at Windsor, suggesting that the deer herds in Hampton Court and Bushy Parks were depleted. The sport at Hampton Court was shooting, and George and the prince enjoyed a number of shooting parties, killing pheasant and partridge and exercising the retrieving spaniels that were kept at the mews. Even after George had abandoned Hampton Court, he made short visits from Windsor to shoot in Bushy Park.[82]

Vanbrugh and Hewett died within a fortnight of each other in 1726 and the gift of the two most influential places on the Board of the Office of Works lay in the hand of Sir Robert Walpole. Walpole was heavily lobbied by Lord Burlington, the Duke of Devonshire and others and eventually appointed the Honourable Richard Arundel, a Yorkshire squire, MP and architectural connoisseur as Surveyor, and his own man, Thomas Ripley, as Comptroller. William Kent, who had been championed as new Comptroller, had to make do with the consolation prize of Master Carpenter. In due course he took the rooms in the Houses of Offices in the Outer Court that his predecessor Thomas Ripley had occupied.[83] George himself died in June 1727 in Osnabrück, leaving the British throne to his son, George II.

259 Philippe Mercier, *The Music Party: Frederick Prince of Wales, with his Three Eldest Sisters in the Hampton Court Banqueting House*, 1733.

Chapter 14

APOGEE: GEORGE II

THE ACCESSION OF GEORGE II IN June 1727 ended ten years of near abandonment for Hampton Court and ushered in ten years of regular use. Like his father, George spent considerable time in Hanover – two whole years (1729–31) and eight visits (1740–55) – yet while he was in England Hampton Court was his favoured summer residence and his use of it to 1737 saw William's III's buildings finally come alive.

George secured the most generous civil list of the eighteenth century, which included a parliamentary guarantee of £800,000 a year. This fact combined with his relatively modest architectural ambitions kept the Office of Works free from the financial problems that had dogged the Stuart period. After 1737, when George all but abandoned Hampton Court, expenditure plummeted; in 1751 it was calculated that expenditure at Hampton Court had only been £1,662 over the last decade, with £556 being spent on the gardens. In January 1745 Thomas Fort died after presiding over work at the palace for thirty years. He was succeeded by John Vardy, an admirer of William Kent, who had been Clerk of Works at Greenwich since 1736. His clerkship was short, and in November 1746 Kent's assistant Stephen Wright was appointed Clerk, a post that he retained until 1758. Kent himself had been appointed Master Carpenter in 1726, so in one way or another he and his cronies dominated the repair and embellishment of Hampton Court for over thirty years. George's accession brought changes in the Royal Household too, mainly in personnel and largely as a result of the new grafting of his princely entourage on to the existing Household establishment. Two new departments were formed: a Privy Kitchen for the queen and a new Household Kitchen, neither of which had been deemed necessary under George I. One other factor distinguished George II's household from that of his father – unlike George I who always maintained a small inner German court, English favourites and friends were important to the new king both personally and as household attendants.[1]

George II's First Visit

The royal family arrived at Hampton Court in time for supper on 2 July 1728, and two days later the Privy Council convened in the Cartoon Gallery for the first time in the reign. George and Caroline immediately established a standard of formality and etiquette that had been lacking at Hampton Court since William III's death. They also established a Germanically regimented routine for the court. This was centred round the king's levee and couchee, audiences, drawing rooms, dining in public, occasional balls, diplomatic receptions and hunting. Particular days were set aside for specific activities. During their visit of 1728, Tuesdays and Wednesdays were for meetings of the Privy Council; during later visits Thursdays were appointed as Council days. Thursdays and Sundays were always the days for dining in public, and Wednesdays and Saturdays were for hunting.[2] Public dining formed the backbone both of court life and of George's public policy. When in 1717, as Prince of Wales, George had launched his public dining, the Bishop of Lichfield and Coventry noted that

> The public manner in which the King lives, makes [Hampton Court] the rendezvous, not only of the ministers and great men, but of all ranks and conditions. He dines openly and with company every day and the novelty of the sight draws a mighty concourse . . . he certainly does a right thing, for by this means his face . . . will not only be familiar to his people, but he will enter into a degree of intimacy with the nobility above what could be arrived at in the cabinet or drawing-room.

What George had begun as prince he developed with a vengeance as king. On an early occasion when he and Caroline dined in public at Hampton Court as king and queen the press of spectators was so great that 'the rail surrounding the table broke and causing some to fall, made a diverting scramble for hats and wigs at which their majesties laughed heartily'.[3]

Dinner was at about three o'clock in the afternoon, except on Sundays when it took place after chapel. It lasted about two hours. Count Charles Pollnitz, who visited the court in 1733, described the scene:

> Their majesties dine in public only upon Sundays when none eat with 'em but their children. The table is in the form of an oblong square in the middle of which sit the king and queen with the Prince of Wales on the right and the three eldest princesses on the left . . . The table is placed in the midst of a hall, surrounded by benches to the very ceiling, which are filled with an infinite number of spectators.

King William's Eating Room on the south front was deemed too small for this and most public dining took place in the much larger Music Room, or Dancing Room (now called the Public Dining Room). On occasion, particularly after hunting and with smaller parties, George would use William III's downstairs dining room, as for instance with the Duke of Lorraine in October 1731.[4]

The king's levee and the drawing rooms were equally easy to obtain access to. According to Pollnitz,

> Tis very easy to obtain the honour of being introduced to their majesties and the royal family, nothing more being necessary than to send in one's name to the Duke of Grafton, his Majesty's Lord Chamberlain and my Lord Grantham, the queen's Master of the Horse. People go to the Kings levee and the queen's drawing room as they do in France.

During the levee, amidst bowing lords, the king spoke to ministers, guests and even members of his own family, using it as an opportunity to make public his thoughts. So important was this as a part of his public policy that, as Lord Hervey noted, he would 'get out of his bed, choking with a sore throat and in a high fever, only to dress and have a levee, and in five minutes undress and return to bed until the same ridiculous farce of health the next day at the same hour'. Drawing rooms usually coincided with 'public' days at court. They started at about ten o'clock in the evening, when the entire royal family would enter the great east-front Drawing Room which was set up with tables and chairs. The royal family would circulate for about an hour before leaving. Sometimes they would withdraw to the Queen's Bedchamber where favoured courtiers would be invited for intimate conversation. On non-public days the royal family would dine in their private dining room, presumably entering the Drawing Room through the jib door in its west wall.[5] The summer also saw the reception of foreign ambassadors; during 1728 first the Marquess Ricardi, extraordinary envoy of the Grand Duke of Tuscany, then Signor Vignola, resident from the Republic of Venice, followed by the extraordinary envoy from the King of Spain and Count Kinsky, extraordinary envoy from the emperor. Each was received first by the king in his privy chamber in exactly the way that his predecessors had received envoys. The queen then saw them in her privy chamber, and finally visits were paid to the prince and princesses.[6]

Thanks to the existence of a number of private diaries and memoirs from this period, we have a much clearer picture of the private life of the king and queen at Hampton Court than ever before. They seem usually to have slept together in the bedchamber in the Queen's Private Apartments. It is difficult to know how far this was a departure from past royal protocol, because the evidence simply does not survive for earlier reigns. Lord Hervey, however, records that the king would generally return to the Queen's Apartments towards the end of the evening before retiring with her. The next morning he would leave for his levee while the queen breakfasted; the levee lasted an hour and a half and when it was over George would return to her apartments where he remained in conversation until mid-morning when he left for his own apartments. In general the queen was dressed privately by her ladies, often being read to. Although we know she held levees at St James's, there is no evidence that she did so as queen at Hampton Court. The private apartments were thus genuinely private and only personal friends and body servants gained admittance. Hervey records the reception of Sir Robert Walpole in the apartments (possibly in what is known as the Queen's Private Drawing Room) as unique. The bedroom, on which the queen's private life centred, was the most exclusive of all. Usually only the king and the queen's ladies had access. Caroline ordered Mary, Countess Cowper, one of her Ladies of the Bedchamber, to write to a lady who persistently attempted to gain access: 'I hope you know nobody goes into the dressing room up the backstairs but those who belong to the bedchamber.' Even Lord Hervey had to communicate with the queen in her bedchamber through the door left ajar. However, on one occasion when the queen was laid up with gout and could not leave bed, court etiquette was broken and Hervey visited her there alone.[7]

George wished to enjoy hunting throughout the season when he was in England, and whether he was in town or out Wednesdays and Saturdays were set aside for stag-hunting (he thought fox-hunting beneath him). George I had neglected the post of Master of the Horse, but in 1727 his son revived the office, giving it to a close friend, Richard Lumley, Earl of Scarborough. George was also quick to fill the post of Master of the Buckhounds and for the first time since James II's reign a Master of the Harriers and Foxhounds was appointed. The queen and Princess Amelia would follow the hunt in a four-wheel chaise, the queen usually accompanied by her companion Lord Hervey. Princess Caroline would follow in a two-wheel chaise. In addition crowds of courtiers and household servants joined in, with the result that the royal hunt looked like a small army on the move. In the end this actually hindered the king's enjoyment, and so tickets were sold to courtiers wishing to join in the fun. The royal hunting grounds were Hounslow Heath, Sunbury Common, and occasionally Windsor Park and forest, but the most favoured hunting ground was Richmond. This was easily accessible from both Hampton Court and Kensington, and George even added land to the new park there to improve the facilities. The Hampton Court parks were never hunted in George II's reign. The Hanoverian court hunted as energetically as their Stuart forebears. The king would sometimes chase a stag for 40 miles and courtiers would frequently swim the Thames on their horses. Henrietta Howard, the king's mistress, wrote from Hampton Court complaining that 'we hunt with great noise and violence, and have every day a tolerable chance to have a neck broke'. In August 1727 the Princess Royal fell from her horse, and on another occasion the Princess Amelia fell and was dragged along by her long skirts for 200 yards. The Household accounts show that the Household Surgeon was always in attendance. He let blood from Sir Robert Walpole after a fall, but was unable to save a page of honour of the queen's who was left for dead during a hunt in 1732. Between November 1731 and January 1734 a hundred stags and sixty-four hinds were killed at royal hunts.[8]

Yet despite all this courtly activity, the court of George and Caroline when king and queen had not the sparkle and competitive edge that it had had when they were Prince and Princess of Wales. During their first stay in 1728 Mrs Howard wrote to Lady Hervey telling her that 'Hampton was very different from the place you knew... *Frizelation, flirtation,* and *dangealation* are now no more, and nothing less than a Lepell [Lady Hervey's maiden name] can restore them to life.'[9] The principal criticism was the unvarying nature of the routine. Lord Hervey wrote to Mrs Clayton in July 1733 describing life at court:

No mill-horse ever went in a more constant track, or more unchanging circle, so that by the assistance of an almanac for the day of the week, and a watch for the hour of the day, you may inform yourself fully, without any other intelligence but your memory, of every transaction within the verge of the court. Walking, chaises, levees and audiences fill the morning; at night the king plays at commerce and backgammon, and the queen at quadrille.

The Countess of Pomfrett wrote from Hampton Court in a similar vein in August 1731: 'All things appear to move in the same manner as usual, and all our actions are as mechanical as the clock which directs them.'[10]

The Palace Refurnished

George's and Caroline's first long visit to Hampton Court, which only ended on 3 September, gave them time to contemplate their surroundings. What they saw was, frankly, not up to scratch. The palace looked tired, dirty and downtrodden. The King's Apartments were much as William had left them nearly thirty years before. Care had been taken to replace worn tassels, maintain fire-hearths and clean the architectural shell, but this could not conceal the fact that the rooms were not only tatty but also old-fashioned. The king therefore ordered that the palace be given an overhaul. That the work was necessary there should be no doubt, but that George was enthusiastic about it is far less certain. In his memoirs Lord Hervey records a conversation that he had with the king and queen in 1735. Hervey described to them the restoration of Torrigiano's iron screen round Henry VII's tomb in Westminster Abbey. The queen was fascinated and kept asking for more details. The king was not and said to Hervey, 'My Lord, you are always putting some of these fine things in the queen's head, and then I am to be plagued with a thousand plans and workmen.' After the king had criticised Caroline's building projects in Kew Gardens, the conversation moved on to the subject of visiting other people's houses, whereupon George said, 'You do not see me running into every puppy's house to see his new chairs and stools.' According to Hervey, the king's ill temper continued in the same vein, with complaints about the futility of the queen's love of paintings.[11] Clearly an allowance must be made both for Hervey's maliciousness and the king's argumentativeness, but certainly George cannot be seen to have taken the same interest in the palaces as he had done as Prince of Wales. His wife, however, was more concerned. She, for instance, ordered paintings to be brought to her levee at St James's in December 1733 and had Holbein's drawings of Henry VIII's courtiers (which she found in a drawer) framed and hung in her rooms. She also attempted to rearrange the paintings in some of the state rooms at Kensington while George was in Hanover, moving some to Hampton Court and Windsor. George, who hated any disruption to what he knew and felt comfortable with, and who equally disliked the queen exercising her taste in his apartments, ordered the paintings to be reinstated, thanking God that 'she had left the walls standing'.[12]

Thus King George's taste in furnishing was conservative to say the least, and his refurbishment of the palace was modest in scope if not in cost. The original white silk curtains in the principal state rooms were taken down and replaced by crimson damask festoons hung from new cornices with valances. A single crimson damask valance survives at Hampton Court today with spirited 'ears', similar to those on the queen's bed, and rich lace dressing. It is likely that this was the pattern throughout. The long forms in the Presence and Eating Rooms were re-upholstered to match. George signalled his plan to increase the use of the rooms in the evenings by markedly improving the lighting. The Presence Chamber, originally lit by the central chandelier and four candelabra on stands, was supplied with two gilded glass sconces in frames with two arms each and a new walnut pier table, with glass and candlestands. Where these last were located, given that the principal furniture was symmetrically arranged giltwood, is uncertain. Both the Presence Chamber and Eating Room were also supplied with brass chimney arms for candles. The Eating Room was furnished with a giltwood chandelier with twelve arms. It still hangs in the room today. The Queen's Guard Chamber was supplied with a new chandelier, and large eight-sided glass lanterns with brass frames topped with crowns fitted for either candles or oil lamps were made for both the king's and Queen's Stairs. The Queen's Stair still retains its lantern, though the interior has been lost. The chapel gallery was provided with fourteen walnut side lanterns, and the playhouse with two twelve-light brass chandeliers. The seats there were re-upholstered, and yet more sconces were sent from St James's. Benjamin Goodison supplied all the new furniture and light fittings.[13]

The King's Private Apartments on the ground floor were not only refurnished but were also extended. The whole of the area from the vestibule on the east front round to the King's Private Dining Room on the south front was colonised. The large room next to the vestibule was set up for cards. It was furnished with a mahogany table with a green cloth and fourteen walnut chairs. A giltwood pier table, stands and glass were also provided, and the windows dressed with festoon curtains and cane blinds to prevent people looking in. Other rooms on the ground floor included a waiting room, a withdrawing room and a closet. All of these had new furnishings, as did William III's former corner closet and the closet next to the Orangery (see fig. 253). Goodison once again supplied the furniture. The downstairs bedchamber used by King William was provided with new chimney sconces, a pair of stands and a table with leather covers matching a pre-existing mirror and a walnut bedside table. The King's Private Dining Room, to be much used by George, was given two new side tables.

In what now became the Queen's Private Apartments (on the principal floor looking on to Fountain Court) the Oratory was finally furnished with two long forms and six square stools covered in crimson serge, a walnut reading desk and crimson velvet carpets to cover the desk. The three rooms in the north-east corner of the State Apartments which had been George's whilst Prince of Wales were assigned to Frederick, the new Prince of Wales. The first room was his presence chamber, furnished with a green damask canopy of state trimmed with silver lace with his crown and feathers. Beneath it in matching damask was a chair and two stools in the traditional manner. The windows were given green festoon curtains and the walls provided with six glass sconces in gilt frames with two arms each. Against the window pier were a glass, table and two stands in walnut by Benjamin Goodison. His drawing room was at the corner and was furnished similarly by Goodison, but with a walnut card table, stools and an armchair for the prince. The bedchamber had a four-post bed hung in green

260 Plan showing additions to Hampton Court made during the early Georgian era, 1714–37. Parts added or altered are shown in hard black line. Drawing Daphne Ford.

damask 'in the best manner', a bookcase and a writing table. The nearby rooms in the old Tennis Court Lodgings set aside for the Princess Royal, the Duke of Cumberland and Princess Amelia were refurnished in similarly rich style with blue mohair and green damask. The rooms of the royal body servants were not neglected and large quantities of furniture were provided for everyone from the Grooms and Ladies of the Bedchambers to valets, pages and necessary women. Forty-four pieces of tapestry throughout the palace were cleaned and given new canvas linings, and some were given new borders. This was all undertaken at considerable cost, the largest expenditure on the palace since King William's time. It began a process of modest and measured modernisation that was to continue until 1737, finally completing the palace that William had begun.[14]

★ ★ ★

The Visit of 1731

By the time George and Caroline next visited Hampton Court the first phase of furnishing in the State Apartments had been accomplished. They arrived on 10 July, and the following evening the king's accession day was celebrated with a ball. The royal children and their Households were all in attendance and the inns and taverns for several miles about were full of the royal retinue. After the ball the children's lessons continued. The Duke of Cumberland, Princess Mary and Princess Louisa were receiving drawing lessons from Bernard Lens the enamel painter, who lodged outside the court and was given an allowance of £62 18s. Meanwhile, Nicholas Harding instructed the Prince of Wales on the laws and constitution of England.[15] Lens's residence at Hampton Court in 1731–3 produced a number of valuable and informative paintings now bound together in an album at the Yale Center for British Art. Several of these show the setting of the palace from the south-west from Hampton and Molesey, but three contain important information on the palace itself. The first is a view taken from the Barge Walk looking west. It shows the river-

261 Watercolour by John Spyers of c.1780, showing the outer Green Court, with (right) the barracks and (left) the Tudor Houses of Offices.

262 Ink-and-wash drawing by Bernard Lens of 1733, looking west along the Barge Walk, with the corner of the Banqueting House (right) and, in the distance, the Houses of Offices and the Toye Inn.

263 Wash, ink and graphite drawing by Bernard Lens of 1733, showing the east-front gardens, with the semicircular canal (complete with swans), the Long Water and courtiers enjoying the gardens. This is the only contemporary work depicting courtiers at the palace.

side, ferry and Toye Inn immediately before the construction of the bridge (fig. 262). Then there is an impression of five courtiers enjoying themselves in the east-front gardens beside the semicircular canal with the Long Water in the background (fig. 263). In addition to these, there is a valuable view by John Spyers showing the outer Green Court, barracks and Houses of Offices (fig. 261).[16]

As in 1728 George received envoys from all over Europe including Denmark, Tuscany and Brunswick. In October the Duke of Lorraine (who later became Emperor Charles of Germany) paid an incognito visit to the palace and the description of his reception throws light on George's use of the State Apartments. The duke arrived at the Great Gate where he was met by two Gentleman Ushers. He was led through the outer courts to the King's Great Stair and led up to the Admiral's Gallery via a backstair. In the ante-room to the Cartoon Gallery waited the Lord Chamberlain and the king's ministers. From here the duke was ushered along the Cartoon Gallery through the jib door into the King's Great Bedchamber, and thence into the King's Closet. Afterwards he was taken back along the same route to the top of the Queen's Stairs before being guided through the Guard and Presence Chambers into the Queen's Oratory. The duke was then received jointly by George and Caroline in one of the private rooms before being taken out into the Queen's Apartments through the Private Dining Room. Next he visited the Prince of Wales in his rooms. On leaving Frederick, the duke joined the drawing room which was in progress on the east front before retiring with the royal family to see them dine, probably in the Private Dining Room where he stood behind the king's chair. After the first course he left by way of the Caithness Staircase. Two days later he returned to Hampton Court to hunt. After the hunt was over the duke was invited to dine in the Private Dining Room where the table was laid for fourteen. The king sat the Prince of Wales on his right and the Duke of Lorraine on his left.[17] On 18 October Colley Cibber's company of actors performed a comedy, *The Recruiting Officer*, in the playhouse for the duke. The guests arrived at a quarter past six and were seated on long benches in the front row in the 'Foreign Minisyters seat'. The king and queen sat on armchairs and the royal family in the 'middle box'. Between each act there was dancing in the pit and afterwards the whole company retired to the Queen's Drawing Room for cards. The duke returned to London by carriage well after midnight.[18]

Religion was a formality for which George had little affection. Yet chapel attendance was still the backbone of court life and a central part of the most important day at court – Sunday. Consequently the chapel closet was refurnished as part of the major overhaul of 1731. An armchair and footstool covered in velvet were provided for the queen. These presumably matched existing ones for the king. Four square stools en suite were provided, and hassocks for both king and queen. In 1728 there were twenty-seven Gentlemen of the Chapel including the organist, the Master of the Children, a lute player, a violinist and ten children, in addition to the dean and sub-dean. In 1727 George I had made a radical break with tradition, ordering that Chaplains in Ordinary should hold positions less than a deanship and that they should not attend the king or queen in their closet. This meant that the clerk of the closet, always a bishop, became the only cleric authorised to attend the monarch privately. Little is known of the bishops who attended George II but Caroline, more interested in religion, certainly heard prayers and sermons regularly both in her

private apartments and in the drawing room. Often prayers were read while she dressed – her dressing room door was kept ajar and the chaplain sat in the next room. On one occasion Isaac Maddox, Bishop of St Asaph (later Bishop of Worcester), reputedly commented on a painting of a naked Venus in the outer room: 'and a very proper altar-piece is here, Madam!'[19]

The Cumberland Suite

William Augustus was made Duke of Cumberland in July 1726 but it was not until 1731 that the Treasury approved his first separate establishment. That year George set aside suites of rooms at St James's, Kensington and Hampton Court, together with a small Household and an allowance of £6,000 a year. His attendants included two Grooms of the Bedchamber, four footmen and four pages. In addition he had his own huntsmen and stable hands. From 1727, as we have seen, William was housed with his sisters in the old Tennis Court Lodgings, but after the constitution of his household more space was needed. The continuing and deepening rift between the king and queen and Frederick, Prince of Wales, put William into a favoured position. His mother in particular doted on him. It is for these reasons that George II's only major architectural work at Hampton Court was a suite of lodgings built for his second son.[20]

In October 1718, during William Benson's disastrous reign as surveyor, and in an attempt by him to ascertain the condition of the various royal buildings, it was ordered that the Clerk of Works at each palace should deliver a plan marking the areas of good and bad repair and those areas 'ruinous and of little use'. Thomas Fort had one week in which to prepare a plan of Hampton Court and table it at Scotland Yard. The plan showed that while the outlying buildings and the Wren courtyard were in good order, parts of the Tudor palace were not, and that the range between Clock Court and Fountain Court was derelict.[21] In the aftermath of the collapse of Benson's regime and with the abandonment of Hampton Court by George I, nothing was done other than to take down the ceiling of one of the largest and most dangerous rooms there in July 1721. Right at the start of George II's reign concern was expressed about the condition of the range and Fort was asked to send an elevation of the Inner Court 'that is in danger of falling'. The elevations and accompanying plans survive as a beautiful and important record of Wolsey's principal domestic range (fig. 264). When, four years later, George II raised the issue of accommodating his second son, it was resolved that it should be pulled down and rebuilt for 'the more commodious reception of His Majesties Family' and an estimate for £3,454 14s 2d was agreed in June 1732. Demolition started two months later and in October the final detailed designs were examined and approved and the mason Andrews Jelfe started work.[22]

The architect who produced designs for the new work was William Kent, Master Carpenter since 1726 and the most fashionable architect and designer of his day. Promoted into the Office of Works, like so many of his colleagues, by Richard Boyle, Third Earl of Burlington, he had already captured a major royal commission at Kensington in George I's reign. But this was for painting not architecture and the commission to build new rooms for the Duke of Cumberland may have come as a direct result of his success in meeting the king's finicky requirements at the Royal

264 Elevations of the range between Clock and Fountain courts, probably by Thomas Fort, 1727.

Mews, his first official architectural commission. At any rate his proposals for the new range aroused considerable interest, not (as far as we know) from the king, but from Sir Robert Walpole, who through his role at the Treasury had an influence over the final design. Walpole (according to his son Horace) rejected Kent's first Palladian design of which no record exists, and insisted on a gothic style for the new buildings.[23] Historians no longer see the Whigs as being solely interested in Palladian architecture, but the fact that Sir Robert insisted on a gothic style still calls for explanation. This probably lies in his knowledge of the work that was underway for his close friend and associate Henry Pelham, Secretary at War.

Pelham had bought an estate at Esher, on the River Mole in Surrey, in 1729. It lay next to the estate of his brother, the Duke of Newcastle, at Claremont, and contained the ruined remains of the great episcopal and royal palace of Esher which was noted in chapter 2. Nearly forty designs exist for Pelham's new estate, most in the hand of William Kent. Kent's first proposal was to build a neo-Palladian villa on a hill with the Tudor gatehouse as a folly in the gardens on the other side of the Mole. But this idea was abandoned in favour of a restoration and extension of the

265 View of Esher Place and Hampton Court in conjunction with a building resembling the Temple of Fortune at Palestrina, by William Kent with verses from Michael Drayton's *Poly-Olbion*, c.1730–31.

Tudor gatehouse. The precise chronology of the design process is unknown. The only dated drawing, of 1733, is for the porch and shows detail rather than proposals for the whole site. It is likely that Kent's first proposals were made somewhat earlier, possibly soon after the acquisition of the estate in about 1730–31, a year or so before the design work for Hampton Court in July–October 1732. Thus by the time Kent came to consider plans for the east side of Clock Court he had already produced a scheme for reconstructing Esher in a gothic style. It is likely that Pelham would have discussed his plans with Walpole, and may even have shown him the drawings. It was perhaps for these reasons that Kent's instructions to build in the gothic style were issued. Further weight is given to this theory by an illustration for a poem on the river Mole in Kent's hand that closely links the two buildings (fig. 265). It shows Hampton Court and Esher Place nestling in the river valley with a classical temple above them on a hill. Further proof that the projects coexisted in Kent's mind is one of the design proposals for Esher that shares the bastardised gothic Venetian window and other features of the Hampton Court gateway.[24]

None of Kent's drawings for his Hampton Court work survives, even though his executors handed over most of his drawings and papers to the Office of Works in 1749.[25] Yet close examination of the building has revealed that although the elevation to Clock Court was entirely rebuilt, the new range was built upon the ancient cellars of the earliest buildings on the site and engulfed Wolsey's massive spine wall with its fireplaces, flues and closets.

The most significant part of the range architecturally was the gatehouse, clearly modelled on the existing ones at Hampton Court and Esher. Originally this had a tall cupola, reminiscent of Sir Christopher Wren's Tom Tower at Christ Church, Oxford, and echoing the cupola on Anne Boleyn's Gate, itself recorded by Kent (figs 265, 266). This was removed as being unstable in around 1853, much diminishing the original design. The gateway also included as decoration a reuse of four of the Maiano medallions, themselves the subject of intense antiquarian interest.[26]

Kent, Pelham and Walpole were not alone in recognising Hampton Court as an interesting and important example of what they termed gothic architecture. A case can be made for Hampton Court occupying an important part in the upswing of interest in gothic buildings. Not far from the palace in Twickenham, in the 1720s, lived a group of important figures in the promotion of the mid-eighteenth-century gothic style. Robert Morris and Batty Langley, both architectural theorists and proponents of gothic, were two of the most important of these. Neither seems to have published examples of Tudor architecture from Hampton Court, although Batty Langley published plans and elevations of Windsor Castle in 1743 and the following year asked permission of the Lord Chamberlain to measure and make a plan and prospect of Hampton Court.[27] In fact it was one of Kent's designs that was to become the first important published record of the Tudor palace. John Vardy engraved William Kent's imaginary reconstruction of the Great Hall in 1749 (at the time it was filled with the theatre).[28] This view, together with Kent's elevations for Esher

266 Drawing by an anonymous hand showing the east side of Clock Court, with William Kent's range for George II as originally completed.

Place and other of his gothic works, had the distinction of being, together with Langley's work, the earliest appearances in print of the new gothic (fig. 267).

Work on the duke's new apartments was completed early in 1734. Both externally and internally the Cumberland Suite has long been characterised as a precocious exercise in gothic revivalism. Externally its vaults and Venetian window, and internally its Jacobethan ceiling with pendants, are seen as precursors to the later gothic revival. Kent's work was designed sixteen years before Lady Oxford's interiors at Welbeck Abbey and Horace Walpole's gothicising of Strawberry Hill and, in reality, form a distinct chapter in the history of the gothic style. We have seen that since Elizabethan times the Tudor palace had been treated with respect and admiration. Under George I the turrets of the Great Hall were finished 'according to a design' approved by the Board of the Office of Works.[29] The Office was in effect the guardian of the gothic style, having in its care the most important secular gothic structures in England. Wren, and after him Hawksmoor and Dickinson, frequently designed and executed both minor and major works of repair to gothic structures, both in their private practices and for the Office. The clerks of works too, such as John Ball and Thomas Fort, were very familiar with gothic mouldings, four-centred arches and Tudor roof construction. Jelfe, the mason for the Cumberland Suite, was clearly adept at making gothic mouldings from Portland stone, although he charged 18d a foot for doing them 'the gothick way'.[30] Kent's work at Hampton Court was placed firmly within this tradition. While the duke's outer chamber has a Jacobethan feel (fig. 268), the bedchamber and withdrawing room within are robustly Palladian (fig. 269). The Cumberland Suite was a practical solution to the problem of preserving a harmonious Tudor appearance in Clock Court.

The Queen's Stair

George and Caroline visited the palace again between July and October 1733. Their stay was identical in format to the previous trips. During the visit Frederick, Prince of Wales commissioned a remarkable portrait of himself and his sisters from Philippe Mercier who had become Painter, Page of the Bedchamber and Librarian to the Prince in 1728–9 (fig. 259). The painting is as important as it is mysterious. It is the only depiction surviving of the royal family in an identifiable part of Hampton Court, and is thus a unique record. The twenty-six-year-old prince is seen playing the cello with his sisters, Anne, Caroline and Amelia, in the Banqueting House. The mirrors and painting on the wall are identifiable, as is the view of the Tudor palace from the window. Yet the commission is surprising since not only did the prince not get on with his sisters, but he also had significant differences over musical theory of the day. The painting thus captures both the domesticity of the life of the royal children at Hampton Court and the prince's desire to record his family for posterity.[31]

During the summer some minor redecoration was undertaken, mainly for the Prince of Wales, but the main outcome of the stay

from an historical point of view was the decision to redecorate the Queen's Stair. Work had barely begun on the stair at Mary II's death in 1694, and it had to wait until 1697 for it to be battened out and panelled with a timber box cornice against a plaster ceiling. Robert Streeter painted the panelling with 'Japan Varnish' from top to bottom. This was a very high gloss varnish that gave the paint below the appearance of being lacquered. Unfortunately, it is not clear whether the varnish on the Queen's Stair was black or white. The scaffolding was only finally removed in February 1701 when Jean Tijou installed the ironwork balustrade. The entrance was then paved with Swedish limestone and the landing with marble hexagons. The finishing touch was seven great door-cases, four with semicircular pediments at the stair top and two with triangular pediments down below. The upper landing was given special consideration with rich carving in the pediments: above the door to the Communication Gallery was the royal crown surrounded by laurel leaves and palms; opposite, above the door to the chapel gallery a dove (with leaves and palms); and above the Guard Chamber doors 'the Union Roses in a Garland' and the 'Nassau Lyon Billeted in an Eschallop'.[32] Unlike the other rooms on the Queen's Side, which were not even floored, the staircase formed part of William's processional route from the Communication Gallery to the theatre and chapel, and thus required a measure of splendour. Yet there is no doubt that the stairwell must have seemed very plain compared with the King's Side.

Under Queen Anne the staircase was again scaffolded but no significant work seems to have been undertaken. As part of Vanbrugh's completion of the Queen's Apartments for the Prince and Princess of Wales in 1717 William III's door-cases were dismantled and replaced with big bold cases with broken pediments to match the doors within the Guard Chamber. Vanbrugh's involvement at Hampton Court was, of course, suddenly curtailed by the arrival of William Benson as Surveyor, and it is likely that Benson was commissioned to devise a scheme for the completion

267 (*above*) Perspective view of the Great Hall at Hampton Court, engraved by John Vardy after a drawing by William Kent and dedicated to George II, 1749.

268 William Kent's Jacobethan ceiling in the outer chamber of the Cumberland Suite.

of the Queen's Stair. A model was made and Benson persuaded Thornhill to agree to paint a series of classical scenes with Apollo on the ceiling.[33] Benson's disgrace once again put the completion of the staircase on ice, and it was not until May 1734 that a report and estimate were obtained for its redecoration at a cost of £450.[34] The plan was to dismantle the decaying panelling and paint the stair in *chiaroscuro* on canvas. The painter was to be William Kent.[35]

Kent had, in 1718, thanks to his patron the Earl of Burlington (and some judicious undercutting), ousted Thornhill from the commission for painting the new rooms at Kensington. This launched his career as a decorative painter and won him other commissions, but Burlington's patronage was still of great importance to his success and through it Kent was appointed, in January 1728, Surveyor or Inspector of Paintings in the Royal Palaces. This led to his winning the important commission to restore the ceiling of the Banqueting House at Whitehall in January 1734. George and Caroline visited Kent on the scaffold at the Banqueting House and his employment, only four months later, to paint the Queen's Staircase must have been largely due to his success there. Kent's manner was very different from the canonical all-over decoration of Verrio and Thornhill. Perhaps fortunately, given his ability, Kent's paintings were subordinated to a compartmented architectural framework of niches, half domes and pedimented recesses, filled with classical sculptures or busts (fig. 270).[36] An insight into Kent's technique was gained in 1953 during the restoration of the murals when, behind the canvas, were found strips of pouncing paper. Kent clearly calculated the perspective effects in his studio on paper at first, pricked through the designs and transferred them to the ceiling by blowing graphite through the pin pricks (fig. 271).

Yet despite Kent's commission for painting the walls, the centrepiece of the staircase is the vast canvas by Honthorst, *The Presentation to Jupiter and Juno of the Liberal Sciences by Apollo*, painted for Charles I to hang in the Whitehall Banqueting House. It had been hanging at Somerset House and was cleaned in preparation for being hung at Hampton Court in 1733. The reason for its removal and inclusion in the Hampton Court scheme is not clear (fig. 270).[37] At the same time Kent was requested to fit-out the gallery leading to the chapel and playhouse, a key processional route that dated partly from the Tudor period and partly from 1700. Kent introduced a solid dado with a deep top moulding and skirting, and vigorous door-cases (fig. 272).[38]

George left for Hanover on 26 May 1735 and only returned in October. He was not to remain long enough to make a summer trip to Hampton Court, because on 22 May 1736 he set off for Hanover again to see his new mistress, Amelia Sophia Walmoden, and did not return until January 1737. It is thus possible that work on the Queen's Staircase was commissioned in anticipation of the queen's use of the palace in his absence. If that was the case the effort was wasted, because Caroline did not use the palace while he was away, much preferring to remain in London. But plans must have been laid well in advance for their visit in the summer of 1737, since more redecoration and refurnishing had been achieved by the time they arrived on 14 July.

Preparations for the Visit of 1737

In 1737 the Duke of Cumberland's rooms were finally fitted out. The Presence Chamber was sparsely furnished with a pier glass, table and stands, and a curtain for the window in crimson Florence taffeta. The withdrawing room next door also had festoon curtains of crimson damask, and a pier glass, table and stands, but additionally an armchair and eight square stools in walnut upholstered in crimson mohair. The bedchamber was handsomely hung with blue mohair with blue lutestring window curtains. Against this hung giltwood glass sconces. A bed was hung with 108¾ yards of rich blue mohair, with vases, cornices and a carved headboard. Previously supplied stools covered with blue mohair were probably also used. The two closets to either side of the bed alcove

269 The Cumberland Suite bedchamber showing the ceiling, bed alcove and doors to the closets in a derelict state in the 1950s.

270 The Queen's Stair, showing the great painting by Gerard van Honthorst, *The Presentation to Jupiter and Juno of the Liberal Sciences by Apollo*, and William Kent's decorative scheme.

were set up, one as a stool room, and the other, which had a window, as a dressing room. The closet facing Clock Court (the 'large light closet') was hung with blue mohair and furnished as a study with a mahogany desk and bookcase, a writing table and a round table on a central pier.[39] The rooms of the princesses were improved too, probably making use of the space recently vacated by their brother. New furniture was ordered and the rooms were certainly splendid enough to be regularly visited by the king who liked to play quadrille in the evenings with them there.[40]

The King's State Apartments having been redecorated in 1731 it was now the turn of the Queen's Apartments. The changes here were more significant. The Queen's Drawing Room, never a successful interior, and now looking outdated and inappropriate, was disliked by the queen. Verrio's mural was covered with 457¼ yards of green Genoa damask stretched on wooden battens nailed to the wall. The damask was trimmed with self-coloured arras lace, braid and binding, and lined with canvas. Gold cord was stitched round the top to highlight George I's frames for the *Triumphs of Caesar*, which had been removed there from the Queen's Gallery. New green window curtains were supplied and Henry Williams made two armchairs and twenty-four stools with carved and gilt frames covered in green. The gallery, denuded of its treasures, was re-hung with a set of tapestries of the *History of Alexander* purchased by the king. The series is based on designs for the French royal tapestry workshop of Gobelins executed in the 1660s by Charles Le Brun, Louis XIV's court painter. The Hampton Court set is a high quality reweaving of the series from the leading Brussels workshop of Judocus de Vos. They were probably originally pur-

271 Pouncing paper for setting out the architecture of the Queen's Stair, used by William Kent and his studio and found behind panelling in the Queen's Stair.

chased by William, First Earl Cadogan during his embassy to the States General in July 1716, and then sold by him at auction in February 1727 when the king bought them. The gallery was refurnished with four settees and eighteen square stools with richly carved giltwood frames. It was lit by four new lustres (fig. 273).[41] The Prince of Wales's rooms were also completely redecorated. The green scheme installed only six years previously was removed and replaced with a crimson one, and new walnut furniture was delivered. The bed and the canopy are not mentioned, but since there were new crimson curtains it seems very unlikely that these remained green. The canopy was probably removed and the bed swapped with another.[42]

This extensive overhaul of some of the principal east front rooms is particularly interesting because it is very likely that William Kent had a hand as principal decorator or designer. We have seen that he was in favour of the king and queen, but the Lord Chamberlain, the Duke of Grafton, the man ultimately responsible for the palace interiors, also befriended and later employed him. Even more significant was his relationship with the Master of the Wardrobe. On the death of Ralph, First Duke of Montagu, in 1705, his son John, the Second Duke, became Master, a position he held until his death in 1749. He shared his father's interest in the arts and lived both at Montagu House in Bloomsbury and at Ditton Park, conveniently close to Hampton Court. His taste was for the avant-garde. He commissioned work in both the gothic and the Chinese style, and was an admirer of Kentisme; he had ordered furniture in a Kentian style from Burlington's protégé Henry Flitcroft.[43] It has been long accepted that Kent worked closely with the royal cabinet-makers Gumley and Moore, and Benjamin Goodison, but it seems as if he also worked at Hampton Court with Henry Williams who supplied the seat furniture for both the Duke of Cumberland's rooms and the Queen's Apartments. Williams succeeded Richard Roberts as Royal Chairmaker in 1729, and as such would have had to work closely with whoever was responsible for the design of the rooms.[44] Williams's furniture of 1737 is in a style characteristic of Kent (fig. 273).

★ ★ ★

272 Herbert Railton, *The 'Haunted' or Chapel Gallery*, 1918. A view before the gallery was opened to the public. Kent's heavy dado and door-case can be seen.

The Court's Last Visit

Relations between George and Caroline and Frederick and Augusta were no better than those between the king and queen and the Waleses in the previous reign, and Hampton Court became the setting for the most celebrated clash between father and son. The visit of 1737 was dominated by the pregnancy of the Princess of Wales. George and Caroline had been insistent that the princess's lying-in should be at Hampton Court where they could easily supervise the birth and verify the legitimacy of the child. Their son resented this parental intrusion and was determined that the lying-in should be in London, concocting elaborate plans so that Augusta frequently moved from Hampton Court to Kew and St James's, ostensibly for her health. On Sunday, 31 July, after attending chapel and then dining in public with the king and queen, the princess's contractions began and the prince ordered that she should be removed to St James's. Before the coaches arrived on the east front the princess's waters had broken and she had to be carried downstairs by her dancing master and one of the prince's equerries. Understandably she wanted to stay at Hampton Court, being about to give birth, but the prince, driven by Hanoverian contrariness, urged the coachmen to drive as quickly and quietly as possible to St James's, leaving his parents playing cards at the palace. A small girl was born to the prince and princess at about a quarter to eleven that night. By this time news of the labour was reaching Hampton Court and the king and queen, who were by now asleep, were woken by a Woman of the Bedchamber and heard with incredulity the news that the princess was giving birth at St James's. By half past two sufficient coachmen and footmen had been raised from their slumbers and the queen set off at full tilt for St James's, arriving at the princess's bedside at four o'clock. The queen, furious to find that it was all over, returned to Hampton Court where she joined her husband at six o'clock the same morning.[45]

The royal family succeeded in putting on a united public face, despite a torrent of hostility running beneath the surface. George was gracious enough to receive a delegation of the Lord Mayor and Aldermen from the City to congratulate him on the birth of his granddaughter on 4 August, and throughout the rest of that month a steady stream of congratulations arrived at Hampton Court. The great and good of England and Scotland were received, thanked for their kindness and as often as not dined. On 11 October a great gathering of the nobility, foreign ministers and other people of distinction celebrated the anniversary of the king's coronation, and only on 28 October did the royal family leave Hampton Court for the winter.[46] For many months the king and queen had known that the queen had suffered an umbilical rupture during the birth of her last child. As the royal family left Hampton Court the queen was seriously ill, and on 9 November she began to vomit, suffering agonising stomach cramps. In the two weeks that followed she was sped towards her grave by the brutality and incompetence of eighteenth-century medicine. On 20 November she died. With Caroline's death the history of Hampton Court as a principal royal residence was over. George never went there again with the whole court, nor did any of his successors. Yet it is possible that Hampton Court's days would have been numbered even if it had not been for the queen's death. George had long wanted to build himself a new palace near Richmond Lodge where he had resided since 1718. It was much closer to the hunting than Hampton Court, and would have been more modern, convenient and private. Soon after his accession he commissioned designs for a hunting lodge from the Irish architect Sir Edward Lovett Pearce. It was a substantial square building designed round a courtyard with identical suites of royal apartments. Nothing came of this project, and in 1735 George turned to William Kent to create a palace for him at Kew. In mid-September Kent presented the king and queen with a model of a full-blown Palladian palace. Royal reaction to this design is not known, but presumably a model costing the large sum of £120 would not have been constructed by the Office of Works unless George had liked paper designs shown to him previously. Both projected buildings were substantial palaces that would have been capable of taking on Hampton Court's role. Thus Caroline's death not only put a stop to visits to Hampton Court, it probably also halted the king's plans for a palace that would almost certainly have replaced Hampton Court as the favoured country seat.[47]

George II and Hampton Court after 1737

During the remainder of his reign George spent six or seven summers in England, and during that time he was frequently at Richmond Lodge and sometimes came over to Hampton Court. The Lord Steward's accounts are missing for much of the latter part of George's reign, and so it is not clear how often this took place, but a single entry survives proving that he dined at Hampton Court on 8 July 1749.[48] Despite the court's absence, ser-

273 R. Cattermole, *The Queen's Gallery*, original watercolour prepared for W. H. Pyne, *Royal Residences*, 1817–20.

vices in the Chapel Royal were maintained. Eighteen prayer books for 'the service of the chapel in the absence of the court' were delivered, and two surplices for the chaplain 'who reads prayers all the year'. The State Apartments were not so well maintained. In 1744–5 many wagonloads of furniture were taken from the palace and sent to Greenwich, Windsor, Somerset House and Kensington.[49]

There were other reasons for visiting Hampton Court. George's stable establishment numbered just over one hundred in 1755, with two Stud Grooms and four Stud Helpers based permanently at Hampton Court. The stud remained one of the attractions of the palace after Caroline's death in 1737, and in 1743 the stud buildings were repaired prior to a visit by the royal family. Again in 1755, and in response to a letter from the Duke of Dorset, Master of the Horse, the stud stables were repaired at the considerable cost of £458.[50]

During George I's reign the two easternmost Bowling Green pavilions seem to have been granted out to Crown servants, one of them being in the gift of the head gardener. Henry Wise petitioned the Treasury for the removal of a former labourer who was occupying it in 1717. In 1726 both of the eastern pavilions were granted to Christopher Tilson and his wife Mary, who lived there until Tilson's death in 1742. Tilson was Deputy Steward of the Honour and Manor of Hampton Court, and one of the four Chief Clerks to the Treasury. He was granted permission to move the front door to each of these pavilions to the centre of the three bays, the former doorways being converted to windows.[51] In 1748 Princess Amelia, George's second daughter, visited the pavilions with the Lord Chamberlain and soon after obtained permission to convert the two easternmost ones into a residence, adding a bow window to each at a cost of £320. This was a consequence of her having being appointed Keeper and Paler of Hampton Court Park, a post she relished as a huntswoman, an occupation considered disconcertingly unladylike. The pavilions were refurnished for her. One contained three bedrooms, a dressing room and a dining room, and a staircase hung with linen-lined 'Royal Chink' paper with a border. Each room had festoon curtains of the same flowered printed linen that covered the furniture. The

274 Samuel Ireland's drawing of the first bridge at Hampton Court, 1790.

floors were covered with French carpets, and the rooms provided with walnut and mahogany furniture by Benjamin Goodison. The other pavilion also had three bedrooms, a dining room and a number of rooms for servants. These rooms had furniture covered in blue and white chequered linen, with curtains to match. In 1756–7 new chintz paper and mosaic paper 'with borders completed on cloth' were hung in the 'closets tea room and staircase'.[52] The spinster princess continued to live at the pavilions until 1761, when she moved to Gunnersbury Park.[53]

A new role that the palace began to take on in the second half of George I's reign was that of a regular tourist attraction. In 1742 George Bickham wrote the first guide to Hampton Court, being book II of *Deliciae Britannicae; or, the Curiosities of Hampton-Court and Windsor-Castle*. Bickham's book was intended 'to set the *best* Pieces of the *best* Painters in the fairest and most advantageous Point of Light', describing the paintings and furniture in each of the State Rooms with historical notes and observations. Bickham's guide took visitors on a route that was used continuously until 1992. They entered by the King's Staircase and proceeded through the King's Side, then backwards through the Queen's before doubling back along the private apartments into the Cartoon Gallery. From there visitors walked through the Communication Gallery to the Queen's Staircase. The Queen's Guard Chamber, Presence Chamber and chapel gallery only finally opened in the 1950s. The book is a guidebook in the modern sense – Bickham even marked the important paintings with an asterisk as deserving 'the spectators particular attention'.[54] Indeed the most striking thing about the guide is the way it shows what a high reputation Hampton Court already had for its painting collections. George, in the tradition of Queen Anne, gave permission for the most famous paintings to be copied. One Mr Nappen was allowed to copy the portrait of *Henry, Prince of Wales*, and one of the Rousseau overdoors in June 1723, and John Faber was authorised to engrave the Kneller beauties, the series being published in 1725. Copies were made of the admirals by Robert Hunt. The Raphael cartoons, however, remained the most popular and famous works of art. In 1717 Baron Kilmansegge commissioned a copy of the cartoons in watercolour for 220 guineas, and in February 1729 Thornhill was hard at work making copies in oil.[55]

The Palace Environs

Finally it remains to consider three changes to the environs of the palace. In May 1731 the majors of the regiments of Foot Guards quartered in the barracks complained that the Field Officers had no lodging. Responsibility for the barracks had been transferred to the Master General of the Ordnance in 1718 and the majors claimed that the Board of Ordnance refused to pay for any works. George cut through the red tape and ordered the Office of Works to make the necessary repairs, but before they could begin the Board of Ordnance ordered a complete refurbishment of the block.[56]

More significant was the construction of a bridge over the Thames at Hampton Court. Since the early sixteenth century, ferries had shuttled workmen and courtiers across from the Surrey side of the river. The operation of this service had been in the gift of the Crown and a series of lessees had made their fortunes servicing the palace. In 1750 James Clarke, the then lessee, assembled a petition and obtained an Act of Parliament authorising him

to build a bridge to replace the ferry service. The bridge, designed by Samuel Stevens and Benjamin Ludgator, opened in December 1753 (fig. 274). In earlier times the court and the royal family would have used a bridge at Hampton Court, but in the absence of the royal family the first bridge was patronised mainly by the local inhabitants of Middlesex and Surrey. It was of flimsy construction, and only twenty-five years later was replaced by another, more substantial bridge, constructed by Fuller White of Weybridge. This remained in use until 1864.[57]

Further afield, in Kingston, there were changes afoot too. The fresh supply of water that the Coombe conduits had efficiently delivered to Hampton Court for 200 years was becoming intermittent. In August 1742 an inquiry was set up into the ownership and past history of the conduits in order to effect changes to the system. Fort was asked to undertake a full survey of the water supply to the palace and made 'a correct plan of the whole course of the side pipes together with a plan of all the drains and sewers'. The survey (fig. 275) shows that the system was much as it had been since Tudor times, and the Office of Works undertook a major overhaul to increase its efficiency.[58]

George II was the last monarch to reside at Hampton Court. From his time on the bureaucrats and architects of the Office of Works became more important than the reigning sovereign. As a consequence, the chronology of this study – so far divided by monarch and dynasty – ceases. The palace's history from 1760 is presented as a series of themes, the first of which is antiquarianism and architecture.

275 Thomas Fort's survey of the Coombe conduit system, 1742. The conduit heads and tampkins on Kingston Hill (top) can be seen clearly. The lead pipe entered an iron section beneath the Thames before running across Home Park. The palace is located at the bottom of the drawing.

Chapter 15

ANTIQUARIANS AND ARCHITECTURE: THE PALACE BUILDINGS 1760–1914

News of George II's death at his stool in October 1760 reached his grandson Prince George while he was riding at Kew. His accession was popular: he was young, he was English and importantly he was not his grandfather. Such popularity had not surrounded the accession of an English monarch since that of Charles II a century earlier. His accession was, as expected, the signal for a major political reshuffle. This affected the Office of Works (at its upper echelons) as much as any other Government department. Under the tutelage of Lord Bute, his principal adviser, the king made three new appointments in the Office. The Surveyor General was to be the veteran architect Henry Flitcroft and a new post of Architect of Our Works was to be occupied jointly by Robert Adam and Sir William Chambers. Adam never took up his position with energy, but Chambers did, becoming surveyor in 1782 on Flitcroft's death. At Hampton Court the Clerkship of the Works went to William Rice on the promotion of Stephen Wright in 1758. Rice remained in post until his death in 1789 when Thomas Tildesley (d.1808) succeeded him.

Because few of George III's architectural works remain he is rarely associated with the promotion of royal domestic architecture, yet he was responsible for several plans for new or enlarged royal residences and substantial building projects at Buckingham House, Kew and Windsor. Hampton Court never featured high on his list of priorities. After his father's sudden death the young Prince George had been sent to live under his grandfather's eye and this meant spending his summers at Hampton Court. One of George III's contemporary biographers was told by an acquaintance that the Duke of Sussex (one of George's sons), while wandering through the palace, mused upon 'which of these rooms it was that George the second struck my father. The blow so disgusted him that he could never afterwards be induced to think of it as a residence.' Whether it was unpleasant memories alone that induced George to abandon Hampton Court as a residence is doubtful but when, in 1770, there was a fire in the outbuildings George remarked to Lord Hertford (who told him of the calamity) 'that he shou'd not have been sorry if it had burnt down'.[1] Despite this remark (which was partly Hanoverian contrariness) George did not ignore Hampton Court, occasionally visiting the palace.

A number of times in 1768 the king and queen called on Lady Lichfield at the Stud Lodge there and the State Apartments were sometimes used for audiences. In 1794 the Royal Water Closet next to the King's Closet was modernised to make these visits more comfortable. George also took an active interest in the Office of Works and when, in 1789, the clerkships of Hampton Court and Windsor fell vacant correspondence reveals his active knowledge and concern.[2]

Yet it was clear to the Office of Works, which had, by Burke's Economical Reform Act of 1782, been made subservient to the Lord Chamberlain, that Hampton Court was not going to be a priority. In 1783 proposals were drawn up for the reduction of the size of the estate by selling off properties that would not be needed in the future – especially those on the Green including those of the gardeners and the Housekeeper's house.[3] George III clearly studied these proposals, for at least one house he wanted reserved for possible future use. As will become clear George also began to use the State Apartments as a quarry for pictures and furniture for other palaces.[4]

Maintenance and Restoration to 1800

Throughout the 1760s and 1770s the Board of the Office of Works regularly met at Hampton Court and made tours of inspection of the fabric and gardens. During George III's reign £1,000–£2,000 a year was spent on general maintenance. It was possibly George's love of paintings that resulted in the restoration of Verrio's mural on the King's Stair in 1781. This restoration and another of 1792 (undertaken by a painter called Thomas Ellis) resulted in a considerable amount of overpainting, particularly of the grisailles. The Georgian attention was not enough and further problems meant that significant restorations were undertaken in 1836 and 1864. The latter resulted in a considerable repainting of the east wall.[5] In August 1769, during one of the Board's routine inspections, the Great Gatehouse was found to be in danger of immediate collapse. Constructed on the edge of a moat and of such a great height it had given trouble to successive surveyors since it was built. In 1625, only a hundred years after its comple-

276 The Great Hall, looking west and showing Edward Jesse's scheme in its heyday, *c*.1890. The parapet of the screen contained painted panels depicting the wives of Henry VIII.

tion, it was shored up and repaired. In 1666–7 part of it had been dismantled and rebuilt using old bricks, then in 1680 one side was taken down again, new stone was cut into the archway and new gates provided. In 1685 the southern tower needed underpinning and in 1720 the northern one required the same treatment.[6] It was the south tower that was problematic again in 1769, and Chambers ordered that it be dismantled immediately and proposed that the rest of that side of the gatehouse be taken down and rebuilt at a cost of £1,986. But work still had not started by late May 1770 and it was only the following month when the Treasury gave approval to the rebuilding. On 27 July it was reported that the design was to be altered so as to make it cheaper and a new design signed by William Chambers, William Oram (Master Carpenter), Robert Taylor and Robert Adam was shown to the king and approved. The saving was very straightforward. The Office proposed not to build back the top two storeys and redesign the top part of the gatehouse. The upper part of Wolsey's gatehouse had always been a little unusual; like that at Lambeth it had higher sides with a low centre seemingly originally enlivened by tall stone pinnacles (figs 16, 17). Chambers did not build back the higher northern and southern towers, removing their cupolas and truncated the four pinnacles.[7] The central part of the gatehouse was now to be raised rather than recessed as before and it is likely that the present pierced battlement with quatrefoils and lozenges was designed at this date to crown its centre. The fretwork certainly cannot be distinguished on any depiction of the gatehouse before 1820 (for example, fig. 205). What is particularly interesting about Chambers's treatment of the gatehouse is that it precisely coincided with his commission for Lord Milton at Milton Abbey in Dorset. Chambers was clearly very uncomfortable with the gothic style but still created, at Milton, a gatehouse with canted towers, ogee types and a pierced quatrefoil parapet with small finials. The whole design is recognisably from the same family as Hampton Court (fig. 277).[8]

Chambers rode high in royal favour until the 1790s when James Wyatt replaced him as the king's favoured architect. It was thus Wyatt who succeeded Chambers at the Office of Works as Surveyor in March 1796. Wyatt, although a remarkable and talented architect, was a disaster as Surveyor. If he had the required administrative skills he was too lazy or busy to employ them. In practice the day-to-day business of the Board was delegated to the Examining Clerk, Charles Alexander Craig. At Hampton Court the clerkship passed from Tildesley to William Rice's nephew Thomas, who had previously worked at Richmond and Kew. On his death in 1810 the post at last passed to a man of ability, Thomas Hardwick, a talented pupil of Chambers. In practice the role of the Clerk of Works was changing: no longer did he have responsibility for the supervision of work – that was left to the Labourer in Trust, although in 1815 the drunken and illiterate William Miles Stone was found by Hardwick to be 'by no means efficient to execute the duties of his office'. During Wyatt's surveyorship Hardwick was, in effect, the architect for Hampton Court.[9]

Wyatt, through his work for William Beckford, had acquired the reputation of being England's greatest authority on the gothic style. The king, who was a tolerable draughtsman and pupil of Sir William Chambers, did not favour the gothic at the start of his reign but in the late 1780s Windsor Castle, which had been more or less abandoned since the time of Queen Anne, caught his imagination. Inspired by the medieval fabric, he paid for the restora-

277 Sir William Chambers, the entrance (north) front of Milton Abbey, Milton Abbas, Dorset 1771–4. Was Hampton Court the inspiration for this?

tion of St George's chapel and the erection of Emlyn's Coade Stone screen there and the construction of the barrack-like Queen's Lodge in the castellated style. Later he was also to gothicise Hugh May's state apartments at a cost of £150,000. Another important commission in the gothic mode was the construction of the new so-called castellated palace at Kew at a cost of £500,000. These projects, somewhat to the king's surprise, set him up as the greatest patron of the gothic style in the country – in 1804 he 'thought it impossible 30 years ago that he should ever encourage gothic architecture'.[10] It is less surprising therefore that George and Wyatt turned to the most important gothic interior at Hampton Court in 1800. The insertion of the theatre into the Great Hall by William III and George I had completely obscured the proportions and character of the Tudor hall and for fifty years architects and antiquarians had attempted to visualise the room without its encumbrances (fig. 267). Wyatt, on the king's orders, removed the entire theatre fitting. William's workmen had caused significant damage to the windows, corbels and the stone mouldings to the doors and bay window. John Vidler, the mason, repaired the mouldings with the assistance of the stuccoist Francis Bernasconi. The old wall plaster was hacked off and the walls replastered 'jointed in imitation of ancient stonework' and the roof was repaired and new mouldings and panels were added. Bernasconi cleaned the corbels and the 'springing of groins' and a five-inch cresting of crenellations was added to each corbel. Most importantly a new doorway was cut through from the Great Watching Chamber to the east end of the hall carefully crafted in the best gothic style at a cost of £59 10s 1½d (fig. 286).[11]

Bernasconi was the son of the Italian stuccoist Bernato who had been responsible for the great plastered ceilings at Claydon Park in Buckinghamshire. Francis was to become the principal stuccoist working in the gothic style of the Regency period and one of the largest contractors working for the Office of Works. His work was to include some of the most fantastical gothic interiors at Carlton House and Windsor Castle. Hampton Court, though, was one of his first works and almost certainly his first commission for the Office of Works. It was undertaken concurrently with that at Cobham Hall in Kent, where Wyatt had designed a series of gothic structures and interiors for the Fourth Earl of Darnley. At Cobham a door-case at the top of the stairs and the screen in the chapel are both highly reminiscent of the Hampton Court work. At Hampton Court, the new door in the Great Hall was a copy of the one to the Horn Room and was derided in the *Gentleman's Magazine* in 1812 as a 'ridiculous and wasteful doing away the character of the high pace [sic], an undertaking of no use or benefit.[12]

278 Philip Hardwick, the new hall at Lincoln's Inn Fields, 1843, one of the most direct quotations from the Hampton Court hall.

The Rise in Interest in Tudor Architecture 1800–1840

Wyatt's restoration of the Great Hall was undertaken against a background of increasing interest in the Tudor monuments of England. Between 1800 and 1840 a number of architects came to Hampton Court to draw the Tudor buildings and in particular the recently exposed ceiling of the Great Hall. One of the first was Thomas Hardwick's youngest son Philip, whose knowledge of the Hampton Court hall formed the inspiration for his great hall at Lincoln's Inn twenty years later (figs 51, 52, 278). About the same time came the first published measured survey: A. C. Pugin's *Specimens of Gothic Architecture* of 1821–3 with descriptions by

279 A. C. Pugin, longitudinal section of the Great Hall roof with details of badges, hammerbeam terminations and corbels, from *Specimens of Gothic Architecture*, 1821–3.

289

280 Charles Digman Wingfield, *An Historical Romance in the Cartoon Gallery, Hampton Court*, c.1849.

the architect and antiquarian E. J. Willson. Pugin's and Willson's book was designed for practical application not merely antiquarian interest and incorporated a pioneer glossary of medieval technical terms. Their accurate and clear drawings were designed to correct gothic revival work of earlier times that had been 'miserably deficient in fidelity of details'. Although Willson considered Hampton Court to be in 'degenerate taste', it was none the less 'highly interesting to the architect as examples of a very late use of the gothic style' (fig. 279).[13] Another architect who came to Hampton Court in the early 1830s was Anthony Salvin who drew mainly the Tudor palace but also sketched ironwork details from the eighteenth century.[14]

The first book devoted to Tudor architecture was T. H. Clarke's *The Domestic Architecture of the Reigns of Queen Elizabeth and James I* (1833). It was introduced by noting 'That a taste for the old English style of Architecture is now rapidly reviving, is manifest from the spirited manner in which it has been advocated, and from the preservation and restoration of the few specimens still remaining.' Yet Hampton Court was not amongst his examples. Indeed the palace did not feature in any of the early books on Tudor architecture. This was largely because it fell between the military and defensive architecture of the Middle Ages and the exuberance of the Elizabethan prodigy houses. The Reverend James Dallaway in his *Observations on English Architecture* was in many ways typical in acknowledging Hampton Court as one of the important buildings of the early Tudor period together with Thornbury Castle, Richmond and Nonsuch, but thought 'The effect of brick is gloomy, although partially intermixed with stone; and so overpowering is that gloom, that no correctness of architectural form or distribution of parts can counteract it.'[15] Those who admired the building in the first half of the nineteenth century did so largely because of its historic associations. Very influential amongst these was Joseph Nash's three volumes of *The Mansions of England in Olden Times* which came out over a decade from 1839. Nash peopled his views with characters in period costume and included two views of Hampton Court. Later in the century Charles Digman Wingfield (d.1872) painted a series of at least eight Romantic views of Hampton Court peopled with seventeenth-century figures (figs 280, 281).[16] It was this Romantic perception that also attracted the antiquarians. Horace Walpole, a neighbour to Hampton Court, was a frequent visitor and took notes and made sketches. Amongst his Strawberry Hill collection there was a preponderance of items relating to the Henrician and Elizabethan eras including Wolsey's hat and a clock given by Henry VIII to Anne Boleyn. But the rooms at Strawberry Hill were inspired by Windsor rather than Hampton Court, which was still regarded as being a late debased gothic.[17]

In addition to these Romantic reactions to Hampton Court there was also a growth in serious scholarship. Following on from George Bickham's 1742 guidebook a number of itineraries and topographical descriptions appeared including a descriptive poem in three cantos of 1778. Although these are important in revealing attitudes to Wren's building (see below), they made no contribution to furthering an historical understanding of the palace.[18] But the years 1790 to 1830 saw a rash of well-written and competently researched books and chapters on the palace. By far the best and most influential of these was by the topographer Daniel Lysons, whose *Middlesex Parishes* was published in 1800 as an addition to his popular volumes *The Environs of London* of 1792–6. This was the first true history of Hampton Court Palace and became a quarry for most writers on the palace for a century. Indeed, despite the occasional correction or addition printed in the *Gentleman's Magazine*, Lysons's errors and assumptions coloured the historiography of the palace until Ernest Law's magisterial tomes of the 1890s. Lysons's descriptions of the interiors were less detailed than Bickham's; indeed the private apartments were still occupied by the Prince of Orange and thus unavailable to him (see chapter 16). Later writers such as the novelist and topographer J. Norris Brewer and David Hughson added to Lysons's material but mainly by including a much fuller description of the contents and interior of the palace and relating recent events.[19] Perhaps the most surprising, certainly the most ambitious and surely the most valuable publication of all was W. H. Pyne's lavish three-volume *The History of the Royal Residences*. Pyne's book was a pioneering production, not only as a large-scale book with lavish colour aquatints, but as a book that recorded the interiors rather than merely the exteriors of important buildings. In his venture he was helped by a group of talented watercolourists who contributed thirteen views of Hampton Court. These are the earliest record of the Wren State Apartments and still capture something of the interior of the palace as it was in its eighteenth-century heyday (figs 187, 189, 197, 202, 237, 246, 273, 286).[20]

281 Charles Digman Wingfield, *An Historical Romance in the King's Great Bedchamber, Hampton Court*, 1849. The Windsor Beauties by Sir Peter Lely, brought from Windsor in 1835, hang on the east wall.

Maintenance and Restoration 1813–1830

James Wyatt was killed in a coaching accident on the Marlborough Downs in September 1813. The latter part of his reign as Surveyor had been dominated by persistent inquiries into the financial state of the Office and his death opened the way for comprehensive reform. As a result the Office of Works was removed from the authority of the Lord Chamberlain and handed over to a superintendent responsible for administration and three attached architects. This triumvirate would direct the clerks responsible for the groups of royal palaces and Crown buildings. The three architects were John Nash, John Soane and Robert Smirke, and the Prince Regent chose the head of the Royal Household at Windsor, Benjamin Stephenson, as Surveyor General. Each architect was given a group of buildings to oversee and Hampton Court, Home and Bushy Park fell to John Soane. Hardwick theoretically assisted Soane in his duties at Hampton Court, although he was largely an absentee rarely occupying his official house at Hampton Court, being heavily engaged in private practice. On his death William Lewis Wyatt succeeded him. George Slade, another corrupt and ineffective labourer in trust, assisted them – he was dismissed in 1833.[21]

Soane has been described as an 'early architectural conservationist' and his careful stewardship of Hampton Court certainly bears this out. He instituted a series of regular condition surveys and a programme of conservative repairs. However, his proposals also included some subtle suggestions for restoration, including the demolition of the eighteenth-century Round Game Larder in Round Kitchen Court and the embellishment of the stairs up to the Great Hall from Anne Boleyn's Gatehouse with a timber ceiling.[22] His most important repair work was in the Great Hall, only recently recorded by Pyne (fig. 286). While the hall was scaffolded both Hardwick and A. C. Pugin made detailed measured drawings (figs 51, 52, 279). The screen too was carefully recorded and restored.[23]

George IV: The Stud and Tennis Court

George IV's interest in Hampton Court centred round its stud and tennis court. As Prince of Wales, he had visited the stud and in 1812 established a new one for grey thoroughbreds. On his accession the horses were sold and the stud was handed over to the Duke of York who used it for breeding racehorses from the 1822 Derby winner, Moses. These horses were also sold on the duke's death in 1827, whereupon George once again took control and expanded the stud and its paddocks to house 33 brood mares in 43 walled paddocks: 17 in Home Park and 26 in Bushy (fig. 283). After his death William IV was to maintain the stud as a commercial venture, selling yearlings annually at the auctioneer Tattersalls on the Monday of Epsom week but in 1837 the entire stock was sold and the twelve staff laid off. Only a few privately owned horses remained. In 1851 the stud was revived on the advice of the Prince Consort. Albert, a great lover of country sports, had been appointed Ranger of Windsor Great Park in 1840, a post that he took up with gusto. He loved to hunt and ride and the following year established a pack of beagles at Windsor and a riding school to the south-west of the castle. The development of the stud at Hampton Court ten years later was made possible by the death of Queen Adelaide who had continued to occupy Bushy House as her dower-house. It now became possible to acquire the paddocks that adjoined the house and redevelop the stud. The racing stud was eventually sold in 1894 and a small number of carriage horses retained for ceremonial use.[24]

The Prince Regent's interest in the stud led to an interest in the Stud House in Home Park (figs 282, 347). Initially George wished to use it to house General Blomfield, his secretary, First Equerry and Clerk Marshall (and therefore Comptroller of the Stud) and repairs were undertaken under Hardwick's supervision for the purpose. However, soon the prince became interested in

282 The Stud House after John Nash's alterations.

the house himself and in early 1818 Nash prepared plans for its conversion for royal use. The cost was to be £2,350, but further expansion was requested to avoid the prince's footmen sleeping in tents. A second phase of alterations was begun in 1820–21 costing nearly £3,000. The idea of using the Stud House as a royal residence was never very practical and Nash tried to dissuade the prince from it, arguing that the park would not afford him any privacy. Unlike the Royal Lodge at Windsor completed a few years earlier, the Stud House, Nash felt, was too easily accessible to the public. In the end George never took up residence there and the house later reverted to its historical use as a residence for the Master of the Horse. It was occupied after 1853 by the Lord Chamberlain, Lord Breadalbane and in 1865 by the Crown equerry, Sir George Ashley Maude.[25]

Despite George's interest in the stud and Stud House, the palace itself never claimed his attention, with one exception – the Tennis Court. After George I's abortive attempt to use the court as a billiard or ball room it probably remained abandoned until the late 1780s when the Duke of Gloucester (for whom see below) and the Duke of York had it fitted up for their use.[26] Their use of the court, however, seems to have been brief, for the Keeper of the Royal Courts, Mr Maynell (appointed 1791), complained to the Treasury that his income had collapsed due to lack of patronage. He had expected £200 a year, but the Whitehall court was in disrepair and Hampton Court yielded only £35.[27] In 1818, thanks to the interest of the Prince Regent, the Tennis Court was

given a major overhaul by Thomas Hardwick that included retiling the roof, repairing the cornices, repaving and repainting the interior as well as making new nets. The Master of the Court's Lodging was also repaired. It seems as if George occasionally played tennis there and thanks to his interest a committee was set up to oversee the 'Royal Tennis Club' at Hampton Court. From that time onwards the committee paid for improvements to the court, while the Office of Works covered structural repairs. Members were recruited from the surrounding towns and paid 16d towards running costs and the Marker's salary.[28]

For most of the nineteenth century Major the Rt. Hon. William Beresford was the Master of the Court. Appointed in 1816 at the age of eighteen, he held the post until his death and its abolition by the Treasury in 1883. Major Beresford was responsible for a number of improvements including the construction of the present changing rooms in 1848 (fig. 284). He had the privilege of welcoming Prince Albert, the Prince Consort, to the court when he was a regular player in the mid-1850s. He also had the west upper lights glazed in 1843 and then the east ones in 1883–4. After Beresford's death a marker was appointed by the club to be the permanent officer. Minor improvements were effected by the markers, such as the addition of a bath in the changing room.[29] Before the First World War the club's future was far from secure. Tennis had been played only intermittently during the late nineteenth and early twentieth century and the club's finances were precarious.

* * *

283 (*above*) Bushy Park Estate in 1823. The plan was drawn with a key showing the quantity of mowable pasture, the lengths of fences and the total land area. It calculates Bushy Park at just over 1,086 acres. No. 1 is Bushy House; 32 is Upper Lodge; 36 is the Pheasantry House; the king's paddocks by the road are numbered 43 to 59. The remainder of the numbers are mainly field names.

284 Detail from one of the changing-room lockers in the Royal Tennis Club at Hampton Court, *c*.1850.

William IV and Reform

The accession of William IV saw the end of one of the greatest eras of royal building in English history, an era that had, of course, almost entirely passed Hampton Court by. However, the huge recriminations in the Office of Works that followed George IV's death were to lead, in due course, to a revival in the fortunes of Hampton Court. Stephenson's reign as Surveyor-General with his three attached architects was regarded as expensive and unaccountable. Some also questioned the quality of work delivered by the three great men. Proposals were therefore put forward for further reform which would see the amalgamation of the Office of Works with the Commission of Woods, Forests and Land Revenues under a Board of three commissioners, the chief of whom would sit in Parliament. The principal change was that architects were now to be brought in for the job in question and not be full-time employees. There was to be a Surveyor of Works and Buildings, an Itinerant Surveyor, an Assistant Surveyor, and clerks responsible for groups of buildings. The new arrangements came into force in April 1832. The accession of William IV was important for another reason too. In January 1797, while Duke of Clarence, William had been made Ranger of Bushy Park and thus came into possession of Bushy House where he moved with his mistress Dorothy Jordan and their children. William came to love the house like no other, borrowing money to embellish and improve it and the home farm nearby. After her marriage to William in 1818, Princess Adelaide formed a strong liking for the place too – as we have seen, she continued to occupy Bushy House until her death. Thus for the first time for many years there was a monarch on the throne with an affection for the palace.[30]

Edward Jesse and the Antiquarian Vision: The Great Hall and Chapel

It was William IV who, on the recommendation of Lord Dartmouth, appointed Edward Jesse as Itinerant Deputy Surveyor in the Office of Woods, Forests and Land Revenues with responsibility for the Hampton Court district in 1834. This post gave Jesse responsibility for supervising the buildings, dealing with applications for work, checking estimates and ensuring the quality of work. The reform also led to the revival of a direct labour force at the palace. From 1832 there were once more a carpenter, bricklayer, a painter and glazier, a plumber, a mason and mason's labourer and two labourers to clean the courts. Jesse became a central figure in the mid-nineteenth-century history of the palace. He was born in 1780, the second son of the Reverend William Jesse who lived near Halifax. He became private secretary to Lord Dartmouth who found him a place in the Royal Household as Gentleman of the Ewry (a lucrative post he retained until 1832). He had developed a deep love of natural history, horticulture and architecture. As well as editing Gilbert White's *Natural History of Selbourne* and Izaak Walton's *Compleat Angler*, he wrote half a dozen books on natural history, architecture and a book on the history of tennis. Soon after the amalgamation of the two departments in 1832, Jesse became Itinerant Deputy Surveyor, a post to which he was in many ways ill suited. Jesse had a delicate and nervous temperament that made him difficult to deal with and confined him to the seaside at Brighton for most of the winter. His experience of architecture was thin, but his enthusiasm for it was boundless. Jesse rapidly acquired a knowledge of the great palaces in his charge, especially Hampton Court and Windsor. In this he relied heavily on his close friend, the Reverend John Mitford who was editor of the *Gentleman's Magazine* between 1834 and 1850.[31]

Jesse's architectural views are best gleaned from his guidebook to Windsor Castle and Eton, where he reveals first a profound distaste for anything other than the gothic and second an unquestioning admiration for the work of Jeffrey Wyatville. His attitude towards both Windsor and Hampton Court was essentially Romantic, admiring the buildings for their ancient historical associations and their picturesque irregularity. Like many other enthusiasts for Hampton Court's gothic architecture of the period, his most poisonous venom was stored up for Wren's Clock Court

285 Edward Jesse's proposed new gothic screen to replace the Wren colonnade, from his *A Summer's Day at Hampton Court*, 1840.

colonnade for which he proposed a new gothic screen published in his own guidebook – *A Summer's Day at Hampton Court* – in 1840 (fig. 285).[32] These opinions informed a series of significant restorations at Hampton Court superintended by Jesse between 1838 and his retirement in 1851. In these he was aided first by William Craib as clerk and then after 1845 by Henry Riley Wilson. The work was made possible because of two factors. First, the universal free entry granted to the public in 1838 which encouraged the Office of Woods and Forests to invest in what had suddenly become a significant tourist attraction. Expenditure on restoration ran at about £7,000 a year during Jesse's reign, more than twice the average of the preceding five years. The second factor was that in 1837–8 responsibility for paying for internal fittings and furnishings at the unoccupied palaces was removed from the Lord Chamberlain's department and transferred to the Office of Works. Henceforth if the Lord Chamberlain wanted works undertaken an application would be made to the Board. This gave Jesse much greater freedom in rearranging the palace interiors.[33] The first of these to be restored by Jesse was the Great Hall.

Despite Wyatt's restoration of the Great Hall in 1800 visitors did not see it on public tours of the palace provided by the resident housekeeper (fig. 286). In 1835 one observer referred to this as like a performance of *Hamlet* without the prince. An apt description, since by the 1830s not only was the hall well known amongst antiquarians and connoisseurs but there was a strong romantic attach-

ment to the idea of the Great Hall as the social and moral heart of a great house. The hall conjured visions of ancient English hospitality, of the feudal duties owed to their tenants by the great lords. The halls at houses such as Haddon Hall, Cotehele, Penshurst or Knole were seen as amongst the most important and powerful historic interiors for their ability to evoke the spirit of old England. It was for this reason that when, in 1838, Queen Victoria decided to throw open the palace to the public there was a pressing need to include the hall in the list of rooms seen. Jesse therefore drew up a scheme that was, in his view, to restore the hall to its former glory. In doing so archaeological considerations did not loom large and Mitford was called upon to provide the inspiration. His aim was stated to be 'to evoke some of the atmosphere of the time of the builder of the palace, King Henry VIII'.[34]

Jesse's transformation of the Great Hall was effected between July 1840 and 1846. When completed Jesse believed that the hall had 'an appearance similar, perhaps, to that it formerly presented when it was occupied by the Cardinal of York'. At first he was authorised to introduce massive plaster corbels for supporting armour and other weapons but permission was denied for re-hanging the hall with tapestry. In order to persuade the Board to change its mind, Jesse enlisted the help of the genealogical expert and stained-glass designer Thomas Willement, A. W. N. Pugin (A. C. Pugin's son and expert on gothic architecture) and William John Bankes of Kingston Lacy, a traveller, scholar and a great arbiter of taste. Tapestry had remained in the Great Watching Chamber throughout the eighteenth century and was noted there by John Carter in 1812 and by Pugin and Willson ten years later.[35] The Great Hall, however, since its restoration by Wyatt, had been very empty. The principal objection to re-hanging was the impact the removal of the *Abraham* tapestries would have on the William III State Apartments. However, as described below, the State Rooms were rapidly filling up with pictures and the tapestries were being jeopardised by picture fixings being driven through them. Thus Jesse with the backing of Bankes and others was to succeed in his request and for the first time since the sixteenth century the *Abraham* tapestries returned to the Great Hall in 1841.

The tapestries necessitated the insertion of a fine neo-Tudor cornice from which to hang them and permission was also given for the manufacture of silk banners at a cost of no more than £60. This first phase of work overstepped the authorised budget and when in 1844 Jesse made a further request to repair the roof and paint the hammerbeam ceiling he was summoned before the Board to explain his intentions. Jesse had time on his side because he had already erected scaffolding in the hall and argued that to dismantle it would cost more than to finish his restoration. Permission was thus given for some limited painting and for a careful drawn record of the ceiling in case it was ever burnt down; the Board also requested an investigation into the existence of the former louvre. Jesse's painting of the ceiling followed his re-reading of the original building accounts and involved covering the blue painted panels with varnished oak graining and the highlighting of the heraldic badges in paint and gold leaf (figs 52, 279, 286). In April 1845 Jesse proposed that the dais and bay window be laid with encaustic tiles, a request that was refused. Three months later a far more expensive improvement was requested, the glazing of the windows of both the hall and the Great Watching Chamber with stained glass to the designs of Thomas Willement (fig. 288). Willement set out the descent of each of Henry VIII's

286 W. J. Bennett after Charles Wild, 'Gothic Hall, Hampton Court', from W. H. Pyne, *Royal Residences*, 1817–20. This view shows the Great Hall immediately after it had been cleared by Wyatt. Prominent at the east end is the new stucco door.

six wives in alternate windows on the north and south sides with the seven intermediate windows containing the king's heraldic badges. The west window was dedicated to Henry and his wives and the east to Henry's own lineage; the bay window was devoted to Wolsey. The glass in the Watching Chamber presented a more balanced historical picture, Wolsey and the king sharing the same heraldic panorama.[36]

Jesse's Great Hall (figs 276, 287) is one of the great Romantic interiors of the mid-nineteenth century. It drew on all the components then considered essential for a truly ancient hall: arms and armour, banners, tapestry, ancient woodwork, heads of antlers and stained glass. Armour had of course decorated medieval halls, ready for use, but had never previously been hung at Hampton Court. Some of Jesse's armour was newly made, together with the large metal dragon for St George to slay – the Tower of London loaned the rest. The display was designed and arranged by the virtuoso armourer and decorator William Stacey, who was responsible for the extraordinary sculptures of weaponry in the White Tower at the Tower of London from the 1820s.[37] The first major country house hall to be re-hung in this manner was at Cotehele in Cornwall in 1812 following on from both Walter Scott at Abbotsford and Horace Walpole at Strawberry Hill. These led to a fad for medievalising great halls including those at Battle Abbey (Sussex) and Audley End (Essex). But it is almost certain that the immediate inspiration for Jesse's work was Wyatville's St George's

287 East end of the Great Hall from *The Thames Illustrated*, 1897.

mission was granted to redecorate the Tudor vault. Pyne's view of the chapel published in 1819 shows that whilst the ribs of the ceiling and the pendants were painted and gilded, the vaults themselves were painted in white lead, as a result of Thomas Highmore's redecoration for Queen Anne in 1711. Jesse wished to repaint and gild the ceiling in its former rich colours. This aim was jeopardised by the extensive structural repairs that were found to be necessary and it was suggested that perhaps the gilding of the angels in the pendants be omitted to save money. Jesse appealed, and the architect Edward Blore was twice consulted for his advice and trial sections of the ceiling were painted. The Board, still uncertain of what to do, consulted A. W. N. Pugin. Ultimately it was his advice that was taken and Pugin's scheme created the ceiling seen today (figs 67, 289). The grounds of the ceiling panels were to be painted blue and spangled with gold stars while ten of the panels were to be enriched with 'scrolls and relief, and antient writing' at a cost of £831.[41] While the chapel was

288 Thomas Willement's design for a stained-glass window for the south wall of the Great Hall, showing the descent of Queen Jane Seymour, 1845.

Hall at Windsor of 1829–30. Jesse was superintendent at Windsor and the corbels supporting suits of armour and arrangement of pikes are strikingly similar to that at Hampton Court. Stained glass too was seen as an essential indicator of antiquity in Tudor and medieval buildings, and Willement's ambitious scheme was much admired in contemporary guidebooks. His iconography was treated with as much respect as the truly ancient scenes on the tapestries below (fig. 288). As we have seen, Jesse already had an association with Willement whom he probably met at Windsor during the installation of the new glass for St George's chapel. This work gave Willement the title 'stained glass artist to Queen Victoria'. He had begun his career executing heraldic glass and wrote a book in 1821 entitled *Royal Heraldry*, and by the 1840s he was at the peak of his career. Remarkably, he owned the complete set of original vidimuses for Erhard Schön's scheme for Wolsey's chapel, although he didn't know that they were for Hampton Court.[38] He had also been involved in a number of Romanticising schemes including glass for the new Horse Armoury at the Tower of London.[39]

In an effusive and biased review of the newly completed room in 1847 the *Gentleman's Magazine* described it as 'probably the finest and most brilliantly embellished building in Europe'. The Watching Chamber next door was no less admired even though it still served as the occasional meeting place of members of the Board of the Green Cloth. Sometime in the 1840s seven large-scale cartoons by Carlo Cignani were hung above the tapestries, filling a space that might have otherwise been another recipient of military trophies.[40]

Flushed with success, Jesse requested permission to turn his Romanticising hand to the chapel. Like work on the hall, authority to proceed with the various elements of the scheme came piecemeal from the Office of Works. First, in 1845, there was a wise insistence that external works to the roof of the chapel be completed before any work began on the ceiling, but in 1847 per-

289 (*facing page*) The Chapel Royal looking west to the royal pew showing Thornhill's mural, the windows of 1893 and the Victorian curtains to preserve the privacy of the grace and favour ladies during services, 1992.

290 Watercolour of the west front of Hampton Court by H. B. Ziegler, 1830. This view shows the palace immediately before its Victorian re-Tudorisation under the hands of Jesse and Blore. The Gatehouse retains its Charles II form with lesser gates flanking the central arch.

scaffolded, the murals over the royal pew and altar were cleaned (fig. 289). As a second phase Jesse wanted to repair the wainscot, re-lay the marble floor and most ambitiously replace the casement windows with traceried lights. This last scheme was triggered by the discovery that a single Tudor window, which could form a model for the rest, had survived behind Thornhill's wall paintings. Wainscot repairs would cost £92, the floor £925 and the windows a colossal £1,300. In the end, in view of the cost of the proposals, only work in the ante-chapel went ahead, repairing the wainscot and floor.[42]

THE ANTIQUARIAN VISION: THE PALACE EXTERIOR

Disagreement over the chapel ceiling had been Edward Blore's introduction to Hampton Court. Soon after he was the first architect to be employed there under the new arrangements of 1832 and was to be responsible for some very significant external restorations between 1841 and 1847. Blore began his career not as an architect but as an antiquarian draughtsman, recording medieval buildings first for his father then for the architects Thomas Rickman and William Atkinson, and for Sir Walter Scott himself.

Through this work he acquired a first-hand knowledge of the principles and detailing of medieval buildings. His first high-profile public commission was the rebuilding of the residential parts of Lambeth Palace for Archbishop William Howley in 1828–33. It was this task, completed at a cost of over £50,000, that won him a reputation for the gothic. Walter Scott thought the work 'in the best gothic taste' and welcomed 'the splendour of church architecture returning again'. As a result of his efficient management of the Lambeth contract he was employed, in 1832, by the Office of Works to complete Buckingham Palace after Nash's expensive failure. It was his successful deployment of gothic at Lambeth and his steady financial control at Buckingham Palace that led, ten years later, to employment at Hampton Court.[43]

Blore was the perfect choice. He was expert in the Tudor and Elizabethan styles and, as Surveyor to Westminster Abbey, highly sympathetic to the fabric of ancient monuments. As executing architect he was assisted by the Surveyor of Works and Buildings, William Southcote Inman (in post 1844–56).[44] Jesse's first commission to Blore was to restore the west front of the palace to its Tudor appearance by replacing sash windows, inserted during the eighteenth century, with stone casements, removing later doors

292 (below) Drawing by William Southcote Inman for the north elevation of the south-west wing as proposed in 1841. Compare with figure 291.

291 (above) Watercolour view by Emily Rebecca Prinsep of the south wing of the west front in 1826. Compare this with Inman's scheme (figs 292, 294).

and enlivening the parapets. He instructed Blore to start with the refenestration of the west elevation of the north-west wing. Blore carefully took profiles from a surviving original and presented drawings for a new elevation and an estimate for £535 to Jesse in July 1841.[45] This scheme was the first example at Hampton Court of a deliberate attempt to re-Tudorise the external elevations and marked a definitive rise in favour of both Hampton Court and its 'debased' Tudor architecture. The southern wing of the west front was given the same treatment in 1846 and the whole renovated for the occupation of Lady Emily Ponsonby. Seven drawings survive for this scheme, all in Inman's hand (figs 292, 294). Blore was asked by Jesse to restore and renovate 'so as to harmonise with the most ancient part of the building and having regard to those portions already renovated'.[46] In 1847 the last phase to the west front improvements was completed when Blore and Inman restored the mullions in the north-west angle of the west front at a cost of £1,499.[47]

There is no doubt that this work transformed the appearance of the palace's main entrance. The writers of guidebooks lavished praise; Charles Knight enthused that 'The whole front is fast growing harmonious and picturesque' and John Fisher Murray hoped that 'the laudable ambition of restoration may continue'.[48] Continue it did. In 1844 windows in the upper storey of the east side of Clock Court were restored 'in accord with the original style of the building' and in 1847 the roof on the north side of Base Court. In 1846 one of the most successful and romantic Tudorisations started for Sir George Seymour, Admiral of the Fleet (d.1870) in what is now known as Master Carpenter's Court. This work, over a forty-year period, transformed the kitchen courtyards from their original functional, slightly dreary appearance (figs 293, 295), into one of the most enchanting suites of Tudor views in

293 (*above*) Watercolour view by John Spyers of Master Carpenter's Court, looking east, *c*.1780. This view and that in figure 295 are the earliest depictions of the kitchen courts and show that many of the Tudor casements had been replaced in the seventeenth century when the buildings became residential.

294 Drawing for the west elevation of the south wing of the west front by William Southcote Inman, 1846.

295 (*above*) Watercolour view by John Spyers of Master Carpenter's Court, looking west, *c.*1780. Planting along the left-hand side would have provided some privacy for the grace and favour residents in the north range of Base Court.

296 Drawing for the restoration of the north elevation of Master Carpenter's Court by William Southcote Inman, 1847. Both the existing structure and his embellishments are shown.

297 John Lessels, south side of Master Carpenter's Court (Mrs Bagot's apartment), 1884. This work was undertaken in the second wave of Tudorisation in the 1880s. It was executed more or less as drawn here.

England. Of the surviving drawings, one (fig. 296) shows the eighteenth-century covered walkway and fenestration and the transforming refenestration and alterations to the gables.[49] Opposite, the façade of Mrs Bagot's apartment was redesigned. The before and after designs, again, chronicle the effect (fig. 297).

The astonishing point about the transformation of the kitchen courtyards is the sensitivity of the Victorian work. Only the harshness of the red brick spoils their otherwise utterly convincing atmosphere. Yet the survey drawings demonstrate that the Victorians made these courtyards far grander and more imposing than they originally were intended to be. A Victorian admiral of the fleet demanded a richer rendition of the Tudor style than the officers of the Pastry House could have ever hoped for in the sixteenth century.

Sadly, detailed accounts do not survive for Blore's and Inman's important work and so we know little of the craftsmen who effected the transformation of Hampton Court or of the provenance of the materials they used. Yet it is worth noting that from the late 1820s brickworks had begun to cater specifically for new Tudor revival styles, making moulded bricks and eventually whole set-piece brick features such as chimneys and windows. These ranged from successful provincial manufacturers such as the Cotessy brickworks in Norfolk (which did not, as far as we know,

supply bricks to Hampton Court) to the big national manufacturers such as Doulton (who may have done). Since there were few models to copy at Hampton Court, many of the brick chimney-shafts and moulded bases, and much of the decorative brickwork in the kitchen courts and Clock Court must have been copied from elsewhere. It is possible that some were even stock items mass produced. Most (particularly the chimneys) were based on surviving Tudor examples at Thornbury Castle, outside Bristol, and East Barsham in Norfolk.[50] Careful observation resulted in much of the pointing being black, due to soot being added to the mortar. Some Tudor pointing was black, and all the original white pointing would have been dirty by the nineteenth century. Thus the addition of soot would have helped the old blend in with the new. Similarly, new stonework seems to have been painted with boiled linseed oil instantly to age it.

Of the external restorations guided by Jesse, none attracted more scholarly attention than his work on Wolsey's terracotta plaques. In April 1840 Jesse commissioned a restoration of the roundels in Clock Court stimulated by a realisation that in his capacity as surveyor at Windsor he had seen two other roundels in Windsor Park. These had probably originally come from the Holbein Gate at Whitehall Palace and had been removed to Windsor by the Duke of Cumberland after the gate's demolition

in 1759 in anticipation of re-erection. Jesse negotiated the removal of the roundels, heads of *Tiberius* and *Nero*, and had them erected on the outside of the Great Gatehouse.[51] In 1845 Jesse then discovered that the terracotta heraldic plaque in Clock Court in fact depicted the arms of Wolsey and not those of Henry VIII and published his findings in the *Gentleman's Magazine* with a short history of the Maiano medallions. In this he repeated the apocryphal story that they had been the gift of Pope Leo X to Wolsey. In doing so he opened up a correspondence in both the *Gentleman's Magazine* and *The Athenæum* which led Sir Henry Ellis to print the original documents to clear the matter up in his third series of *Original Letters* in 1846.[52]

Restoration 1880–1911: The Gatehouses, Chapel and Moat

In 1851 the ebb and flow of reform that had affected the Office of Works since the accession of George III took its final turn. The Office of Works as it had existed for hundreds of years was finally transformed into a ministry of state directly responsible to Parliament. Its permanent staff under a First Commissioner were to be civil servants.[53] Any direct royal involvement in the day-to-day workings of Hampton Court was finally over.

Queen Victoria was a rare visitor to Hampton Court. She came in 1844 when she, the Prince Consort, the King and Queen of the French, the Belgians and the Dutch were entertained by Queen Adelaide at Bushy House and again in 1871 when she reviewed troops in Bushy Park. Edward, Prince of Wales, showed more interest. He, like George IV as Prince Regent and the Prince Consort, retained an interest in the Tennis Court. In the late 1850s he was playing tennis there two or three times a week and for him some small improvements were made. After his accession he showed an interest in restoration work at the palace and for courtesy's sake his permission was sometimes asked for some of the more major works. Yet for all intents and purposes the direct involvement of the royal family ended in 1851.

Despite reform, arrangements in the Gladstonian Office of Works between 1856 and 1874 had not worked well, a combination of inefficiency and character clashes led to a conclusion by Disraeli's administration in 1874 that 'the place was an Augean stable and must be swept out'. In this the key was to be a young and energetic diplomat, Bertram Mitford, who in his memoirs recalls 'I was to evolve kosmos out of chaos, and chaos it certainly was. I was at once opposed tooth and nail by Lord Henry Lennox backed by the solicitor to the department and the director of works.' Mitford tendered his resignation, triggering the appointment of a committee to review the operation of the Office. The resultant report vindicated Mitford's position and he was left at the helm until 1886.[54] Mitford had a personal and educated enthusiasm for Hampton Court, which he found crumbling away. He was to preside over, in Ernest Law's words,

> A gradual ridding of the palace, as opportunity served, of several unsightly excrescences which had been allowed to build up and disfigure its appearance in former days; while of equal importance were the replacing of shabbily executed modern repairs by work in harmony with the old and the renewal of all decayed ornamental features, in a style and manner adhering as closely as possible to that of the past, great care being taken, neither to destroy the smallest portion of the old work or to mar the antique aspect of the palace, by sham and unnecessary restoration.

He was also to form an efficient and effective fire service for the protection of the palace.[55]

Mitford's architect was John Lessels, who had been appointed architect to the Windsor District in 1860, gaining responsibility for the Hampton Court estate. Lessels was the son of a Scottish architect of the same name who had learnt his trade in Edinburgh and working for the Prince Consort at Windsor before being posted to care for the embassy and consular buildings in Turkey. From 1873 he worked on the restoration of the medieval fabric at Windsor and Hampton Court. On his retirement the Board wrote to him saying that he had 'an archaeological knowledge and dis-crimination and an artistic sympathy which have enabled them [the Board] to deal with questions of maintenance, of alteration, or of restoration in a manner which they believe has met with general approval'.[56] Lessels was to preside over the most important and radical works of restoration yet undertaken at Hampton Court.

The most destructive work of the late eighteenth century had been the reduction of the Great Gatehouse. Chambers's penny-pinching solution to its problems seems not to have solved its instability. In September 1837 Edward Jesse reported that once again the tower needed underpinning and that it might be best to take it down and start again. The Office of Works decided to postpone a rebuilding but ordered that the whole should be shored up instead.[57] It was at this juncture that Jesse added the two terracotta roundels he had found in Windsor Great Park. The problem seems not to have been pressing, because it was finally only in 1880 when attention again turned to the gatehouse. At that point it was decided to take in not only work to the Great Gatehouse but to restore Anne Boleyn's Gatehouse too. No financial accounts survive for this restoration and a small number of drawings, newspaper cuttings and other references are all we have for some of the most important restoration works of the late nineteenth century.[58]

A. C. Pugin made a careful Measured Drawing of the Tudor vaulting beneath the Middle Gate in 1821, suggesting that it had, in fact, been inserted by Henry VIII at the time of his reconstruction of the Great Hall – it bore the initials of Henry and Anne (fig. 298). By the 1880s its condition was such that Lessels felt it had to be replaced and the stone vault *in situ* today is a close copy of the original. While the new vault was being inserted, work went ahead to restore the astronomical clock above. By 1830 the clock had ceased to work – a fact that was lamented in a long poem by G. P. R. James.[59] In 1835 it was decided that the clock be dismantled and replaced by one made in 1799 for St James's Palace by B. L. Vulliamy. The installation of this saw the final destruction of the original movement and the replacement of the subsidiary dial in Base Court with a tablet bearing William IV's monogram. Beneath the tablet was inserted the slate clock face of the St James's clock. The St James's mechanism was never designed to power the astronomical dial and so it was removed to store and the void boarded over. The clock remained in this sad state until 1879 when, ambitiously, it was decided to build a new mechanism that could drive the original dial. The commission was given to the clock-makers and bell-founders Gillett and Bland of Croydon

who made the present movement with many 'ingenious contrivences', several of which were patented by the firm. The clock, they claimed, 'is guaranteed not to vary more than five seconds a week', if that.[60] With the clock and the vault renewed attention moved on to the stairs leading up to the Great Hall, which were merely plastered and whitewashed. The walls were lined with red brick and the ceiling given carved oak rafters. A charming blue and gold gothic handrail was added to the staircase.[61]

Work to the Great Gatehouse was more radical. There was a general awareness that the gatehouse had been truncated and its visual importance diminished in the eighteenth century, and there was a determination to restore it to its dominant position on the west front. The evidence was, however, weak. Lessels found only the stubs of some shafts and some springing stones of the original vault torn out by Chambers and from these he devised a new vault and interior (fig. 299). The western elevation of the gate gave rise to more debate and an option was prepared that would have returned the gatehouse to its original height and crowned it with lead ogee domes. Its face was to be enlivened by two needle shafts crowned by lesser stone ogee caps (fig. 300). This option was abandoned for a less expensive version without the additional

298 A. C. Pugin's survey of the fan vault beneath the so-called Anne Boleyn Gatehouse (the Middle Gate) from *Specimens of Gothic Architecture*, 1821–3.

299 (*below*) Presentation drawing by John Lessels for the elevations of the carriageway beneath the Great Gatehouse and proposal for a new fan vault, May 1881.

300 Presentation drawing by John Lessels for the west elevation of the Great Gatehouse restored to its original form, 1882. Compare this proposal to figures 16, 17 and 290.

301 Presentation drawing by John Lessels for the west elevation of the Great Gatehouse as restored in 1882.

storey but retaining the new shafts framing Chambers's reset cresting (fig. 301).

On 21 January 1882 it was reported that the vault was approaching completion. It was entirely structured of 40 tons of Bath stone from Corsham with a central boss weighing nearly a ton and a half. The ribs, Queen Victoria's arms and Wolsey's badges were carved by Ruddock and Sons and R. J. Carless of Richmond. Advice on heraldry had been provided by the College of Arms. Mitford, Lessels and a small party of antiquarians including the palace chaplain watched it being lowered into place. As it finally slotted into position, some gleaming new coins of 1882, supplied by the Royal Mint, were slipped into the joints. Another important improvement was the recovery of the original wooden gates that had probably been removed in 1771 and their reinstallation instead of Chambers's iron gates. They had been used for a hundred years as the floor of the carpenter's shop.[62]

The addition of the slender pinnacles to the west face of the tower was presumably intended to reflect the original shafts on its east face; it is unclear whether there was ever any more evidence for them. At any rate they, and the speculative vault and internal cladding, created the entrance that now introduces visitors to the palace.

These works took the standard of gothic revivalism at Hampton Court on to a new level. Kent's gothic gatehouse had been admired in the mid-eighteenth century by Horace Walpole who had damned Wren's Ionic colonnade as a 'glaring blemish, by its want of harmony with the rest of Wolsey's fabric'. But by 1821, when A. C. Pugin and Willson published their *Specimens of Gothic Architecture*, it was regarded as 'a wretched imitation in stucco . . . too contemptible to be described'. Charles Eastlake in his *History of the Gothic Revival*, published at the zenith of the revivalist movement in 1872, the very year of the completion of the Albert Memorial, followed suit. Tudor Fountain Court with its four-centred arches was a perfect example of late Perpendicular domestic architecture, quite unlike Kent's gothic that was executed 'on such a plan as to make it at once apparent that no constructive element is involved in the design'. Yet Eastlake praised the 'originality in design' that he believed was 'undertaken by some one who possessed something more than the skill of a mere copyist'.[63] Lessels, under Mitford's regime, was engaged on a programme of repair and restoration that carefully followed precedent. Whether he supervised the replacement of the beasts on the roof of the Great Hall or the royal arms over the entrance archways, Lessels insisted on the most faithful copying of the Tudor work. In Master Carpenter's Court (work already described) his improvements were carefully informed by surrounding examples. In Round Kitchen Court where he was asked to design a boiler house for the palace heating system, he invented a 'Tudor' building to house it (fig. 302).[64] The quality of this external work was to be matched by a series of internal repairs and restorations. The so-called Horn Room was opened to the public and an elegant gothic balustrade added (fig. 303).[65] Next door the ceiling of the Great Watching Chamber was given a thorough overhaul. The leather *mâché* roundels were taken down after a careful record and new roundels manufactured and erected (figs 56, 60, 304).[66] Only one restoration was an anachronism. In 1891 Base Court was 'restored', its cobbles removed and the whole laid to grass so as to resemble an Oxford college. Base Court had never before been sown and although an attempt was made to recobble the surface in 1991–2 the courtyard remains today in its Romanticised form.[67]

Arguably the most scholarly restoration of the late nineteenth century was of the chapel windows in 1891. We have seen that Jesse had argued for the replacement of the Queen Anne casements in 1845. During the winter of 1890 the chaplain complained that the great leaded casements were draughty and ugly and that they ought at least to be double-glazed but preferably replaced with new traceried windows based on the surviving original. The Office of Works undertook some preliminary investigations and

302 Presentation drawing by John Lessels showing the Tudor-style boiler house built in Round Kitchen Court in 1884.

proposed a restoration based on a surviving example of the Tudor work. On 23 October 1893 Thackery Turner, the Secretary to the Society for the Protection of Ancient Buildings, wrote to the Office of Works objecting to the proposed replacement of 'Wren's' windows in the chapel and suggesting that this and other 'ill advised works' had damaged the building in recent years. It was an important moment in the history of the palace, the first time that in the name of modern conservation questions had been asked about restoration. By the time Turner's letter was received

303 Ghostly postcard from c.1920 showing John Lessels's Tudoresque balustrade to the Horn Room staircase. It shows also on the far left some of the cages used to protect works of art.

it was too late. The masonry was cut and the finances committed (fig. 289). The SPAB were informed that the windows were not designed by Wren and that the new work was a scholarly reproduction of the old. Nevertheless, a shot had been fired across the bows of the Office of Works.[68]

The last of the great Hampton Court restorations was the excavation of the west front bridge and the re-creation of the Tudor moat, a project that finally caused a collapse in relations between the Office of Works and Ernest Law, the retired lawyer, grace and favour resident and self-appointed historian of the palace. The survival of parts of the original bridge spanning the moat at the west front of the palace had been known since 1872 when some of it had been revealed during a drainage project. But the quest proper began in the summer of 1908 by E. Chart, the Office of Works surveyor for Hampton Court. The following February a trial hole sponsored by the Office of Works and supervised by J. Fitzgerald, Inspector of Ancient Monuments, revealed a 'chamber' – in reality one of the arches of the buried bridge. Permission was obtained from Edward VII to continue the dig whereupon it was realised that much of the bridge, minus its parapet, survived beneath ground (fig. 306). This was all too much for Ernest Law who had been a close observer and sometime adviser to the Office's restoration programme. He had not been consulted or involved in the excavation and on 26 March 1909 wrote an account of the excavations in *The Times*, giving the impression that the work had been done under his instigation and supervision. This was received very badly by Lewis Harcourt, the First Commissioner of the Office of Works, Sir Schomberg McDonnell, the Secretary, and Mitford (now Lord Redesdale) who nevertheless realised that Law's skills

304 Survey of the Watching Chamber ceiling showing the battens and roundels in preparation for restoration in 1836. Many of the original roundels were removed to store at this date and plaster copies substituted.

might be useful in undertaking the work. They resolved to set up an excavation committee made up of all the interested parties including Law.[69]

Edward VII himself took a personal interest in the work of the committee and the debate over historical authenticity. Law, who was determined that the fullest possible restoration should take place, including a reinstatement of the lost height of the gatehouse, gave an extensive interview to H. Avray Tipping, which appeared in *Country Life* in March 1910 under the title 'Suggestions for the West Front of Hampton Court'. Tipping and Law employed the architect C. E. Mallows (b.1864), a protégé of John McKean Brydon and Sir Aston Webb, to visualise their dream of restoring the west front to its Tudor appearance (fig. 305). The article further enraged the Office of Works since the committee had, in fact, already approved many of the suggestions.[70]

Yet Law still provided the committee with transcripts of the original accounts for the construction of the bridge[71] and the same month it resolved to rebuild the bridge parapets and to adorn them with carved heraldic beasts as described in the building accounts. In this they were aided by a number of fragments from the originals, including the complete shield of Jane Seymour (fig. 62). The heraldic scholar, the Reverend E. E. Dorling, devised the plan for the beasts on the parapet and it was to his designs that ten beasts, alternating between those of Henry and of his queens, were chosen. The beasts weathered very badly and were replaced with the present ones in 1950.[72]

Through all this Redesdale and Harcourt felt that Law had abused his position both on the committee and as a resident of the palace. 'Mr Law', we learn from a report, 'has a very offensive method of pressing in an article that certain steps should be taken, which he knows have already been determined by the committee, in order that he may appear to be the originator of them.' Despite this Law had the last word, publishing an account of the completed project in *The Times* in 1911, scooping all the credit for himself.[73]

305 Charles Edward Mallows's suggested reconstruction of the west front of Hampton Court, 1910.

306 The Tudor stone entrance bridge buried in 1700 under excavation in 1910.

Work on the restoration was delayed by Edward VII's death in May 1910 but was completed a little under a year later. It occasioned a final phase of alteration to the gatehouse itself. The remaining northern pedestrian side door, inserted by Charles II, was blocked and the whole refaced again in a less harsh brick than that of the 1880s. The brick of the bridge parapets was reused Tudor material from the moat. This was the first restoration of the palace that extensively used modern archaeological techniques and the first to use the original accounts of the palace. It marked both a beginning and an end. Hampton Court now had to wait until the 1970s to see works undertaken on such a scale again in the name of restoration.

The Wren Revival 1823–1930

This chapter has so far concentrated almost solely on the architecture of the Tudor palace in the context of the gothic revival from about 1800. But during the late eighteenth century, before the advent of the gothic, Wren's quadrangle was frequently admired. Topographical itineraries and descriptions praised the magnificence and dignity of the south and east façades: 'Elegant and superb apartments', 'an elegant design by Sir Christopher Wren', 'the two fronts... beyond comparison the finest of the kind in England excel anything that was erected before'.[74] But around 1800 the tide of taste began to turn against Wren and by the 1840s the tone had drastically changed. Wren's building was categorised as a 'national misfortune' and an 'impertinent construction'; his Ionic colonnade was a symbol of desecration; and Wren was described as 'one of the many men ruined by a madness for the classical'. The inner quadrangle, or Fountain Court, was described in 1849 as 'sombre and melancholic... the ordinary result of narrow spaces enclosed with lofty buildings on every side, dribbling fountains and little fishes – prisoners of state'.[75] Yet by the 1850s Wren's Hampton Court was not only back in favour, but was, arguably, influencing contemporary architecture to a greater extent than the Tudor palace had ever done. A growing appreciation of Wren's genius had begun in 1823 with the publication by the architect and antiquary James Elmes of *Memoirs of the Life and Works of Christopher Wren*. Ten years later C. R. Cockerell, the first professional president of the Institute of British Architects, was the first major architect of the nineteenth century to admire Wren's life and architecture. In 1838 he painted the remarkable *Tribute to Sir Christopher Wren*, a large watercolour in which Wren's major works were shown together (fig. 307). John Clayton was inspired by the *Tribute* to produce his 1848 study of Wren's City churches, which he dedicated to Cockerell.[76] By the 1860s there was anyway a fading of the evangelical fervour that had characterised the gothic revival. It was giving way to something more English, more compromising and entirely secular in the Queen Anne movement and Arts and Crafts.

Kinmel Park in Denbighshire is the first and perhaps most extravagant expression of Hampton Court's calm classifying influence on English architecture in the period 1860–1930. It was built for H. R. Hughes, whose vast fortune had come from copper mining. Hughes's architect was William Eden Nesfield with whom he had a deepening friendship while executing a number of projects on Hughes's estate. On 25 May 1868 Nesfield and the Hughes family paid a trip to Hampton Court with the intention of gaining inspiration for a much larger project – an entirely new house. Immediately on their return some magnificent iron gates in the style of Tijou were commissioned. These led to a design for the new house. Ignoring the French roof added to avoid the bleak parapets of Hampton Court, Kinmel Park is recognisably a child of Wren's Hampton Court. The walls are red brick with stone dressings and have great sashes with thick glazing bars. The house was a pioneer of the Queen Anne movement and owed this entirely to Hampton Court. But the house was less influential than it might have been because it was remote and Nesfield refused to publicise his designs.[77] In the end the champion of the English baroque revival was Nesfield's assistant John McKean Brydon, who in a series of well-informed and historically based lectures and articles argued for the revival of classical architecture.[78]

Despite a small group of buildings such as Brydon's Chelsea Town Hall (1885–7), John Shaw's Wellington College (1856–9) and the Municipal Buildings, Leicester (1873–5), by Frances John Hames, interest in the later English renaissance did not take off until the turn of the century.[79] In 1897 Reginald Blomfield published *A History of Renaissance Architecture in England 1500–1800*.

307 C. R. Cockerell, *A Tribute to Sir Christopher Wren*, 1838. The east and south fronts of Hampton Court are shown on the left-hand side.

In some ways the crescendo of the book is the work of Sir Christopher Wren, whom he saw as the most English of English architects. He regarded the design of Hampton Court as 'completely successful' apart from a few minor errors that could be laid at the feet of King William.[80] While engravings enhanced the effect of Blomfield's book, the books that followed it were transformed by the extensive use of photography. John Belcher and Mervyn Macartney's *Later Renaissance Architecture in England* (1901) had minimal text and was a vehicle for sensational photographs. The Hampton Court chapter reproduced photographs, original plans and drawings.[81] Soon new magazines such as the *Architectural Review* began to use both photography and detailed drawings to bring details of buildings to the rapidly expanding architectural profession. The *Architectural Review*'s series, 'The Practical Exemplar of Architecture', carried eight pages a month of eighteenth-century details, including sections on Hampton Court – a favourite. Young architects visited Hampton Court to draw sections, elevations and details. One such was Alner Wilson Hall (b. 1884) who as a nineteen-year-old drew two bays of the south façade in 1903.

In the early years of the twentieth century the architecture of Wren gave birth to a spectrum of public and private buildings led by a group of country-house architects working in his style. Disentangling Hampton Court's part in this revival is not the role of this book, but it is important to note that, in both detail and overall composition, the palace provided inspiration and frequently direct models for Edwardian 'Wrenaissance' architects. It is perhaps worth listing a few of the more important buildings that were directly inspired by Hampton Court. Blomfield's own Moundsmere House in Hampshire (1908–9) for Wilfred Buckley is one of the most extravagant (fig. 308), while his cousin A. C. Blomfield rebuilt Stansted Park, Sussex (1900), which is scarcely less spectacular.[82] In the field of public architecture examples include John Murray's new building for the Offices of the Commissioners of Woods and Forests in Scotland Yard and the new store for D. H. Evans on Oxford Street, both of 1910.[83] But the two most strikingly like Hampton Court are Bentalls store in Kingston upon Thames by Sir Aston Webb's son, Maurice, of 1931–5 (fig. 310) and the extensive Peabody Estate at Cleverly, Hammersmith (1928), by Victor Wilkins (fig. 309).

308 Reginald Blomfield, Moundsmere House, Hampshire (1908–9), the south-west corner. The silhouette, frontispiece and round windows are all direct quotations from Hampton Court.

310 Maurice Webb, Bentalls department store in Kingston upon Thames, 1931–5, in some parts a direct copy of Wren's Hampton Court.

309 The Peabody Estate, Cleverly, London, W12, designed by the Peabody's favoured architect, Victor Wilkins. The estate, in the Hampton Court style, has 272 units of mainly three-storey blocks in pairs. Despite war damage and additional later units the estate retains its 1928 character well.

The upswing in interest in the seventeenth-century history of the palace was not in any sense to the exclusion of the Tudor parts. Interest in the details of the sixteenth-century palace was, if anything, greater than it had been in the 1830s and '40s. Hampton Court remained an important quarry for details and inspiration, and above all the Great Hall remained a crucial model in visualising neo-Tudor design.[85]

The Hampton Court Picture Collection 1760–1850

The accession of George III led to a reorganisation of the paintings in the royal collection. This was sparked by the acquisition of Buckingham House for the queen in 1762 and the need to furnish its walls. Hampton Court and Windsor were plundered and paintings were brought out of store at Somerset House to fill the resultant gaps. In 1762–3 Stephen Slaughter (Surveyor of Pictures 1745–65) was employed to make 'new lists and taking the Dimensions of His Majesty's pictures at the Palaces of Kensington Hampton Court and Windsor' to give the king further scope for rearrangement. The most important outcome of this for Hampton Court was George's decision to move the Raphael cartoons to Buckingham House. This may have been partly motivated by concerns over their condition; since the palace was not regularly used the Cartoon Gallery was never heated. They were taken down, rolled up and transported to Buckingham House where they were hung in the Great Room in 1763. Their departure from Hampton Court was the occasion of a broadside from John Wilkes in the House of Commons. His outrage was characteristically patriotic but also disconcertingly modern. He argued that the cartoons were 'an invaluable national treasure' and that they should remain on show at Hampton Court rather than being hidden from view in a private palace. His complaints fell on deaf ears and anyway their sojourn at Buckingham House was brief, because

Just as contemporary architects rediscovered Wren's architecture so did owners of country houses find their late seventeenth-century interiors fashionable again. For instance in 1811 the Sixth Duke of Devonshire had regarded the State Apartments at Chatsworth 'ponderous' and 'dismal', reminding him uncomfortably of Hampton Court. He and Wyatville originally planned a complete modernisation of them. But all had changed by the 1920s when Evelyn, the wife of the ninth Duke, set out with the help of her architect H. Romaine-Walker to disguise the impact of Wyatville's alterations. The oak stairs were given a seventeenth-century cornice and door-cases in the style of Talman (using some old material) and a corner fireplace was inserted in the China Closet modelled on an example from Hampton Court.[84]

311 King George III's elevations and plan of the hang of the cartoons in the Cartoon Gallery at Hampton Court in preparation for their return, c.1804.

they didn't fit into the complex picture hang devised by the king and queen. In 1787–8 they were moved to Windsor, where they decorated the new Queen's Lodge.[86]

In 1804 another upheaval hit the royal paintings collection as George turned his attention to Windsor Castle where he began to set up new apartments for himself and the queen. That year, and the following one, many more paintings were reallocated from the unoccupied palaces. Once again this had an impact on Hampton Court in that it triggered the return of the Raphael cartoons, a suitable place for which could not be found in the new work at Windsor. By this stage their constant removal was causing concern and so as they left Windsor George 'ordered a roller to be made, three feet in diameter. Yet, not withstanding every precaution, upon unrolling them several pieces were found to be separated from the canvas; fortunately the injury occurred to the backgrounds only and the pieces were carefully repasted.' With the cartoons arrived their giltwood 'Carlo-Maratta' frames made for their installation at Buckingham House at a cost of £500. These were retained and Benjamin West, the King's Surveyor of Pictures, reinstalled them in a new order, probably necessitating alteration to Wren's panelling. A drawing in the Royal Library (fig. 311) shows the hang and panelling layout in George's precise and explicit manner.[87] It is in this state that they were incorporated into one of Charles Digman Wingfield's historical views of the palace (fig. 280). Yet despite their homecoming great demands continued to be made on them. They were frequently taken down for copying, and even sent to London and elsewhere for exhibition. This constant activity led to persuasive arguments to remove them from Hampton Court for good and re-hang them in the new National Gallery in Trafalgar Square.[88]

The cartoons' return to Hampton Court in 1804 was a welcome move for the rapidly growing tourist industry at the palace. Indeed by the 1830s they formed the principal part of the visitors' tour. Dr Carus, who enjoyed a meticulously planned fact-finding tour of England and Scotland with his master, the King of Saxony, in 1844, wrote in his diary 'To-Day, again, a remarkable event of my journey! I have seen Raphael's cartoons at Hampton Court, examined them with time and attention, both near, and at a distance!' But he and most other visitors thought the cartoons badly displayed; another German visitor, Frederick von Raumer, noted in a letter home that they had suffered 'the most barbarous treatment ... They all hang too high; and for some incomprehensible reason, the upper round windows in this apartment are walled up, so that the only clear light is reflected upwards, from the pavement of the courtyard.'[89]

In the last years of his father's reign George IV began to take an interest in the collection of paintings that he would soon inherit. Indeed he commissioned Benjamin West, who was the Surveyor, Cleaner and Repairer of the King's Paintings, to survey those at Kensington, Buckingham House, St James's and Carlton House so he could have a hand-list to work from. In addition, from at least 1818 he employed as art adviser the painter and art expert William Seguier. The choice was a shrewd one, because he was very knowledgeable in both art history and the infant art of picture conservation. In 1818 Seguier was let loose on the paintings at Kensington which had been ignored and abandoned, and found many pictures of first quality unnoticed. In 1820 Seguier succeeded Benjamin West as Surveyor and on his advice George removed over 600 paintings from Kensington, three-quarters of which were re-hung at Hampton Court. Five years later, when

work started to convert Buckingham House for the king, another forty paintings were removed and hung at the palace. To this rapidly growing collection were added more by William IV.[90]

The effect of this on the interior of the State Apartments was dramatic. A room such as the King's Drawing Room that was described by David Hughson in his guide of 1809 as having four paintings had six by 1816, nineteen by 1841, twenty-two by 1849 and thirty-four by 1881. In a similar timescale the number of paintings in the Eating Room increased from seven to thirty-eight and those in the Queen's Presence Chamber from five to fifty-three. Behind this monster picture hang that comprised over 1,000 paintings by 1840 lay the eye of William Seguier. The paintings were distributed with care so as to tell a story wherever possible. The King's Guard Chamber, in keeping with its military function, contained battle pieces and portraits of admirals. To accompany the great equestrian portrait of William III in the Presence Chamber hung the Kneller beauties brought up from the Dining Room below. The rest of the King's Apartments contained old masters, with large canvases in the State Rooms, and smaller ones in the closets. The exception was the King's Bedchamber where the tapestries were over-hung with the Windsor Beauties by Sir Peter Lely brought from Windsor by 1835 (fig. 281). In the Queen's Gallery the tapestries were covered over too and Seguier hung the best Tudor portraits and a number of early Stuart ones. In all, the room contained 131 paintings, 73 of which were portraits. Other groups included landscape and still life (34), religious (17) and history and mythology (17). Two rooms away in the Queen's Drawing Room he gathered the Hanoverian portraits mainly by Benjamin West. In the Queen's Presence Chamber and the ante-room before it there was a naval theme with more than sixty sea battles, ships and naval portraits – these rooms were praised by Charles Knight as being 'peculiarly appropriate to a national Palace'. In the private chapel there were twenty-three small-scale religious subjects.[91]

All this was a truly astonishing achievement and bears a striking similarity to Louis Philippe's exactly contemporary conversion of the north wing of the palace of Versailles into a museum to commemorate 'all the glories of France'. In the preface to the first catalogue of the museum its aims were stated to be 'To devote the former residence of Louis XIV to all the glories of France, to assemble therein all the great memories of our history'. Louis had himself ordered 'a search to be made in the crown furniture stores and royal residences for all the paintings statues, busts or bas-reliefs representing famous events or persons in our annals'. These were all installed in a suite of new exhibition rooms carved out of the old palace. The great project was completed and opened to the public at a party in 1837. The Hampton Court rooms, although not constituted as a 'national museum', certainly fulfilled that function with their chronological layout and specific rooms devoted to history painting and England's naval achievements. It is unlikely that Seguier was ignorant of developments at Versailles and as we shall see the historical and didactic nature of the hang was strengthened as the century wore on.[92] Perhaps more significant and important than the comparison with France is that the Hampton Court picture gallery in the 1840s and 1850s in terms of its scale, arrangement and interpretation was far more sophisticated than anything in London, including the new National Gallery in Trafalgar Square. In 1838 the National Gallery had 163 pictures, rising to 300 ten years later, a fraction of the Hampton Court total. Moreover, because the former was free, it attracted large numbers of picnickers and those sheltering from the elements, many of whom cared little for the paintings. The catalogue, priced at a shilling, was a bare list, bought by less than 1 per cent.[93]

A French diarist wrote of Hampton Court in the early 1850s that 'The picture gallery is the largest in the country and contains over 1,000 pictures of all schools.' Yet despite this the collection could not compare in quality to the National Gallery. The King of Saxony's physician, Dr Carus, visiting in 1844 noted, 'The rooms are crowded with an enormous multitude of pictures, few very valuable, some good, an innumerable number mediocre, and many – even portraits – falsely baptised and bad; in short a whole flood of pictures, two thirds of which I should have great pleasure in throwing into the fire.' The greatest vitriol was poured out by Anna Brownell Jameson, the first person to attempt a serious scholarly catalogue of the paintings in 1842. She also thought the palace full of 'an immense quantity of nameless rubbish' arranged badly in inappropriate rooms. She thought that responsibility for the display was unclear and took the Queen's Gallery as an example of how not to hang a great room, making several pages of her own (sensible) suggestions for improvement. She recommended that 'an accomplished connoisseur or antiquarian' should set aside one or two years to catalogue the lot properly.[94]

The Victorian Picture Hang 1850–1901

The reign of William Seguier as Surveyor of the Royal Pictures ended on his death in November 1843. The following month the queen began to turn her mind to the question of the royal picture collection and after a number of sessions examining their distribution and condition wrote in her journal that she was

> thunderstruck & shocked . . . at the way in which the pictures, many fine ones amongst them, & of interesting value, have been thrown about and kept in lumbar rooms at Hampton Court, whilst this Castle [Windsor], & Buckingham Palace are literally *without* pictures . . . My care, or rather more my dear Albert's, for he delights in these things, will be to have them restored, to find places for them, & to prevent, as much as it is in our power, pictures of the Family, or others of interest and value, from being thrown about again.

In the short term Victoria's and Albert's wishes were hard to achieve because Seguier's successor resigned after just a year and Thomas Unwins who succeeded him showed little interest in tackling the perceived problems of the hang at Hampton Court. Unwins did, however, commission a report on the Raphael cartoons, whose condition was still giving cause for concern. But correspondence between him and the housekeeper makes it clear that it was still uncertain under whose control the paintings at the palace were. In 1855 this contributed to the theft of one painting and the damaging of a number of others. The following year the queen succeeded in appointing Richard Redgrave as Surveyor, the first not to hold the title of 'Cleaner and Repairer' too.[95]

Redgrave, a prolific painter and writer, was a prominent figure in the field of public art education and close friend of Henry Cole, the civil servant who had been so important on the executive committee for the Great Exhibition and went on to found the South Kensington, later the Victoria and Albert Museum.

Through Cole, Redgrave was involved in both the exhibition and the museum.[96] Between them they set about a campaign to draw attention to the problems of works of art at Hampton Court. First, in 1858 Redgrave made a report on the collections and their display which the queen accepted and had passed on to the Board of the Office of Works. This report does not survive, but it probably ran along similar lines to another prepared by Henry Cole. Cole had been interested in Hampton Court since the late 1830s (he was introduced to the palace by Thomas Willement) and in 1859 published *Some Thoughts on Hampton Court Palace*. One hundred and fifty copies of this were distributed to the Royal Household and the Office of Works and the Prince Consort gave his approval to many of the ideas in it. Essentially Cole proposed that the greatest works of art be removed and hung in London and the remaining historical collection of portraits and history pieces be re-hung in conjunction with tapestries and furniture in order to restore the historical appearance of the interiors.[97]

Cole's motivation must be suspect. Certainly during the early years of the palace's opening to the public the coherence of the displays was diluted by initiatives to either remove or add items to the historic collections. The queen herself ordered the canopy and other decorations from the Duke of Wellington's lying in state to be displayed in the Public Dining Room. To it were added a number of models, including William Kent's model of Kew Palace and a model of the Indian palace at Mooreshedabad.[98] But some of these were moved to the South Kensington Museum in 1857 and this started a gradual drift of pieces of architecture, fittings and even furniture to Kensington. Cole and Redgrave were certainly behind this. In 1858 substantial items of iron work were transferred, culminating the next year with most of the Tijou screens from the Privy Garden. In 1859 there were so many items on loan to the new museum that it had to be made clear that the loans were temporary and not gifts. Finally in 1884 it was decided that the South Kensington museum had enough exhibits of its own and provision was made to return everything to Hampton Court. Yet connections between the two remained close and after the First World War the museum was still asking for doors, locks and other decorative items for its galleries.[99]

Yet despite the obvious self-interest many, but not all, of Redgrave's and Cole's ideas were accepted. Redgrave's first recommendation, the preparation of a catalogue of the entire royal picture collection, was completed in 1879, the Hampton Court pictures alone taking up 1,077 sheets of paper. The catalogue, an essential prerequisite to any rearrangement, led to the renumbering of paintings giving them their characteristic white-painted numerals on the face of the canvas. The previous system of numbering had been instituted soon after the opening of the palace to the public in 1842. In the 1865 edition of Grundy's *Stranger's Guide* to the palace, a notice explains that previously numbers were attached to the frames of the paintings and when paintings moved each room was re-numbered to enable visitors to identify them. But 'by a late regulation the numbers are made registering numbers and are never to be changed'.[100] The Prince Consort also insisted (following Cole's recommendation) that Redgrave should be solely accountable for the care, cleaning and arrangement of the pictures there. This was necessary, because former royal neglect had enabled figures such as Jesse to seize the initiative, prepare inaccurate catalogues, rearrange the collection and order the repair and restoration of paintings.[101] The Prince Consort insisted that these responsibilities should be Redgrave's and it was eventually agreed that the Office of Works would make an annual sum of £250 available for the repair of paintings at Hampton Court to be administrated by Redgrave (another Cole recommendation).[102]

The prince himself visited the palace in 1861 to encourage Redgrave to make a plan for the rearrangement of the galleries. But Redgrave was absorbed by the problems of Hampton Court's two greatest treasures, the Mantegna *Triumphs* and the Raphael cartoons. The *Triumphs*, Redgrave concluded, were beyond repair and rescue, and the cartoons would soon also be beyond repair if something were not done. The Prince Consort's special concern was the cartoons and he was keen to promote a more general and international interest in them, even arranging a special lunch at Hampton Court for the King of Saxony after he had viewed them. Albert formulated a plan, which, as we have seen, had much older roots, to relocate them to the National Gallery, where they would be safe from the damp, dust and overcrowding of Hampton Court. The suggestion that the cartoons might be moved from the palace produced local outrage, and innkeepers predicted a catastrophic fall in visitor numbers and certain personal ruin. After Albert's death the decision as to the future of the cartoons rested with the queen who, after fierce lobbying from Henry Cole, finally resolved to send them to South Kensington to the new museum there. The decision was controversial and opposed by R. N. Wornum and Sir Charles Eastlake from the National Gallery. But Kensington's victory was based on the queen's belief that the atmospheric conditions there would be better than those in Trafalgar Square. A committee was formed to deal with the logistics of moving the paintings (fig. 312) and the cartoons finally arrived at their new home in April 1865.[103]

The removal of the cartoons finally triggered a major re-hang of the palace. Redgrave decided to transform the former Cartoon Gallery into the principal portrait gallery by dismantling the hang in the Queen's Gallery and Communication Gallery and rearranging it historically. In the Queen's Gallery the *Alexander* tapestries were uncovered (they had been covered in papered linen) re-establishing its historical appearance.[104] Two hundred and twelve paintings were gathered together in the Cartoon Gallery, of which ninety-six were portraits; most of these were not hung on the walls but on four tall green screens. The best Tudor paintings and portraits including the great history paintings were re-hung in the Queen's Audience Chamber – a room that had never really had a strong theme. The *Triumphs of Caesar* were removed from the Public Dining Room and re-hung in the Communication Gallery where the Office of Works devised floor traps for their quick removal in case of fire. The canvases were also glazed for the first time to protect them from the public. Their relocation made space for some of the Stuart portraits from the Queen's Gallery and Communication Gallery, to follow on historically from their Tudor forbears in the previous room. Several of the rooms in the private apartments facing Fountain Court were re-hung too; the queen's private chapel was re-hung with still-life paintings and her private chamber made over into a gallery of portraits of the families of the first two Georges to maintain the historical progression of portraits. All this made a lot of sense and gave visitors a more coherent view of the collection. Indeed Redgrave believed that it made Hampton Court more of a palace and less of a museum. Yet the introduction of screens into the Cartoon Gallery was the first

312 The removal of the Raphael cartoons from Hampton Court to the Victoria and Albert Museum by the Royal Engineers in 1865.

of a series of unsatisfactory solutions to the removal of the cartoons before the final resolution of the problem in 1992.[105] But despite the programme of cleaning and restoration that Redgrave initiated and his didactic redisplay, the Princess Royal wrote to the queen in June 1878 suggesting that a commission under 'dear old Redgrave (who is getting a little weak of sight)' might 'hang them in a better light, give them their right names, do up some of the frames, put other pictures under glass – & *weed* some out which are altogether unworthy of being hung up where they are much seen!' Two years later Redgrave retired a worn-out man and on the advice of the princess John Charles Robinson was appointed to succeed him.[106]

Redgrave's work both as a cataloguer and as the rearranger of the Hampton Court collection laid the foundations for the first published catalogue of the paintings based on intensive archival research. In February 1881 the palace's resident historian, Ernest Law, requested that he should be granted access to Redgrave's catalogue to undertake the final checks on his own substantial catalogue then almost ready for publication. His request was granted and later that year Law's comprehensive 300-page catalogue complete with introduction, index and cross-references was produced. Law was nothing if not a populist and certain entries were placed in bold type, those he thought the most interesting. This allowed visitors to scoot through 1,000 paintings stopping at the most romantic and important. The same year saw the issue of the first Baedeker guide to the palace which, like Law, paid 'no regard to the naming in the catalogue' on sale at the palace.[107]

J. C. Robinson was an intelligent and active curator of the Hampton Court collection who appointed a Superintendent of Pictures, one Mr Brown, in 1877 to assist him (Brown remained in post till 1916). He also argued vociferously for the return of the Raphael cartoons from South Kensington on the grounds that

313 The 'bed museum' as set up by the 1880s. Queen Caroline's bed is on the left, a George II field bed in the middle and King William's bed on the right.

they were not any safer there than they would be at Hampton Court and that they should be reunited with their historical context. As a response a commission was set up to consider their fate in 1891. It reported late that year and the majority recommendation was that they were safer, better lit and seen by more people at South Kensington. Robinson disagreed and the queen sympathised but both had to acquiesce in the face of the report. The cartoons remain at South Kensington to this day, despite further outbursts from Robinson into the late 1890s.[108] Robinson was also much involved in advising on fire precautions especially after the Hampton Court fire of 1882 (see chapter 16). Together with the architect John Lessels he invented a special lifting tackle that was inserted behind all the larger important paintings in the palace including the overmantels. For the Mantegnas an even more ingenious arrangement was devised. Since the paintings were glazed and very heavy, a special hydraulic mechanism was introduced for lowering the paintings to the floor. Each frame had small brass castors at its base that allowed it to be rolled along to a slot in the floor. Here another device with a canvas sling could lower the paintings to the cloisters below from where they could be rolled to safety.[109]

Furniture and Interiors to 1901

These enormous changes to the appearance of the State Rooms were accompanied by a gradual dispersal of the historic furniture and tapestries. William Pyne's history of the palace (figs 187, 189, 237, 246, 273) shows that in 1819 many tapestries and much of the eighteenth-century furniture remained *in situ*.[110] But already by 1804 cartloads of furniture had twice been moved from Hampton Court to Kensington. Most furniture that left the palace did so for other royal residences,[111] but a group of items seem to have been sold at the end of the century.[112] The remaining furniture gradually began to be grouped, like the paintings, in a didactic manner. By 1839 King William's bed had been removed to the Queen's Private Bedchamber and replaced with Queen Charlotte's embroidered bed. Two other beds, including the George II field bed, joined William's bed in the private apartments by the 1880s, making a bed museum for the public (fig. 313). As already noted, tapestries were finally removed from the walls of many of the State Apartments in 1841 during the restoration of the Great Hall. The rooms then had their walls papered. This was not a sign of neglect, rather of the changing nature of the rooms influenced by Victorian museology. Indeed the rooms continued to be well maintained; roller blinds were installed in 1803 to reduce the light levels; ceilings and walls were whitewashed; floors were pieced in; and doors and panelling varnished.[113]

It was J. C. Robinson who began to show an interest in the tapestries at the palace, stimulated by the enthusiasm of the South Kensington Museum. Experts from the museum arrived in 1883 to examine the condition of the gothic tapestries in the Great Watching Chamber. The following year Robinson argued that the tapestries were so decayed now that they were no longer works of art, rather 'curious relics of antiquity' and efforts should be directed towards stabilisation rather than restoration. A detailed

314 One of two options for the restoration of the Wolsey Closet prepared in 1889 by John Lessels. This is the adopted option.

survey of the condition of the pieces on show supported this view. The only tapestries in his opinion in prime condition were the *Abrahams* in the Great Hall. Inevitably Robinson's report led to a dispute between the Lord Chamberlain and the Office of Works as to who should pay for the stabilisation of the rest. The Victoria and Albert Museum suggested that they should be given the repair work, but were told sternly to mind their own business by the Lord Chamberlain. Even the queen was overruled on the matter of where the tapestries should be worked upon, her preference being that they should be taken to Windsor. In the end work began at Hampton Court, funded by the Government, under the supervision of Mr Brown. It was nearly completed by the summer of 1885. The *Abraham* tapestries still caused great interest and in 1893 Robinson succeeded in bringing back from St James's Palace the two lost *Abraham* tapestries for the Great Hall.[114]

Robinson's interest in the historic context of the royal collection also extended to Kensington Palace where, after the completion of structural repairs in 1898, he embarked upon the creation of a more historically based picture hang for opening to the public. A Committee of Taste (that included Ernest Law) identified suitable paintings and consulted the queen on her views. In the end many Hanoverian paintings were moved there from Hampton Court in March 1899. The following year further paintings were removed to Kew Palace, which had been surrendered by Queen Victoria in 1897 and opened to the public.[115]

In 1886 Robinson's interest resulted in a new restoration project. Although the room now known as the Wolsey Closet (fig. 48) had been described by George Vertue in 1725, it seems to have been ignored by antiquaries and even the Office of Works until the 1880s. This was because it had been part of a continuously occupied apartment, first by the Prince of Orange (see chapter 16), and after 1798 by Mr Louis de Curt. In 1802 the apartment was granted to Sir James Hawkins-Whitshed and his wife who remained in residence until 1843, when the long-living daughter of a former governor of India moved in; the Hon. Lady Hill remained ensconced until she died at the age of 88 in 1886. Therefore it was with great curiosity that J. C. Robinson and the officers of the Board of Works gained access to the apartment in 1886–7. A letter by Robinson written to Sir Spencer Ponsonby Fane, the Comptroller of the Household, soon after he had viewed Lady Hill's butler's pantry, is crucial in showing what then existed. Apparently much of the Tudor ceiling was intact including the window soffit. The panel paintings were still *in situ* and even Wolsey's motto in lead letters adorned the walls. One assumes that none of this was added in an antiquarian spirit by the grace and favour residents and that the interior had remained intact as a service room since 1700. When the grace and favour apartment was regranted in 1886 the closet and adjacent rooms were omitted to allow the room to be restored and opened to the public.

The room acquired its present shape only in 1700, and to this significant additions were made. Ernest Law offered to sell the Office of Works some linenfold panelling, apparently genuine, for 12s a panel; this was installed on the walls. Robinson meanwhile obtained permission for the panel paintings (fig. 48) to be loaned to the Society of Antiquaries for exhibition in early 1888 and for this they were thoroughly cleaned. In 1889 work to re-assemble the closet was completed and it was decided to make it open to the public on request (fig. 314).[116]

The restoration of the Wolsey Closet was a prelude to an equally dramatic transformation in the Queen's Apartments. The removal

of paintings to Kensington from the Queen's Drawing Room in 1899 raised questions about the future display of the room. In 1833 the green damask hung by William Kent for Queen Caroline had been removed and the walls papered with red flock wallpaper without any consideration being given to the murals beneath. But in 1899, as the Benjamin West portraits were taken from the walls, a sharp official noticed that the walls were painted as well as the ceiling. This led to the decision to remove the paper and to commission Haines and Sons Limited to clean the blackened walls beneath. The murals had been badly damaged by the insertion of wooden battens for stretching the damask and flock paper and by holes caused by hundreds of picture-hanging nails. Yet the murals were in good enough condition to be re-exposed, restored and shown to the public.[117]

Tourists at Hampton Court

Hampton Court had been part of the tourists' itinerary of the western Thames valley since the reign of Queen Elizabeth. A tip to the Palace Keeper almost always ensured a guided tour as long as the court was neither present nor imminent. As a result of the increasing formalisation of the housekeeper's tour, with the standard charge of a shilling after 1737, a new breed of housekeeper was created around 1758. The new lady housekeeper's task was as much concerned with providing access to the palace for tourists as it was with caring for the valuable contents, and her salary of £250 a year was enormously boosted to £800 by entrance fees. By the end of the century the housekeeper led tours using a long stick to point out the various paintings and tapestries, lecturing as she went. A visitor recalls one such tour: 'The few rooms that were shewn were thronged by a hot crew, who each had to pay some toll to a virago of a housemaiden at each several door. "Pay a shilling here, sir!" sounded like a death knell in one's ears.' A German visitor who was studying the cartoons in 1835 found his musings interrupted when at the strike of the palace clock 'several hundreds of persons crowded into the hall of the cartoons, but they hurried past without attending to them'. According to Francis Wey, a Frenchman touring England, this was because 'English people are not keen on art, and visit their galleries out of a sense of duty . . . the custodians rush the visitors on.' He complained that 'We were hustled through the Great Hall, I scarcely had time to glance at the magnificent gothic ceiling'. Wey was one of the few who 'opposed a certain force of inertia to their injunctions to hurry, and as they did not dare take me by the scruff of the neck I gained a few moments here and there'.[118]

These rude tours led to the inclusion of Hampton Court in pocket guidebooks to London.[119] *The Picture of London* was a very popular one in which Hampton Court appeared in 1802 and in subsequent editions in 1805, 1806 and 1809. The guide explains that the State Apartments can be seen for about a shilling and that 'To visit the palace is a favourite excursion of the Londoners, who go to it either by way of Hammersmith and Twickenham or by Wandsworth and Kingston.' The early editions include a table of prices to sites on the river by boat. To reach Hampton Court by boat from London Bridge in 1802 cost 12s and 1s 9d for each extra person. *Leigh's New Picture of London* of 1818 included (for the first time) the numbers of the coaches that went to the palace from the Strand, Royal Exchange, Holborn Bars and Tottenham Court Road. The first guidebook with Hampton Court as its sole subject was the anonymous *Hampton Court Guide* of 1817, but John Grundy's 1825 *The Stranger's Guide to Hampton Court Palace and Gardens* eventually became the 'official guidebook' sold to the public in the Great Hall and King's Guard Chamber.[120] John Grundy was a minor official in the Royal Household, holding the position of Groom of the Great Chamber between 1823 and 1837. More importantly, he was married to the palace housekeeper and until 1855 was responsible for the opening of the palace to the public and the security of its treasures.[121]

Thus Hampton Court was open to the public through the private enterprise of the housekeepers, fed by the allure of the great picture collections sensationally described in cheap guidebooks. It was one of the five great tourist attractions of London, together with the Tower of London, the British Museum, St Paul's cathedral and Westminster Abbey. All these charged visitors to enjoy the treasures within and the British Museum, in addition, operated a restrictive admissions policy. With the coming to power of the reforming Whig Government in 1832 there was suddenly political will behind liberal attitudes to mass education. Increasingly pressure was brought to bear to make access to great public assets free of charge. In the years around 1840 four out of the five national monuments made significant concessions to public access to avoid what they saw as possible coercion through Parliamentary Select Committees. The British Museum extended its opening times and printed guides; the admission charge to the Tower was dropped to sixpence; charges were abolished at the abbey for all but the tombs; the shilling at Hampton Court was abolished; and only St Paul's stubbornly retained its charges.[122]

At Hampton Court the stimulus was undoubtedly the Parliamentary Select Committee on 'The Arts and Their Connection to Manufactures', set up in 1836 under the chairmanship of William Ewart, an MP interested in public art education. Ewart and his fellows championed the notion that public galleries should be open free and after working hours for ordinary people. Their discussions eventually moved to what were regarded as among the greatest of national treasures, the Raphael cartoons, and the opinion was expressed that they should be moved to the National Gallery. The Gallery's architect, William Wilkins, was called before the committee in July 1836 to state whether or not the cartoons could be suitably housed there. Although amongst the expert witnesses opinion was split as to whether the cartoons would be damaged by central London pollution or not, the majority favoured their relocation to Trafalgar Square. William Seguier, who as both royal adviser and Keeper of Paintings at the Gallery was in a compromised position, argued that the cartoons should remain at Hampton Court, believing that the smoke of London would destroy them within twenty years. Whether he really believed this or whether he was defending the queen's right to retain the paintings in a royal palace may never be known.[123] At any rate, the work of the committee brought out into the open the long-running debate between the Office of Works and the Lord Chamberlain over rights and privileges attached to the royal art collection and the spectre of the forcible removal of parts of it to enable free access in central London. The queen probably felt that the easiest way to resolve the tension was to open the palace to the public, for free.

The death of the palace housekeeper, Lady Emily Montagu, in April 1838 provided the trigger the Royal Household needed to

agree to free access. The Office of Works were to be responsible for administering it and Jesse was instructed to make preparations the following August. As a result the palace was opened free of charge from Saturday to Thursday, with Fridays being reserved for cleaning. In addition to the housekeeper (with revised duties), a superintendent, two assistants and a porter were appointed to stand duty in the State Apartments. The following year two new assistants were appointed and by the 1850s there were nine attendants in all.[124] A discerning American visitor to the palace in 1856 remarked,

> Soldiers were standing sentinel at the exterior gateways, and at the various doors of the palace; but they admitted everybody without question, and without fee. Policemen, or other attendants, were in most of the rooms, but interfered with nobody; so that in this respect, it was one of the most pleasantest places to visit that I have found in England. A good many people of all classes, were strolling through the rooms.

Later he was to note, 'The English Government does well to keep it up, and to admit the people freely to it.'[125] The numbers of visitors were substantial in 1839, 115,971 people in all. In the following years, partially because of the restoration of the Great Hall, the numbers rose steeply: 147,740 in 1841 and up to 176,000 in 1843. Thereafter the numbers reached a plateau until 1851, the Great Exhibition year, when they rose to a colossal 350,848 before subsiding back to the 170,000 or so of the 1840s. In 1858 there was a rise that took visitor numbers to just over 200,000. Easter was always the busiest time and on Whit Monday 1860 just over 26,000 people visited the palace. Ernest Law was able to boast, correctly, in his catalogue of 1881 that ten million people had visited the palace since its public opening.[126]

Visitors to Hampton Court before its universal opening had come by coach, steamboat or, later, horse-bus from London (fig. 315). In the late 1830s there was a bus every twenty minutes

315 The Magnet Road coach. Built in 1886 the coach was renamed Magnet in 1937 and ran each summer weekday from the Dorchester Hotel to the Hampton Court Hotel. The journey took 2½ hours, arriving at 1.15 pm. The coach returned to London at 3.45 pm. The return fare was 10 shillings and the box seat was five shillings extra. It is now in the Museum of London.

316 Sir William Tite, Hampton Court railway station, 1848–9. Tite's best-known gothic-style railway stations are in Carlisle (1847) and Perth (1848).

317 A London Transport poster advertising trips to Hampton Court by tram, 1927. This example, one of many advertising the palace, was designed by Dorothy Paton and illustrated the Privy Garden.

between 9 a.m. and 9 p.m., making the palace easily accessible. The changes of 1838 stimulated demand for even greater access and in 1849 the London and South-Western Railway built a line to Hampton Court. At the insistence of the Office of Works Sir William Tite's design for the station, built in 1848–9, was in a neo-Jacobean style (fig. 316).[127] At first the station, built on Cigarette

318 The construction of the tramway to Hampton Court in 1902 with the Lion Gate in the background.

Island, was connected to East Molesey by a drawbridge, an arrangement that terminated with the construction of the new bridge by Lutyens in 1930–33. By 1869 there were fifteen weekday and eleven Sunday trains from Waterloo and by 1906 twenty-seven and twenty-two respectively. In 1916 the service was electrified and in 1958 the present half-hourly service was instituted.[128] In 1903 the tramway was extended to Hampton Court too (figs 317, 318). It ran from Hammersmith and had its terminus at Trophy Gates disgorging, on bank holidays, as many as ten loads of eager visitors. The tram was replaced by a trolley-bus in 1929.[129] The tramway and railway were the palace's greatest impact on its locality, but the hordes of visitors brought increased prosperity too. By 1903 nine hotels and two restaurants offered lunch, tea and dinner at the palace gates. The dining rooms in Clegg's Temperance Hotel on the Green alone sat 500.[130]

Further stimulation to the visitor trade was the Bank Holidays Act of 1871. Bank holidays, then as now, were the biggest days at the palace. The *Surrey Comet* reported that on Whit Monday 1864 'vast numbers came by rail . . . As great a variety of conveyance was exhibited as on any Derby day. Everything that could run on wheels and many things that threatened to run off their wheels were to be seen, all crammed to the utmost and the interstices between the grown-ups were filled with babies and children.' On these days the Green was populated by stalls providing refreshments, shellfish, gingerbread and ices, and jostling for prime sites with them were organ-grinders, jugglers, tricksters and all the fun of the fair. Petty crime, drunkenness and mild hooliganism meant that after bank holidays Spelthorne magistrates held special sessions at Hampton Court to deal with miscreants. Edward Jesse was even appointed on to the bench because so many of those who came before them were troublemakers from the palace. A letter to *The Times* by an angry resident of Hampton Court who feared that the respectability of the neighbourhood was being compromised complained of the 'tens of thousands of the smoke begrimed toilers of London . . . who indulge without let or hindrance in kiss-in-the-ring and the various other amusements'. These people, he suggested, should be under the supervision of the police. The correspondent was adding his complaint to long-standing ones from the Sabbatarians who objected to the palace being open on Sundays. Soon, in response to these concerns the Office of Works launched a licensing scheme for stall-holders on the Green.[131]

One of the remarkable aspects of the huge popularity of Hampton Court during the second half of the nineteenth century was the social make-up of its visitors. As Anthony Trollope observed in *The Three Clerks*, it was a 'well-loved resort of cockneydom' populated with what the *Gentleman's Magazine* described as 'the humbler classes'. Saturday was the only day of fashion when the middle classes would come. A band of the cavalry regiment stationed at the palace would play on the east front for them for

319 Visitors arriving at Hampton Court by the paddle steamer *Queen Elizabeth* in 1911.

two or three hours while the fashionable would enjoy their *passegiata*, but generally not visit the interior of the palace itself.[132] The cockneys began to have a significant impact on the fabric of the palace almost as soon as it was opened. Wear and tear became an issue as hundreds of thousands of hobnailed boots pulverised the softwood floors of the State Apartments. By 1911 most of the original floors had been replaced by narrow oak-strip boarding much more resistant to heavy wear.[133] Metal barriers had to be erected to keep the public off the furniture and paintings; in 1857 metal grilles were added to these, caging-in works of art. Despite this the Lord Chamberlain's correspondence with the Office of Works is full of incidents of damage to the palace furnishings. Knives, sticks and umbrellas were all used to poke, slash and stab paintings causing considerable damage. The sentry at the foot of the King's Stairs seemed to be little deterrent.[134]

It soon became clear too that privies must be provided for visitors. Although this had been suggested in December 1837, it took two years to persuade grace and favour residents that the old Round Game Larder in Round Kitchen Court should be converted for the purpose. At a cost of £753 Inman installed self-flushing urinals and lavatories. Later, public lavatories were added in the gardens, at Trophy Gate and in the Tiltyard. Other conveniences were gradually added for the visitors, including drinking fountains in the gardens and, in winter, charcoal stoves in the apartments.[135]

For this new generation of visitors a series of guidebooks were rapidly provided. In 1839 Jesse published the first edition of *A Summer's Day at Hampton Court*[136] and in 1841 Henry Cole published *A Handbook to Hampton Court*. Since Cole was a Government employee his book had to be written under a pseudonym,

of Felix Summerly. Both guides were in a pocket-sized format conveniently designed for use in the State Apartments. Both were illustrated with a choice selection of engravings. In 1843 Cole's book was republished in a second expanded version with more scholarly information, mainly on the buildings. It was later translated into French and remained the standard guide to the palace until one by Ernest Law replaced it in 1881.[137] Guidebooks were sold at the palace through the private enterprise of the authors. Jesse, using his official position, at first found it easier to distribute his version, but the name of Summerly was getting well known for guidebooks elsewhere and Jesse had to be stopped, by a legal injunction, from pirating Cole's guidebook on site. Cole continued his interest in Hampton Court, publishing in 1842 a guidebook giving the opening times of attractions in and around London.[138]

The opening to the public of Hampton Court with specially arranged facilities for both comfort and interpretation was a milestone in popular education and tourism. On the doorstep of London, accessible to all but the poorest, was a great palace filled with works of art set in beautiful gardens maintained at State expense and available free to all. In 1841 a Select Committee was convened on 'National Monuments' under the chairmanship of John Hume, and Hampton Court was considered as the prime example of the effects of free access. The committee noted that 'the number of visitors has also greatly increased; and the propriety of their demeanour has fully warranted this accommodation'. John Britton, the antiquary, and John Grundy, the Palace Superintendent, were amongst those questioned; both testified to the fact that opening the palace had been beneficial to the public and had no detriment to the monument. The committee concluded

320 The King's Guard Chamber, c.1900, showing the protective metal grilles, dense picture hang and the admissions desk displaying guidebooks in front of the fireplace.

that 'the evidence of several witnesses tends to show that much advantage would be derived from similar opportunities being afforded, under proper regulations, at the British Museum and the National Gallery with beneficial results'.[139]

The opening of Hampton Court should thus be seen as a leading part of the complex changes of the mid-nineteenth century that led to the creation of parks and open spaces, free museums and the Great Exhibition – fundamental changes in education and access that were facilitated by the growing railway network and an increase in leisure time.[140]

The Palace Environs

As the tides of architectural and historical fashion and appreciation ebbed and flowed round the main palace buildings, the outlying structures had mixed fortunes. The Trophy Gate buildings utilised since the 1760s by grace and favour residents and later the Palace School had long been a target for demolition. A memo in 1840 from the Chief Commissioner of the Office of Woods, Forests, Land Revenues, Works and Buildings, Lord Duncannon, had proposed that the buildings should be dismantled and demolished as vacancies enabled. But as soon as apartments were vacated new occupiers were found and installed, leaving the Office of Works powerless to move on its ambition. Finally a combination of the structural collapse of the buildings (fig. 45) and a group of vacancies enabled the Office to act. In February 1878 the Tudor buildings were finally pulled down and the materials sold for £25. Eighty pounds were spent on building a wall between Trophy Gate and the Barge Walk and erecting railings along the latter.[141]

Throughout the eighteenth and nineteenth centuries the mews and the barracks on the west front were the focus of interdepartmental squabbles regarding maintenance. In 1724 the upkeep of the guard-houses and barracks at the royal palaces including Hampton Court was transferred to the Ordnance Office and certainly up to 1760 (and possibly for thirty years after) the buildings continued to be used by the Corps of Invalids. Significant reductions were made to their numbers after 1783 and they were finally disbanded in 1802. At any rate in 1794 George III resolved to station a troop of cavalry at Hampton Court.[142] The use of the barracks by the Army led to further disagreements and a direction by the Treasury that the Commissioners of Barracks should pay for the barracks and the mews. This was a fairly impractical order given that both buildings were by that time partially occupied by grace and favour residents. The mixed use led to a survey of the royal mews by Thomas Hardwick that reported that the main part of the mews was used as a barracks while the upper rooms were used by royal grooms and the coach-houses by palace residents. On 15 March 1811 the Treasury directed the Commissioners of Barracks to undertake the repairs of all buildings at Hampton Court used as barracks or stables for troops. The same year another barracks was built on the Green. It was demolished in 1932 and its site is now a car park (fig. 321).[143]

The troops stationed at Hampton Court played a part in the security of the gardens, park and palace, especially at night. In 1858 their band played twice a week in the Great Hall. A less attractive feature was the fact that they attracted prostitutes and other 'loose women' who gathered round Trophy Gate and solicited on the parade ground. To prevent this gates were once again erected between the Trophy Gate pillars in 1892 and a sentry posted at

321 The 1811 barracks built on Hampton Court Green photographed between the wars.

322 The rear (north side) of the barrack block in 1931. The view looks west to the guardroom and detention block in the far centre.

the gateway.[144] This precaution opened up a wider debate into the setting of the barrack block.[145] At some point in the 1890s and certainly before 1908 (when it appears on a plan) a guardroom was built for the barracks to its north (fig. 322). Containing rooms for the guard, the orderly and two detention cells for miscreants with an exercise yard, the red brick building had only a short life. By the mid-twentieth century it was already a practice room for the palace choir.

Further afield, and a frequent matter for concern, were the Coombe conduits. In 1715–17 the system had been overhauled and a contract let to a plumber called John Golding for their maintenance.[146] This smooth arrangement had broken down by the early 1740s and the Office of Works launched an inquiry into the course of the conduits and the terms of land ownership along its course. Thomas Fort produced a careful survey of the system in the autumn of 1742 (fig. 275). This resulted in a number of prosecutions against people who had been diverting the royal water supply.[147] For a hundred years the conduits continued to supply water to grace and favour residents, but after 1850 concerns were raised about pollution in the system from cesspools on Coombe Hill and the continual damage to the submerged pipes under the Thames from the anchors of Thames barges. In 1869 another legal search was ordered to ascertain the queen's rights to water from Coombe and soon after it was resolved that it would be better for

the palace to buy water from a commercial water company. The conduit system stopped providing drinking water in 1876.

The pipes remained in the ground to the benefit of various domestic users. But in the early 1890s royal rights over the course of the conduit started to inhibit Surrey County Council's plans to build social housing schemes and several of the pipe runs were diverted. In 1894 the Duke of Cambridge announced his intention to divert the water from the conduit as a perk for the water on his land that had been withdrawn; the Office of Works agreed this. It was only one step from here to a decision to sell the conduits and put the conduit houses under the care of the Ancient Monuments Act. The leadwork was dug up and sold. The total length of pipe was 3,476 yards weighing a total of 42 tons, yielding £360 in scrap value. Today English Heritage maintains Coombe conduit while Gallows and Ivy conduit houses are Scheduled Monuments on private land.[148]

Chapter 16

LODGING THE COURT 1700–1737
AND GRACE AND FAVOUR 1760–1914

THE CONSTRUCTION OF WREN'S new quadrangle not only transformed the quality and number of rooms available to the royal family, but also provided purpose-built lodgings for the Royal Household. William's attention did not turn to the completion of the upper floors of Fountain Court until the latter part of 1699. It has already been noted that in December Wren visited the palace to 'view the old lodgings and consider of a plan for the new' and that Sir John Stanley, on the Lord Chamberlain's behalf, began to allocate lodgings.[1] There were two tasks in hand: first the completion of the rooms over the south and east fronts and second the fitting out of all the rooms on the north side. Everything was to be done as cheaply and as fast as possible. Staircases to the upper floors were to be given straight balusters and not 'fine work', and even in the grandest lodgings (including the Archbishop of Canterbury's and Lord Chancellor's) the painting should be performed at the cheapest rates.[2] Once panelled, painted and provided with stone fireplaces, the apartments were the responsibility of individual courtiers to furnish. Only a handful of attendants who worked on a duty rota were provided with furniture. The apartments of the Groom and the Gentlemen of the Bedchamber in Waiting were quite lavishly furnished with beds, bedding, chairs, tables, looking glasses and curtains; everyone else had to provide their own furniture.[3]

A survey of the courtier apartments taken two months into Queen Anne's reign makes it clear that, once allocated in 1699, William's courtiers retained their lodgings until his death (fig. 324).[4] The survey reveals that, as one would expect, the rooms above the King's Apartments were allocated to those who needed to attend most closely such as the Bedchamber staff; on the east were the less important body servants such as the barber, Closet Keeper and the doctor. In the range between Fountain and Clock Courts were sited servants of lesser importance still, grooms and pages and lesser officers of the privy purse. Those who bore no body service, such as the Secretaries of State and other Government officials, were lodged in the Tudor parts of the palace, especially Base Court.[5] Frustratingly nothing is known of life in the courtier lodgings during the last two years of William's reign.

Despite a much greater survival of letters and diaries for the period, crucial questions about furnishing, servants, wives and families, laundry arrangements, cooking, security and access are unanswered. Sometimes the building itself gives a clue, such as in the 'hidden stair' down which full chamber pots were taken each morning by necessary women, but mostly we shall never know.

Court Visits 1702–1737

After William's death and for the period of court residences between 1702 and 1737 a number of documents do survive that help illustrate the use of the non-royal apartments. First are the surveys undertaken by Fort and Vanbrugh in the reign of George I which show in detail the configuration of the apartments in Fountain Court. Then there is an inventory in the Royal Archives at Windsor recording the furnishing of the non-state apartments compiled in 1740 and revised in 1741, 1749 and 1754.[6] Added to this information is that contained in the posting and delivery books for furniture taken to Hampton Court for the early eighteenth-century court residences. These sometimes contain lists of furniture for the non-royal rooms. A particularly full list survives for the visit of 1731 and another for 1733.[7]

Thus it is possible to tell the story, in outline, of the use of the courtier apartments down to 1737. Under Queen Anne, and particularly during her longer visits in 1710–11, the story is very straightforward. It seems certain that the Queen's Household servants and officers simply occupied the same rooms that their predecessors had done under William III. For instance, Elizabeth Percy the queen's First Lady of the Bedchamber, and successor to Sarah, Duchess of Marlborough in Anne's affections, seems to have resided in the Earl of Albemarle's old apartments in the south-east corner of Fountain Court. Meanwhile Charles Seymour, Duke of Somerset, the Queen's Master of the Horse, occupied the traditional lodgings of his office on the south side of Clock Court.[8] George I, during his brief enjoyment of the palace, also made full use of the courtier lodgings and in 1717 at last ordered the fitting-out of the queen's half storey in Fountain Court undertaken on

323 The principal room in the Banqueting House furnished for grace and favour use, 1936.

324 Plan of the palace as completed for William III with the locations of lodgings marked according to the 1702 lodgings survey. Original spellings are maintained throughout. Drawing Daphne Ford.

'The First Court' (Base Court)
1 Mr. Secretary Vernon
2 Lord Keeper
3 Mr. Vanhulse
4 Doctor Hutton
5 Sir Richard Blackmore
6 Lord Cutts
7 Lord Scarborough
8 Secretary of Scotland
9 Secretary, Sir Charles Hedges

'In the Second Court' (Clock Court)
10 Pantry Office
11 Ewry Office
12 Mr. Vice Chamberlain
13 Mr. Boyle
14 Lord Treasurer
15 Master of the Horse

'In the Green Cloath Court' (Lord Chamberlain's Court)
16 Lord Wharton, Comptroller
17 Board of Greencloth
18 Lord Montague
19 Sir William Forester

'In the next Court Yard' (Master Carpenter's Court)
20 Mr. Clarke 1st Clerk kitchen
21 Serj. Hardiman for the Scullery and Charcole house
22 Belonging to the Fish Larder
23 King's Footmen
24 Pastry Office
25 Sempstress and Starcher

'In the Cloyster on the left hand' (Fish Court)
26 Mr. Reniat, Surgeon
27 Mr. Vantone, Surgeon
28 Second Clerk of the Kitchen's Clerk
29 Larder Lodgings

'In the passage behind the Great Hall' (North Cloister)
30 Lord Albermale's Kitchen offices
31 Scullery office
32 Avenor
33 Sir James Forbes
34 Master of the Household
35 Sir Charles Isaac
36 Mr. Lowman
37 Lord Steward's Lodgings

'In the Prince's Court by the Chappell' (Chapel Court)
38 Prince's Lodgings

'In the New Cloyster Court' (Fountain Court)
39 Lord President

Rooms of State (this list is compiled from various sources):

A Old Guard Chamber
B Old Presence Chamber
C Council Chamber (with passage room and 2 closets adjacent)
D King's Great Stair
E King's Guard Chamber
F King's Presence Chamber
G King's Eating Room
H King's Privy Chamber
I King's Withdrawing Room
J King's Great Bedchamber
K King's Little Bedchamber
L Gentlemen of the Bedchamber
M King's Closet
N closet
O Green Gallery
P King's Backstairs
Q Cartoon Gallery.

All remaining State Rooms were in an unfinished state in spring of 1702.

a strict budget of £101.[9] Yet his informality and circumnavigation of normal English court etiquette meant that the apartments were distributed in a non-typical way. For instance he did not appoint a Groom of the Stool, preferring to rely on his Turkish servants Mehemet and Mustapha, who were lodged above the King's Apartments. Other apartments were occupied by members of the Prince and Princess of Wales's court and household.

It was perhaps the lack of a rigid system of posts under George I that led the king to issue new instructions to the Board of Works restricting work to non-royal parts of the palace to keeping the envelope of the building watertight. If officers or courtiers wished 'to make Any Alteracon or Addicon or any ways to adorn or embellish their said Lodgings' they must do at their own expense and only after scrutiny by the Board and with approval of the Lord Chamberlain.[10] These new orders set up the battle that was to run between occupants of Hampton Court, the Board of Works, the Royal Household and the Treasury well into the twentieth century. Less than a year after the new orders the king was forced to complain to the Board of Works that they were being ignored. The problem, the king was told, was defining who was an officer or courtier and who was a member of the royal family. Was, for instance, a king's mistress a courtier or family member?[11] We have already seen that controlling the costs of the king's mistresses' furnishing bills was a significant task.

During the major court visits in George II's reign the palace was at full stretch to accommodate everyone necessary. Not only did the king and queen have their household servants and officers but so did the royal children. The right to an apartment was still regarded as one of the greatest perks of royal service. In this, Hampton Court and Windsor continued to be particularly important since Kensington and St James's were regarded as being too small to provide space for courtiers. Moreover an apartment at Hampton Court or Windsor guaranteed 'travelling wages', a payment of something between 3s and 1s 6d a day depending on rank. In addition, many received allowances for stabling and other costs. The only disadvantage at Hampton Court was that during the long summer visits the travelling allowances were halved. Thus in the summer of 1717, when George spent almost four months at Hampton Court, his physician earned an additional £45, a gentleman usher, £22 and many other servants, between £5 and £10.[12]

For those allocated lodgings in Fountain Court George made significant improvements for the summer of 1731. New furniture worth £5,300 was ordered for the apartments including basic but comfortable, modern beds and bedding, curtains, tables, chairs, looking glasses, stools and close stools. Care was taken to match the colour of wall hangings, curtains and upholstery in a range of blues, greens, yellows and reds.[13] Later visits required no further new furniture and so the inventory of 1740 records the courtier apartments largely as they were in 1733. The apartments were smaller than those occupied by William III's courtiers, probably through lack of space. Henry Herbert, Lord Pembroke, the Groom of the Stool, only had a bedchamber, dressing room and servant's room near the backstairs, while the queen's Lady of the Bedchamber in Waiting had a 'first room', dressing room, bedroom and servant's room. Most household members apart from the very grandest seem to have had only three rooms.

★ ★ ★

The Start of Grace and Favour

After 1737 the non-royal apartments in the palace were never again allocated for a court visit. The permanent residents of the palace were the housekeeper, under-housekeeper, Keeper of the King's Privy Lodgings and the chaplain. However, there is evidence in the Lord Chamberlain's warrant books that from the early 1740s permission was granted to a limited number of select people to stay the summer at the palace. Many of these may have been the *nouveau pauvre* who later were classified as grace and favour residents. One such fortunate (or unfortunate) was Lady Sophia Thomas (née Keppel), daughter of William III's favourite the Earl of Albemarle, who entertained Horace Walpole to dinner in her rooms in 1748.[14]

Walpole noted, in 1762, that George III had decided to settle 'for good and all' at Buckingham House and had observed him sending for 'pictures from Hampton Court, which indicated them never living there'.[15] Walpole's presumption was correct and during the 1760s, apart from a few apartments granted out on an ad hoc basis by the Lord Chamberlain, Hampton Court endured the most silent decade of its long history. It seems as if the first official grace and favour apartment was granted to one Mr Pennington in 1767 and from that time on an increasing flow of residents were granted apartments. From 1773 the Lord Chamberlain began to issue official warrants and the history of grace and favour at Hampton Court officially began.[16] In granting these lodgings George III was following the precedent set at Somerset House where a formal decision had been taken in 1694 to convert the then redundant royal palace into a retirement home for people at the monarch's grace and favour.[17] At Hampton Court the palace housekeeper was given responsibility for monitoring the residents and maintaining up-to-date records, and in April 1773 the Office of Works was instructed to make surveys of the palace to be held by the Lord Chamberlain to enable him to determine the location of various apartments.[18]

Hannah More who visited the palace in 1770 noted that 'The Private apartments are almost full, they are occupied by people of fashion, mostly of quality; and it is astonishing to me that people of large fortune will solicit for them.' The rapid occupation of Hampton Court after 1767 was not by the well connected but poorly endowed widows and soldiers that were to live there later, but by peripheral courtiers with good contacts. Mrs More observed that 'Mr Lowndes has apartments . . . notwithstanding he has an estate of £4,000 a year. In the opposite one lives Lady Augustus FitzRoy. You know she is the mother of the Duke of Grafton.' One such early resident was Beau Brummell's father William, who was granted apartments in 1772. William Brummell was private secretary to Lord North who, having been made Ranger of Bushy Park, and thus granted the Ranger's House, wished to have Brummell nearby. But the king, who disapproved of Brummell living with a mistress there, required him to marry or move out. He did marry, and the couple brought up their children at Hampton Court. Ernest Law prints a letter by no less a character than Samuel Johnson requesting of the Lord Chamberlain an apartment at Hampton Court in 1776. Johnson was told that the palace was full and that there was a waiting list.[19] This list was maintained throughout the nineteenth century and by the 1880s and 1890s it contained over a hundred people. As fewer than thirty vacancies occurred in the whole period between

1860 and 1901 the chance of rising to the top of the list in the applicant's lifetime was slim.

By the 1830s grace and favour had become firmly established and publicly recognised, so much so that the local parochial authorities began to issue demands for the payment of a poor rate by the inhabitants. In 1838 Hampton Wick began proceedings against Sir George Seymour (the Admiral of the Fleet), Major Beresford (the Tennis Marker) and the Clerk of the Works. Four years later three law lords ruled, in the Court of Queen's Bench, that the palace was no longer exempt from taxes since the queen no longer lived there and thus was technically not a royal palace at all. It took three years for the palace residents and the Office of Works to accept the implications of this judgement, and although disputes continued to arise in respect of other taxes, the residents gradually were assimilated into the national tax system.[20]

Disputes over taxation began to draw more general attention to the privileges enjoyed by grace and favour residents at Hampton Court. As a result of questions in the House of Commons a detailed review of Hampton Court and its accommodation was launched in April 1842. It noted

> apartments in the Palace which are in the occupation of Private individuals; some consist of spacious drawing rooms, dining rooms, bedrooms, servants' rooms, kitchens and other domestic offices suitable for the accommodation of persons with considerable household establishments, and now, and always have been, occupied by persons of rank and distinction; and others are occupied by persons of respectable stations . . . The number of families now occupying suites of apartments in the palace may be taken to amount from 60 to 70, and the number of servants in their employment may be computed on average at between 150 and 200.[21]

The following year the Earl of Lincoln, while admitting that Hampton Court was the most expensive palace to keep up, noted that the public were admitted freely and that 'it was infinitely better that the apartments of the palace should be inhabited and kept in repair by those inhabitants, than that they should be allowed to go into decay, to be ultimately repaired at the public expense, or perhaps sold by auction'. 'Would it not,' he asked, 'be revolting to every lover of his country to have a palace erected by Wolsey and restored by King William, sold by Auction?'[22] The question of privilege was thus temporarily sidelined.

'Persons of rank and distinction' became gradually less common as residents and by the later nineteenth century all were needy in some way or another and almost all were women.[23] The Lord Chamberlain had ruled in 1844 that single men or widowers were not eligible and in the 1870s the rules tightened further and occupants were forced to resign their apartments on remarriage. Those urgently in need, and whose husbands had in some way valiantly served the nation, were rushed to the top of the list. Only three years after the death of Lord Napier of Magdala his widow was granted a suitably capacious apartment. During the nineteenth century, apartments were granted increasingly to widows of servants (either military or civilian) who had served overseas in the empire. By the twentieth century, almost all grace and favour apartments were granted to widows of distinguished military men.[24]

★ ★ ★

The Allocation of Lodgings

The allocation of lodgings at first was a simple, even naïve process.[25] A simple warrant made rooms over to a resident until further notice. But after 1782, largely due to absenteeism, warrants insisted that the holder, or a member of their family, should live there for a part of each year. By the nineteenth century the housekeeper had to present an annual return to the Lord Chamberlain showing the number of nights each resident spent at the palace. As the century wore on warrants became more restrictive and complicated, banning everything from dogs to measles and setting out clearly upon what terms the warrant could be revoked. In the early twentieth century the warrants were transformed into legal agreements signed by each party. From the late nineteenth century onwards warrants or agreements had little plans attached to specify precisely the area granted (fig. 325). The process of granting out the non-royal parts of the palace was complete before the end of the eighteenth century and about fifty suites of apartments had been carved out of former courtier apartments. A small number of new apartments were created after 1800, but essentially the suites that survive today were fixed before then. Within each suite is an enormously complex social and architectural conundrum. It would be possible in many suites to trace their decorative and structural form and social usage over 200 years. Plans, warrants and correspondence are voluminous, and for the twentieth century overwhelming in quantity.

The atmosphere in what William IV called 'the quality poor house' was brilliantly captured by Charles Dickens in a passage in *Little Dorrit* in 1857:

> The venerable inhabitants of that venerable pile seemed, in those times, to be encamped there like a sort of civilised gypsies. There was a temporary air about their establishments, as if they were going away the moment they could get anything better; there was also a dissatisfied air about themselves, as if they took it very ill that they had not already got something better. Genteel blinds and make-shifts were more or less observable as soon as their doors were opened; screens not half high enough, which made dining rooms out of arched passages, and warded off obscure corners where footboys slept at night with their heads among the knives and forks; curtains that called upon you to believe that they didn't hide anything; panes of glass that requested you not to see them; many objects of various forms, feigning to have no connection with their guilty secret, a bed; disguised traps in walls, which were clearly coal cellars; affections of no thoroughfares, which were evidently doors to little kitchens. Mental reservations and artful mysteries grew out of these things. Callers, looking steadily into the eyes of their receivers, pretended not to smell cooking three feet off; people, confronting closets accidentally left open, pretended not to see bottles; visitors, with their heads against a partition of thin canvas and a page and a young female at high words on the other side, made believe to be sitting in a primeval silence. There was no end to the social accommodation-bills of this nature which the gipsies of gentility were constantly drawing upon, and accepting for, one another.[26]

Alterations to the apartments were usually made as they changed hands. Although the Office of Works was prohibited from undertaking works more than putting the rooms into 'fair and tenantable

325 A typical grace and favour lodging plan from 1925. A Mrs Saunderson had occupied apartment 4, and on her death it was refitted for Mrs Carlton. This plan accompanied her grant.

repair', this in practice meant a complete overhaul and redecoration. In the later twentieth century this was transformed by the Property Services Agency into a 'reoccupation service', an almost complete refitting of the apartment. The cost of preparing an apartment rose as grace and favour became more formalised. In the eighteenth century 'fair and tenantable repair' cost less than £100, but by the mid-nineteenth century costs had risen to perhaps £500. In 1984–6 one apartment in Fountain Court cost £140,000 to prepare. Once a tenant was ensconced the rules were theoretically simple – other than keeping out the weather no work would be undertaken at public expense. A vast number of minor alterations were thus undertaken in the apartments to the design of the occupants and at their cost. Two of the most spectacular apartments in the palace were fitted out in this way. Mrs Offley Shore and the widow of Field Marshall Wolseley both transformed their apartments in the most fashionable and expensive modern style. The Offley Shore apartment fitted-out in 1936 was in the finest Arts and Crafts Tudor with state-of-the-art marble and chrome bathrooms to match (fig. 326). Lady Wolseley transformed hers into a shrine for her husband, laying a black and white marble floor with his arms in lead and creating an oratory in Italian Renaissance style in his memory (fig. 327).[27]

★ ★ ★

The Amenities of the Apartments

The apartments were often very large, indeed like a small country house, with all the ancillary rooms and servants quarters expected of an elegant residence before the First World War. In terms of convenience, however, most were very old fashioned. During the eighteenth century there were no water closets and residents had to rely on chamber pots and commodes. By the 1840s most apartments had one flushing water closet and by the end of the century there were usually two, one for the resident and their family and guests and a second for their servants (fig. 334). Kitchens were likewise primitive. In the eighteenth century they were always on the ground floor, even for residents with third-floor apartments. In the early nineteenth century residents began to fit-up kitchens within the upper floors of the palace. The Board of Works showed great concern at the fire risk this represented and for the damage to the fabric the works caused. The residents' servants cannot have been delighted either as they carried coal and provisions up the steep staircases. Gradually, all the apartments were fitted with kitchens with ranges and running water and eventually with gas and electricity.[28]

Likewise bathrooms were not a feature until the 1890s and when at first they were demanded they were restricted to the

326 Lavish panelling installed in her apartment by Mrs Offley Shore who moved in in 1935. Three years of work by this American widow transformed an apartment where she found 'dry rot, crumbling stone and other effects of age'.

lower floors due to concern for the possibility of leaks over the state rooms (fig. 328). By 1930 all the apartments had at least one bathroom. All these amenities had a creeping but decisive impact on the fabric of the palace. The burgeoning population of Hampton Court by the late 1860s was giving rise to concern about sewage being let directly into the river. In 1867 the Thames Conservancy Act was passed to prevent raw sewage being released into the river and a notice was served on Hampton Court to stop emptying its drains into the Thames by April 1870. In November 1867 the Board of Works turned to Joseph Bazalgette, engineer to the Metropolitan Board of Works, for his advice. He recommended a scheme for sewage treatment that would have taken up twelve acres of Home Park. This was blocked by the Master of the Horse who thought it would pollute the Long Water and spoil people's enjoyment of the Barge Walk. The scheme fell into abeyance and eventually the Thames Conservators instructed lawyers to prosecute the palace in March 1871. Work finally went ahead (at speed) in 1872 to solve the problem. Bazalgette built a sewer along Tennis Court Lane across the park and on to irrigated osier beds that could be ploughed up every third year and a crop planted.[29]

★ ★ ★

Grace and Favour Life

Grace and favour life at Hampton Court in the nineteenth century is chronicled in great detail in over 5,000 letters in the Lord Chamberlain's series at the Public Record Office.[30] Most of the correspondence is between the palace housekeeper and the ladies over details of regulations and their servants, dogs, maintenance problems and the increasing intrusion by the public. The greatest battleground was, however, the chapel. Under George II a permanent chapel establishment was maintained at the Whitehall chapel in the Banqueting House and in the chapels at St James's, but not at Hampton Court where during the summer a detached part of the Chapel Royal would attend the king. There, and at Kensington, there were also ministers appointed by the Lord Chamberlain to preach and say prayers for the royal family. The Reverend Samuel Croxall was appointed Chaplain in Ordinary to the king at Hampton Court in 1715. He was also vicar of Hampton and was in due course appointed Reading Chaplain by the Dean of the Chapel in the Chapel Royal. Croxall lived until 1752.[31] Thereafter, during George II's reign and into George III's, a chaplain was maintained at the palace during court absences and services were attended by the resident staff and the increasing number of grace and favour residents.

The institution of grace and favour in the 1770s meant that the Chapel Royal became the natural place of worship for the residents and after 1794 for the 200 cavalrymen stationed in the barracks. Seating in the chapel was strictly by rank and precedence and supervised by the housekeeper. The royal pew was reserved for members of the royal family which, in practice, meant that it was empty. After the opening of the palace to the public the chapel remained private and the only way to see it was to attend service. As Sunday was the most popular day for visitors this became a problem and in the 1840s a verger was appointed specifically to deter them. In 1864 it was reported that 'every Sunday morning the chapel is crowded. As soon as the doors are open, people rush in. The Ladies of the palace do not find room enough in the pews allotted to them, and there is much discontent among them. Sharing a pew leads to the greatest strife.' By 1866 the problem had become so pressing that Anthony Salvin was invited to re-order the pews to increase the capacity. His scheme involved adding box pews down the centre of the choir (fig. 329). While these were being installed the congregation used the King's Guard Chamber. The new layout led to a revised seating plan devised by the Housekeeper, Mrs Heaton. This was a complicated task given the need to separate the ladies from their servants and everyone from the soldiers who 'are sometimes a little affected by the smell of the stables'. Inevitably there was an outcry about both her new plan and Salvin's arrangement. The furore led to a decree from the Lord Chamberlain that henceforth there were to be no seats reserved in the chapel. Salvin was ordered to take the doors off the pews and ladies had to sit where they could.[32]

In 1831 Hampton Court acquired its first organist, W. H. Fitzgerald, who persuaded the Board of Works to pay for a restoration of the organ by Mr Hill in 1839.[33] Fitzgerald retired in 1845 and was replaced by Dr William Christian Sellé. On his instigation, in 1846, a letter was sent from the chaplain to the Board of Works reporting that there was no money to pay the choristers and that it was difficult to get them to attend. The Board had some sympathy with this problem but the Treasury refused to

327 The hall of Lady Wolseley's apartment, designed by the architect J. C. Davenport, with the memorial to Lord Wolseley on the floor.

328 Lady Baden Powell's bathroom inserted in one of the great fireplaces in Henry VIII's kitchen, photographed during demolition in 1978.

make over £50 a year to solve it. As a consequence the choir was disbanded in 1853. Yet by 1867 it was reported that 'the choir was augmented considerably' and a request was made to have the organ modified for them. Over the next fifty years a series of alterations to the organ were made to make it suitable for public worship. These culminated in 1902 when a hydraulic engine was installed to work the bellows and the post of Blower (a boy to pump the handle) abolished.[34]

As part of the Chapel Royal the Hampton Court chapel did not, at first, undertake the normal parochial duties of marriages, baptisms and funerals. However, changes in the law meant that after 1890 the chapel was opened for marriages for the families of palace residents. Before 1883 there was no font in the chapel and on the rare occasions that baptisms took place a makeshift arrangement with a bowl and a table sufficed. In 1883 two sisters, the Misses Ward, gave the chapel a stone gothic font that was installed in the centre of the nave (fig. 329). It remained until 1976 when the present font salvaged from All Hallows, Upper Thames Street, replaced it.[35] That there should be baptisms in the chapel is perhaps a cause for surprise given the average age of the palace residents. Yet there were enough children at the palace for it to have its own school.

The school seems to have been in Tennis Court Lane from the 1840s, serving the children of palace employees. In May 1859 it

329 The Chapel Royal in its re-ordered state for grace and favour worship, c.1897.

330 The palace school in Tennis Court Lane.

moved to the old bakehouse in the Trophy Gate buildings where it flourished – in the 1860s it had twenty-four children from the palace and mews. When in 1877 the Houses of Offices were finally demolished, the Lord Chamberlain insisted that a new school should be built, there not being any suitable in the vicinity. The matter was debated in Parliament and it was agreed that £300 should be awarded to the Board of Works to construct a new school. The site chosen was on the north side of Tennis Court Lane. John Lessels prepared designs for a new schoolhouse, which was built at a cost of £385. This was partly a conversion and partly new build and was to include a schoolroom, a house for the mistress and outbuildings (fig. 330). In March 1879 the new school was inspected by the Education Department and the work of the mistress praised as being careful and kind. The buildings, however, were criticised as being draughty, too high and damp. The palace chaplain, the Reverend Wodehouse, wrote to the Board requesting immediate improvements but as so often in the late nineteenth century grace and favour improvements were low in the Board's priorities and nothing was done. In 1883 there was an outbreak of diphtheria in the school and two children died. This inevitably led to cries for the building improvements to be executed. Lessels was clear that the disease owed nothing to the design of his schoolhouse, but nevertheless it led to an agreement by the Board to maintain the buildings. In 1893 the Education Department required the school to construct proper lavatories for the children and in 1898 the school mistress's house was extended. In 1907 the mistress's garden was converted into a playground for the pupils. This remained in use until 1955, by which time most pupils actually came from surrounding villages.[36]

The Danger of Fire

Fire had always been a great concern at Hampton Court and in 1716 all wooden chimney-pieces and chimney-beams were removed and replaced with iron or stone. At the same time Thomas Fort was instructed to inspect the Hampton Court fire engines and an order given that a bricklayer and a carpenter should be appointed to serve as fire watchmen while the court was in residence. In 1770 there was in fact a fire in the Houses of Offices, but it was quickly put out. Everyone recognised that

1. Room where the fire began. 2. Interior of the same. 3. Mrs. Crofton's dining-room. 4. Lady Torrens's drawing-room.

THE FIRE AT HAMPTON COURT PALACE.

331 An artist's impression of the 1882 fire from the *Illustrated London News*, 23 December 1882.

the increasing use of the palace by grace and favour residents was a fire hazard and precautions were periodically tightened up. In November 1823, for instance, the state of the palace fire engines and water supply was examined.[37] Soon after the appointment of Bertram Mitford as Secretary to the Board of Works a substantial overhaul of the palace fire precautions was undertaken. In 1870 a 30 horsepower steam engine capable of pumping 700 gallons a minute had been built to pump six jets up to roof level. In 1876 the palace Fire Brigade was reconstituted, made up of fifteen men, four of whom were employed at Hampton Court itself. In 1879 a Merryweather Patent double-cylinder, horizontal-fiscea steam-fire engine was purchased and fitted in a shed in the Wilderness connected to the canals and ponds.[38] Fifty-five fire hydrants were installed in the courtyards and a dry ring main at parapet level in Fountain Court. It was as well that these precautions had been taken for on Thursday 14 December 1882 a fire broke out on the third floor over the Queen's Gallery in an apartment occupied by Mrs Crofton, her daughter and two servants. It was started in the cook's room by an overturned oil lamp (fig. 331). The fire drill (amazingly practised only the previous evening) worked perfectly. The Clerk of Works telegraphed the Fire Brigade, and as the telegraph system did not extend to nearby towns a mounted hussar rode to Kingston, Twickenham and Richmond to summon extra help. Meanwhile, steam was got up in the pump and within ten minutes water was being played on the flames while men from the Queen's Own Hussars evacuated furniture from the grace and favour apartments and the State Rooms below. Three rooms on the third floor were destroyed and the Queen's Gallery and Bedchamber suffered water damage. Sadly the cook suffocated.

An inquest two days later at which the main protagonists, as well as Mitford himself, gave evidence agreed that a committee be set up to consider *The Protection of the Royal Palaces not Occupied by the Queen from Fire*. Under the chairmanship of Sir Spenser Ponsonby Fane, the Comptroller of the Household, it recommended that substantial fire breaks should be introduced, hot water and not oil stoves should be used for heating, a fire watchman's rota be set up, electric bells be introduced to warn of fire and a plan made for the evacuation of works of art. Implementation started immediately. Seventy-five pushes were installed to sound bells in the event of fire, a new watchman system instituted, fire walls built at a cost of £1,223 and hot water heating introduced into the State Apartments and Great Hall at a cost of £1,850. In

332 John Lessels, elevation of the north façade of the north range of Chapel Court before the fire of 1886.

333 John Lessels, presentation drawing showing the restored north elevation of the north range of Chapel Court as built 1886.

334 Possibly John Lessels, plan of 1887 of the first floor of the apartments to be formed in the range rebuilt after the 1886 fire.

the State Apartments the backs of the doors were given steel plates (only finally removed in 1990) and the most important pictures marked to facilitate a prioritised salvage operation. It was noted in chapter 15 that lifting mechanisms were also installed behind most large paintings; at the same time tapestries were attached to large timber stretchers to allow their rapid removal. These likewise were only removed in the 1990s and replaced by Velcro strips. On 9 January 1883, soon after the reopening of the State Apartments to the public, a presentation was made to the firemen in reward of their quick work.[39]

On 19 November 1886 another, far more serious, fire broke out. This time it was on the north front in the apartment of Miss Cuppage and had been caused by a candle left burning in a dark cupboard by a housemaid. Once again it was the palace Fire Brigade assisted by local brigades (150 men in all) and troops from the barracks who extinguished the fire. An unruly crowd who pilfered the evacuated contents of the apartments watched their efforts. The fire was made much worse by the Tudor construction of the apartments that provided voids to convey the flames both vertically and laterally. In all, seventy-five rooms were destroyed or damaged. Almost immediately the committee of 1883 was reconvened to consider what further action should be taken. After deliberation it was decided that while it was impractical to recommend the complete removal of residents from the palace, they should be required to insure their apartments against destruction by fire. They also felt that although the introduction of electric light would reduce the risk (as suggested by the SPAB) the cost of installation (£6,000) and maintenance (£1,200) made it uneconomical. Their main criticism was held over for the steam engine, which took at least twenty minutes to become an effective pump. Although no alternative was recommended, it was noted that a new method of delivering water was required. A number of other recommendations were made, including increasing the complement of the Fire Brigade by four and placing gates at the end of Tennis Court Lane to keep out the public in emergencies. Work started on the new precautions in 1887 at a cost of £1,022 and a water main laid from the pumping station of the Grand Junction Water works at Hampton was to replace the steam pump of 1870. Insurance cover of £40,000 was organised for the palace at an annual premium of £30, which was to be allocated between the various apartments determined by the Board and the insurers.[40]

The destruction of such a large section of the Tudor palace offered the opportunity for the work of Tudorisation to spread to the north front. A careful elevation was made of the damaged portions and Lessels proposed a complete refenestration substituting new casements for the old sashes (figs 332, 333).[41] Ernest Law noted of the work, 'the patched walls, the slated roofs, the commonplace sash windows, the nondescript doors, the shapeless chimneys' all gave way to a new Tudor aspect. Inside 'dark narrow passages, stuccoed walls, flimsy inflammable partitions' were succeeded by 'ample spaces, in harmony with the old cloisters, by solid walls, by oak panelled doors and the various quaint and picturesque features of the Tudor style' (fig. 334).[42] The new rooms were built in a solid, grand manner in a muscular Victorian style – the fireplaces of a particular gothic and the joinery details fine; even the door handles were designed by Lessels. Much had been made in 1882 of Wren's use of pugging in the floors and the way this had stopped the fire spreading downwards. In the new apartments pugging was inserted amongst the steel joists as a fire precaution too. This was a very early use of structural steel, and probably the first in a major historic building in England.[43] These forty rooms built at a cost of £8,000 are important because they were designed specifically for grace and favour use – the only such rooms at Hampton Court. The apartments were nothing if not spacious, stylish and modern, reflecting the needs of a grace and favour resident. Today (2003) they still retain many of their original fittings and as such are a valuable record of nineteenth-century grace and favour.

Gas and Electricity

The fires of 1882 and 1886 had done nothing to end the use of oil lamps by palace residents. But in reality there were few other choices. Despite the development of gas supplies in the 1860s the technology was unreliable and expensive, and most great country houses remained lit by lamps. Yet Windsor Castle had been supplied with gas by the Prince Consort ten years earlier and Brighton Pavilion twenty years before that. Thus in 1896 a petition was addressed to the Board of Works by a group of residents urging that the palace be put on a gas main. It was rejected as likely to be dangerous and the question of electricity also rejected as too expensive. In 1902 another small fire broke out in Fountain Court caused by an oil lamp and Sir Arthur Ellis, Comptroller of the Household, wrote to the Office of Works emphasising the urgency to abolish the use of oil: 'These decayed residents – mostly old women – get the cheapest twopenny halfpenny lamps, the cheapest and most dangerous mineral oil, the cheapest and most common "general maid servants" to look after them. Result – continual danger.' His pleas for electric power fell on deaf ears, but were not unreasonable. Since the 1880s many country houses had been lit by electricity and by 1900 there were thirty power stations in London. But the nearest power station was at Kingston and the cost of bringing electricity to the palace was estimated at £2,000. This the Office of Works could not justify, particularly as electric power was not needed in the State Apartments but only for the residents. Finally in 1900 the Twickenham and Teddington Electric Supply Company was established and their power station completed in Edwin Road, Twickenham, on 21 July 1902. Negotiations began between the Board of Works and the company to run a main under Bushy Park to the palace in 1904. The cable was finally run two years later and a main distribution installed in the palace at a cost of £9,556. Residents then had a choice whether to wire their own apartments. Those who wanted to but could not afford the cost paid a rental to the Board equivalent to 5 per cent of the capital cost.

Inevitably it was more expensive than expected to install all the cabling required. The builder's work to conceal the cable runs was expensive and soon after work started the question of electric heating and the requirements of the State Apartments were raised. During 1907, after considerable negotiation between the Lord Chamberlain, the Office of Works and the Treasury, it was agreed that electric heaters would be installed in grace and favour apartments. The following year the Board also decided to extend electric lighting to the State Apartments. The only area omitted from the scheme was the chapel.[44]

335 The south-west corner of Hampton Court from the railway station. The new grace and favour wing is distinguished by its striped tiled roof. In the foreground hay is being stacked on Cigarette Island.

Royal Residents

In 1795 William V, Prince of Orange, grandson of George II, fled to England in the face of the advancing French army, immediately to be welcomed by George III and granted apartments at Hampton Court. The prince moved into the former private apartments of George II on the east side of Fountain Court and was granted the use of the Queen's Guard and Presence Chambers as his outer reception rooms. The prince quietly resided at the palace, occasionally visited by George III until the Treaty of Amiens in 1802, after which he was free to return to the Continent.[45] Eighty-eight years later Queen Victoria granted an apartment to another royal resident. Princess Frederica of Hanover was the grand-daughter of the Duke of Cumberland who, in 1837, had become the King of Hanover (since Salic law excluded Queen Victoria, as a woman, from the succession). As a direct descendent of George II, she required Queen Victoria's permission to marry Luitbert Freiherr von Pawel Rammingen in 1880. After their marriage at Windsor they were granted the former housekeeper's lodgings on the south-west wing of the west front at Hampton Court. There Frederica gave birth to a short-lived girl. The baron and princess intended to live in some style and soon began to lobby the Lord Chamberlain for more space to accommodate their twelve servants and coachmen. The first suggestion was that they should absorb the Vine-Keeper's Cottage, but the Lord Steward in whose gift the cottage lay, refused to yield it up. As a consequence the prince and princess constructed the last major addition to the palace buildings. They converted the former stable buildings at the south-west corner of the palace, adding an extra storey and linking them to the main buildings (fig. 335). Since they paid for the work themselves, it is not known who designed the modest rooms or how much they cost. Although the Rammingens had a house in Biarritz they spent quite a lot of time at Hampton Court. The baron shot rabbits in the park and the princess played a full role with local charities; they even had a pew in Hampton Church marked with their arms. During the mid-1890s they spent much less time at the palace and finally gave up their apartment in 1898.[46]

The last royal occupant of Hampton Court was Grand Duchess Xenia Alexandrovna, the elder sister of Nicholas II, the last emperor of Russia, who fled to England in 1919 with the last Romanovs. Xenia was the favourite cousin of King George V and he had sent HMS *Marlborough* to Yalta to bring her back to England. At first she lived at Frogmore Cottage in Windsor Great Park but was moved to Hampton Court, to Wilderness House, in 1936. There she had a quiet life in the company of a Russian Orthodox nun. For their devotions a small chapel was set up in the house. She died at the age of 85 in 1960.[47]

Outlying Apartments

In addition to the principal grace and favour apartments in the palace, there were a number of outlying residences that included the Banqueting House, Wilderness House, George I's kitchen and the Pavilion.[48] Wilderness House (fig. 336) became a grace and favour residence only in 1881 when finally vacated by Mr Knight the Gardener of the Private Gardens (see chapter 17). The Lord Steward commissioned a series of works to improve the house to make it suitable 'for the residence of a lady or Gentleman, and not for a servant of her Majesty'. John Lessels conducted the alterations and in 1883 Lady Adam became the first resident. The house was given electricity in 1907 and its first bathroom in 1912.[49]

George I's kitchen on Tennis Court Lane was redundant by the late 1760s when it became clear that it would no longer be needed. It seems as if the western part was converted into a residence for one of George III's gardeners, Mr Padley, in 1785 to enable him to keep a close eye on the King's Kitchen Garden in the old Melon Ground.[50] The rest of the building seems to have remained empty until 1834 when the Clerk of Works, who had lost the old official Clerk's House on Hampton Court Green (Faraday House) to grace and favour in 1832, needed accommodating. For C. A. Carib, the new clerk, the eastern half of the kitchen was converted. By descent the western half was still occupied by a senior gardener in 2000, while the larger eastern half became the residence of the Palace Superintendent. After the abolition of that post in 1989, the apartment was leased to the Landmark Trust as a holiday home.

An important Williamite structure that became a grace and favour residence through a private gift was the Thames-side Banqueting House. In 1818 Soane had recommended extensive repairs be undertaken, but little was done above keeping the water out. In 1836 it was granted, on a whim of William IV's, to the Duke of Cambridge's secretary, Sir James Reynett, who built, at cost of £1,100 to himself, a dining room, pantry, bedroom and nursery on to the building. Ten years later he applied unsuccessfully to the Office of Works for an attic to be built on the house

336 The south elevation of Wilderness House (c.1700), the official home of the Hampton Court gardeners until the nineteenth century.

337 The two easternmost pavilions on the Bowling Green were first joined by a lath-and-plaster linking range in 1792. This was later rebuilt in brick and remained until the 1850s.

at a cost of £363 10s.[51] In 1864 it was granted to one Miss Baly who found 'very objectionable the large undressed figures in the frescoes on each side of the fireplace'. She ventured to suggest 'that they should either be draped or clouded in such a manner as to render them appropriate decorations for a drawing room'; Lady Reynett, the previous occupant, 'had large book-cases which entirely concealed them'.[52] Permission was given for her to cover them in silk wall hangings, under the supervision of the Office of Works (fig. 323).

The most substantial outlying residence was the Pavilion. Charting the history of the pavilions in the eighteenth and nineteenth century could fill a small book in itself. But for the history of the palace a number of key points should be made. The first is that they remained in royal occupation (on and off) until 1822, maintaining a direct royal connection with the estate. Soon after the accession of George III the Lord Chamberlain was instructed to fit-up the pavilions for the king's brothers, the Princes William and Henry. In June 1764 several loads of modern elegant furniture were delivered and the rooms redecorated with flock wallpaper.[53] Henry Frederick, Duke of Cumberland, died in 1790 (and seems not to have resided at the pavilions long before then) and William, then Duke of Gloucester, decided to make the pavilions a principal residence. In 1792 the duke commissioned William Tyler, a sculptor and architect who enjoyed his patronage, to link the two easternmost pavilions with a plain lath-and-plaster building 13ft high at a cost to him of nearly £1,000. This created a house that he, the duchess and their daughter could use (fig. 337).[54] The Duke of Gloucester died in 1805 and George III granted the title of Ranger of Hampton Court to Edward Augustus, Duke of Kent. The following year the duke wrote to the Office of Works stating that the pavilions, Ranger's Lodge, Stud House and stables were all out of repair and that £38,000 was needed for improvements. The Treasury flatly turned him down, probably in light of the enormous expenditure on his apartments at Kensington Palace. Yet work was eventually undertaken to maintain the house and embellish the garden for the duke, and the temporary linking building between the pavilions was rebuilt, for him, in brick. It is unclear how much time the duke spent at Hampton Court, but it is likely that its principal attraction for him was as a suburban hunting and shooting lodge. At any rate in 1819, after the birth of Victoria, he granted his equerry Major General James Moore the right to use the house. At this juncture it was probably already in a poor state of repair, as suggested by a survey by Thomas Hardwick in 1816.[55]

The Duke of Kent died in 1820 and two years later George IV confirmed General and Mrs Moore in their occupancy and agreed to the demolition of the two pavilions in worst condition. The general had never held a Crown post and so his tenure was not considered grace and favour and he thus had to repair the buildings at his own cost. Both the Board of the Office of Works and Lord Chamberlain were happy about this arrangement and intended to demolish the remaining pair just as soon as they were vacant. In 1844 the widowed Mrs Moore was offered an apartment in the palace to make this possible, but she declined to move. When she finally died in 1853 no maintenance had been undertaken for thirty years and Inman reported to the Board that the

house was not fit for habitation. But before any decision could be taken on demolition there was a change in government and the house was offered to Lady Isabella Wemyss, the widow of a general, and the Treasury asked for £1,562 to put it in order. At this point William Gladstone, Chancellor of the Exchequer, stepped in and the queen herself got involved. The result was that the connecting wing and the north-east pavilion were demolished and the remaining pavilion restored and granted to Mrs Shadforth, the widow of a colonel killed at Sevastapol, Lady Wemyss having been accommodated at Kensington. The Pavilion (as it now became known) thus became a grace and favour residence (fig. 338).[56]

This was granted to Ernest Law in 1895. Law had been brought up at Hampton Court where his mother and sister had had an apartment since 1833. He was called to the Bar but did not practise for long due to ill health. Instead he became involved in a number of business ventures, including omnibuses and railways. After petitioning the queen for a post as Curator of Pictures and later asking for the Banqueting House, Law was granted the Pavilion, where he lived until his death in 1930. In 1894 he built a library and bedrooms on to the building at his own cost.[57]

Law played an important part in the history of nineteenth-century Hampton Court and his influence is discussed in chapters 15 and 17. Yet he belongs as much in a chapter about grace and favour as he does in those about architecture and gardens. Law was the palace's greatest historian and his *History* will in some senses never be superseded. It combines a modern historical analysis with first-hand observations and remarks from a period of great change. All previous histories of the palace had given over the greatest space to Wolsey's ownership and had truncated the rest of its history into a few pages. Pyne, for instance, devoted twenty-five pages to Wolsey and six pages to the rest of the palace's history to 1813. Law's three-volume format was part of the restoration of the palace's fortunes around 1900. But in 1883, long before he had begun his greatest work, he had gained permission to set up a museum in two rooms lent to him by Lady Lyndhurst. Both the Office of Works and the palace housekeeper lent objects and in due course J. C. Robinson bought items including a copy of the Wyngaerde drawings to add to it. The museum was ultimately housed in the room behind the Queen's Gallery that still bears his name.[58]

338 The Pavilion today.

Chapter 17

THE PARKS AND GARDENS 1714–1914

THE GARDENS OF WILLIAM AND ANNE at Hampton Court enjoyed only a brief spell of fashionability. While most travel writers and topographers before about 1715 admired their formality, the tide of taste turned firmly against them early in the reign of George I. Thus while Thomas Cox in *Magna Britannia* thought the gardens 'improved to a wonderful degree' and Daniel Defoe in his *Tour* thought of the Wilderness that 'nothing of that Kind can be more beautiful', Batty Langley in 1728 thought the Great Parterre would be much improved if 'those trifling plants of Yew, Holly, &c. and their Borders taken away, and made plain with grass'. In the 1742 edition of Defoe's *Tour* the Hampton Court entry had been rewritten to accord with contemporary views. The Wilderness was now 'far from affording any Pleasure, since nothing can be more disagreeable than to be immured between Hedges'. Just as the baroque palace of Wren had fallen victim to the craze for the Palladian, so had the formality of William's gardens fallen to the dominance of landscape gardening.[1]

Under George I the post of Superintendent of the Royal Gardens was revived and Sir John Vanbrugh appointed to it. Henry Wise succeeded in keeping the post of Royal Gardener and continued to work for Vanbrugh through contract. In 1716 Wise entered into a partnership with Joseph Carpenter for the maintenance of the royal gardens at a fee of £20 an acre. His biggest responsibility was the 73 acres of Hampton Court; Kensington, the next largest, was only 55 acres. The Hampton Court gardens were quiet during George I's reign. The bower in the Privy Garden, which had decayed, was replaced in 1720; the Lower Wilderness, which had been damaged by flooding, was rebuilt in 1722;[2] and the timber steps at the south end of the Privy Garden terraces which had rotted were replaced by slopes in 1723. Otherwise a good level of maintenance was kept up, the walks were gravelled, the Tijou screens painted, border boards replaced and thousands of flower pots supplied for seedlings.[3]

The Gardens Under George II

Henry Wise retired in 1728 and his former assistant, and since 1726 partner, Charles Bridgeman succeeded him as Royal Gardener. Bridgeman's success was certainly due to his powerful private clients who included Sir Robert Walpole, but was also due to the fact that he had been employed by the king, while Prince of Wales, for his mistress Henrietta Howard at Marble Hill House, in Twickenham. The clinching factor must have been, however, his work for the Princess of Wales. In 1727 George II had settled the Richmond estate (that he had lived in as prince) on his queen, Caroline of Anspach. She immediately instituted a major programme of landscape works there to Bridgeman's designs with William Kent as architect.[4]

Although Bridgeman already had a house at Hampton Court where he had spent much time, in 1728 he moved into the 'Master Gardners Capitall house' as was his right. The building, now known as Wilderness House, was constructed in William III's reign and was the official residence of the Palace Gardener and a major perk (fig. 336). His fee for maintaining the royal estate was lowered from the £20 an acre of his partnership with Wise to £15 an acre. Although Bridgeman was the King's Gardener, at Hampton Court his client, in practice, was the queen. Although the remarkable gardens at Richmond were the focus of her interest, George and Caroline enjoyed Hampton Court as a summer residence. They also appreciated the gardens; Lord Hervey describes the king and queen having breakfast in the Privy Garden in 1733.[5] Caroline was responsible for a series of alterations at Hampton Court that had the effect of eroding the formality of the Williamite garden and introducing more naturalistic elements. In the Privy Garden, for instance, she ordered the removal of the steps in the centre of the terraces and before the queen's death in 1737 the *gazon coupé* was grassed over and the curviform beds (or *plates bandes*) were removed and the outer ones joined up. Yet the evergreens continued to be clipped, a visitor in 1727 noting the parterre crowded by huge evergreens clipped 'into the shape of obelisks on square pedestals'.[6] The Privy Garden henceforth was a straightforward *parterre à l'Angloise* – a garden of grass and evergreens.

In 1729 it was decided to resite the Tijou screens, removing them from the southern end of the Privy Garden and replacing it with simple tall iron spikes. After some consideration the screens were removed and placed on the park side of the Pavilion Terrace where courtiers could admire them as they walked to the bowling green. John Rocque recorded the Hampton Court estate in a fine map dedicated to Frederick, Prince of Wales in 1736 (fig. 340). Although probably based on Bridgeman's survey of around 1711, it shows the effects of the continued erosion of the formal gardens.

339 *(facing page)* Detail of a watercolour by John Spyers (fig. 345) showing the Wilderness, with the centre of the Maze, *c.*1780.

340 John Rocque, plan of the palace and gardens of Hampton Court dedicated to Frederick, Prince of Wales, 1736. The plan clearly shows the gradual erosion of the Williamite formality. In the Privy Garden, for example, the steps have been removed from the ends and middle of the terraces.

The year after Rocque's plan was published, approval was given for the construction of new offices on the north side of the palace on the site of the Melon Ground. This started a process that quickly gathered momentum whereby the north side of Tennis Court Lane became a village of store yards and workshops. After Fort's death in 1745 the Office of Works Architect and Gardener William Robinson made a survey of the Office Yard and Garden Ground on the north of the palace.[7]

Although the Hampton Court gardens were regarded as old-fashioned, the fact that the court regularly visited until 1737 ensured that they were of popular interest and frequently recorded.

The fashion for making prints of royal residences had come from France, where Louis XIV had set out to ensure that images of Versailles would be distributed all over Europe. In England Henry Winstanley's publication of the (then) royal house of Audley End in 1676 was the first contribution to the genre, but Leonard Knyff was the first to exploit the market for views of great houses systematically and on a large scale. His *Britannia Illustrata* of 1707 began by illustrating the royal estates, prominent amongst which was Hampton Court. In the 1730s and '40s Hampton Court drew a number of artists and printmakers who captured the gardens in their Georgian heyday.[8]

341 Jacques Rigaud, drawing of the east-front gardens, 1736. This drawing demonstrates that, despite the unfashionability of the formal gardens, they were beautifully maintained in the spirit in which they were planted in 1700.

The most important of these was Jacques Rigaud, the French artist who had recorded Louis XIV's palaces and whom Bridgeman had invited to England in 1733. He drew the Fountain Garden from the south in 1736 (fig. 341) and his view, engraved many times and in several versions, continued to be sold into the nineteenth century. Five views of the gardens by the designer Anthony Highmore were engraved by John Tinney and published in 1744. Like Rigaud, Highmore (who had painted Queen Caroline at Hampton Court) populated his views with courtiers strolling in the gardens (figs 342, 343).[9] The most remarkable record of the gardens was not, however, made for mass consumption but for Catherine the Great of Russia, who paid the huge sum of 1,000 roubles for two albums of drawings depicting Hampton Court and its two parks. The drawings were by John Spyers, the assistant and surveyor to Capability Brown and a competent but far from brilliant topographical artist. The first album contains 100 drawings of the estate and palace exteriors, capturing them in a state half-way between formality and the picturesque in about 1780 (figs 344–8).[10]

Charles Bridgeman died in 1738 and after that each royal palace was assigned its own gardener.[11] George Lowe was appointed to Hampton Court. His tenure of the post was almost without incident and in 1758 it passed to John Greening. In December of his first year Greening submitted an estimate for making a new plantation of fruit trees which led to the planting of 300 cherries, 30 peaches, 100 plums, 200 apples and 200 pears in the kitchen gardens for the king's supply.[12] Greening was only Head Gardener for six years, giving up his post to Lancelot 'Capability' Brown in 1764.

342 (*above*) Anthony Highmore, *The Diagonal Walk, Fountain and Canal in the Garden of Hampton Court* [on the east front], 1744.

343 (*right*) Anthony Highmore, *A Perspective View of the East Front of Hampton Court taken from the Park Gate*, 1744.

346 (above) Drawing by John Spyers showing the east-front gardens looking towards the Tennis Court, c.1780.

Capability Brown, Thomas Haverfield and the Rise of Tourism

Brown had long desired a royal position and the Hampton Court job, with a salary of £2,000 a year and a fine house, was, other than the post at Kensington, the leading salaried gardening post in England. Brown was no stranger to Hampton Court and its environs and had even advised David Garrick on some improvements at his Thames-side villa at Hampton. Thus despite acquiring a country house at Fenstanton in Cambridgeshire and a place in Hammersmith, he principally resided at Hampton Court.[13] Theoretically Brown had free reign over the gardens but in October 1770 he was reprimanded by the Board of Works for the gardens being in disorder and instructed to maintain them according to his contract. Brown replied robustly, firstly throwing doubt on the authority of the Board to instruct him, and then writing on 5 November 'My wish and intention is to keep them better and to put them in better order than ever I saw them in & have stopped at no expense in procuring trees and plants, nor grudged any number of hands that were necessary.' Yet Brown lost and the Office of Works secured Treasury authority over him and instructed him to answer to the Board.[14]

The apparent neglect of the gardens may, in fact, have been the result of deliberate policy. It is often noted that when given the opportunity to sweep away William III's formal layout by George III, Brown refused 'out of respect to himself and his profession', but it seems certain that from 1764 he stopped cutting the topiary

344 (facing page top) Watercolour by John Spyers showing the Privy Garden from the terrace looking south, c.1780.

345 (facing page bottom) Watercolour by John Spyers showing the Wilderness, with the centre of the Maze, c.1780.

and the garden began, perforce, to take on a more naturalistic aspect. The evidence of Spyers's drawings (figs 347, 348) suggests that he also felled sections of the avenues in Home Park in order to open cross vistas between the Stud House and the pavilions. The effects of these changes may not have been appreciated. Thomas Jefferson on his 1786 tour of gardens in England noted bluntly of Hampton Court, 'Old fashioned – clipt yews grown wild'.[15] Brown's tenure is best known for the planting of a vine in one of Queen Mary's hothouses in the Glass Case Garden. The Black Hamburgh vine, grown from a cutting from an Essex manor house, still survives. In 1800 the Grape House was enlarged to accommodate the expanding vine and the same year it reputedly yielded 2,200 bunches for the royal table. In 1825, due to the decay of the seventeenth-century building, it was decided to build an entirely new Grape House to a design by Thomas Hardwick.[16]

In 1783 Thomas Haverfield succeeded Brown as Royal Gardener.[17] Like Brown before him he was principally responsible for

347 Watercolour by John Spyers of the view looking north across Home Park with the Stud House in the distance, *c*.1780. This view and that in figure 348 suggest that Capability Brown may have felled parts of the formal avenue to open up vistas across the park between the Stud House and pavilions.

348 Watercolour by John Spyers showing the view looking south across Home Park towards the pavilions, *c*.1780.

349 Wash drawing of the east-front gardens in about 1800 by Thomas Rowlandson, showing their neglect by the palace gardeners and their use by fashionable visitors.

maintaining the status quo. According to the anonymous compiler of the *Pocket Companion to the Royal Palaces* published in 1801, the gardens still 'appear to best advantage in their present state; which is not the modern natural stile, but that which prevailed some years ago, when mathematical figures were preferred to natural forms'.[18] But Haverfield, and to a lesser extent Brown before him, was having to contend with an important new influence – tourism. Access to the Hampton Court parks and gardens had been restricted while the monarchy still used the palace, with the exception of the road through Bushy Park that was seen as a public right of way. An attempt to close the road by the Earl of Halifax, the occupier of Bushy House, led to a celebrated campaign that resulted in a judgement against him in 1752.[19] After 1760 it was possible for respectable people to visit Bushy Park, the Wilderness and the Fountain Garden via the Lion Gate without charge or hindrance. James Boswell was one such visitor in 1785. He set out in a chaise to see Strawberry Hill, the Hampton Court gardens and Pope's Grotto, having a picnic in Bushy Park on the way.[20] A series of drawings by Rowlandson captures the atmosphere of the gardens at the end of the eighteenth century (fig. 349). The increasingly overgrown walks are filled with ambling visitors and lovers arm in arm, and a rowdy element is hanging around outside.

During the reign of George IV the parks and gardens reached their nadir. The king had decided to denude them of all their sculpture and re-erect it on the east terrace at Windsor.[21] His brother William, Duke of Clarence, who lived at Bushy House as Chief Steward, turned to the trees in Bushy Park as a source of income and embarked on a series of major fellings yielding a substantial income. The area of deer park was reduced and over 400 acres let out for pasture. As we have seen, the king meanwhile enclosed more space for the stud. J. C. Loudon visiting the gardens in 1833 wrote in the *Gardener's Magazine*, 'The Gardens are excellent of their kind, and it is to be regretted that they are not kept up, either with sufficient care in point of order and neatness, or due attention to their original form. The walks are harrowed, instead of being rolled, and look more like newly sown ridges of corn land in a gravely soil than walks. The flowers and shrubs are straggling and tawdry, neglected or badly pruned, and either overgrown or deformed.'[22] The only saving grace was the careful work of Sir John Soane who paid special attention to the Privy Garden in his surveys of 1816–22 and in 1822 undertook considerable repairs to its architectural shell.[23]

The Reform of the Gardens

The tide of governmental reform in the 1830s (discussed in chapter 15) touched the gardens as much as the palace. The orders that came into effect in April 1832 divided the gardens into two parts, recognising an unofficial division that had existed for several decades. The Wilderness (except the Maze), Fountain Garden and Pavilion Terrace were to become the public gardens and fell under the authority of the Office of Woods and Forests, while the South Gardens would be reserved for the grace and favour residents and would be maintained by the Royal Gardener, Augustus

350 Detail of a plan of the Hampton Court estate by Henry Sayer, 1841. This important survey records the early years of the gardens as public pleasure grounds. The Tiltyard is still a kitchen garden with greenhouses in its south-east quarter. While the Privy Garden has been transformed beyond all recognition from its eighteenth-century form, the Wilderness retains much of its historic layout. The flower beds on the east front are clearly visible, as are a number of grace and favour gardens – in Chapel Court, to the east of the Georgian kitchen and to the south of the Trophy Gate buildings. The paddocks for the royal stud are shown in the bottom right corner.

Turrell. Edward Jesse, the Itinerant Surveyor, and a naturalist by training, would henceforth have responsibility for the public gardens as well as the palace buildings. He took immediate steps towards improvement under a new gardener, Mr Johnson. The *Gardener's Magazine*, that had bemoaned the poor state of the Hampton Court gardens in 1833, was full of praise by 1837.[24] The gravel paths had been overhauled, borders were planted with climbing roses and the herbaceous planting was being improved with the introduction of flower bedding (fig. 350). In 1844 the Barge Walk was created as a towing-walk, superseding sedgy winding borders and providing a place for local people to stroll and picnic.[25] The huge surge in visitors after the palace was opened free brought more problems for Jesse and Johnson but also stimulated a desire to bring the quality of the gardens up to the quality of display in the palace. By the 1850s they had succeeded and the Fountain Garden was famous for its flowers. The *Cottage Gardener* reported in 1855 that 'there are just as many, if not more, plants bedded out here than at Crystal Palace' and that 'the Flower gardening at Kew is as that of a cottage garden' by comparison (fig. 351). In September 1859, the *Gardeners' Chronicle* noted 'The flower beds are just now at their best, having been within these last three years greatly increased in numbers, upwards of 100 having been added to them'. Crystal Palace Park, Hyde Park, Kew and elsewhere had all turned to flower gardening with gusto in the mid-century and Hampton Court was riding on a tide of popular fascination with horticulture. The *Gardeners' Chronicle*

noted that 'Flowers are wanted in the people's parks just because people's houses have no gardens'.[26]

Since the mid-1840s there had been a debate as to whether the kitchen gardens could or should continue to supply the Queen's Household with fruit and vegetables. In 1848 it was decided that with the exception of the vine (which would continue to supply grapes) all the kitchen gardens at Hampton Court would be relinquished to the Office of Woods in exchange for some land at Frogmore in Windsor Great Park. The old kitchen garden, it was decided, would be let to a fruitier from Kingston, Thomas Jackson, who had just been appointed as head gardener for the public gardens in place of Johnson. Jackson would henceforth both run his private business from Hampton Court and undertake his official duties. Jackson's lease was renewed in 1878 and in 1887 it was granted for another fourteen years to Jackson's son.[27] From this on-site nursery Jackson senior provided the vast quantities of bedding plants required for the east front. His successor as head gardener, James Donald, improved the prospects for bedding even further. The east-front yews, ragged, overgrown and covered in ivy, made underplanting with bedding impossible. By cutting back and clearance he removed the romantic air of decay from the gardens and subjected them to the rigidity of Victorian flower gardening.

Donald was replaced in 1874 by W. Brown and two years later by Archibald Graham. Brown and Graham were responsible for introducing the new fashion for carpet and tapestry bedding to the east front – that is to say bedding out with foliage plants and succulents as well as flowers. These displays were again the pride of Hampton Court and the envy of other public gardens. Plans of Brown's tapestry and carpet bedding schemes were published in the *Journal of Horticulture* for others to imitate (fig. 352).[28] In the 1880s the fashion for carpet bedding gave way to something less garish, and the use of foliage declined as bushier and spikier plants such as fuchsias were introduced (fig. 353). In 1897 J. A. Gardiner took over from Graham and began to introduce a more unrestrained aspect to the gardens. It was he who was responsible for restructuring the enormously long herbaceous border on the east front. Ten feet wide and a quarter of a mile long, the border was set against the ancient palace walls heavy with cascades of clematis. The southern section was wilder and purely herbaceous while the northern part to the Flower Pot Gate was mixed in bulbs and shrubs and was more formal with an edging.[29] Walter Jerrold, the writer of an Edwardian book on Hampton Court, thought these borders

> with their succession of spring bulbs and summer flowers, their brilliant annuals and massed perennials are not only a delight to the eyes of all, but that they afford endless hints, are as it were horticulturally educational to garden loving visitors, may

351 Bedding on the south front with exotic plants and citrus trees on the terrace in 1875.

352 Planting plan for one of the beds on the east front, from the *Journal of Horticulture*, 1879.

354 The long herbaceous border looking north, painted by Robert Hughes in the 1920s.

be gathered from the frequency with which such visitors are seen to consult the name labels of the various plants[30]

Ernest Law, who took as particular an interest in the gardens as he did in the palace claimed, with a degree of truth in 1926, 'There are no gardens in England where the modern developments in bedding out and the planting of herbaceous and mixed borders have been carried out to so high a pitch as at Hampton Court. Indeed, to a great extent, the fashion was started here' (fig. 354).[31]

Despite the rise of a more naturalistic approach to the Hampton Court gardens, the tradition of bedding out the east front continued with vigour. W. J. Marlow, the Superintendent, in 1910, was congratulated by the *Journal of Horticulture* for providing this more old-fashioned type of display as well as the great borders. For the coronation of George V he created a bed 30ft long and 14ft wide bedded out with the royal monogram, crowns and the dates of the king's birth and coronation. Indeed he was styled 'The Wizard of Hampton Court' by the *Daily Sketch* for his ability to create such striking displays. Yet he had learnt to balance the formal bedding styles of the previous century with a more informal style of gardening developed in the Wilderness.[32] The Wilderness had long been regarded as the weak spot of the Hampton Court gardens, especially since the public were still admitted through the Lion Gates and it gave visitors their first impressions. A guidebook for 1851 had regarded it as 'a subordinate and inferior part of the whole, and which might be removed without any loss, beyond the shadiness of the walks which it affords'.[33] J. A. Gardiner, for the first time since the eighteenth century, had a clear vision for this compartment and converted it into a naturalistic 'wild garden'. Many of the old elms were felled, the ivy cleared and quantities

353 The east-front gardens, showing the bedding in 1919, as photographed for the *Gardeners' Chronicle*.

350

355 The Privy Garden in the late nineteenth century. The garden had turned in on itself creating hidden boxes or groves that grace and favour residents could enjoy.

of flowering dwarf trees and shrubs planted. Beneath these were bulbs and flowers set in a new matrix of paths and vistas. Although the hornbeam maze survived the naturalising campaign, 'Troy Town' was converted into a rocky dell. Marlow developed and nurtured this naturalistic garden in the first quarter of the twentieth century, actively encouraging, for instance, the growth of tall dandelions.[34] The naturalising theme had also touched the Privy Garden, which too fell under Gardiner's remit. One-quarter of this was transformed into a 'wild garden' (fig. 355).

In 1856 the Maze that had been retained under royal control was handed over to the Office of Works and one William Dobson put in charge of maintaining it in exchange for collecting the fee 'not exceeding 1d per person' (fig. 356). It was in 1889 with the Maze in Dobson's lucrative care that Jerome K. Jerome immortalised a visit to it. His character Harris claimed 'We'll just go in here, so that you can say you've been, but it's very simple. It's absurd to call it a maze. You keep on taking the first turning to the right. We'll just walk around for ten minutes, and then go and get some lunch.' Needless to say Harris and the group of lost tourists he gathered around him were trapped for several hours and even a rather young keeper could not rescue them. In the end 'They had to wait for one of the old keepers to come back from his dinner before they could get out.' Dobson was still in post in 1898 at the age of 74, taking at least £200 a year. In 1900 after some difficult negotiation he was removed and a brutal turnstile added. In the first month of the turnstile there were 8,474 visitors.[35]

The Tijou Screens and Statuary

The Tijou screens that had been gracing the Pavilion Terrace Walk since 1729 were in a very poor state of repair by 1859[36] and on the instigation of Henry Cole the Commissioner of Works authorised the panels (but not the gates) to be removed to the Victoria and Albert Museum on the condition that they were properly restored and that the transfer should be strictly regarded as a loan. The screens were duly transferred to South Kensington and the resultant gaps filled in with new iron railings. By 1867 increasing awareness of the importance of the screens, both inherently and to the history of Hampton Court, led to calls for their return, calls that were stoutly resisted by the V&A on the grounds that the work of restoration would be undone if they were placed outside again. Nevertheless in 1867 two screens were returned while the others still made up part of the V&A circulating collection in places as far away as Dublin and Edinburgh. In due course the matter reached the House of Lords where the point was made, forcibly, that the screens were only ever loaned and that

356 The Maze was famous from the 1840s and a diagram was reproduced on the back cover of Grundy's *A Stranger's Guide to Hampton Court* to help people find their way to the centre.

their eventual return was always understood. In the autumn of 1900 they started to return, first from Wolverhampton Art Gallery, then from Edinburgh. The Town Clerk of Nottingham was very reluctant to release their screen, as was Sheffield Museum, but both eventually gave up their booty. Meanwhile the battle over whether to place them outside was won by the champions of restoration who, with Edward VII's support, had them replaced at the south end of the Privy Garden (figs 357, 358).[37]

Since the removal of the original statuary by George IV, the Hampton Court gardens had been devoid of any sculpture. By 1856, with over 200,000 visitors annually to the gardens, Charles Knight argued, 'Restore the old statues, or give us something even more instructive in their place. Fill these gardens with such choice sculptures – we care not whether they are copies or originals – as may harmonize with the character of the buildings.' He even suggested that 'It is a place for statues of our British worthies.'[38] His pleas, and those of others, carried the weight of public opinion behind them and so in the 1860s the Board of Works decided that it should purchase statues to fill the empty pedestals. In 1864 the dealers Austin Seely and Company provided a series of vases and figure groups and a set of figures showing the four seasons by Robert Jackson.[39]

★ ★ ★

The Parks

Bushy Park was freely accessible to the public for most of the nineteenth century. One of the attractions was the horse chestnut blossom each spring that drew thousands of Londoners to marvel at the sight. Local publicans marketed the Sunday when the blossom was at its height as 'Chestnut Sunday', from the 1890s drawing many thousands more (fig. 359).[40] Another public use of Bushy Park was the cycle meets that had started in the early 1870s. By 1877 the *Scientific American* claimed that the biggest ever meet of penny-farthing cyclists (numbering nearly 2,000 people) had taken place in the park. After the invention of the safety bicycle the meetings trailed off. Meanwhile the lodges in Bushy Park were in need of new uses. Bushy House became, in 1900, the home of the National Physical Laboratory (NPL), in response to a search by the Royal Society to find a suitable location for a laboratory for national standards. The laboratory still occupies the house and grounds and was responsible for some of the most important scientific advances of the twentieth century, including the development of radar. From 1919 until the mid-1930s Upper Lodge was an open-air residential school (known as the King's Canadian Camp School) for poor boys from the East End recovering from respiratory diseases. In 1945 it became an outpost of another Government research facility – the Admiralty Research Laboratory. Both the NPL and the Admiralty built substantial test buildings including ship tanks large enough to test Barnes Wallis's bouncing

357 J. M. W. Turner, *Hampton Court seen across the River*, c.1829. This view shows the end of the Privy Garden without the Tijou screens.

358 (*below*) The Tijou screens after restoration in 2002.

359 Royal Chestnut Sunday at Bushy Park in 1909. Note the number of cyclists.

bomb and a vast circular submarine tank at Upper Lodge. Upper Lodge was relinquished to the Crown Estate in 1994.[41]

While Bushy Park was a public amenity, Home Park throughout the nineteenth century had been retained as a private royal reserve centred on the residence of the Master of the Horse at the Stud House.[42] The stud itself was more or less active at various periods; venison from the herd had been provided for the royal table and the ice house had been in service for keeping game. Grace and favour residents were the only ones who had recreational access to the park, and only by key. In 1889 there was a disagreement between the Office of Works and the Master of the Horse about the right of the local poor to gather firewood in the park. The queen made it quite clear that the poor were not entitled to do this and that the perk belonged to the Master of

360 Skating on the Long Water in the winter of 1905/6.

the Horse. This disagreement led to a scrutiny of the rights and privileges of the Crown in the park that was resolved in the favour of the local poor. It also questioned the justification for maintaining the park for private use. G. Shaw Lefevre wrote from the Board of Works to Lord Harcourt in 1892: 'Sooner or later the Park must be thrown open – there is a great population growing up on the other side of the river from Kingston to Thames Ditton which it will not be possible long to exclude. Even now it is found impossible to exclude them when the Long Water and Ponds are frozen. They swarm over the fences in such numbers that it is found necessary to admit them' (fig. 360). The following year Lefevre received a delegation from Kingston and Hampton asking for the opening of at least part of the park. Negotiations led by Lefevre during 1893 led to the agreement of the queen to open two-thirds of the park to the public from Whit Monday 1893.[43] Only a small area was reserved for the stud and the herbage (right to hay) was retained.

Things moved quickly after Lefevre's initial victory. The following year it was decided to close the stud, and as the deer had been removed some years earlier it was proposed that the Master of the Horse's department give up possession of the park completely and cease to pay the herbage there (a saving of £500 a year). The former grasslands were advertised in the hope of getting a tenant, but as high enough bids were not forthcoming it was let on a short-term basis while it was decided what to do. In 1895 a number of important resolutions were made. It was decided that 120 acres were to be retained for public use and recreation; 6 acres of meadow were to be set aside for allotments for the labourers of Hampton Wick; and a golf club was to be formed on the south side of the Long Water. Pressure to form a golf club in Home Park had been brought to bear by a local committee of golfing enthusiasts who saw the withdrawing of deer and brood mares as a chance to establish a golf course in the overpopulated area. A nine-hole course was built; a shed (not a club pavilion) was erected; and membership fees set at 1 guinea for men and 10s 6d for women. By 1898 the club had about 400 members and pressure was brought to bear to extend the course by another nine holes. This was eventually agreed to in 1904 but without granting any extra land. The following year the club obtained permission to extend their 'shed', a structure built by J. Nixon Horsfield in 1899, to include a ladies' room, smoking room and other facilities. It burnt down in 1910 and was rebuilt larger and more elegantly by Godfrey Pinkerton.[44] Two years after the golf club was founded permission was given for the establishment of a model yacht club in the rick pond at the far eastern part of the park. In 1911 their boat-house was extended and painted green. It remains *in situ* today. This increasing use by the public led to a series of new access gates being introduced into the park.[45]

The Private Gardens

Although the Privy Garden had been handed over to the Office of Works and opened to the public in 1893 (apart from a tennis court at the south end), the Glass Case Garden was still entirely private in 1900.[46] Visitors had, however, been able to get access to the vine by knocking on the garden gate. By 1899 on bank holidays over 10,000 people squeezed in and out of a single door to marvel at the famous plant. In October 1899 it was recommended that a new circulation be built with an 'in' and an 'out',

361 The Victorian vine house as recorded by Augustus Turrell in November 1810. The fireplace for heating the walls can be seen, as can the ropes and pulls for operating the ventilation system.

but the upkeep of the vine, and the private gardens, was still the responsibility of the Royal Household who refused to make any alterations for a public attraction. This opened up a debate as to whether the Office of Works should take responsibility for the vine and indeed the gardens to the south. Viscount Esher, Secretary to the Office of Works, was told that there were two principal objections: first, the right of the grace and favour residents to privacy and second, the absolute requirement of the queen to have grapes at her table. The debate rumbled on into 1902 when Edward VII agreed in principle that the Glass Case Garden should be transferred to the Office of Works. This it duly was in April, and the following year the Vine House was rebuilt for public access (figs 361, 362).[47]

As part of the same process Esher considered the matter of the leased kitchen gardens in the Tiltyard. In 1900 they were leased to one Mr Naylor who lived in the single surviving tiltyard tower, which he had converted into a comfortable residence. Naylor's business was very successful. Market gardening had swept Middlesex and was the main land use of the parish of Hampton. In 1884 there had been only one nursery in Hampton, but by 1900 there were thirty-two with about six hundred greenhouses. Many produced flowers but vegetables were almost as popular and were transported to London daily by rail.[48] In 1902 Esher argued that Naylor should be bought out because 'the immediate precincts of a great historical monument such as Hampton Court, should not be utilised for the purpose of obtaining a small rental, at the expense of the public, who are thereby prevented from fully enjoying the amenities of the place'.[49] As shall be seen, despite this, Naylor clung on to his highly lucrative rights for over twenty years more and his son still had a vegetable stall at Trophy Gate in 1932.[50]

By the First World War the Hampton Court gardens had turned full circle. They had never been more popular or influential; they

362 Grapes being harvested and weighed in the autumn of 1924. The new Vine House with its public viewing cabin was built in 1903.

were at the forefront of public appreciation and enjoyment of horticulture; and, together with Kew, they were probably the most famous public pleasure gardens in England. They were an essential part of the tourist's itinerary and an integral part of the English summer holidays.[51]

Chapter 18

THE TWENTIETH CENTURY

ERNEST LAW'S GREAT THREE-VOLUME HISTORY OF Hampton Court was published in 1899–1901, taking the history of Hampton Court up to the writer's own time. The history of the palace in the twentieth century has thus, before now, not been written. It is perhaps for this reason that Hampton Court has not been considered a particularly influential building in the twentieth century. This chapter will attempt to dispel that view. The palace has been signally important in the development of attitudes to the presentation of historic buildings open to the public and in attitudes to building conservation. It could also be argued that the palace's management arrangements have been influential both in Britain and elsewhere, particularly in the 1990s.[1]

The nineteenth century saw a number of changes in the management and control of the palace; these accelerated during the twentieth century and it is necessary to give an account of these to set the administrative scene. In 1882 the Inspectorate of Ancient Monuments was set up with the task to 'report to the commissioners of Works on the condition of such monuments and the best mode of preserving the same'. The first Inspector was Augustus Pitt-Rivers, the general, anthropologist and archaeologist. Their work was essentially archaeological until the appointment in 1910 of C. R. Peers (1868–1952), who was an architect and architectural editor of the *Victoria County History*, later to become Surveyor to the Dean and Chapter of Westminster. Peers was the first Inspector to be really interested in historic buildings, and was involved in the excavation of the moat at Hampton Court. His successors, particularly George Chettle and John Charlton (who were successively Inspectors for London), were to be the first professional scholars of the royal palaces and thus of Hampton Court. The Inspectors' views on the treatment of Hampton Court were to have a fundamental influence on its history during the century.[2] In 1962 the Ministry of Works became the Ministry of Public Buildings and Works, and Hampton Court was one of the public buildings in its care under a Parliamentary Funding Stream (vote) that covered the royal palaces. In 1969 the Hampton Court vote moved from the royal palaces to Ancient Monuments and fell to the care of the Directorate of Ancient Monuments and Historic Buildings of the Ministry of Public Buildings and Works. The following year the Ministry was absorbed by the new Department of the Environment (DoE). Within the DoE the Directorate of Ancient Monuments and Historic Buildings (DAMHB) became responsible for policy and the big developmental projects in all ancient monuments and historic buildings, either in the guardianship of the State or directly managed (like the royal palaces). These projects were known as part I works. Meanwhile a new body, the Property Services Agency (PSA), officially constituted in September 1972, became responsible for new buildings (part II works) and maintenance (part III works).

In April 1984, as a result of the previous year's National Heritage Act, DAMHB was moved into one of Prime Minister Thatcher's 'Next Steps' executive agencies, as part of the move to place any activities that could be out of direct Government control.[3] Most State-controlled ancient monuments and historic buildings (but not the royal palaces like Hampton Court) were transferred into the Historic Buildings and Monuments Commission (HBMC). The unoccupied royal palaces, it was felt, could not be transferred out of central Government control to HBMC without its looking as if they were being privatised. This left Hampton Court (and the other five royal buildings in this category) in an ambiguous position. HBMC (soon to be given the popular name English Heritage) was to retain an advisory role on the historical and archaeological side; the PSA was to continue to undertake building and repair work; but the actual management of the buildings would be undertaken directly by the DoE from its offices in Marsham Street, London. At Hampton Court the position was complicated by the continued involvement of the Lord Chamberlain, creating a four-way split of responsibility. In 1986, after a disastrous fire, the DoE gathered together all its responsibilities under a single administrator to whom the PSA answered. This arrangement led, two years later, to the formation of an executive agency, Historic Royal Palaces (HRP), that was given complete control over Hampton Court and five other unoccupied palaces answering to the Secretary of State for the Environment. After the election of 1992, responsibility for HRP transferred to the newly created Department of National Heritage and after the Labour victory of 1997 to the Department of Culture, Media and Sport. Finally in 1999 HRP became an independent charitable trust receiving no grant in aid from Government.

Amidst these chopped and changed structures different monarchs took a varying interest in the palace. Some, such as Edward VII and Queen Mary, had affection for it – Edward was

'amazed at the splendour of his possession'; others like George VI were less interested.[4] Yet 'royal' events continued to be held at Hampton Court, and still are today. Throughout the 1920s there were garden parties on the east front for a variety of causes, including the National Art Collections Fund and the Royal Institute of British Architects. For ten years from 1944 the Orangery was used for weekend summer concerts some of which were broadcast. The war also brought a spate of events to the Great Hall, many for raising money for the war effort. In June 1946 Hampton Court was the venue for a party after the Victory parade. There were 1,000 guests including the Prime Minister, the queen and several Indian princes. After the war permission was given for the performance of two masques acted for the Festival of Britain. As an austerity measure in the 1950s a certain amount of Government entertaining was moved from Lancaster House to Hampton Court.[5] The state visit of the Dutch queen in 1982 concluded with a banquet at Hampton Court and in 1984 it was there that the Prince of Wales delivered his famous speech – criticising much modern architecture and denouncing a proposed extension to the National Gallery as a 'monstrous carbuncle' – to the 150th anniversary dinner of the Royal Institute of British Architects (RIBA). Although Her Majesty the Queen has visited Hampton Court several times during her reign, it has not been an object of special interest (fig. 402). Indeed she informed me that she was glad that her predecessors had given it up as she found it 'terribly confusing'.[6]

Despite, and often because of, these rapidly changing accountabilities the twentieth century saw three major periods of restoration, 1930–38, 1974–83 and 1989–95. It also saw a rapidly developing appreciation and understanding of the palace's history and archaeology. Law's *History of Hampton Court* had laid the foundations, but as good as the book was its focus was social history and there was no attempt at an archaeological interpretation of the building. The standard for such a work was the remarkable *Windsor Castle, an Architectural History* by W. H. St John Hope, the Assistant Secretary to the Society of Antiquaries, published in 1913. Hampton Court was not to have such a comprehensive analysis that century. Yet enormous progress was made before the First World War in further untangling the palace's history. In 1911 came the second volume of the *Victoria County History for Middlesex* containing sections on Hampton Court by Edith Keate. Although in places she had relied on Law, her footnotes and referencing met much higher standards and the whole account was less anecdotal. The next steps forward came with the bicentenary of the death of Sir Christopher Wren in 1923. There was an exhibition, a service of commemoration at St Paul's, and Sir Frank Baines, the Director of the Office of Works, personally led a tour round Hampton Court for the RIBA and the London Society. But the most important and longest-lasting product was the foundation of the Wren Society, which set out to publish all the primary documentation relating to his architectural career. It published twenty volumes between its foundation and 1943. Two volumes cover Hampton Court and provided, in print for the first time, the full spectrum of seventeenth-century material. The fourth volume, written in 1927 by A. T. Bolton and H. Duncan Hendry, was the most scholarly attempt to date to understand the Wren building.[7]

Until his death in 1930 Ernest Law had a monopoly over the publication and sales of guidebooks. In his time he wrote eleven guides to the palace and gardens squeezing out any competition by sheer energy as much as knowledge. In 1932, based on her researches for the county history, Edith Keate offered to replace Law's guides with one of her own. Keate's new guide was published in 1932 and remained the standard companion for visitors for nearly twenty years.[8] By 1951 it was felt that more accurate and modern information should be provided for the visitor and H. C. Marillier was commissioned to write a guide to the tapestries (the first of its kind). The same year George Chettle, the Inspector for London, wrote his guide to the palace, a twenty-two-page landscape-format 'description' with black and white photographs.[9] This was translated into a more manageable booklet three years later and into a card-covered guidebook in 1955 selling at 1s 6d. Chettle's approach was more informed than that of Keate and he was responsible for introducing, for the first time, a sense of how the rooms might have functioned when the palace was in use. Chettle's guide, with its text of 1951, remained the standard until 1971. That year Pitkin Pictorials added Hampton Court to their 'Pride of Britain' series. As the first guidebook with colour pictures (and sold on Hampton Court Bridge by street vendors) it began to outsell Chettle's dowdy guide. The Department of the Environment responded in the same year with a new guidebook incorporating limited colour photography. Chettle had died in 1957 and the Inspector for London, John Charlton, revised his text. Charlton was the obvious choice. He had been one of the writers of the Royal Commission on Historical Monuments of England volume on Middlesex, published in 1937. This included the first serious architectural description of the palace from an archaeological point of view and included a phased plan showing building periods. It officially recognised the palace as 'in many ways the most important example of early Tudor architecture in the country'. In 1951 the Middlesex volume of Nikolaus Pevsner's *The Buildings of England* appeared. Pevsner was critical of the Wren buildings:

> from the point of view of the Grand Manner Hampton Court is infinitely inferior to Versailles or the Louvre Colonnade. The English have never been able to carry off that autocratic grandeur'. He was also dismissive of Verrio: 'he has done in his far from masterly way what Wren did in architecture: he has made the sweeping compositions of Southern Baroque palatable in our climate by freezing all individual figures. Thus they appear as firm and fixed as a Wren column.[10]

Despite Pevsner's strongly held views, neither he nor Charlton had made much scholarly progress. The turning point in the scientific understanding of Hampton Court came about with the start of the *History of the King's Works* in the same year as the publication of Pevsner's volume. This project, led by Sir Howard Colvin, set out to write the history of the Office of Works down to its transformation into a Ministry of State in 1851. It was commissioned by the DoE with an official dedication to the queen. The first volume appeared in 1963, but the volumes containing the history of Hampton Court followed in 1973 (1782–1851), 1976 (1660–1782) and 1975–1982 (1485–1660).

A number of crucial steps were taken to make this vast undertaking possible. The first was a survey of the palace begun in 1969 with 1 inch to 8 feet (i.e., 1:98) plans, sections of the whole building, a record of below ground services and a new numbering system.[11] A series of excavations were also commissioned to answer questions about the early development of the palace. The first of

these was triggered by the discovery of the foundations of Lord Daubeney's range in Clock Court in a trench for a fire main. The range was excavated by the Inspectorate under Peter Curnow and Alan Cook in 1966–7 and again by John Dent and Brian Davidson in 1973–4 (fig. 7).[12] This dig led to one of the *King's Works* authors, Martin Biddle, preparing a list of crucial questions to answer by archaeology. As a result John Dent and Brian Davidson excavated beneath the Great Hall, revealing the earlier halls there and a smaller investigation in Base Court that revealed the early moat. Two further investigations were suggested by Alan Cook: one in Lady Mornington's garden on the east front to find the Queen's Gallery, and the other in the west range of Clock Court to find the footings of the bay windows. While these excavations contributed to the *King's Works* project, Batchelor's east-front dig was the only one to be written up and the interpretation of the often sketchy records was left to Daphne Ford, myself and others in the 1990s.[13] Likewise, the great part I restoration projects by DAMHB in 1974–84 (see below) failed to produce anything of note in print despite the enormous amount of unpublished research. The notable exception was the unpublished report on the parks and gardens written by David Jacques of Travers Morgan in 1982. Much of this subsequently found an outlet in Jacques's privately published works referred to in chapters 5 and 12. The last phase of twentieth-century publication accompanied the restoration work of 1989–95 and led directly to this book.

New Areas Opened to the Public 1917–1952

Despite Ernest Law's interference in the excavation of the moat in 1909-10, and the harm it did to his relationship with the Office of Works, his persuasive powers exerted a considerable public benefit on the opening of more of the Tudor palace to the public. The first of these was the so-called Haunted Gallery from the Queen's Stairs to the chapel. Law wrote to Sir Lionel Earle, the Permanent Secretary, stating 'I feel the Haunted Gallery should be open to the public on all days. The Chapel is on a different footing, being unadapted to promiscuous crowds. The opening of the Haunted Gallery would be a popular move.' The campaign to open the gallery was to result, eventually, in the opening of the Horn Room and rerouting of the public into the Watching Chamber. First a door had to be reopened between the north arm of the gallery and the Great Watching Chamber and the horns (in a heap at the bottom of the Horn Room stairs) refixed. Some negotiations were necessary regarding rooms occupied by grace and favour residents, and in the process of change rooms were granted to the Curator of Pictures. All this achieved, the public was admitted into the gallery in 1917.[14] The chapel gallery was the next part to be opened up, but only in the teeth of fierce opposition from the chaplain and the residents. The king agreed in principle to open the royal pew in March 1918 and on the 25th Lady Rossmore wrote to the Lord Chamberlain from the Stud House, 'Well I need not tell you how simply impossible it will be for us or for anyone to attend church if this plan is carried out. The chapel gallery has an oak floor and a carpet where a great many of us sit and hundreds of very dirty, smelly unwashed that will tramp through during the week will leave it so that we, none of us, could even try to sit any service out.' The Lord Chamberlain told Earle that this letter 'might have been written before the French Revolution' and that the king thought these objections 'on the score of the risk of infection to be almost ridiculous'. The ladies (who had not had permission to use the pew anyway) were firmly told that the public came first.[15]

Another part to be opened thanks to Law's interest was apartment 35, the so-called Wolsey Rooms, formerly the apartment of Lady Georgiana Peel. During a refurbishment of the apartment in 1914 the Office of Works discovered beneath paper wall-hangings significantly large sections of linenfold panelling, a sixteenth-century fireplace and, beneath a later plaster ceiling, parts of a Tudor one (figs 32, 363). Law persuaded the Office of Works carefully to restore the rooms, removing a later partition, adding new ironwork (handles, hinges and grates) and panelling to match. At the time their importance was acknowledged – Garner and Stratton included a photograph of the ceiling in *The Domestic Architecture of England during the Tudor Period* (see below) – Edwin Lutyens came to examine them and photographs were sent to Queen Mary. Lady Georgiana never really enjoyed the rooms, they being too cold and large, and she died in 1922. The following year, on 7 August, they were thrown open to the public with little modification.[16] Sadly the rooms did not remain open for long. The sound of visitors' feet disturbed the grace and favour lady residing below and the rooms were subsequently closed. Only in 1951, with the vacation of the lower apartment, was there a general agreement to reopen the rooms to the public. Yet the condition of both the early panelling and the Wolsey ceiling meant that the rooms had to be closed again eight years later for another restoration. The most significant part of this was the completion of the missing parts of the Wolsey ceiling in painted and gilded fibrous plaster presenting the interiors as they are today (fig. 363).[17]

Outlying parts of the palace were to be opened to the public too. The Orangery was restored and opened in 1931.[18] After underpinning in 1915–17 and more major structural work in 1924, the

363 The restoration of the Wolsey Rooms ceiling in April 1960. Here original battens are being fixed to a base in order to make a mould for creating new sections in fibreglass. About half the present ceiling dates from 1961.

364 The so-called Wolsey Rooms during the occupation of Lady Georgiana Peel, c.1920. This is a rare photograph of the interior of a grace and favour residence and suggests why Lady Georgiana did not care much for her uncomfortable apartment.

Banqueting House finally fell out of grace and favour use and entered the public domain. It became part of the everyday visitor route in 1983.[19] The Tennis Court had struggled during the First World War during which only four or five games were played. After the war there were a mere dozen or so members. The king led the way in the club's post-war revival, paying his £1 subscription and the Middlesex Cricket Club made a small donation. It was able to open for official business in 1921 and by 1927 it had 200 members.[20] In 1927 major repairs were again carried out, principally cutting away the stone face of the internal walls and replacing it with hard cement render.[21] Yet the club remained short of money and there was a dispute with the Office of Works as to who should pay the cost of heating and who should bear maintenance costs. In 1949, in an attempt to resolve this, the club secretary Tony Negretti agreed that the court should be open to the public for an admission fee of 3d which would be taken by the department. In return the department would maintain the structure of the court. From 1952 it was open every summer afternoon.[22] Negretti was also responsible for securing the future of the club, increasing its membership from 160 to over 900 in just over twenty years (fig. 365).[23]

One of the last major parts to be opened to the public was the Cumberland Suite vacated as a grace and favour residence only in 1950. The restoration project that began to prepare it for opening to the public was interrupted on the night of 18 November 1952 by a severe fire in the rooms above. Earlier that day painters had been using blow torches to strip paint, and despite a check being made at 4.35 p.m., there must have been smouldering debris left on the second floor, since by 8.30 p.m. flames were seen above the roofline. The resultant blaze destroyed the attic rooms and the ceiling of the Duke of Cumberland's Bedchamber. By 1954 £67,000 had already been spent on restoring the suite and another

365 The Tennis Court in use in the 1980s.

£15,000 was needed to repair the fire damage. All this was seen as too much by the Treasury, and after the ceiling in the bedchamber had been reinstated, work was stopped. The rooms lay empty for eleven years until in 1963 the Government Hospitality Fund requested the use of the suite for official functions. Plans set aside in 1952 were dusted off and elements of chimney-pieces dismantled after the fire were brought back from store. New oak floors were laid (after seasoning for over a decade in the kitchens) and flock wallpaper ordered from Cole and Sons. The colours chosen were the same as those used at Chiswick House in 1954. The only element not recovered was the overmantel carving from the Middle Chamber and this was reinstated as an unadorned timber block showing the original shape.[24]

Although carefully executed (the floors were so well laid that in 1995 they were thought to be William Kent's), the restoration lacked any emotional appeal. The requirements of Government hospitality meant that the rooms looked corporate and not remotely domestic. The feeling was made worse when a wall-to-wall beige carpet was added to soften the footsteps of guests so as not to disturb the grace and favour resident below.[25]

Hampton Court's Continued Architectural Influence

The advance in understanding of the architectural and social history of Hampton Court and its gradual opening up to the public should be seen against the background of continued and developing interest by architects in the Tudor style and a serious attempt by scholars to write the history of Tudor architectural design. We have already seen (in chapter 15) that the restoration of the west front moat was accompanied by a flurry of scholarly articles. These were part of a upswing of scholarly interest in the architecture of the reigns of Henry VII and Henry VIII. J. Alfred Gotch was the first to write a learned account of early Tudor architecture in England in his *Early Renaissance Architecture in England* of 1901. This expanded his earlier two-volume book of architectural photographs and drawings that covered the Elizabethan and Jacobean periods and added a significant and carefully researched text.[26] In the preparation of this, Hampton Court was of special significance; Gotch recognised it as being 'the most important building of its time' and was granted access to large parts closed off to the public by E. Chart, the Clerk of Works there. Gotch's contemporary was Thomas Garner who at the same time was compiling an even larger and more ambitious project on the Tudor houses of England. Garner died in 1906 and Arthur Stratton, an architect and lecturer at King's College London, took up his research and notes. Based on these and his own researches Stratton wrote *The Domestic Architecture of England during the Tudor Period*, published in 1911. The list of subscribers to the massive two-volume work included many of the leading architects of the day, including Edwin Lutyens, C. R. Ashbee and W. D. Caroe, and the study relied heavily on the researches of a wider group of historians, including Gotch, Sir Maxwell Lyte, Ernest Law and N. H. J. Westlake. Hampton Court again was to be recognised as the principal monument of its age: 'the palace stands unrivalled as a work of the Tudor builders, and the copious accounts, fortunately preserved ... help give it an interest second to that of no domestic building in the country'.[27] Stratton introduced his book with the claim that

> one of the chief reasons that make this particular period of such supreme importance is that the house building is indigenous to the soil. It is as national as the name with which it is stamped; it breathes the restful yet vigorous spirit of the time that gave it birth, and withal is characterised by a self-contained homeliness, redolent of the life and customs of the Englishman of the day, and impossible to be either originated or imitated by his continental contemporaries. This was also the view of a large number of architects and private house owners, especially the very rich who, at about the time of the First World War, turned to the Tudor style in force.[28]

Tudor mania led to the restoration of many houses, often incorporating substantial parts of original buildings from elsewhere. Ightam Mote and Sissinghurst in Kent, Ockwells in Berkshire, Athelhampton in Dorset and Avebury in Wiltshire are just a small number of important Tudor projects of the period 1910–39. A few were new houses like Bailiffscourt in Sussex by Amyas Phillips for The Hon. Walter Guinness (later Lord Moyne). Here, a number of genuine Tudor buildings were bodily transported and re-erected as part of the mansion.[29] In all of this Hampton Court was a reference point, a source of detail and inspiration. Hampton Court's Tudor parts were a source of inspiration for public buildings too. Most notable amongst these was J. S. Gibson's design for the new Middlesex Guildhall (in Broad Sanctuary, Westminster), which placed a three-dimensional carving of the interior of the Great Hall over the front door. Designed by H. C. Fehr in 1913, the relief showed the abbots of Westminster gathered in the Great Hall with figures of law on either side (fig. 366).

The Restoration of the Hall and Chapel

The most significant work of the first half of the century at Hampton Court was the restoration of the ceilings of the Great Hall and chapel. The Office of Works had become increasingly

366 The relief over the main door of Middlesex Guildhall (now Middlesex Crown Court), showing the interior of the Great Hall at Hampton Court. J. S. Gibson designed the guildhall in the then (1912–13) unfashionable gothic style to pay homage to the adjacent Westminster Abbey. The historical frieze was designed by H. C. Fehr and carved by Carlo Magnoni.

knowledgeable about medieval oak hammerbeam ceilings after the complete restoration of the roof of the Great Hall at Eltham in 1911–14. This had led on to a second major project at Westminster Hall in 1921–3 which, like its predecessor, saved the roof from possible collapse. In response to these a series of examinations was made of the Hampton Court roof both from inside and out in 1922–3. This was the first proper consideration given to the structure since the big restoration of 1820 when the original tiles were removed and the roof covered in lead laid on new rafters and boards over the originals. The work of 1844, referred to in chapter 15, to cover the blue paint on the ceiling was accompanied by further strengthening, including the insertion of iron bolts and straps. Again in 1855–6 repairs and strengthening were undertaken. However, investigations in 1922 found both serious dry rot and wood-boring beetle.[30] Additionally it was found that the outer walls had been pushed 4in. out of true by the thrust of the decaying rafters. Almost immediately the roof was propped internally with the same timber formwork prepared for Westminster Hall and when the steel working-platforms were taken down at Westminster these too were moved to Hampton Court. The permanent solution to the structural problems was similar to that used at Westminster and Eltham. A steel truss system was inserted to undertake the structural work leaving the original roof as internal decorative facing. With the agreement of the Inspector of Ancient Monuments, C. R. Peers, the supports introduced in 1923 were by the same firm that had worked at Westminster. The whole was completed in April 1927 at a cost of £36,000. While the steel frame is invisible from the ground (it can be seen from the minstrels' gallery with binoculars), the effect on the hall interior was significant in other ways. The graining and the original blue beneath it was stripped away and the roof presented in its present raw oaken state. Later softwood repairs were then replaced in oak so they remained invisible. The flagstone floor was taken up (it had been damaged during the repair works) and an oak strip floor laid which put less strain on the floor structure. Jesse's corbels were taken down from the east end and the cornice carried across the dais wall, allowing tapestry to be hung. Beneath the hall the intermediate walls were demolished and the beer cellar opened up.[31] The restoration of 1925 was the last major intervention in the hall of the twentieth century (figs 367, 368). In 1959 more beetle was found in the ceiling, but was eradicated, and stonework repairs were undertaken on the windows. In the 1960s the stained glass underwent considerable repair and the floor strengthened. In the 1970s and '80s more permanent strengthening was introduced into the floor structure and minstrels' gallery.[32]

The serious problems exposed in the hall in the 1920s highlighted the possibility of similar decay in the chapel. This is what, in fact, was found in 1927. The chapel roof was also infested by beetle and contained pockets of rot; the Gibbons carving was riddled with woodworm, and the painted wall plaster was detaching. The chapel was closed, its services moved to the Great Hall in 1929. The ceiling was treated in much the same way as the hall, with new structural supports carrying the weight of the original. The chapel reopened in December 1929.[33] After paint research by

367 The interior of the Great Hall during repair in the 1920s. The photograph illustrates the quantity of new timber added during the repairs.

368 One of the bosses from the Great Hall supported by the Clerk of Works during the repair of the hall in the 1920s.

Jan Keevil in 1973 the chapel ceiling was redecorated and the same year, at the request of the subdean James Mansel, the pews were removed from the centre of the choir and a scheme to introduce new choir stalls initiated. These were altered again in 1993 at the request of the organist Gordon Reynolds, when the organ was computerised to his specification and a small subsidiary instrument installed in the choir. The 1973 restoration was completed in May and on the 31st a special service of thanksgiving was held. In 1975 the font from All Hallows, Upper Thames Street, was installed.[34]

Attitudes to the Display of the State Apartments

Robinson did not last long as Surveyor of the Queen's Pictures and immediately on the accession of Edward VII Lionel Cust, the Director of the National Portrait Gallery, and a close friend and admirer of the king, was appointed. The new king with Cust at his side made an extensive tour of the royal collections and formed an affection for Hampton Court in which he took an interest all his reign.[35] Cust published two volumes on the pictures at Windsor Castle and Buckingham Palace, despite moving to be editor of the *Burlington Magazine*. The arrangement of furniture in the State Apartments had, since the palace opened to the public, been the responsibility of the Office of Works and its successors.[36] Until 1901 the Lord Chamberlain had made an annual contribution of £110 to the cost of cleaning and security, but after that date the full cost for the care and presentation of furniture and tapestries (but not china and pictures) fell to the State. From the turn of the century there had been an increasing interest in furniture history that culminated in Percy MacQuoid's seminal *History of English Furniture* published in four 'ages' or sections, 1904–8. Mac-Quoid was the first furniture historian to realise the importance of provenance and used many original documentary sources to inform his narrative. In this royal furniture was particularly important in that it was generally better documented than most pieces in private collections. Hampton Court thus featured largely in his 'Age of Walnut' section covering the late seventeenth and early eighteenth centuries. Although MacQuoid's commentary was the first scholarly analysis of the Hampton Court furniture collection, he got much wrong. He was most badly misled over the dating of the beds, wrongly identifying Queen Caroline's as William III's. This error was picked up by Ernest Law before the First World War and was used to create an argument for the rearrangement and reattribution of the palace's beds. Consequently, Sir Lionel Earle, Permanent Secretary, proposed a rearrangement of the beds along historic lines to ensure, at the very least, that each of the bedchambers was furnished with a bed. The war intervened and nothing was done.[37]

In 1921 complaints were made in *The Times* about the neglected state of furniture and decoration at Hampton Court that aroused the attention of Queen Mary. This stimulated the queen to send down from Kensington William III's writing table for display and Sir Frank Warner of Warner Fabrics bore the cost of reproducing exactly some of the old faded-silk damask. Possibly as a reaction to this interest, the Ministry of Works appointed the historian Ingleson C. Goodison to have a hand in Hampton Court. He addressed the Royal Society of Arts in 1925 pleading for improvements to the presentation of furniture based on his own (and others') documentary research.[38] Yet nothing significant was done

before December 1927 when Lionel Cust resigned as Surveyor of the King's Pictures and C. H. Collins Baker, the Keeper and Secretary of the National Gallery, succeeded him. Although Cust had rearranged paintings at many other palaces, he had not at Hampton Court. Attempts by the Board of Works to redecorate and open the Prince of Wales's apartments, for instance, had been hindered by Cust's indecision regarding the picture hang. Baker turned his full attention to the palace. Of primary concern was the nature of the wall hangings in the State Apartments. Much of the old silk had decayed and many of the rooms still bore their nineteenth-century paper. Baker and the Office of Works undertook a number of trials with paper and stencilled canvas (inspired by work at the National Portrait Gallery). The public were horrified. A correspondent of *The Times* likened the wallpaper to some he had seen at the *Ideal Home Exhibition*, and vox pop captured for the *Evening Standard* claimed that 'That paper wouldn't look so bad at home, but it makes the galleries look cheap.'[39] In the winter of 1929 it was decided to go for Warner's damask in the King's Drawing Room, Queen's Audience Chamber and the Queen's Bedroom and flock wallpaper in the lesser rooms – the King's Dressing Room, Writing Closet, Private Drawing Room and Queen Mary's Closet (fig. 370). On the completion of the rooms it was acknowledged that although they looked well, a new tension had opened up between preserving 'the domestic attraction of Hampton Court, coupled with a background suitable to pictures and, at the same time, dignified as regards the historic associations of the palace and the uses to which it was put in the past'.[40] This tension between (at its most blunt) social history and art history remained at the core of debate surrounding the public interpretation of Hampton Court until 1989.

Baker's reign at Hampton Court was not a notable success. His relining of the *Triumphs of Caesar* was criticised by the king, and his catalogue of the pictures which was published in 1929 met with criticism. Lord Harewood opined 'I could give you concrete instances at Hampton Court of labels put there by him which are ridiculous even to an amateur.'[41] Despite this there was serious scholarly work underway on the collections. From before the First World War F. J. Rutherford had been compiling an inventory of the furniture at Hampton Court for the Office of Works and by 1926 a draft existed covering all the main pieces.[42] This process led in 1924 to a report on the locations of the beds based on primary research. In May 1924 the Lord Chamberlain agreed that William III's bed should be returned to his bedchamber, Queen Caroline's to her bedchamber and that Queen Anne's and Queen Charlotte's beds should be placed in the Public Dining Room. Rutherford went on to publish, in 1927, two articles on the Hampton Court furniture which informed future decisions and stimulated public interest in the palace's furniture collections.[43]

The greatest obstacle to refurnishing the apartments in a more sympathetic way was the Victorian heating system with its heavy pipes and grilles. By the summer of 1933 a prototype of a new heating system was built. It comprised steel plates set flush into the floor and coloured to match the floorboards. To install it all over the palace would have cost at least £16,500 and the idea was mothballed. In 1937 Sir Philip Sassoon (d.1939) was appointed First Commissioner. He was not only a politician and heir to his father's great fortune, but was also a considerable connoisseur with a passion to redeem the State Apartments from their inter-war torpor. He realised that 1938 was the 100th anniversary of the

369 The chapel today, with its collegiate choir stalls and choir organ.

370 The Queen's Drawing Room in 1890. Verrio's murals were covered in green damask in 1737 and re-hung with red flock wallpaper in 1833. The picture hang dates from William Seguier's time and shows Hanoverian portraits. The furniture, squashed against the wall, is protected by a metal grill and positioned immediately next to large heating pipes.

opening of the palace to the public and decided to undertake a major restoration of the rooms in celebration. Due to the defence programme there was no money in the Office of Works for anything other than necessities and so the philanthropist Lord Duveen was persuaded to donate £11,500 for the replacement of the heating in the King's and Queen's Apartments. Both he and Sassoon were to contribute to the re-hanging of some of the walls afterwards. The State Apartments closed for eight months in September 1937. Furniture and paintings were removed while building work went ahead. In April 1938 Sassoon made an inspection of the completed spaces prior to their reinstatement. As a result he asked for a number of improvements in presentation and for the furniture, particularly the beds, to be reallocated.

Sassoon was not, however, the only figure interested in the completed interiors. The Surveyor of the King's Pictures, Kenneth Clark (who had been appointed in 1934), had visited them a number of times with Queen Mary, who had her own clear views. The queen's enthusiasm was more important than her opinions (Rutherford recommended that the work should go ahead 'without consulting Queen Mary') and Sassoon's scheme was implemented on the basis of Rutherford's research and with Clark's endorsement. That April, a period that Clark thought 'Miserable', he was occupied in re-hanging the pictures. His scheme was to place the great sixteenth-century Venetian paintings in the south-front rooms (apart from the Presence Chamber, which was to contain seventeenth-century portraits). The west front was to contain the paintings from the seventeenth and eighteenth centuries. In the Public Dining Room hung the vast canvases by Sebastiano Ricci. Clark's arrangement of 1938 was, in actuality, to remain the basis of the Hampton Court hang until 1970 and elements of it remain to this day.[44] The effect of the new arrangement was fundamental. The King's Apartments were cleared of much later furniture and became, once again, large open spaces with stools round the walls. The grilles were removed and a bronze stanchion was designed to support ropes in front of vulnerable items.[45] A compromise was reached between Clark and Rutherford and the Presence Chamber was hung with a couple of the *Solebay* tapestries for historical accuracy. All the rooms not hung in silk in 1930 were now hung with green, blue or gold silk. The exception was the King's Bedchamber where the flock wallpaper was simply re-painted. In the Queen's Apartments Queen Anne's bed was erected in the Drawing Room (the only 'Queen Anne' room in the palace) (fig. 371) and Charlotte's bed returned to the Public Dining Room. Sassoon was still not happy. His greatest concern was the lack of thrones beneath the canopies. So he offered to donate two chairs of about 1690 that he had bought from the Duke of Leeds's sale and which were illustrated in MacQuoid's book. These were positioned beneath the throne canopies in the King's Apartments on low daises (fig. 372).[46] On 14 July 1938 Queen Mary attended the formal reopening of the apartments and a garden party on the east front in her honour (fig. 373).[47]

The restoration of 1930–38 was nothing short of remarkable given the economic background and the political priorities of the period. Some of the credit has to be laid at the feet of Queen Mary who devoted enormous amounts of time to the rearrangement and conservation of works of art at Windsor and Buckingham Palace. The unoccupied residences did not escape her eye; Holyrood House and Kensington were equally treasured. At Kensington she was responsible for reconstructing the room in which Queen Victoria was born and her nursery for the public. She was remarkably scientific in her approach, taking extensive notes commissioning catalogues and consulting museum experts. Under her patronage, for instance, the excellent *Buckingham Palace:*

371 (*above*) Queen Anne's bed was erected in the Queen's Drawing Room in 1938 uniting the only two Queen Anne elements in the palace. This photograph was taken in 1960.

372 The King's Privy Chamber (then known as the Audience Chamber) after the restoration of 1938. One of the Sassoon chairs sits under the throne canopy on a small dais. The walls were covered in silk damask and hung with large sixteenth-century paintings.

Its Furniture Decoration and History was written by H. Clifford Smith and Christopher Hussey and published in 1931. Although her advice was not always taken, her interest is evident at each stage of the Hampton Court work; she was closely involved, for instance, in the crucial meeting in June 1937 when the new wall hangings were chosen.[48]

The Two World Wars

In February 1912 both Hampton Court and Kensington Palace were closed to the public due to the threat posed by violent Suffragette demonstrations. When Hampton Court reopened more warders and security staff were employed and it was decided that a 1s charge would have to be levied to cover their cost. In 1915, after sporadic wartime closures, the palace was fully opened again with a charge only on Tuesdays. The following year it was realised that this was not enough and a 6d charge was imposed for week-days (the palace was closed on Fridays) and access would be free at the weekends. In March 1921 it was decided that because of the increasing cost of maintenance (especially in the gardens) that on Saturdays too there should be a fee of 6d and that only Sundays

AN AFTERNOON RECEPTION AT HAMPTON COURT

373　Queen Mary at the opening of the restored apartments in a garden party on the east front on 14 July 1938, from *The Times*.

(after 2 p.m.) would be free. Additional charges were made for the Mantegnas (2d), the vine (1d) and the Maze (1d).

Throughout the 1920s there was pressure from the Board of Works to increase the charges and abolish free days at both Hampton Court and Holyrood House, but it was realised that this raised matters of principle and the First Commissioner was not keen to be exposed to criticism. When in 1925 it was proposed to increase the admission price, objections were raised in Parliament by Mr Morgan Jones: 'There might have been a case some time ago, when wages and earnings were higher than they are now, for a higher scale of charges, but just now, when wages are very much lower, we ought to make it possible . . . for members of the general public and of the working class to avail themselves of the opportunity to see these works of art.' Jones was particularly eager that children should have free access to make history more interesting in schools. Despite this plea new charges were introduced in August the following year; the standard price was now a shilling during the week and sixpence on Saturdays. Revenue soared and visitor numbers fell by over 10,000 people that year. In 1930 the palace opened on Fridays and the cleaners were directed to work in the mornings before the public arrived.[49] Tickets were sold in the King's Guard Chamber by three sellers, an arrangement that continued until 1979, by which time there was also a shop and sound-guide sales-point.[50]

In 1938 it was thought that Hampton Court's isolated position made it an unlikely target for bombing and only minor precautions were adopted. At any rate as the result of a 1910 report the palace had an efficient Fire Brigade of eleven volunteers (fig. 374) linked to the palace by a 'Gamewell' telephone system installed by the General Post Office in the mid-1920s. There were also ninety-two fire hydrants, three hose reels and two hose-carts, providing what was regarded as adequate cover.[51] Yet when a shower of between 200 and 300 incendiary bombs fell on and around the east front at 11 p.m. on 26 September 1940 attitudes changed. Many of the bombs were extinguished on the roof but some penetrated into the upper floors and at one time up to ten fires were burning. In the event the palace Fire Brigade quenched them all but for the future it was decided to establish a permanent night fire-watch on the roof. Throughout 1941 it proved difficult to either persuade or recruit people to keep watch. The problem was that the unions advised palace employees to undertake the work only if they were paid overtime, which the ministry declined to do. It was not until the Fire Prevention (Historic Buildings) Order had been passed classifying Hampton Court as a Government building that an adequate fire watch was established. Six rooftop watching posts were staffed each with three people, mainly women. Through the war further precautions were taken including the placing of anti-incendiary concrete slabs in the Great Hall

gutters and rating the palace an 'A' category building for the fire service.[52]

The raid of September 1940 caused other concerns too, especially for the works of art. By October 1941 seventy-two of the most important paintings had been evacuated to the National Library of Wales at Aberystwyth. Some were too large or delicate to be moved and two ventilated brick stores were built in the Lower Orangery. In these were hung, on racks, most of the Gibbons carvings, the *Triumphs of Caesar*, two great Tintorettos and other paintings.[53] In addition it was decided to commission a comprehensive photographic survey of decorative elements in the palace in case it was damaged by further attacks. James Jack, the

374 (*above left*) The Hampton Court Fire Brigade posing with their apparatus on the west front, *c.*1905.

375 (*above right*) An unexploded German bomb dug up from the Broad Walk on the east front in May 1941. It was 7½ feet long and weighed 1½ tons. If it had detonated, the east side of the palace would have been destroyed.

376 Vertical photograph taken by the RAF in June 1941, showing bomb craters and anti-glider trenches dug across Home Park. In one of the paddocks on the north side of the park, grace and favour allotments can be seen. These remained in use until the 1990s.

head of the Ministry of Works mural restoration team, recommended 'that while there was yet time the artists should commence making colour records of the important ceilings and painted rooms at the royal palaces.'[54] Copies were made, in oil on hardboard, of the murals in the King's and Queen's Staircases. Fortunately none of these precautions was necessary: the 1940 raid was the only direct hit. High explosive bombs fell in the park in 1941 breaking windows and cracking plaster and a flying bomb missed the palace and landed on the Broad Walk damaging the Tennis Court in 1944 (figs 375, 376).[55]

Post-war Grace and Favour Arrangements

After the Second World War there was still a cohesive community of grace and favour residents and staff living at the palace. The Hampton Court school in Tennis Court Lane, for instance, continued to operate until 1953 despite proposals to close it twenty years earlier. Eventually the Middlesex Development Plan identified the school as an anomaly and the children were sent elsewhere. The school buildings were handed over from the Lord Chamberlain to the Office of Works, which allocated it for use by the warding and security staff. The school today contains a warders' mess room.[56]

In 1951 the Privy Purse Office, the Treasury and the Ministry of Works agreed a ceiling of forty-four grace and favour apartments at Hampton Court that would all be brought up to an acceptable standard. In 1950–54 the block between Clock and Fountain Courts was restored creating six apartments with modern facilities. In 1952 it was agreed that the programme should continue with apartments being modernised or subdivided as they became vacant. Over the following eight years seven apartments were replanned in this way, but in 1960 there were still thirteen vacant and derelict apartments some, like apartment 19, that had been vacant since 1949.[57] In 1959 a master plan was presented designed to be executed over a twenty-year period at a cost of nearly £2 million split more or less equally between modernisation and backlog maintenance. The modernisation side was based on increasing the number of grace and favour apartments to sixty-nine in all, modernising them (with central heating, lifts, etc.), inserting fire breaks and preserving the important rooms for public view. The plan turned on whether there would be a need for grace and favour residences in future and if there were (considering that in 1959 there was still a waiting list) whether it was going to continue to be politically acceptable. If grace and favour were to end, another consideration was whether the Crown Estate would be permitted (or would have the powers) to take on the empty parts of the palace for commercial letting (as had already been done at the Pavilion and Stud House).[58]

These political questions could not be answered in the short term and it was decided that the maintenance side of the plan should be executed immediately. Accordingly 'D' expenditure at the palace was doubled to £50,000 a year for the foreseeable future. 'D' expenditure was that part of the royal palaces vote devoted to repair at each palace. In 1831 the cost of maintaining Hampton Court (and the other royal palaces in hereditary possession of the Crown) had been transferred to the Surveyor General of Works under a specific vote for the royal palaces. This had become a problem in the post-war era since Hampton Court remained under the Palaces vote rather than the Ancient Monuments and Historic Buildings vote like other ancient monuments such as the Tower of London. This meant that Hampton Court became the Cinderella of the bidding round, the occupied palaces receiving the lion's share of resources. In 1961 Hampton Court received only 17 per cent of the total Palaces vote and the additional £50,000 a year was only one-fifteenth of the estimated maintenance backlog of £750,000.

This situation was not a problem for Hampton Court alone, it was one for Buckingham Palace too. The Lord Chamberlain had a diminishing interest in the palace, although the contents remained under his control, and it was becoming increasingly difficult to find grace and favour residents who could afford the upkeep of the apartments. One of the modernised suites between Clock and Fountain Courts had remained empty for years, despite being offered to a number of needy candidates. More seriously was the attention that the size of the Palaces vote was drawing from Parliament. Hampton Court was not one of the queen's residences and distorted the Royal Household's financial position. Cameron Cobbold, the Lord Chamberlain, a former governor of the Bank of England and a radical, even left-wing (for a courtier), thinker was to drive through a significant reform. If the Hampton Court money could be moved to the Ancient Monuments vote, he suggested in 1967, the Royal Household would consider giving up their interest in it for good. The sole proviso would be that the existing grace and favour residents would be allowed to see out their natural lives at the palace.[59]

Two years later in 1969 Hampton Court's vote was transferred from Parks and Palaces to Ancient Monuments and Historic Buildings and it was agreed that grace and favour would be allowed to end naturally. Plans were immediately laid for the long-term future of the vacant space within guidelines set by the Inspector of Ancient Monuments, John Charlton. Calculations showed that as a first phase at least 24,000 sq ft of office accommodation could be released in Base Court. Letters were written to the National Museums asking whether they might be interested in taking it on. Only the National Portrait Gallery considered it seriously before turning the idea down. The request was premature, since the Treasury had refused point blank to make money available for bringing derelict space at Hampton Court back into use.[60]

Hampton Court as an Ancient Monument: The Yexley Plan

The transfer of the vote was a turning point in the history of the palace. Henceforth it was treated as an ancient monument not a living palace. Funds were now increasingly directed to the palace's preservation and presentation to the public. Harold Yexley, the senior architect in DAMHB, was asked to produce a report recommending future use of the palace that was completed in March 1974. Out of this came a plan to spend about £250,000 a year on the palace until about 1980, first to provide better visitor facilities, including a visitor centre, shop and ticket office, then to create a series of new picture galleries for the display of the Royal Collection. At the same time the picture conservation studio would be moved out of the Queen's Guard Chamber to complete

the circuit of State Rooms round Fountain Court. Alongside these significant projects was the intention to assign vacant grace and favour apartments to craft organisations involved in trades reflecting the palace collections. Karen Finch's Textile Conservation Centre was to be the first of these.[61] This master plan was in fact to be executed almost exactly as envisaged by the DAMHB architect John Thorneycroft in the following ten years. In order to ensure the smooth running of the palace during the project a Superintendent was appointed.[62] With so many conflicting interests the job was not easy. In January 1977 after R. D. Harman had been Superintendent for four months he claimed 'I have only managed to keep in touch if at all, by prying and haphazard/random meeting of individuals and an occasional structured meeting.' The Superintendent, was, however, to retain nominal control until after the fire of 1986.[63]

The announcement that Hampton Court was to become a centre for craft skills, a move that was supported enthusiastically by the queen, triggered ten years of refurbishment of the Tudor parts of the palace. Some of the apartments were quickly assigned – others proved more testing. The hardest was the vast Birdwood apartment in the south-west corner of Base Court which had for many years been occupied by Field Marshall Lord Birdwood. A series of ideas were put forward for this including a European Discussion Centre, a Museum Conservation Centre and an Archaeological Excavation Centre. Finally the idea of accommodating the recently formed Building Conservation Association was accepted and Thorneycroft converted the wing into a permanent exhibition, library and lecture theatre in 1981 at a cost of £425,000 (fig. 377).[64] In 1986 the Embroiderers Guild moved into apartment 41 at a conversion cost of £100,000 and the following year the Royal

377 Building Conservation Association exhibition in the Birdwood apartment in 1981.

School of Needlework were installed in apartments 38 and 43. Despite finding uses for a number of the vacant apartments in Base Court the very extensive former grace and favour apartments in Fountain Court were still causing concern. At the suggestion of the Keeper of the Privy Purse, and with the support of the queen, the estate agents Chestertons were commissioned to undertake a study to ascertain whether it might be possible to market some or all of the apartments commercially. The study got underway in June 1985 and reported in March the following year. Their conclusion was that there would be a strong commercial market for modernised apartments in Fountain Court yielding a 10 per cent return on the investment to convert them. For this to take place the apartments concerned would have to be transferred to the Crown Estate Commissioners, who had the legal powers to convert and sell leases in the palace. The fire of 1986 and the fundamental administrative changes following it overtook Chestertons' conclusions and the use of the Fountain Court apartments (all but one vacant at time of writing) is still unresolved.[65] In the late 1990s, under Historic Royal Palaces, the craft organisations moved from occupying their apartments on a grace and favour basis and were charged rent to avoid the private trusts being subsidised by the taxpayer. This led to several, including the Building Conservation Association and the Textile Conservation Centre, moving out and a further escalation of the problem of vacant space.[66]

The Picture Gallery Strategy

Because the Royal Household regarded the paintings at Hampton Court as the palace's principal importance, it was discussion over their display that continued to drive the presentation of the palace to the public under the Yexley Plan. With the Raphael cartoons gone to the Victoria and Albert Museum, the *Triumphs of Caesar* were widely held to be the greatest treasures of Hampton Court. They had hung in the Communication Gallery under glass where subsequent Surveyors of the Queen's Pictures had been anxious about their condition. In 1914 they were removed from the gallery for the duration of the war and in 1919 a plan was formulated to display them in the Lower Orangery. The principal motivation was fire safety as much as presentational impact and the scheme was agreed by George V and executed by July 1921. Visitors, who were charged 2d extra for the visit, greeted the move with apathy. In 1928 only 25,000 visited the paintings while over 200,000 visited the vine next door. Lionel Earle, the permanent secretary, noted, 'I fear the joy riders at Hampton Court will always be more attracted by the vine than by any Mantegna Pictures, and they would be more attracted by instruments of torture than by either. This, I fear we cannot help – such is the mentality of the ordinary British public.' Not only were the paintings undervisited in their new home, there were concerns about environmental conditions and the effectiveness of the display (there were terrible reflections from the windows). After a series of unfavourable newspaper reports in 1930–31 it was decided to remove the paintings, restore them and re-hang them in the Communication Gallery.[67]

Fire was, however, the overriding concern and while the paintings were coated in paraffin wax (the main outcome of the restoration) debate raged as to where they should be most safely hung. Eventually it was decided that they should return to the Orangery but only after an air-treatment plant had been installed. The Orangery was redecorated, the canvases remounted and the gallery reopened in 1934.[68] The plant was a remarkably early example of such precautions being installed for paintings and the

378 The installation of Mantegna's *Triumphs of Caesar* in the 1930s in the Lower Orangery. The pre-war air-treatment grill can be seen at the far end.

379 The installation of the *Triumphs of Caesar* in the Lower Orangery in 1975. The top lighting meant that the canvases were tipped forward to avoid reflections, while the lowered ceiling containing air-conditioning ducts created an oppressive feel.

380 The *Triumphs of Caesar* as shown since 1995. Lighting the canvases by artificial light enabled them to be shown vertically and the pilasters, cornice and base to be installed. It proved too expensive to remove the ceiling ducting.

machinery that powered it remained in use until 1973. After the wartime bomb shelter was removed from the Lower Orangery in 1946, the Mantegnas were put back on display and the question of how to present the paintings was raised again. Anthony Blunt, the Surveyor of the King's Pictures, was keen to try and reset them in a continuous wall divided by pilasters as they had been in sixteenth-century Mantua. He was even more determined that natural light should be used to illuminate them. Yet in 1950, when the paintings were re-hung, they were shown, much to Blunt's disappointment, as before, unframed behind a grey wall with glazed openings and under a mixture of fluorescent light and venetian blinds (fig. 378).[69] In July 1961, Bryan Robertson, in a talk on the BBC Home Service (later published in *The Listener*), was very critical of both the condition and display of the Mantegnas. Anthony Blunt was well aware of the problems and the same year began a restoration of the canvases, which reopened the issue of how they should be shown. Blunt started a series of regular meetings with the Inspector, John Charlton, and the Ministry of Works architect, Peter Holland. By November 1968, after considering a number of alternatives, they had agreed a new strategy for the Renaissance paintings at Hampton Court. The Mantegnas were to stay in the Orangery, but only after it had been widened and natural top light introduced. In the dilapidated south range of Base Court behind it another gallery was to be built to contain the other early Italian paintings at the palace. Work was to start in the Orangery once a mock-up had shown that the top lighting would work. In the event this took another two years and ultimately the £180,000 contract for the work was let in 1971.[70] On 26 April 1975 *The Guardian* noted sourly 'It's taken 12 years to get Mantegna's *Triumphs of Caesar* back on show at Hampton Court, that's longer than it took the artist to paint it, and longer than most of the military campaigns that Mantegna's masterpiece celebrates.' The work was a qualified success, the paintings looked much better and benefited from a 'Roman Sculpture Hall' as an introduction, but the lighting was still a problem since the mock-up had shown that the paintings had to be tipped forward to avoid reflections on the glass. This prevented the introduction of pilasters between the paintings and forced their installation in simple frames instead (fig. 379).[71] It was only with the creation of the Historic Royal Palaces Agency that the ambition to display the canvases in their original context was realised. In 1995, after the discovery of an original pilaster in Mantua and after a series of comprehensive trials, the paintings were finally given a home that befitted their status (fig. 380).

While the Mantegna gallery was being built Blunt's plans for the rest of the palace developed. His view of both the palace and the painting collection was straightforward, and ideologically motivated. His views had developed in the late 1940s while he was picture adviser to the National Trust, where he helped display the collections of newly acquired houses. He felt that Trust houses should not be monuments to the aristocracy, but rather public galleries. Likewise, the royal houses should not be a celebration of royal life and the closer they could be brought to public picture galleries the better.[72] The Mantegna project was a step in the right

direction, but he wanted to take Hampton Court much further, and laid plans to do so.

Work began on two more galleries, one for eighteenth-century and northern European painting and the other for anything that could not be shown elsewhere. In 1976 the conversion of the ground-floor rooms on the southern part of the east front started. This was to contain the palace's eighteenth-century paintings. At a cost of £70,000 the rooms were cleared of later partitions and were provided either with wall-hangings or restored panelling. The aim was to have minimum lighting and heating and attempt to display pictures 'in a way approaching their original setting.' The rooms opened in July 1977 and remained part of the summer tour until the fire of 1986.[73]

After a series of major enabling works including inserting air-conditioning plant into a Tudor roof space and strengthening the Tudor floors, work started on the Renaissance Picture Gallery in Base Court in July 1980. The contract was worth £475,000. Although the principal building work was completed two years later, the air conditioning continually failed to meet standards and eventually a temporary exhibition was installed in December 1984 pending the installation of the Renaissance pictures the following year.[74] The final piece in the jigsaw was the creation of the Reserve Picture Collection Gallery in apartment 29. This was the gallery to display paintings that did not fall into other categories and would enable all the Hampton Court pictures to be on show. They would be exhibited in the Henrician Tennis Court range that still retained its Georgian panelling. The conversion was undertaken by the Gilmore Hankey Kirke Partnership under John Thorneycroft's supervision. The contract sum was £95,500 and work started in 1978 and was completed in January 1980. It was largely a redecoration but included the installation of state-of-the-art lighting. It was recognised that the rooms should broadly revert to the wall finishes of 1730 when the rooms were last fitted-up for George II's daughters, but the colours and details were to be agreed by the then Surveyor of the Queen's Pictures, Sir Oliver Millar, who was, effectively, the client.[75]

Presentation of the State Apartments to the Public 1950–1986

In the immediate post-war years the Inspectorate played a major role in developing ideas of how buildings should be shown to the public and at the forefront of that thinking was George H. Chettle. Chettle was an architect, a pupil of the Arts and Crafts architect and designer C. R. Ashbee, and was a member of the Art Workers Guild and a leading figure in the Georgian Group. Chettle cut his teeth as Inspector (and architect) at the Queen's House in Greenwich, where between 1934 and 1936 he presided over a reconstruction of the house to its 1630s state, guided by his documentary researches. His research was published in 1937 in a special volume of the *Survey of London*. The impetus behind this radical treatment seems to have been Professor Geoffrey Callendar, a prime mover in the foundation of the Naval Museum, but the philosophy of re-creating the rooms as they were in their heyday appealed to Chettle and became the hall-mark of his work. The next major building at which his influence can be seen is Chiswick House, taken into guardianship by the Ministry of Works in 1948 and thrown into the limelight by the Georgian Group soon after the war. The group, with Chettle in their midst, pressed for the restoration of Lord Burlington's villa. In 1956–7 he led the team that demolished the important later wings of 1788 by John White and masterminded the refurnishing and decoration of the interior. In 1961–2 the Ministry of Works took a similarly radical approach at Audley End, a house bought in 1948 after being used during the war by the Special Operations Executive. In 1962 Chettle, assisted by John Charlton, was responsible for clearing the southern neo-classical interiors by Robert Adam of their nineteenth-century clutter and restoring them (with the aid of full surviving archives) to their appearance in 1797.[76] It cannot be stressed too much how radical the Greenwich, Chiswick and Audley End approach was. It clashed with the core Ancient Monuments view expressed by a Chief Inspector which was that 'a monument should be preserved without imaginative embellishment of what might have been. The most well intentioned and scholarly restoration inevitably makes assumptions and rests on hypothesis. Once started the restorer is on the slippery slope ... By its nature restoration makes suspect the original fabric.'[77]

Chettle had little to do with Hampton Court but his successor John Charlton, a clever Northumbrian archaeologist full of avant-garde ideas, formed an alliance with a number of other progressive thinkers about the State Apartments.[78] These included Sir Owen Morshead, the Royal Librarian, and Ralph Edwards, Keeper of the Woodwork Department at the V&A and author, with MacQuoid, of the *Dictionary of Furniture*.[79] Charlton stated in 1968 'the palace is not a picture gallery: the pictures are part of the furnishing of a royal palace and it is as such that they are primarily presented'. Yet these ideas were only slowly carried through against the tremendous pressure from the Queen's Surveyors to create more gallery space for paintings. Despite this, Charlton was involved in the early 1950s in making improvements to the historical presentation of the State Apartments. From 1954 the King's Drawing Room, the Prince of Wales's Drawing Room and the Ante-Room were all re-hung with silk. Two reproduction mirrors were made to match the historic ones in the Banqueting House and in the Presence Chamber a new backcloth was made for the throne canopy. Two years later work began on the conservation of William III's and Queen Charlotte's beds.[80]

Charlton retired in 1974 and was succeeded by another archaeologist, his deputy and a great expert in castles, Peter Curnow. Curnow was to benefit from a major change in direction in the Royal Household and the Department. The Lord Chamberlain, Cameron Cobbold, was sophisticated, interested in art, especially Italian art, and was passionate about the Royal Collection. He wanted to transform the presentation of Hampton Court and formed an alliance with a senior civil servant, Michael Carey, to do so. Cobbold instructed the Assistant Comptroller of the Household, Lieutenant Colonel John (Johnny) Johnston, to effect the transformation from the Royal Household's side. The principal mechanism to gain agreement during the 1970s and early 1980s was the Lord Chamberlain's walk-round. At these, approximately quarterly, events those responsible for the palace would make a tour under Johnston's chairmanship to make decisions on presentation. A typical walk-round would comprise up to twenty people. Johnston would be accompanied by the Surveyor of the Queen's Pictures, Sir Oliver Millar and the Deputy Surveyor of the Queen's Works of Art, Sir Geoffrey de Bellaigue, while other officials from

381 Sketch designs for the green curtains to be erected in the Prince of Wales's rooms by the DAMHB architect, the Hon. John Thorneycroft. These were the first reproduction curtains designed for the palace.

his office would attend to take notes. The staff of the Chapel Royal would be in attendance for the visit to the chapel and then each of the principal departments of the DoE would be represented – the architects, inspectors, district works office, supplies division, etc. The visits were a blunt instrument. Sometimes good decisions were made, but too often snap decisions were taken without sufficient debate. A typical mix of business was transacted on 6 February when Johnston asked that an offending postcard of Catherine Howard be withdrawn from sale and decided that the Queen's Guard Chamber would in future be the Royal Collection's conservation studio. Through this mechanism the State Apartments were gradually improved. In 1971 a carpet was placed beneath the throne canopy in the King's Apartments and in 1977 thought was being given to retrieve Royal Collection stools from Chiswick House and reinstate them in the Queen's Apartments. Reproduction festoon curtains were hung in the Prince of Wales's Drawing Room by 1977 (fig. 381) and in 1979 restoration work started on the furnishing textiles, such as the counterpane for the king's bed.

These presentational improvements were sponsored, in the main, by Curnow's assistant, Juliet Allan (later Juliet West), and his senior architect, John Thorneycroft, in DAMHB. They were later assisted by Pamela Lewis, a former theatre and film designer who had been recruited by Harold Yexley in 1972 to produce interior designs for DAMHB schemes. One of her earliest successes at Hampton Court was the redecoration of the Queen's Guard and Presence Chambers to colours that were, at least, historically plausible. Lewis had to work through the PSA supplies branch whose main work was the furnishing of British embassies abroad. Tensions were therefore inevitable, but nevertheless historic curtains were designed, made and hung both in apartment 6 and in the Prince of Wales's rooms based on historic research. Lighting the State Apartments underwent significant changes in practice and philosophy too. In 1959 there was only a single light bulb in each room, no matter how large, to provide light for the night security patrols. In 1960 proposals were made to light the State Apartments through a combination of spotlights, wired historic chandeliers and lighting on the cornices. The work took five years to complete, but by the early 1970s it was generally regarded as a failure. During 1971–3 a new scheme of lighting was installed comprising fluorescent strips perched on the cornices throwing light up on to the ceilings.[81] In the Queen's Apartments these lighting arrangements still remain.

Conservation Arrives at Hampton Court 1977–1986

In 1977 the tide began to turn against the big projects that characterised the Yexley plan. The Inspectorate of Ancient Monuments had been strengthened with a number of new recruits, the most important being the young Oxford architectural historian Juliet Allan. Allan joined in 1975 and was a pupil of Sir Howard Colvin's and brought an absolute conviction that the answer to the practical problems of repairing and displaying the palace could be found in the historic bill books and accounts of the Office of Works. She was appalled by the destruction caused by the PSA's conversion of the ground floor of apartment 35 for the new Hampton Court exhibition (see below). With the support of Peter Curnow, the Principal Inspector, she wrote to the PSA's superintending architect, 'huge steels have been inserted to support original oak floors, massive trenches to carry duct-work have been cut through surviving brick floors and sixteenth-century foundations, chasings for myriad cables have been gouged in the walls, and original stone door jambs ruthlessly sliced through'. The list of destruction continued, but in the next paragraph she argued 'Vandalism of this degree at any other monument or indeed any other archaeological site would provoke an outcry. At Hampton Court, the finest surviving Tudor Palace in the country, it seems to be accepted as a matter of course.' The only solution was 'a complete reconsideration of the department's policy towards Hampton Court and the relative emphasis placed on the preservation and presentation of the historic building'. Allan was, in fact, echoing concerns voiced by the SPAB in 1973 when their secretary wrote to the superintending architect at Hampton Court to complain about an earlier phase of the same scheme.[82] Although her complaint made some difference to the conduct of the PSA developmental projects, Allan's plea left the rolling programme of brick and stonework repair to move forward unobstructed. This programme, undertaken on a daywork contract from the builders Dove Brothers, gradually moved round the palace cutting away decaying brick and repointing entire elevations.

Eighteen months after her original minute, Allan wrote again criticising the work of the PSA, this time focusing on repair work: 'Gradually an old building is being replaced by a modern replica ... Philosophically, it is almost impossible to explain the value of the original fabric to those used to modern work and who are mainly concerned that the building should not look old and shabby.' Her criticisms were just. A brick-and-stone repair programme was underway using mass-produced replica Tudor bricks made by Redland (dubbed by DAMHB 'Tonbridge Tudors') that was changing the face of the Tudor parts of the palace. The parapets on the south side of Base Court, for instance, were entirely rebuilt with these unforgiving red bricks; brand new shiny Swedish limestone was laid in the cloisters; and the entire bay window of the Great Watching Chamber was replaced in 1978. At root the problem was now too much money rather than too little. In 1978 the PSA repair budget had more than £1m set aside for repairs at Hampton Court, and civil service annuality (that annual underspends would be docked from the following year's grant) meant that extreme pressure was applied to spend it all. The Chief Inspector of Ancient Monuments, Andrew Saunders, wrote to the PSA stressing that 'too much is being done too fast for the good of the monument and we would go further to say that money is being wasted on over-restoration'.[83]

The arguments of DAMHB led to two important changes. First, under the guidance of the architects the gargantuan store of 800,000 Tonbridge Tudors was set aside and appropriately sized and coloured handmade bricks by Bulmers substituted. Soon after, with advice from the building scientist John Ashurst, modern Portland cement was largely abandoned for pointing work and substituted by historically correct hydraulic lime.[84] This led to the re-establishment of Tudor double-struck pointing. Second, in March 1976 a permanent archaeological draughtsman from the Ancient Monuments drawing office was stationed at Hampton Court 'so that we can gradually build up a more accurate and complete picture of Hampton Court's architectural development

to which surprisingly little serious attention has been given'. The person identified for the task was Daphne Hart (later Daphne Ford) who came to Mediterranean archaeology via theatre design and ended up in the Ancient Monuments drawing office in 1969 (fig. 382). She had worked on the *History of the King's Works* with Sir Howard Colvin and was a brilliant draughtsman with a genius for the interpretation of complex buildings. Her recording of the Hampton Court fabric led to a methodology for unravelling the complex phasing of the Tudor parts of the palace based on brick typology. By 1991 every elevation of the palace would be analysed in terms of brick type, providing a crucial tool both for historians and for architects going about their work (fig. 383).[85] Daphne Ford remained working at Hampton Court until 1996, probably making it the best recorded and understood post-medieval secular complex in England. Her contribution to the understanding of the palace cannot be overestimated.[86]

★ ★ ★

382 Daphne Ford recording brick elevations.

383 A brick typology sheet by Daphne Ford showing the west elevation of Base Court.

New Facilities for Visitors

Throughout the century improvements were made to the facilities for visitors. On the whole these were designed to aid visitors to the palace, but in 1923 a scheme was devised to create a separate recreation centre in the Tiltyard. This was to incorporate tennis courts, a bowling green, a putting green and a refreshment house entered both from Hampton Court Green and from the gardens (fig. 384). The aim was to charge for the complex and make an annual profit of around £2,200. The Treasury agreed on the condition that the works were undertaken as part of the cabinet's unemployment relief programme. Mr Naylor who still occupied the Tiltyard Tower, and ran his 'Royal Nurseries' from the grounds (see chapter 17), was removed by means of a dilapidation notice and the new 'Tilt Yard Gardens' were opened in sections during 1925,[87] the tennis courts first, then the new tea house in the tower. The bowling green and car park were never built but the putting green was. The tea house with its veranda was operated by an outside contractor and proved to be the only successful part of the scheme. The building was extended by the addition of a cafeteria in 1932. In 1938 the present rose garden was laid out near the tearoom.[88] The issue of a car park remained a live one and in 1928 concerns were raised again over traffic congestion. On Chestnut Sunday that year the whole of the western approach of the palace was jammed full of cars. It was suggested that the parade ground area to the north of the barrack block might be converted into a car park. The War Office gave up the barracks in 1930 and so the car park idea was feasible, but in the end it was decided to convert the space into a tree nursery. In 1931 it was reported that the trees were doing well, yet pressures on parking continued and the area was finally given over to car parking.[89]

Facilities for visitors to the palace were improved too. New lavatories were built on Vrow Walk and in the Wilderness in 1924 and finally inside the palace (after ten years of debate, including a visitor poll) on the south side of Fountain Court in 1939. Lavatories were installed in Base Court in 1965.[90] In 1974 Lady Baden Powell, widow of the founder of the Scout movement, relinquished apartment 18, the first-floor area to the north-west of the Great Hall. This triggered a complete reassessment of other visitor facilities at the palace and gave rise to a plan to make a new shop-cum-functions area in the hall buttery (at its west end); to remove the shop from the King's Guard Chamber; to construct a new ticket office, new visitor lavatories and staff facilities; and to create a Hampton Court exhibition. This project, known as the Amenities Scheme, was undertaken for the PSA by the consultant architect Ian Hodgson. The King's Guard Chamber, which had been the ticket office and shop, was finally cleared when rooms were set up between Base and Clock Courts in 1979. The work involved stripping out a number of rooms within the west range of Clock Court and revealing the garderobe shafts of Lord Daubeney's house and important Elizabethan wallpaper (fig. 385).[91] In 1976 the designer Robin Wade was appointed to create an exhibition to be installed behind the colonnade in the south range of Clock Court telling the history of the palace.[92] The display, which was a piece of groundbreaking interpretation for its time, remained the principal introduction to the palace until 1991.

The café in the Tiltyard remained an important part of the visitor's experience and by 1960 the original rooms from the 1930s were adequate neither for the numbers nor the type of food that visitors wanted. In 1964 Trusthouse Forte built a restaurant and cafeteria at a cost of £60,600. It was of black brick, steel and glass and its deeply corrugated roof was intended to reflect the battlements of the Tiltyard Tower (fig. 386). A journalist in May 1977 recorded 'bright colours abound. Brilliant floor tiles and plastic

384 A Sunday afternoon in the Tiltyard in the 1920s drawn by A. Forestier.

385 Fragments of printed black-and-white Elizabethan wallpaper found during the creation of the Base Court shop.

386 The new Tiltyard café completed in 1964. Its roofline was intended to reflect the outline of the palace battlements.

orange tables vie with garish illustrations of sample dishes illuminated above the display cabinets from which customers serve themselves. Most lurid of all, however, was the blueberry cheesecake inside the cabinet priced at 40p a slice.'[93] The contract with Trusthouse Forte expired in September 1986 and was re-let to the cook and restaurateur, Prue Leith, who retained the cafeteria and opened a sophisticated restaurant aimed at richer, more discerning visitors. In the winter of 1994/5, after another change of contract a private catering operator, Town and County, undertook a £1m refurbishment of the Tiltyard cafeteria disguising the brutal Trusthouse Forte café with an orangery façade based on the original 1930s building.

The Parks and Gardens 1914–1989

Maintaining the rich borders and the bedding schemes of Hampton Court was labour-intensive and in 1916 an old gardener at Hampton Court was heard to remark to a visitor, 'It is a wilderness lady, but we need men and money for killing people – not for growing flowers.' The bedding out had stopped almost immediately the war began and by 1917 most of the large beds on the east front had been taken over for growing potatoes and beetroot. That year the gardens yielded two and a quarter tons of potatoes for the war effort.[94] In 1918 the gardens were in a denuded state with most of the east-front beds turfed over and proposals afoot to take out the herbaceous borders as an economy measure. This state of affairs led to considerable agitation in the press and a campaign by the district council to get the gardens reinstated.[95] In May 1919 the Office of Works, under considerable pressure, published in *The Times* their proposals for a new bedding scheme that reduced the number of beds from the 114 pre-war peak to only 54. At the same time they embarked on a wholesale pruning of the overgrown yew trees on both the east and south fronts. This was very controversial and the popular and specialist press began to take sides. Without an official position, and in order to demonstrate that it listened to public opinion, the Office of Works set up a committee under Sir Aston Webb, the architect whose designs had included the façade of Buckingham Palace, to determine what should be done. The committee, which included W. Watson, Curator of Kew Gardens, and Ernest Law, decided to propose an entirely new scheme balancing historical precedent with more recent horticultural developments. Twenty-eight beds were to be reinstated in the semicircle and along the Broad Walk for bedding and twenty-nine new yews were to be planted to fill the gaps. The committee also recommended thinning the planting around the semicircular canals that had become overgrown.[96] Work started on reinstating the beds in November.

In the early twentieth century the parks gradually took on the appearance they have today.[97] In 1854 Home Park had been re-stocked with 20 male and 20 female fallow deer and Bushy Park with 250 male and 150 females. By 1907 the herds had grown to 150 in the Home Park and 450 in Bushy. After the Second World War, the practice of wintering the deer under cover was abandoned, the deer pens demolished and the fawns born and bred under bracken.[98] In 1921 a Royal Warrant granted the paddocks along Church Grove for use as allotments and in 1932 the paddocks in Home Park were transferred from the Master of the Horse to the Office of Works. Most of the walls were then demolished in 1931–5. In Bushy Park a new woodland garden was planted in 1925 with the use of unemployed labour and between 1921 and 1930 land was transferred to the National Physical Laboratory. During the Second World War parts of both Home Park and Bushy Park were taken in for food production (fig. 387). Care was taken not to destroy ancient ditches and boundaries and little recognisable damage was done. After 1942 the American Eighth Army took over buildings in Bushy Park as their headquarters and named them Camp Griffiss (after the first American serviceman to be killed during the war) (fig. 388). In 1944 General Eisenhower chose the camp as his headquarters and from the huts, swathed in camouflage netting, planned the Normandy landings. Despite the use of some of the huts for prisoners of war in 1945,

387 A crop of corn in Home Park in 1947.

388 Supper given to American soldiers based at Camp Griffiss in the Large Oak Room (King's Private Dining Room) at Hampton Court. The dinner, just before D-Day, included palace residents. The palace Chaplain is the fourth on the right side.

the Americans kept a foothold in Bushy Park until 1962, when the camp was finally bulldozed and a memorial erected to mark the spot.[99]

By the early 1970s it was clear that the original lime avenues in Home Park and round the semicircular canals on the east front would need replacing. In 1977 the advisory committee on trees recommended to the Government that the semicircular double avenue on the east containing 186 trees should be felled and replanted. Both the Department and the Royal Household accepted the advice but not the public who, with the support of local MPs, objected vociferously. Work was suspended while a committee of experts could be convened to discuss the plan. The committee failed to agree a way forward and was stood down with a change of Government. The issue was taken up again in 1985 and consultants appointed to stage an exhibition and public consultation. This opened in 1986, by which time the queen herself had been consulted and agreed to a clear felling; this was announced with Government support, by Lord Elton, at Hampton Court in June. By May 1987 the work was complete.[100] The same year a great hurricane caused devastation in both parks and the gardens. In Bushy Park 1,329 trees were found felled in the aftermath and in Home Park, 500. This made the replanting of the rest of the avenues in Home Park a priority and between 1992 and 1996 the cross avenue was felled and replanted (fig. 389). At the time of writing work is planned on the main Long Water avenue.

Throughout the second half of the twentieth century small improvements and changes were made to the gardens' appearance. Many had the effect of diluting their original historic character and bringing them more into line with municipal practice. Both Joseph Fisher and George Cooke, Gardens Superintendents in the post-war period (from 1948 to 1974 and 1974 to 1990, respectively), came from municipal backgrounds and had little feeling for the historic fabric or horticulture of the estate. The rise of garden history had been much slower than the rise of architectural history and for much of the twentieth century the gardens were hardly seen as part of the historic estate at all. Indeed, the gardens were centrally manured and planted, without consideration of Hampton Court's special historic nature. Until his death in 1930 Ernest Law had been as much of a force in the gardens as he had been in the palace. In 1926 he wrote *Hampton Court Gardens Old and New: A Survey, Historical, Descriptive and Horticultural*; part guide part history, it set out to provide 'the lay-out, the full schemes of all the bedding in the herbaceous and mixed borders . . . and show the position of every flower and shrub in the garden'. It was supplemented by an annual leaflet produced throughout the 1920s, 'The Flower Lover's Guide', which described the changing spring and summer bedding in the mixed borders and the flowers in the beds in the Broad Walk and the Grand Circle. He had also written a book, *Shakespeare's Garden*, that was based on preliminary historical research into Tudor gardens. In the spring of 1924 he designed a knot garden inspired by his 1920 work at Shakespeare's birthplace in Stratford-upon-Avon. It was installed at a cost of £1,000 on the south front (fig. 390).[101] After this it had to wait until 1949–52 for further serious attention to be given to the historical layout. In 1952 one of the Tudor pond gardens was restored based on some archaeological investigation and early plant research. The new garden attempted to capture both the configuration and planting of the original. But there was no concerted commitment to historical research and the original bower in the Privy Garden, having been killed by Dutch elm disease, was replanted in 1976 in beech (rather than elm) against a steel four-centred Tudor arch (rather than a round-headed timber one).[102]

This lack of historical attention did not represent neglect. For instance, the Tijou screens in the Privy Garden were restored over a ten-year period, 1929–39. Work was more or less a continuous process with a smith on site repairing the framework and another at Horseguards in Whitehall restoring the repoussé work. The restoration was interrupted by the war but restarted afterwards and was completed by 1951. Great care was taken not to replace parts regarded as original, but the screens continued to cause concern, and in the 1990s a second long-term restoration, still underway at time of writing, was begun.[103]

Edward VII, although a great horse breeder and keen racegoer, had no use for the paddocks in Hampton Court park; his stallions were kept at Newmarket which was closer to Sandringham. As a consequence the king ordered the stud to be further reduced and the Master of the Horse to give up any remaining interest at Hampton Court. The grazing was therefore let to dairy farmers in 1908 and again in 1909. Neither tenant found the royal park

389 The restoration of the cross avenue in Home Park. The degraded state of the Central and Kingston avenues can be seen top right.

much to their liking – the growing deer herd left little grass for the cows and sheep.[104] In 1918 the widow of Henry Hanson who had rented Home Park for his dairy herd gave up the lease, at which stage the Master of the Horse was keen to regain the former stud lands. This was not popular at a time when food production was at a premium.[105] The paddocks were finally taken over by the Office of Works in 1932. In 1965 the Crown equerry, Colonel John Miller, set on a scheme to draw together the queen's horses from rented accommodation all over the country and settle them at Hampton Court. The paddocks chosen were those at the Kingston end of the park by the river. The following year it was agreed that twenty horses should be kept there at a rate of 10s per head per week paid to the Office of Works.[106]

The cost of maintaining the roads around the palace rose steeply from 1800 onwards. Indeed other than the stud, and limited grace and favour traffic, they were essentially public highways. Eventu-

390 Ernest Law's design for the Tudor knot garden prepared in 1924.

ally in 1870 the Crown announced its intention to give up bearing the cost of the road from Kingston Bridge to the palace and in 1877 the roads around the Green and between the park walls were transferred to the local authorities.[107] Increasing visitor numbers and road traffic at Hampton Court also began to affect the bridge. After much negotiation the bridge was replaced by its owner, Thomas Newland Allen, in 1864, and in 1924 discussions about replacing that bridge began. In 1925 the Queen's Private Secretary wrote, 'I need not say that Her Majesty hopes there is no serious question of the building of a new bridge, or road, that will interfere with the beauty, or amenities, of Hampton Court Palace.' Royal concern, coupled with local agitation and official anxiety over bridge design, delayed decisions until 1928 when a Bill was passed authorising the construction of a new bridge. The architect was to be Edwin Lutyens, who designed the new bridge whilst on board ship on his way to India. His drawings arrived in England in March 1928 to everyone's delight. The Prince of Wales opened the new bridge on 3 July 1933.[108]

★ ★ ★

The Fire of 1986

The dynamic phase of restoration that had begun with the Yexley plan of 1974 ended in 1984 with the abolition of DAMHB and the transfer of complete responsibility for the palace's fabric to the Property Services Agency. The PSA had two divisions, the District Works Office based at Hampton Court, headed by a technical officer responsible for routine repair and maintenance works (part I works); and the Special Services Group based at St Christopher House in Southwark responsible for all work requiring design input (part II and III works). All was not well with the PSA, and the situation at Hampton Court collapsed that very year. An enormous scandal was exposed in the District Works Office by a *News of the World* reporter in November. In a £3m fraud contractors had been paid for work they had not undertaken in return for gifts and favours for PSA staff. The District Works Officer John Trevillion was fined and imprisoned for three years and a number of his staff and two private contractors were also put on trial. Against this background of corruption and incompetence the palace was now governed by a matrix of officials from the DoE, the PSA, HBMC, the Royal Collection, the Lord Chamberlain's Office and the Privy Purse.[109] These split management responsibilities were to lead indirectly to a massive fire on the south front, an event that was to dominate the palace's history in the last fifteen years of the twentieth century.[110]

On Easter Monday, 31 March 1986, at 5.20 a.m. an intruder alarm was triggered in the Cartoon Gallery and a security guard, investigating, found plaster falling from the ceiling. It was soon discovered that there was a fire in the apartment above and the Fire Brigade was called. Six minutes later fire engines from Twickenham were at the site. It was quickly realised that the fire was serious and more fire tenders were called in, twelve in all; eventually there were to be more than twenty. The brigade was very anxious to stop the fire spreading to the south front (figs 391, 393). A team of firemen took twenty minutes to break into the roof to vent the fire and reduce its intensity. Yet the fire did break

391 Flames belching from the window of Lady Gale's apartment where the fire of 1986 started.

392 Fragments of the original building salvaged archaeologically lying in a vacant apartment and waiting assessment.

through and soon the south front was ablaze too. It had long been known that the gateway from the east front on to the south terrace was too narrow to accommodate a modern fire engine and until the early 1980s a special narrow fire engine had been stationed locally to reach the terrace in case of a fire. But by 1986 all the engines called out were too wide to squeeze on to the terrace – a factor that significantly inhibited the fire fighting.

As the brigade tackled the burning roof a salvage operation was underway in the State Apartments. The fire of 1952 had led to a careful reassessment of the salvage corps founded in the 1920s and further developed during the war. It was agreed that the Office of Works should bear the cost of equipping and training a squad of twelve men.[111] Fortunately this team had trained regularly through the 1970s and '80s and were quickly mobilised on the night of the blaze. Their quick action under Joe Cowell, Superintendent of the Royal Collection at Hampton Court, removed almost all the significant works of art from the south front rooms and it was only the orders of the firemen that prevented their saving more. As a result just one table and a single painting were destroyed.

The queen was told of the fire immediately on her waking and at 8.30 a.m. she sent a message enquiring after Lady Gale, the occupant of the apartment where the fire had started. At 1 p.m. Lady Gale's body was found and an hour later the queen was touring the site, the blaze firmly extinguished. The Secretary of State appointed Sir John Garlick to investigate the fire and the palace's response to it. The inquiry took three and a half months and the report was published on 3 July. His strongest criticisms were reserved for the management regime. The fire, he found, had been allowed to smoulder undetected for many hours because the detector in the relevant zone had been disabled through repeated faulty alerts. The failure of the automatic system led to

a second report by the fire consultants Ewbank Preece, who reported in 1988. This contained management recommendations and led to the installation of an extensive new, addressable, fire detection system. A sad postscript to the enquiry was the suicide of the palace fire patrolman, George Indge, a week after the fire. He was found drowned in the Thames after blaming himself for the tragedy.

On 23 October Nicholas Ridley, Secretary of State for the Environment, decided to visit the damaged area with his wife and a high-powered delegation. At the end of the visit the party, numbering twelve in all, descended from the third floor in the Prince of Wales lift.[112] It jammed between floors and took fifteen minutes to lower to ground-floor level by hand, only to establish that the manual emergency door-opening device did not work. The lift maintenance contractor could not contact a fitter and so the Fire Brigade was called. The Secretary of State was a chain-smoker and his wife suffered from claustrophobia. When the Fire Brigade eventually managed to open the doors with a hydraulic jack the party had been incarcerated for an hour and three-quarters.[113] This incident was to convince Nicholas Ridley that the palace management was a foggy maze of incompetence and that a thoroughgoing review of it should be undertaken. This was completed in March 1987 and recommended that a manager or administrator should bring together under single command all the Department of the Environment's responsibilities at the palace and have charge of liaison with the Royal Household. This would include taking on the Hampton Court parks and gardens, Kew Palace and Queen Charlotte's Cottage in the Royal Botanical Gardens at Kew.[114]

The model settled upon by the DoE was that which existed at the Tower of London, whereby a senior retired figure from the Armed Forces was to be appointed as sole command of the building. This, it was felt, would give 'the [royal] Household a familiar animal with which to deal as well as giving the Secretary of State someone capable of managing the operation'. In July 1987 Major General Christopher Thompson, the former Director of Military Survey at the Ministry of Defence, was appointed as the first Administrator, with full responsibility for all the palace's functions.[115] This included a staff of 150 and a budget of £9.8m. The PSA was to provide building services to the Administrator and HBMC was to advise them on the historic impact of their work. Thought had already been given to the long-term viability of requiring the Administrator to use the PSA and a three-year service contract provided for him to let three jobs a year to external consultants to 'test the market'. This came as a relief to those in charge at St Christopher House who admitted that, with a budget of only three and a half million pounds, it would be uneconomical to continue to provide the palace with a service on the level that had historically been achieved.[116] Yet the new administration with the PSA quickly began to grasp some of the serious maintenance issues revealed by a detailed survey of the palace undertaken in 1987 by Martin Funnell. The Funnell report was the first of its kind and aimed to place Hampton Court on the same footing as the great cathedrals that benefited from quinquennial surveys. It led to a five-year maintenance plan from the PSA.

* * *

MENDING THE FIRE DAMAGE

The fire damage repair was to be the responsibility of the architect Michael Fishlock, who had oversight of Hampton Court special projects for the PSA. His job was a difficult one. Although he was in charge of the work, the PSA had to accept an English Heritage advisory team as an integral part of the project. Although this ultimately transformed the quality of the end result, it made its management difficult. Fortunately Fishlock was a charming, witty and theatrical manager whose sympathies lay with the historical and archaeological side of the project and he managed, despite the tensions, to keep the team together. During his first two years the PSA was unable to find a suitably talented job architect until in January 1989 they appointed an architect of Italian extraction, Dante Vanoli, who in effect ran the contract on a day-to-day basis until its completion.

The philosophy adopted by the fire team was that all areas requiring restoration would be treated equally and that historic investigation should be integrated into the approach. In a speech at the topping out of the south range in 1990, the Duke of Gloucester summarised this: 'the important thing . . . is that it should be restored and replaced to be as similar as possible to what was there before . . . so that future generations . . . will feel that this is the real Hampton Court, not a modern version, not an improved version, but as authentic a building as the one conceived by Sir Christopher Wren'. In fact there were to be improvements. Fire breaks were introduced, a much more efficient version of the 1930s metal-plate heating system developed, drop-down smoke vents were built into the roof and a more effective lighting system installed. Presentational changes came too. The south terrace steps

394 Above the King's Apartments on the south front looking east in January 1989. A birdcage scaffold inside the range both supported the building and provided access to it. A scaffolding roof above kept the range watertight.

393 View of the Cartoon Gallery looking east the morning after the fire. It had started in a room over the centre of the gallery. Remarkably, much of the fine carving on the capitals and architraves was undamaged.

were rebuilt, the gymnasium floors were taken out and replaced by new softwood floors with wide boards, and William III's Private Dining Room was reinstated. Yet the spirit of the restoration was highly conservative and the result incorporated much more of the original fabric than did, say, the later restoration of Windsor Castle.

Within eighteen days of the fire a complicated scaffolding roof had been thrown over the entire range (fig. 394). This was to keep out the elements for four years. Meanwhile a demolition contractor secured parts of the building that might cause further collapse. English Heritage had insisted that work on clearing the debris was an archaeological excavation and that every piece of timber should be saved and plotted on to a grid. This was enormously time-consuming and attracted some criticism. Yet it was a crucial part of reassembling the building and was subsequently to be adopted as standard methodology for the fires at Uppark House (Sussex) in 1989 and Windsor Castle in 1992. Ultimately 75 per cent of the original oak panelling was reused, 64 per cent of the softwood panelling and 64 per cent of the mouldings.

The archaeological side of the restoration was one of its most innovative aspects. Never before had there been an opportunity to study a seventeenth-century building of this importance in such detail. Led by Daphne Ford, the team of surveyors, draughtsmen and recorders produced a comprehensive record of the structure.

395 New queen-post trusses being erected *in situ* over the Cartoon Gallery.

Only the survey work at Windsor Castle since the fire there superseded this task in scale. Unusually, the archaeological record drawings fed directly into the PSA's contract documentation and a proportion of the nine hundred or so drawings necessary for the contract were based on extensive advice drawings from the archaeologists. The contract was let in August 1988 to the building firm James Longley and Company for the price of £9.7m. It was to last three years. Longley began at roof level and worked down, starting with the construction of new roof trusses (fig. 395). The new trusses, weighing over two tons each, were swung into position and the roof boards covered in more than 93 tons of milled lead. The traditional ceremony of 'topping out', which marks the completion of the highest point of a building, was performed in April 1990 by the Duke of Gloucester, who tapped home the last clip securing the lead sheeting. The PSA handed over the building on 2 October 1991. The total cost of the work had been £8.5m, a reduction on the original figure largely owing to the fact that at this stage the third-floor rooms were not reinstated.

Historic Royal Palaces

Major General Thompson's reign did not last long. He resigned in March 1988 'for personal reasons'. In his place a caretaker Administrator was appointed, John Yarnall. Yarnall was a high-flying civil servant from the Department of the Environment who had set up the new arrangements for Hampton Court in 1987. His principal challenge was to keep the PSA maintenance and fire damage programmes on track while attempting to unravel a future direction for the palace's commercial activities. Yet it was clear politically that it was not necessary for the DoE to manage the unoccupied palaces directly and that the best solution would be to hive them off as had been done in 1984 with the rest of the Government's historic estate open to the public. Since, as we have seen, it was considered inappropriate to put them in the charge of English Heritage, the decision was taken to create a separate Next Steps agency, run by a chief executive, into which Hampton Court, the Tower of London, Kensington Palace State Apartments, Kew Palace and the Banqueting House, Whitehall, would fall. This finally took place on 1 October 1989 and was named Historic Royal Palaces (HRP). It was to be run by David Beeton, a lawyer who had been an outstandingly successful town clerk at Bath City and latterly the Secretary of the National Trust. Hampton Court and the other unoccupied palaces thus became the first major state-owned historic buildings in Europe to become stand-alone businesses. In due course the lessons learnt in England were copied across Europe as other major palaces such as Versailles and Het Loo gained their own financial and operational independence.

Beeton set about recruiting a team that would for the first time give Hampton Court (and the other palaces in the group) an integrated professional management. For Hampton Court the key appointment was for a director who would take over from John Yarnall. Crawford MacDonald, who arrived at the palace in December 1990, had no experience of working in historic buildings and had come from British Airways and the Health Service. Elements of the Royal Collection were rightly suspicious that he and Beeton would turn Hampton Court into 'Disneyland'. They were wrong. Beeton was determined to use the palace's royal status to present an unashamedly upmarket experience for visitors and MacDonald had the managerial skills and commercial daring to make this happen. A few months before MacDonald arrived Beeton had appointed me to the post of Curator (for all the HRP sites) and I rapidly formed an alliance and a friendship with him. Between 1990 and 1995, with Beeton's backing, the palace Director and I undertook the most thoroughgoing recasting of the public parts of Hampton Court since 1974–83.[117]

The problem was a simple one. Although the DAMHB works of the 1970s and early '80s had in some senses transformed the palace, there had never been the necessary focus to capitalise on

their success. The big picture gallery projects never lived up to expectations, the Reserve Picture Collection Gallery was open for just a few years and apartment 6 for summers only. There was little marketing skill and the State Apartments, through the split responsibility with the Royal Household, trailed far behind what the National Trust was providing at its historic properties. The result was a catastrophic fall in visitor numbers from a high of 730,000 in 1977 to 460,000 in 1982. In 1991 there were only 520,000 visitors. Part of MacDonald's strategy was to increase the palace's profile and in his first year, 1990, a flower show was staged in Home Park with sponsorship from British Rail. It was subsequently let to the Royal Horticultural Society and continues to produce substantial revenue and profile for the palace. In June 1993 MacDonald launched another initiative, an international music festival in Base Court with the IMG group. The festival made little money at first and caused significant disruption for staff and visitors, but it too made Hampton Court a household name over the summer. Yet it was the big presentation projects of 1990–95 that made the greatest impact on the palace's profile. The Tudor kitchens were seen by HRP as a part of the palace that could be easily and quickly transformed to demonstrate its credentials. I had already published an article explaining their use and development and since the Royal Collection had little influence there work could go ahead without complex external negotiations.[118]

The eastern part of the Great Kitchens, which had never been significantly altered, had first been opened to the public in 1925 at a special charge of 3d (fig. 396). It became the Hampton Court

397 The Tudor kitchens, illustrating the archaeological approach to restoration. Scars in the plasterwork indicate the location of floors, walls and staircases removed in 1978.

396 The Great Kitchens as they appeared at their opening in 1925.

398 (*right*) The north-west corner of Henry VIII's Great Kitchen showing two of the meat-roasting fireplaces. The left-hand fireplace contains a seventeenth-century brick-and-stone oven, the right-hand fireplace, a range inserted in grace and favour times. The storage deck is also seventeenth century.

museum containing pieces of masonry, a few kitchen artefacts and the gilded Charles II bed rails, thought at the time to be rails from the chapel (see chapter 10).[119] Since that time it had been an ambition to remove the grace and favour apartments that filled the three-storey space of the western half. In 1950 it was estimated that this would cost £10,000, a sum thought too much. Instead of this big project the metalwork expert Seymour Lindsay constructed a model of how the kitchens would have looked in Henry VIII's time, complete with glowing electric fires. Then in 1956 the Office of Works bought Seymour Lindsay's collection of historic kitchen implements which were added to the kitchen museum in an attempt to bring the gaunt space to life. Further improvements were made to the presentation of the kitchens in 1960 when empty beer barrels were placed in the wine cellar.[120] The Yexley plan, however, provided for the ambition to clear the western part of the kitchen and in June 1978 DAMHB closed the kitchens in order to dismantle the three-storey grace and favour annexe formerly occupied by Lady Baden-Powell. The architect for the scheme was again John Thorneycroft working with Allan and Ford. It was completed by the summer of 1979 and for the first time since the eighteenth century the full volume of the Tudor kitchens could be appreciated. The philosophy of the scheme, that just ten years later would have been regarded as unthinkably destructive, was clear. The removal of the nineteenth-century work was balanced by leaving scars in the fabric of the walls showing where the later work had been removed (figs 397, 398). Certain key parts of the apartment (such as a kitchen range) were also left so that visitors could 'read' the fabric. This archaeological approach was mainstream practice at DAMHB at the time. Projects elsewhere such as at Gloucester, Blackfriars and the Tower of London were conducted wth similar ruthlessness and conviction. The result was often to emasculate the architectural integrity of the building in order to expose its archaeology. Yet at Hampton Court the work was a success and demonstrated that it was possible to clear later accretions whilst not oversimplifying what visitors saw. But the timing was bad; 1984 marked the end of the series of major projects that had characterised the previous decade under the Yexley plan. The necessary interpretation of the wall scars was never installed nor was it possible to consider furnishing the rooms to make them come alive.[121]

It was life that David Beeton wanted to bring to the kitchens, and my team and I provided it. We scoured the dealers of London to acquire an outstanding collection of sixteenth-century cooking equipment, re-lit the fire in the great fireplace and asked the gardeners to grow fresh herbs and vegetables to place, daily, in the displays. The aim was to liberate the rooms from barriers, labels and glass cases and for visitors to be able to touch everything. As the Tudor kitchens opened to the public, a new kitchen shop and interpretative model opened in the undercroft of the hall.[122]

Transforming the State Apartments 1992–1995

Between 1992 and 1995 the State Apartments at Hampton Court were transformed in appearance. That this was possible was due to three factors. First, the individual drive and determination of Beeton, MacDonald and myself underpinned by substantial new revenue generated by raising admission charges at the Tower of London; second, that almost everyone involved with historic buildings saw the necessity of the work, supported it and agreed with the philosophy; third, because one of the reforms instituted by the Lord Chamberlain, Lord Airlie, had created a new department in the Royal Household by amalgamating the Surveyorship of Pictures, Works of Art and the Library. In 1987 this became the Royal Collection Department.[123] Its director was Sir Geoffrey de Bellaigue who had two deputies, one for furniture and the decorative arts, Hugh (now Sir Hugh) Roberts, and another for painting, Christopher Lloyd. Roberts and Lloyd were both committed to the Hampton Court programme and without their support the transformation of the rooms could never have been effected. They were able to extract from other royal palaces missing paintings and items of furniture and were able to smooth the path to enable work that was highly contentious to take place.

In the summer of 1989, with the structural work on the damaged wing underway, thoughts began to turn to the interiors of the new rooms and a small group led by Sir Geoffrey de Bellaigue went to Het Loo to learn from the experiences of the Dutch under the director there, Adrain Vliegenhardt. On our return I (then English Heritage's Assistant Inspector for Hampton Court) wrote to de Bellaigue suggesting that a room-by-room analysis should be prepared of what might be achieved. This resulted in a scheme in March 1991 for the complete restoration of the first-floor apartments to their appearance in 1700. This was expanded to include the ground-floor rooms a few months later. The scheme became my responsibility on becoming Curator of the Historic Royal Palaces and I gathered together a team to realise it. The group included veterans of the old DAMHB as well as much new blood. Pamela Lewis was recalled from retirement to design the curtains and soft furnishings; Daphne Ford provided archaeological advice; and a former senior DAMHB architect, Percy Flaxman, returned to undertake some of the architectural work.

The philosophy that lay behind the restoration grew naturally out of the work of 1974–83 in that it was based on social history rather than on a narrower understanding of the building centring on the painting collections. The staff of the new curatorial department were social historians heavily influenced by Mark Girouard's *Life in the English Country House* (1988) and Peter Thornton's *Seventeenth-Century Interior Decoration in England, France and Holland* (1988), both of which set out to explain architecture and interiors in terms of function rather than style.[124] A strong influence too was the work underway at Spencer House, in St James's, at the Villa Windsor in the Bois de Boulogne in Paris and, of course, Het Loo itself. At each of these houses there was an attempt to re-create a suite of interiors at a particular moment in their past. This led to some tough decisions being taken about authenticity. Some of the hardest were to resolve the problems of the tapestry hang. As has been explained, William III's rooms were originally hung with some of the finest tapestries from Henry VIII's collection, but these were dispersed and re-hung during the nineteenth century leaving the State Apartments as a picture gallery. To re-create William's rooms it would be necessary to find enough appropriate tapestries.

Achieving this had two aspects to it, conservation and acquisition. Although, in 1986, there were more tapestries on show at Hampton Court than at the V&A, there were many more in store, most in too poor a condition to remain on show long-term. In 1912 the William Morris Tapestry Company under the great textile

399 The tapestry restoration workshop at Hampton Court in the 1930s.

historian H. C. Marillier had taken over the old Office of Works tapestry restorers and operated a workshop in the Queen's Guard Chamber (fig. 399). This was forced into liquidation at the outbreak of the Second World War and in 1940 it was agreed that the Board of Works would take the needlewomen into their direct pay. This was the foundation of the body now known as the Textile Conservation Studios (TCS). The TCS worked for various parts of the Office of Works after the Second World War, gradually restoring damaged tapestries and arguing for better protective measures for them (such as curtains to shield them from sunlight).[125] In 1984 it was decided to construct a studio for the TCS in apartment 29, which was completed in 1987 at a cost of £991,000.[126] This development, together with a new emphasis on conservation rather than the more radical restoration methods, led to an opportunity to release more of the stored tapestries for show. Since 1980, under the leadership of Jenny Band, the TCS had been undertaking trials on the best way to clean these large tapestries and other furnishing textiles. For many years they had been scrubbed and hosed in one of the back courts. In 1985 Band commissioned a prototype system for safer washing and a feasibility study was conducted for its construction in apartment 29. However, eventually the pressure to complete the King's Apartments meant that a new machine was built in a greenhouse in the nursery to the north of the palace with a 20ft by 30ft flatbed washing surface (fig. 400). The construction of the machine was in due course to facilitate the restoration of not only nineteen tapestries for the Wren State Apartments but also twenty-seven tapestries for Henry VIII's rooms too.[127]

Since 1905 a series of *Acts of the Apostles* tapestries had hung in the Cartoon Gallery in place of the original cartoons. The tapestries had been bought by Baron Emile d'Erlanger at the Duke of Alba's sale and had originally been offered to the Victoria and Albert Museum as a gift. However his son, Edmund, suggested that perhaps they should go to Hampton Court to fill the gaps left by the original cartoons. It was eventually agreed, after the mediation of Edward VII, that as long as the V&A had the cartoons Hampton Court should have the tapestries. The Office of Works therefore prepared frames and fireproof backings for the

A permanent loan was arranged between the museum and the palace and the panelling in the gallery altered to take the paintings (fig. 401). At a stroke the gallery was transformed and enough tapestries released to hang in the King's (and later) the Queen's Apartments.

The combination of tapestries restored and rearranged filled the walls of William's apartments. Furniture and paintings were brought back from Windsor Castle and a series of pier tables made for the enfilade (for which see chapter 10). On 8 July 1992 the queen reopened the fire-damaged King's Apartments (fig. 402). The completed rooms were greeted with almost universal admiration.[130] They fitted into a pedigree of restorations stretching from the Queen's House in the 1930s to the big restorations of the 1980s such as Spencer House. Yet they had the merit of balancing the archaeological approach of DAMHB with the less evangelical approach of the National Trust's former interior decorator John Fowler. In his book, *English Decoration in the 18th Century* (1974), written with John Cornforth, there was a thinly veiled attack on the old Inspectorate approach to restoration:

> it is important to realise that research cannot provide all the answers, and so a great deal has to be left to the restorer's knowledge and disciplined imagination. The trouble is that experts whose knowledge is based to a large extent on documentary research find this the hardest part of the process of restoration to accept. But surely it must be so if rooms and houses are to have a quality of life and balance.[131]

400 The flatbed washing-machine built in a greenhouse in the nursery.

tapestries which were hung that October.[128] In 1990 it was realised that if these could be released not only could the King's Eating Room be re-hung with tapestry but that in due course several of the Queen's Rooms could also be rehung. A discovery in the basement of the Ashmolean Museum in Oxford solved the problem.[129] A set of copies of the Raphael cartoons given to the museum by the Duke of Malborough (who had no space to hang them at Blenheim) were found in store. They are most likely the set painted in the gallery in 1697 by Henry Cooke (see chapter 10).

In the King's Apartments detailed documentary research was finely balanced with disciplined imagination to produce not a slavish reproduction of William III's rooms but a powerful series of historic interiors that could stand in their own right.

Almost more important than the achievement of the restoration was the initiation, on the same day, of a new route for visitors, finally abandoning the route set out by Edward Jesse in 1838. The palace was to be divided into six sections, three based on the historic use of its parts – the King's Apartments, the Queen's

401 Copies of the Raphael cartoons being restored in the Cartoon Gallery before their installation in 1992.

402 H.M. The Queen being shown the completed apartments in June 1992.

403 William III's ground-floor closet next to the Orangery, as restored in 1992. The overmantel has oak carvings depicting musical instruments.

Apartments and the 'Georgian Rooms', and three on date principles – Henry VIII's Apartments, the Tudor Kitchens and the Wolsey Rooms and Renaissance Picture Gallery. This set the timetable for restoration, and the order which would finally provide an experience for visitors that explained what they were seeing in historical terms. As part of this, in May 1992 a café was opened in Queen Elizabeth's Privy Kitchen to allow visitors to refresh themselves between visiting routes.

That year was also significant as it was then that Hampton Court disengaged from the Property Services Agency and transferred its property maintenance programmes worth £8–10m in house. For the first time in its history Hampton Court was separated from the mechanism of State Works procurement. This was not before the PSA fire-damage restoration left a legacy for the history of conservation. The fire came at exactly the right time to stimulate a whole group of craftsmen whose skills were waning through lack of a market. Carvers in limewood and oak, makers of passementerie, weavers of silk, restorers of glass and ancient textiles all went on to consolidate their businesses or form new ones as a result (fig. 404).[132]

In June 1993 Henry VIII's State Apartments became the third 'route' to reopen in a new guise. The project was philosophically more complex than the restoration of the King's Apartments, which had benefited from a unique survival of documentation, original artefacts and an unaltered architectural shell. The aim of the 1993 project was essentially to make some sense of the Great Hall, Great Watching Chamber, Haunted Gallery and the chapel as an historical unit. This was achieved by a significant redecoration and refitting of the Watching Chamber, including reinstating a fireplace and introducing an oak cornice for the tapestries (figs 405, 407). Next door a small room, formerly the Henrician pages' chamber, was stripped of its eighteenth-century panelling and reinstated in its sixteenth-century appearance. It was furnished with Tudor furniture and artefacts bought at auction and borrowed from the Burrell Collection in Glasgow (fig. 406). The Haunted Gallery was stripped of its fluorescent lights and an archway of 1918 and the royal pew was refurnished. The project undoubtedly transformed the appearance of the rooms for the better, but due to the academic and conservation subtleties of the project it is

404 Trevor Ellis carving replacement elements for damaged Grinling Gibbons carvings for the King's Apartments.

unclear whether the rooms are, in fact, any better understood by visitors. Today the hall is shown much as it was in Jesse's time, the Watching Chamber as it might have been in 1700, the Haunted Gallery as it was around 1730 and the chapel as it was under Queen Anne. The most 'original' Tudor room in the palace was the restored Pages' Chamber – so much for a 'Tudor' route.

The next restoration opened in June 1995 and was the last of the new routes to be opened to the public. The rooms, that comprised the Cumberland Suite, the Cartoon Gallery and the Georgian Rooms, were the last to be occupied by the royal family and remained little changed. The restoration was a careful re-creation of the rooms as they might have been in 1737 (figs 408, 409). The Georgian Rooms thus became the most domestic interiors at the palace and perhaps the most easily understandable of the interiors on show. Yet while the restoration was certainly state of the art in terms of quality of research and presentation, much of the furnishing was either purchased or on loan from museums or private collectors. Thus the principle of the integrity of the

405 The Great Watching Chamber in the 1980s.

406 (*below*) The Pages' Chamber after the removal of eighteenth-century panelling and the restoration of Tudor plasterwork.

407 The Great Watching Chamber after restoration. An oak cornice (modelled on a lost original) was added, the fireplace unblocked and a bolection marble surround installed.

Royal Collection, established formally by both the Office of Works and the Lord Chamberlain as early as the 1930s, was finally broken.[133] While the Sassoon chairs and the *Acts of the Apostles* tapestries had been introduced for presentational reasons earlier in the century, never before had an item as large or as important as the Raynham Hall state bed been put on display (fig. 408). Thus while the Georgian route successfully communicated to the public a royal way of life, it challenged the basis of the palace's importance as a uniquely preserved collection in its original location.

None of these quibbles disturbed the public. Visitor numbers surged in 1992–3 to 596,000 largely as a result of the opening of the fire-damaged wing. The following year, mainly due to international events, they were 578,000 and they then slipped to 540,000 in 1994–5, but crucially by 1994–5 visitors were spending 75 per cent more time in the palace than they had in 1989.

More Facilities for Visitors

The opening of the kitchens began to grab the imagination of the press, but also of visitors and staff and led to the achievement of a long-held ambition to remove a Portakabin in Base Court that had been the ticket office since 1986. The idea was to set up a new ticket office and shop in the barrack block on the west front. The barrack block had remained the responsibility of the War Office until 1930 when it was formally handed to the Ministry of Works. In 1934 the Office of Works had created four flats in the centre of the eastern part of the building and rented two of them to employees who were obliged to be full-time members of the palace Fire Brigade.[134] In 1985 there were substantial changes. The PSA District Works Office converted the western part of the first floor into offices for itself and in the space below

the Crown Equerry installed an exhibition of carriages and royal memorabilia after being ejected from the Upper Orangery. The mews exhibition was never a success and eventually moved to Windsor Castle, releasing the barrack block for a new ticket office and shop. It was converted at a cost of £100,000 and opened in 1991.[135]

Transforming the Gardens

The idea of restoring William III's Privy Garden on the south front was not new in 1991 when the team that was putting the finishing touches to the fire-damage restoration turned its attention to it. The idea had been mooted in the early 1960s, and Charlton was asked to propose a budget for the project. It was too expensive and Geoffrey Ripon, the Secretary of State, turned it down. Yet it was clear that the philosophical arguments behind the re-creation of the King's Apartments had inflamed the imagination of David Beeton, MacDonald and those who would have to agree to finance the project. In the history of garden restoration in England the project was pivotal. Never before had a garden for which such superb documentary, archaeological and horticultural evidence survived been restored. Never before had such a methodical and scientific approach been taken to garden restora-

409 The Queen's Private Bedchamber as displayed in the 1980s before the restoration of 1995.

410 Excavation of the Privy Garden in progress in 1994. Most of the topsoil and original beds were removed archaeologically leaving the garden as a negative imprint in gravel. Work to restore the garden included filling the empty trenches with fresh soil before replanting.

408 (*facing page*) The Queen's Private Bedchamber as restored in 1995.

tion. The rebuilding of William III's garden was based on a minute textual analysis of the original construction accounts in the Public Record Office, a thoroughgoing re-examination of the extensive topographical archive, a major archaeological excavation (fig. 410) and meticulous scientific analysis of the evidence for planting. I masterminded this with a small design team and it was executed by a mixture of the palace's own gardens staff and external landscape contractors (fig. 411). The result transformed not only the appearance of the palace but people's perceptions of baroque architecture and monarchy (figs 412, 413). For the first time in nearly a hundred years of restoration at Hampton Court the academic research behind the project was published on the day the garden opened to the public.[136] Importantly, the completion of the garden led directly to a comprehensive strategy being developed

411 (*left*) The reconstruction of the garden in early 1995. The new plants were botanically as close as possible to originals identified in Wise's plant lists and in Sir Hans Sloane's herbarium at the Natural History Museum.

412 The Privy Garden before restoration in 1992. The fountain, walls, terraces, nine of the yew trees and some of the paths survived from the reign of William III.

413 The Privy Garden after restoration.

for the rest of the Hampton Court estate. This document was published in 1997 and should form the basis of developments in the future.[137]

1995–2000

The winning of Visitor Attraction of the Year and a Civic Trust Award for the Privy Garden in 1995 marked the end of the most recent period of restoration. By that date HRP had spent over £50m on visitor-related restoration projects on the six palaces in the group. This was made possible by the dramatic rise in group revenue from £12m in 1989 to £29m in 1995. Almost £9m of this was commercial surplus.

The projects of 1990–95 had been undertaken by a very small number of staff and as the Agency matured it became more bureaucratic and slower moving. More people became involved in the decision-making process and staff numbers rapidly increased. By 1997 there were 130 more people working in HRP than eight years previously. Not only had HRP become strangled by its own administrative processes, but by 1997 two of the main sponsors of the changes, Crawford MacDonald and myself, had moved on, and in due course Robin Evans, MacDonald's 'successor and another champion of restoration, would move too. Nevertheless the reputation that Hampton Court had gained through six years of restoration and the influence of the Flower Show and Music Festival meant that by 1998, ten years after the establishment of the Agency, visitor numbers had risen to 651,000 and the palace's profile as an international monument was higher than it had been since the late 1970s.

By this date, behind the scenes David Beeton and Lord Airlie were working on a scheme that would not only continue to

reduce Government grant in aid but would eliminate it completely. Their aim was to break free from the Department of National Heritage and manage the palaces in the group as an independent trust. This was achieved on 1 April 1998 when Historic Royal Palaces became a Royal Charter body with charitable status. The Secretary of State for the newly created Department of Culture, Media and Sport contracted out the management of Hampton Court and the other Historic Royal Palaces to the new body. Grant in aid from the Treasury decreased in the first year from £7.5m to £3.5m and in 1999/2000 the trust received no Government funding at all. The Trustees, under the chairmanship of the Earl of Airlie, henceforth had absolute management responsibility for Hampton Court.[138] The palace is thus now governed for the nation by an independent trust; the collections it contains are too administered by an independent trust. The time cannot be too distant when the two trusts amalgamate and the royal houses held in right of Crown fall into a larger body held in trust for the nation and the reigning monarch. This would complete a long and tortuous administrative circle and return the care of Britain's most important historic royal ensemble to a single body.[139]

Abbreviations

Acts of the Privy Council	*Acts of the Privy Council*, ed. J. R. Dasent et al., n.s., 46 vols (London, 1890–1964)
All Souls	All Souls College, Oxford
BDBA	Howard Colvin, *A Biographical Dictionary of British Architects 1600–1840* (New Haven and London (1978), 1995 (3rd edition))
BL	British Library
BM	British Museum
Cal. Charter Rolls	*Calendar of Charter Rolls*
Cal. Fine Rolls	*Calendar of Fine Rolls*
Cal. Pat. Rolls	*Calendar of Patent Rolls*
Cal. S.P. Dom.	*Calendar of State Papers Domestic*
Cal. S.P. For.	*Calendar of State Papers Foreign*
Cal. S.P. Milan	*Calendar of State Papers and Manuscripts Existing in the Archives and Collections Of Milan*, ed. A. B. Hinds (London, 1912)
Cal. S.P. Span.	*Calendar of Letters, Documents and State Papers Relating to Negotiations between England and Spain preserved in the Archives at Simancas and Elsewhere,* ed. G. A. Bergenroth, P. de Goyangos, G. Mattingley and R. Tyler (London, 1862–1965)
Cal. S.P. Ven	*Calendar of State Papers and Manuscripts Relating to English Affairs Existing in the Archives and Collections of Venice and other Libraries of North Italy,* ed. R. L. Brown, G. Cavendish-Bentinck, H. F. Brown and A. B. Hinds, 38 vols (London, 1864–1940)
Cal. Treasury Books	*Calendar of Treasury Books*
Cal. Treasury Papers	*Calendar of Treasury Papers*
Cavendish	*The Life and Death of Cardinal Wolsey by George Cavendish*, ed. R. S. Sylvester (Early English Text Society, CCXLIII, 1959)
Commons Journals	*Journals of the House of Commons*
DNB	*Dictionary of National Biography*
EH	English Heritage
EH HPR	English Heritage, Historic Plans Room
HKW	H. Colvin, gen. ed., *The History of the King's Works*, vols I–IV (1962–83)
HMC	Historical Manuscripts Commission
Law	Ernest Law, *The History of Hampton Court Palace*, 3 vols (London, 1885–9)
Lords Journals	*Journals of the House of Lords*
L&P	*Letters and Papers Foreign and Domestic of the Reign of Henry VIII*, catalogued, J. S. Brewer, 2nd edition revised and enlarged, R. H. Brodie, 21 vols (London, 1861–3)
PRO	Public Record Office
RIBA	Royal Institute of British Architects
Soane Museum	Sir John Soane's Museum, London
Statutes of the Realm	*Statutes of the Realm*, 11 vols (1810–28)
VCH	*Victoria County History*
Wren Society	*The Wren Society*, 20 vols (1924–43)

Notes

Preface

1. S. Thurley, *The Lost Palace of Whitehall* (Royal Institute of British Architects, London, 1998); S. Thurley, *The Whitehall Palace Plan of 1670* (London Topographical Society Publication Number 153, 1998); S. Thurley, *Whitehall Palace: An Architectural History of the Royal Apartments, 1240–1698* (New Haven and London, 1999).

Chapter 1

1. J. S. Penn and J. D. Rolls, 'Problems in the Quaternary Development of the Thames Valley around Kingston: A Framework for Archaeology', *London and Middlesex Archaeological Society*, XXXII (1981), pp. 1–12; N. Merriman, *Prehistoric London* (Museum of London, 1990). I am grateful to John Cotton from the Museum of London for help with the prehistory of Hampton Court.
2. G. F. Lawrence, 'Antiquities from the Middle Thames', *Archaeological Journal*, LXXXVI (1929), p. 75; *VCH Middlesex*, I (1969), pp. 34–49; D. Longley, 'The Archaeological Implications of Gravel Extraction in North-West Surrey', *Research Volume of the Surrey Archaeological Society*, no. 3 (1976); P. Andrews, 'Hurst Park, East Molesey, Surrey: Riverside Settlement and Burial from the Neolithic to the Early Saxon Periods', in P. Andrews and A. Crockett, eds, 'Three Excavations along the Thames and its Tributaries, 1994', *Wessex Archaeology Report*, no. 10 (1996); J. Yonge Ackerman, 'Notes of Antiquarian Researches in the Summer and Autumn of 1854. Teddington, Middlesex', *Archaeologia*, XXXVI (1855), pp. 175–6.
3. *The Itinerary of John Leland*, ed. Lucy Toulmin Smith, 5 vols (London, 1906–10, 1964), IV, p. 85.
4. D. Hawkins, 'Roman Kingston-upon-Thames: A Landscape of Rural Settlements', *London Archaeologist*, VIII, no. 2 (autumn 1996), pp. 46–50; *The Itinerary of John Leland*, IV, p. 85.
5. D. Hawkins, 'Anglo-Saxon Kingston: A Shifting Pattern of Settlement', *London Archaeologist* (autumn 1998), VIII, no. 10, pp. 271–8.
6. David C. Douglas, *William the Conqueror* (London, 1969), pp. 265–72.
7. G. Herbert Fowler, 'De St Walery', *The Genealogist*, XXX (1914), pp. 1–17.
8. David Sullivan, *The Westminster Corridor: An Exploration of Westminster Abbey and its Nearby Lands and People* (London, 1994), maps F, G, I, J, K; Oliver Rackham, *The History of the Countryside* (London, 1995), pp. 75–8.
9. *Domesday Book, 11, Middlesex*, trans. and ed. J. Morris (Chichester, 1975), p. 130; A. C. B. Unwin, 'Hampton and Teddington in 1086: An Analysis of the Entry in the Doomsday Book', *Borough of Twickenham Local History Society Paper*, no. 2 (1965), pp. 1–16; *VCH, Middlesex*, I, pp. 112–13. I am grateful to Paul Hill at Kingston Museum for his help on Saxon and Norman Hampton.
10. G. Herbert Fowler, 'De St Valery', pp. 1–17; *VCH, Middlesex*, I, pp. 113–14.
11. Christopher Tyerman, *England and the Crusades 1095–1388* (Chicago and London, 1988), p. 217; R. L. Nicholson, *Joscelyn III and the Fall of the Crusader States 1134–1199* (Leiden, 1973), pp. 29, 30n; Jonathan Riley-Smith, *The First Crusaders* (Cambridge, 1997), pp. 202, 224, 248.
12. *VCH, Middlesex*, II, pp. 324–5.
13. Some land in Hampton and the advowson of the parish church remained with the Benedictine monastery of Saint-Valery sur Somme. They presented the living to various chaplains in the mid-thirteenth century and at various times the living fell into the hands of the king while England was at war with France (*Cal. Pat. Rolls, Edward III*, VIII, pp. 303, 423; IX, p. 35). Finally in 1391 the monastery of Saint-Valery alienated their interest in all property and advowsons in Isleworth, Twickenham, Heston and Hampton to the College of St Mary in Winchester (*Cal. Pat. Rolls, Richard II*, IV, p. 413).
14. *Rotuli Litterarum Clausarum*, I, p. 385b (1218).
15. *VCH, Middlesex*, I, p. 83; III, p. 103.
16. *Cal. Pat. Rolls, Henry III* (1232–47), p. 201.
17. *VCH, Middlesex*, II, p. 325.
18. *Cal. Charter Rolls*, II (1257–1300), p. 226; Charles R. Young, *The Royal Forests of Medieval England* (Leicester, 1979), pp. 46, 97; *Cal. Pat. Rolls, Edward I* (1301–7), p. 157; W. Dugdale, *Monasticon Anglicanum* (1665, 1661), VI (ii), p. 832.
19. L. B. Larking, *The Knights Hospitallers in England: Being the Report of Prior Philip de Thame to the Grand Master Elyan de Villanova for A.D. 1338* (Camden Society, LXV, 1857), pp. 127–8.
20. This definition was provided by Professor Jonathan Riley-Smith in a letter to Barney Sloane of the Museum of London Archaeology Service.
21. Some of what follows is based on the very useful pamphlets by Peter Foster, 'The Hospitallers at Hampton in 1338', 2 parts, *Borough of Twickenham Local History Society Paper*, 26 and 50 (1975).
22. *HKW*, I, pp. 470–73; II, pp. 906, 994–7; F. J. Mitchell, 'The Manor House at Byfleet', *Surrey Archaeological Collections*, XX (1907), pp. 156–7; L. R. Stevens, 'Byfleet House, "A Noble House of Brick"', *Surrey Archaeological Collections*, L (1949), pp. 99–104; L. R. Stevens, 'Notes on Byfleet Manor and the Manor House', *Surrey Archaeological Collections*, XLV (1937), pp. 53–4.
23. The extent states that the expenses of the house include visitors 'because the Duke of Cornwall is staying near'.
24. PRO C54/134m.14d.; C54/134m.17d.; C54/172m.23d.; C54/195m.24d.; C54/199m.43d.; C54/216m.17d.; C54/217m.2d.
25. These details come from a manuscript list of Hospitallers in England compiled by Pamela Willis. Most of the Hampton references come from BL MS Nero E VI.
26. PRO C66/239m.18 (*Cal. Pat. Rolls, Edward III* (1350–54), p. 417).
27. W. H. St John Hope, *Windsor Castle: An Architectural History*, 3 parts (1913), part I, p. 162; John Harvey, *English Medieval Architects* (Gloucester, 1984), pp. 315–16.
28. It is possible that the Order may have retained the chapel.

29 R. Gilchrist, 'The Archaeology of the Military Orders', in R. Gilchrist, ed., *Contemplation and Action: The Other Monasticism* (Leicester, 1995), pp. 104–5; J. Blair, 'Hall and Chamber: English Domestic Planning 1000–1250', in G. Meirion-Jones and M. Jones, eds, *Manorial and Domestic Buildings in England and Northern France* (London, Society of Antiquaries, 1993), p. 15.

30 Excavations made in 1977 and 1994 suggest that the ditch on the east and north sides was dry. D. Batchelor, 'Excavations at Hampton Court Palace', *Post Medieval Archaeology*, XI (1977), p. 46; G. D. Keevill and C. Bell, 'The Excavation of a Trial Trench across the Moat at Hampton Court Palace', *London and Middlesex Archaeological Society*, XLVII (1996), pp. 145–56.

31 1966–7, excavation by P. Curnow and A. Cook (Archive); 1971, excavation by A. Paccito (Archive); 1973–4, excavation by J. Dent and B. Davidson (Archive); 1977, excavation by T. Higgenbottom (Archive); Batchelor, 'Excavations at Hampton Court Palace', p. 46.

32 Table of dimensions of surviving Hospitaller structures in England.

33 J. F. Wadmore, 'The Knights Hospitallers in Kent', *Archaeologia Cantiana*, XXII (1897), pp. 251–5; S. E. Rigold, 'Two Camerae of the Military Orders, Strood Temple, Kent, and Harefield, Middlesex', *Archaeological Journal*, CXXII (1965), pp. 86–132; Thomas Hugo, 'Moor Hall in Harefield', *London and Middlesex Archaeological Society*, III (vii) (1866), pp. 1–30.

34 1974, excavations by J. Dent and B. Davidson (Archive).

35 BL MS Lansdowne 200 f. 30v.

36 N. W. Alcock, 'The Hall of the Knights Templar at Temple Balsall, W. Midlands', *Medieval Archaeology*, XXVI (1982), pp. 155–8; W. H. Shimield, 'On Shengay and its Preceptory', *Cambridge Antiquarian Society*, VII (1888–91), pp. 137–47.

37 In 1871 two burials were found to the south of the chapel in the present Fountain Court. Although at the time thought to be for victims of the Commonwealth, they may have been part of a Hospitaller graveyard (*Law*, II, p. 160).

38 R. Gilchrist, 'The Archaeology of the Military Orders', pp. 74, 100–01.

39 There are a number of John Wodes in the late fifteenth century and this has caused some confusion. The identification of John Wode, the Yorkist Speaker of the House of Commons, with the John Wode named in the Hampton Court lease rests on documents that name him 'of Hampton Court' (see *Cal. Pat. Rolls, Edward IV, Edward V, Richard III* (1476–85), pp. 23, 144). It is heavily supported by his ownership of the manor of Molesey, for which see, for instance, *Cal. Fine Rolls, Edward IV, Edward V, Richard III*, XXI (1471–85), p. 305. See also J. S. Roskell, 'Sir John Wood of Molesey, Speaker in the Parliament of 1483', *Surrey Archaeological Collections*, LVI (1959), p. 15n.

40 Roskell, 'Sir John Wood of Molesey, Speaker in the Parliament of 1483', pp. 15–28; J. C. Wedgewood, *History of Parliament: Biographies of the Members of the Commons Houses 1439–1509* (HMSO, London, 1936), I, pp. 965–6; J. S. Roskell, *The Commons and their Speakers in English Parliaments 1375–1523* (Manchester, 1965), pp. 291–3; Charles Ross, *Edward IV* (London, 1974), p. 345; Paul Murray Kendall, *Richard III* (London, 1955), pp. 149, 184, 312. I am very grateful to Greg O'Malley of Christ's College, Cambridge, who is working on a doctoral thesis on the Knights Hospitallers in England, for his help with the late fifteenth-century house. He has furnished me with several crucial references.

41 *Feet of Fines for Essex*, IV: *1423–1547*, ed. P. H. Reaney and Marc Fitch (Colchester, 1964), p. 59. English Heritage List description for Rivers Hall, Boxstead, makes it clear that none of the sixteenth-century house remains (*VCH, Surrey*, III (ii), pp. 453–4).

42 But see his inquisition post-mortem which describes his lands in Molesey (PRO C141/6 no. 19).

43 An inquisition post-mortem was held for Wode's Surrey lands in October 1484 (PRO C141/6 no. 19).

44 For Daubeney see D. A. Luckett, 'Crown Patronage and Political Morality in Early Tudor England: The Case of Giles, Lord Daubeney', *English Historical Review*, CX (1995), pp. 578–95; *DNB*; *History of Parliament*; S. B. Chrimes, *Henry VII* (London, 1964, 1987), pp. 109–11.

45 *Cal. S.P. Milan*, I, p. 335.

46 Ian K. Jones and Ivy W. Drayton, *The Royal Palaces of Enfield* (Enfield Archaeological Society Research Report no. 4, n.d.).

47 John Cloake, *Palaces and Parks of Richmond and Kew*, 2 vols (Chichester, 1995–6), I, pp. 152–4.

48 BL Lansdowne MS 200 ff. 30–30v.

49 National Library of Malta, A.O.M. MS 392 ff. 103v–104 (I am grateful to Pamela Willis for obtaining this reference for me); A.O.M. 79, ff. 37r, 79v (I am grateful to Greg O'Malley for providing me with these references).

50 BL Cotton MS Claudius C VI f. 8.

51 PRO C47/7/2(2), m.13.

52 S. Bentley, *Excerpta Historica* (London, 1831), p. 124; PRO E101/415/4 f. 24v.

53 N. H. Nicolas, *The Privy Purse Expenses of Elizabeth of York: The Wardrobe Accounts of Edward the Fourth. With a Memoir of Elizabeth of York and Notes* (London, 1830), pp. 2, 6, 7, 12.

54 Ibid., pp. 94–5; A. F. Pollard, *The Reign of Henry VII from Contemporary Sources*, 3 vols (London, 1913), I, p. 231; *HKW*, III, p. 263; Michael Van Cleave Alexander, *The First of the Tudors* (London, 1981), p. 185.

55 PRO E36/214 ff. 16v, 17; PRO E36/214 f.17; J. Gardiner, *Memorials of Henry VII* (London, 1858), p. 104.

56 BL Cotton MS Claudius C VI f. 8.

57 Or alternatively was destroyed by it.

58 It should also be pointed out that in the incomplete documentation for Wolsey's building work no mention is made of the construction of kitchens. This argues against my earlier article 'The Sixteenth Century Kitchens at Hampton Court', *Journal of the British Archaeological Association*, CXLIII (1990), pp. 1–28.

59 Pers. comm. John Schofield, Museum of London.

60 Thurley, 'The Sixteenth Century Kitchens at Hampton Court', pp. 2–7.

61 On Bradgate see Sean O'Harrow 'The Country House Architecture of Henry VII and the Nobility', unpublished PhD thesis (University of Cambridge, 1997), pp. 198–221.

62 John A. A. Goodall, 'Henry VII's Court and the Construction of Eton College', in Laurence Keen and Eileen Scarff, eds, *Windsor: Medieval Archeology, Art and Architecture*, BAA Conference Transactions, XXV (2002), pp. 247–63; Duncan Hawkins with Alistair Douglas, Andrew Harris and Victoria Ridgeway, 'The Archbishop of York's Battersea Mansion', *London Archeologist*, IX, no. 5 (summer 2000), pp. 129–36; Jones and Drayton, *The Royal Palaces of Enfield*, pp. 29–47; C. Philpots, 'Elsyng Palace', unpublished survey by Compass Archaeology for the London Borough of Enfield, National Monuments Record.

Chapter 2

1 Peter Gwyn, *The King's Cardinal: The Rise and Fall of Thomas Wolsey* (London, 1990), p. 4. See pp. 1–32 for Wolsey's early life and rise to power.

2 PRO Prob 11/16 q.16. For Henry Daubeney see Helen Miller, *Henry VIII and the English Nobility* (Oxford, 1986), pp. 28–9.

3 BL Cotton MS Claudius E vi, f. 139.

4 Wolsey, *DNB*; J. A. Guy, *The Cardinal's Court: The Impact of Thomas Wolsey in Star Chamber* (Hassocks, 1977), pp. 28, 37, 30, 100–01.

5 J. Galea, 'Henry VIII and the Order of St John', *Journal of the British Archaeological Association*, 3rd ser., XII (1949), p. 65; Archives of Malta 406 ff. 162v.–4r. See also below, chapter 3.

6 *L&P*, I, no. 3024; *Cal. S.P. Ven.*, II, no. 385.

7 Battersea had been used as a building depot since the twelfth century, especially for the stockpiling of Reigate stone. Thus in using Battersea Wolsey was capitalising

8 A. D. K. Hawkyard, 'Thornbury Castle', *Transactions of the Bristol and Gloucestershire Archaeological Society*, XCV (1977), p. 51.
9 A list of Cromwell's expenses shows him making regular trips to visit Wolsey at Hampton Court on College business, both by river and by road (PRO E101/518/14).
10 S. Thurley, 'The Domestic Building Works of Cardinal Wolsey', in S. J. Gunn and P. G. Lindley, eds, *Cardinal Wolsey: Church, State and Art* (Cambridge, 1991), pp. 80–81.
11 For example, PRO E36/235 pp. 823–6.
12 PRO E36/235 pp. 683–836; E101/518/14; E101/474/8; SP11/17 ff. 212–13.
13 John Harvey in his *Dictionary of English Medieval Architects: A Biographical Dictionary down to 1550* (London, 1984), p. 247, suggests that Redman was the Master Mason at Hampton Court. There is no documentary evidence for this. Lebons was quite senior enough to have undertaken both the design work and supervision there alone.
14 *HKW*, III, pp. 26, 214; PRO E36/235, p. 804.
15 Neither Abraham nor Rowe appears in any domestic building account during Henry VIII's reign.
16 His wages are entered in the York Place accounts for December 1515 (PRO E36/236 p. 132). Harvey, *English Medieval Architects*, pp. 260–63; *HKW*, III, pp. 29–30; D. R. Ransome, 'Artisan Dynasties in London and Westminster in the Sixteenth Century', *Guildhall Miscellany*, II (1960–68), pp. 240–42.
17 Or Smeyton.
18 Anthony Emery, 'Ralph Lord Cromwell's Manor at Wingfield (1439–c.1450): Its Construction, Design and Influence', *Archaeological Journal*, CXLII (1985), pp. 276–339; P. A. Faulkner, 'Sudeley Castle', *Archaeological Journal*, CXXII (1965), pp. 189–90.
19 PRO E36/235 ff. 738, 777.
20 During excavations in 1976 massive foundations were revealed, as shown on English Heritage drawing no. AS2/7. For Oatlands see Alan Cook, 'Oatlands Palace Excavations 1968 Interim Report', *Surrey Archaeological Collections*, LXVI (1969) pp. 1–9.
21 Although if the cloister at Christ Church had been finished the courtyard would have been smaller.
22 Tatton-Brown, 'The Quarrying and Distribution of Reigate Stone in the Middle Ages', p. 199. Wheatley limestone is indistinguishable from Headington stone, and so Wolsey's masons could just as easily have used that.
23 See below for the care with which nineteenth-century restorers copied original stone profiles. An early survey of stone profiles at Hampton Court is Augustus Pugin and E. J. Willson, *Specimens of Gothic Architecture Selected from Various Ancient Edifices in England . . . etc.*, 3 vols, 3rd edition (London, 1821–3; Edinburgh, 1895), II. It should be noted that by the time Pugin made his record much stonework had already been replaced and in some cases he was making a record of mouldings only ten years old.
24 Painted brickwork has been found preserved in sheltered places, and excavated Tudor stonework and terracotta show signs of limewash on both interior and exterior faces.
25 Tim Tatton-Brown, *Lambeth Palace: A History of the Archbishops of Canterbury and their Houses* (London, 2000), pp. 51–5. Another example of the wide-bodied gatehouse is at Layer Marney, Essex.
26 Pugin and Willson, *Specimens of Gothic Architecture*, II, p. 4. The ribs of the vault are also mentioned during Charles II's reign (PRO Work 5/41 f.242r.).
27 P. A. Faulkner, 'Some Medieval Archiepiscopal Palaces', *Archaeological Journal*, pp. 137–8; A. D. Stoyel, 'The Lost Buildings of Otford Palace', *Archaeologia Cantiana*, C (1984), pp. 262, 267.
28 See examples in W. A. Pantin, 'Chantry Priests' Houses and other Medieval Lodgings', *Medieval Archaeology*, III (1959), figs 79–90; M. Wood, *The English Medieval House* (1965), pp. 181–7.
29 PRO E36/235 pp. 740, 826.
30 PRO E36/236 p. 835.
31 S. Thurley, *Whitehall Palace: An Architectural History of the Royal Apartments, 1240–1698* (New Haven and London, 1999), pp. 13–16; PRO E36/235 pp. 767, 796.
32 J. Blair, 'Hall and Chamber: English Domestic Planning 1000–1250', in G. Meirion-Jones and M. Jones, eds, *Manorial and Domestic Buildings in England and Northern France* (London, Society of Antiquaries, 1993), p. 15.
33 PRO E36/235 p. 711. I first postulated the existence of this gallery in my 1988 article reconstructing Henry VIII's Hampton Court ('Henry VIII and the Building of Hampton Court: A Reconstruction of the Tudor Palace', *Architectural History*, XXXI (1988)), and two years later was, as the English Heritage Inspector for Hampton Court, able to excavate it beneath the wing damaged by fire in 1986. The results of that excavation are not published and remain in archive at Hampton Court.
34 'The Life of Sir Thomas More, Knight, written by William Roper Esquire', ed. E. V. Hitchcock, *Early English Text Society*, CXCVII (1935), p. 19.
35 Thurley, 'The Domestic Building Works of Cardinal Wolsey', pp. 97–9.
36 Bruce Allsopp, ed., *Inigo Jones on Palladio: Being the Notes by Inigo Jones in the Copy of I Quattro Libri dell Architettura di Andrea Palladio*, 2 vols (Oxford, 1970), II, 3rd flyleaf.
37 *L&P*, IV (ii), no. 4461. A single reference to the northern garden survives (PRO E36/237 p. 301). The existence of a Wolseyan garden to the south is supposition, although Jean du Bellay, the French ambassador, describes Wolsey in disfavour fortifying 'his gallery and his garden' (*L&P*, IV (iii), no. 5754). See below.
38 Brian Dix, 'The Excavation of the Privy Garden', in S. Thurley, ed., *The King's Privy Garden at Hampton Court 1698–1995* (London, Apollo, 1995), pp. 112–14; and archive report held at Hampton Court. Another column base was found by the writer embedded in the lower walls of Wren's new building on the gallery site during the fire-damage restoration of 1986–92.
39 For the demolition of the Tudor palace and reuse of materials see below, chapter 10.
40 Importantly a number of fragments of terracotta have been found embedded in Tudor foundations. These include two pieces reused in the foundations of Henry VIII's Queen's Gallery of 1537 from an excavation by David Batchelor in 1977; and fifteen pieces reused in Wolsey's new south range of around 1526. These fragments were both reused in parts of the building adjacent to the Wolsey work which may have contained terracotta (especially the south-range fragments) (D. Batchelor, 'Excavations at Hampton Court Palace', *Post-Medieval Archaeology*, XI (1977), pp. 44–7).
41 Richard K. Morris, 'Architectural Terracotta Decoration in Tudor England', in P. G. Lindley and T. Frangenberg, eds, *Secular Sculpture 1350–1550* (Stamford, 2000) p. 194. Also see M. Howard on the Laughton Place terracottas in J. Farrant et al., 'Laughton Place: A Manorial and Architectural History', *Sussex Archaeological Collections*, CXXIX (1991), pp. 142–52.
42 The exterior face of the west end of the gallery survives two storeys high within the present Wolsey rooms. It is of brick with diaperwork and double-struck pointing like the rest of the Wolsey phase work. At its south corner there is a small octagonal corner-turret with a plain terracotta plinth. This is the only piece of sixteenth-century terracotta *in situ*. The window in this end wall was removed and filled in during the construction of Wolsey's c.1526 south range. It is probably from this window that the fifteen sections of terracotta found under the Wolsey rooms came.
43 Richard K. Morris, 'Windows in Early Tudor Country Houses', in Daniel Williams, ed., *Early Tudor England* (Proceedings of the 1987 Harlaxton Symposium), pp. 125–30; Batchelor, 'Excavations at Hampton Court Palace', pp. 36–9.

44 PRO SP1/22 f.201 (*L&P*, III (i), no. 1355). On the roundels generally see Alfred Higgins, 'On the Work of Florentine Sculptors in England in the Early Part of the Sixteenth Century: With Special Reference to the Tombs of Cardinal Wolsey and King Henry VIII', *Archaeological Journal*, LI (1894), pp. 191–7; P. G. Lindley, 'Playing Check-Mate with Royal Majesty? Wolsey's Patronage of Italian Renaissance Sculpture', in Gunn and Lindley, *Cardinal Wolsey*, pp. 279–85.

45 The earliest written record of the busts in their modern locations is J. Grundy, *A Stranger's Guide to Hampton Court Palace and its Gardens* (1865), p. 17.

46 They were restored in April 1840 (PRO Work 1/24 pp. 157–8) and again in 1996 (report in archive at Hampton Court); in 1996 traces of polichromy were found in the deepest recesses.

47 'Plantagenet', *Gentleman's Magazine*, CXVIII (i) (1846), p. 154; Monique Chatenet, *Le Château de Madrid au Bois de Boulogne* (Paris, 1987), p. 113.

48 E. Jesse, *Gentleman's Magazine*, CXVII (ii) (1845), p. 593; Letter from Horace Walpole of November 1779, in W. S. Lewis and A. D. Wallace, eds, *Horace Walpole's Correspondence with the Rev. William Cole* (London, 1937), pp. 176–7; H. B. Wheatley, *London Past and Present*, 3 vols (London, 1891), III, p. 513. In 1742 George Bickham claimed he saw four heads (including those now on the west side of the Anne Boleyn Gate) on the Great Gatehouse on the west front (G. Bickham, *Deliciae Britannicae; or, the Curiosities of Hampton-Court and Windsor Castle* (London, 1742), pp. 57–8). This must be an error, because many views of the west front including Wyngaerde's Elizabethan view and John C. Buckler's very reliable view of 1826 (BL Add MS 36369 p. 181) show the west front without any roundels.

49 *The Diary of Baron Waldstein*, ed. G. W. Groos (London, 1981), pp. 146–7. I dismiss as confusing and inaccurate the observations of Paul Hentzner, who claims in 1597 to have seen 'twelve roman emperors in plaster' on the inner side of the Anne Boleyn Gate (Paul Hentzner, *Travels in England* (London, 1797), pp. 56–8).

50 See Jesse, *Gentleman's Magazine*, CXVII (ii), for details of the discovery of this plaque.

51 Bernard Garside, *People and Homes in Hampton-on-Thames in the Sixteenth and Seventeenth Centuries* (Richmond, 1956), pp. 42–4. The debate over remote and local manufacture is concisely summarised in Morris, 'Architectural Terracotta Decoration in Tudor England', pp. 196–200. But see also the excellent B. Sloane, 'The Priory of Clerkenwell' (Museum of London, in press).

52 PRO E101/474/8.

53 Graham Keevill and Chris Bell, 'The Excavation of a Trial Trench across the Moat at Hampton Court Palace', *Transactions of the London and Middlesex Archaeological Society*, XLVII (1996), pp. 145–56; Batchelor, 'Excavations at Hampton Court Palace', p. 46.

54 E. Ives, *Anne Boleyn* (Oxford, 1986), pp. 132–3.

55 PRO E101/474/8; PRO E36/235 p. 689.

56 PRO E101/474/6; E101/474/8; *L&P*, II (ii), no. 4662.

57 T. Campbell, 'Cardinal Wolsey's Tapestry Collection', *Antiquaries Journal*, LXXVI (1996), pp. 77–83.

58 *Ibid.*, pp. 83–4.

59 *Ibid.*, pp. 123–5.

60 *L&P*, III (i), no. 1114.

61 Wolsey must have been expecting the visit ever since the signing of the secret treaty of Bruges the previous year, one of the provisions of which was a visit to England by the emperor (*L&P*, III (iii), p. 819).

62 *The Complete Poems of John Skelton*, ed. P. Henderson (London and Toronto, 1931), pp. 311, 350; Greg Walker, *John Skelton and the Politics of the 1520s* (Cambridge, 1988), pp. 133–6, 159–61.

63 *L&P*, II (ii), no. 2446.

64 This was pioneered by Mrs Daphne Ford whose detailed brick analysis records exist in archive at Hampton Court.

65 The size range is 9–9¼in. × 4¼–4½in. × 2–2½in.; the fabric is slightly darker and often brown–orange in colour (a product of higher kiln temperatures), and the mortar used is of better quality.

66 *Cal. S.P. Ven.*, IV, no. 682.

67 David Loades, *Mary Tudor: A Life* (London, 1989), pp. 28–9, 39, 61.

68 *Cal. S.P. Span.*, IV (ii), pp. 855–6; *L&P*, IV (iii), pp. 2265, 2296.

69 PRO E36/238 p. 521; E36/243 p. 482; E36/239 p. 351; E36/237 p. 304; E36/243, p. 519.

70 It should be noted that Lawrence Stubbs is a link between Thornbury and Hampton Court.

71 Simon Thurley, *The Royal Palaces of Tudor England* (New Haven and London, 1993), pp. 41–4.

72 *Cal S.P. Span.*, III (i), nos 6, 119.

73 John Stow, *Annales of England* (London, 1592), p. 525; *Cal. S.P. Span.*, III, no. 4662.

74 *L&P*, III (ii), no. 1913, p. 819; PRO SP1/21 f.215.

75 *Cal. S.P. Span.*, III (i), no. 119; Edward Hall, *Chronicle containing the History of England, during the Reign of Henry the Fourth, and the Succeeding Monarchs, to the End of the Reign of Henry the Eighth etc.* (London, 1809), pp. 703–4.

76 *L&P*, II (ii), no. 1935.

77 N. Samman, 'The Henrician Court during Cardinal Wolsey's Ascendency, *c*.1514–1529', unpublished PhD thesis (University of Wales, 1989), p. 222.

78 The whole area on which the early buildings had been built was probably levelled at that stage, and the foundations of the new range cut through 1.5m of sandy dump which levelled it. See archive report on excavations by the Inner London Excavation Unit undertaken by David Whipp in May 1976.

79 Reports of the panelling's discovery suggest that a small amount may have been *in situ* sixteenth-century material. See *The Sphere*, 11 August 1923; *Country Life*, 11 August 1923.

80 This identification is based on the fact that when Henry VIII built another storey on the Long Gallery, the original first-floor gallery became known as the Middle Gallery (i.e. with one above and one below). The rooms in question abut the east end of the Middle Gallery.

81 *Cal. S.P. Span.*, III (i), nos 6, 86, 119, 122, 379.

82 Charles Giry-Deloison, 'A Diplomatic Revolution? Anglo-French Relations and the Treaties of 1527', in D. Starkey, ed., *Henry VIII: A European Court in England* (London, National Maritime Museum, 1991), pp. 77–83.

83 *Cal. S.P. Ven.*, IV, no. 205.

84 *Cavendish*, pp. 71–5.

85 Greg Walker, *John Skelton and the Politics of the 1520s* (Cambridge, 1988), pp. 133–7.

86 See Gwynn, *The King's Cardinal*, p. 4; Gunn and Lindley, eds, *Cardinal Wolsey*, pp. 3–5.

87 PRO E36/239 p. 40.

88 Roger Bowers, 'The Cultivation and Promotion of Music in the Household and Orbit of Thomas Wolsey', in Gunn and Lindley, eds, *Cardinal Wolsey*, pp. 179–83.

89 See notes on the summer meeting at Oxford in *Archaeological Journal*, LXVII (1910), pp. 327–9; H. Colvin, *Unbuilt Oxford* (New Haven and London, 1983), pp. 2–6.

90 Thurley, *The Royal Palaces of Tudor England*, p. 196; S. Thurley, 'English Royal Palaces 1450–1550', unpublished PhD thesis (University of London, 1992), pp. 126–8.

91 Hilary Wayment, 'Twenty-four Vidimuses for Cardinal Wolsey', *Master Drawings*, XXIII–XXIV, no. 4 (1985–6); Hilary Wayment, 'Wolsey and Stained Glass', in Gunn and Lindley, eds, *Cardinal Wolsey*, pp. 116–30; Peter Curnow, 'The East Window of the Chapel at Hampton Court Palace', *Architectural History*, XXVII (1984), pp. 1–14.

92 Thurley, *Whitehall Palace*, p. 118.

93 BL MS Harl. 599 ff. 113–21.

94 For evidence of a possible western side to the cloister see drawings in archive at Hampton Court.

95 Close examination shows the crown to have been added. It should also be noted that Wolsey's supporters were often angels (e.g. fig. 38) and the king's never were, nor were the royal arms ever painted on a shield of this shape.

96 It is possible, but unproved, that these panels originally occupied the spaces over the Great Gatehouse and the Anne Boleyn Gate before the royal arms were added around 1536.
97 PRO SP1/50 f.123.
98 *Cal. S.P. Span.*, III (ii), pp. 85–6; *L&P*, IV (iii), nos 5154, 5188, 5211, 5366, 5375, 5593, 5681, 5754, 5806. The fall of Wolsey is covered well in G. W. Bernard, 'The Fall of Wolsey Reconsidered', *Journal of British Studies*, XXXV (July 1996), pp. 292–310.
99 PRO E101/518/14; E101/496/30.
100 Thurley, 'Cardinal Wolsey's Domestic Building Works', pp. 96–7; P. Hembry, 'Episcopal Palaces 1535 to 1600', in E. W. Ives, R. J. Knecht and J. J. Scarisbrick, eds, *Wealth and Power in Tudor England* (London, 1978), pp. 146–58; Faulkner, 'Some Medieval Archiepiscopal Palaces', p. 144.

Chapter 3

1 *L&P*, IV (ii), no. 4497; *HKW*, III, pp. 27–8; *DMA*, pp. 205–6; M. J. Williams, 'Wills of Freemasons and Masons', *Masonic Record*, XVI (1936), p. 204.
2 John Harvey, *Dictionary of English Medieval Architects: A Biographical Dictionary down to 1550* (London, 1984), p. 83.
3 John Musty, 'Brick Kilns and Tile Suppliers to Hampton Court Palace', *Archaeological Journal*, CXLVII (1990), pp. 413–14. The Hampton Court brick typology to which all historians of the palace are in debt was undertaken by Daphne Ford and is held in archive on site.
4 Simon Thurley, *The Royal Palaces of Tudor England* (New Haven and London, 1993), pp. 145–62.
5 This was excavated in 1988 beneath apartment 37 by the central excavation unit of English Heritage. Drawings and site data are held in the E. H. archive.
6 PRO E351/3241.
7 S. Thurley, 'The Sixteenth-Century Kitchens at Hampton Court', *Journal of the British Archaeological Association*, CXLIII (1990), pp. 1–28, covers the construction and working of the kitchens in the reign of Henry VIII in detail. A more anecdotal account dealing with cookery and food production in Tudor Hampton Court is P. Brears, *All the King's Cooks: The Tudor Kitchens of King Henry VIII at Hampton Court Palace* (London, 1999).
8 *Cal. S.P. Ven.*, IV (1527–33), p. 305; *L&P*, V, nos 264, 285.
9 Thurley, 'The Sixteenth-Century Kitchens', pp. 20–21.
10 S. Thurley, 'Henry VIII and the Building of Hampton Court: A Reconstruction of the Tudor Palace', *Architectural History*, XXXI (1988), p. 8.
11 Possibly from the original south range.
12 Thurley, 'Henry VIII and the Building of Hampton Court', pp. 4–6.
13 Ibid., pp. 7–8.
14 *Cal. S.P. Milan*, I (1385–1618), p. 544.
15 PRO E36/241 pp. 483, 521, 524.
16 F. Boudon and J. Blécon, *Le Château de Fontainebleau de François Ier à Henri IV* (Paris, 1998), pp. 56–8; M. Chatenet, *La Cour de France au XVIe Siècle: Vie Sociale et Architecture* (Paris, 2002), pp. 231–8.
17 For example, Cowdray House, Sussex (c.1540); Middle Temple Hall (1561–70); Hatfield House (1607–12); Wadham College, Oxford (1610–15); Oriel College, Oxford (1640).
18 *HKW*, IV, p. 134. Jonathan Foyle, in 'A Reconstruction of Thomas Wolsey's Great Hall at Hampton Court', *Architectural History*, XLV (2002), pp. 128–58, suggests that the bay window may be a surviving element of an entire hall built by Wolsey. Neither Daphne Ford nor I accept his arguments. They do not explain why Henry VIII would have wanted to build a new hall slightly smaller than Wolsey's given the enormous cost and disruption. In an exact parallel Henry VIII was perfectly content with Wolsey's hall at York Place. They ignore the evidence presented by the northern stair, the nibs of the stone treads of which demonstrate that it could never have serviced a pre-Henrician first-floor hall. They ignore the insertion by Henry VIII of the staircase from Anne Boleyn's Gatehouse to the new Henrician Great Hall; crucially, they ignore evidence of brick typology. There are also a number of complex archaeological points that cannot be covered here. All these issues are summarised in a paper by Daphne Ford and Dr Michael Turner held in the English Heritage Hampton Court files.
19 An analysis of the technical terms used in the building accounts and further details of the cost of the individual elements can be found in L. F. Salzman, *Building in England Down to 1540: A Documentary History* (Oxford, 1952), pp. 217–19.
20 PRO Work 19/583 (report of the Government Chemist, 3 April 1924).
21 The stone stair wound anticlockwise; the timber one, clockwise around a new central brick newel. The remains of the old stair can still be seen at the bottom of the Horn Room stairs.
22 The northern service stair and its associated features are built of Henrician brick and bonded into the hall. The processional stair can be seen to be an insertion in the range because (a) within the gatehouse's north-east turret there is a blocked doorway that formerly led to lodgings at first-floor level (and destroyed by the new stair) and (b) at first-floor landing level there is a recess, part of a remodelled fireplace from a former lodging – all the lodgings had fireplaces and flues on their west walls.
23 I have previously suggested that such straight flights of stairs were a Tudor innovation, first seen at Bridewell, but this has recently been shown to be incorrect. Long straight flights are found in both medieval keeps and in later medieval palaces, such as at Windsor Castle. Christopher Wilson, 'The Royal Lodgings of Edward III at Windsor Castle: Form, Function, Representation', in Laurence Keen and Eileen Scarff, eds, *Windsor: Medieval Archaeology, Art and Architecture of the Thames Valley* (British Archaeological Association Conference Transactions, XXV, 2002), p. 68; Thurley, *The Royal Palaces of Tudor England*, pp. 44, 53–4, 118–19.
24 Thurley, *The Royal Palaces of Tudor England*, pp. 113–20.
25 PRO Work 16/583. The below-stairs staff usually ate in their working houses in the kitchen ranges.
26 *Literary Remains of Edward VI*, ed. J. G. Nichols, 2 vols (London, 1857), II, pp. 331–3, 335, 359.
27 T. P. Campbell, *Tapestry in the Renaissance: Art and Magnificence* (exh. cat., New York, Metropolitan Museum of Art, 2002), pp. 416–23.
28 Thurley, *The Royal Palaces of Tudor England*, pp. 182–8.
29 Thurley, 'Henry VIII and the Building of Hampton Court', pp. 12–13; Thurley, *The Royal Palaces of Tudor England*, pp. 182–8. Since my article of 1988 it has become clear that the location for the pre-1530 Tennis Court cannot have been the site of the Elizabethan Privy Kitchen. A full archaeological analysis of the present interpretation as shown on figure 39 can be found in archive at Hampton Court.
30 *HKW*, IV, p. 31.
31 S. Thurley, *Whitehall Palace: An Architectural History of the Royal Apartments 1240–1698* (New Haven and London, 1999), pp. 39, 50; Thurley, 'Henry VIII and the Building of Hampton Court', pp. 13–14.
32 *L&P*, V, nos 1139 (32), 1207 (7); E. W. Ives, *Anne Boleyn* (Oxford, 1986), p. 194. The Hanworth accounts are interspersed with the Hampton Court ones in PRO E36/239; E36/241; E36/243; E36/244; E36/245.
33 In addition to my 'Henry VIII and the Building of Hampton Court', see also the addendum to it in S. Thurley, 'English Royal Palaces 1450–1550', unpublished PhD thesis (University of London, 1992), pp. 447–51. The easternmost alignment of the new lodgings was dictated by a pre-existing boundary wall, the foundations of which were reused. The boundary was almost certainly a moat revetment and thus the new lodgings, like the west front, overlooked a moat (Thurley, 'Henry VIII and the Building of Hampton Court', p. 15).
34 Thurley, 'Henry VIII and the Building of Hampton Court', pp. 13–16. Details of

35 the decoration are in PRO E36/243 pp. 278–81, 297. A wider discussion of the decorative forms and techniques can be found in Thurley, *The Royal Palaces of Tudor England*, pp. 86–98, and of the craftsmen in Erna Auerbach, *Tudor Artists* (London, 1954), pp. 14–16.

35 On the chimneys see Salzman, *Building in England down to 1540*, p. 145.

36 Thurley, 'Henry VIII and the Building of Hampton Court', pp. 16–17.

37 Ibid., pp. 17, 21. At the same time a stair was made at the west end of the Privy Gallery giving access from the King's Privy Tower to the Privy Garden.

38 *L&P*, VI, no. 957; PRO E36/242 p. 172.

39 George Bernard, 'The Fall of Anne Boleyn', *English Historical Review*, CVI (July 1991), p. 605; Ives, *Anne Boleyn*, pp. 394–6

40 This is not mentioned in my 'Henry VIII and the Building of Hampton Court', because at the time it was written it seemed that archaeological evidence pointed to the insertion of the door at a later date. The single mention of the door in Henry VIII's accounts was deemed to be insufficient. Since the reconstruction of the room in 1992–3 and an opportunity to see the evidence anew, my view has changed, and I now accept the evidence of the account, which does not conflict with the structural evidence (PRO E36/235 p. 77).

41 PRO E36/243 pp. 420, 462, 476–7.

42 Thurley, 'English Royal Palaces 1450–1550', pp. 447–51. This revises the reconstruction in my 'Henry VIII and the Building of Hampton Court'.

43 For a list of serving clerks see John Bickersteth and Robert W. Dunning, *Clerks of the Closet in the Royal Household* (Stroud, 1991), pp. 107–9.

44 PRO E36/244 pp. 40, 51, 79, 81; E36/239 p. 427.

45 Thurley, 'Henry VIII and the Building of Hampton Court', pp. 24–5. The brick drain from the fountain was neatly cut through the Daubeney range and the cut made good in Henrician brick. The drain was built in September–October 1535 (PRO E36/243 pp. 135, 137) and therefore the demolition of the Daubeney range can be dated to between that time and the start of construction on the new stair tower in early summer 1536.

46 Thurley, 'Henry VIII and the Building of Hampton Court', p. 26; Thurley, *The Royal Palaces of Tudor England*, pp. 173–6.

47 Thurley, 'Henry VIII and the Building of Hampton Court', p. 26; C. R. Peers, 'On the Stone Bridge at Hampton Court', *Archaeologia*, LXII (1910), pp. 309–16; H. Stanford London, *Royal Beasts* (London, The Heraldry Society, 1956), pp. 67–70.

48 PRO E36/241 p. 328; E36/241 p. 410; E36/244 p. 96; Thurley, *The Royal Palaces of Tudor England*, pp. 98–102.

49 PRO E36/243 p. 679, E36/244 p. 75; Thurley, 'Henry VIII and the Building of Hampton Court', p. 27.

50 *L&P*, IV, no. 5951; BL Add MS 4847 f. 159; G. D. Heath, *The Chapel Royal at Hampton Court* (Borough of Twickenham Local History Society Paper 42, 1983), pp. 6–7.

51 PRO E36/237 p. 533; E36/240 p. 565; E36/243 pp. 640–41.

52 F. Kisby, 'The Royal Household Chapel in Early-Tudor London, 1485–1547', unpublished PhD thesis (University of London, 1996), pp. 128–71. This revises some of the work on secular etiquette in Thurley, *The Royal Palaces of Tudor England*, pp. 196–200.

53 F. Kisby, 'Kingship and the Royal Itinerary: A Study of the Peripatetic Household of the Early Tudor Kings', *Court Historian*, IV (i) (April 1999), p. 34

54 Thurley, 'Henry VIII and the Building of Hampton Court', pp. 28–38.

55 Thurley, *The Royal Palaces of Tudor England*, pp. 136–41.

56 D. Batchelor, 'Excavations at Hampton Court', *Post-Medieval Archaeology*, XI (1977), pp. 41–2, 46.

57 Thurley, 'Henry VIII and the Building of Hampton Court', pp. 34–7.

58 Excavation of the Wolsey Gallery during 1990 by the author and Daphne Ford showed that part of the gallery had been widened by about 5 ft in Henrician brick. It cannot be shown to which phase of alteration this can be attributed. The drawings are in archive at Hampton Court, number AS9/34.

59 Thurley, 'Henry VIII and the Building of Hampton Court', pp. 32–4. However, it should be noted that in 1988 I failed to spot the fact that the second-floor gallery was retained as the King's Privy Gallery, and therefore confused a number of first-floor rooms described as 'below the king's gallery' with ground-floor rooms. The potential for confusion, even in the sixteenth century, is noted on pp. 32–3 of the article.

60 Ibid., pp. 41–2.

61 Ibid., pp. 30–31. Note, however, that my suggestion is now that the gallery between the tennis plays was L-shaped and principally ran north–south, not exclusively east–west.

62 Ibid., p. 35. Again, I now diverge from my 1988 article, locating the birthplace in the old lodgings rather than the new. See also Thurley, *The Royal Palaces of Tudor England*, pp. 140–41.

63 *The Diary of Baron Waldstein*, ed. G. W. Groos (London, 1981), p. 153.

64 College of Arms, London, MS M6 ff. 23–26v, 82v; W. D. Hamilton ed., C. Wriothesley, 'A Chronicle of England', 2 vols, *Camden Society*, n.s. XI, parts I and II (1875, 1877), I, p. 68; *L&P* XII (ii), nos 911, 923.

65 *L&P*, XII (ii), no. 1004.

66 Thurley, 'Henry VIII and the Building of Hampton Court', p. 36.

67 *Cal. S.P. Span.*, V (ii) (1536–8), nos 213, 214; *L&P*, XIII (i), no. 1011.

68 J. J. Scarisbrick, *Henry VIII* (London, 1968), pp. 623–7.

69 *Statutes of the Realm*, III, pp. 721–4 (31 Henry VIII c.5).

70 For honours see Thomas Maddox, *Baronia Anglica* (London, 1736), pp. 2, 5, 7–9, 261–2.

71 On the honour and chase see S. Thurley, 'The Impact of Royal Landholdings in Surrey', *Surrey Archaeological Collections* (2003), which deals with the wider landscape setting of Tudor Hampton Court, and T. E. C. Walker, 'The Chase of Hampton Court', *Surrey Archaeological Collections*, LXII (1965), pp. 83–7.

72 The papers for this huge task are in the Surrey History Centre: MSS LM 707, 708/1–2, 710–14, 717, 718, 720–23.

73 *Acts of the Privy Council*, II (1547–50), pp. 190–92. See also *Acts of the Privy Council*, I (1542–7), pp. 239–40.

74 D. Lysons, *Middlesex Parishes* (London, 1800), p. 57; Surrey History Centre MS LM 711.

75 *HKW*, IV, pp. 182–5; *L&P*, XIV (i), no. 499.

76 *HKW*, III, pp. 11–12.

77 A letter written in November 1538 refers to the complexity of running three sites from a single office (PRO SP1/242 f.105); *L&P*, add. I (ii), no. 1371.

78 Surrey History Centre MS LM 708/1.

79 Musty, 'Brick Kilns and Tile Suppliers to Hampton Court Palace', pp. 414–15.

80 PRO E36/236 p. 293; E36/239 p. 95.

81 PRO E36/245 pp. 241–67.

82 N. H. Nicholas, *The Privy Purse Expenses of Henry VIII* (London, 1827), pp. 27, 58; PRO E36/235 p. 757.

83 *L&P*, XVI, nos 380 (pp. 178, 181), 678, 1489 (pp. 699, 701, 706, 708); PRO E351/3201; Cedric Jagger, *Royal Clocks: The British Monarchy and its Timekeepers 1300–1900* (London, 1983), pp. 5–6.

84 PRO E351/3219; E351/3253; E351/3278; Work 5/6 f.230v.

85 PRO AO1/2431/79. For students of clockmaking the account is very detailed, and a more expert eye than mine could tell what work was done.

86 Brian Hellyer and Heather Hellyer, *The Astronomical Clock: Hampton Court Palace* (HMSO, London, 1973), *passim*.

87 PRO E36/243 p. 380; E36/237 p. 124; E36/241 pp. 241, 455; E36/244 p. 136.

88 Thurley, *The Royal Palaces of Tudor England*, pp. 164–6. J. W. Lindus Forge, 'Coombe Hill Conduit Houses and the Water Supply of Hampton Court Palace', *Surrey Archaeological Collections*, LVI (1959), pp. 3–14, is still useful although now out of date.

89 PRO E351/3236.

90 *L&P*, XIV (ii), no. 286; *L&P*, XV, nos 899, 925, 953; *Cal. S.P. Span.*, VI (i), no. 149, pp. 305–6.

91 *Cal. S.P. Span.*, V (ii) (1536–8), no. 204, p. 384.
92 Lacey Baldwin Smith, *A Tudor Tragedy: The Life and Times of Catherine Howard* (London, 1961).
93 *Cal. S.P. Span*, VI (ii) (1542–3), pp. 185–6, 223–4; *L&P*, XVIII (ii), no. 517; Scarisbrick pp. 562–3; Thurley, 'Henry VIII and the Building of Hampton Court', pp. 38–9. In 1988 I attributed the rooms to the queen rather than to the princess, who now (2001) seems the more likely occupant.
94 *L&P*, XVIII (i), no. 873; *L&P*, XVIII (i), no. 886; Thurley, *The Royal Palaces of Tudor England*, p. 121. The accounts for the revels are in the Folger Shakespeare Library: Loseley MS LB153.
95 BL Add MS 6113 f.114; *L&P*, XIX (i), nos 954, 979, 1019 (ii), nos 39, 58, 136, 688.
96 Folger Shakespeare Library, Loseley MS LB 5, 266, 267. See also *Archaeologia*, XVIII (1817), pp. 329–30.
97 W. Douglas Hamilton, ed., 'Wriothesley's Chronicle of England During the Reigns of the Tudors from 1485–1559', *Camden Society*, 2 vols, nos XI, XX (1875, 1877), I, pp. 171–3; *Hall's Chronicle: Containing the History of England during the Reign of Henry the Fourth, and the Succeeding Monarchs, to the End of the Reign of Henry the Eighth, etc.*, ed. Henry Ellis (London, 1809), p. 867; *Cal. S.P. Span.*, VIII (1545–6), nos 465, 316; *L&P*, XXI (ii), p. 7; PRO E351/3326.

Chapter 4

1 I have compiled an itinerary for Edward's reign based on his journal and the biographical memoir printed by Nichols in *Literary Remains of Edward VI*, ed. J. G. Nichols, 2 vols (London, 1857). His most visited residence was Whitehall, followed by Hampton Court and Greenwich. Oatlands and Windsor come an equal fourth.
2 *Literary Remains of Edward VI*, I, p. cxxxi.
3 PRO E351/3326.
4 *Acts of the Privy Council*, II (1547–50), pp. 306, 188; III (1550–52), p. 311.
5 *Literary Remains of Edward VI*, I, pp. cx–cxi.
6 *Literary Remains of Edward VI*, II, pp. 235–6; J. Loach, *Edward VI* (New Haven and London, 1999), pp. 89–93.
7 Richard W. Stewart, *The English Ordnance Office: A Case Study in Bureaucracy*, Royal Historical Society Studies in History 73 (Woodbridge, 1996), pp. 122–6. *The Inventory of Henry VIII*, ed. D. Starkey (London, Society of Antiquaries, 1998), pp. 162–3. The armoury at Hampton Court is mentioned in, for instance, PRO E351/3212.
8 *Cal. S.P. Dom.*, CCL (1591–4), p. 555; CCLI (1595–7), p. 15.
9 Loach, *Edward VI*, pp. 94–8.
10 *Acts of the Privy Council*, III (1550–52), p. 56.
11 *Literary Remains of Edward VI*, II, pp. 331–3, 335; *Cal. S.P. For.* (1547–53), p. 175; *Cal. S.P. Span.*, X, p. 332; Surrey History Centre MS LM713, 714.
12 *Cal. S.P. Dom.* (1547–53), p. 207.
13 *Literary Remains of Edward VI*, II, pp. 359–60; *Cal. S.P. For.* (1547–53), p. 190; see also Loach, *Edward VI*, pp. 142–4.
14 Loach, *Edward VI*, pp. 159–69.
15 *Cal. S.P. Span.*, XIII (1554–8), pp. 30–34.
16 *Cal. Pat. Rolls, Philip and Mary II* (1554–5), p. 103; also D. Loades, *Mary Tudor* (Oxford, 1989), p. 256.
17 Beatrice Webb, *Mary Tudor* (London, 1933), p. 309.
18 *Cal. S.P. Span.* VIII (1554–8), no. 178; J. Dent, *The Quest for Nonsuch* (London, 1962), pp. 144–5.
19 'The Diary of Henry Machyn', ed. J. G. Nichols, *Camden Society*, XLII (1848), p. 85.
20 W. Douglas Hamilton, ed., 'Wriothesley's Chronicle of England during the Reigns of the Tudors from 1485–1559', *Camden Society*, 2 vols, nos XI, XX (1875, 1877), II, p. 128; PRO E36/239 p. 564, E36/244 p. 274.
21 *Cal. S.P. Ven.*, VI (i) (1555–6), no. 174; Loades, *Mary Tudor*, pp. 248–53.
22 *Cal. S.P. Ven.*, VI (i), pp. 93, 126.
23 'The Diary of Henry Machyn', p. 139.
24 Ibid., pp. 37, 57, 58, 63, 120, 166–7.
25 S. Thurley, *Whitehall Palace: An Architectural History of the Royal Apartments, 1240–1698* (New Haven and London, 1999), p. 65; PRO E351/3326; E351/3200; E351/3201; E351/3302.
26 *HKW*, III, p. 77.
27 PRO SP12/4 no. 55. This letter is misdated by *HKW*. Although the date at the top is in a later hand, it is clearly dated 1559 at the bottom by the writer.
28 *Cal. Pat. Rolls, Elizabeth*, I (1558–60), pp. 15–16; D. Lysons, *Middlesex Parishes* (London, 1800) p. 57. The office of Keeper of the Ponds had been granted five months earlier to Thomas Bussarde.
29 *A Collection of Ordinance and Regulations for the Government of the Royal Household . . . etc.* (London, Society of Antiquaries, 1790), p. 262; *Cal. Pat. Rolls, Elizabeth*, II (1560–63), p. 531.
30 *Cal. S.P. For., Elizabeth* (1561–2), no. 540; J. E. Neale, *Queen Elizabeth* (London, 1937), pp. 82–3.
31 *Cal. S.P. Span.*, I (1558–67), nos 187–8, 190; James Melville, *Memoirs of his Own Life, by James Melville of Halhill, 1549–93*, ed. T. Thomson (Edinburgh, 1827), p. 153; *Cal. S.P. For.* (1562), no. 1053; B. Garside, *The Parish Church, Rectory and Vicarage of Hampton upon Thames during the Sixteenth and Seventeenth Centuries* (London, 1937), pp. 13–15.
32 *Cal. S.P. Span.*, I (1558–67), no. 445.
33 After Henry VIII's death Nonsuch had been leased, first to Sir Thomas Cawarden, and then to the Earl of Arundel (*VCH, Surrey*, III, p. 268).
34 Information on the Elizabethan royal itinerary is taken from E. K. Chambers, *The Elizabethan Stage*, 4 vols (London, 1923), IV, pp. 75–117, supplemented by the evidence of the Kingston churchwardens' accounts – the bells were rung when the queen arrived at the palace (Kingston Borough Archives KG2/2 (1561–6); KG2/3 (1567–81)).
35 J. Cloake, *Palaces and Parks of Richmond and Kew*, 2 vols (Chichester, 1995), I, pp. 53, 77, 93, 171–2; *Cal. Pat. Rolls, Philip and Mary*, I (1553–4), p. 376; *Cal. Pat. Rolls, Philip and Mary*, III (1555–7), p. 284; *Cal. Pat. Rolls, Elizabeth*, II (1560–63), p. 620; *Cal. Pat. Rolls, Elizabeth*, IV (1566–9), no. 468; *Cal. Pat. Rolls, Elizabeth*, V (1569–72), no. 526.
36 Conyers Read, *Mr Secretary Cecil and Queen Elizabeth* (London, 1955), pp. 413–14.
37 Alan Young, *Tudor and Jacobean Tournaments* (London, 1987), p. 202; Roy Strong, *The Cult of Elizabeth: Elizabethan Portraiture and Pageantry* (London, 1977), pp. 134–7.
38 Strong, *The Cult of Elizabeth*, pp. 164–76, 212–3; BL Add MS 36768 ff. 16v–17.
39 *HKW*, III, pp. 71–5, 99.
40 PRO E351/3204.
41 Julian Mumby, 'Medieval Carriages and the Origins of the Coach: The Archaeology of the European Transport Revolution', *Antiquaries Journal* LXXXIII (2003). I am most grateful to Mr Mumby for allowing me to see his manuscript in draft.
42 Personal communication from Dr Giles Worsley.
43 PRO E36/237 521, 526; S. Thurley, *The Royal Palaces of Tudor England* (New Haven and London, 1993), pp. 69–70; Royal Commission on Historical Monuments, *Middlesex* (London, 1937), pp. 48–9, pl. 35.
44 Kingston Borough Archives KG2/3 (1567–1681), p. 18; KD5/1/1 (1567–1637) p. 195, see also pp. 185, 196.
45 PRO E351/3227.
46 P. Cunningham, ed., *Extracts from the Accounts of the Revels at Court in the Reigns of Queen Elizabeth and King James I from the Original Office Books of the Masters and Yeomen* (London, The Shakespeare Society, 1842), pp. 62, 68, 87–8, 95, 98, 101, 113; *Acts of the Privy Council*, XXIV (1592–3), p. 102; *Acts of the Privy Council*, XXIII (1592), p. 205.
47 Simon Adams, ed., 'Household Accounts and Disbursement Books of Robert Dudley, Earl of Leicester, 1558–1561, 1584–1586', *Camden Society*, 5th ser., VI (1995), pp. 80–83, 143–5, 181, 183, 185, 194, 196.
48 PRO E351/3216; E351/3219; E351/3234; E351/3230; E351/3233; E351/3235; E351/3229.
49 *Cal. S.P. Dom. 1598–1601*, CCLXXII, no. 94, p. 316.
50 *Memoirs of his Own Life, by Sir James Melville of Halhill*, pp. 115–26.
51 PRO E351/3204; E351/3217; E351/3219; E351/3224.

Chapter 5

1. PRO E36/235 p. 689; S. Thurley, *Whitehall Palace: An Architectural History of the Royal Apartments, 1240–1698* (New Haven and London, 1999), pp. 25–6.
2. PRO E36/235 pp. 695, 747, 755; PRO AO1/2482/294.
3. A recent summary of Henry VIII's work can be found in S. Thurley, ed., *The King's Privy Garden at Hampton Court 1689–1995* (London, Apollo, 1995), pp. 23–5.
4. PRO E36/241 pp. 42, 39, 410; E36/243 p. 320.
5. Brian Dix and Stephen Parry, 'The Excavation of the Privy Garden', in Thurley, ed., *The Privy Garden at Hampton Court*, pp. 80–87.
6. S. Thurley, *The Royal Palaces of Tudor England* (New Haven and London, 1993), pp. 11–23. See also R. Strong, *The Renaissance Garden in England* (London, 1984), pp. 32–3, where he discusses the influence of Burgundy.
7. J. H. Harvey, *Early Nurserymen* (London, 1974), p. 30; PRO E36/243 pp. 267, 277.
8. PRO E36/237 p. 306.
9. *Thomas Platter's Travels in England 1599*, ed. Clare Williams (London, 1937), p. 200.
10. PRO E36/237 p. 148.
11. PRO E36/241 pp. 250, 267, 280.
12. PRO E36/237 p. 42; N. H. Nichols, *The Privy Purse Expenses of Henry VIII* (London, 1827), p. 255.
13. Roy Strong, *The Artist and the Garden* (New Haven and London, 2000), pp. 24–26.
14. PRO E36/242 pp. 44, 71, 297, 302, 303; E36/245 p. 359; E36/243 p. 484.
15. Helen Miller, *Henry VIII and the English Nobility* (Oxford, 1986), p. 82; T. L. Jones, *Ashby de la Zouch Castle* (English Heritage Official Guidebook, 1993).
16. PRO E36/237 pp. 171, 216; E36/242 pp. 98, 241; E36/245 pp. 27, 83.
17. PRO E36/245 f.27; E36/241 p. 525.
18. PRO E36/243 ff.61, 83; BL Add MS 8219 f. 133v; *Thomas Platter's Travels in England*, p. 200. This feature was also noted by Baron Waldstein on his visit in 1600 (G. W. Groos, *The Diary of Baron Waldstein* (London, 1981), p. 147).
19. PRO E36/237 p. 384; E36/245 p. 359; E36/242 p. 71; E36/238 p. 594.
20. PRO E36/240 pp. 502, 582; E36/243 p. 222; E36/237 f. 745.
21. PRO E36/237 pp. 520, 532, 751; E36/239 p. 412; E36/243 p. 640; E36/244 pp. 28, 417.
22. PRO E36/243 pp. 366, 639; C. K. Currie, 'Fishponds as Garden Features, c.1550–1750', *Garden History*, XVIII (i) (1990), pp. 22–46.
23. PRO E36/239 p. 340; E36/244 p. 36; E36/243 pp. 139, 221, 243, 264; E36/245 p. 26; E36/241 p. 15.
24. PRO E36/245 p. 190; E36/241 p. 589; E36/239 p. 630; E36/243 p. 593; E36/244 p. 229; Thurley, *The Royal Palaces of Tudor England*, pp. 188–90.
25. PRO E36/239 p. 553.
26. BL Royal MS Appx. 89 f. 67; BL. Cott. MS Vesp. CXIV f. 105.
27. *HKW*, IV, pp. 433–47.
28. PRO E36/237 p. 522; E36/243 p. 723; E36/239 p. 622; E36/244 pp. 277, 286.
29. The Parliamentary Survey is printed in *Law*, II, Appendix A.
30. *L&P*, VII, no. 823; *L&P*, VIII, no. 1178, p. 463; James Melville, *Memoirs* (Edinburgh, 1827), p. 116; *L&P*, XXI (ii), p. 433.
31. *Cal. Pat. Rolls, Elizabeth*, II (1560–63), p. 123.
32. *Acts of the Privy Council*, II (1547–50), pp. 188, 306; *Acts of the Privy Council*, III (1550–52), p. 311.
33. Surrey History Centre MS LM709/1.
34. E351/3362; E351/3218–19.
35. PRO E36/235 p. 742; E101/474.
36. E351/3237.
37. Katie Fretwell, 'Lodge Park, Gloucestershire: A Rare Surviving Deer Course and Bridgeman Layout', *Garden History*, XXIII (ii) (1997), p. 136; John Musty, 'Deer Coursing at Clarendon Palace and Hampton Court, *Antiquaries Journal*, LXVI (1986), pp. 131–2; *Cal. S.P. Dom.* (1690–91), pp. 548–9; Arthur MacGregor, 'Deer on the Move: Relocation of Stock Between Game Parks in the Sixteenth and Seventeenth Centuries', *Archaeozoologica*, XVI (1992), p. 171.
38. PRO E351/3228; John Norden, *Speculum Britanniae, the first parte: An Historicall & Chorographicall discripcion of Middlesex* (London, 1593), p. 26.
39. PRO E36/245 f.119; Work 16/650.

Chapter 6

1. PRO SP1/12 p. 72.
2. Maurice Howard, *The Vyne, Hampshire* (National Trust Official Guidebook, 1998), pp. 42–7; Maurice Howard, *The Early English Country House: Architecture and Politics 1490–1550* (London, 1987), pp. 24–30; Maurice Howard, 'Sutton Place and Early Tudor Architecture', in *The Renaissance at Sutton Place* (exh. cat., London, Sutton Place, 1983), pp. 23–32.
3. Howard, *The Early English Country House*, pp. 43–58; S. Thurley, *The Royal Palaces of Tudor England* (New Haven and London, 1993), pp. 11–24, 85–112; Anthony Wells-Cole, *Art and Decoration in Elizabethan and Jacobean England* (New Haven and London, 1997), pp. 3–14.
4. P. J. Drury, 'A Fayre House Built by Sir Thomas Smith: The Development of Hill Hall, Essex, 1557–81', *Journal of the British Archaeological Association*, CXXXVI (1983), pp. 98–123.
5. A. Young, *Tudor and Jacobean Tournaments* (London, 1987), pp. 32–42; F. A. Yeats, *Astraea: The Imperial Theme in the Sixteenth Century* (London, 1985), pp. 88–111; Roy Strong, *The Cult of Elizabeth: Elizabethan Portraiture and Pageantry* (London, 1999), p. 116.
6. Mark Girouard, 'Elizabethan Architecture and the Gothic Tradition', *Architectural History*, VI (1963), pp. 23–38; Mark Girouard, *Robert Smythson and the Elizabethan Country House* (New Haven and London, 1983), pp. 28–38.
7. S. Thurley, *Whitehall Palace: An Architectural History of the Royal Apartments, 1240–1698* (New Haven and London, 1999).
8. *HKW*, IV, pp. 107–11.
9. For Elizabethan Richmond see John Cloake, *The Palaces and Parks of Richmond and Kew*, 2 vols (Chichester, 1995), I, pp. 117–50; Stephen Passmore, *The Life and Times of Queen Elizabeth I at Richmond Palace* (Richmond Local History Society paper no. 7, 1992); *HKW*, IV, pp. 229–31.
10. Henry's VIII's movements are taken from an itnerary in PRO OBS 1/1419; F. Kisby, 'Kingship and the Royal Itinerary: A Study of the Peripatetic Household of the Early Tudor Kings', *The Court Historian*, IV (i) (April 1999), p. 34.
11. *The Diary of Baron Waldstein*, ed. G. W. Groos (London, 1981), pp. 145–54; *Thomas Platter's Travels in England, 1599*, ed. Clare Williams (London, 1937), pp. 199–205; Paul Hentzner, *Travels in England* (London, 1889), pp. 74–7; G. von Bülow, 'The Diary of Philip Julius Duke of Stettin Pomerania through England in the year 1602', *Transactions of the Royal Historical Society*, n.s. VI (1892), pp. 53–7; W. B. Rye, ed., *England as seen by Foreigners in the Days of Elizabeth and James I* (London, 1865); 'Journey through England and Scotland made by Lupold von Wedel in the years 1584 and 1585', *Transactions of the Royal Historical Society*, n.s. IX (1895), pp. 250–51; Victor von Klarwill, *Queen Elizabeth and some Foreigners* (London, 1928).
12. *Cal. S.P. Span.*, XIII, p. 37; *Cal. S.P. Ven.*, VII, p. 93.
13. A dozen visitors commented that the tapestries at Hampton Court were the most splendid in England. See, for instance, *Cal. S.P. Span.*, XIII (1554–8), p. 33; *Cal. S.P. Ven.*, XV (1617–19), p. 271.
14. *Cal. S.P. Ven.*, XII (1610–13), p. 153. See also the report in *Cal S.P. Ven.*, XV (1617–19), pp. 270–71.
15. *The Inventory of Henry VIII*, ed. D. Starkey (London, Society of Antiquaries, 1998).
16. For aspects of this argument see Girouard, *Robert Smythson and the Elizabethan Country House*, pp. 32–6. R. Malcom Smutts, *Court Culture and the Origins of a*

17 Rosalys Coope, 'The Long Gallery: Its Origins, Development, Use and Decoration', *Architectural History*, XXIX (1986), pp. 54–5; Nicholas Cooper, *Houses of The Gentry 1480–1680* (New Haven and London, 1999), pp. 301–5; Mark Girouard, *Life in the English Country House* (New Haven and London, 1978), pp. 100–02.
18 Thurley, *The Royal Palaces of Tudor England*, pp. 113–43.
19 Pam Wright, 'A Change in Direction: The Ramifications of a Female Household, 1558–1603', in D. Starkey, ed., *The English Court from the Wars of the Roses to the Civil War* (London, 1987), pp. 147–52.
20 On the influence of Italy on English architecture in this period see particularly Nigel Llewellyn, 'Accident or Design? John Gildon's Funeral Monuments and Italianate Taste in Elizabethan England', in Edward Chaney and Peter Mack, eds, *England and the Continental Renaissance* (Woodbridge, 1990), pp. 143–51.
21 M. Chatenet, *La Cour de France au XVIe Siècle: Vie Sociale et Architecture* (Paris, 2002).
22 Paulo Pereira, *Jerónimos Abbey of Santa Maria* (London, 2002), pp. 45–8; José Custódio Vieira da Silva, *The National Palace, Sintra* (London, 2002), pp. 37–42, 61–2; Thomas Da Costa Kaufmann, *Court, Cloister and City: The Art and Culture of Central Europe 1450–1800* (London, 1995), pp. 139–47.

Chapter 7

1 *Cal. S.P. Ven.*, X (1603–7), pp. 71, 182.
2 F. P. Wilson, *The Plague in Shakespeare's London* (Oxford, 1927), pp. 85–111; B. Garside, *Incidents in the History of Hampton-on-Thames during the Sixteenth and Seventeenth Centuries* (n.d.), p. 9.
3 *Cal. S.P. Dom.* (1603–10), p. 59; Sara Jayne Steen, *The Letters of Lady Arbella Stuart* (Oxford, 1994), p. 197; Maurice Lee, Jr, ed., *Dudley Carleton to John Chamberlain, 1603–1624: Jacobean Letters* (New Brunswick, N.J., 1972), pp. 53–7. See also Leeds Barroll, *Anna of Denmark, Queen of England* (Philadelphia, 2001), pp. 79–80.
4 Alvin Kernan, *Shakespeare, the King's Playwright: Theater in the Stuart Court 1603–1613* (New Haven and London, 1995), pp. 30–31.
5 Wilson, *The Plague in Shakespeare's London*, p. 111; J. T. Murray, *English Dramatic Companies 1558–1642*, 2 vols (London, 1910), I, pp. 56, 148, 207.
6 Lee, *Dudley Carleton to John Chamberlain*, pp. 53–7.
7 Ibid.; PRO E351/3239; E351/3231. The Tennis Court had been minimally maintained during Elizabeth's reign. A single account in 1596–7 refers to repairing windows in the brick boundary wall (PRO E351/3231).
8 J. Nichols, *The Progresses, Processions and Magnificent Festivities, of King James the First, His Royal Consort, Family and Court*, 4 vols (London, 1828), I, pp. 300–02.
9 Lee, *Dudley Carleton to John Chamberlain*, pp. 53–7.
10 PRO E351/3239.
11 This account is based on an anonymous (Puritan) account of the conference in R. G. Usher, *The Reconstruction of the English Church*, 2 vols (New York and London, 1910), II, pp. 341–54; an account by William Barlow who wrote a tract called 'The summe and Substance of the Conference', in Edward Cardwell, *A History of Conferences and other Proceedings Connected with the Revision of the Book of Common Prayer* (Oxford, 1840), pp. 169–214; and a letter from the Bishop of Durham to the Archbishop of York printed in John Strype, *The Life and Acts of John Whitgift* (London, 1822), pp. 402–7. The relative merits of the first two of these are discussed in Mark H. Curtis, 'Hampton Court Conference and its Aftermath', *History*, XLVI, no. 156 (February 1961), pp. 1–16.
12 Henry Ellis, *Original Letters Illustrative of English History*, 3rd ser. (London, 1846), IV, p. 162.
13 PRO E351/3239.
14 PRO E351/2340.
15 *HKW*, III, pp. 119, 180, 130–31.
16 *Cal. S.P. Ven.*, XV (1617–19), p. 271.
17 *Cal. S.P. Dom.* (1603–10), pp. 64, 81. The Keepership of the 'little garden' was awarded to William and Anne Hogan, ibid., p. 75.
18 *Cal. S. P. Ven.*, X (1603–7), pp. 182, 184; XI (1607–10), nos 78, 463, 685; XII (1610–13), no. 68.
19 Kernan, *Shakespeare, the King's Playwright*, p. 73.
20 Ibid., pp. 75–6; Curtis Perry, *The Making of Jacobean Culture: James I and the Renegotiation of Elizabethan Literary Practice* (Cambridge, 1997), pp. 137–47. Curtis gives the full literature on *Macbeth* at Hampton Court and its possible meaning.
21 *Cal. S.P. Dom.* (1619–23), p. 1; *The Letters of John Chamberlain*, ed. N. E. McClure, 2 vols (American Philosophical Society, 1939), II, pp. 196–7.
22 I have modernised the spelling in these quotations. 'Madame the Quein's Death. And Maner thairof', *Miscellany of the Abbotsford Club*, I (1837), pp. 81–3. Also see *Cal. S.P. Ven.*, XV (1617–19), p. 494; *Cal. S.P. Dom.* (1619–23), pp. 20–21; and *The Letters of John Chamberlain*, pp. 219–20.
23 *Cal. S.P. Dom.* (1619–23), p. 214.
24 PRO SP14/185 no. 105.
25 Wilson, *The Plague in Shakespeare's London*, pp. 133–73.
26 The unhappy struggle at Hampton Court is recorded in detail (from a French perspective) in *Mémoires inédits du Comte Leveneur de Tillières Ambassadeur en Angleterre sur la Cour de Charles Ier et son marriage avec Henriette de France*, ed. M. C. Hippeau (Paris, 1863), pp. 88–113. See also Quentin Bone, *Henrietta Maria: Queen of the Cavaliers* (London, 1973), pp. 41–60.
27 Forty-one thousand Londoners died of the plague (Wilson, *The Plague in Shakespeare's London*, p. 160); *Cal. S.P. Dom.* (1625–6), pp. 67, 84, 132.
28 *Cal. S.P. Dom.* (1625–6), p. 84; Thomas Duffus Hardy, *Syllabus of Rymer's Feodera* (London, 1869), p. 860; James F. Larkin, ed., *Stuart Royal Proclamations*, 2 vols (Oxford, 1983), II, pp. 64–5; PRO E352/3260.
29 *Cal. S.P. Dom.* (1625–6), p. 179.
30 PRO E351/3259.
31 PRO E351/3238; E351/3242.
32 *Cal. S.P. Dom.* (1611–18), p. 86. Also see Marcia Vale, *The Gentleman's Recreations: Accomplishments and Pastimes of the English Gentleman 1580–1630* (Cambridge, 1977), pp. 100–07; J. Marshall, *The Annals of Tennis* (London, 1878), pp. 74–5, 79–80.
33 PRO E351/3259; E351/3270; E351/3271, 3272; W. L. Spiers, ed., 'The Note Book and Account Book of Nicholas Stone', *Walpole Society*, VII (1919), p. 111. Also see Heiner Gillmeister, *Tennis: A Cultural History* (Leicester, 1997), p. 152, where it is suggested that this court influenced the design of a court built for Elector Fredrick V.
34 Gervase Markham, *Country Contentments; or, The Husbandman's Recreations* (London, 1631), pp. 57–8; PRO LC5/1327 October 1628; E315/3413; Vale, *The Gentleman's Recreations*, pp. 108–11.
35 Dates gleaned from the *Calendars of State Papers* suggest the following approximate periods of residence: 1625: 8 July–10 July, 2 Nov.–7 Jan. 1626; 1627: 26 Sept.–14 Oct.; 1628: 5 Feb.–9 Feb., 25 Sept.–13 Oct.; 1629: 25 Sept.–16 Oct.; 1630: 24 Sept.–28 Oct.; 1631: 22 Sept.–13 Oct.; 1632: ?30 Sept.; 1633: 3 Oct.–6 Oct.; 1634: 23 Sept.–21 Oct.; 1635: 18 Sept.–1 Nov.; 1636: 20 June–28 June, 19 Nov.–24 Jan. 1637; 1637: 17 Sept.–17 Oct.; 1638: 16 Sept.–22 Oct.; 1640: ?13 Sept.–?4 Oct.; 1641: 26 Nov.; 1647: 12 Oct.–2 Nov.
36 PRO E351/3261; E351/3265; Henry Ellis, *Original Letters Illustrative of English History*, 2nd ser. (London, 1969), III, p. 270.
37 PRO E351/3269.
38 PRO E351/3265. Also a little house was made for the queen's dogs (PRO E351/3262), and in the early summer of 1637 a green velvet bed was delivered to Hampton Court and altered and enlarged for the queen's use (PRO LR5/66, Ralph Grynder's Lady Day to Michelmas bill).

39 PRO E351/3261, E351/3262.
40 Wilson, *The Plague in Shakespeare's London*, p. 174; *Cal. S.P. Dom.* (1636–7), p. 105.
41 On 17 November they acted *The Coxcombe* by Beaumont and Fletcher. On 19 November they played *The Beggar's Bush*, on the 29th *The Maid's Tragedy* and on 6 December *The Loyal Subject* (all by Fletcher, possibly in collaboration with others). Two days later came Shakespeare's *Merchant of Venice*, on the 16th *Love's Pilgrimage*, probably by Giles Fletcher and others, and on St Stephen's and St John's Days the first and second parts of *Arviragus and Philicia* by Ludovick Carlell. On New Year's Day Sir William Davenant's *Love and Honour* was shown. On 5 January *The Elder Brother* (by Fletcher) was performed, on the 10th Beaumont and Fletcher's *A King and noe King*, on Twelfth Night William Cartwright's *The Royal Slave* and on the 17th *The Bloody Butcher* by Fletcher with Ben Jonson. The season ended on 24 January with an old Shakespearean favourite, *Hamlet* (*Cal. S.P. Dom. Charles I*, CCCXXXVII (1636–7), p. 228; P. Cunningham, ed., *Extracts from the Accounts of the Revels at Court in the Reigns of Queen Elizabeth and King James I, from the Original Office Books of the Masters and Yeomen London* (London, Shakespeare Society, 1842), pp. xxiv–xxv.
42 *Cal. S.P. Dom.* (1636–7), p. 563; J. Payne Collier, *The History of English Dramatic Poetry to the Time of Shakespeare, and Annals of the Stage to the Restoration*, 3 vols (London, 1879), II, pp. 12–13.
43 *RCMH*, 4th Report (1874), p. 292.
44 Oliver Millar, ed., 'The Inventories and Valuations of the King's Goods 1649–51', *Walpole Society*, XLIII (1970–72), p. 167 [97], pp. 167–9 [100–05, 108], p. 163 [58], p. 169 [111].
45 Examples of the repair of Henrician furnishings in use can be found in PRO LC5/134 pp. 407, 412. *Cal. S.P. Ven.*, XV (1617–19), pp. 270–71. Anna Keay and Simon Thurley 'The Stuart Royal Bedchamber' (forthcoming).
46 PRO LC5/134 pp. 79, 91. For Smithsby see chapter 8.
47 For James I see Oliver Millar, *Tudor, Stuart and Early Georgian Pictures in the Collection of Her Majesty the Queen* (London, 1963), pp. 13–16. For Charles I's collections see Francis Haskell, 'Charles I's Collection of Pictures', in Arthur MacGregor, ed., *The Late King's Goods* (London and Oxford, 1989), pp. 203–31.
48 Malcom Rogers, 'Van Dyck in England', in Christopher Brown and Hans Vlieghe, eds, *Van Dyck* (exh. cat., Antwerp, Koninklijk Musum voor Schone Kunsten, and London, Royal Academy of Arts, 1999), pp. 79–91.
49 Millar, *Tudor, Stuart and Early Georgian Pictures in the Collection of Her Majesty the Queen*, cat. nos 3, 23, 35; Millar, 'The Inventories and Valuations of the King's Goods 1649–51', p. 193 [115], p. 197 [181, 197], p. 198 [214]. See also Oliver Millar, *The Queen's Pictures* (London, 1977), p. 49 for the suggestion that Charles located his early Dutch paintings at Hampton Court.
50 Gabriele Finaldi, ed., *Orazio Gentileschi at the Court of Charles I* (exh. cat., London, National Gallery, 1999), pp. 99–100. Millar, 'The Inventories and Valuations of the King's Goods 1649–51', p. 186 [5], p. 191 [97].
51 Millar, 'The Inventories and Valuations of the King's Goods 1649–51', p. 198 [203–4], p. 206 [332, 336, 337, 338].
52 Oliver Millar, ed., 'Abraham Van der Doort's Catalogue of the Collections of Charles I', *Walpole Society*, XXXVII (1958–60).
53 It should also be noted that there were no statues, the great symbol of the new collecting.
54 Henry and Margaret Ogden, 'Van der Doort's Lists of the Frizell and Nonsuch Palace Pictures in the Royal Collection', *Burlington Magazine*, LXXXIX (1947), p. 248.
55 Andrew Martindale, *The Triumphs of Caesar by Andrea Mantegna in the Collection of Her Majesty the Queen at Hampton Court* (London, 1979), pp. 92–6, 109; Giovanni Agosti, *Le nozze de perseo: un varietà mantovano*, quaderni del restauro, IIX (1992), pp. 20–27.
56 PRO E351/3271; LC5/134, 4 July 1640.
57 Jones, however, was interested in the palace and noted down the dimensions of its courtyards as marginalia in his copy of Palladio. He also spent some time in his official lodgings there, drawing the view from the window in 1636 and taking experimental cures. Bruce Allsopp, ed., *Inigo Jones on Palladio: Being the Notes by Inigo Jones in the Copy of I Quattro Libri dell Architettura di Andrea Palladio*, 2 vols (Oxford, 1970), II, 3rd flyleaf.
58 Curtis Perry, *The Making of Jacobean Culture: James I and the Re-negotiation of Elizabethan Literary Practice* (Cambridge, 1997), pp. 153–87; Kevin Sharpe, *The Personal Rule of Charles I* (New Haven and London, 1992), pp. 216–22.
59 *Cothele* (National Trust Guidebook, 1991), pp. 19–22; Mark Girouard, *Hardwick Hall* (National Trust Guidebook, 1989), pp. 39–41. I am grateful to Giles Worsley for discussing this idea with me. Mark Girouard also suggests Haddon Hall and Belvoir Castle might fit into this category.
60 *Cal S.P. Span.*, VI (i) (1538–42), p. 296; *Cal. S.P. Span.*, VI (ii) (1542–3), pp. 58, 218, 334.
61 *Cal. S.P. Ven.*, X (1603–7), pp. 403, 419; *Cal. S.P. Ven.*, XI (1607–10), p. 172; *Cal. S.P. Ven.*, XII (1610–13), p. 213.
62 John Finet, *Finetti Philoxenis, some choice observations of Sir John Finet, Knight and Master of Ceremonies to the last two Kings touching the reception and precedence, the treatment and audience, the punctillios and contests of Foreign Ambassadors in England* (London, 1656), p. 195; *Cal. S.P. Ven.*, XII (1610–13), p. 350.
63 Albert J. Loomie, *Ceremonies of Charles I: The Note Books of John Finet 1628–1641* (New York, 1987), pp. 185–6.
64 Ibid., p. 168.
65 Ibid., p. 45. In October 1616 the ambassador of Savoy prepared himself in the Lord Chamberlain's lodgings (*Cal. S.P. Ven.*, XIV (1615–17), p. 321).
66 Loomie, *Ceremonies of Charles I*, p. 201.
67 Ibid., p. 202.
68 *Cal. S.P. Ven.*, X (1603–7), pp. 71–2.
69 *Cal. S.P. Ven.*, XII (1610–13), pp. 185, 227.
70 Ibid., pp. 392, 395.
71 *Cal. S.P. Dom.* (1619–23), p. 171.
72 *Cal. S.P. Ven.*, X (1603–7), pp. 71–2. Finet, *Finetti Philoxenis*, p. 159–66; *Cal. S.P. Ven.*, XVII (1621–3), p. 39.
73 A useful introduction is A. MacGregor, 'The Household out of Doors: The Stuart Court and the Animal Kingdom', in E. Cruikshanks, ed., *The Stuart Courts* (Gloucester, 2000), pp. 98–106.
74 *Cal. S.P. Ven.*, XV (1617–19), pp. 259–60.
75 *Cal. S.P.Ven.*, X (1603–7), pp. 300, 416, 419; *Cal. S.P. Dom.* (1623–5), p. 425.
76 *Cal. S.P. Dom.* (1603–10), pp. 99, 376; *Cal. S.P. Dom.* (1637–8), p. 376.
77 J. P. Hoare, *History of the Royal Buckhounds* (Newmarket, 1895), pp. 142–3.
78 M. M. Reese, *The Royal Office of Master of the Horse* (London, 1976), pp. 166–77; Arthur Fitzgerald, *Royal Thoroughbreds: A History of the Royal Studs* (London, 1990), pp. 8–9; C. M. Prior, *The Royal Studs of the Sixteenth and Seventeenth Centuries* (Horse and Hound, London, 1935), p. 39; PRO E351/3255.
79 Hoare, *History of the Royal Buckhounds*, chapters 5 and 6; Millar, ed., 'The Inventories and Valuations of the King's Goods 1649–51', pp. 180–82.
80 *Cal. S.P. Dom.* (Addenda 1580–1625), p. 467; *Cal. S.P. Dom.* (1603–10), pp. 99, 376; *Cal. S.P. Dom.* (1611–18), p. 63; *Cal. S.P. Dom.* (1619–23), p. 179. A copy of the warrant by writ of Privy Seal is in the archives of St Mary's church, Hampton.
81 Arthur MacGregor, 'Deer on the Move: Relocation of Stock Between Game Parks in the Sixteenth and Seventeenth Centuries', *Archaeozoologica*, XVI (1992), p. 171; *Cal. S.P. Dom.* (Addenda 1580–1625), p. 504.
82 John Cloake, *Palaces and Parks of Richmond and Kew*, I: *The Palaces of Shene and Richmond* (Chichester, 1995), pp. 197–205, 240–54. A Kingston chamberlain's account book records a series of payments made in 1637 relating to Charles I's purchase of lands from Kingston for the new park (Kingston Borough Archives KD5/1/1 (1567–1637), pp. 531, 536).

83 Paint research by Catherine Hassell of University College London has confirmed that the heads have two layers of paint, the top layer being nineteenth century and the original 'either sixteenth or seventeenth century'. Pers. comm. Susanne Groom.
84 *Law*, II, p. 284.
85 Reports were undertaken on the Hampton Court antlers, first in 1918 (PRO Work 19/445), and subsequently during the construction of the present Horn Room in 1993. The modern scientific report of 1993 is held by Historic Royal Palaces. None of the antlers is a particularly unusual variety; most are from red deer and a few from moose and reindeer. On the symbolic importance of stags' heads see Michael Bath, *The Image of the Stag: Iconographic Themes in Western Art* (Baden-Baden, Germany, 1992), pp. 42–4 and n. 23; John Cummins, *The Hound and the Hawk: The Art of Medieval Hunting* (London, 1988), pp. 12–46. The legend referred to here concerned Charles VI of France who, in 1380, was said to have captured a stag with a collar bearing the motto *Caesar hoc mihi donavit*. Charmed by the idea that the stag had survived in the forest since the time of one of the Caesars, the king let him go free.

Chapter 8

1 Charles was at Hampton Court in early August 1640 when the plague broke out killing two or three stable hands. The Council was immediately dissolved and the court moved on. It was debated whether to move the queen to Hampton Court to avoid London, but Windsor seemed a safer option. She later moved to Hampton Court (*Cal. S.P. Dom.* (1640), pp. 549, 551, 634).
2 However, Prince Charles did use the palace in January 1641 (PRO LC5/136 f. 34r).
3 Quentin Bone, *Henrietta Maria, Queen of the Cavaliers* (London, 1973), pp. 130–32; Agnes Strickland, *Lives of the Queens of England*, 12 vols (London, 1845), VIII, pp. 81–9.
4 PRO LC5/135 6 September, 1 October 1641.
5 *Cal. S.P. Dom.* (1641–3), pp. 164, 171, 188, 192; Agnes Strickland prints a letter from Henrietta Maria setting out the royal family's intentions (*Lives of the Queens of England*, VIII, pp. 88–9).
6 *Cal. S.P. Dom.* (1641–3), pp. 252, 254, 262, 281; Bone, *Henrietta Maria, Queen of the Cavaliers*, pp. 139–41.
7 G. E. Aylmer, *The State's Servants: The Civil Service of the English Republic 1649–1660* (London, 1973), p. 79; W. L. F. Nuttall, 'King Charles I's Pictures and the Commonwealth Sale', *Apollo*, LXXXII (October 1965), pp. 308–9; PRO LC5/134 pp. 11, 30, 68–9, 367–412; George H. F. Nuttall, 'Unpublished Documents Relating to the Personal Effects of Charles I at Hampton Court', *Notes and Queries*, 7th ser., XI (1891), pp. 263–4, 322–3.
8 *Lords Journals*, VI (1643–4), pp. 227–9. Expenditure at Hampton Court was as follows: 1644–5: £167 2s; 1645–6: £112 11s 2d; 1646–7: £172 6s 5d; 1647–8: c.£580; 1648–9: c.£174 (PRO AO1/2429/72, 73, 76, 79, 82).
9 PRO AO1/2481; E351/3419; LC5/134 p. 218.
10 *Perfect Occurrences of Parliament; and Chief Collections of Letters from the Armie* (1645), the 41st week, 29 September 1645. S. Thurley, 'The Stuart Kings, Oliver Cromwell and the Chapel Royal 1618–1685', *Architectural History*, XLV (2002), pp. 248–50.
11 *Lords Journals*, VIII (1645–6), pp. 426; *Commons Journals*, IV (1644–6), p. 597.
12 I am very grateful to Sir Oliver Millar whose perceptive correspondence with me on this matter I have developed. O. Miller, *The Tudor, Stuart and Early Georgian Pictures in the Collection of Her Majesty the Queen* (Oxford, 1963), pp. 94–5, 97, 98, 99–100. Note that *Charles I on Horseback* was at Somerset House when it was sold (O. Miller, 'The Inventories and Valuations of the King's Goods 1649–1651', *Walpole Society*, XLIII, 1970–72, p. 316 [283]).
13 O. Millar, *The Age of Charles I, Painting in England 1620–1649* (exh. cat., London, Tate Gallery, 1972), cat. no. 171. Another painting by Lely of Charles's three youngest children is at Petworth House. This was probably painted at Syon in 1647 for Northumberland.
14 *Cal. S.P. Dom.* (1645–7), p. 574; *Cal S.P. Ven.*, XXVIII (1647–52), p. 51; PRO AO1/2431/79; Henry Ellis, *Original Letters Illustrative of English History*, 2nd ser., III (London, 1827), pp. 329–31; *Cal. S.P. Dom.* (1645–7), p. 602. See also John Callow, *The Making of King James II: The Formative Years of a Fallen King* (Stroud, 2000), pp. 45–8.
15 Charles Carlton, *Charles I: The Personal Monarch* (London, 1983), pp. 317–18.
16 *Commons Journals*, IV (1644–6), p. 597; Edward Hyde, Earl of Clarendon, *The History of the Rebellion and Civil Wars in England*, 6 vols (Oxford, 1888), IV, pp. 249–51; Lucy Hutchinson, *Memoirs of the Life of Colonel Hutchinson* (London, 1846), pp. 305–6; *RCHM*, 7th report (1879), p. 594b; *The Diary of John Evelyn*, ed. E. S. De Beer, 6 vols (Oxford, 1955), II, p. 537; *Memoirs of Lady Fanshawe Wife of the Right Hon. Sir Richard Fanshawe, Bart.*, ed. N. H. Nicolas (London, 1829), pp. 66–8.
17 My account of the escape is compiled from the following: *A Narrative by John Ashburnham of his Attendance on King Charles the First from Oxford to the Scotch Army, and from Hampton Court to the Isle of Wight*, 2 vols (London, 1830), II, pp. 101–12; *Memoirs of Sir John Berkeley* (London, 1699), pp. 47–57; *The Memoirs of Edmund Ludlow*, ed. C. H. Firth, 2 vols (Oxford, 1894), I, pp. 167–8. Whalley's account is printed in Francis Peck, *Desiderata Curiosa*, 2 vols (London, 1779), I, pp. 374–7.
18 Thomas Carlyle, *Oliver Cromwell's Letters and Speeches*, 5 vols (London, 1893), pp. 263–4; Christopher Hill, *God's Englishman: Oliver Cromwell and the English Revolution* (Harmondsworth, 1972), pp. 92–5.
19 *Law*, II, pp. 150–54; Nuttall, 'Unpublished Documents relating to the Personal Effects of Charles I at Hampton Court', pp. 322–3.
20 *Lords Journals*, VIII (1645–6), p. 541; *Commons Journals*, V (1646–8), p. 368.
21 *Lords Journals*, VIII (1645–6), pp. 526–7; According to the Venetian ambassador the king's children were allowed to go to Hampton Court in March 1648 'for their amusement', *Cal. S.P. Ven.*, XXVIII (1647–52), p. 51.
22 *Cal. S.P. Dom.* (1648–9), pp. 158, 165–6, 169, 171; S. R. Gardiner, *History of the Great Civil War*, 4 vols (London, 1893, repr. 1987), IV, pp. 154–62.
23 C. H. Firth and R. S. Rait, eds, *Acts and Ordinances of the Interregnum 1642–1660*, 3 vols (London, 1911), II, pp. 160–68, 187–9; *Cal. S.P. Dom.* (1649–50), p. 155.
24 *Commons Journals*, VI (1648–51), pp. 246–7; *Cal. S.P. Dom.* (1649–50), p. 296.
25 *Commons Journals*, VI (1648–51), p. 441; VII (1651–9), pp. 216–17, 222, 237; Firth and Rait, *Acts and Ordinances of the Interregnum*, pp. 691–2; see also *The Memoirs of Edmund Ludlow*, I, p. 347.
26 Survey printed in *Law*, II, pp. 258–71.
27 *Cal. S.P. Ven.*, XXIX (1653–4), p. 202.
28 *Commons Journals*, VII (1651–9), pp. 278, 307; *Cal. S.P. Dom.* (1652–3), p. 405.
29 *Commons Journals*, VII (1651–9), pp. 307, 321, 324.
30 *Commons Journals*, VII (1651–9), p. 404.
31 *Cal. S.P. Dom.* (1653–4), pp. 300, 356, 363, 385, 396–7, 408–9, 419. There was one final complication before the issue of land ownership was resolved – the Hare Warren had been set aside to pay the wages of the train of artillery and it was necessary to get them to agree to a cash settlement instead. This was achieved in October 1655 (*Cal. S.P. Dom.* (1654), p. 406; (1655), p. 376). See also H. J. Habakkuk, 'The Parliamentary Army and the Crown Lands', *Welsh Historical Review*, III (1966–7), pp. 403–26.
32 Details of the technicalities of the Parliamentary sales, unless otherwise indicated, come from Millar, 'The Inventories and Valuations of the King's Goods 1649–51', pp. xi–xxiv, and A. MacGregor, ed., *The Late King's Goods: Collections, Possessions and Patronage of Charles I in the Light of the*

33 *Cal. S.P. Dom.* (1649–50), pp. 296, 410, 437.
34 *Cal. S.P. Dom.* (1653–4), p. 111.
35 Aylmer, *The State's Servants: The Civil Service of the English Republic 1649–1660*, pp. 79, 124; *Cal. S.P. Dom.* (1654), pp. 99, 347; (1655), p. 130; Sean Kelsey, *Inventing a Republic: The Political Culture of the English Commonwealth* (Manchester, 1997), p. 162.
36 On Kinnersley see R. Sherwood, *The Court of Oliver Cromwell* (Cambridge, 1977), pp. 119–34.
37 *Commons Journal*, VII, p. 404; *HKW*, III, pp. 163–8. Dr Andrew Barclay informs me that Major-General Haynes was related to Smithsby, having married the daughter of Thomas Smithsby Esquire, Saddler to Charles I.
38 PRO SP25/75 no. 195, SP 25/105 no. 27; *Cal. S.P. Dom.* (1654), pp. 32, 99.
39 Sherwood, *The Court of Oliver Cromwell*, pp. 25–9.
40 *Cal. S.P. Ven.* XXXI (1657–9), pp. 8–9.
41 Mark Noble, *Memoirs of the Protectoral House of Cromwell*, 2 vols (London, 1784, 1787), I, p. 143; Roy Sherwood, *Oliver Cromwell: King In All But Name, 1653–1658* (Stroud, 1997), pp. 108–17.
42 *Cal. S.P. Dom.* (1658–9), pp. 98, 100, 103, 109; Sherwood, *Oliver Cromwell*, pp. 130–34.
43 *The Journal of George Fox*, ed. Norman Penney, 2 vols (Cambridge, 1911), I, p. 327.
44 *Commons Journals*, VII (1651–9), p. 681; *Cal. S.P. Dom.* (1658–9), p. 360; *Law*, II, p. 307.
45 Estelle Frances Ward, *Christopher Monck Duke of Albemarle* (London, 1915), pp. 17–18; *Commons Journals*, VII (1651–9), p. 791; *The Memoirs of Edmund Ludlow*, II, p. 101. Andrew Barclay has pointed out to me that serious doubt has been thrown on Ludlow's memoirs and it is possible that the passage I refer to here could in fact have been inserted in the 1690s.
46 *HMC*, 7th report, p. 463.
47 PRO SP18/203 no. 41.
48 D. Howarth, 'Charles I, Sculpture and Sculptors', in MacGregor, *The Late King's Goods*, pp. 106–7; T. P. Campbell, *Tapestry in the Renaissance: Art and Magnificence* (exh. cat., New York, Metropolitan Museum of Art, 2002), p. 246.
49 Lodewijck Hugens, *The English Journal, 1651–2*, ed. A. G. H. Bachrach and G. Collmer (Leiden, 1982), p. 134.
50 Michael Roberts, 'Swedish Diplomats at Cromwell's Court, 1655–1656: The Missions of Peter Julius Coyet and Christer Bonde', *Camden Society*, 4th ser., XXXVI (1988), pp. 119–29, and see also 320–21.
51 *Cal. S.P. Ven.*, XXX (1655–6), p. 109; *HMC*, 5th report, p. 176; S. Thurley, 'Oliver Cromwell, The Stuart Kings and the Chapel Royal', op. cit., pp. 253–5.

Chapter 9

1 *Lords Journals*, XI, p. 19.
2 Stephen Gleissner, 'Reassembling a Royal Art Collection for the Restored King of Great Britain', *Journal of the History of Collections*, VI (1994), pp. 103–15.
3 *HMC*, 5th report (1876), pp. 168, 170, 174.
4 *Cal. S.P. Dom.* (1660–61), p. 174; *Cal. S.P. Dom.* (1660–61), p. 27.
5 *Cal. S.P. Dom.* (1660–61), p. 369; *The Diary of Samuel Pepys*, ed. R. Latham and W. Matthews, 11 vols (1970–83), III, pp. 81–2; PRO LC5/138 p. 43; LC5/137 pp. 240, 147; LC5/140 p. 101; LC5/137 p. 349.
6 *Cal. S.P. Dom.* (1660–61), p. 72; PRO LC5/137 p. 218; *Memoirs of Tobias Rustat Esq*, ed. William Hewett (London, 1849); MS biography of Rustat by Philip Lewin and Lady Renfrew. PRO LC5/67 f. 4v; LC5/144 p. 261.
7 PRO Work 5/1 ff. 408, 409v; Maurice Ashley, *James II* (London, 1977), pp. 84, 94, 96.
8 PRO LC5/60 p. 91, 205; LC5/137 p. 53.
9 *HMC*, 5th report (1876), pp. 169, 170.
10 R. Hutton, *Charles II, King of England, Scotland, and Ireland* (Oxford, 1989), pp. 19–24, 39–42, 82–3; *The Diary of John Evelyn*, 6 vols, ed. E. S. de Beer (Oxford, 1966), II, pp. 112, 118, III, p. 563; *Jeu de Rois, Roi des Jeux, Le Jeu de Paume en France* (Musée National du Château de Fontainebleau, 2001), pp. 133–8.
11 PRO Work 5/1 ff. 385v, 405r, 408r, 411r, v, 414r; Work 5/2 ff. 252r, 253r, 257r, v, 258r, 271r. Some of these accounts are duplicated in BL Harl. MS 1656, 1657.
12 Pepys (fig. 57) shows six buttresses and ten oval windows; the 'long view' (fig. 59) seven buttresses and nine tall rectangular windows; Schellinks (fig. 58) thirteen rectangular windows and a single buttress; and the painting (fig. 114) six buttresses and seven windows. The oval windows in the Pepys drawing are almost certainly a misreading of the great window nets and curtains which, when drawn back and tied in the middle as on the 'long view', would produce an oval shape. Hawksmoor (figs 139, 140) correctly shows seven buttresses.
13 PRO Work 5/2 f. 405v; Work 5/10 f. 283r; Work 5/2 f. 263r. There are several accounts of provisions for the Tennis Court being ordered. In May 1671, for instance, 15 yards of black cloth and curtains, nets and lines were bought. PRO LC5/14 p. 9; LC5/61 p. 254; LC5/62 f. 41v; LC5/137 p. 150.
14 PRO Work 5/2 f. 252r; PRO LC5/60 p. 126, LC5/137 p. 21, 34.
15 PRO Work 5/2 f. 264r: 'paveing all the side of the gallerie by the tennis court with 10 inch tiles, where the ould wale stood'. See also f. 265r.
16 PRO LC5/137 pp. 410–11. It should be noted that the dimensions of the Whitehall court were not the same as those at Hampton Court. The Whitehall court measured 118ft by 39ft.
17 PRO Work 5/2 ff. 270v, 277v, 281r, 283r, 295r, 304r, v, 305r; Work 5/3 ff. 321r, 340r.
18 *The Diary of John Evelyn*, III, p. 311; PRO Work 5/2 ff. 297r, 299r, 304r, v.
19 PRO Work 5/2 ff. 304r, 304v, Work 5/3 ff. 312v, 322v, 329v, 340v, 332v, 333r, 353v; PRO LC5/60 pp. 304, 314.
20 PRO Work 5/2 f. 304v; Work 5/3 ff. 312v, 313v, 324r.
21 A traverse curtain is one that is used for dividing a space, in this case the Royal Closet.
22 PRO Work 5/3 ff. 333v, 334v, 328v, 322v, 324r, 329v; PRO LC5/60 pp. 267, 375; LC5/61 p. 66; LC5/137 p. 153.
23 PRO LC5/60 p. 267; LC5/137 pp. 209, 153. After the queen's arrival a large cupboard was made in her chapel, presumably for vestments PRO Work 5/3 f. 333v. LC5/138 p. 407. For the children of the chapel in 1636 see LC5/134 p. 136.
24 PRO Work 5/3, ff. 305r, 307r, 312r; PRO LC5/60 pp. 302, 309, 314, 319, 320.
25 PRO Work 5/3 ff. 312v, 315r, v, 323r, 324r, 332v.
26 PRO Work 5/3 f. 332v; Work 5/3 f. 319r; PRO E351/3235; Work 5/32 f. 234r.
27 *Cal. S.P. Dom.* (1660–61), p. 203; PRO Work 5/3 ff. 323r, 326r, 361r.
28 Andrew Barclay, 'Charles II's failed Restoration: Administrative Reform Below stairs 1660–4', in E. Cruikshanks, ed., *The Stuart Courts* (Stroud, 2000), pp. 158–61.
29 *The Diary of John Evelyn*, III, p. 322–5.
30 The text was Hosea 3:5 'Afterwards the Israelites will return and see the Lord their God and David their king. They will come Trembling to the Lord and to his blessings in the last days'.
31 *Memoirs of Lady Fanshawe Wife of the Right Hon. Sir Richard Fanshawe, Bart.* (London, 1829), pp. 144–5; *The Diary of John Evelyn*, III, p. 320; Maurice Exwood and H. L. Lehmann, eds, 'The Journal of William Schellinks, Travels in England 1661–63', *Camden Society*, 5th ser., I (1993), pp. 86–90; *The Kingdom's Intelligencer* (30 May, 2 June 1662) nos 21–2.
32 *The Kingdom's Intelligencer* (1 August, 9 August 1662) nos 31–2. See also Agnes Strickland, *Lives of the Queens of England*, 12 vols (London, 1845), VII, pp. 326–7, quoting a Portuguese source.
33 PRO Work 5/3 ff. 312r, v, 319v, 320r, 324r.
34 Barclay, 'Charles II's Failed Restoration, pp. 161–4.
35 PRO LS 13/33 and LS 13/34 show the Household lists before and after the reforms.
36 PRO Work 5/21 f. 249r; Work 5/23 f. 269v; Work 5/9 f. 286v; PRO LC5/12 p. 294.

37 PRO Work 5/35 f. 189r; Work 5/4 f. 291r, 292r; Work 5/41 f. 204r.
38 Kingston Borough Archives KG2/3 (1567–1681), pp. 247, 262, 270, 271, 277; KD5/1/2 (1638–1710), pp. 104, 110, 128, 142, 147, 185.
39 Kingston Borough Archives KD5/1/2 (1638–1710), p. 177; G. Roots, *Charters of the Town of Kingston upon Thames* (London, 1797), pp. 215–18.
40 Kingston Borough Archives KD5/1/2 (1638–1710), pp. 315, 321, 322; Roots, *Charters of the Town of Kingston upon Thames*, pp. 218–19; John Miller, 'The Crown and the Borough Charters in the Reign of Charles II', *English Historical Review*, C (1985), pp. 75–6; P. D. Halliday, *Dismembering the Body Politic: Partisan Politics in England's Towns, 1650–1730* (Cambridge, 1998), pp. 218–19.
41 *Cal. S.P. Dom.* (1661–2), pp. 357, 358, 361.
42 *Cal. Treasury Books*, IV (1672–5), p. 22.
43 PRO LC5/142 p. 90; B. Garside, *The Parish Church, Rectory & Vicarage of Hampton-on-Thames during the Sixteenth and Seventeenth Centuries* (Hampton-on-Thames, 1937), p. 11. It was probably building at the parish church rather than at the palace that contributed to the sudden rise in the population of Hampton in 1676 (see B. Garside, *Incidents in the History of Hampton-on-Thames during the Sixteenth and Seventeenth Centuries* (Hampton-on-Thames, 1937), p. 28).
44 Stephen Porter, *The Great Plague* (Stroud, 1999), pp. 33–78; *The Diary of Samuel Pepys*, VI, pp. 141–2.
45 PRO LC5/138 p. 407.
46 *The Diary of Samuel Pepys*, VI, pp. 156, 165–7, 171. On 26 July the king and duke visited Greenwich where Pepys saw them (ibid., p. 169); J. J. Jusserand, *A French Ambassador at the Court of Charles II: Le Comte de Cominges, from his Unpublished Correspondence* (London, 1892), pp. 167–9, 246; *The Newes* (1665) nos 53, 56, 58.
47 *The Diary of Samuel Pepys*, VII, 25–6, 32; Clarendon's account of the fire is printed in F. Grose and T. Astle, eds, *The Antiquarian Repertory*, 4 vols (1775–84), II, p. 154.
48 Although some minor improvements were made in 1663 (PRO LC5/137 p. 368) and musicians were in attendance there in July (PRO LC5/137 p. 384). There is a list of attendants serving the king at Hampton Court in 1665 in PRO LC5/138 p. 375. References to visits in 1668–71 can be found in Waldemar Westergaard, trans. and ed., *The First Triple Alliance: The Letters of Christopher Lindenov Danish Envoy to London 1668–1672* (New Haven, 1947), pp. 13, 15, 17, 156, 170, 284, 406, 431. In 1669 Charles moved to Hampton Court while Whitehall was being hung with mourning cloth for his late mother. *HMC*, 12th report, appendix VII (1890), p. 66.
49 *HKW*, V, pp. 131–2, 214–16.
50 PRO E351/3278; PRO Work 5/6 ff.227r, v.
51 S. Thurley, 'The Whitehall Palace Plan of 1670' (London Topographical Society, publication no. 153, 1998), pp. 47–8. There is a duplicate set of accounts for this work in BL Harl. MS 1618.
52 PRO Work 5/145 pp. 42, 45, 54–5; *HKW*, V, p. 154.
53 PRO Work 5/13 ff. 277r, 414v–20r; Work 5/15 f. 279r; Work 5/24 f. 425r–32r; Work 5/145 pp. 54–5. Structural investigation of this range by Daphne Ford in 1985 made it possible to reconstruct the sequence of work and the original plan. The drawings from this are in EH HPR AS3/19–22.
54 PRO LC5/12 p. 285; PRO Work 5/39 f. 176r.
55 Simon Thurley, *Whitehall Palace: An Architectural History of the Royal Apartments, 1240–1698* (New Haven and London, 1999), pp. 108–10.
56 PRO Work 5/17 ff. 437r–458r; Work 5/21 ff. 346r; 5/24 ff. 425r–432r.
57 *HMC, Hastings*, II, pp. 321–2; N. Luttrell, *A Brief Historical Relation of State Affairs*, 6 vols (Oxford, 1857), I, p. 73.
58 PRO Work 5/25 f. 251v; Work 5/21 f. 252v; PRO LC5/62 p. 120; LC5/64 p. 69; LC5/64 p. 77; LC5/64 p. 127; *HMC*, 7th report (1879), p. 491.
59 *HKW*, V, pp. 3–6.
60 PRO Work 5/13 ff. 298r, v, 300.
61 *HKW*, V, p. 155n. is very cautious in rejecting May as architect for the King's New Building. I believe the evidence for May's involvement is at least as strong as it is for several of his other works. See *BDBA*, pp. 646–8. For Wren's workload see Kerry Downes, *The Architecture of Wren* (London, 1982, rev. edn 1988), pp. 129–31; Kerry Downes, *Sir Christopher Wren: The Design of St Paul's Cathedral* (London, 1988), p. 50; Thurley, *Whitehall Palace*, pp. 99–104. For Frogmore see Nicola Smith, 'Frogmore House before James Wyatt', *Antiquaries Journal*, LXV (1985), pp. 405–7. For Moor Park see Alison Maguire and Howard Colvin, 'A Collection of Seventeenth-Century Architectural Plans', *Architectural History*, XXXV (1992), pp. 164–5, fig. 36. For May's working practices see J. Newman, 'Hugh May Clarendon and Cornbury', in J. Bold and E. Chaney, eds, *English Architecture, Public and Private: Essays for Kerry Downes* (London, 1993), pp. 81–7.
62 PRO Work 5/13 f. 278v; A. H. Haynes, *The Story of Bowls* (London, 1972); Count Anthony Hamilton, *Memoirs of Count Grammont*, trans. with notes by Horace Walpole (Philadelphia, 1888), pp. 342–3.
63 For this visit see the illuminating letter from Joseph Williamson to Robert Francis in *Cal. S.P. Dom.* (1668–9), pp. 473–4 (PRO SP29/264 no. 219).
64 In 1670 the queen stayed on 16, 20, 23 August and 1 September, and in 1671 on 15, 18 July. *Cal. S.P. Dom.* (1670), pp. 378, 384, 389, 408; *Cal. S.P. Dom.* (1671), pp. 384, 387. She also stayed in 1674 (*Cal. S.P. Ven.*, XXXVIII (1673–4), pp. 257, 299, 305). Also see Westergaard, *The First Triple Alliance*, pp. 17, 156, 197, 406. Repairs and re-furnishing can be found in PRO Work 5/17 ff. 276v, 278v; PRO LC5/62 p. 99; LC5/64 p. 68.
65 PRO Work 5/7 f. 150v; Work 5/7 f. 156v; Work 5/15 ff. 283v, 303v; LC5/201 pp. 153, 155. Work 5/25 f. 259r, v.
66 J. Dent, *The Quest for Nonsuch* (London, 1962), pp. 207–11.
67 *Cal. S.P. Dom.* (1670), p. 14.
68 *Cal. Treasury Books*, III (1669–72), pp. 971, 1018; *Cal. Treasury Books*, IV (1672–5), p. 458. *Cal. Treasury Books*, V (1675–9), p. 568; *Cal. Treasury Books*, VII (1681–5), p. 3.
69 Hutton, *Charles II.*, pp. 337–8; *HMC, Hastings*, II, p. 165; G. S. Steinman, *A Memoir of Barbara, Duchess of Cleveland* (privately printed, 1871), pp. 147–9; PRO Work 5/23 f. 273r.
70 PRO LC 5/12 pp. 206, 209, 268, 269, 281. For the allocation of lodgings at Whitehall and the mechanisms of distribution see Thurley, 'The Whitehall Palace Plan of 1670', pp. 16–26. In May 1671 the French nobility were entertained by the Treasurer in the Great Hall with a long buffet groaning with meat for show. *HMC*, 12th report, appendix VII (1890), p. 78.
71 PRO LC5/201, p. 153; PRO Work 5/23 f. 257v; Work 5/23 f. 271. C. H. Josten, ed., *Elias Ashmole: His Autobiographical and Historical Notes, his Correspondence, and Other Contemporary Sources Relating to his Life and Work*, 5 vols (Oxford, 1966), IV, pp. 1391–2. For Bedchamber usage in Charles II's reign see Anna Keay's work in Anna Keay and Simon Thurley, 'The Stuart Royal Bedchamber' (forthcoming).
72 PRO LC5/201 f. 157r.
73 *HKW*, V, pp. 315–30; Robert Richard Tighe and James Edward Davis, *Annals of Windsor* (London, 1888), pp. 387–408. The dates of the arrivals of the court as recorded in contemporary newspapers are 1 May 1680, 28 April 1681, 20 April 1682, 14 April 1683, 5 April 1684.
74 *Cal. S.P. Dom.* (1671), p. 264; PRO LC5/14 p. 16; LC5/143 f. 4; PRO Work 5/32 f. 232r; PRO LC5/66 ff. 47r, 48r.
75 This is based on a thorough reading of all the Council-related entries in the Calendars for those years.
76 PRO Work 5/33 f. 195r; PRO LC 5/66 p. 48.
77 PRO LC5/144, p. 64, 67; LC5/16, p. 147; R. W. Blemcowe, *Henry Sidney, Diary of the Times of Charles the Second*, 2 vols (London, 1843), p. 21; Sir Robert Southwell to the Duke of Ormonde, *HMC, Ormonde*, IV, p. 528; *HMC*, 13th report, appendix VI, p. 263; Duke of Ormonde to the Earl of Derby, *HMC, Ormonde*, VI, p. 369. He

dined at a round table, PRO Work 5/32 f. 228r.

78 *The Journal of George Fox*, ed. Norman Penny, 2 vols (Cambridge, 1911), pp. 298, 303. *Memoirs of Sir John Reresby*, ed. Andrew Browning (Glasgow, 1936), p. 227.

79 PRO LC5/148; PRO Work 5/42 f. 167r; Ashley, *James II*, p. 192; Work 5/39 ff. 168r, 174r, 176r, 185r, 195v; Work 5/40 ff. 148r, 162r, 164r, 165r, 176r, 178v.

80 PRO Work 5/41 ff. 209v, 216v, 225v; Work 5/41 ff. 224v, 231r, 237v. The extraordinary account, totalling £378 4s 4d, is in Work 5/42 ff. 301r–305v. PRO LC5/148 pp. 10, 12, 13, 14, 16.

81 PRO Work 5/41 ff. 219r, 220r, 222v, 228r, 228v; *The London Gazette*, no. 2281, 24 September 1687.

82 E. M. Thompson ed., 'Correspondence of the Family of Hatton', *Camden Society*, n.s. XXIII (1878), 2 vols, II, p. 131; *The Diary of John Evelyn*, III, pp. 322–3; *Journal des Voyages de Monsieur de Monconys, Conseiller du Roy en ses Conseils d'Estat & Privé, et Lieutenant Criminel au Siege Presidial de Lyon*, 3 parts (Lyon, 1665), part II, pp. 77–8; Count Lorenzo Magalotti, *Travels of Cosimo the Third, Grand Duke of Tuscany, through England, during the Reign of King Charles the Second* (London, 1821), p. 330; Antonio Caetano De Sousa, *Historia Genealogica de Casa Real Portuguez* (Lisbon, 1740), VII, pp. 305–7.

83 On Charles's ambitions see S. Thurley, 'A Country House Fit for a King: Charles II, Greenwich and Winchester', in Cruikshanks, *The Stuart Courts*, pp. 214–39.

84 PRO Work 5/27 f. 266v; Work 5/37 f. 189v; PRO LC5/144 p. 615. See also Hentie Louw and Robert Crayford, 'A Constructional History of the Sash Window c.1670–1725', *Architectural History*, XLI (1998), p. 99.

85 PRO Work 5/24 f. 321r; Work 5/38 f. 195r; Oliver Millar, *The Queen's Pictures* (London, 1977), pp. 71–3. The great canvases seem to have remained until August 1689 (PRO Work 5/55), when 'a great large picture' was taken from the Queen's Privy Chamber and others were taken from other rooms by carpenters. Also in 1660 three very large stretchers were made for paintings sent down to Hampton Court by the king (PRO Work 5/1 f. 400).

86 PRO Work 5/7 f. 196v.

87 The painting hung at Whitehall in 1688 (BL Harl. MS 1890 f. 52v).

88 PRO Work 5/5 f. 261r, Work 5/9 ff. 271r, v; Work 5/10 f. 261r; LC5/137 p. 290; *Cal. Treasury Books*, IV (1672–5), p. 769; O. Millar, *The Tudor, Stuart and Early Georgian Pictures in the Royal Collection* (Oxford, 1963), p. 153. PRO Work 5/6 f. 230v. The clock dial was repaired again in 1680–81 (PRO E351/3294).

89 PRO E351/3203; PRO Work 5/32, ff. 225r, 251, 258r.

90 The inventory is held in the Surveyor's Office of the Royal Collection. I am grateful to Christopher Lloyd for allowing me to transcribe it.

91 There is an account in July 1665 for 'boarding behind the picture of the great whale in the great hall 10ft high 56ft long' (PRO Work 5/7 f. 129v).

92 According to a plaque affixed to the horns, the horns were given to Ormonde by one Mr Von Delure.

93 For the Frizell purchase see Gleissner, 'Reassembling a Royal Art Collection for the Restored King of Great Britain', pp. 109–14; Henry and Margaret Ogden, 'Van Der Doort's Lists of the Frizell and Nonsuch Palace Pictures in the Royal Collection', *Burlington Magazine*, XXCIX (1947), pp. 247–50; Brian Reade, 'William Frizell and the Royal Collection', *Burlington Magazine*, XXCIX (1947), pp. 70–75.

94 I am most grateful to Dr Andrew Barclay for discovering this inventory and telling me about it: Glasgow University Library MS Hunter 238. A version of this inventory, less complete, survives in BL Add. MS 15752 ff. 23v–27v.

95 J. Y. Akerman, ed., 'Moneys Received and Paid for Secret Services of Charles II and James II', *Camden Society*, LII (1851), p. 198; Arthur MacGregor, 'Deer on the Move: Relocation of Stock Between Game Parks in the Sixteenth and Seventeenth Centuries', *Archaeozoologica*, XVI (1992), p. 174; Arthur MacGregor, 'The Household out of Doors: The Stuart Court and the Animal Kingdom', in Cruikshanks, *The Stuart Courts* (Gloucester, 2000), pp. 98–105. Magalotti, *Travels of Cosimo III*, pp. 327–8.

96 Gladys Scott, *Life in a Noble Household, 1641–1700* (London, 1937), pp. 232–3.

97 PRO E351/3295.

98 PRO Work 5/38 f. 183r; J. Crofts, *Packhorse, Waggon and Post: Land Carriage under the Tudors and Stuarts* (London, 1967), p. 122; PRO Work 5/25 f. 398r; A. MacGregor, 'The Royal Stables: A Seventeenth-Century Perspective', *Antiquaries Journal*, LXXVI (1996), p. 185; *HKW*, V, p. 459; *Kingston Chamberlain's Accounts 1638–1710*, p. 268.

99 Marie Catherine, Baronne D'Aulnoy, *Memoirs of the Court of England in 1675*, trans. W. H. Arthur (London, 1927), p. 311.

Chapter 10

1 Martha Hamilton-Phillips, 'Painting and Art Patronage in England', in P. Maccubbin and Martha Hamilton-Phillips, eds, *The Age of William III and Mary II: Power, Politics and Patronage, 1688–1702* (College of William and Mary, Virginia, 1989), pp. 249–50; J. G. Gelder, 'The Stadtholder: King William III as Collector and "Man of Taste"', in *William and Mary and Their House* (exh. cat., New York, Pierpont Morgan Library, 1979), pp. 29–41.

2 Dr R. Doebner, *Memoirs of Mary Queen of England, together with her Letters and those of King James II and William III to the Electress Sophia of Hanover* (Leipzig and London, 1886), p. 15.

3 Henri and Barbara van der Zee, *William and Mary* (London, 1973), pp. 114–23, 170–73.

4 *Lettres et Memoires de Marie Reine d'Angleterre, epouse de Guillaume III: Collection des documents authentiques inédits* (The Hague, 1880), p. 116.

5 Gilbert Burnet, with notes by the Earls of Dartmouth and Hardwicke, Speaker Onslow and Dean Swift to which are added other annotations, *History of his Own Time*, 6 vols (first published in 2 vols, 1724; 2nd edn, enlarged, Oxford, 1833), IV, p. 152. HMC, 14th report, appendix ii (1894), p. 431.

6 N. Japikse, *Prins Willem III de Stathouder Koning*, 2 vols (Amsterdam, 1930), II, p. 278; PRO LC5/149 p. 22; Burnet, *History of his Own Time*, IV, p. 152.; Giovanni Gerolamo Arconati Lamberti, *Mémoires de la Dernière Revolution*, 2 vols (Paris, 1702), II, pp. 203–4, 393–4; *Memoirs of Sir John Reresby*, ed. Andrew Browning (Glasgow, 1936), p. 102.

7 PRO LC5/24 ff. 285v, 289v, 295v, etc. A lodging list for the queen's side is in PRO LC5/149 pp. 40–42.

8 In addition to the main work series giving monthly financial records (PRO Work 5/42–52) and the annual returns submitted to the Audit Office (PRO AO1 2442/122–2446/139) there are the extraordinary accounts set up in the spring of 1689 to account for the new building project. There were originally three volumes covering the detail of the work, but only the one for April 1689–March 1692 survives (Work 5/55). The gap can be supplemented by the Audit Office rolls (AO1 2482/294, 296, 297) printed in *Wren Society*, IV, pp. 20–29. For the work of 1697–1702 no extraordinary account was opened, and the Work 5 series and the AO series continue the record. Many estimates and other financial details are in Work 6/2 and the Treasury papers T 1/60, 65, 67–8, some of which are printed in the *Wren Society*, IV, pp. 55–63. To these must be added the very full records of the Lord Chamberlain's department; the warrants, which cover the entire period 1695–1760, are preserved as originals in LC5/125–9 (and for the Wardrobe in LC5/70–76) and as copies in the warrant books LC5/152–61 (1697–1753). The study of Hampton Court and the other royal houses of the period has long been dominated by the publications of the Wren

9 Jane Lang, *Rebuilding St Paul's after the Great Fire of London* (Oxford, 1956), pp. 136–8; *HKW*, v, p. 20.

10 *BDBA*, pp. 948–9.

11 *Cal. Treasury Books*, IX, pp. 30–31. The Hampton Court design process has been analysed many times, most recently in my 'The Buildings of the King's Apartments: A Most Particular Monarch', *Apollo*, CXL, no. 390, n.s. (August 1994), pp. 10–20. A number of my conclusions have been revised and incorporated into this book. Other crucial literature includes, *HKW*, v, p. 156; E. Sekler, *Wren and his Place in European Architecture* (London, 1956), pp. 159–66; K. Downes, *English Baroque Architecture* (London, 1966), pp. 36–42; K. Downes, *The Architecture of Wren* (London, 1988), pp. 95–102; *Wren Society*, IV, pp. 9–14; John Summerson, *Architecture in Britain 1530–1830* (Harmondsworth, 1983), pp. 245–8; Margaret Whinney, *Wren*, pp. 163–78.

12 *HKW*, v, pp. 183–4; Lang, *Rebuilding St Paul's after the Great Fire of London*, pp. 142–4; *Wren Society*, XVI, pp. 37–8; Paul Jeffery, *The City Churches of Sir Christopher Wren* (London, 1996), p. 50; S. Thurley, *Whitehall Palace: An Architectural History of the Royal Apartments, 1240–1698* (New Haven and London, 1999), pp. 137–9; *Wren Society*, XVIII, pp. 175–7.

13 The problem is posed and some solutions suggested in an article by Anthony Geraghty, 'Nicholas Hawksmoor and the Wren City Church Steeples', *Georgian Group Journal*, X (2000), pp. 1–14. Also see Anthony Geraghty, 'Introducing Thomas Laine: Draughtsman to Sir Christopher Wren', *Architectural History*, XLII (1999), pp. 240–45. Both draw on his important PhD thesis, 'New Light on the Wren City Churches: The Evidence of the All Souls and Bute Drawings' (Cambridge, 1999). I am enormously grateful to Gordon Higgott of English Heritage who is working on the Wren office drawings at the Soane Museum for his help and advice.

14 The best information on the Office of Works library comes from the sale catalogues of the libraries of Wren and Hawksmoor (D. J. Watkin, ed., *Sale Catalogues of Libraries of Eminent Persons*, IV: *Architects* (London, 1972), pp. 1–43, 45–105; Kerry Downes, 'Hawksmoor's Sale Catalogue', *Burlington Magazine*, XCV (1953), pp. 332–5).

15 E. W. Brayley, J. Britton and J. N. Brewer, *The Beauties of England and Wales*, 18 vols (London 1816), X (iv), p. 462.

16 Van der Zee, *William and Mary*, pp. 299–300; *HKW*, v, pp. 457–8.

17 Daniel Defoe, who knew both old palace and new, noted that he 'must acknowledge it was a very complete palace before, and fit for a king; although it might not, according to the modern method of building, or gardening, pass for a thing exquisitely fine' (Daniel Defoe, *A Tour through the Whole Island of Great Britain*, ed. Pat Rogers (Harmondsworth, 1971), p. 182). Some of the first work in April 1689 was the careful repair of the panelling in 'Henry VIII's closet' (PRO Work 5/55).

18 Mansart's drawings for Blois are illustrated in Claude Mignot, 'L'Aile Gaston d'Orléans', *Connaissance des Arts*, 'Blois' issue (1993), p. 45. Bernini's first scheme, the most likely source, had semicircular colonnades on the south front. A possible alternative is Perrault's 1667 scheme published by Jean Nicolas Louis Durand. Both are conveniently illustrated in Jean-Claude Daufrense, *Louvre et Tuileries: Architectures de Papier* (Brussels, 1987), pp. 55, 76–7.

19 Soane Museum vol. 110/4, the site plan for scheme 1 (i) (fig. 128) is drawn at about 300ft to an inch, giving a 337ft frontage on the long side of the State Apartments quadrangle. All Souls I.10, the first-floor plan (fig. 130), has a frontage of identical length. It also has a link to the Great Hall and a terrace and steps to the south front, as on the site plan 1a. The main difference between the two plans of the quadrangle is that 1a. shows protruding stair towers into the court, whereas in All Souls I.10 they are integral. The drawing is attributed to Hawksmoor on the basis of his handwriting and the scale.

20 All Souls I.10 (fig. 130) has a front of twenty-one bays facing north and south. It is the only surviving plan with this number of bays. Soane Museum vol. 110 f. 7 is the only elevation with this number of bays. The fenestration appears to be of the same rhythm as the plan. It does not have a scale, but if the central opening on the ground floor were about 9ft the elevation would be the same length as the south front shown on the plan, i.e. 340ft. The only variance is that the giant order does not show on plan.

21 Wren was disparaging about Versailles in a letter of September/October 1665 to a friend written from Paris. As I shall argue, the Louvre, which he admired, is the key to Hampton Court. Lydia M. Soo, *Wren's 'Tracts' on Architecture and Other Writings* (Cambridge, 1998), p. 104.

22 The plan is All Souls II 116★ and the elevations Soane Museum vol. 110/1a, 1b, 6 and All Souls IV.17. The plan is drawn on a 30ft pencil grid.

23 The only advantage William had over his wife was that his apartments faced south to the Privy Garden, with a private stair to reach it.

24 Charles Saumarez Smith, *The Building of Castle Howard* (London, 1997), pp. 64, 47–53. Hawksmoor's crucial role at Hampton Court was recognised as long ago as 1956 by E. Sekler in a footnote to his study on Wren (E. Sekler, *Wren and his Place in European Architecture* (London, 1956), p. 162n). Work by Dr Gordon Higgott of English Heritage and Dr Anthony Geraghty at the University of York will further clarify the role of Hawksmoor. I am very grateful to both of them for their help in this chapter; needless to say the views in it are mine and not necessarily theirs.

25 Also see Hawksmoor's pencil sketches for the layout of the avenue on All Souls IV.1, and the setting out lines for the avenue on All Souls VI.4.

26 All Souls IV.4 & 5; PRO Work 34/112.

27 Both these schemes (Soane Museum vol. 110/5, 22) scale to about 300ft, the eventual width of the south and east fronts.

28 Marot does not appear in his sale catalogue, but a copy of Perrault's 1684 *Architecture de Vitruve* does. It was also engraved by Sebastien Le Clerc in 1677.

29 Soane Museum vol. 110/14. This plan has the fenestration and dimensions of the final design.

30 Paint research in March 1988 by Cruik Smith Conservation confirmed that the window frames and bars were not originally painted with oil paint but varnished with a clear untinted varnish. The windows throughout the new building were overhauled in 1702. PRO Work 5/53.

31 Christopher Wren, Jr, *Parentalia; or, Memoirs of the Family of the Wrens* (London, 1750), pp. 326–7; John Macky, *A Journey through England*, 3 vols (London 1732), I, p. 72.

32 A similar, but different trick had been played by Wren at Trinity College Library where the colonnade had round heads from without and square heads within (D. McKitterick, ed., *The Making of the Wren Library, Trinity College, Cambridge* (Cambridge, 1995), figs 32–3).

33 PRO AO1/2482/296. A report in archive at English Heritage prepared by Susan Jenkins in 1988 covers the sources of Laguerre's images. They have always been unstable and were repaired as early as 1707–8 by Laguerre himself (PRO AO1/2447/142). Subsequent restorations include 1891 (*Law*, III, p. 49), 1906–7 (PRO Work 19/71) and 1925–6 (PRO Work 19/590).

34 Lang, *Rebuilding St Paul's after the Great Fire of London*, pp. 143–5.

35 See Fire Damage repair drawings AS9/2–5.

36 M. Clegg, *Het Loo Palace: Journal of a Restoration*, trans. Adriaan W. Vliegenthart (Het Loo, 2002).

37 H. J. Louw, 'Anglo-Netherlandish Archi-

tectural Interchange *c.1600–c.1660*', *Architectural History*, XXIV (1981), pp. 1–23; Henry-Russell Hitchcock, *Netherlandish Scrolled Gables of the Sixteenth and Early Seventeenth Centuries* (New York, 1978), pp. 95–8.
38 Eva Wilson, 'Swedish Limestone Paving in Seventeenth- and Eighteenth-Century English Buildings', *Post-Medieval Archaeology*, XVII (1983), pp. 95–109.
39 PRO Work 5/51 f. 382v.
40 M. D. Whinney, 'William Talman', *Journal of the Warburg and Courtauld Institutes*, XVIII (1955), pp. 125–7; John Harris, 'Thoresby House, Nottinghamshire', *Architectural History*, IV (1961), pp. 11–19; John Harris, 'Thoresby Concluded', *Architectural History*, VI (1963), pp. 103–5; *BDA*, p. 951.
41 Gervase Jackson-Stops, 'The Building of Petworth', *Apollo*, CV, no. 183 (May 1977), pp. 326–9; Gordon Batho, 'Notes and Documents on Petworth House, 1554–1632', *Sussex Archaeological Collections*, XCVI (1958), pp. 108–34; Gervase Jackson-Stops, *The Country House in Perspective* (London, 1990), pp. 70–73. A fourth element for consideration is Nottingham Castle, which possibly influenced Talman's design for Chatsworth and which Hawksmoor sketched in his youth. See Harris, 'Thoresby House, Nottinghamshire', pp. 10–11.
42 'Journaal van Constantijn Huygens, den zoon 21 October 1688 to 2 September 1696', *Werken Historisch Genootschap, nieuwe reeks*, nos 23, 25, 32, 46 (Utrecht, 1876–88), no. 23, 1876, pp. 122, 132, 147, 157, 171, 193.
43 *HKW*, V, p. 21.
44 The narrative over the following paragraphs is based on the dense and fulsome monthly accounts in Work 5/55. A more comprehensive account of the chronology of the new building can be found in *HKW*, V, pp. 156–70. I have deliberately set out to avoid duplicating this.
45 Lang, *Rebuilding St Paul's after the Great Fire of London*, pp. 174–6. The Baltic pine was *Pinus sylvestris*.
46 John Musty, 'Brick Kilns and Brick and Tile Suppliers to Hampton Court Palace', *Archaeological Journal*, CXLVII (1990), pp. 416–17; Bernard Garside, *Incidents in the History of Hampton-upon-Thames during the Sixteenth and Seventeenth Centuries* (Hampton-on-Thames, 1937), p. 29; Gerald Heath, *Hampton Court: The Story of a Village*, ed. Kathy White and Joan Heath (The Hampton Court Association, 2000), pp. 34–7; *Cal. Treasury Books*, X, p. 781.
47 This was undertaken for English Heritage by a team led by Daphne Ford.
48 David Yeomans, 'Inigo Jones's Roof Structures', *Architectural History*, XXIX (1986), pp. 85–101; John Bold, *Greenwich: An Architectural History of the Royal Hospital for Seamen and the Queen's House* (New Haven and London, 2000), pp. 87, 119–23; D. Yeomans, *The Trussed Roof: Its History and Development* (Aldershot, 1992). Also see D. Yeomans, *The Architect and the Carpenter* (London, 1992).
49 On Wren and Ironwork see Lisa Jardine, *On a Grander Scale: The Outstanding Career of Sir Christopher Wren* (London, 2002), pp. 209–11, 326; McKitterick, ed., *The Making of the Wren Library*, p. 43. On the Louvre, Robert W. Berger, *The Palace of the Sun: The Louvre of Louis XIV* (University Park, Pa, 1993), pp. 66–7.
50 Narcissus Luttrell, *A Brief Historical Relation of State Affairs*, 6 vols (Oxford, 1857), I, p. 616: 'Part of the new buildings at Hampton Court are fallen down, occasioned by the slightensse of the wall, and killed 3 or 4 men and hurt several'. R. T. Gunter, ed., *Early Science in Oxford* (Oxford, 1935), p. 171.
51 Lang, *Rebuilding St Paul's after the Great Fire of London*, pp. 114, 129, 138–9.
52 *The Diary of John Evelyn*, ed. E. S. de Beer, 6 vols (Oxford, 1955), V, p. 2.
53 PRO T29/7 p. 189, reprinted in *Wren Society*, IV, pp. 73–4; *Cal. Treasury Papers* (1697–1702), p. 330; *Cal. Treasury Books*, XIV, p. 87; *Cal. Treasury Books*, IX, p. 1226; R. T. Gunther, ed., 'Robert Hooke's Diary 1688–1693', *Early Science in Oxford*, X (1935), 23 January 1690; H. W. Dickinson, *Sir Samuel Moreland* (Cambridge, 1970), p. 100; *Cal. Treasury Books*, XVII, p. 559.
54 This section relies heavily on the brilliant analysis of the structure of the south front by a team of English Heritage archaeologists under the leadership of Daphne Ford. Mrs Ford's drawings are in archive at English Heritage and Hampton Court (AS4/1-52; AS5/1-35; AS6/1-6; AS9/1-43).
55 Doebner, *Memoirs of Mary Queen of England*, p. 17; *HKW*, V, p. 159.
56 For earlier royal use of the Water Gate see PRO E351/3239, E351/3255. For the Duchess of Cleveland see PRO Work 5/26, ff. 292r, 293r; LC5/40 ff. 176r, v, 178v; LC5/201 p. 155.
57 PRO AO1/2482/296; Tessa Murdoch, 'Carving a Brighter Niche: Nadauld the Sculptor', *Country Life* (13 October 1988), pp. 240–41. I am grateful to Tessa Murdoch for pointing out her article to me.
58 PRO LC5/43 ff. 15v, 19r, 90v, 95r, 96–7, 107–10, 112r–v, 116r, 122; LC5/68 p. 121; LC5/42 ff. 286r, 291r, 296, 314; Work 5/55.
59 O. Millar, *The Tudor, Stuart and Early Georgian Pictures in the Collection of Her Majesty the Queen* (London, 1963), pp. 146–8, 124–5; LC5/43 f. 34; J. Douglas Stewart, *Sir Godfrey Kneller and the English Baroque Portrait* (Oxford 1983).
60 PRO AO1/2482/296 & 297; Huygens, op.cit., I, pp. 332–3, 550.
61 Defoe, *A Tour through the Whole Island of Great Britain*, p. 183; Pat Rogers, 'Defoe at Work: The Making of A Tour thro' Great Britain, Volume 1', *Bulletin of the New York Public Library*, LXXVIII (1975), pp. 431–50; *The Journeys of Celia Fiennes*, ed. Christopher Morris (London, 1947), pp. 59–60; PRO LC5/69 f. 60v.
62 Two recent articles are of importance in understanding the interior of the Gallery: Adriana Turpin, *Important English Furniture*, Sotheby's catalogue (Friday, 10 July 1998), pp. 216–41; Adriana Turpin, 'A Table for Queen Mary's Water Gallery at Hampton Court', *Apollo*, CXLIX, no. 443, n.s. (January, 1999), pp. 3–14. It should be noted that Turpin's identification of the Water Gallery in plan and view is incorrect in both articles and that use is made of *Wren Society* transcriptions rather than the original accounts.
63 Defoe, *A Tour through the Whole Island of Great Britain*, p. 175, 183; Francis Thompson, *A History of Chatsworth* (Country Life, 1949), pp. 148, 157–8.
64 There is a considerable literature on this subject. The principal sources are covered in: A. M. L. E. Erkelens, *Queen Mary's 'Delft Porcelain': Ceramics at Het Loo from the time of William and Mary* (Paleis Het Loo, 1996); Mark Hinton and Oliver Impey, eds, *Kensington Palace and the Porcelain of Queen Mary II: Essays in Association with the Exhibition China Mania: A Re-creation of Queen Mary's Display of Oriental Porcelain at Kensington Palace in the 1690s* (London, Christie's, 1998); Joan Wilson, 'A Phenomenon of Taste – The China Ware of Queen Mary II', *Apollo*, XCVI (August 1972), pp. 116–23 (although her identification of an engraving (fig. 4) as a design for the Water Gallery cannot be supported); T. H. Lunsingh Scheurleer, 'Documents on the Furnishing of Kensington House', *Walpole Society*, XXXVIII (1960–62), pp. 15–58; Linda Shulsky, 'Kensington and Voorst: Two Porcelain Collections', *Journal of the History of Collections*, II, no. 1 (1990), pp. 47–62.
65 Erkelens, *Queen Mary's 'Delft Porcelain'*, pp. 16–20.
66 The Gallery had a short life, being demolished in 1687. P. de Nolhac, 'Trianon de Porcelaine', *Revue de l'historie de Versailles et de Seine-et-Oise* (1901), pp. 1–16; E. P. De Lorme, *Garden Pavilions and the 18th Century French Court* (London, 1996), pp. 51–4.
67 Reinier Baarsen, Gervase Jackson-Stops et al., *Courts and Colonies: The William and Mary Style in Holland, England and America* (Washington, D.C., 1988), pp. 194–9.
68 Arthur Lane, 'Daniel Marot: Designer of Delft Vases and Gardens at Hampton Court', *Connoisseur*, CXXIII (1949), pp. 19–22; PRO LC5/43 f. 59r; G. Beard and C. Gilbert, eds, *Dictionary of English Furniture Makers 1660–1840* (Furniture History Society, 1986), p. 965; Gervase Jackson-Stops, 'Huguenot Upholsterers and Cabinet-makers in the Circle of Daniel

69 *Catalogue of the Drawings Collection of the Royal Institute of British Architects*, 21 vols (London, 1969–76), XVIII (L–N), p. 64.
70 PRO Work 5/43 f. 120; Howard Coutts, 'Hangings for a Royal Closet', *Country Life* (13 October 1988), pp. 232–3; Reinier Baarsen, Gervase Jackson-Stops et al., *Courts and Colonies*, pp. 106–8; Tessa Murdoch, *The Quiet Conquest: The Huguenots 1685–1985* (Museum of London, 1985), pp. 184–5. There are dozens of references to Mary's enjoyment of and skill at embroidery, for instance: PRO LC9/279 18 December 1689; LC9/280 30 October 1691. There is also a payment to Isaac Marot for a design for embroideries (BL Add. MS 5751A).
71 *The Journeys of Celia Fiennes*, p. 355. See also George Bickham, *Deliciae Britannicae; or, the Curiosities of Hampton-Court and Windsor-Castle* (London, 1742), pp. 55–6.
72 Examples of similar albums from France include: *Nouveaux desseins de Chiminées a peu de Frais In. et gravez par J. Le Pautre a Paris Chez Mariette* (n.d.); *Nouveaux Desseins de Chiminées executés á Paris et Gravée par D'Aigremont, pub. Mariette* (n.d.); *Livre Nouveau de Chiminées tirée de divers ouvrages de mr. Bullet Architect du Roy grave par J. Nolin* (c.1661). See Maxime Préaud, *Inventaire de fonds français, Graveurs du XVIIe Siècle, XII, Jean Lepautre*, part 2 (Paris, 1999), pp. 122–45.
73 The drawings are now in a bound volume acquired by Sir John Soane from George Dance in 1817. The only other place that could reasonably lay claim to being the intended location for the chimneypieces is Kensington, a far smaller project, which is known to have included major porcelain collections as shown on a number of the drawings. Another possibility is that the drawings were a speculative collection for presentation to William and Mary in an attempt to gain work. This is rejected on the basis of the fact that the closet drawings required careful measurement, and they appear more like a commission than a speculation.
74 The important Gibbons literature is H. Avray Tipping, *Grinling Gibbons and the Woodwork of his Age (1648–1720)* (London, 1914); M. Whinney, *Sculpture in Britain 1530–1830* (Harmondsworth, 1964), pp. 51–9; David Green, *Grinling Gibbons: His Work as Carver and Statuary 1648–1721* (London, 1964); Frederick Oughton, *Grinling Gibbons and the English Woodcarving Tradition* (Hertford, 1979); Geoffrey Beard, *The Work of Grinling Gibbons* (London, 1989); David Esterly, *Grinling Gibbons and the Art of Carving* (London, Victoria and Albert Museum, 1998). See also Reinier Baarsen's review of this last book (and exhibition), 'Grinling Gibbons', *Burlington Magazine*, CXLI (January 1999), pp. 47–8, and David Esterly's reply, pp. 355–6.
75 Green, *Grinling Gibbons*, pp. 71–2.
76 PRO Work 19/48/1 ff. 30–32, 38–9; PRO Work 5/42 f. 381v.
77 A drawing and contract dated 10 May 1689 for Clifton upon Teme, Worcestershire, is in volume six of the Prattinton collection of manuscripts on Worcestershire at the Society of Antiquaries of London.
78 See for instance 'a panel glewed for Mr. Gibbons 6ft long and 5ft high to draw upon' at Whitehall in March 1686 (PRO Work 5/54 f. 186).
79 I am very grateful to Dr Gordon Higgott for discussing this whole section with me. His current pioneering work will further unravel the hands of Hawksmoor, Gibbons and Wren. Kerry Downes, *Sir Christopher Wren: The Design of St Paul's Cathedral* (London, 1988), cat. nos 185, 186. On Hawksmoor's pen-and-wash technique see Geraghty, 'New Light on the Wren City Churches', p. 148.
80 PRO T1/68/47.
81 G. Miege, *The Present State of Great Britain and Ireland* (London, 1711), pp. 273–4; E. Chamberlayne, *Angliae Notitia*, 2 vols (5th edn, London, 1704), II, p. 183; C. G. T. Dean, *The Royal Hospital Chelsea* (London, 1950), pp. 162–3, 171; Captain C. G. T. Dean, 'The Corps of Invalides', *Journal of the Royal United Services Institution*, LXXXIX (August 1944), pp. 282–5.
82 David Green, *Queen Anne* (London, 1970), p. 54; Lutterell, *A Brief Historical Relation of State Affairs*, I, p. 561; Lamberti, *Mémoires de la Dernière Revolution*, II, pp. 512–13; Burnet, *History of His Own Time*, IV, p. 3. In August the king and queen made a short trip to Windsor to avoid the dust of demolition, but by the 31st they were back at Hampton Court again (Lamberti, *Mémoires de la Dernière Revolution*, II, p. 554).
83 PRO LC5/149 p. 256.
84 William's and Mary's itinerary vis-à-vis Hampton Court has been researched by G. D. Heath and exists in manuscript in the Curatorial Office at Hampton Court. His work is largely based on the LS papers in the PRO, supplemented by the records of the Privy Council and the State Papers. All references to William's and Mary's movements in this chapter come from Heath's paper. Where I have found additional evidence it is cited.
85 SP8/7 ff. 190–91r; *Cal. S.P. Dom.* (1690–91), p. 97.
86 Doebner, *Memoirs of Mary Queen of England*, pp. 32–3; *Memoirs of Sir John Reresby*, p. 94.
87 Ibid., p. 94.
88 PRO Work 6/2 f. 39r.
89 In his funeral oration Archbishop Tennison stated 'How reasonable were her many diversions, such as building and gardenage, and continuing and improving and adorning and adjusting everything there and there unto belonging' (T. Tennison, *A Sermon Presched at the Funeral of her Late Majesty Queen Mary in Westminster Abbey* (London, 1694), p. 16). See also Defoe's comments (*A Tour Through the Whole Island of Great Britain* p. 183); PRO LC5/42 ff. 295v, 337v; LC5/43 f. 22v.
90 The drawings are Soane Museum vol. 110 ff. 17, 19, 20, 21. For Versailles see Pierre-André Lablaude, *The Gardens of Versailles* (London, 1995), pp. 46–9.
91 PRO Work 5/55. Hawksmoor's drawing for the portal is in Soane Museum vol. 110 f.53. PRO AO 1/2482/296; Work 5/145.
92 Van der Zee, *William and Mary*, pp. 383–9; PRO LC5/124 24 February 1694–5.
93 PRO SP8/7 ff. 190r–191r.
94 R. O. Bucholz, *The Augustan Court: Queen Anne and the Decline of Court Culture* (Stanford, 1993), pp. 26–31.
95 *Cal. Treasury Books*, XVI, p. 81; XVII, p. 118.
96 *HKW*, V, pp. 31–2.
97 On Charles I's probable treatment of the cartoons see Sharon Fermor and Alan Derbyshire, 'The Raphael Tapestry Cartoons Re-examined', *Burlington Magazine*, CXL (April 1988), p. 250.
98 Van Leeuwen, *William III and the Royal Collections*, pp. 23–4; PRO LC5/149; *Cal. Treasury Books*, XVII, pp. 707–8.
99 *Cal. Treasury Books*, XVII (ii), pp. 637, 707; PRO Work 5/49 f. 39; *Correspondence of the Family of Hatton*, ed. E. M. Thompson, 2 vols (1878), II, p. 229; John Shearman, *Raphael's Cartoons in the Collection of her Majesty the Queen and the Tapestries for the Sistine Chapel* (London, 1972), p. 148n.; Timothy Clayton, *The English Print* (New Haven and London, 1997), pp. 49–50.
100 *HMC, Buccleuch and Queensberry*, II (ii), pp. 628–49; W. Coxe, ed., *Private and Original Correspondence of Charles Talbot, Duke of Shrewsbury, with King William, the Leaders of the Whig Party and Other Distinguished Statesmen*, 3 vols (London, 1821), III, pp. 612–22.
101 *Cal. Treasury Books*, XIV, p. 80.
102 *HKW*, V, pp. 43–4; Lang, *Rebuilding St Paul's after the Great Fire of London*, pp. 198–219.
103 Van der Zee, *William and Mary*, p. 443; Paul-Emile Schazmann, *The Bentincks: The History of a European Family* (London, 1976), pp. 104–9; Jane Roberts, *Royal Landscape: The Gardens and Parks of Windsor* (New Haven and London, 1997), pp. 20–21.
104 *HMC, Marquis of Bath*, III (Prior Papers), pp. 309, 311, 312, 315, 326, 329, 332; Nottingham University Library MSS Pw

A.843; *Mémoires de Marquis de Sourches sur Règne de Louis XIV*, ed. Gabriel-Jules de Cosnac, Arthur Bertrand and Edouard Pontal, 13 vols (Paris, 1882–93), VI, p. 35; Philippe de Courcillon Dangeau, *Journal de Marquis de Dangeau*, ed. Soulié and Dussieux, 19 vols (Paris, 1854–60), VI, p. 352. On Marly see Emmanuel Ducamp ed., *Views of the Gardens at Marly. Louis XIV: Royal Gardener* (Paris, 1998).

105 R. G. M. Baker, 'William Talman and a Supposed Project to Improve Hampton Court', *Surrey Archaeological Collections*, LXXV (1984), pp. 177–83. Baker's thesis that the *trianon* was for Talman himself cannot be supported on the following grounds: (1) The design included an avenue from the palace to the house. No royal servant could possibly propose to build a house linked to a royal palace in this way. (2) The interiors are, as the drawings indicate, of the highest quality. Only the royal purse could have afforded such lavish treatment. (3) The drawings were bound for presentation; a scheme for personal use would not have required such expense. (4) Talman's son John continued to devise schemes for a *trianon* on the site in an attempt to sell the idea to Queen Anne, for which see Harris, 'The Hampton Court Trianon Designs of William and John Talman', below. The most powerful argument for the house being for private use is Talman's use of his personal monogram, a flourish not at odds with what is known of Talman's ego.

106 John Harris, 'The Hampton Court Trianon Designs of William and John Talman', *Journal of the Warburg and Courtauld Institutes*, XXIII (1960), pp. 139–49; Giles Worsley, 'William Talman: Some Stylistic Suggestions', *Georgian Group Journal* (1992), pp. 12–13.

107 *HKW*, V, p. 35; PRO Work 6/2 f.123r.; John Harris, *William Talman, Maverick Architect* (London, 1982), p. 44, fig. 87. I am very grateful to Giles Worsley and John Harris who both have been kind enough to discuss this matter with me and to direct me to parallels.

108 PRO Work 6/2 f. 125v; *Wren Society*, IV, Pl. VIII; All Souls IV.18; *London Illustrated News* (29 September 1962), p. 489.

109 De Lorme, *Garden Pavilions and the 18th Century French Court*, pp. 54–66.

110 PRO Work 5/51 ff. 372r, 381v, 384v, 417v; Work 5/52 ff. 330v, 332r-v, 334v, 339v, 360v, 374v. For the layout of the bowling green see 'The Pavilion, Hampton Court', *Country Life* (2 December 1900), pp. 815–16.

111 See PRO T1/70.33a.

112 Also see G. F. Wingfield Digby, 'Damasks and Velvets at Hampton Court', *Connoisseur*, CIII (May 1939), pp. 248–53 and F. J. Rutherford, 'The Furnishing of Hampton Court Palace for William III, 1699–1701', *Old Furniture*, II (London, 1927), pp. 16–17.

113 Victoria and Albert Museum Inv. E1085–1916.

114 PRO Work 6/2 f. 125v; Work 5/51 f. 420v; Work 5/52 ff. 272v–3r, 292v, 330r–331r, 350r, 370r, 372r. For the furnishings see the following documents. The closet: PRO LC5/153 f. 75; LC9/281 ff. 68, 79, 84, 93. The painted room: PRO LC9/281 ff. 68, 79, 80, 83, 91; LC5/153 ff. 72, 101. Millar, *The Tudor, Stuart and Early Georgian Pictures in the Collection of Her Majesty the Queen*, pp. 164–5.

115 Pierre-André Lablaude, *The Gardens of Versailles* (London, 1995), pp. 69–73; PRO Work 5/52 ff. 340v, 360r, 376v–377r, 393r, 401v, 403v, 409v, 428r-v; PRO Work 4/9 8 January 1746.

116 John Harris, *William Talman*, p. 31.

117 Lutterell, *A Brief Historical Relation of State Affairs*, IV, p. 553; BL Add. MS 20,101 f. 69 (printed in *Wren Society*, IV, pp. 59–60).

118 HMC, 12th report, appendix ii (1888), p. 393.

119 Lutterell, *A Brief Historical Relation of State Affairs*, IV, p. 565.

120 PRO Work 5/50 ff. 326r–327v.

121 For Nost see Whinney, *Sculpture in Britain 1530–1830*, pp. 59–62, and R. Gunnis, *Dictionary of British Sculptors 1660–1851* (revised edition), pp. 279–82; *Cal. Treasury Books*, XV, p. 227; *Cal. Treasury Papers* (1697–1701/2), p. 375.

122 Van der Zee, *William and Mary*, p. 432.

123 All the primary material for this room is published in Susan Jenkins, 'William III at Hampton Court: The King's Private Eating Room', *Apollo*, CXXXIX, no. 381 (November 1993), pp. 311–15. The *Beauties* became one of Hampton Court's tourist attractions. They are treated as a famous sight in Henry Fielding's *Tom Jones* ([1749], Harmondsworth, 1982), p. 154.

124 Van der Zee, *William and Mary*, pp. 456, 458.

125 Tessa Murdoch, 'The Dukes of Montagu as Patrons of the Huguenots', *Proceedings of the Huguenot Society of London*, XXV (iv) (1992), pp. 340–50; Tessa Murdoch, 'The Patronage of the Montagus', in Tessa Murdoch, ed., *Boughton House: The English Versailles* (London, 1992), pp. 33–8; Jackson-Stops, 'Daniel Marot and the first Duke of Montagu'; Jackson-Stops, 'Huguenot Upholsterers and Cabinet-makers in the Circle of Daniel Marot', p. 114.

126 *Cal. Treasury Books*, XV, p. 42; National Art Library, Victoria and Albert Museum, MSS 57.A.38 (published by Edward F. Strange in 'The Furnishing of Hampton Court in 1699', *Connoisseur*, XIV (1906), pp. 169–72; HMC, *Buccleuch and Queensberry*, II (ii) (London, 1903), p. 644. Some useful and alternative insights into the furnishing of Hampton Court are in Adam Bowett, *English Furniture 1660–1714, from Charles II to Queen Anne* (Woodbridge, 2002), pp. 170–95.

127 W. G. Thompson, *A History of Tapestry from the Earliest Times until the Present Day* (3rd edn, Wakefield, 1973), pp. 427–40.

128 PRO LC5/43 ff.98r–99v; LC5/69 p. 58; LC5/70 p. 30; LC9/281 p. 30. For a detailed analysis of the tapestry hang see Thomas Campbell, 'Report on the Tapestries Hung in the Hampton Court State Apartments in the First Half of the Eighteenth Century' (unpublished report for Historic Royal Palaces at Hampton Court).

129 PRO LC9/281 f.17. For the soft furnishings see also Geoffrey Beard, *Upholsterers and Interior Furnishing in England 1530–1840* (New Haven and London, 1996), pp. 98–102; John Fowler and John Cornforth, *English Decoration in the 18th Century* (London, 1974), pp. 100–09; Annabel Westman, 'Splendours of State: The Textile Furnishings', in S. Thurley, ed., 'The King's Apartments, Hampton Court Palace', *Apollo*, CXL (August 1994), pp. 39–45.

130 National Art Library MSS 57.A.38; PRO LC9/281 f. 17.

131 Tessa Murdoch, 'Jean, René and Thomas Pelletier, a Huguenot family of gilders in England, 1682–1726 (part 1)', *Burlington Magazine*, CXXXIX, (November 1997), pp. 732–42. On the furniture generally see also F. J. Rutherford, 'The Furnishing of Hampton Court Palace for William III, 1699–170' and 'The Furnishing of Hampton Court Palace 1715–1737', *Old Furniture*, II (1927), pp. 15–33, 76–86, 180–87; Tessa Murdoch, 'The Furniture for the King's Apartments: 'Walnuttree Gilding, Jappanning and Marble', in Thurley, ed., 'The King's Apartments, Hampton Court Palace', pp. 55–9.

132 LC9/281 f. 23; Beard and Gilbert, *Dictionary of English Furniture Makers 1660–1840*, pp. 485–6; D. Marot, *Oeuvres du Sieur D. Marot, architecte de Guillaume III, roy de la Grande Bretagne, contenant plusieures pensées utiles aux architectes, peintres, sculpteures, orfèvres* (The Hague, 1702).

133 Geoffrey Parnell, 'The King's Guard Chamber: A Vision of Power', *Apollo*, CXL, no. 390 (August 1994), pp. 60–64.

134 I have identified this inventory with that in the Surveyors' Office known as OM19.

135 Rieke van Leeuwen, *William III and the Royal Collections* (The Hague, The Mauritshuis, 1988), pp. 21–2.

136 This is based on an inventory in the Surveyors' Office known as OM 22 dated 1705–10. Copies are in BL Add. MS 20913 and Stowe 567 (but this one is in French and has variations). The inventory of paintings on the ground floor is in BL Harl. MS 5150 f. 13 and is printed in Susan Jenkins, 'A Sense of History: The Artistic Taste of William III', *Apollo*, CXL (August 1994), p. 9.

137 E. A. Evans 'Jacques Rousseau, A Huguenot Decorative Artist at the Courts

of Louis XIV and William III', *Proceedings of the Huguenot Society of London*, XX (ii) (1972), pp. 157–8; Martha Hamilton-Phillips, 'Painting and Art Patronage in England', in Maccubbin and Hamilton-Phillips, *The Age of William III and Mary II: Power, Politics and Patronage, 1688–1702*, p. 251; van Leeuwen, *William III and the Royal Collections*, p. 25; Millar, *The Tudor, Stuart and Early Georgian Pictures in the Collection of Her Majesty the Queen*, p. 164 and cat. nos 482–3.

138 LC5/152 f. 242; Work 5/51 f. 420v; LC5/153 f. 147; J. Douglas Stewart, 'William III and Sir Godfrey Kneller', *Journal of the Warburg and Courtauld Institutes*, XXXIII (1970), pp. 330–36; Peter Burke, *The Fabrication of Louis XIV* (New Haven and London, 1992), p. 172.

139 PRO LC5/125 8 April 1700; van Leeuwen, *William III and the Royal Collections*, p. 115; *Cal. Treasury Books*, XVII, p. 42.

140 Andrew Martindale, *The Triumphs of Caesar by Andrea Mantegna in the Collection of Her Majesty the Queen at Hampton Court* (London, 1979), pp. 111–12.

141 PRO LC9/281 ff. 78–9, 82, 91.

142 PRO LC9/281 p. 31; E. Croft-Murray, *Decorative Painting in England 1537–1837*, 2 vols (London, 1962), I, pp. 57–9, 237.

143 PRO LC9/379 unpaginated bill for 'a room adjoining to his majesties closet at Hampton Court'; *Cal. Treasury Books*, XV, p. 42; G. Walton, *Louis XIV's Versailles* (Harmondsworth, 1986), pp. 189–90; Béatrix Saule, *Versailles Triomphant une journée de Louis XIV* (Paris, 1996), p. 31; LC9/281 f. 49; LC5/152 f.233; Gervase Jackson-Stops, 'William III and French Furniture', *Furniture History*, VII (1971), pp. 122–3; G. Bidloo, *Komste van zijne majesteit Willem III, koning van Groot Britanje enz. In Holland; ofte omstandelijke beschrijving van alles, het welke op des selfs komste en gedurende zijn verblijf in 's Gravenhaage en elders ten teeken van vreugde en eere is opregt en voorgevallen* (s' Gravenhaag, 1961), p. 70; *The Journeys of Celia Fiennes*, p. 355. On the use of the backstairs see R. O. Bucholz, 'Going to Court in 1700: A Visitor's Guide', *Court Historian*, V (iii) (December 2000), pp. 208–11.

144 PRO LC9/379 unpaginated bill of Richard Bealing, and for 'ye lower closet'; LC9/281 f. 48; LC5/125 8 April 1700.

145 LC11/5 ff. 151, 166, 168, 173; LC9/379 unpaginated bills of Richard Bealing; LC9/279 ff. 75, 76, 102.

146 For details of the sconces see the Royal Collection inventory, in MS at Hampton Court; LC5/152 f. 235; Fowler and Cornforth, *English Decoration in the 18th Century*, p. 224; LC5/125 16 July 1701. Glass branches like those at Hampton Court still remain at Boughton House, Northamptonshire.

147 Luttrell, *A Brief Historical Relation of State Affairs*, IV, pp. 553, 638; *London Gazette*, 7 May 1700; *Cal. Treasury Books*, XVII, p. 165; Luttrell, *A Brief Historical Relation of State Affairs*, IV, pp. 707, 717.

148 *Post Boy*, nos 787 (23 April 1700), 870 (3 November 1700); Bucholz, 'Going to Court in 1700', p. 200.

149 PRO LC5/149 pp. 61, 88, 150; *Cal. Treasury Books*, IX, p. 1048; *Cal. Treasury Books*, X, p. 298.

150 Bucholz, 'Going to Court in 1700', pp. 204–5. For Kensington see, for instance, *Post Boy*, no. 748 (22 January 1700), and for Hampton Court see nos 817 (3 July 1700) and 866 (22 October 1700).

151 PRO LC5/149 p. 7. See my *Royal Palaces of Stuart England* (in preparation) but in the interim see Anna Keay and Simon Thurley, 'The Stuart Royal Bedchamber' (forthcoming). The warrant was issued to Sir Thomas Duppa, Chief Gentleman Usher and the man in day-to-day charge of the lodgings at court. He would presumably have been working closely with Wren and Hawksmoor on the design of the new buildings.

152 Andrew Ashbee and John Harley, *The Cheque Books of the Chapel Royal*, 2 vols (Aldershot, 2000), II, p. 287; PRO Work 5/42 ff.198r, 199r; Doebner, *Memoirs of Mary Queen of England* (Leipzig and London, 1886), pp. 12, 19.

153 Samuel Weller Singer, *The Correspondence of Henry Hyde Earl of Clarendon* (London, 1828), p. 267; PRO LC5/42 f. 331; LC5/151 p. 213; LC5/151 p. 261; LC5/42 f. 315.

154 The works are enumerated in PRO Work 5/55 and more fully summarised in G. D. Heath, *The Chapel Royal at Hampton Court* (Borough of Twickenham Local History Society paper XLII, 1983), pp. 30–34. For the organ see PRO LC5/149 p. 130.

155 *Cal. Treasury Books*, XVI, pp. 162–3.

156 PRO AO1/2482/297; E351/3464; Work 6/14 p. 110; Thomas Cocke, *900 Years: The Restorations of Westminster Abbey* (Dean and Chapter of Westminster, 1995), pp. 40–43, 125–6; Thurley, *Whitehall Palace*, pp. 116–18.

157 HMC, *Buccleuch and Queensberry*, II (ii), pp. 636, 639; *Cal. Treasury Books*, XVI, p. 344; PRO LC5/150 p. 279.

158 PRO LC5/149 p. 119.

159 Julian Marshall, *The Annals of Tennis* (London, 1878), p. 59; J. C. Sainty and R. O. Bucholz, *Officials of the Royal Household, 1660–1837, part I: Department of the Lord Chamberlain and Associated Offices* (London, 1997), p. 51.

160 PRO Work 5/50, ff. 273r, v, 274r, 279r; Work 5/51 ff. 284r, 289v, 292r, 312v; Work 5/52 f. 428r; *Cal. Treasury Books* XIV, p. 204; *Cal. Treasury Books* XVI p. 134; PRO Work 5/52, February 1702.

161 William Van Lennep, *The London Stage 1660–1800*, 5 vols (Carbondale, 1965), I, pp. 371, 376, 377, 379, 417, 474; PRO LC5/153 p. 150. The details are in PRO Work 5/52 ff. 440, 436r–437v.

162 Defoe, *A Tour through the Whole Island of Great Britain*, p. 185; *Cal. Treasury Books*, XV, p. 227.

163 Francis Watson, *A History of Chatsworth* (London, Country Life, 1949), pp. 148–59.

164 William Camden, *Britannia* (Edmund Gibson, London, 1695), p. 368; H. M. Colvin, 'Roger North and Sir Christopher Wren', *Architectural Review*, X (1962), p. 259. See also his comments in his treatise on building, in *Of Building: Roger North's Writings on Architecture*, ed. Howard Colvin and John Newman (Oxford, 1981), p. 57: 'It is new built, but the old had a better view, for that had gate towers, and some risings, but this is all of an height: balustred, flatt, which looks like combs stuck at the topp, and a series of round windoes, like the ports of a ship.'

165 Maria Kroll, ed., *Letters from Liselotte* (London 1970), p. 171; G. F. Wingfield Digby, 'Damasks and Velvets at Hampton Court', *Connoisseur*, CIII (May 1939), pp. 248–53.

166 There are a few contemporary instances of Hampton Court's architecture exerting a greater influence. Although Isaac Ware thought there was something 'harsh in the transition from the red brick to stone...' (*Complete Body of Architecture* (London, 1756)), Lord Raby wrote to Sir William Wentworth within ten years of the completion of the palace that he was 'at last persuaded to make it of brick and stone as Hampton Court is which I am assured will look better than all stone' (J. J. Cartwright, ed., *The Wentworth Papers 1705–1739* (London, 1883), p. 26).

Chapter 11

1 The history of the royal court has been written for the period covered by this chapter and the next. Queen Anne's court is covered in R. O. Bucholz, *The Augustan Court: Queen Anne and the Decline of Court Culture* (Stanford, Calif., 1993). This will be referred to as Bucholz in the notes to this chapter.

2 For St Paul's see Carol Gibson-Wood, 'The Political Background to Thornhill's Paintings in St Paul's Cathedral', *Journal of the Warburg and Courtauld Institutes*, LVI (1993), pp. 229–37.

3 Bucholz, pp. 57, 63.

4 *HKW*, V, pp. 39–46.

5 R. Tighe and J. Davis, *Annals of Windsor, being a History of the Castle and Town*, 2 vols (London, 1858), II, pp. 485–6, 494–5.

6 The balance of evidence for social and architectural life at Hampton Court begins to shift in the reign of Queen Anne. The excellent run of detailed works accounts begun after the Restoration ceases. The

summarised Audit Office accounts continue for the period 1700–82, but are of course far less informative (AO1 2446/138–2471-217). The building history has to be written from the warrants to and from the Treasury, Lord Chamberlain and the Office of Works (PRO Work 6/2–6/7, 6/14–6/17), the Lord Chamberlain's Accounts and Miscellanea (LC9) and Miscellaneous Records (LC5) and the Treasury Papers. In the last case most of the papers have been calendared and although I refer to the calendar reference in the notes I have generally cross-checked with the original. Added to these is the increasingly important evidence of diaries, letters, newspapers and other material.

7 PRO Work 5/53 ff. 233r, 234v, 239r, 243r, 250r; T29/14 p. 88. Verrio's final payment was on 1 November 1703.

8 Edgar Wind, 'Julian the Apostate at Hampton Court', *Journal of the Warburg and Courtauld Institutes*, III (1939–40), pp. 127–37.

9 Edward Croft-Murray, *Decorative Painting in England 1537–1837*, 2 vols (London, Country Life, 1962), I, p. 59; E. Waterhouse, *Painting in Britain 1530–1790* (Harmondsworth, 1978), p. 125.

10 PRO AO1/2450/156; Accounts for the 1750 restoration are in Work 6/17 ff. 61v, 77r; Work 4/10 5, 10 July, 7 August, 11 September 1750, 11 June 1751. See letter from Charles Allom to J. B. Westcott (Work 19/309) for a full assessment of the extent of over-painting in 1906.

11 *The Journeys of Celia Fiennes*, ed. Christopher Morris (London, 1947), p. 354; George Bickham, *Deliciae Britannicae; or, the Curiosities of Hampton-Court and Windsor-Castle* (London 1742), pp. 29–30.

12 PRO LC5/44 ff. 188v–189r. This bed is described as the 'party-coloured-velvet bed' and hangings from the Little Bedchamber. It was converted into a 'great bed' for Kensington. This is probably the bed known today as Queen Anne's bed with multi-coloured cut silk velvet. Examination of the bed suggests that it has been considerably altered. When it was installed in the Little Bedchamber is presently unclear, but it was replaced by a yellow damask bed with silver galloon (PRO LC5/125 warrants (unpaginated) 28 October 1703 and 3 August 1703; PRO LC5/153 p. 396).

13 PRO T54/18 pp. 282–3, 295; PRO LC5/44 ff. 210r, 211v, 212r, 213v, 216r, 216v, 217r, 225r–v; LC5/70 pp. 244, 249, 254; LC5/154 pp. 6, 9.

14 *Cal. Treasury Books*, XIX (1704–5), pp. 123, 124, 316, 369, 495; PRO AO1/2446/140; PRO T29/15.

15 Anna Keay has pointed out that Verrio's depiction of George is closely based on his earlier *modello* for Charles II, his first work for the king. O. Millar, *Tudor, Stuart and Early Georgian Pictures in the Collection of Her Majesty the Queen*, 2 vols (London, 1963), I, p. 133, II, fig. 121.

16 Croft-Murray, *Decorative Painting in England*, I, pp. 50–60, 69–71; *BDBA*, pp. 975–6; J. Buckridge, *The Lives of the Most Eminent Painters* (London, 1754), p. 137.

17 Henry L. Snyder, *The Marlborough-Godolphin Correspondence* (Oxford, 1975), p. 522; G. Heath, *The Chapel Royal at Hampton Court* (Borough of Twickenham Local History Society, 1983), p. 34; *Cal. Treasury Books*, XIX (1704–5), pp. 498–9; PRO LC5/44 f. 219r. John Macky, *A Journey through England*, 3 vols (London, 1732), I, p. 72 (the sentence about Prince George is not in the 1714 edition); N. Luttrell, *A Brief Relation of State Affairs from September 1678 to April 1714*, 6 vols (Oxford, 1857), VI, p. 154.

18 PRO T54/18 p. 362; *Cal. Treasury Books*, XXI (1706–7), p. 303; XXIII (1709), pp. 79, 176–7; *Cal. Treasury Papers* (1714–19), p. 195; Bucholz, p. 131.

19 Kathy White and Peter Foster, *Bushy Park: Royals, Rangers and Rogues* (East Molesey, 1997), pp. 18–28; *Law*, III, pp. 180–83; John Harris, 'Water Glittered Everywhere', *Country Life* (6 January 2000), pp. 44–7.

20 LC5/154 p. 260.

21 *Cal. Treasury Books*, XX (1705–6), p. 179; Gerald Heath, *Hampton Court: The Story of a Village*, ed. Kathy White and Joan Heath (The Hampton Court Association, 2000), pp. 80–81. Verrio had rooms at the palace on the ground floor, to the left of the Great Gatehouse (PRO LC5/156 10 July 1717).

22 *Cal. Treasury Books*, XXI (1706–7), p. 374; HKW, V, p. 43; *Cal. Treasury Books*, XX (1705–6), p. 749; PRO T29/16; *Cal. Treasury Books*, XXII (1708), p. 26; Heath, *Hampton Court*, pp. 71–3.

23 PRO Work 6/14 p. 150; Work 5/3 f. 258r; Work 6/5 pp. 100, 119, 120, 121; PRO LC5/155 f. 75r; Cedric Jagger, *Royal Clocks: The British Monarchy and its Timekeepers 1300–1900* (London, 1983), pp. 6–7. In May 1721 John Davis of Windsor undertook another major overhaul of the clock (PRO Work 4/1 f. 34v).

24 Jonathan Swift, *Journal to Stella (1710–1713)* (London, 1924), pp. 249, 255–6, 262, 270–71; PRO LC5/155 f. 78v; LC5/155 f. 132r; Bucholz, pp. 221, 223–4. The Wentworth Papers contain a number of details about Anne's visits to Hampton Court in this period (J. J. Cartwright, *The Wentworth Papers* (London, 1883), pp. 26, 148, 151, 153, 208, 209–10, 292, 345).

25 *Memoirs of Sarah, Duchess of Marlborough*, ed. William King (London, 1930), p. 274.

26 HMC, *Bath*, I, p. 201.

27 PRO AO1/2447/145; PRO LC5/155 f. 112v. The bill books covering these alterations give more details and can be found in LC5/71 ff. 80v, 91.

28 PRO LC5/71 f. 72v; LC5/155 f. 106v; PRO AO1/2448/147. The bill books covering these alterations give more details and can be found in LC9/284 ff. 31v, 63v, 65r, 66r, 70v; LC5/285 ff. 22v, 38, 41v; LC5/155 pp. 131, 176; LC5/71 ff. 72v, 91; LC5/126. For Queen Anne and the backstairs see R. O. Bucholz, 'Going to Court in 1700: A Visitor's Guide', *The Court Historian*, V (iii) (December 2000), pp. 209–11.

29 J. W. Croker, ed., *Letters to and from Henrietta, Countess of Suffolk*, 2 vols (London, 1824), I, pp. 292–4.

30 PRO LC5/155 p. 33; *London Gazette*, no. 4,923 (6 November 1711).

31 Swift, *Journal to Stella*, p. 18.

32 *The Poems of Alexander Pope*, ed. John Butt (London, 1963), p. 227.

33 PRO T54/18 p. 37; PRO LC5/44 ff. 233r, 237r–v, 242, 246.

34 Swift, *Journal to Stella*, p. 209; PRO LS1/55.

35 *The Poems of Alexander Pope*, p. 227.

36 Bucholz, pp. 235–6; *The Journeys of Celia Fiennes*, pp. 355–6; Bickham, *Deliciae Britannicae* (London, 1742), pp. 103–10.

37 John Sherman, *Raphael's Cartoons in the Collection of Her Majesty the Queen and the Tapestries in the Sistine Chapel* (London, 1972), pp. 150–51.

38 *Cal. Treasury Books*, XVII (1702), p. 42; PRO LC5/154 p. 329; LC5/155 f. 74v. Brackyn also copied Van Dyck's Cupid and Psyche in 1712 (LC5/155 f. 104r); Horace Walpole, *Anecdotes of Painting*, with additions by J. Dallaway and notes by R. A. Wornum, 3 vols (London, 1862), II, pp. 655, 664; Arline Meyer, *Apostles in England, Sir James Thornhill and the Legacy of Raphael's Cartoons* (New York, 1996), pp. 19, 22; PRO LC/160 25 February 1728/9; Timothy Clayton, *The English Print* (New Haven and London, 1997), pp. 49–52. A full-scale set of copies of the cartoons by Thornhill are in the Royal Academy, London.

39 Luttrell, *A Brief Relation of State Affairs*, V, p. 159.

40 Bucholz, pp. 125, 204, 229–30; PRO T29/15; E. Gregg, *Queen Anne* (London, 1980), p. 137; J. Grant, ed., *Seafield Correspondence from 1685–1708* (Edinburgh, 1912), p. 30.

41 S. Thurley, 'The Stuart Kings, Oliver Cromwell and the Chapel Royal 1618–1685', *Architectural History*, XLV (2002), pp. 238–74.

42 PRO Work 6/5 p. 97; PRO LC5/155 f.52v.

43 PRO AO1/2447/145.

44 Soane Museum vol. III, f.39. William III's pulpit of 1701 was removed to store and ordered to be sold in 1716; eventually it was removed to Greenwich Hospital, being sold for £10. PRO Work 4/1 23 October, 5 December 1716, 12 February 1717.

45 PRO AO1/2448/146; PRO Work 5/56 p. 20.

46 PRO AO1/2447/145; PRO LC3/53 25;

47 Work 5/56 p. 12.
48 PRO T54/21 pp. 32, 397; PRO LC5/155 ff. 75v, 109v, 137r; LC5/71 ff. 56v–57r, 73v.
49 *Cal. Treasury Books*, XIX (1704–5), pp. 277, 350; *HKW*, v, p. 360; PRO Work 6/5 pp. 205, 208; PRO AO1/2448/147; C. G. T. Dean, *The Royal Hospital Chelsea* (London, 1950), p. 175; C. G. T. Dean, 'The Corps of Invalids', *Journal of the Royal United Services Institution*, LXXXIX (August 1944), pp. 286–7.
50 In 1698 Sir Christopher Wren had been granted the exclusive right for fifteen years to print and publish views of Hampton Court (SP44/347 pp. 383–5; *Cal. S.P. Dom.* (1698), pp. 343–4). John Harris and Gervase Jackson-Stops, eds, *Britannia Illustrata; or, Views of Several of the Queen's Palaces also of the Principal Seats of the Nobility and Gentry of Great Britain* (Bungay, 1984), pp. 5–8; John Harris, *The Artist and the Country House* (London, 1979), pp. 91–5; Millar, *Tudor, Stuart and Early Georgian Pictures in the Collection of Her Majesty the Queen*, p. 157; L. Stainton and C. White, *Drawing in England from Hilliard to Hogarth* (exh. cat., London, British Museum, 1987), pp. 203–4.
51 See T. P. Connor, 'The Making of Vitruvius Britannicus', *Architectural History*, XX (1977), pp. 14–30.
52 PRO Work 6/5 p. 82; AO1/2447/144; Jane Roberts, *Royal Landscape: The Gardens and Parks of Windsor* (New Haven and London, 1997), pp. 22–4.
53 Swift, *Journal to Stella*, p. 206.
54 *Cal. Treasury Books*, XVII (1702), p. 278, 1,077, 1,078; PRO T54/18 p. 187; *Cal. Treasury Books*, XIX (1704–5), p. 257.
55 *Cal. Treasury Books*, XVII (1702), pp. 72, 77; XVIII, pp. 68, 109, 111, 278; XIX, p. 113; PRO T54/18 pp. 59, 453.
56 J. C. Sainty and R. O. Bucholz, *Officials of the Royal Household 1660–1837*, 2 vols (Institute of Historical Research, London, 1997–8), II, pp. 67 and 128; PRO T54/21 p. 24.
57 *Cal. Treasury Books*, XXIX (1704–5), p. 192; M. M. Reese, *The Royal Office of the Master of the Horse* (London, 1976), p. 204; *Cal. Treasury Books*, XXX (1716), pp. 170, 208, 308; *Cal. Treasury Papers* (1714–19), p. 287. In 1726 John Wooton painted *The Hampton Court Chestnut Arabian: George I's Horse Held by an Arab Groom*; see Millar, *Tudor, Stuart and Early Georgian Pictures in the Collection of Her Majesty the Queen*, I, no. 553.

Chapter 12

1 *Cal. S.P. Ven.*, XV (1617–19), pp. 270–71; PRO E351/3243; E351/3250; PRO AO1/2481/286; Roy Strong, *The Renaissance Garden in England* (London, 1984), pp. 167–87.
2 Roy Strong, *The Renaissance Garden*, pp. 138–197; W. H. Adams, *The French Garden 1500–1800* (London, 1979), pp. 44–62; Timothy Wilks, '"Forbear The Heat and Haste of Building": Rivalries amongst the Designers at Prince Henry's Court, 1610–12', *Court Historian*, VI, 1 (May 2001), pp. 49–65.
3 John Cloake, *The Palaces and Parks of Richmond and Kew*, 2 vols (Chichester, 1995), I, pp. 197–8, 241–53.
4 PRO AO1/2482/291; *Cal. S.P. Dom., Charles I* (1639–40), p. 389; *Law*, pp. 122–5; *HKW*, IV, pp. 231–2.
5 PRO E351/3259; E351/3263 351/3265; A. MacGregor, ed., *The Late King's Goods* (Oxford, 1989), pp. 392–3.
6 PRO E351/3413; *Cal. S.P. Dom. Charles I* (1638–9), p. 605. The marquis was also instructed to make repairs in the park that had been damaged by flooding. On Pell Mell see Edgar Sheppard, *Memorials of St James's Palace* (London, 1894), pp. 25–7.
7 Count Lorenzo Magalotti, *Travels of Cosimo the Third, Grand Duke of Tuscany, through England, during the Reign of King Charles the Second* (London, 1821), p. 330.
8 T. Mowl and B. Earnshaw, *Architecture without Kings: The Rise of Puritan Classicism under Cromwell* (Manchester, 1995), pp. 205–24; David Howarth, 'Charles I, Sculpture and Sculptors', in MacGregor, *The Late King's Goods*, pp. 106–7; The Parish of St Margaret, Westminster, II, *The Survey of London*, XIII (1930), pp. 90–91
9 This account is based on the following: David Jacques, Arend Jan van der Horst et al., *The Gardens of William and Mary* (London, 1988), pp. 18–22; David Jacques unpublished 'Royal Parks Historical Survey, Hampton Court and Bushy Park', 3 vols., I (The Royal Parks 1982), pp. 18–24; Julian Mumby, 'Signor Verrio and Monsieur Beaumont, Gardeners to King James II', *Journal of the British Archaeological Association*, CXLIX (1996), pp. 55–71. Additional material not covered in these accounts is footnoted separately.
10 PRO LC5/132; PRO E351/3243; PRO Work 5/2 ff. 290r, 299r; Work 5/33 f. 217r.
11 PRO LC5/132 p. 79; PRO Work 5/13 f. 278v.
12 PRO AO1/2481/292; Stephen Switzer, *The Nobleman, Gentleman and Gardener's Recreation* (London, 1715), p. 75.
13 *The Diary of John Evelyn*, ed. E. S. De Beer, 6 vols (Oxford, 1955), III, p. 324; Maurice Exwood and H. L. Lehmann, trans. and eds, 'The Journal of William Schellinks: Travels in England, 1661–1663', *Camden Society*, 5th ser., I (1993), p. 87.
14 PRO Work 5/11 ff. 378r–480r; Work 5/15 f. 286v; Work 5/23 f. 285v; Work 5/25 f. 364r.
15 PRO Work 5/19 f. 268r; Work 5/30 f. 292r; Work 5/35 f. 180.
16 PRO Work 5/27 f. 250v; Work 5/27 f. 297r.
17 Sir John Soane's Museum, MS Court Orders Sir Christopher Wren 1671 ff. 97r–99r; *Wren Society*, XVIII, pp. 62.
18 David Jacques, 'The Grand Manner: Changing Style in Garden Design, 1660–1735', unpublished PhD thesis (University of London, 1998), pp. 125–9.
19 Mumby, 'Signor Verrio and Monsieur Beaumont, Gardeners to King James II', pp. 55–71.
20 PRO AO1/2482/293.
21 John Dixon Hunt and Erik de Jong, 'The Anglo-Dutch Garden in the Age of William and Mary', *Garden History*, VIII, nos 2, 3 (1988), pp. 28–32, 77–83.
22 Thanks to ten years of intensive research and a number of good publications the material for the William and Mary gardens is well known. Much of this work was undertaken while I was Curator of the Historic Royal Palaces and some of it was commissioned by me then. The William III section is therefore based on the following secondary sources; where additional material has been used I footnote it separately. S. Thurley, ed., *The King's Privy Garden at Hampton Court Palace 1689–1995* (London, Apollo, 1995); 'A Strategy for the Park and Gardens at Hampton Court Palace', unpublished document in Historic Royal Palaces archive at Hampton Court, summarised in D. Jacques, 'A Strategy for the Park and Gardens at Hampton Court Palace', *London Gardener*, II (1996–7), pp. 43–55; Jacques and van der Horst et al., *The Gardens of William and Mary*; Jacques, 'Royal Parks Historical Survey', I, pp. 25–42. See also *HKW*, v, pp. 170–74; S. Thurley, 'William III's Privy Garden', *History Today*, XLVII (v) (May 1997), pp. 62–3.
23 Jacques, 'The Grand Manner', pp. 29–31.
24 Arthur Lane, 'Daniel Marot: Designer of Delft Vases and Gardens at Hampton Court', *Connoisseur*, CXXIII (1949), p. 24.
25 The date, apparently, is not in his handwriting.
26 Gervase Jackson-Stops, 'English Baroque Ironwork', *Country Life* (28 January 1971), pp. 182–5.
27 Called the Melon Ground because it was set out with hot beds, i.e. beds filled with rotting manure that gently heated glass frames within which tender plants like melons could be grown.
28 *Cal. Treasury Books*, IX (1689–92), p. 1592; *Wren Society*, VI, pl. XI.
29 PRO LS13/172, 25 January 1682–3. *Cal.*

Treasury Books, XVI (1700–01), p. 110; *Cal. Treasury Books*, XVII (1702), p. 886. See also John Cornforth, 'Who Used the Front Door?', *Country Life* (7 December 2000), pp. 116–21; Jacques, 'The Grand Manner', pp. 55–7.
30. Jacques, 'The Grand Manner', p. 26.
31. Stephen Switzer, *The Nobleman, Gentleman and Gardener's Recreation* (London, 1715), pp. 57–8.
32. David Green, *Gardener to Queen Anne: Henry Wise (1653–1738) and the Formal Garden* (Oxford, 1956), p. 54.
33. PRO T1/71.35.
34. Jane Roberts, *Royal Landscape: The Gardens and Parks of Windsor* (New Haven and London, 1997), pp. 175–83. Another version of the plan is at Hovingham Hall, MS Vd f. 39. This drawing is attributed to Charles Bridgeman.
35. PRO T1/67.39. For the above paragraphs also see David Green, *Henry Wise*, pp. 59–65.
36. They are All Souls IV. 12, 13.
37. PRO T1/75.6.
38. For other statues commissioned for the gardens see Dixon Hunt and de Jong, 'The Anglo Dutch Garden', pp. 219–20.
39. All Souls IV.1.
40. Dixon Hunt and de Jong, 'The Anglo-Dutch Garden' p. 253, no. 103.
41. Jacques, 'The Grand Manner', pp. 22–3.
42. Jane Roberts suggests that one of Wise's draughtsmen may have been Tilleman Robart (*Royal Landscape*, p. 538, n. 70).
43. Also, not illustrated, are All Souls IV. 13, 15, 16.
44. His specification and estimate is PRO T1/81.37.
45. Work 6/3 f. 7.
46. See Jacques, 'The Grand Manner', pp. 188–192.
47. PRO AO1/2447/141; PRO Work 5/53 f. 444r; AO1/2448/147.
48. PRO T1/126 f. 21a, including the map.
49. BL Add. MS 20101 f. 71r, v; PRO Work 5/53 f. 292r.
50. *Cal. Treasury Books*, XVIII (1703), p. 76; The drawing is PRO Work 34/311. PRO T1/159.42 explains Wise's role in surveying and draughtsmanship: 'For making severall Surveys & Draughts of Her Majesty's Palaces, Gardens, Parks & Plantacions, Mr. Wise never had or craved anything, tho' he has kept one man Constantly in pay, & sometimes more for that every purpose, & he can instance Allowance both of Salary from the Crown for that service, & of Bills for Paper, Colours &c.'
51. PRO Work 6/14 p. 150; PRO AO1/2447/141; PRO T1/107.3. It should be noted that the turf in the Fountain Garden was dead by 1707 due to three summers' severe drought.
52. PRO Work 6/5 pp. 82, 94; PRO LC5/155 p. 55v. PRO T1/126 f.21a includes a plan and details for the canal scheme.
53. The plans are All Souls IV.15, 16. For the preceding paragraphs see also Green, *Henry Wise*, pp. 66–72.
54. PRO T1/179A no. 5.
55. AO1/2448/147; PRO Work 5/56 p. 41; Work 5/56 p. 41. *Cal. Treasury Papers* (1708–14), p. 616; David Jacques, 'The Grand Manner', pp. 129–31, and Jacques and van der Horst, *The Gardens of William and Mary*, pp. 163–6, although Jacques erroneously attributes the maze to William III.
56. The original survey is PRO Work 32/313A; a fair copy of this is Work 32/313B and the presentation copy is Soane Museum vol. 36 (3), no. 1. To these is related a fourth map, probably also in Bridgeman's hand, apparently unfinished (Bodleian Library MS Gough Drawings a.4 f. 62r). It is likely that Work 32/313A&B were part of the collection of drawings sold to the Office of Works in March 1742/3 by Bridgeman's widow (Work 4/8 15 March 1742/3).

Chapter 13

1. The history of the royal court has been written for the period covered by this chapter and the previous one. George I's court is covered in John M. Beattie, *The English Court in the Reign of George I* (Cambridge, 1967). This will be referred to as Beattie in the notes to this chapter. Ragnhild Hatton, *George I: Elector and King* (London, 1978), pp. 134, 206; PRO LC5/158 8 April 1726; LC5/157 f. 36v; C. R. Grundy, 'Documents Relating to an Action brought against Joseph Goupy in 1738', *Walpole Society*, IX (1921), pp. 77, 80.
2. Hatton, *George I*, pp. 128–9.
3. This is an important development in the spectrum of evidence available for the history of the palace. The minute books are in PRO Work 4/1–12 and cover the period 1715–61.
4. *HKW*, pp. 47–53.
5. John, Lord Hervey, *Some Materials towards Memoirs of the Reign of George II*, ed. R. R. Sedgewick, 3 vols (London, 1931), I, p. 66.
6. PRO T54/22 p. 369; PRO Work 6/6 p. 30. The drawings are All Souls IV. 6–9.
7. A. Führer, *Residenz Ansbach* (Munich, 1984), pp. 53–7; H. Brunner, G. Hojer and L. Seelig, eds, *Residence Munich* (Munich, 1991), pp. 54–5; Hugh Murray Baillie, 'Etiquette and the Planning of State Apartments in Baroque Palaces', *Archaeologia*, CI (1967), pp. 193–8.
8. George Knox, 'Sebastiano Ricci at Burlington House: A Venetian Decoration "alla Romana"', *Burlington Magazine*, CXXVII (September 1985), pp. 601–10; Benedict Nicholson, 'Sebastiano Ricci and Lord Burlington', *Burlington Magazine*, CV (March 1963), pp. 121–5.
9. William Aglionby, *Painting Illustrated* (London, 1685), p. xiv.
10. Carol Gibson-Wood, 'The Political Background to Thornhill's Paintings in St Pauls Cathedral', *Journal of the Warburg and Courtauld Institutes*, LVI (1993), pp. 229–37; Horace Walpole, *Anecdotes of Painting*, with additions by J. Dallaway and notes by R. A. Wornum, 3 vols (London, 1862), II, pp. 664–5.
11. *Cal. Treasury Books*, XXIX (1714–15), pp. 760, 816; PRO Work 6/6 p. 87.
12. PRO Work 6/6 p. 106; *Cal. Treasury Papers*, CXCII (1714–19), p. 147.
13. For Gumley and Moore's extensive work for the royal family see Ralph Edwards and Margaret Jourdain, *Georgian Cabinet-makers c.1700–1800* (London, 1955), pp. 39–44.
14. The warrant is in PRO LC5/72 f. 32 and LC5/89 ff.39. The account for the bed is in LC5/45 ff. 307, 313. Vouchers for the curtains and bed are in LC9/390 ff. 31, 38v. Gumley and Moore's bill is in LC9/379 no. 66. For the tapestries see PRO LC9/390 f. 36v. For the paintings see G. Bickham, *Deliciae Brittanicae* (London, 1742), p. 100; Vertue Note Books, I, *Walpole Society*, XVIII (1929–30), p. 158; and for identifications (which are mine) see O. Millar, *The Tudor, Stuart and Early Georgian Pictures in the Collection of Her Majesty the Queen* (London, 1963), cat. nos 103, 105, 121, 142.
15. The warrants are in PRO LC5/45 ff. 307, 313, 319; LC5/72 f. 32; LC5/89 f. 39; LC5/156 ff. 109, 128, 298; LC5/127 no. 50. The vouchers are in LC9/390 (first bundle) ff. 31, 38v.
16. The warrants are in PRO LC5/45 ff. 307, 313, 319, 322; LC5/156 ff. 109, 128; LC5/127 nos 50, 63; LC5/72 f.32; LC5/89 f. 39. The vouchers are in LC9/390 ff. 31, 36v, 38v. Gumley and Moore's bill is in LC9/379 no. 66. For the tapestries see PRO LC9/390 f. 36v. For the paintings see Bickham, *Deliciae Brittanicae*, p. 104; and for identifications (which are mine) see Millar, *The Tudor, Stuart and Early Georgian Pictures in the Collection of Her Majesty the Queen*, cat. nos 91, 116, 122.
17. The day after the prince left Hampton Court in the autumn of 1716 the rooms were referred to as 'The Prince of Wales Apartment, now her grace the Duchess of Munster's below stairs' (PRO LC5/89 f. 29).
18. PRO Work 4/1 pp. 13, 18; *Cal. Treasury Books*, XXIX (1714–15), p. 555; PRO Work 6/6 pp. 67, 68; PRO LC9/379 nos 66, 96; PRO LC5/127 no. 50.
19. PRO AO1/2449/149; PRO Work 4/1 p. 45; PRO LC5/156 f.109; *Cal. Treasury Books*, XXIX (1714–15), pp. 455, 528; PRO LC5/45 p. 295.
20. PRO LC5/156 f. 109; LC5/45 p. 322; PRO Work 4/1 p. 57; *Cal. Treasury Books*, XXIX (1714–15), p. 763. For the picture hang in

21 *The Diary of Dudley Ryder 1715–1716*, ed. William Matthews (London, 1939), pp. 298, 310. Nowhere is it made clear where they dined, but it is likely to have been in the music room, today called the Public Dining Room.

22 Letters from Walpole to Stanhope in William Coxe, *Memoirs of the Life and Administration of Sir Robert Walpole 1700–1745* (London, 1798), pp. 61, 64.

23 *The London Gazette*, 23 August, 13, 17, 20, 29 September, 7, 22, 25 October 1716.

24 *Diary of Lady Cowper*, ed. Spencer Cooper (London, 1864), pp. 123–6.

25 PRO Work 4/1 15 December 1716; *Cal. Treasury Books*, XXX (1716), p. 520; Work 6/6 f. 208; PRO LC5/156 f. 169.

26 Francis Thompson, *A History of Chatsworth* (London, Country Life, 1949), pp. 127–8. The research on bathing undertaken for the restoration of 1995 is summarised in Joanna Marschner, 'Baths and Bathing at the Early Georgian Court', *Furniture History*, XXXI (1995), pp. 23–8.

27 PRO Work 4/1, p. 161; *Cal. Treasury Books*, XXX (1716), p. 361; PRO Work 6/6 p. 129.

28 PRO Work 5/157 f.60; *Cal. Treasury Books*, XXX (1716), p. 372; PRO LC5/2 f. 69.

29 Bickham, *Deliciae Britannicae*, pp. 107–14, 119; C. White, *Dutch Pictures in the Collection of Her Majesty the Queen* (Cambridge, 1992), cat. nos 218–29; Millar, *The Tudor, Stuart and Early Georgian Pictures in the Collection of Her Majesty the Queen*, pp. 25, 142, 152.

30 Investigation of this room in 1995 revealed the precise configuration of the mezzanine and stair. Plans are in archive at Hampton Court.

31 PRO LC5/89 p. 20; LC5/45 p. 346; *Cal. Treasury Books*, XXX (1716), p. 386; PRO Work 6/6 p. 127.

32 These were prepared in July 1716 and are Royal Library 19449 and 19447.

33 The drawings are Royal Library 19447 and 19449. Paul-Emile Schazmann, *The Bentincks* (London, 1976), pp. 127–8.

34 The plans prepared in late 1716 are Royal Library 19450 and 19451.

35 PRO LC9/382 no. 36; *HMC*, 12th report, appendix iii (1889), pp. 114–15, 185; *Cal. Treasury Books*, XXX (1716), p. 609. The shadows of the balconies can still be seen on the window reveals of the Drawing Room.

36 PRO Work 4/1 31 May 1717.

37 Quoted in Beattie (p. 264) from a manuscript at Chatsworth.

38 Abel Boyer, *The Political State of Great Britain*, 60 vols (London, 1717), XIV, pp. 349–52; *HMC, Polwarth*, I (1911), pp. 320–21; *Cal. Treasury Books*, XXXI (1717), pp. 171, 499.

39 David Nichol Smith, ed., *The Letters of Thomas Burnet to George Duckett (1712–1722)* (Oxford, 1914), pp. 139–41. See also *HMC, Portland*, V (1899), p. 568.

40 *HMC, Portland*, V (1899), pp. 536–8; PRO LC5/72 f.88; BL Add. MS 17677 KKK2.

41 Boyer, *The Political State of Great Britain*, XIV, pp. 349–52; *HMC, Polwarth*, I (1911), pp. 320–21; Hatton, *George I*, p. 204; *Cal. Treasury Books*, XXXI (1717), pp. 651–2; PRO LC5/72 p. 35; *Cal. Treasury Books*, XXXII (1718), p. 675; PRO T56/18 pp. 53, 165. For details see warrants for summer 1717 in PRO LC5/157.

42 Abel Boyer, *The Political State of Great Britain*, XIV, pp. 83–4; Beattie p. 264, quoting a manuscript at Chatsworth; John Murray Graham, ed., *The Stair Annals. Annals and Correspondence of the Viscount and the First and Second Earls of Stair*, 2 vols (London, 1875), II, pp. 25, 28.

43 PRO AO1/2449/151; *Diary of Lady Cowper*, p. 19; Hatton, *George I*, pp. 204–6; Beattie, p. 268.

44 *The Complete Works of Sir John Vanbrugh*, ed. B. Dobrée and G. Webb, 4 vols (London, 1928), IV, pp. 70, 73, 77.

45 PRO Work 4/1 6 March 1716; G. Beard, *Craftsmen and Interior Decoration in England 1660–1820* (Edinburgh, 1981), p. 290; K. Downes, *Vanbrugh* (London, 1977), p. 195; Hawksmoor also used such brackets at, for instance, All Souls, Oxford, and St Alfege, Greenwich.

46 PRO AO1/2449/152. A scaffold was provided for masons in the Guard Chamber (PRO AO1/2449/152). See also Howard Colvin, 'Herms, Terms and Caryatids in English Architecture', in H. M. Colvin, *Essays in English Architectural History* (New Haven and London, 1999), pp. 124–6. Information on the painted schemes for both rooms comes from a report prepared by Catharine Hassell of UCL in 1993 and an analysis and commentary on her results by Ian Bristow. Both are in archive at Hampton Court.

47 PRO Work 6/7 f. 52. More furniture was ordered in 1731 (PRO LC5/73 f. 73). LC9/286 f. 39; LC5/47 f. 14; LC9/288 f. 168.

48 *The Complete Works of Sir John Vanbrugh*, IV, p. 154.

49 PRO Work 4/1 18 April 1716; *Cal. Treasury Books*, XXXI (1717), p. 273; Work 4/1 6 March 1716.

50 PRO Work 4/1 7 February 1716; PRO AO1/2449/152; Work 4/1 10 April 1717; Kerry Downes, 'The Kings Weston Book of Drawings', *Architectural History*, X (1967), cat. no. 126, fig. 63.

51 PRO Work 4/1 21 June 1717; *Cal. Treasury Books*, XXXI (1717), p. 273; Work 6/6 p. 232; PRO AO1/2449/152. Three arches were also made at the bottom of the stairs to the princesses' lodgings to give light to the passage below. PRO Work 4/1 6 March 1716.

52 Beattie, pp. 266–75.

53 The list which includes a huge number of small items is in *Cal. Treasury Books*, XXXI (1717), pp. 574–5.

54 Downes, *Vanbrugh*, pp. 88–90; K. Downes, *English Baroque Architecture* (London, 1966), pp. 48–9; *HKW*, V, pp. 195, 239. The St James's schemes have been confused in the past. There are two groups of drawings: three drawings annotated by Vanbrugh in English, two of which have matching scales (Royal Library 26299–26301); and two annotated in French, which have matching scales distinct from the English group (Royal Library 262302–3). The English set are dated 1712; the French set mention the king and so must date from the first part of George's reign.

55 They are: two accurate sketch survey plans of the State Apartments quadrangle at ground- and first-floor levels (PRO Work 34/33–4); a survey plan of the half storey on the east front (Work 34/35); a survey plan of the third floor of the State Apartment quadrangle dated 1717 (Work 34/41); a sketchier survey plan of the principal floor with pencil annotations dated 1717 (Work 34/37); a block plan of the whole palace showing drainage (Work 34/47); a large coloured presentation plan showing the whole scheme (fig. 248) (Work 34/32). Additionally there are two further plans in the same hand, which may form part of the set. They are PRO Work 34/38, which is a plan of the principal floor of the State Apartments but with a title in a different hand (although the scale is the same as the others), and PRO Work 34/51, a survey of the north-west corner of Chapel Court. This is annotated by the same hand as Work 34/38, but has a different scale from the others.

56 Several of these also have the fleur-de-lis scale so characteristic of the Hampton Court set and possess the characteristic 5s and 6s. The handwriting labelling three of the plans might conceivably be Vanbrugh's. Several of the Elton Hall drawings although not drawn by him are titled in his hand.

57 *BDBA*, pp. 565–6; H. Colvin and Maurice Craig, eds, 'Architectural Drawings in the Library of Elton Hall by Sir John Vanbrugh and Sir Edward Lovett Pearce' (Oxford, The Roxburghe Club, 1964), p. xxxiv, Pls xiiib, xv, xvii, xvxvi.

58 Downes, *Vanbrugh*, pp. 114–18; Kerry Downes, *Sir John Vanbrugh: A Biography* (London, 1987), pp. 451–6.

59 The most recent work on Benson is Anna Eavis, 'The Avarice and Ambition of William Benson', *Georgian Group Journal*, XII (2002), pp. 8–37.

60 *HKW*, V, pp. 57–60. One of Campbell's examples of malpractice involved a number of accusations against Thomas Fort, including a claim that he had built a

60 house for himself at royal expense and that he was sub-letting one of the pavilions without authority. *Cal. Treasury Papers* (1714–19), p. 416.
61 See H. M. Colvin's notes on the Benson-Campbell conspiracy theory in *BDBA*, pp. 122–3.
62 BL Add MS 47028 f. 250r.
63 John Cloake, *The Palaces and Parks of Richmond and Kew*, 2 vols (Chichester, 1996), pp. 31–2.
64 *HMC*, 12th report, appendix iii (1889), p. 186.
65 *Cal. Treasury Books*, XXXII (1718), pp. 295, 471; PRO Work 6/7 p. 55. PRO AO1/2449/152.
66 PRO Work 4/1 11 September 1718; PRO AO1/2449/153; *Cal. Treasury Books*, XXXII (1718), p. 628; Richard Southeren, *Changeable Scenery: Its Origin and Development in the British Theatre* (London, 1952), pp. 177–9; Colley Cibber, *An Apology for the Life of Mr Colley Cibber* (London, 1740), pp. 446–7, 453–6. The other plays were *Sir Courtly Nice*, *The Constant Couple*, *Love for Money*, *Volpone* and *Rule a Wife and Have a Wife*; John Grundy, *The Stranger's Guide to Hampton Court* (London, 1865), p. 87.
67 PRO Work 4/1 4 November 1719. For theatres see Downes, *Vanbrugh*, pp. 40–44, 89.
68 PRO LC5/89 26 September, 12 October 1718; LC5/157 f. 88v.
69 *Cal. Treasury Books*, XXXI (1717), p. 442.
70 Howard E. Stutchbury, *The Architecture of Colen Campbell* (Harvard, 1967), pp. 25–6.
71 J. Harris, *Catalogue of the Drawings Collection of the RIBA, Colen Campbell* (London, 1973), fig. 37. Campbell built another free-standing kitchen for the Duke of Richmond in 1724 of which there is no record (T. P. Connor, 'Colen Campbell as Architect to the Prince of Wales', *Architectural History*, XXII (1979), p. 67).
72 Beattie, pp. 84–7, 259; *Cal. Treasury Books*, XXXI (1717), p. 574.
73 *Cal. Treasury Books*, XXXI (1717), pp. 273–4; Beattie, pp. 88–9, 91, 183; PRO T56/18 p. 124; PRO Work 19/13 pp. 1–2, fig. 309.
74 See for instance PRO LS1/59; LS1/61; LC5/109, fig. 309. 19 July 1716, 17 July 1717; LC5/157 17 July, 2 August 1717; *Cal. Treasury Books*, XXXII (1718), p. 678.
75 PRO Work 6/7 pp. 53–4. This appears wrongly as a work at St James's in *Cal. Treasury Books*, XXXI (1717), p. 574.
76 PRO Work 4/2 f. 25v.
77 PRO LC5/158.
78 PRO Work 4/2 p. 168. The overall survey of the palace may be Soane Museum vol. III.41, or conceivably the crude plan, vol. 36/3/2 titled on the reverse 'plan of basement story'. The plan of the attic storey is almost certainly Soane Museum vol. 36/3/4, and the plan of the principal floor with annotations Soane Museum vol. 36/3/3.
79 *Cal. Treasury Books*, XXVI (1712), p. 438; *Cal. Treasury Papers* (1714–19), p. 473; PRO LC5/152 11, 17 July 1717; PRO AO1/2449/151; PRO Work 6/7 p. 88, 89, 91; Work 4/3 p. 7; *HKW*, V, pp. 459–60; Hatton, *George I*, p. 134.
80 R. Blanchard, ed., *The Correspondence of Richard Steele* (Oxford, 1941), p. 106; PRO Work 6/7 p. 315. Some, apparently minor, repairs were undertaken at the mews in 1718 (PRO AO1/1449/152).
81 Beattie, pp. 98–105; *Cal. Treasury Books*, XXX (1716), pp. 170, 208, 308. The Duke of Somerset had the right to the hay from the park and Marshall had to buy hay in for the horses in the winter (*Cal. Treasury Papers* (1720–28), p. 326).
82 J. P. Hore, *The History of the Royal Buckhounds* (Newmarket, 1893), pp. 252–62; PRO Work 6/7 p. 315.
83 PRO LC5/160 26 October 1727.

Chapter 14

1 PRO Work 4/10 15 July 1751; *HKW*, V, p. 475; J. M. Beattie, *The English Court in the Reign of George I* (Cambridge, 1967), pp. 141, 179–80; J. C. Sainty and R. O. Bucholz, *Officials of the Royal Household 1660–1837*, 2 vols (London, Institute of Historical Research, 1997–8), II, pp. 36, 38.
2 *Mist's Weekly Journal*, 6 July 1728; *Read's Weekly Journal*, 7 May 1737; John, Lord Hervey, *Memoirs of the Reign of George the Second from his Accession to the Death of Queen Caroline*, ed. J. W. Croker, 3 vols (London, 1884), I, p. 266; *Cal. Treasury Books and Papers* (1731–4), pp. 68, 394.
3 *Letters of Rachel, Lady Russell*, 2 vols (London, 1853), II, p. 213; *Mist's Weekly Journal*, 20 July 1728.
4 *Memoirs of Charles-Lewis, Baron Pollnitz*, 2 vols (London, 1739), II, p. 449.
5 Ibid.; Hervey, *Memoirs*, I, pp. 280–81, 195; II, pp. 78, 226; III, pp. 52, 156.
6 *The London Gazette*, 25 July, 15 August, 28 August, 31 August, 5 September 1728.
7 Hervey, *Memoirs*, I, p. 298; II, pp. 46, 75–6, 148, 218, 231, 290; III, pp. 227, 313–14; *The Letter Books of John Hervey, First Earl of Bristol*, ed. S. H. A. Harvey, 3 vols (Wells, 1894), III, p. 37.
8 M. M. Reese, *The Royal Office of Master of the Horse* (London, 1976), pp. 209–11; J. P. Hore, *History of the Royal Buckhounds* (Newmarket, 1893), pp. 268–371; J. W. Croker, ed., *Letters to and from Henrietta, Countess of Suffolk, and her Second Husband, the Hon. George Berkeley*, 2 vols (London, 1824), II, pp. 375–7; Lord Ribblesdale, *The Queen's Hounds and Stag-Hunting Recollections* (London, 1897), pp. 28–9; *Cal. Treasury Books and Papers* (1731–4), p. 510.
9 Croker, *Letters to and from Henrietta, Countess of Suffolk* (London, 1824), I, pp. 320–23.
10 *Memoirs of Viscountess Sundon*, ed. Mrs Thompson, 2 vols (London, 1847), II, pp. 231, 156.
11 Hervey, *Memoirs*, II, pp. 221–4.
12 *HMC, Egmont*, I, p. 466, II, p. 190.
13 Lists of deliveries to Hampton Court specifying the supplier is in LC5/90.
14 All recorded in minute detail in PRO T56/18 pp. 354–83 and PRO LC5/89 ff. 113–31. The bills are in LC9/9 nos 53–123; LC9/10, 4, 13, 17, 49, 54, 55, 82, 85. A useful summary broken down by tradesmen is in LC5/90.
15 Payments are in PRO LC5/19 July, August, September and November, and LC5/20 December.
16 A photograph of another view by Lens from Molesey is in the Mellon Centre. The view is dated 24 June 1731. This particular vantage point was a popular one. A similar view was painted by Thornhill from the roof of the Toye Inn in July 1730. His watercolour is in the Victoria and Albert Museum.
17 PRO LC5/3 (Cottrell Dormer note books) ff. 118v–119r. For another account see Hore, *History of the Royal Buckhounds*, pp. 283–4.
18 Colley Cibber, *An Apology for the Life of Mr Colley Cibber* (London, 1740), p. 457; PRO LC5/3 (Cottrell Dormer note books) f. 119v.
19 PRO LC5/89 f. 114; *Cal. Treasury Books and Papers* (1731–4), p. 54; PRO LC5/18 20 January 1729; David Baldwin, *The Chapel Royal Ancient and Modern* (London, 1990), pp. 266–7; *Reminiscences Written by Mr Horace Walpole in 1788 for the Amusement of Miss Mary and Miss Agnes Berry*, ed. P. Toynbee (Oxford, 1924), p. 73.
20 Rex Whitworth, *William Augustus, Duke of Cumberland: A Life* (London, 1992), pp. 11–12, 16.
21 PRO Work 4/1 unpaginated but at 14 October 1718. The plan is PRO Work 34/33. The key plan shows those parts in good repair as yellow, those in bad repair as red, and the ruinous parts as dark brown.
22 PRO Work 4/2, July 1721; Work 4/3 p. 19; Work 4/5 pp. 7, 10, 12; *Cal. Treasury Books and Papers* (1731–4), pp. 232, 286.
23 Horace Walpole, *Anecdotes of Painting*, with additions by J. Dallaway and notes by R. A. Wornum, 3 vols (London, 1862), II, pp. 563–4. An article in *Fraser's Magazine* of August 1846 (p. 179) states (without giving a source) that Kent's proposal was to throw a colonnade across the court to match Wren's.
24 The designs are in Wimbledon Public Library, the Minet Library in Lambeth and the Victoria and Albert Museum. They are published in part in John Harris, 'A William Kent Discovery: Designs for Esher Place, Surrey', *Country Life* (14 May 1959), pp. 1076–8; John Harris, 'Esher Place,

Surrey', *Country Life* (2 April 1987), pp. 94–7; and more fully in John Harris, 'William Kent and Esher Place', in Gervase Jackson-Stops, ed., *The Fashioning and Functioning of the British Country House* (Washington, National Gallery of Art, 1989), pp. 13–26. A full catalogue setting the designs in a wider landscape context is in John Dixon Hunt, *William Kent, Landscape Garden Designer: An Assessment and Catalogue of his Designs* (London, 1987), pp. 55–8, cat. no. 62.

25 PRO Work 4/10 3 January, 12 December.
26 Juliet Allan, 'New Light on William Kent at Hampton Court', *Architectural History*, XXVII (1984), pp. 50–58.
27 PRO LC5/161 10 July 1744.
28 For Vardy and his interest in the gothic, see Roger White, 'John Vardy, 1718–65: Palladian into Rococo', in Roderick Brown, ed., *The Architectural Outsiders* (London, 1985), pp. 63–81.
29 PRO Work 4/1 p. 65.
30 Peter Smith, 'Lady Oxford's Alterations at Welbeck Abbey, 1741–55', *Georgian Group Journal*, XI (2001), pp. 148–51; PRO Work 4/5 p. 13.
31 O. Miller, *The Tudor, Stuart and Early Georgian Pictures in the Collection of Her Majesty the Queen*, 2 vols (London, 1963), I, pp. 174–5.
32 PRO Work 5/49 ff. 324, 330; Work 5/50 ff. 261, 265, 273, 302; Work 5/51 ff. 365, 377, 399, 349, 367; Work 5/52 September 1701, January 1701/2, February 1701/2. On Japan varnish see Ian Bristow, *Architectural Colour in British Interiors 1615–1840* (New Haven and London, 1996), pp. 26, 47, 50.
33 *Memoirs of Viscountess Sundon*, II, pp. 54–5.
34 PRO Work 6/16 f. 19r.
35 PRO Work 6/14 p. 13
36 Although at Hampton Court this culminated in a dome.
37 The Honthorst was restored by John Kent at a cost of £45 in April 1733 (PRO LC5/19). J. Richard Judson, *Gerrit van Honthorst: A Discussion of his Place in Dutch Art* (The Hague, 1959), p. 182; Vertue Note Books, III, *Walpole Society*, XXII (1933–4), p. 76.
38 Vertue Note Books, III, *Walpole Society*, XXII (1933–4), p. 140. Walpole, *Anecdotes of Painting*, II, p. 564. See also Margaret Jourdain, *The Work of William Kent, Artist, Painter and Landscape Designer* (London, 1948), pp. 61–4, 69–73.
39 PRO T56/19 pp. 89–93; T56/18 p. 365; PRO LC9/9 no. 78.
40 It is not clear what was done in the Tennis Court Rooms, although the large sum of £1,358 5s was spent 'carcassing the new building over the princess apartment' and taking brickwork down there. Fort attended the Board with the heights of the apartment (PRO Work 4/7 p. 1, 3; Hervey, *Memoirs*, II, p. 218).
41 George Bickham, *Deliciae Britannicae; or, the Curiosities of Hampton-Court and Windsor-Castle* (London 1742), pp. 60–81. Bickham wrongly states that the tapestries were hung in George I's reign. The tapestries may be those mentioned in the earl's sale catalogue, *A Catalogue of the Rich Furniture of the Right Honourable the Earl of Cadogan . . . etc.*, p. 11; Tom Campbell, 'Report on the Tapestries Hung in the Hampton Court State Apartments in the First Half of the Eighteenth Century', MS in archive at Hampton Court. PRO LC5/127 July 1716. One of the twenty-four stools provided for the drawing room was sold by Mallett in 2001; see *Mallett, English and Continental Antique Furniture, Objets d'Art, Paintings and Watercolours* (London, 2001), pp. 10–11.
42 PRO T56/19 pp. 89–97. The bills are in PRO LC9/11 nos 46, 48, 49, 55, 57, 58, 61, 62, 64, 81, 82, 83, 84. See also LC5/48 for further details. Duplicate sets of these accounts, some of which add further details, are in the Royal Archives at Windsor.
43 John Hardy, 'The English Furniture', and Tessa Murdoch, 'The Patronage of the Montagus', in Tessa Murdoch, ed., *Boughton House: The English Versailles* (London, 1992), pp. 36–8, 134–5.
44 Geoffrey Beard, 'William Kent and the Cabinet-Makers', *Burlington Magazine*, CXVII (December 1975), pp. 867–71; Christopher Gilbert, 'James Moore the Younger and William Kent at Sherborne House', *Burlington Magazine* (March 1969), pp. 148–9; G. Beard and C. Gilbert, eds, *Dictionary of English Furniture Makers 1660–1840* (Furniture History Society, 1986), p. 980.
45 The official version of the story is told in the *London Gazette* for 1 August 1737; Lord Hervey's version gives more colour (Hervey, *Memoirs*, III, pp. 164–81).
46 See *London Gazette*, 4, 22, 26 August and 11 October 1737.
47 *HKW*, V, pp. 218–21.
48 PRO LS9/161, 8 July 1749.
49 PRO T56/18 pp. 349–50; T56/19 p. 227; PRO LC9/13 no. 59; LC9/13 nos 18, 19. Furniture was also removed from Windsor and sent to Hampton Court (LC 9/13 no. 37).
50 PRO Work 4/8; Work 6/17 f. 140v; Work 4/11, Work 1/1 18 March 1755.
51 *Cal. Treasury Books*, XXXI (1717), pp. 251–2; 293; PRO Work 4/3 3 November 1726; *Gentleman's Magazine* (August 1742), p. 444; *Cal. Treasury Books and Papers* (1742–5), p. 132. Another Mr Tilson, George, was later a preacher at Hampton Court and had a house there. PRO Work 4/12 p. 7 and *Cal. Treasury Books and Papers* (1739–41), p. 395.
52 PRO Work 6/17 f. 45r; Work 4/10 24 May and 7 June; PRO T56/19 p. 272. The bills are in PRO LC9/14. Those for 1747–8 are nos 40, 42, 43, 46, 47, 72, and those for 1748–9 are nos 47, 48, 49. For other maintenance accounts see PRO LC9/17 nos 4, 22, 34; LC9/18 no. 17.
53 Letters by Amelia from Hampton Court describing her life there can be found in BL Eg. 1710, pp. 1, 16, 18. A chronological list of the Keepers and Palers of Hampton Court Park is in Work 16/151 p. 1. The position was abolished in 1869.
54 Bickham, *Deliciae Britannicae*, pp. iii, 31.
55 PRO LC5/158 June 1723; LC5/160 February 1729; C. R. Grundy, 'Documents Relating to an Action Brought against Joseph Goupy in 1738'. *Walpole Society*, IX (1920–21), pp. 79–80.
56 *Cal. Treasury Books*, XXXII (1718), p. 573; *Cal. Treasury Books and Papers* (1731–4), p. 53; PRO WO51/129 pp. 139–41.
57 *Law*, pp. 286–7; R. G. M. Baker, 'A History of the Thames Bridges Between Hampton Court and East Molesey', *Surrey Archaeological Collections*, LVIII (1961), pp. 79–86; Geoff Potter, 'The First Hampton Court Bridge', *Transactions of the London and Middlesex Archaeological Society*, XLVIII (1997), pp. 169–72.
58 PRO Work 4/8 31 August 1742, 10 August 1743.

Chapter 15

1 J. H. Jesse, *Memoirs of the Life and Reign of King George the Third*, 3 vols (London, 1867), I, pp. 10–11; *The Letters and Journals of Lady Mary Coke*, ed. J. A. Home, 4 vols (Edinburgh, 1889–96), III, pp. 242, 244.
2 *The Letters and Journals of Lady Mary Coke*, II, pp. 69, 285; *The Correspondence of George Prince of Wales, 1770–1812*, ed. A. Aspinall, 8 vols (London, 1963–71), III, p. 142; PRO Work 5/83, Midsummer quarter 1794; *The Later Correspondence of George III*, ed. A. Aspinall, 5 vols (Cambridge 1962–70), I, p. 401.
3 PRO MPE1/500 and MPEE1/49.
4 PRO Work 6/20 pp. 103–6; PRO T29/53 p. 272; Work 4/15 4 March 1785 and Work 6/21 11 February 1785; *The Later Correspondence of George III*, V, p. 268.
5 PRO Work 4/15, 4 August 1775; Work 6/20 p. 2; Work 1/22 22 September 1836; Work 19/309.
6 PRO E351/3259; PRO Work 5/9 ff. 263r, 271r, 277r, 279v; Work 5/10 ff. 247r, 250v, 254r, 257r, 261r; Work 5/32 ff. 241r, 248r, 251r, 255r; Work 5/38 f. 207v; Work 4/2 f. 9r.
7 PRO Work 1/17 pp. 219, 239; Work 4/14 27 July 1770; AO1/2467/207.
8 Conveniently illustrated in John Harris, *The Architect and the British Country House 1620–1920* (New York, 1985), p. 166. It is worth noting that Milton's original architect was John Vardy to whom some of the design may be due. Vardy, as has been shown, also knew the palace and its gatehouse well.

9 *HKW*, VI, pp. 49–75, 118–19; PRO Work 6/27 ff. 219v–220r.
10 Jane Roberts, 'Sir William Chambers and George III', in J. Harris and M. Snodin, eds, *Sir William Chambers: Architect to George III* (New Haven and London, 1997), p. 45.
11 PRO Work 5/89 pp. 1–4. In 1806 the floor of the hall was relaid too, in York stone (PRO Work 5/95 Lady Day quarter).
12 Rupert Gunnis, *Dictionary of British Sculptors 1660–1851* (rev. edn, London, 1968) p. 51; Geoffrey Beard, *Craftsmen and Interior Decoration in England 1660–1820* (Edinburgh, 1981), p. 246; *HKW*, VI, pp. 139, 271, 282, 313, 274; *Gentleman's Magazine* (March 1812), p. 236.
13 RIBA DC: E3/57, 1–3 1810–29; A. C. Pugin and E. J. Willson, *Specimens of Gothic Architecture; Selected From Various Antient Edifices in England . . . etc*, 3 vols (London, 1821–3), I, pp. x–xii; II, pp. 1–8. See also the drawings of William Twopeny from 1833 (British Museum Prints and Drawings PDB27268, 27262, 27237).
14 RIBA drawings collection SC96/7 (1–11). Also see drawings by William Twopeny done in 1833 and 1841, BM 1874-2-14-576-7.
15 T. H. Clarke, *The Domestic Architecture of the Reigns of Queen Elizabeth and James I* (London, 1833), p. iii; James Dallaway, *Observations on English Architecture* (London, 1806), pp. 102–3, 191. Books such as James Hakewill's *Attempt to Determine the Exact Character of Elizabethan Architecture* (London, 1835) do not mention Hampton Court, but John Britton and Charles Boutell, *Illustrations of the Antient Domestic Architecture of England* (London, 1846), describes and illustrates a dozen of the brick chimney-stacks.
16 S. Redgrave, *A Dictionary of Artists of the English School* (London, 1878); A. Graves, *A Century of Loan Exhibitions 1813–1912*, 3 vols (1913–15, repr. Bath, 1970), II, p. 1697, no. 557 refers to *Summer Afternoon at Hampton Court* belonging to the Prince Consort. Wingfield's paintings are widely dispersed and the ownership of some cannot now be traced.
17 Clive Wainwright, *The Romantic Interior* (New Haven and London, 1989), pp. 71–107.
18 For instance: Anon., *The English Traveller*, 3 vols (London, 1746), III, p. 221; Anon., *London in Miniature* (London, 1755), pp. 296–7; Anon., *A Description of England and Wales* (London, 1769), p. 36; Nathaniel Spencer, *The Complete English Traveller* (London, 1771), pp. 317–18; Anon., *A Description of the County of Middlesex* (London, 1775), p. 192; F. Streeter, *Hampton Court: A Descriptive Poem in Three Cantos* (Rochester, 1778).
19 James Norris Brewer, *A Descriptive and Historical Account of Various Palaces and Public Buildings English and Foreign with Biographical Notices of their Founders or Builders, and Other Eminent Persons* (London, 1810), pp. 192–218; E. W. Brayley, J. Nightingale and J. Norris Brewer, *London and Middlesex*, 4 vols (London, 1810–16), IV, pp. 444–83; *Gentleman's Magazine* (January 1834), pp. 45–6; David Hughson, *London: Being an Accurate History and Description of the British Metropolis and its Neighbourhood, to Thirty Miles Extent, from an Actual Perambulation*, 6 vols (London, 1805–9), VI, pp. 476–85. To these should be added the anonymous *A Compendious Gazetteer; or, Pocket Companion to the Royal Palaces, Towns, Villages, Villas, and Remarkable Places, within Sixteen Miles of Windsor* (London, 1796) which has a large section on Hampton Court and its interiors.
20 David Watkin, *The Royal Interiors of Regency England* (London, 1984), pp. 5–6; John Cornforth, *Pyne's Royal Residences* (London, 1976), pp. 3–8, 22–3.
21 *HKW*, VI, pp. 101–55.
22 David Watkin, *Sir John Soane and Enlightenment Thought* (The Annual Soane Lecture, 7 March 1996), p. 20. The surveys can be found in PRO Work 4/21 15 April 1814; Work 1/7 23 December 1816; Work 1/9 6 May 1819, Work 19/15/1. Also Soane Museum, Private Correspondence XII.G.1.2, 1816; XII.G.1.5, 1817; XII.G.1.6, 1818; XII.G.3.2, 1822. Also Soane Museum, Journal, 6, pp. 191, 409; Soane Museum, Day Book 1819–21, p. 9; 1823–5 p. 133.
23 Pugin's engraving may, in fact, be taken from Hardwick's drawing. Hardwick's drawings are RIBA SB 58/6(2), SB 58/6(3), SD 85/6(5) in Soane Museum vol. 36/3/9; Pugin and Willson, *Specimens of Gothic Architecture*, II, Pls VII–XI.
24 M. M. Reese, *The Royal Office of the Master of the Horse* (London, 1976), pp. 262, 7; *Law*, III, pp. 334–40; *VCH, Middlesex*, II (1910), pp. 386–7; Jane Roberts, *Royal Landscape: The Gardens and Parks of Windsor* (New Haven and London, 1997), pp. 92–8. A drawing dated 1902 for the Stud Groom's house is in Work 24/1304.
25 PRO Work 6/26 ff. 37v–38r; Work 4/23 16, 17 February, 10 April, 6 August 1818; Work 1/8 1, 9 April 1818; Work 4/24 16 May, 31 July 1820; Work 1/9 11 August 1818; Work 1/10 31 July 1820; Work 19/68. See also the letter from Nash pointing out the difficulties of converting the house (Work 1/8 16, 23 February). The mews was also fitted up at minimal cost for some of his servants (Work 4/22 24 July 1816; *VCH, Middlesex*, II (1910), p. 387). *HKW*, VI, pp. 143–4, 337–8 deals with the nature of alterations to the house in some detail. See also M. Mansbridge, *John Nash: A Complete Catalogue* (Oxford, 1991), pp. 218–19. Alterations to the gardens for Breadalbane can be found in Work 1/47 15 December 1855.
26 *The Times* (4 August 1788; 28 February, 21 March 1789).
27 BL Add. MS 33,056, f. 130; PRO LC5/163 p. 141; J. C. Sainty and R. O. Bucholz, *Officials of the Royal Household 1660–1837*, 2 vols (London, Institute of Historical Research, 1997–8), I, p. 51.
28 PRO Work 4/29 8 September 1829; Work 4/23 27 January 1818, Work 1/8 26 January 1818; Work 19/66 5 February 1818; Work 1/17 23 July 1829; Work 19/14/5. For the history of the Royal Tennis Club see David Best, *The Royal Tennis Court: A History of Tennis at Hampton Court Palace* (Oxford, 2002). The most reliable and original parts of this compendium of tennis information concern the history of the club, pp. 70–93, 107–71.
29 Sainty and Bucholz, *Officials of the Royal Household*, I, p. 51. PRO Work 19/66.
30 Philip Ziegler, *King William IV* (London, 1971), pp. 82–3, 84, 144; Kathy White and Peter Foster, *Bushy Park: Royals, Rangers and Rogues* (East Molesey, 1997), pp. 35–9; *HKW*, VI, pp. 338–9.
31 *HKW*, VI, p. 187; *Gentleman's Magazine* (May 1868), pp. 682–3; M. Houston, *Sylvanus Redivivus* (London, 1889). Two letters exist from Jesse from before his appointment, both showing his interest in Hampton Court: PRO Work 1/10 5 May 1821, Work 1/16 29 February 1828. *The Imperial Calendar* gives Jesse's appointments as follows: Surveyor of Works and Building (1833–4), Assistant Surveyor (1833–4), Surveyor of Houses (1833–4), Itinerant Deputy Surveyor of Woods and Works (1834), Clerk of the Works (1833–4).
32 Edward Jesse, *A Summer's Day at Windsor and a Visit to Eton* (London, 1841, 1843), p. 48. Jesse was not alone in his dislike of Wren's screen: dozens of commentators thought it a disfigurement. See for example Charles Knight, *The Land We Live in: A Pictorial and Literary Sketch Book of the British Empire*, 4 vols (London, 1847–50), I, p. 138; John Fisher Murray, *A Picturesque Tour of the River Thames in its Western Course; Including Particular Descriptions of Richmond, Windsor and Hampton Court* (London, 1849), p. 152.
33 *HKW*, VI, p. 203.
34 *The Mirror of Literature, Amusement and Instruction*, no. 710 (14 March 1835); Wainwright, *The Romantic Interior*, pp. 18–25.
35 *Gentleman's Magazine* (March 1812), p. 236; Pugin and Willson, *Specimens of Gothic Architecture*, II, p. 7.
36 PRO Work 1/24 7 July, 23 September 1840; Dorset Record Office D/BKL: HJ 1/575. I am grateful to Tim Knox for pointing this out. Work 1/25 18 August 1841; Work 1/25 16 January, 12 June 1844; Work 1/27 8 July, 7 August, 21 October; Work 1/28 10 April, 2 July, 13, 26 August, 13 September, 16 October 1845; Work 2/4 15 July 1844; Edward Jesse, *A Summer's*

37 *Day at Hampton Court, being a Guide to the Palace and Gardens with an Illustrative Catalogue of the Pictures* (London, 1939), pp. 135–9; (London, 1841), pp. 21–3, 147.

37 See the forthcoming essay by Anna Keay in *The White Tower: The Tower of London* to be published by Yale University Press.

38 Mark Girouard, *The Return to Camelot: Chivalry and the English Gentleman* (New Haven and London, 1981), pp. 50–54; Wainwright, *The Romantic Interior*, pp. 54–69; Hilary Wayment, 'Twenty-four Vidimuses for Cardinal Wolsey', *Master Drawings*, 23–4, no. 4 (1985–6), pp. 503–4.

39 PRO WO 52/601 p. 233. I am grateful to Anna Keay for this reference.

40 Houston, *Sylvanus Redivivus*, p. 54; *Gentleman's Magazine* (March 1847), pp. 291–2. For other effusive accounts see Knight, *The Land We Live in*, I, p. 138. Fisher Murray, *A Picturesque Tour of the River Thames*, p. 155; *Fraser's Magazine* (August 1846), p. 181.

41 PRO Work 1/31 pp. 156, 187, 347, 367; Work 19/302 22 July 1846, 28 January, 13 September 1847.

42 PRO Work 1/28, 2 April 1845; Work 1/31 26 August and 13 September; Work 1/29 24 August 1847; Work 1/30 16 August.

43 Dorothy Gardiner, *The Story of Lambeth Palace: A Historic Survey* (London, 1930), pp. 227–31; *HKW*, VI, p. 277. See also the favourable views of Lambeth's historian in 1883, J. Cave Brown, *Lambeth Palace and its Associations* (London, 1883), p. 27n.

44 Sir Howard Colvin is incorrect in assuming that his role was administrative (*BDBA*, p. 526). As shall be seen, he was closely involved with the process of design.

45 PRO Work 1/25 pp. 144, 159; Work 34/69.

46 PRO Work 1/29 pp. 273, 337–9. Inman's drawings are Work 34/65 (survey of the west elevation as existing in 1845); Work 34/64 (Inman's first proposal for the west elevation without a bay window); Work 34/67 (west elevation as executed); Work 34/66 (presentation drawing showing west front as executed); Work 34/60 (sketch elevation of the north front of the south-west wing); Work 34/61 (proposed elevation of the western part of the north front of the south-western wing); Work 34/62 (alternative elevation of the north front of the south-western wing (fig. 292)).

47 Work 34/63 (Inman's elevation of the new parapet for the north elevation of the north-west wing).

48 PRO Work 1/25 13, 15 July 1841; Charles Knight, *Knight's Cyclopedia of London* (London, 1851), p. 61; Fisher Murray, *A Picturesque Tour of the River Thames*, p. 151.

49 PRO Work 34/74. Work 34/75 is a presentation drawing of the proposals. Work 34/73 shows the extant elevation and proposal for the west side of the court.

50 Robin Lucas, 'Neo-Gothic, Neo-Tudor, Neo-Renaissance: The Cotessey Brickyard', *Victorian Society Journal* (1997), pp. 25–37. I am grateful to Imogen Grundon for this reference. Paul Atterbury and Louise Irvine, *The Doulton Story* (London, Victoria and Albert Museum, 1979), p. 67.

51 PRO Work 1/24 9 April 1840; W. S. Lewis and A. D. Wallace, eds, *Horace Walpole's Correspondence with the Rev. William Cole* (London, 1937), pp. 176–7; H. B. Wheatley, *London Past and Present*, 3 vols (London, 1891), III, p. 513; J. T. Smith, *Antiquities of Westminster* (London, 1807), p. 23.

52 *Gentleman's Magazine* (December 1845), pp. 593–4; *Gentleman's Magazine* (February 1846) p. 154; *The Athenaeum*, no. 947 (20 December 1845), p. 1226; no. 948 (27 December 1845), p. 1251; H. Ellis, *Original Letters Illustrative of English History*, 3rd series, 4 vols (London, 1846), I, p. 249.

53 *VCH, Middlesex*, II (1910), p. 387; *HKW*, VI, p. 249.

54 Algernon Bertram Freeman Mitford, Baron Redesdale, *Memories*, 2 vols (London, 1915), II, p. 703; M. H. Port, 'A Regime for Public Buildings: Experiments in the Office of Works, 1869–75', *Architectural History*, XXVII (1984), pp. 74–85.

55 *Law*, III, pp. 385–6.

56 I am grateful to David Walker for providing me with a manuscript of a history of the Lessels family by Miss Jane Lessels, from which my information about John Lessels derives.

57 A plan entitled 'New gateway' may relate to this work (PRO Work 34/95).

58 The following details are taken from the *Surrey Comet* (21 January 1882 and 28 October 1882); *Law*, III, pp. 390–91. See also PRO Work 19/309 and Work 34/621. The drawings are Work 34/617.

59 E. J. Wood, *Curiosities of Clocks and Watches, From the Earliest Times* (London, 1866), pp. 62–3.

60 PRO Work 19/525; Cedric Jagger, *Royal Clocks: The British Monarchy and its Timekeepers 1300–1900* (London, 1983), pp. 7–8; Brian Hellyer and Heather Hellyer, *The Astronomical Clock, Hampton Court Palace* (HMSO, 1973), *passim*; *The Times* (8 March 1880). The clock was subsequently overhauled in 1947 and 1959–60, on both occasions by Thwaites and Reed of Clerkenwell. Its history from 1834 to 1960 can be traced in PRO Work 19/1166.

61 *Law*, III, pp. 391–2.

62 *Surrey Comet*, 21 January and 28 October 1882. A presentation drawing survives for the work in PRO Work 34/617 (fig. 302). Note the plan which shows the added 'Tudor' details.

63 Horace Walpole, *Anecdotes of Painting*, with additions by J. Dallaway and notes by R. A. Wornum, 3 vols (London, 1862), II, pp. 563–4. Pugin and Willson, *Specimens of Gothic Architecture*, II, p. 2n. Charles Eastlake, *A History of the Gothic Revival*, ed. with an introduction by J. Mordaunt Crook (rev. edn, Leicester, 1978), pp. 55–7, 211.

64 In the same tradition is the new oil store built in Tennis Court Lane in 1901 (PRO Work 34/1303).

65 The drawing is PRO Work 34/629. See also *Law*, III, p. 392.

66 PRO Work 34/84. The ceiling was also recorded by Pugin in 1822 (Pugin and Willson, *Specimens of Gothic Architecture*, II, pp. 7–8).

67 *The Times* (21 April 1892). My scheme to re-cobble was given permission by English Heritage and Richmond Borough Council but was stopped in 1991 due to concern that it would be impossible to complete it before the Queen opened the State Apartments in the summer of 1992.

68 PRO Work 19/13/6; *The Times* (21, 26 April, 31 December 1892); *Surrey Comet* (17 November 1894). New glass was installed by Lavers and Westlake at a cost of £160. For a recent analysis of the anti-restoration movement see Gavin Stamp, *An Architect of Promise: George Gilbert Scott Junior (1839–1897) and the Late Gothic Revival* (Donington, 2002), pp. 221–39.

69 Sir Charles Peers FSA, 'On The Stone Bridge at Hampton Court', *Archaeologia*, LXII (1910), pp. 309–16; *The Times* (23 March 1909 and 4 August 1910). Further excavation in 1995 revealed that the excavation of 1910 had removed all traces of the original moat fill (*Report on Archaeological Excavations of Test Pits* (Oxford Archaeological Unit, June 1995).

70 H. Avary Tipping, 'Suggestions for the West Front of Hampton Court', *Country Life* (5 March 1910), pp. 329–33. Mallows was also preparing his own history of Hampton Court which remains in note form in the RIBA drawings collection (DC/Mallows, C.E., vol. 7).

71 Although Peers in his article credits Frank Baines (of the Office of Works) and the historian L. F. Salzman for doing this.

72 E. E. Dorling, *Leopards of England* (London, 1913), pp. 39–56; H. Stanford London, *Royal Beasts* (Heraldry Society, 1956), pp. 7–8, 66–70. PRO Work 19/1171. The drawings are PRO Work 34/1307–9.

73 E. Law, 'The Kynge's Beastes at Hampton Court', *The Times* (20 March 1911), p. 8.

74 For instance: Anon., *The English Traveller*, 3 vols (London, 1746), III, p. 221; Anon., *London in Miniature* (London, 1755), pp. 296–7; Anon., *A Description of England and Wales* (London, 1769), p. 36; Nathaniel Spencer, *The Complete English Traveller* (London, 1771), pp. 317–18; Anon., *A Description of the County of Middlesex* (London, 1775), p. 192; Streeter, *Hampton Court: A Descriptive Poem in Three Cantos*.

75 *Fraser's Magazine* (August 1846), pp. 174, 179; Fisher Murray, *A Picturesque Tour of the River Thames*, p. 162. See also Brayley,

Nightingale and Norris Brewer, *London and Middlesex*, IV, p. 462.

76 James Elmes, *Memoirs of the Life and Works of Sir Christopher Wren, with a View of the Progress of Architecture in England, from the Beginning of the Reign of Charles I to the End of the Seventeenth Century* (London, 1823); Adrian Tinniswood, *His Invention so Fertile: A Life of Christopher Wren* (London, 2001), pp. 372–3; John Clayton, *The Works of Sir Christopher Wren: The Dimensions, Plans, Elevations, and Sections of the Parochial Churches of Sir Christopher Wren, Erected in the Cities of London and Westminster* (London, 1848).

77 Mark Girouard, *The Victorian Country House* (rev. and enlarged edn, London, 1979), pp. 318–28; Mark Girouard, *Sweetness and Light: The 'Queen Anne' Movement 1860–1900* (New Haven and London, 1977), pp. 45–6.

78 *Building News*, LVI (2 February 1889), pp. 263–4; *Architectural Association Notes*, XIII (1898), pp. 172–3.

79 Girouard, *Sweetness and Light*, pp. 76–7.

80 Reginald Blomfield, *A History of Renaissance Architecture in England, 1500–1800* (London, 1897), pp. 176–80.

81 John Belcher and Mervyn E. Macartney, *Later Renaissance Architecture in England: A Series of Examples of the Domestic Buildings Erected Subsequent to the Elizabethan Period*, 2 vols (London, 1901), I, pp. 35–9, pls XLII–XLVII.

82 Clive Aslet, *The Last Country Houses* (New Haven and London, 1982), pp. 127–53; J. M. Crook, *The Dilemma of Style: Architectural Ideas from the Picturesque to the Post Modern* (London, 1987), pp. 207–13.

83 *The Builder*, XCVIII (8 January 1910), pp. 39, 42; *Architectural Review* (August 1910), pp. 54–61; *Building News*, XCVIII (7 January, 21 January 1910), pp. 12, 98.

84 Francis Thompson, *A History of Chatsworth* (London, Country Life, 1949), pp. 153, 166; The Duchess of Devonshire, *Chatsworth* (official guidebook, 2001), pp. 26, 38. At Petworth the revival of interest had come much earlier: the 'carved room' had been assembled by the 1860s.

85 *Building News* (3 February 1888), pp. 180–81; *The Builder*, LXI (17 October 1891), pp. 294–5; James Newlands, *The Carpenter and Joiner's Assistant: A Complete Course of Practical Instruction* (Glasgow, 1860), p. 144, pl. xxxi.

86 Oliver Millar, *The Queen's Pictures* (London, 1977), p. 118. The following is largely based on J. Shearman, *Raphael's Cartoons in the Collection of H. M. the Queen and the Tapestries for the Sistine Chapel* (London, 1972), pp. 152–7; Francis Russell, 'George III's Picture Hang at Buckingham House', *Burlington Magazine*, CXXIX (1987), pp. 524–31. Accounts for moving pictures in June 1779 and December 1792 are in PRO Work 5/67 and Work 5/81.

87 The drawing should be compared to those for Buckingham House published by Francis Russell in 'George III's Picture Hang'.

88 Millar, *The Queen's Pictures*, p. 127; Brayley, Nightingale and Norris Brewer, *London and Middlesex*, IV, p. 476. (These comprise volume ten of the series edited by E. W. Brayley, J. Britton et al. entitled *The Beauties of England and Wales*, 18 vols (London, 1801–15, with subsequent additions).) W. H. Pyne, *The History of the Royal Residences*, 3 vols (London, 1819), II, p. 77, and for details of copyists, pp. 81–5.

89 C. G. Carus, *The King of Saxony's Journey through England and Scotland in the Year 1844*, trans. S. C. Davison (London, 1846), pp. 118–19; Frederick von Raumer, *England in 1835: Being a Series of Letters Written to Friends in Germany*, trans. Sarah Austin and H. Evans Lloyd, 3 vols (London, 1836), III, pp. 122–4. For another disparaging account of the cartoons' display see William Howitt, *Visits to Remarkable Places* (London, 1840), pp. 296–7.

90 Millar, *The Queen's Pictures*, pp. 128, 188; G. Martin, 'The Founding of The National Gallery in London', *Connoisseur*, CLXXXVII (1974), pp. 108–10.

91 Paintings on public view are listed comprehensively in David Hughson, *London: Being an Accurate History and Description of the British Metropolis and its Neighbourhood, to Thirty Miles Extent, from an Actual Perambulation*, 6 vols (London, 1805–9), VI, pp. 476–85; Brayley, Nightingale and Norris Brewer, *London and Middlesex*, IV, pp. 444–83; Jesse, *A Summer's Day at Hampton Court*. William Howitt's list of paintings in his *Visits to Remarkable Places* (London, 1840), pp. 281–302, is full of mistakes, as was pointed out in a damning review in the *Gentleman's Magazine* (May 1840), p. 456. Ernest Law gives his own account of the growth of the collection in the early nineteenth century in his 1881 catalogue, *A Historical Catalogue of the Pictures in the Royal Collection at Hampton Court, with Notes, Descriptive, Biographical and Critical; An Account of the State Rooms; and a Few Illustrations* (London, 1881), p. xxxi. Knight, *Knight's Cyclopaedia of London*, p. 65.

92 Pierre Lemoine, *Versailles and Trianon: Guide to the Museum and National Domain of Versailles and Trianon* (Paris, 1990), pp. 150–51. A similar conversion was effected at the Hermitage in St Petersburg.

93 Richard Altick, *The Shows of London* (Harvard, 1978), pp. 415–19.

94 Carus, *The King of Saxony's Journey through England and Scotland in the Year 1844*, p. 121; Valerie Pirie, *A Frenchman sees the English in the Fifties* (London, 1935), p. 194. *Gentleman's Magazine* (May 1840), pp. 456; Anna Brownell Jameson, *A Handbook to the Public Galleries of Art in and near London* (London, 1842). For further criticism of the picture hang see Knight, *The Land We Live in*, I, p. 139.

95 On Redgrave see O. Millar, 'Redgrave and The Royal Collection', in Susan P. Casteras and Ronald Parkinson, eds, *Richard Redgrave* (New Haven and London, 1988), pp. 86–92; Millar, *The Queen's Pictures*, pp. 189–90. On Unwin see also PRO Work 1/34 20, 30 November 1849; Work 1/36 27 February 1851; Work 1/45 25 April, 28 July, 11 August 1855; Work 1/52 24 September 1856.

96 See Elizabeth Bonython and Anthony Burton, *The Great Exhibitor: The Life and work of Henry Cole* (Victoria and Albert Museum, London, 2003), pp. 82–5.

97 PRO LC1/69; LC1/217.

98 PRO Work 1/41 22 August 1853, Work 1/43 28 February, 5 October 1854; Work 19/13/1; G. F. Cruchley, *Guide to London* (London, 1862), p. 318.

99 PRO Work 1/54 20 June 1857; Work 1/83 28 March 1867; Work 1/62 18 May 1859; Work 1/63 22 August 1859; Work 1/64 17 November 1859; Work 19/196; PRO LC1/424 14 February 1884; Work 19/208.

100 An order for numbering is in Work 1/84 18 May 1867.

101 For example, in November 1840 Jesse ordered that Beechey's portrait of *George III*, two of the great Tintorettos, and two of the Riccis be cleaned at a cost of over £32 (PRO Work 1/24 2 November 1840). In 1848 fifty paintings were to be repaired at a cost of over £97 (Work 1/33 23 November 1848). Yet in 1841 a request to move paintings by a copyist named Mr Tidy was referred by Jesse to Seguier (PRO Work 1/25 5 November 1841). Paintings were restored on the premises in what is now known as the Haunted Gallery.

102 PRO LC1/69 13 December 1859 Sydney to Sir Charles Phipps, and 12 April 1858 De La Warr to Lord John Manners. In February March 1861 three restorers were appointed to work at the palace under Redgrave's supervision (PRO Work 1/67).

103 See correspondence in PRO LC1/531; Shearman, *Raphael's Cartoons*, pp. 157–61; John Physick, *The Victoria and Albert Museum* (London, 1982), pp. 95–6.

104 PRO Work 6/280 27 September 1865.

105 All this can be traced in Law, *A Historical Catalogue of the Pictures in the Royal Collection at Hampton Court*.

106 Millar, *The Queen's Pictures*, pp. 198–9.

107 PRO LC1/380 Law to Ponsonby Fane 12 February 1881, 16 February 1881; Work 19/201 15 August 1881, 4 April 1882, 13 June 1883; K. Baedeker, *London and its Environs* (London, 1881), p. 301.

108 PRO Work 19/209; Work 19/197; PRO LC1/570 contains 'Report of the Commission appointed to inquire into the Question of the Housing of the Raffaelle

109 PRO LC1/531 report by Robinson to Ponsonby Fane 20 August 1890. Work 19/13/9. One of the hydraulic mechanisms failed in 1886 causing one of the Mantegnas to fall to the ground (Work 19/71 23 January 1886).

110 Pyne, *The History of the Royal Residences*, II, pp. 1–88.

111 For instance the four remaining pieces of Queen Mary II embroideries from her closet were sent to Holyrood House in 1863. PRO Work 1/74, 9 September 1863; Margaret Swain, *Tapestries and Textiles at the Palace of Holyroodhouse in the Royal Collection* (London, 1988), p. 49.

112 These were some of those given in about 1880 by Queen Victoria to Princess Frederica for her apartment on the west front of the palace (see below, chapter 16). When she gave up her rooms in 1897 much of her furniture was moved to Germany in eight removal vans, but an equal quantity was left behind in her apartment and passed to the housekeeper, who sold it. In this way some important Hampton Court pieces left the collection: PRO Work 19/193, Lionel Earle to Mr Preedy 25 November 1913; *Law*, III, pp. 446, 382–4. Amongst the furniture dispersed may have been one of the X-frame stools made by Henry Williams (*Mallett: English and Continental Antique Furniture, Objets d'Art, Paintings and Watercolours* (London, 2001), pp. 10–11) and two giltwood tables with lacquer tops (*Important English Furniture*, Sotheby's catalogue (Friday, 10 July 1998), lot no. 116).

113 W. Pyne, *The History of the Royal Residences*, 3 vols (London, 1819), pp. 51, 55, 67; PRO LC 9/361 pp. 135, 137; W. E. Trotter, *Views of the Environs of London* (London, 1839), p. 58; PRO Work 1/25 26 August, 8 September (King's and Queen's Audience Chambers); PRO LC9/361 p. 22; PRO Work 1/9 6 May 1819.

114 These had been spotted rolled up in store at Hampton Court by Princess Louise and her husband, the Duke of Argyll, in 1873–4 and removed to Kensington Palace to their private apartments. Later they were rolled up again and remained in store at Kensington until 1893, when a plan was submitted to place them in the Chapel Royal at St James's. They were hung there, but the arrangement was unsatisfactory and Robinson succeeded in securing them for Hampton Court. PRO LC1/405 2 February 1883; 17 February 1883; LC1/424 letter and survey of 27 June 1884, 30 July, 19 August, 10 September, 14 October 1884; LC1/440; LC1/589 24 July 1893.

115 PRO LC1/690 9 November 1898; LC1/178 4 July 1900; Royal Archives PP Household 1622; PRO Work 19/222 4 February 1899; Work 19/220 26 January 1899. The full list of paintings transferred to Kensington is in PRO Work 19/220. See Ernest Law, *Kensington Palace: The Birthplace of the Queen* (London, 1899), pp. 40–45.

116 Vertue Note Books, II, *Walpole Society*, XX (1931–2), pp. 5, 67; PRO LC1/473 October 6 1887; LC1/495 15, 23 January 1888; PRO Work 19/415. Edward Croft-Murray, *Decorative Painting in England 1537–1837*, 2 vols (London, 1962), I, p. 21. Alterations were made to the window casements in 1929, PRO Work 34/1491. The room underwent a thoroughgoing restoration in 1961–2 when the ceiling and panel paintings were cleaned (PRO Work 19/1281; Work 19/1216; Work 19/1097).

117 *Surrey Comet* (22 July 1899).

118 Madame van Muyden, *A Foreign View of England in the Reigns of George I & George II: The Letters of Monsieur César de Saussure to his Family* (London, 1902), pp. 145–6; *Fraser's Magazine* (August 1846), p. 180; von Raumer, *England in 1835: Being a Series of Letters Written to Friends in Germany*, III, p. 124; Valerie Pirie, *A Frenchman Sees the English in the Fifties*, p. 194.

119 Pre-dating the guidebooks was the publication of a print by J. Cadell Jr and W. Davies showing the principal floor of the palace with the names and dimensions of the rooms. It is dated 5 June 1800. Royal Library 702872. Three views of the palace accompany it (702888 a–c).

120 Almost all the nineteenth-century guides to London and its environs mention Hampton Court and these state that guidebooks were on sale in the Guard Chamber for 6d (for instance, John Weale, *London and its Vicinity* (London, 1851), p. 409).

121 *Gentleman's Magazine* (May 1840), p. 455; PRO Work 1/46 5 October 1855.

122 Altick, *The Shows of London*, pp. 434–54.

123 Select Committee on Arts and Principles of Design and their Connection with Manufactures, 1836 (568), IX.1, pp. v, x.

124 PRO Work 1/23 17, 27 August, 6 December 1838; Work 1/25 29 April.

125 Nathaniel Hawthorne, *The English Notebooks*, ed. Randall Stewart (New York and London, 1941), p. 284.

126 John Grundy, *A Stranger's Guide to Hampton Court Palace and Gardens* (London, 1865), p. 23. See also the *Gentleman's Magazine* (August 1841), pp. 188–9; Law, *A Historical Catalogue of the Pictures in the Royal Collection at Hampton Court*, p. xxxii.

127 On Tite's railway architecture see Gordon Biddle and O. S. Nock, *The Railway Heritage of Britain* (London, 1983). I am grateful to Gavin Stamp for pointing this book out to me. The awning was added in 1899.

128 Vic Mitchell and Keith Smith, *Branch Lines around Effingham Junction, including the Hampton Court Branch* (Midhurst, 1990), unpaginated; John Sheaf and Ken Howe, *Hampton and Teddington Past* (London, 1995), pp. 63–6.

129 G. D. Heath, 'Hampton in the Nineteenth Century', *Borough of Twickenham Local History Society*, paper 27 (1973, 2nd edn, 1993), p. 41.

130 These were the Mitre Hotel, the Thames Hotel, the Whitehall Private Hotel, the Greyhound Hotel, Cardinal Wolsey Hotel, the Castle Hotel, Clegg's Temperance Hotel, the King's Arms Hotel, the Palace Gate Restaurant, the Queen's Arms Hotel and the Queen's Arms Restaurant (see PRO Work 19/201, which contains a threepenny plan entitled 'Hampton Court. What to See! How to See it!').

131 Gerald Heath, *Hampton Court: The Story of a Village*, ed. Joan Heath and Cathy White (East Molesey, 2000), pp. 56–7. For disorder and drunkenness at Hampton Court see Adrian Tinniswood, *The Polite Tourist: A History of Country House Visiting* (London, National Trust, 1998), pp. 139–44.

132 *Gentleman's Magazine* (March 1847), p. 293.

133 In 1986 a cocoa tin was found beneath the boards of the (then) Second Presence Chamber; in it a piece of paper dated March 1911 gave the names of the four carpenters who had laid the floor.

134 PRO Work 1/55 11 July 1857; Work 19/71 12 May 1879; Work 19/71; Work 1/47 5 December 1855; Work 1/86 12 March 1868; Work 1/65 25 April 1860.

135 Soane had recommended in 1822 that the Round Larder be removed as a disfigurement: Soane Museum XII.G.3.2, 1822; PRO Work 1/32 p. 64; Work 1/34 pp. 48–9; Work 1/35 pp. 139, 231–2; Work 1/36 p. 2. Work 1/36 6 December 1850, 18 January 1851; PRO Work 1/66 19 July 1860; Work 1/32 20 December 1847.

136 Subsequent editions were dated 1840, 1841 and 1847.

137 The last edition was published in 1899.

138 Bonython and Burton, *The Great Exhibitor*, pp. 82–5.

139 Select Committee on National Monuments and Works of Art, 1841 (416), VI.437, pp. v–vi. See also *HKW*, VI, p. 641.

140 Tinniswood, *The Polite Tourist: A History of Country House Visiting*, pp. 145–53.

141 PRO Work 1/42 4 November, 31 December 1853.

142 *HKW*, V, p. 112; C. G. T. Dean, *The Corps of Invalids*, pp. 587–8; *The Times* (4 April 1794).

143 PRO Work 19/14/2; Work 1/7 1 August 1816; Work 4/20; Work 19/14/2; Work 6/357/6 May 1817.

144 PRO Work 1/57 11 February, 6 September 1859; Work 1/63; Work 1/69 16 November; Work 19/80; Work 19/14/3.

145 PRO Work 19/80.

146 PRO Work 4/1 pp. 75, 108; Work 5/145.

147 PRO Work 4/8 31 August 1742, 10 August 1743, 6 December 1743.

Chapter 16

1. *HMC, Buccleuch and Queensberry*, II (ii), pp. 629–30; chapter 10.
2. *Cal. Treasury Books*, XV (1699–1700), p. 227.
3. National Art Library MS RC U 6.
4. PRO LC5/202 ff. 195–201.
5. A detailed commentary on the location of William III's courtiers can be found in Peter Gaunt, 'The Non-State Rooms in Wren's Fountain Court' (report commissioned by English Heritage in 1987, copies held at Hampton Court and English Heritage).
6. In the Royal Archives in the Cumberland Papers: 'Inventory of Furniture in his Majesties Palace of Hampton Court taken by Officers of his Majesties Removing Wardrobe'.
7. PRO LC5/89–90; PRO T56/18.
8. For further examples see Gaunt, 'The Non-State Rooms', pp. 143–5.
9. PRO AO1/2449/152.
10. PRO Work 6/11 ff. 1–13.
11. PRO Work 6/7 ff. 82, 113–4; Work 6/11 f. 110.
12. *Cal. Treasury Books*, XXX (1716), pp. 322–3; J. M. Beattie, *The English Court in the Reign of George I* (Cambridge, 1967), pp. 186–8.
13. PRO LC5/89 ff. 113–30.
14. PRO LC5/161–LC5/162; *Horace Walpole's Correspondence*, ed. W. S. Lewis, 48 vols (Oxford, 1937–83), XXXVII, p. 297.
15. *Horace Walpole's Correspondence*, X, p. 33.
16. PRO Work 4/14 12 August 1767. For early grace and favour see also *The Letters and Journals of Lady Mary Coke*, ed. J. A. Home, 4 vols (Edinburgh, 1889–96), III, pp. 45–6, 49.
17. R. Needham and A. Webster, *Somerset House Past and Present* (London, 1905), pp. 168–70.
18. PRO LC5/204 pp. 208–9, 214–15; PRO Work 4/14 23 April 1773. Work 34/42 dated 1771 was probably a similar survey.
19. W. Roberts, ed., *Memoirs of the Life and Correspondence of Mrs Hannah More*, 4 vols (2nd edn, London, 1835), I, p. 45; H. Cole, *Beau Brummell* (London, 1927), pp. 16–17, 19; *Law*, III, p. 309.
20. PRO Work 19/14/5. Land tax had been paid since at least 1763.
21. PRO LC5/249ff. 145–7.
22. *Hansard's Parliamentary Debates*, 3rd ser., LIX, pp. 646–51; LXVII pp. 1334–43.
23. For grace and favour see *VCH, Middlesex*, XI (1911), pp. 369–72; *Law*, III, pp. 307–492; Gaunt, 'The Non-State Rooms'; G. D. Heath, 'Hampton Court Palace: "Grace and Favour" in the Nineteenth Century', *Borough of Twickenham Local History Society*, paper 62 (1988); I. Gray, *Hampton Court Palace: List of Occupants of Private Apartments 1891–1989* (Hampton Court Palace, 1989).
24. See Gaunt, 'The Non-State Rooms'.
25. See for instance PRO LC5/162 pp. 195, 233, 261, 267.
26. M. C. Houston, *A Woman's Memories of World-Known Men*, 2 vols (London, 1883), I, p. 41; Charles Dickens, *Little Dorrit* (Harmondsworth, 1998), pp. 303–4.
27. *Surrey Comet* (29 September 1917). The stone for this floor is probably that removed from the choir of the chapel when the central pews were installed.
28. See Gaunt, 'The Non-State Rooms'.
29. PRO Work 16/650; Work 19/13/8; Work 1/85 12 November 1867.
30. See Heath, 'Hampton Court Palace'.
31. Andrew Ashbee and John Harley, *The Cheque Books of the Chapel Royal*, 2 vols (Aldershot, 2000), II, pp. 199–200, 275; G. D. Heath, 'The Chapel Royal at Hampton Court', *Borough of Twickenham Local History Society*, paper 42 (1979), p. 38.
32. PRO Work 1/82 5 September 1866; Work 1/85 8 November 1867; Work 1/86 20 April 1868. Heath, 'Hampton Court Palace', pp. 9–10; Heath, 'The Chapel Royal at Hampton Court', pp. 43–8.
33. PRO Work 1/24 19, 30 December 1839.
34. Details of repairs to the organ 1852–1912 are in PRO Work 19/192.
35. Heath, 'The Chapel Royal at Hampton Court', pp. 45–6, 52–3.
36. PRO Work 13/7; Work 1/62; Work 19/198; Gerald Heath, *Hampton Court: The Story of a Village*, ed. Joan Heath and Cathy White (East Molesey, 2000), p. 50.
37. PRO Work 6/7 p. 24; Work 4/1 12 June, 23 July 1716; *The Letters and Journals of Lady Mary Coke*, III, pp. 242–3; Work 1/12.
38. Work 19/69; Work 19/13/9.
39. *Daily Telegraph* (15 December 1882); *Weekly Dispatch* (17 December 1882); PRO Work 19/76; Work 19/13/9; *Law*, III, pp. 395–8.
40. Work 19/76; Work 19/13/11; Work 19/13/10.
41. The elevations are PRO Work 34. Plans are in PRO Work 19/13/10.
42. *Law*, III, p. 401.
43. Jonathan Clarke, 'A Discreet Revolution: Early Structural Steel in London Buildings before the "Steel Frame" Act of 1909', English Heritage report in the National Monuments Record.
44. PRO Work 19/82. See also Work 19/88 on the question of the cost of electricity and fittings in the apartments of those who worked at the palace (1908–10). Donald Simpson, *Twickenham Past* (Borough of Twickenham Local History Society, 1993), p. 104; Mark Girouard, *The Victorian Country House* (London, 1979), pp. 24–5, 445 n. 46; *Country House Lighting, 1660–1890*, Temple Newsam Country House Studies, no. 4 (Leeds, 1992), pp. 31, 97, 104–6.
45. *Law*, III, pp. 319–23; *The Later Correspondence of George III*, ed. A. Aspinall, 5 vols (Cambridge 1962–70), II, pp. 294–5.
46. Correspondence covering the extension and conversion is in PRO LC1/381, LC1/382, LC1/396, LC1/397. See also *Law*, III, pp. 382–4. The princess died in 1926 and the baron in 1932.
47. Obituary, *The Times*, 21 (27 April 1960).
48. For the Stud House see PRO Work 19/317.
49. PRO Work 19/77.
50. PRO Work 6/21 14 May 1785.
51. PRO 19/15/2; Work 2/5 12, 30 November 1846; Soane Museum vol. 2, xii, G. 1, f. 7; *Law*, III, pp. 336–7.
52. Heath, 'Hampton Court Palace', pp. 10–11.
53. PRO Work 1/4 22 May 1764; LC5/29 9 June 1764; LC 5/96 p. 55.
54. PRO Work 4/17 4 January 1793; Work 4/18 26 December 1792; Work 6/22 ff. 81–2r. *BDBA*, p. 999. Further work was requested in 1805 (Work 6/23 f. 278).
55. PRO Work 4/19, 18 July, 1, 15 August 1806; Work 6/24 ff. 51r, 53r–v, 55, 59r–60r; PRO T29/88 p. 47; Work 5/96; Work 4/20 11 March 1808, 2 July 1808, 21 December 1810; *The Later Correspondence of George III*, V, pp. 91–2; Work 16/28/71 8 July 1816; Work 4/22 25 July 1816.
56. Work 1/42 pp. 576–88, 626–7; Work 1/43 9 February 1854; Work 1/47 22 November 1855; Work 19/67. Soane Museum XII.G.3.2 is the proposal to demolish the two pavilions in the worst condition.
57. PRO Work 19/67. See also Work 19/839.
58. PRO LC1/405 18 January, 1 February, 29 June 1883.

148. PRO Work 1/886 January 1869; Work 19/15/9 – Work 19/15/11; Work 19/15/5; Work 19/15/7; Work 19/15/9 – Work 19/15/14.

Chapter 17

1. Daniel Defoe, *A Tour through the Whole Island of Great Britain*, 3 vols (London, 1724–7), I (iii), p. 9; Batty Langley, *New Principles of Gardening* (London, 1728), p. vi; Daniel Defoe, *A Tour Through the Whole Island of Great Britain*, 4 vols (London, 1742), I, pp. 239–40; J. Dixon Hunt and Peter Willis, eds, *The Genius of the Place: The English Landscape Garden 1620–1820* (London, 1975), pp. 1–43.
2. Charles Bridgeman was clearly involved in the rebuilding of the Lower Wilderness. A number of plans for its planting survive in his hand, as do proposals for embanking the Thames to prevent a reoccurrence of the floods. These are catalogued in Peter Willis, *Charles Bridgeman and the English Landscape Garden* (reprinted with supplementary plates and a catalogue of additional documents, drawings and attributions, Newcastle, 1993), p. 429, Pls 202–4.
3. *The Complete Works of Sir John Vanbrugh*, ed. B. Dobrée and G. Webb, 4 vols (London, 1928), IV, p. 165; PRO Work 4/1 pp. 89,

137–8, 144, 156; PRO AO1/2450/154; AO1/2450/155.
4. Willis, *Charles Bridgeman*, pp. 33–6.
5. John, Lord Hervey, *Memoirs of the Reign of George the Second from his Accession to the Death of Queen Caroline*, ed. J. W. Croker, 3 vols (London, 1884), I, p. 264.
6. From the diary of Sir John Clerk of Penicuik, National Archives of Scotland GD 18/2107 1 April 1727.
7. PRO Work 4/7 pp. 6, 7, 13; PRO AO1/2458/180. For Robinson see *BDBA*, p. 832.
8. Roy Strong, *The Artist and the Garden* (New Haven and London, 2000), pp. 259–62; Timothy Clayton, 'Publishing Houses: Prints of Country Seats', in D. Arnold, *The Georgian Country House: Architecture, Landscape and Society* (Stroud, 1998), pp. 43–60.
9. Timothy Clayton, *The English Print* (New Haven and London, 1997), p. 163.
10. Mikhail Dedinkin, 'Hampton Court Rediscovered', and D. Jacques, 'Capability Brown at Hampton Court', *Hermitage Magazine*, 1 (Summer 2003), pp. 48–55; *Daily Telegraph* (19 April 2003), 'Gardening', p. 1.
11. For a complete list of postholders see David Jacques's unpublished 'Royal Parks Historical Survey, Hampton Court and Bushy Park' (1982), I, appendix B.
12. PRO Work 4/12 12, 19 December 1758; Work 6/17 f. 182r.
13. Dorothy Stroud, *Capability Brown* (London, 1950), pp. 72–4, 97–9.
14. PRO Work 4/1; Work 4/14; Work 6/18 pp. 254–5.
15. Dixon Hunt and Willis, *The Genius of the Place*, p. 333.
16. *Law*, III, pp. 297–300; *Notes and Queries*, XII, p. 404; PRO Work 6/23 f. 117v; Soane Museum XII.G.3.4, 1825; Work 16/150 6 December 1825.
17. Haverfield was prosecuted for fraud and dismissed (*The Later Correspondence of George III*, ed. A. Aspinall, 5 vols (Cambridge, 1970), IV, p. 253).
18. Anon., *A Compendious Gazetteer; or, Pocket Companion to the Royal Palaces, Towns, Villages, Villas and Remarkable Places, within Sixteen Miles of Windsor* (London, 1796, 1801), p. 20.
19. *Law*, III, 290–2; J. Beckett, 'Battles at the Park Gates', *Country Life* (13 November 1980), pp. 1744–5.
20. Geoffrey Scott and Frederick A. Pottle, eds, *Private Papers of James Boswell from Malahide Castle: The Journals of James Boswell 1783–1786*, 18 vols (New York, 1928–34), XVI, p. 106.
21. PRO Work 4/29 8 September 1829; Work 4/23 27 January 1818, Work 1/8 26 January 1818; Work 19/66 5 February 1818; Work 1/17 23 July 1829.
22. *Gardener's Magazine*, IX (2 July 1833), p. 478.
23. Soane Museum XII.G.3.2, 1822.
24. *Gardener's Magazine*, XIII (January 1837), p. 8.
25. *Fraser's Magazine* (August 1846), p. 173. In 1875 benches were put along the Barge Walk for the public (PRO Work 16/157). Later controls were imposed on the mooring and landing of boats on the foreshore (Work 16/162).
26. *Cottage Gardener*, XV (1855), pp. 83–4, 104–5; Mireille Galinou, ed., *London's Pride: The Glorious History of the Capital's Gardens* (London, 1990), pp. 155–7.
27. PRO Work 16/152. The ice house at Kingston gate was relinquished by the queen in 1859 and by the occupants of the Stud House in 1867 when it was transferred to the Office of Works (Work 16/156).
28. *Journal of Horticulture* (17, 21 September, 1 October 1874).
29. New gates were designed for the Flower Pot Piers at the north end of the borders in 1919. Two elegant Office of Works drawings showing alternative designs survive (PRO Work 34/1493 and Work 34/1494).
30. Walter Jerrold, *Hampton Court* (London, n.d.), pp. 57–8. See also *Country Life* (10 September 1910), pp. 350–51.
31. E. Law, *Hampton Court Gardens: Old and New* (London, 1926), p. 16.
32. *Journal of Horticulture* (22 September 1910); *Daily Sketch* (12 May 1914); *Evening Standard* (30 May 1911).
33. J. Weale, *London and its Vicinity in 1851* (London, 1851), p. 496.
34. *Morning Post* (8 May 1912).
35. PRO Work 16/153.
36. In the mid-1820s significant repairs to the Tijou screens included replacement of iron repoussé work with copper (Soane Museum XII.G.3.5, 1826).
37. PRO Work 19/73; Work 19/443. A drawing for the new layout is PRO Work 34/1310.
38. Charles Knight, *The Land We Live in: A Pictorial and Literary Sketch Book of the British Empire*, 4 vols (London, 1847–50), I, pp. 143–4.
39. PRO Work 19/304; Work 1/84 31 July 1867; Work 1/88 7 April 1869.
40. 'Chestnut Sunday' was announced beforehand in the newspapers (*Law*, III, p. 425).
41. Kathy White and Peter Foster, *Bushy Park* (Hampton, 1997), pp. 57–60; *Bushy Park: Historic Survey and Landscape Management Plan* (The Royal Parks, July 2002), pp. 28–9; Edward Pyatt, *The National Physical Laboratory: A History* (Bristol, 1983); *Buildings and Monuments in the Royal Parks* (The Royal Parks, London, 1977), pp. 95–101.
42. An Act of Parliament was passed in June 1872 regulating public behaviour in the royal parks and gardens. These included the Hampton Court parks and gardens and had a special section covering the Green.
43. In 1904 new gates were built from the Barge Walk to the Pavilion Terrace, to increase public access to the park (PRO Work 34/1305; Work 34/1306).
44. A drawing dated 1911 is a block plan for this building (PRO Work 34/1302).
45. PRO Work 16/644; Work 6/28/9; Work 16/655; Work 16/164; Work 16/658; Work 16/659. G. Shaw Lefevre, 'The Rangers of the Royal Parks', *The Speaker* (24 May 1902), pp. 217–18. Work 16/158 contains much more material on the rights and privileges of the Rangers and Masters of the Horse.
46. PRO Work 16/166.
47. PRO Work 16/150.
48. PRO Work 16/152; G. D. Heath, 'Hampton in the Nineteenth Century', *Borough of Twickenham Local History Society*, paper 27 (1973, 2nd edn, 1993), p. 21.
49. PRO Work 16/152. The sale of grapes from the vine remained a problem until after the First World War (PRO Work 16/900).
50. PRO Work 19/1131. But by then Naylor's business was struggling (PRO Work 16/1649, 1067).
51. Robert Gibson, *The Quest of Alain Fournier* (London, 1953), p. 55.

Chapter 18

1. In writing this chapter I have consulted, in addition to the PRO documentation, which falls mainly in the Work 19 series, the extensive former PSA archive files now held at Hampton Court (in the notes to this chapter these files are referred to as HRP) and the equally extensive files of the former DAMHB, now English Heritage (referred to as EH). Some of the PRO material that I have had access to is still 'closed'.
2. Andrew Saunders's introduction in M. R. Apted, R. Gilyard Beer and A. D. Saunders, *Ancient Monuments and their Interpretation* (London, 1977), p. xv. The Inspectors with principal responsibility for Hampton Court were George Chettle (1939–51) and John Charlton (1951–74); Principal Inspectors Peter Curnow (1974–87) and Juliet West (1989–92); and then as Assistant Inspector Simon Thurley (1997–8) and as Inspector Michael Turner (1992–present). Since 1989 John Thorneycroft has had overall responsibility for Hampton Court within English Heritage.
3. See J. O'Toole and Grant Jordan, eds, *Next Steps: Improving Management in Government?* (Aldershot, 1995).
4. Maurice V. Brett and Oliver, Viscount Esher, eds, *Journals and Letters of Reginald, Viscount Esher*, 4 vols (London, 1934–8), I, p. 288.
5. PRO Work 19/216; Work 19/1060; Work 19/1168; Work 19/1096.
6. Personal communication.

7 A. Tinniswood, *His Invention so Fertile: A Life of Sir Christopher Wren* (London, 2001), pp. 376–8.
8 PRO Work 19/1131.
9 Separate guides were written for the Banqueting House (1951), the Mantegna Gallery (1930, 1935 and 1949), and the Tennis Court (1950).
10 RCHME, *An Inventory of the Historical Monuments in Middlesex* (London, 1937), p. 32; N. Pevsner, *The Buildings of England: Middlesex* (Harmondsworth, 1951), pp. 74–7. The revised edition maintained this judgement (B. Cherry and N. Pevsner, *The Buildings of England: London 2: South* (Harmondsworth, 1983), pp. 481–500).
11 HRP WM.HB.29/7.
12 Although the dig was triggered by a trench to lay a fire main, the discovery of the range was deemed to be crucial for the *King's Works* project. See PRO Work 19/1373.
13 A full list of twentieth-century excavations is as follows:
 - 1966–7 Peter Curnow and Alan Cook: Daubeney range, Fountain Court
 - 1971 Tony Pacito: Base Court moat ditch
 - 1973–4 John Dent and Brian Davidson: Daubeney range, Fountain Court
 - 1974 John Dent and Brian Davidson: Great Hall basement
 - 1976 David Whip: ground-floor apartment 35, Wolsey range
 - 1977 David Batchelor: Tudor Queen's Gallery, east front
 - 1977 David Batchelor: footings of Tudor bay window, Clock Court
 - 1977 Ted Higgenbottom: west range of Clock Court
 - 1979 Geoffrey Parnell: great kitchens
 - 1982 Geoffrey Parnell: east wall of Chapel Royal
 - 1988 Central Excavation Unit: apartment 37, Wolsey Bridge
 - 1989 Daphne Ford and Simon Thurley: oak rooms, Tudor Foundations
 - 1990 Daphne Ford and Simon Thurley: south cloisters of Fountain Court, Wolsey long gallery
 - 1993–4 Brian Dix and Stephen Parry: Privy Garden
 - 1996 Oxford Archaeological Unit; north arm of moat in Wilderness
 - 1973–96 many small investigations by Daphne Ford recorded in archive at Hampton Court
 EH CB 29/000/E/00 contains information about the excavations.
14 PRO Work 19/587. An archway was made between the east arm of the Gallery and the north arm creating the L-shaped gallery of today. The archway, probably designed by Frank Baines, was dismantled in 1976 and replaced by the present neo-Wren opening (see *The Times* (3 December 1917)).
15 PRO Work 19/587.
16 PRO Work 19/309; Work 19/439; Work 19/587; *The Times* (30 May 1914); *Surrey Comet* (6 June 1914); Thomas Garner and Arthur Stratton, *The Domestic Architecture of England during the Tudor Period: Illustrated in a Series of Photographs and Measured Drawings*, 2 vols (London, 1911), I, pl. lxvii.
17 Work 19/1061; Work 19/1282; Ernest Law, 'My Lord Cardinall's Lodgynges at Hampton Court Palace', *Country Life* (11 August 1923), pp. 186–7.
18 Work 19/605.
19 EH CB 29/079/0/00.
20 *The Sphere* (10 September 1921); *Surbiton Times* (30 May 1919); *The Field* (24 May 1919); *Evening Standard* (5 September 1921); *Law*, III, p. 487
21 *Daily Telegraph* (22 August 1927).
22 PRO Work 19/1095; Work 19/66.
23 For the history of the club and subsequent history of the court see David Best, *The Royal Tennis Court: A History of Tennis at Hampton Court Palace* (Oxford, 2002), pp. 119–71.
24 PRO Work 19/1220; HRP WM.HB.29/13/1; WM.HB.29/13/5.
25 As new parts were opened so was the issue of heating them considered. After the war only the State Apartments were heated and outlying areas (such as the King's and Queen's Stairs) still retained their Victorian pipes. Other parts, like the Haunted Gallery, had anthracite stoves (PRO Work 19/1164).
26 J. Alfred Gotch, *Architecture of the Renaissance in England Illustrated by a Series of Views and Details from Buildings Erected Between 1560 and 1635 with Historical and Critical Text*, 2 vols (London, 1894). The book has a very short introduction and brief chapters on the houses illustrated.
27 The principal Hampton Court section is at pp. 109–13 and pls LXI–LXVII.
28 Another key publication in this process was H. Avray Tipping, *English Homes*, 9 vols (London 1920–37). The *Early Tudor, 1485–1558* volume (period II, vol. 1) was published in 1924.
29 John Cornforth, *The Inspiration of the Past: Country House Taste in the Twentieth Century* (London, Country Life, 1985), pp. 20–46; Clive Aslet, *The Last Country Houses* (New Haven and London, 1982), pp. 164–81.
30 The beetle was identified by the Natural History Museum as *Xestobium tessellatum*.
31 PRO Work 19/583. Roy Brook, *The Story of Eltham Palace* (London, 1960), pp. 59–60, 66. The drawings for the roof work are in the English Heritage historic plans room.
32 PRO Work 19/1275; EH CB 29/082/0/00.
33 PRO Work 19/586.
34 HRP WM.HB.29/2 (2); EH CB 29/071/B/00. PRO Work 19/1214 covers the complicated history of the organ 1867–1957.
35 *Journals and Letters of Reginald, Viscount Esher*, I, p. 288.
36 Much of what follows is based on PRO Work 19/206 (covering the Hampton Court furniture 1911–39). It should also be noted that by 1920 there was an agreement between the Board of the Office of Works and the Lord Chamberlain that where public money had been spent on the restoration of tapestry or furniture restored items should remain on public show and not be removed to the occupied palaces. As a result of this Queen Mary was told that a set of William and Mary chairs that she wanted at Windsor would be difficult to extract from Hampton Court (Work 19/206).
37 P. MacQuoid, *A History of English Furniture* (composite edition, London, 1988), p. 171; *The Times* (30 December 1911); *Surrey Comet* (30 December 1911).
38 Ingleson C. Goodison, 'The Furniture of Hampton Court and Other Royal Palaces', *Journal of the Royal Society of Arts*, LXXIV (December 1925), pp. 50–65.
39 *The Times* (23 October 1929); *Evening Standard* (23 October 1929).
40 PRO Work 19/824; Work 19/821.
41 O. Millar, *The Queen's Pictures* (London, 1977), p. 209.
42 The idea for this inventory was Lionel Cust's, but it was paid for by the State (PRO LC1/756).
43 F. J. Rutherford, 'The Furnishing of Hampton Court for William III, 1699–1701', and 'The Furnishing of Hampton Court, 1715–37', *Old Furniture*, II (1927), pp. 15–33 and 76–86, 180–87.
44 Kenneth Clark, *Another Part of the Wood: A Self Portrait* (London, 1974), p. 274; Millar, *The Queen's Pictures*, p. 210.
45 PRO Work 19/595.
46 PRO Work 19/206; Work 19/829; Work 19/824; MacQuoid, *A History of English Furniture*, p. 146.
47 PRO Work 19/216.
48 James Pope-Hennessy, *Queen Mary 1867–1953* (London, 1959), pp. 524–5. She paid many surprise visits to Hampton Court (*Surrey Comet* (14 May 1927); *Morning Post* (27 April 1912); *Westminster Gazette* (18 April 1923); *Evening Standard* (1 May 1924)).
49 PRO Work 19/215.
50 PRO Work 19/209.
51 PRO Work 19/1042; Work 19/827. See PRO Work 19/600 for fire precautions at the mews.
52 PRO Work 19/1054.
53 Also see N. J. M. Comley, *Saving Britain's Art Treasures* (London, 2003), pp. 6, 64, 113.
54 PRO Work 19/1158. Barbara Bryant, 'Stalwart Young Men: The First Public Picture Conservation Studio', *English Heritage Collections Review*, III (2001), p. 132.
55 PRO Work 19/1161 includes a map showing where these and other bombs fell. Work 19/1058 and Work 19/1095 cover

56 PRO Work 19/818; Work 19/1162.
57 Apartment 24 (now 24a and 24b) was replanned in 1953–4, apartment 17 in 1956–7, apartment 3 in 1957–8, apartment 25 in 1958–9, apartment 42 in 1958–9, apartment 28 in 1958–9 and apartment 26 in 1960–61. This is summarised in PRO Work 19/1219, but individual files show what was undertaken.
58 The Pavilion was made over to the Crown Estate commissioners in 1963 (PRO Work 19/1159).
59 PRO Work 19/1219.
60 PRO Work 19/1219; HRP LRE/D/350/72.
61 The TCC space was increased by the addition of apartment 21 in 1985 (HRP HAM.6000/14).
62 HRP WM.HB.29/2 (3).
63 HRP WM.HB.29/2 (3). The last Superintendent was Ian Gray.
64 Thorneycroft's architects for the conversion were Weston, Lewis, Clarke and Arnold (HRP WM.HB.29/18/2; WM.HB.29/16/1). See also *Building* (17 November 1978).
65 In 1992 the first of three grace and favour apartments was converted into a holiday home for the Landmark Trust. None was in the Wren quadrangle.
66 HRP LRE/D/350/101; HRP SSG/2002/219B; *Financial Times* (1 March 1985).
67 PRO Work 19/574; *Daily Telegraph* (23 September 1930); *Daily Herald* (9 January 1931). See earlier also complaints in *The Times* (4 July 1921).
68 PRO Work 19/842.
69 PRO Work 19/1057; Work 19/1158; Work 19/1215.
70 The work was supervised by John Thorneycroft, his first job at Hampton Court (PRO Work 19/1276).
71 An alternative account concentrating on the technical treatment of the canvases can be found in Andrew Martindale, *The Triumphs of Caesar by Andrea Mantegna in the Collection of Her Majesty the Queen at Hampton Court* (London, 1979), pp. 117–22.
72 Miranda Carter, *Anthony Blunt: His Lives* (London, 2001), pp. 377–9.
73 HRP WM.HB.29/21/5; WM.HB.29/21/8. The rationale behind the picture hang is explained in the minutes of the Lord Chamberlain's walk-round of 8 December 1977 (HRP MAM/8000/1).
74 HRP WM.HB.29/20/1.
75 HRP HAM/6000/12; HAM WS.76010/S.
76 John Bold, *Greenwich: An Architectural History of the Royal Hospital for Seamen and the Queen's House* (New Haven and London, 2000), pp. 89–90; Richard Hewlings, *Chiswick House and Gardens* (official guidebook, 1989), pp. 56–8; Richard Gray, ed., *Audley End* (English Heritage, 1986); Kate Jeffrey, ed., *Audley End* (English Heritage, 1997).
77 Apted, Gilyard Beer and Saunders, *Ancient Monuments and their Interpretation*, p. xvii.
78 I have benefited from a number of conversations with Mr Charlton, to whom I am most grateful.
79 P. MacQuoid and H. C. R. Edwards, *The Dictionary of English Furniture from the Middle Ages to the Late Georgian Period*, 3 vols (London, 1924–7), abridged as *The Shorter Dictionary of English Furniture* (London, 1964).
80 PRO Work 19/1170.
81 PRO Work 19/1218.
82 HRP WM.HB.29/17/1 (1); HRP WM.HB.29/2 (2).
83 EH CB 29/000/C/00.
84 The early mortar mixes from c.1978–90 contained graded crushed chalk since granules were detected in the analysis of historic mortar mixes. This can be seen, for instance, on the repointed elevations on the west front. Later on, changes were made; the French lime, originally supplied by the Société Anonyme des Ciments de Touraine, started to arrive looking greyish and the lumpy mortar was criticised. Most repointing post-c.1990 is without the lumps and is in a greyer lime. The Dove Brothers' contract ended c.1989.
85 HRP WB.HB.29/2 (3).
86 Daphne Ford's archive is now held by the English Heritage National Monuments Record at Swindon. Another twenty to thirty surveys are held at Hampton Court.
87 The palace nurseries were finally removed from the Tiltyard only in 1952 when the Stud House relinquished its garden and the main nurseries were relocated there.
88 PRO Work 16/1086; Work 13/933; Work 16/1067; *Surrey Comet* (3 April 1926); *Illustrated London News* (8 August 1925).
89 PRO Work 16/1649.
90 PRO Work 19/598; Work 19/1163.
91 HRP WM.HB.29/17/8. See *Antiquaries Journal*, v (1925), pl. XIXa; Jean Hamilton, 'Early English Wallpapers', *The Connoisseur*, CXCV (1977), pp. 201–6.
92 The *Daily Telegraph* reported on 14 June 1977 that there was to be an exhibition in Clock Court, and that in 1979 apartments on the north side of the palace were to be opened, and that others to the south of Base Court were to become a picture gallery, commenting that 'the palace promises to become something of a major arts centre'.
93 HRP WM.HB.29/2 (3).
94 *Westminster Gazette* (14 June 1917); *The Globe* (4 October 1917).
95 *Surrey Comet* (15 February, 8, 15 March 1919); *Morning Post* (29 January 1919).
96 H. Avary Tipping, 'The Gardens at Hampton Court Palace', *Country Life* (14 June 1919); *Surrey Comet* (7, 14, 16 June, 27 August 1919). PRO34/1599 is a drawing showing which yews should be replaced.
97 For Bushy Park see Kathy White and Peter Foster, *Bushy Park* (Hampton, 1997), pp. 61–7.
98 PRO Work 1/43 31 January 1854; *VCH, Middlesex*, II, p. 247.
99 White and Foster, *Bushy Park*, pp. 65–7; John Sheaf and Ken Howe, *Hampton and Teddington Past* (London, 2000), pp. 105–10.
100 EH CB 29/075/0/02 PT2.
101 PRO Work 16/1088; Work 16/895.
102 HRP WM.HB.29/2 (3).
103 PRO Work 19/833; Work 19/1093.
104 PRO Work 16/167.
105 PRO Work 16/167.
106 PRO Work 16/1829.
107 PRO Work 1/91 17 March 1870; Work 16/416; Work 6/137/11; Work 16/652. There were also jurisdictional problems over the ownership of the Barge Walk. In 1879 this area had been transferred from the Office of Woods to the Office of Works (except for the foreshore which was a parish responsibility). The towpath had become increasingly used both as a short cut from Kingston to Hampton and for recreation. In 1866 as a result of a cart swerving into the river a boy was drowned and a post and rail fence was put along the water's edge. Meanwhile the automobile lobby claimed that the Barge Walk was a highway and that it was a right of way. The Office of Works conceded that it was a highway, but only to get an order from the Council banning motor vehicles from using it. In 1907 the Office of Works and the District Council jointly made improvements to the Barge Walk (PRO Work 16/1318; Work 16/149; Work 16/168; Work 16/169; Work 16/897). The next set of problems was due to hawkers selling goods on the Barge Walk at the palace gates. This was stopped by the passing of 'The Barge Walk (Hampton Court) Regulations 1934' issued pursuant to the Parks Regulations Act 1872. This introduced rules restricting a range of anti-social behaviour on the walk (PRO Work 16/901).
108 PRO Work 16/1316; Work 16/647.
109 HRP LA/8/9.
110 An anecdotal but broadly accurate story of the fire restoration is Michael Fishlock, *The Great Fire at Hampton Court* (London, 1992).
111 Work 19/1221.
112 The lift contained the Secretary of State and his wife; his APS William Waldegrave; Mr Hornsby; Mr Pain, Directing Architect PSA; Glyn George, the palace security officer; Michael Fishlock, the superintending architect for the PSA; John Thorneycroft, English Heritage architect; Lord Maclean, the Chief Steward; George Cooke, the Superintendent of the Gardens; and Gerald Drayton, the District Works Officer. It was installed in 1983 (PRO Work HRP WS/80043 and *The Times* (1 December 1886), p. 16).

113 HRP HAM.1000/policy.
114 HRP LA/8/9; EH CB/29/000/C/00. *Sunday Times* (23 November 1986).
115 *Evening Standard* (20 July 1987); HRP LA/8/9.
116 HRP RPP/2002/249/E; RPPW/HCP/2 (2).
117 The statistical information in the following paragraphs is taken from Historic Royal Palaces' annual reports, 1990/91–1999/2000.
118 S. Thurley, 'The Sixteenth-Century Kitchens at Hampton Court', *Journal of the British Archaeological Association*, CXLIII (1990), pp. 1–28.
119 *Surrey Comet* (22 August 1925); *Evening Standard* (17 August 1925).
120 PRO Work 19/1130.
121 HRP WS.70010/S; WS.70010/H.
122 See also Richard Hewlings on the kitchens ('History in the Raw', *The Spectator* (7 September 1991), pp. 35–7).
123 O. Millar, 'Caring for the Queen's Pictures: Surveyors Past and Present', in Christopher Lloyd, *The Queen's Pictures: Royal Collectors through the Ages* (National Gallery, London, 1991), p. 17. Throughout the twentieth century there had been two officers answerable to the Lord Chamberlain at the palace: the Housekeeper, who was responsible for liaising with the Office of Works on the building and for looking after the grace and favour ladies; and the Curator of Pictures who was responsible for the works of art. The last curator, Mr Rainbow, had been succeeded as Superindendent of the Royal Collection by Joe Cowell, a museum technician from the Castle Museum at York. In 1979 he was provided with a workshop and two racked picture stores. This was central to the Hampton Court picture strategy discussed above and marked a significant increase in the professionalism of the Royal Household's position at the palace.
124 Girouard was himself inspired by an article written by Hugh Murray Baillie, a former Monuments, Fine Art and Archives officer in Germany after the war, entitled 'Etiquette and the Planning of State Apartments in Baroque Palaces (*Archaeologia*, CI (1967), pp. 169–99). This set out to explain the State Apartments at Hampton Court.
125 PRO Work 19/532.
126 HRP LA/8/8; HRP CEG/100/24/21/8.
127 Historic Royal Palaces, Textile Conservation Studio five-year review, 1991–6. The washing machine is covered in HRP RRP/2002/257/E. Many of the Hampton Court textile issues are discussed in S. Thurley, 'A Conflict of Interest? Conservation versus Historic Presentation, A Curatorial View', in K. Marco, ed., *Textiles in Trust* (London, 1997), pp. 20–24, and Jenny Band, 'The Hampton Court Fire: The Conservation of the Fire Damaged Textiles', *Apollo*, CXL, no. 390 (August 1994), pp. 46–9.
128 PRO Work 19/203; Work 19/211; *The Times* (6 October 1905).
129 The existence of the copies of the cartoons was pointed out by Clare Lloyd Jacob.
130 See for instance John Cornforth, 'Triumph at Hampton Court', *Country Life* (20 August 1992), pp. 42–5.
131 John Fowler and John Cornforth, *English Decoration in the Eighteenth Century* (London, 1974), p. 259.
132 Sarah Howell, 'Who Restored Hampton Court?', *World of Interiors* (December 1995), pp. 66–73.
133 In the early 1960s, in response to a series of comments and questions both in the House of Commons and outside, the Lord Chamberlain set out royal policy for the furnishing of the rooms. It was clear that only items with a secure Hampton Court provenance would be shown in the rooms, a policy that Queen Mary had helped to crystallise in the 1930s (PRO Work 19/1217).
134 PRO Work 19/599.
135 HRP WS.2002/375/A.
136 S. Thurley, ed., 'The King's Privy Garden at Hampton Court Palace 1689–1995', *Apollo* (1995). My own essay (pp. 3–22) explains much more fully the methodology and history of the project.
137 David Jacques, 'A Strategy for the Park and Gardens at Hampton Court Palace', *London Gardener*, II (2) (1996–7), pp. 43–55.
138 The original Trustees were Field Marshall the Lord Inge of Richmond, Lord Camoys, Michael Herbert, Angela Heylin, Simon Jones, Sir Michael Peat, Sir Hugh Roberts and Jame Sharman.
139 This observation is personal and not made in my capacity as a representative of any organisation with which I am associated.

Photograph Sources and Credits

© Historic Royal Palaces. Photograph: Joshua St John: frontispiece, 41, 43, 54, 85, 101, 107, 117, 118, 209, 219, 247, 254, 330, 413; Crown copyright: Historic Royal Palaces: p. vi, 7, 11, 12, 20, 21, 22, 24, 28, 32, 33, 36, 38, 46, 47, 48, 55, 56, 59, 62, 65, 67, 83, 89, 113, 127, 148, 149, 150, 151, 172, 181, 183, 184, 192, 199, 202, 205, 213, 215, 218, 224, 230, 237, 238, 240, 243, 246, 251, 252, 267, 270, 271, 272, 276, 279, 283, 285, 286, 297, 303, 329, 331, 335, 337, 338, 342, 343, 354, 355, 361, 364, 363, 365, 371, 379, 382, 383, 386, 387, 392, 393, 394, 396, 397, 400, 401, 402, 403, 404, 405, 406, 407, 409, 410; Crown copyright: Historic Royal Palaces. Photograph: Earl Beesley: 1, 185, 188, 190, 193, 288, 369, 398; © Historic Royal Palaces: 2, 3, 8, 9, 10, 14, 16, 19, 26, 27, 29, 31, 39, 40, 42, 49, 60, 61, 63, 68, 73, 76, 77, 78, 79, 81, 82, 87, 88, 96, 98, 99, 104, 111, 116, 119, 122, 123, 132, 144, 153, 173, 174, 175, 182, 187, 207, 226, 257, 260, 309, 326; Courtauld Institute of Art: 5, 126, 203, 289; © Copyright The British Museum: 6, 115 (Sh vol. 23, p. 20, no. 44), 201 (1881-6-11-165), 225 (1961-4-8-1), 265, 274 (1936-6-4-4), 340, 341 (1860-07-14-40); English Heritage/NMR 13, 18, 23, 30, 35, 45, 66, 75, 95, 102, 106, 220 (RAF Photography), 278, 361, 380; © LBRUT Orleans House Gallery: 15, 50, 261, 266, 290; Ashmolean Museum, Oxford: 17, 25, 70, 92, 100; Musées Royaux des Beaux-Arts, Brussels: 37; British Architectural Library, RIBA, London: 51, 52, 74, 155, 168, 176, 177, 210, 222, 304; © The State Hermitage Museum, St Petersburg: 53, 255, 291, 293, 344, 345, 346, 347, 348; The Pepys Library, Magdalene College, Cambridge: 57 (PL 2972 210-11), 93 (PL 2972 209a–b), 216; The Austrian National Library: 58;

© Skyscan.co.uk: 64, 389; The Royal Collection © 2003 Her Majesty Queen Elizabeth II: 69, 97, 108, 125, 157, 186, 189, 191, 197, 200, 204, 217, 245, 248, 259, 273, 282, 308, 380; The College of Arms, London: 71 (M6 f. 82v), 72 (M6 f. 77v-78); By permission of the British Library: 80 (Add MS 33767 (b) f. 66), 287 (Add MS 34873 f. 87, no. 227); Crown copyright: Historic Royal Palaces. Photograph: Cliff Birtchnell: 83, 194, 411, 412; © Crown copyright. NMR: 84, 229, 268, 275, 307, 317, 318, 319, 323, 328, 368, 367, 370, 372, 376 (RAF Photography), 378, 399; By courtesy of the Marquess of Salisbury: 86; Private Collections: 94, 124; Country Life Picture Library: 103, 276, 308, 353; The University of Utrecht: 105 (MS 1198 f .143v); Collection of the Duke of Northumberland, Photographic Survey, Courtauld Institute of Art: 109; The Public Record Office: 112 (MPE 1/500), 140 (Work 34/112), 227 (Work 32/311), 232 (Work 32/310), 248 (Work 34/32), 249 (Work 34/37), 253 (Work 34/44), 275 (Work 34/104), 292 (Work 34/61), 294 (Work 34/67), 296 (Work 34/74), 295 (Work 34/575), 298 (Work 34/617), 299 (Work 34/623), 300 (Work 34/623), 301 (34/594), 303 (Work 34/84), 311 (Work 34/635), 332 (Work 34), 333 (Work 34), 334 (Work 34), 350 (Work 34/1349), 390 (Work 34/1595); The Family of John Adams of Holyland, Pembrokeshire/Photograph: Shannon Tofts: 114; Bodleian Library, University of Oxford: 120; Guildhall Library, Corporation of London: 121, 161; The Trustees of the Sir John Soane's Museum: 127, 128, 130, 133, 134, 136, 142, 143, 145, 162, 163, 164, 165, 166, 169, 170, 178, 195, 211, 231, 234; The Warden and Fellows of All

Souls College, Oxford: 129 (I.10), 131 (II.116*), 135 (IV.17), 139 (IV.4), 158 (I.91), 160 (I.93), 196 (IV.2), 221 (IV.12), 228 (IV.15), 234 (IV.6), 236 (IV.9), 239 (IV.10), 264 (I.57); V&A Picture Library: 138, 152, 156, 214, 310, 349; Henry E. Huntingdon Library, California (STB Box 1 (45)): 147; Sotheby's: 154, 357; The Society of Antiquaries of London: 159, 306; Cooper-Hewitt, National Design Museum, Smithsonian Institution: 167; Yale Center for British Art, Paul Mellon Collection/Bridgeman Art Library, London: 179; A. C. Cooper: 199; Rijksmuseum, Amsterdam: 208; Museum Boymans-van Beuningen, Rotterdam: 212; Crown copyright: Historic Royal Palaces. Photograph: Jan Baldwin: 241, 242, 244, 408; Yale Center for British Art, Paul Mellon Collection: 262, 263; Crown copyright: 269, 330, 385, 395; Bridgeman Art Library, London: 281; David Best: 284; Christie's: 282; Private Collection/Bridgeman Art Library, London: 307; Photograph courtesy of Bentalls, Kingston: 310; Museum of London: 34, 315; The *Illustrated London News* Picture Library: 313, 333, 384; London Transport Museum Picture Library: 314; Bristol Record Office, Sir George White Collection: 315; The Collection of L. W. Strudwick: 316; copyright Hulton Deutsch Collection: 337, 355; Birmingham Library Services: 351; © Historic Royal Palaces. Photograph: Vivian Russell: 358; Topham Picturepoint: 362; *The Times*: 373; Brenda Jean Haines (*née* Cole): 374; Private Collection (Mrs E. Thornhill *née* Durndell): 375, 388; The London Fire Brigade: 391.

Index

Page references for figures are in *italics*; those for notes are followed by n

Abbotsford 295
Abraham, Thomas 16
Abraham (tapestry) 52, 112, 196, 295, 316
Acts of the Apostles (Raphael) *see* Raphael cartoons
Acts of the Apostles (tapestry) 389–90, 393
Adam, Lady 337
Adam, Robert 287, 288, 374
Adelaide, Queen 292, 294, 303
Admiral's Gallery 253
 see also Communication Gallery
Admiralty 352
Adonis (sculpture) 127
Aelfgar, Earl of Mercia 1
Aglionby, William 246
Airlie, Lord *see* Ogilvy
Albemarle, Earl of *see* Keppel
Albert, Prince Consort 292, 293, *293*, 303, 312, 313, 335
Alcock, Nicholas 177
Alesbury, Millicent 96
All Souls, Oxford 35
Allan, Juliet 376
Allan and Ford 388
Allen, Elias 224
Allen, Thomas Newland 382
Alleyn, Edward 107–8
altarpieces 217–18, *217*, *218*, 219
Amalia, Princess 173
Ambroise, Georges d' 105
Amelia, Princess (daughter of George II) 245, 253, 256, *268*, 270, 272, 277, 283–4
Amenities Scheme 378
Anglesey, Countess of 123
Angustyn, Brise 92
Anne, Princess (daughter of George II) 245, 253, 256, *268*, 272, 277
Anne, Queen 145, 151, 182, 211–12
 at Hampton Court 216–17
 bed 365, 366, *367*, 419n
 Chapel Royal 217–19, *217*, *218*, *219*, 307
 courtier lodgings 325
 Drawing Room 213, *214*
 gardens 223, *228*, 233, 237–40, *239*, 240, *241*, 242, *242*, 341
 with George at Hampton Court 213, 215–16
 palace engravings 219–21, *220*
 roads 266
 Verrio and the King's Staircase 212–13, *212*

Anne de Montmorency 32–3
Anne of Denmark 107–8, 109–10, 116–17, 247
Anne of Cleves 73, 74
Anne Boleyn's Gate 7, 20, 24, 51, 215, 276
 restoration 303–4, *304*
Anne Hyde as Duchess of York (portait) 199
Annebaut, Claude d' 75
antlers 117–18, *117*, 146, 410n
Apollo (sculpture) 127, 235
arbours *19*, 92, 95
Arbuthnot, John 216
archaeology 358–9, 386
Architect of Works 287
Architectural Review 309
Arethusa (sculpture) (Le Sueur) 127, 223, 225, 230, 240, *240*
Argenville, Dézallier d' 240
Argyll, Duke of *see* Campbell, John
armour 79, 80, 198, 295, *321*
Arthur (draughtsman) 259–60
Arundel, Richard 267
Ashbee, C. R. 361, 374
Ashburnham, John 121
Ashby de la Zouch Castle, Leicestershire 92, 95
Ashmole 141
Ashmolean Museum, Oxford 390
Ashurst, John 376
astronomical clock 42, 72–3, 109, 146, 303–4
Athelhampton, Dorset 361
Athelstan, King 1
Athenæum, The 303
Atkinson, William 298
Aubigny, Lady d' 123
Audley End, Essex 136, 295, 342, 357, 374
Audran, Gérard 186
Augusta, Princess of Wales 282
Augustus (roundel) 24, *25*
Austin Seely and Company 352
Avebury, Wiltshire 361
avenues 229, 232, 233, *234*, 236, 240, 380, *381*
aviary 191, 193

Bacchus (sculpture) 235
Badajoz, Bishop of 27, 31
Baden Powell, Lady *331*, 378, 388
Bagol, Mrs 302, *302*
Bailiffscourt, Sussex 361
Baines, Sir Frank 358
bakehouse 45, 47
Baker, C. H. Collins 365
Ball, John 184, 245, 277

Baly, Miss 337
Banckes, Matthew 171
Band, Jenny 389
bank holidays 319
Bankes, William John 295
Banqueting House *193*, 359–60, 374
 George II *268*, *273*, 277
 grace and favour use *324*, 337–8
 William and Mary 191–3, 202, 208
Barberini, Cardinal 146
Barge Walk 273, 274, 348, 432n
barges 115–16, 168
barracks 133, 182, 284, 321–2, *322*, 378, 393, 395
Barrington Court, Somerset 104
Base Court
 Charles II 146
 cobbles 60
 excavations 359
 George I 260
 grace and favour apartments 371
 Jesse's restoration 299
 Lessels's restoration 305
 tapestries 26–7
 twentieth century 373, 374, 376, *377*, 378
 Wolsey 12, 16, 17–21, *18*, *21*, 24, 26, 31
Basilikon Doron (James I) 111
Basill, Simon 129
Basing, Hampshire 13
Batchelor, David 359
Bath stone 305
Bathroom (Queen's Apartments) 250, 251, *251*
Battle Abbey, Sussex 295
Battle of Pavia, The 113
Battle of the Spurs, The 113
Bayne Tower 49–50
Bazalgette, Joseph 330
Bealing, Richard 182, 202, 204
Beaulieu, Essex 29, 43, 70, 124
Beaumont, Guillaume 229
Beauties (Kneller) 194, 284
Beckford, William 288
Bedchamber (organisation) 131, 156, 204, 216
bedchamber (room) 153
 see also King's Bedchamber; King's Great Bedchamber; King's Little Bedchamber; Queen's Bedchamber
Beddington 51
Bedford, Earl of *see* Russell, William
beds
 Anne 213, 365, 366, 419n
 Charles II 138–9, *205*, 388

435

Charlotte 315, *315*, 365, 366, 374
George II 315
Henrietta Maria 113
Raynham Hall 393
William III 151, *155*, 204, 265, 315, *315*, 374
Beeton, David 386, 388, 395, 398
Belasyse, Thomas, Earl Fauconberg 126
bells 7, 73
Benese, Richard 72
Bennet, Henry, first Earl of Arlington 135
Bennet, Mansell 216
Bennett, W. J. 295
Benson, William 260–62, 264–5, 275, 278–9
Bentalls store 309, *310*
Bentinck, William (Hans Willem) *see* Portland, first Earl of
Beresford, Major William 293, 328
Berkeley, Sir John 121
Berkeley House, Piccadilly 140
Bernasconi, Francis 288, 289
Bernini, Gianlorenzo 152, 153, 163, *166*, 168
Bernstorff, Baron 245
Bickham, George 217, 284, 290, 403n
bicycles 352, *354*
Biddle, Martin 359
Bidloo, Dr 208
Birdwood apartment 371
Bishop, William 5
Blackwell, Edmund 124, 125
Blankston, Henry 56, *56*, 58, 60, 63, 66, 72, 92
Blathwayt, William 236
Blecher, John 309
Blenheim Palace 213, 240, 242, 251, 256
Blois, château of 153, 414n
Blomfeld, General 292
Blomfield, A. C. 309
Blomfield, Reginald 308–9, *310*
Blore, Edward 296, 298–9, 302
Blowfield, Mrs 127
Blunt, Anthony 373–4
Board of Works
 Capability Brown 345
 gardens 352
 George I 327
 grace and favour apartments 329, 330, 332
 Jesse's restoration 294, 295, 296
 Lessels's restoration 303
 Prince of Wales's apartments 365
 tourism 368
 see also Office of Works
Bogdani, Jacob 172, 192, 199
boiler house 305, *306*
boiling house 47, *47*, 49, 135
Boleyn, Anne 26, 41, 43, 65, 290
 arms 60, *63*, 303
 Queen's Lodgings 55, 56, 57–8
 see also Anne Boleyn's Gate
Boleyn, Sir Thomas 29
Bolton, A. T. 358
Bonde, Christer 128
Boonen, William 85
Booth, Abram *110–11*, 111
Booth, Henry, second Baron Delamer and first Earl of Warrington
Boswell, James 347
Bothmer, Baron 245
bowling alleys 92–3, 95, 111, 224

Bowling Green Pavilions 190–91, *190*, 283–4, 337, 338–9, *338*, *339*
bowling greens
 Charles I 111–12, 225
 Charles II 140, *227*
 Cromwell 128
 Tilt Yard Gardens 378
 William and Mary 190–91, *190*, *191*, *192*, 235
box 238–9
Boyle, Richard, third Earl of Burlington 246, 275, 279
Brackyn, Mr 217
Braderton, Hugh 96–7
Bradgate, Leicestershire 14
Bradley, Langley 215–16
Bradshaw, John 127
Bradshaw, Laurence 96
Brandon, Charles, first Duke of Suffolk 70, 99
Breadalbane, Lord 292
Brent, Elyn 9
Brereton, William 58
Brett, Reginald Baliol, Viscount Esher 356
Brewer, J. Norris 290
brickwork 27, 72, 376, 377, *377*
 Base Court 16, 18, 20
 chapel 35
 Henry VIII 44
 Long Gallery 22
 Tudor revival 302
 William and Mary 168
Bridewell 15, 29, 43
Bridgeman, Charles 227, 237, 240, *241*, 242, 267, 341, 343, 429n
bridges
 across Thames 284–5, *284*, 382
 west front 60, *62*, 146, 306–8, *308*
Brigge Court, Battersea 14, 15, 16
Brighton Pavilion 335–6
Britannia Illustrata (Knyff and Kip) 219, 220, *221*, 236, 342
British Museum 317, 321
Britton, John 320–21
Broad Walk 242, *369*, 379
Bronze Age 1
Bronzino, Agnolo 114
Brooke, Lord *see* Greville
Brooke, Margaret, Lady Denham 129
Brown, Mr 314, 316
Brown, Lancelot ('Capability') 343, 345
Brown, W. 349
Browne, Sir Anthony 71
Brummell, William 327
Brydon, John McKean 308
Buckingham, Duke of *see* Stafford, Edward; Stafford, Henry
Buckingham Palace 287, 298, 310–11, 327, 366, 370
Buckingham Palace (Smith and Hussey) 366–7
Buckler, John C. 52
Buckley, Wilfred 309
Building Conservation Association 371, *371*
Building Conservation Trust 371
Buildings of England, The (Pevsner) 358
Bull, John 211
Bulmers 376
Burghley House, Northamptonshire 100, 103–4, *103*, 188, 202, 208

Burgundy 89, *91*, 100
Burlington, Earl of *see* Boyle
Burlington House, Piccadilly 246
Burnet, Gilbert 206
Burnet, Thomas 255
Burrell Collection, Glasgow 391
Burton, Henry 44
Burward, John 120
Bushy House 292, 294, 303, 327, 352
Bushy Park 4
 Anne 221, 240, *240*
 Bronze Age burials 1
 Chestnut Avenue *161*, 163
 Commonwealth 124, 125
 George I 267
 George III 292, 347
 George IV *293*, 347
 Henry VIII 97
 nineteenth and twentieth centuries 234, 254, 352, 379–80, *379*
 Upper Lodge 215, *215*
 Victoria 303
 William and Mary 153, 229, 233, 237
Bute, Lord *see* Stuart, John
Byfleet 4, 5

Cadogan, William, first Earl Cadogan 280–81
cafeterias 378–9, *379*, 391
Caithness Staircase 247, 274
Callendar, Professor Geoffrey 374
Camber, Sussex 95
Cambridge, George William Frederick Charles, second Duke of Cambridge 323
camerae 4, 6
Camp Griffiss 234, 379, *380*
Campbell, Colen 162, 220, 260, 261–2, 265, 423n
Campbell, Donald 261
Campbell, John, second Duke of Argyll, 248
Campeggio, Cardinal 63
canals 227, 229
canopies 112–13, 132, 197, *201*, 256, 366
Capell, Sir Henry 171
car parks 378
Cardinal College, Oxford 43, 51
Carew, Sir Nicholas 51
Carey, Michael 374
Carib, C. A. 337
Carless, R. J. 305
Carleton, Sir Dudley 107, 108
Carlton House 289
Caroe, W. D. 361
Caroline, Princess (daughter of George II) 245, 253, 256, *268*, 270, 277
Caroline, Queen 245, 246
 1733 visit 277
 bathroom 251
 bed *315*, 365
 bedchamber 244, 247, *250*
 court's last visit 282
 and Duke of Cumberland 275
 first visit as queen 269–71
 gardens 341
 portrait 343
 as Princess of Wales 248, *249*, 250–51, 253, 254, *254*, 255, 256–7, 265
 Privy Chamber 246
 Queen's Drawing Room 317

refurnishing 271
Sideboard Room *251*
visit of 1731 272, 274–5
Whitehall Palace 279
Carpenter, Joseph 341
carpets 113
carriages 147, *148*, 149, 232, 266, 317, *318*
Carter, Edward 120, 125
Carter, John 295
Carteret, Sir George 134
Cartoon Gallery 22, *290*, 389, 392
1986 fire 383, *384*, *386*
Anne 217
George I 255
George III 310, *311*
Victoria 313–14
William and Mary 166, 168, 184–6, *185*, *187*, 194, 198, *198*, 200, 202
Cartwright, William 112
Carus, Dr 311, 312
Castle Ashby 115
Castle Howard 160, 163, 190
Castlemaine, Lady *see* Villiers
Caswell, Mr 125
Catenaro, Giovanni Battista 213
Catharine the Great 343
Catherine of Braganza 129, 132–4, *134*, 140, 145, 146, 172, 173, 225
Cattermole, R. *210*, *247*, *256*, *283*
Caus, Salomon de 223
Cavendish, Evelyn, Duchess of Devonshire 310
Cavendish, George 33
Cavendish, William, first Duke of Newcastle 153
Cavendish, William George Spencer, sixth Duke of Devonshire 310
Cawarden, Sir Thomas 75, 80–81
Cawthorne, Richard 206
Cecil, William, Baron Burghley 81, 82, 100
chamber-blocks 6, *6*, 8, 10, 14
Chamber of Estate 50, 104
Chamber of Presence 33
Chamberlain, John 107
Chambers, Sir William 287, 288, *288*, 303, 304–5
chandeliers 204, *291*
Chapel Court 54, 108, 136, *138*, 334
Chapel Gallery 282, 359, 391–2
Chapel Royal *297*
Anne 217–19, *217*, *218*, *219*
Charles I 120–21
Charles II 132, 135
Cromwell 126, 127, 128
Elizabeth I 87
George I 254–5
George II 274, 282–3
grace and favour worship 330, 332, *332*
Henry VIII 56, 63–4, *64*, *65*
James I 109
James II 145
Jesse's restoration 296, 298
Lessels's restoration 305–6
twentieth century 361, 362, *364*, 365, 376, 392
William and Mary 206–7
Wolsey 27, 34–7, *35*, *36*, *37*, 41
chapels
Catherine of Braganza 133
Henrietta Maria 112
Hospitallers 6–7, 10

Privy Closet 59–60, 63
Chapman, John 89
Chapuys, Eustace 70, 74, 115
Charles, Emperor of Germany 270, 274
Charles, Prince of Wales 358
Charles I 107, 109, 119–21, *120*
accession 110–11
court pastimes 111–12
diplomatic protocol 116
furnishings 112–15, 173, 196
gardens 223–5
hunting 117
imprisonment at Hampton Court 121–2
lodgings 109
medallions 179, *181*
paintings 185, 198–9
portraits 113, 121, *122*, 147, 199
Charles I on Horseback with M. de St Antoine (Van Dyck) 113, 121, 147, 199
Charles II 121, 123, 129, 131, 151, *153*
arrival of Catherine of Braganza 133–4, *134*
bed rails *205*, 388
bedchamber 247
building campaign 136–40, *137*, *138*, *139*, *142*, *144*
Chapel Royal 217
gardens 225, 227, 229
Great Plague 135–6
honeymoon preparations 132–3
household reforms 135
hunting 147, 149
later visits 141, 143
porcelain 173
stylistic changes 145–7
Tennis Court 131–2, *131*
and Verrio 202
and Barbara Villiers 140–41
Wren 152
Charles V, Holy Roman Emperor 16, 27, 32, 80
Charles X, King of Sweden 128
Charles with James, Duke of York (Lely) *122*
Charlotte, Queen 315, 365, 366, 374
Charlotte, Elizabeth 209
Charlton, John 357, 358, 370, 373, 374, 395
Chart, E. 306, 361
Chastleton, Oxfordshire 104
Chatsworth House, Derbyshire 115, 188, 208, 310
bathroom 251
Chapel Gallery 177
gardens 236, *236*
Great Chamber 256
lacquerwork 173
marquetry 219
plasterwork 172
south front 168
staircase 213
Chelsea Hospital 163, 219
Chelsea Town Hall 308
Cheminées à la Moderne (Le Pautre) 179, *181*
Chenies, Buckinghamshire 14, 20
Chestertons 371
Chestnut Sunday 352, *354*, 378, 430n
Chettle, George 357, 358, 374
Chevening House 262
Chiffinch, Mr 138
Chiffinch, William 146
chimney-pieces *29*, 179, *180*, *181*, 256

chimneys 18, 20–21
Chiswick House 374
chivalric eclecticism 99–102, 105
Cholmley, Hugh 245
Christ Church, Oxford 16, 17, 112, 276, 402n
Christian IV, King of Denmark 102, 109
Christian IV of Denmark (portrait) 199
Churchill, John, first Duke of Marlborough 390
Churchill, Sarah, Duchess of Marlborough 216
Cibber, Caius Gabriel 167, 183, *236*
Cibber, Colley 261, 274
Cignani, Carlo 296
Civil War 123–4
Clark, Kenneth 366
Clarke, James 285
Clarke, T. H. 290
Claypole, Betty 126
Claypole, John 126, 127
Clayton, John 308
Clement, William 51, 54, 63, 66, 71, 72, 95
Cleopatra (roundel) 24
Cleopatra (sculpture) 127, 225
Cleopatra (tapestry) 141
Clerk of Works 288
Cleveland, Duchess of 140–41, 143, 172, 215
Clifton upon Teme, Worcestershire 177, *177*
Clinton, Henry Pelham Fiennes Pelham, fifth Duke of Newcastle under Lyme (styled Earl of Lincoln) 328
Cliveden House, Buckinghamshire 245
Clock Court 6, *52*, 378
east range 27, *28*, 29–30, *29*, *30*
excavations 10, *10*, 358–9
George I 260
George II 275–7, *277*
Jesse's restoration 294, 299, 302–3
roundels 24, *25*
see also Fountain Court
clocks 42, 72, 109, 146, 215–16, 303–4
Cloister Court 146
Cloister Green Court 56, 68
coach house 85, *85*
coaches 147, *148*, 149, 232, 266, 317, *318*
coalhouse 47
Cobbold, Cameron 370, 374
Cobham Hall, Kent 289
Cockerell, C. R. 308, *309*
Coke, Humphrey 43
Coke, Thomas 194, 253, 261
Coldstream Guards 219
Cole, Henry 312–13, 320, 351
Cole and Sons 361
Coligny, Gaspard de 80
Colin Clout (Skelton) 27
Coling, Richard 141
Collège des Quatre Nations, Paris 153, 156, 163
Colne (river) 223
Coltman, Robert 4–5
Colvin, Sir Howard 358, 376, 377
*Comming of y*e *King's Ma*tie *and y*e *Queenes from Portsmouth to Hampton court, The* (Stoop) 134, *134*
Commonwealth 125–8, 225
Communication Gallery 182, 194, 253, 313, 371
Compton, Henry 206
Compton, Sir William 31
Compton Wynyates House, Warwickshire 31, 115

Coningsby, Lord 219
Conway, Edward 111
Cook, Alan 359
Cook, Thomas 131
Cooke, George 380
Cooke, Henry 200, 390
Coombe conduits 73, *73, 74*, 112, 285, *285*, 322–3
Cooper, Anthony Ashley, first Baron Ashley and first Earl of Shaftesbury 124, 147, 260
Cooper, Anthony Ashley, third Earl of Shaftesbury 260
Cooper, Henry 129
Copt Hall, Essex 103
Corant, Henry 60, 63
Cornwall, Duchy of 4
Corps of Invalids 219, 321
Cosimo III, Grand Duke of Tuscany 83, 145, 147
Cotessy brickworks 302
Cotehele House, Cornwall 114–15, *114*, 295
Cottage Gardener 348
Council Chamber 44, 49, 141
Country Life 307
Course, the (Home Park) 97
Cousin, Peter 192, *193*, 212
Cowell, Joe 383, 433n
Cowper, Mary, first Countess Cowper 248, 250, 270
Cox, David, Junior *240*
Cox, George 341
Craib, William 294
Craig, Charles Alexander 288
Crane, Sir Francis 112
Cranmer, Thomas 74
Critz, John de 111
Croft-Murray, Edward 212, 213
Crofton, Mrs 333
Cromwell, Frances 126
Cromwell, Mary 126
Cromwell, Oliver 117, 121, 122, 145
 at Hampton Court 126–8, *128*
 gardens 223, 225
 New Hall 124
 as Protector 125–6
 stud 147
Cromwell, Richard 127
Cromwell, Robert 16
Cromwell, Thomas 16, 41, 70, 72
Crosby, Sir John 63
Crosby Hall 63
Crown Estate Commissioners 371
Croxall, Reverend Samuel 330
Croydon 20, 21, *21*, 41
Culverden, William 73
Cumberland and Strathearn, Henry Frederick, Duke of 338
Cumberland Suite 275–7, *278*, 279–80, *279*, *281*, 360–61, 392
Cuppage, Miss 335
Curnow, Peter 359, 374, 376
Curt, Louis de 316
curtains 196–7, *375*, 376
Cust, Lionel 365
cycle meets 352

D. H. Evans, Oxford Street, London 309
Dahl, Michael 253
Daily Sketch 350
dairy 172, 229
d'Albon, Jacques 80
Dallaway, Reverend James 290
DAMHB 357, 359, 370–71, 376, 383, 386, 388, 390
Dancing Room *see* Music Room
Danckerts, Hendrick 57, *67*, 146
Daniel, Samuel 108
Danvers, Sir John 223
D'Arcy, James 147
Darlington, Sophie Charlotte, Countess of *see* Kielmansegge, Madame
Dartmouth, Lord *see* Legge, George
Daubeney, Giles, first Baron Daubeney 8–14, *8*, 15, 17, 22, 378
 Clock Court 358–9
 kitchens 45, 49
 parks 97
 Tennis Court 53
Daubeney, Henry 14, 15
D'Aulnoy, Countess 149
Davidson, Brian 359
Davila, Marquis de Flora 116
de Bellaigue, Sir Geoffrey 374, 388
DeCritz, John 118
Deeplove, William 153
deer 355
 Anne 221
 George I 267
 Stuarts 117, 147
 Tudors 70, 97
 twentieth century 379, 380–81
 William and Mary 232
Defoe, Daniel 172–3, 238, 341, 414n
Delamer, Lord *see* Booth, Henry
delftware 173, *173*, 174, 189
Deliciae Britannicae (Bickham) 284, 290
Denely, C. 127
Denham, Sir John 129, 139
Denmark House *see* Somerset House
Dent, John 359
Denton, Lionel 9
Department of Culture, Media and Sport 357, 398
Department of the Environment (DoE) 357, 358, 376, 383, 385, 386
Department of National Heritage 357, 398
Devonshire, Duke of *see* Cavendish, William George Spencer
Devonshire, Duchess of *see* Cavendish, Evelyn
Dickens, Charles 328
Dickinson, Christopher 43, 49, 51, 54, 60, 66, 71, 72, 85, 95, 277
Dickinson, William *249*
Dieren 151, 167, 229
dining rooms 153
 see also Eating Room; King's Private Dining Room; Public Dining Room; Queen's Private Dining Room
diplomatic activity 32, 115–16, 205–6, 270
Directorate of Ancient Monuments and Historic Buildings 357, 359, 370–71, 376, 383, 386, 388, 390
Ditchley Park, Oxfordshire 117–18, 251
Ditton avenue 232
Dobson, William (maze keeper) 351
Dobson, William (painter) 147
Docwra, Thomas 15–16
Doddington, Lincolnshire 104

Domesday Book 1, 2–3
Domestic Architecture of England during the Tudor Period, The (Garner and Stratton) 359, 361
Domestic Architecture of the Reigns of Queen Elizabeth and James I, The (Clarke) 290
Donald, James 349
Dorigny, Nicolas 217
Dorling, Reverend E. E. 307
Dorset, Duke of 283
douche 24, 105
Douglas, Lady Margaret, Countess of Lennox 247
Doulton brickworks 302
Dove Brothers 376
dovecotes 7
Downes, Kerry 166
drawing rooms (event) 206, 216, 270
drawing rooms (room) *see* King's Drawing Room; Private Drawing Room; Queen's Drawing Room
Drayton, Michael 276
du Cerceau, Jacques 89, *91*
Duckett, George 255
Dudley, John, Duke of Northumberland 79
Dudley, Robert, Earl of Leicester 86, 87
Duncannon, Lord *see* Ponsonby, John William
Duppa, Thomas 141, 418n
Duveen, Joseph, Baron Duveen 366
Dyrham Park, Gloucestershire 189

Earle, Sir Lionel 359, 365, 371
Early Renaissance Architecture in England (Gotch) 361
East Barsham, Norfolk 302
east-front gardens 238, 242, 274, *274*, 347
East Moseley 169
Eastbury House, Dorset 260, *260*
Eastlake, Sir Charles 305, 313
Eating Room 194, 206, 270, 271, 312, 390
Edgcumbe, Colonel Piers 114
Edward, the Black Prince 4
Edward, Prince (brother of Prince Rupert) 134
Edward I 4
Edward III 4, 5
Edward IV 7, 22, 45, 51
Edward VI 68–70, *68*, *69*, 75, 79–80, 101, 406n
 gardens 96
 Great Hall 52
 portrait 113
Edward VII 303, 308, 357–8, 365
 gardens 356
 stud 380
 tapestries 389
 Tijou screens 352
 west-front bridge 306, 307
Edward VIII 382
Edwards, Ralph 374
Eisenberg, Peter 102
Eisenhower, General 379
Ekeblad, Johan 128
electricity 336, 337
Elizabeth, Princess (daughter of Charles I) 121
Elizabeth I 81–4, 100, *103*, 406n
 building works 84–7, *84*, 102–3
 Edward VI's christening 69
 gardens 92, 97
 hunting 97
 kitchens 49

Privy Chamber 104
Richmond Palace 101
Elizabeth II 358, 371, 383, 390, *391*
Elizabeth of Bohemia 107, 109, 221, 247
Elizabeth of Bohemia (portait) 199
Elizabeth of York 9, 10
Ellis, Sir Arthur 336
Ellis, Sir Henry 303
Ellis, Thomas 287
Ellis, Trevor *391*
Elmes, James 308
Elsynge, Enfield 14
Eltham Lodge 140
Eltham Palace 22, 36, 43, 45, 47, 51, 362
Elton, Rodney, second Baron of Headington 380
Ely Place *34*, 35
Embree, John 125–6, 127
Embroiderers Guild 371
embroideries *175*, *176*
Emmett, William 177
English, Jasper 215
English Decoration in the 18th Century (Fowler and Cornforth) 390
English Heritage 323, 357, 385, 386
English Kitchen 262
English Vineyard Vindicated, The (Rose) 227
Entombment of Christ, The (Titian) 113
Environs of London, The (Lysons) 290
Eric XIV, King of Sweden 82
Erlanger, Baron Emile d' 389
Erlanger, Edmund d' 389
Esher, Viscount *see* Brett
Esher Place 19, 275–6, *276*
Esselens, Jacob *148*
Esther series (tapestries) 127
Eton College 16, 17, 18, 35, 43, 120
Evans, Robin 397
Evelyn, John 121, 134, 146, 176, 227, 237
Evening Standard 365
Ewart, william 317
Ewbank Preece 383, 385
Exeter, Earl of 202
extent of 1338 4–5

Faber, John 284
Fane, Sir Spenser Ponsonby 333
Fanelli, Francesco 225
Fanshawe, Sir Richard 121
Faraday House 337
Fehr, H. C. 361, *362*
Ferdinand, Cardinal-Infant 113
Festival of Britain 358
Fetti, Domenico 113
Fiennes, Celia 173, 176, 184, 217
Finch, Daniel, second Earl of Nottingham 152
Finch, Karen 371
Finet, Sir John 115
fires 332–3, *333*, 335–6, 369
 1353 5
 1605–6 45, 47
 Great Fire of London 136
 1770 287
 1882 315
 1886 68
 Second World War 368–9
 1952 360–61
 1986 357, 371, 383, *383*, *384*, 385–6, *385*, *386*

Fish Court *47*, 49
Fisher, Joseph 380
Fishlock, Michael 385
Fitch, John 171
Fitzgerald, J. 306
Fitzgerald, W. H. 330
Fitzroy, Anne, Countess of Sussex 140–41
Fitzroy, Henry, first Duke of Grafton 215, 281
FitzRoy, Lady Augustus 327
Fitzwilliam, Sir William 41, 43
Five Eldest Children of Charles I, The (Van Dyck) 113, 121
Flaxman, Percy 388
Flitcroft, Henry 281, 287
Florentius, Balthazar *225*
Floris, Hendrick 229, 231
flower paintings 199
Flower Pot Gate 233
Flower Show 387, 398
Flowre, Thomas 54
font 332, *332*, 365
Fontainebleau 51, 80, *91*, 105, 227
Ford, Daphne 359, 376–7, *377*, 386, 388, 403n
Forman, John 16
Fort, Thomas 245, 248, 254, 266, *266*, 269, 325
 and Benson 261, *262*, 263
 Coombe conduits 285, *285*, 322
 fire engines 332
 glass houses *232*
 gothic architecture 277
 Grand Court 260, *260*
 Music Room 256
 Queen's Apartments 246, *246*, 247, 251
 Tennis Court 131, *131*
 Wolsey's domestic range 27, 275, *275*
Foscarini, Antonio 116
Fountain Court ii, 26, 60, 61, *75*, 150, 305
 Charles II 146
 Elizabeth I 87, *87*
 excavations 22
 fountain 95
 George I 247, 248, 325, 327
 grace and favour apartments 329, 371
 roundels 24
 stacked lodgings 104
 twentieth century 378
 William and Mary 89, 152, 166, 182, 183–4, *184*, 233, 325
 Wren revival 308
 see also Clock Court
Fountain Garden 239–40, *239*, 343, *343*, 347, 348
fountains 87, *87*, 95, 223, 225, 239, *240*
Four Seasons (Laguerre) 166
Fowler, John 390
Fox, Bishop 31
Fox, George 126, 141
Fox, Sir Stephen 135, *139*, 140
France 75
 architecture 100, 105, 153, 156, 163, 166, 168, 170, 174
 beds 204
 culture and court etiquette 51, 153, 206, 208–9
 embassy visits 16, 32–3, 34, 52, 80, 110, 115, 116
 gardens 89, *91*, 190, 223, 229, 240
 prints of royal residences 342
Francis I, King of France 24, 51, 105
Frederica, Princess of Hanover 337, 428n

Frederick, Prince of Wales (son of George II) 245, 247, *268*, 271–2, 274, 275, 277, 282, 341, *342*
Frederick Henry, Prince of Orange 225
Freeman, John 112
Frizell, William 147
Frogmore House, Windsor Great Park 140
Fulham Palace 22
Funnell, Martin 385
furnishings
 George I 247
 George II 271–2, 279–80
 seventeenth century 112–15
 twentieth century 365–7
 Victoria 315–17
 William and Mary 172–4, *174*, 176, 182, 195–9

Gage, Sir John 80–81
Gaillon, château de 105
Galba (roundel) 24
Gale, Lady 383
galleries 49–50, 89, 166
 see also individual galleries
Gamperle, Casper 229
garden parties 358
Gardener's Chronicle, The 348, 349, 350
Gardener's Magazine 347, 348
gardens 22, *91*
 Anne 223, *228*, 237–40, *239*, *240*, *241*, *242*
 Capability Brown 345
 Charles I 223–5
 Charles II 225, 227, 229
 Cromwell 223, 225
 Edward VI and Mary I 79, 96–7
 Elizabeth I *88*, 94, 97
 George I 341
 George II 341–3, *342*, *343*, *344*
 George III *347*
 Haverfield 347
 Henry VIII 89–90, *90*, 92–3, 95–6
 James I 108, 223
 nineteenth century 347–52, *348*, *349*, *350*, *351*, *353*, *355*–6
 twentieth century 359, 378, *379*, 380, *382*, 395–7
 William and Mary 153, *162*, 182, 189–90, 191–3, 207, 223, *224*, 229–32, *230*, *231*, *232*, 233–7, *233*, *235*, *236*, *237*, *238*, 243, 341
 Wolsey 17, 22, 89, 402n
garderobes 11, *11*, 20–21, 60, 378
Gardiner, J. A. 349, 351
Gardiner, Stephen 55, 75
Garlick, Sir John 383
Garner, Richard 86
Garner, Thomas 359, 361
Garrick, David 345
Garway, Herefordshire 7
gas 335–6
gatehouses 7, 11, 20, *20*, 276
 see also Anne Boleyn's Gate; Great Gatehouse; Middle Gatehouse
gazon coupé 229, *230*, 234, 238, 341
Gentileschi, Artemesia 113
Gentileschi, Orazio 113
Gentleman's Magazine 289, 290, 296, 303, 319
George I 221, 245, 248, 267
 at Hampton Court 254–7, *259*

Benson's work 260–62, *262*, *263*, 264–6, *264*, *265*, *266*
courtier lodgings 325, 327
gardens 240, 341
Hampton Court Invalids 219
kitchens 337
palace environs 266–7
personalities 245–6
Queen's Apartments 246–8, *246*, *247*, *248*
Tennis Court 292
Vanbrugh's plan for rebuilding *258*, 259–60, *259*, *260*
George II 245, 267, 269, 272, 287
after 1737 282–4
chapels 330
courtier lodgings 327
court's last visit 282
Cumberland Suite 275–7, *278*, *279*
field bed 315
first visit as king 269–71
gardens 341–3, *342*, *343*, *344*
Gate 24
and George I 245–6
palace environs 266, 267, 284–5
preparations for 1737 visit 279–81
as Prince of Wales 246, *246*, *247*, *248*, 250–51, 252, *254*, 254, 255, 256–7, 259, 261, 265
Queen's Staircase 277–9, *280*, *281*
refurnishing 271–2
visit of 1731 272, 274–5
George III 287
Buckingham Palace 327
cavalry 321
gardens 345, 347
grace and favour apartments 336–7, 338
maintenance and restoration 287–9, 292
picture hang 310–11, *311*
George IV
gardens *236*, 347
grace and favour apartments 338
maintenance and restoration 292
picture hang 311–12
stud and tennis court 292–3
George, Prince of Denmark 145, 212, 213, 215–16, 217, 219, 221, 253
George V 337, 350, 360, 365, 371
George VI 219, 358
Georgian Group 374
Georgian Rooms 392–3
German Kitchen 262, *264*
Gerschow, Frederic 102
Gheeraerts, Marcus, the Elder *88*, 92, *94*
Gibbons, Grinling 176–9, *176*, *177*, *179*, *180*, 256, *257*, 369
Banqueting House 192
Bowling Green Pavilion 191
Chapel Royal 207, 219, 362
dressing room 247
Guard Chamber 198
King's Apartments 194, 197
Oratory 251, *252*
Queen Mary's Closet *178*, *181*, 216
Queen's Gallery 202
Queen's Private Bedchamber 250
restoration of carvings 391
Gibson, Edmund 208
Gibson, J. S. 361, *362*
Gidea Hall, Essex 103

Gillett and Bland 303–4
Gilmore Hankey Kirke Partnership 374
Girouard, Mark 388
Giustinian, Zorzi 115
Gladstone, William 338
Glass Case Garden 193, 231, 232, 234, 235, 238, 345, 355–6
Glorious Revolution 151, 206
Gloucester, William Henry, first Duke of 292, 338
Gloucester, Richard, second Duke of 385, 386
Gloucester, William, Duke of 182
Gobelins 196, 280
Godolphin, Sidney, first Earl of Godolphin 171
Golding, John 322
golf 355
Gomez, Ruy 80
Gondomar, Count 116
Gonville and Caius College, Cambridge 103
Gonzaga paintings 113, 114
Goodison, Benjamin 256, 271, 284
Goodison, Ingleson C. 365
Goodwin, Matthew 114
Gorhambury, Herfordshire 103
Gotch, J. Alfred 361
gothic architecture 275, 276–7
1880–1911 restoration 302, 303–8, *304*, *305*, *306*, *307*
George III 288–9
Great Hall and Chapel 294–6, *296*, *297*, 298
Lessels's restoration 316
palace exterior 298–9, *299*, *300*, *301*, 302–3, *302*
rise in interest 289–90
Goupy, Joseph 245
grace and favour *324*, *336*
allocation of lodgings 328–9, *329*, *331*
apartment amenities 329–30, *330*
fires 332–3, 335
gardens 347–8, 369
gas and electricity 335–6
kitchens 388
nineteenth-century life 330, 332
outlying apartments 337–9
parks 354
post-war 370, 371
royal residents 336–7
start 327–8
Wolsey Rooms 316, 359, *360*
Grafton, Duke of *see* Fitzroy, Henry
Grafton, Ralph 125
Graham, Archibald 349
Grammont, Count of 140
Grand Concern of England Explained in Several Proposals offered to the Consideration of Parliament, The 147
Grand Court 153, 163, 260, *260*
Grape House 345
Grave, John 72
Graveley, Edmund 63
Great Bedchamber *see* King's Great Bedchamber
Great Chamber 22, 52
Great Garden 79, 96
Great Gatehouse
Charles II 146, *147*
Elizabeth I's monogram *103*
George III 287–8
restoration *40*, 302–3, *304*–5, *304*, *305*
Wolsey 18–20, *19*, *24*
Great Hall *278*, *286*, *295*, *296*, 310

Charles I 111, 112, 114
Charles II 133, 135, 146
Daubeney 11–12, 13, 51
Elizabeth I 82, 86
George I 260, 261, *262*, 277
George III 288–9, *289*, 292
Hardwick's survey 53
Henry VIII 51–2, *52*, 53, 61, 104, 404n
influence 103–4
James I 109
Jesse's restoration 294–6, *296*
Lessels's restoration 305
Middlesex Guildhall relief 361, *362*
myths 102
Second World War 368–9
stags' heads *117*, 118
twentieth century 358, 359, 361–2, *362*, *363*, 391
Victoria 316
William and Mary 153, 207–8
Great Kitchens 12–13, *12*, *13*, 44, 45, *45*, 47, *47*, 49, 387–8, *387*
Great Orchard 26, 95
Great Parterre 229, 230, *230*, 341
Anne 238–40
William and Mary 232, *232*, 234
Great Portal 207
Great Watching Chamber
George III 288
Henry VIII 58–9, *58*, 104
Jesse's restoration 295, *296*
Lessels's restoration 305, *307*
twentieth century 359, 376, 391, 392, *392*, *393*
Victoria 315–16
William and Mary 208
Greate Peece (Van Dyck) 113, 121
Green Gallery 246
see also Queen's Gallery
Greenhill, John 146, *146*
greenhouses 230–32, *232*, *233*
Greening, John 343
Greenwich Palace 79, 100, 101, *101*, 374
Cromwell 127, 129
Elizabeth I 81, 83, 85
gardens 223, 232
Henry VIII 32, 43, 52, 64, 68, 102
James I 107, 109
tiltyard 95
Gresham, Richard 26
Greville, Robert, fourth Baron Brooke 153
Grey, Henry, Duke of Suffolk 80
greyhound racing 97
Greystoke Castle 229
Gribelin, Simon *185*, 217
Griffith (Gryffin), Edmund 89
Groome, William 229
Grundy, John 313, 317, 320–21, *352*
guard houses 208
Guardian, The 373
guidebooks 290, 317, 320, 358, 428n
Deliciae Britannicae 284
The History of the Royal Residences 198, 200, 210, 218, 219, 247, 256, 283, 292, 295
Jesse 294, *294*, 299
picture hang 312, 313
Guildford 31
Gumley, John 247–8, 281

Haddon Hall, Derbyshire 45, 295
Hadrian (roundel) 24
Haines and Sons Limited 317
Hall, Alner Wilson 309
halls 6, 13, 51, 52
 see also Great Hall
Ham House, Petersham 153
Hames, Francis John 308
Hamilton, James, third Marquis and first Duke of 224
Hamilton, Lord George, first Earl of Orkney 245
Hamlet (Shakespeare) 107–8, 261
hammerbeams 51, 63, 103–4, 361–2
Hammond, Robert 122
Hammond, Thomas 124
Hampden, Mr 171
Hampton 107, 135, 136, 169, 400n
Hampton Court Chase 70–71, *71*, 97, 102
Hampton Court from the East (Knyff) 219, 220, *220*, 222, 232
Hampton Court Gardens Old and New (Law) 380
Hampton Court Green 319, 378
Hampton Court Guide 317
Hampton Court House, Herefordshire 219
Hampton Court Park 4, 97
Hampton Court seen across the River (Turner) 353
Hampton (manor) 1–3, 49
Hampton Wick 1
Handbook to Hampton Court, A (Cole) 320
Hanns, Dr 216
Hanson, Henry 381
Hanworth House 31, 55, 70
Harcourt, Lewis 306–7
Harding, Nicholas 272
Hardouin-Mansart, Jules *see* Mansart, Jules
Hardwick, Philip 53, 73, *236*, 289, *289*, 292, 293
Hardwick, Thomas 288, 321, 338, 345
Hardwick Old Hall, Derbyshire 104, 115
hare coursing 97
Harewood, Lord 365
Harley, Robert, first Earl of Oxford 216
Harlow, Sir Robert 120
Harman, R. D. 371
Harris, Henry 146, *146*
Harris, John 198
Harry, Thomas 7
Hastings, George, third Lord 92
Hatfield 41
Hatton, Sir Christopher 145, 185–6
Haunted Gallery *282*, 359, 391–2
Haverfield, Thomas 347
Havering, Essex 70
hawking 147
Hawkins-Whitshed, Sir James 316
Hawksmoor, Nicholas 152, 173, 260, 277
 Blenheim 256
 bowling green 190–91, *191*
 Castle Howard 160
 Chapel Royal 217
 Fountain Court *184*
 gardens 236, 240
 and Gibbons 177–8, *178*, *179*, *180*, *181*, 256
 Great Portal *207*
 new quadrangle 153, *155*, *158*, *159*, *163*, *164*, *166*, *168*, 208, 245
 Queen's Terrace 182, *182*
 site plans *154*, *156*, *161*, *162*
 Thoresby Hall 167–8

Haynes, Major Hezekiah 125
Haywood, Christine 4
Headington stone 167
heating system 365, 431n
Heaton, Mrs 330
Hendry, H. Duncan 358
Henning, Caspar Frederick 153, 229
Henrietta Maria 110, 112, 119, 120, 134, 410n
 bed 113
 gardens 223
 portraits 113, 121, 123, 147
 Saint-Germain-en-Laye 131
Henrietta Maria (Van Dyck) 121
Henry III 3, 4
Henry V 5
Henry VII 8, 9, 15, 45, 51, 53, 113
Henry VIII 43, 79, *101*, 102, 104, 105, 114
 and Anne Boleyn 54–61
 arms 37, 41, 63
 astronomical clock *42*
 building work *44*, 50, 59, 66
 carpets 113
 chapel 37, 63–4
 chivalric eclecticism 99–100
 close of Hampton Court Office 71–3
 Council Chamber and Royal Lodgings 49–50, 104
 and Daubeney 15
 Eltham Palace 36
 fountain 87
 and France 32
 furnishings 112–13
 gardens 89–90, *90*, 92–3, 95–6
 Great Gatehouse 19, 20
 Great Hall and Tennis Court 51–4, 404n
 hunting 116, 117
 and Jane Seymour 65–6, 68–70
 kitchens 12, 13, 45, *46*, 47, 49
 last years 73–5
 Middle Gate 303
 Oatlands 17
 Paradise 87
 portraits *98*, 113
 relics 113, 290
 Richmond Palace 101
 setting 70–71
 stables 85, *85*
 swap of 1525 30–31
 tapestries 112, 196
 Tiltyard 83–4
 windows 295
 Windsor Castle 101
 and Wolsey 15, 27, 29, 33, 41
 Wolsey Closet *48*
 workforce 43–5
Henry VIII (Shakespeare) 146, *146*, 261
Henry, Prince of Wales 107, 108, 109, 111, 223, 247
Henry, Prince of Wales 284
Henry de Loffewyke 5
Henry Harris as Cardinal Wolsey (Greenhill) 146, *146*
Henry of St Albans 3
Henslowe, Philip 107–8
Hentzner, Paul 102, 403n
heraldry 60–61, 63, 105, 305
herbers 19, 92, 95
Herbert, Henry, ninth Earl of Pembroke 327

Herbert, William, first Earl of Pembroke 30
Herbery, Thomas 215
Heritage, Thomas 16
Herland, Hugh 51
Herstmonceaux, Sussex 14
Hertford, Lord *see* Seymour, Francis
Hervey, Mary, Lady 270
Hervey, John, Baron Hervey of Ickworth 246, 270–71, 341
Heston 1, 3
Het Loo 151, 167, 200, 205, 386, 388
 gardens 153, 229
 interiors 173–4, *173*, 189, 194
Hethe, John 56, *56*, 58, 60, 63, 66
Hewett, Sir Thomas 245, 265, 267
Highmore, Anthony *192*, 343, *343*
Highmore, Thomas 191, 213, 218, 247, 261, 296
Hill, Lady 316
Hill, Mr 330
Hill, Thomas 171
Hill Hall, Essex 100, 105
Hingston, John 133
Historic Buildings and Monuments Commission (HBMC) 357, 383, 385
Historic Royal Palaces (HRP) 357, 371, 373, 386–8, 397–8
Historical Romance in the Cartoon Gallery, An (Wingfield) 290
Historical Romance in the King's Great Bedchamber, An (Wingfield) 291
History of Alexander (tapestry) 280, 313
History of English Furniture (MacQuoid) 365, 366
History of Hampton Court (Law) 290, 339, 357, 358
History of Joshua (tapestry) 112, 196, 204, 247
History of Renaissance Architecture in England, A (Blomfield) 308–9
History of the Gothic Revival (Eastlake) 305
History of the King's Works 358–9, 377
History of the Royal Residences, The (Pyne) 198, 200, 210, 218, 219, 247, 256, 283, 290, 292, 295
Hodgson, Ian 378
Holbein, Hans 271
Holdenby, Northamptonshire 104
Holland House 182
Holland, Peter 373
Holyday Closet 63, 75
Holyrood House 366, 368
Home (House) Park
 Anne 221, 238
 Capability Brown 345, *346*
 George III 292
 Henry VIII 97
 nineteenth century 354–5
 twentieth century 369, 379, 380, *381*
 William and Mary 232, 233
Hone, Kent 7
Honour of Hampton Court 70, 71, *71*, 140
Honselaarsdijk 153, 167, 173–4, 225, *225*, 229, 232
Honthorst, Gerrit van 279, *280*
Hope, W. H. St John 358
Hopson, Charles 167, 234
Hopson, John 250
Hopson, Thomas 218, 256
Hopton, George 223
Horn Gallery 118, 146
 see also Queen's Gallery
Horn Room 305, *306*, 359
Horsfield, J. Nixon 355

Hospitallers *see* Knights Hospitallers
Hôtel Lambert, Paris 199
Houghton House, Norfolk 262
Houses of Offices 45, *46*, 47, *273*, 274, 332
Houses of Parliament 260, 261
How, Mr 127
Howard, Catherine 74
Howard, Charles, second Baron Howard of Effingham, first Earl of Nottingham 253
Howard, Henrietta, Countess of Suffolk 270, 341
Howard, Philip 147
Howard, Thomas, second Duke of Norfolk 29
Howard, Thomas, third Duke of Norfolk 80
Howard, Lord William, first Baron Howard of Effingham 80, 82, 109
Hoyo, Pedro de 102
Hugens, Lodewijck 127
Huggins, William 96
Hughes, H. R. 308
Hughes, Robert *350*
Hughson, David 290, 312
Huis te Dieren 151, 167, 229
Hull Manor 52
Hume, John 320
Hunsdon, George, Lord 86–7
Hunsdon, Hertfordshire 70
Hunt, Robert 284
hunting 97
 Anne 221
 Charles II 147, 149
 Cromwell 128
 George I 266–7
 George II 270, 274, 282
 Henry VIII 53, 60, 70–71
 James I and Charles I 116–18, *119*
 William III 184, 195
Hurst Park 1
Hussey, Christopher 366–7
Huygens, Constantijn 168, 185, 199, 202
Huysmans, Jacob 146
Hyde, Anne, Duchess of York 133, 134, 136–7, *137*, 151, 172, 199
Hymn to the Light of the World 217

Ightam Mote, Kent 361
Illustrated London News 333
Indge, George 385
Inman, William Southcote 298, *299*, 299, 300, *301*, 302, 320, 338
Inner Court 275, *275*
Inspectorate of Ancient Monuments 357, 374, 376, 390
Invalides, Les, Paris 152
Invalids 219, 321
Inwood, Mr 125
Ireland, Samuel *284*
Ireton, Henry 121
Isleworth 1, 2, 3
Italy 105, 223, 225
Itinerant Surveyor 294

Jack, James 369–70
Jackson, Robert 352
Jackson, Thomas 349
Jacques, David 359
James, G. P. R. 303
James I 87, 107, 109, 110, 114
 Christmas 1603–4 and Hampton Court Conference 107–8
 diplomatic protocol 116
 gardens 223
 hunting 116–18
 maintenance and management 108–9
 portraits 147, 247
 tennis 111
James II 121, *122*, 133, 134, 141, 151, 182, 292
 at Hampton Court 143, 145
 death 205
 gardens 225, 227
 Kingston 135
 lodgings 136–7, *137*, *138*, 140, *249*
 paintings 147, 172, 253
 tennis 131
James, John 240
James Longley and Company 386
Jameson, Anna Brownell 312
Japan Varnish 278
Jefferson, Thomas 345
Jelfe, Andrews 275, 277
Jennings, Robert 194
Jensen, Gerrit 172, 198, *199*
Jerome, Jerome K. 351
Jerrold, Walter 349–50
Jervas, Charles 186
Jesse, Edward 24, 212, 313, 390, 425n
 Clock Court *294*
 gardens 348
 Great Gatehouse 303
 Great Hall and Chapel 294–6, *296*, *297*, 298, 305, 362
 palace exterior 298–9, *299*, *300*, *301*, 302–3, *302*
 tourism 318, 319, 320
Joan de Grey 4
Johnson, Mr 348
Johnson, John 192
Johnson, Samuel 327
Johnson, William 72
Johnston, Lieutenant Colonel John (Johnny) 374, 376
Jones, Inigo 22, 109, 114, 116, 120, 170, 189, 220, 223, 262, 409n
 stables 117
 Tiltyard towers 225
Jones, Morgan 368
Jones, Colonel Philip 125, 127
Jones, Richard, Earl of Ranelagh 189–90, 233
Jonson, Ben 107
Jordan, Dorothy 294
Journal of Horticulture 349, 350, *350*
Journey through England and Wales (Macky) 163, 166
Joynes, Henry 259
Judgement of Solomon (Smythier) 204
Julian the Apostate 212
Julius (roundel) 24
Julius Caesar (tapestry) 112, 114
Justice (fountain) 87, *87*

Katharine of Aragon 29, 41, 55, 60, 65
Keate, Edith 358
Keeper of the Mansion and Honour of Hampton Court 82
Keeper of the Privy Lodgings 109
Keeper of the Wardrobe 83, 109
Keevil, Jan 365
Keppel, Arnold Joost van, first Earl of Albemarle 129, 204, 248, 325, 327
Kendall, John 8, 9
Kenilworth 53
Kenninghall 29
Kensington Gardens 190, 242, 341
Kensington Palace 386
 Anne 211–12
 Caroline 271
 collapse 171
 George I 275
 Queen Mary 366
 Suffragette demonstrations 367
 Vanbrugh 259, 260–61
 Victoria 316
 William and Mary 152, 166, 177, 184, 194–5, 199, 205, 206
Kent, Edward Augustus, Duke of 338
Kent, William 267, 269, *276*, 281, 305
 Chapel Gallery 282
 Cumberland Suite 29, 59, 275–7, *277*, *278*
 Great Hall *278*
 Kew Palace 282, 313
 Queen's Drawing Room 317
 Queen's Staircase 279, *280*, 281
 Richmond Palace 341
Kew Gardens 356, 385
Kew Palace 8, 282, 287, 288, 313, 316, 386
Kielmansegge, Baron 245, 284
Kielmansegge, Madame 245, 255, 265
Killigrew, Anne 123
Kimmel Park, Denbighshire 308
King's Apartments
 Anne 216
 George II 271
 paintings 312
 twentieth century 366, *367*, 376, 390, 391, *391*
 William and Mary 169, 171, 193–9, *195*, 205, 207
King's Bedchamber 312
 Henry VIII 49, 50, 53
 twentieth century 366
King's Bedchamber on the Queen's Side 68
King's Canadian Camp School 352
King's Closet 177, 204, *391*
King's College, Cambridge 16
King's Dining Chamber 22, 31
King's Drawing Room 206, 270, 312, 365, 374
King's Dressing Room 147, 365
King's Eating Room 194, 206, 270, 271, 390
Kings Escape from Hampton Court 11 Nov. 1641, The 123
King's Gallery 114, 146–7, 166
 see also Cartoon Gallery
King's Great Bedchamber *291*
 George I 248
 William and Mary 176, *176*, 177, 194, 198, *199*, 204, 205, 206
King's Guard Chamber 198, *200*, 312, *321*, 330, 368, 378
King's Guard Chamber, Hampton Court (Stephanoff) *200*
King's Little Bedchamber 202, *203*, 204
King's Private Dining Room 194, *195*, 250, 251, 271, *380*, 386

King's Privy Chamber (Household department) 49, 52–3, 104
King's Privy Chamber (room)
 Anne 216
 George I 248
 Henry VIII 50, 52, 59, 60, 104
 James I 108
 twentieth century 367
 William and Mary 186, 194, 196, *196*, *197*, *201*, 206
King's Privy Closet 49, 59–60, 63, 87
King's Privy Gallery 66, 68
King's Staircase 210, 212–13, *212*, 287
Kings Weston Book of Drawings 256
Kingston, William, Earl of *see* Pierrepont
Kingston avenue 232
Kingston upon Thames 1, 85, 135, 285
Kinnersley, Clement 125, 127, 129
Kinnersley, John 125
Kinsky, Count 270
Kinward, Thomas 140
Kip, John 219, 220, *236*
kitchens
 Anne 216
 Charles II 133, 135
 Elizabeth I *78*, 84–5, 102–3
 George I 261–2, *263*, 264–5, *264*, *265*
 grace and favour apartments *331*
 Henry VIII 12–13, *12*, *13*, 44, 45, *45*, 47, *47*, 49
 James I 109
 twentieth century 387–8, *387*, *391*
 William and Mary 206
Kneller, Sir Godfrey 172, 194, 199, *201*, 217, 253, 284, 312
Knight, Mr 337
Knight, Charles 299, 312, 352
Knights Hospitallers 3–5, 8, 9, 49
 chamber-blocks 6, *6*
 chapels 7, *7*
 dovecotes 7
 halls 6
 undercroft 29
 and Wolsey 15–16
Knights Templar 3, 6, *6*
Knole House, Kent 17, 295
Knollys, William 109
Knyff, Leonard 219–21, *220*, *221*, *221*, 222, 232, *236*, *243*, 342
 gardens 235, *237*, *243*
Kratzer, Nicholas 72

Labours of Hercules (roundels) 24, 166
lacquerware 173
Laguerre, Louis 166, 200, 202, 208, 213, 217, 414n
Lambert de Clay 5
Lambert le Wayfrer 5
Lambeth Palace 19, 20, *20*, *34*, 35, 41, 43, 220, 298
Lance, David 256
Landmark Trust 337, 432n
Lane, Nicholas 223
Langley, Batty 276, 277, 341
Lanscroon, Gerard 213
Large Oak Room 194, *195*, *380*
Later Renaissance Architecture in England (Belcher and Maccartney) 309
Latham, Joseph 171
Lauderdale, Earl of 153

Law, Ernest 327, 335, 339, 361
 beds 365
 gardens 350, 379, 380, *382*
 guidebooks 320, 358
 History of Hampton Court 290, 357, 358
 Mitford 303
 paintings 314, 316
 tourism 318, 359
 west front bridge 306–7
Layer Marney House, Essex 99
le Archer, Thomas 4
le Bakere, John 5
Le Brun, Charles 196, 280
le Fosse, Charles 195
le Nôtre, André 184, 229
Le Pautre, Jean 179, 183
Le Pautre, Pierre 198
Le Sage, John 194
Le Sueur, Hubert 127, 223, 225, 230, 240, *240*
Le Vau, Louis 153, 156, *160*, 183, 193
leather mâché 33, 48, 56, 305
Lebons, John 16
Lefevre, G. Shaw 355
Legge, George, third Earl of Dartmouth 294
Legge, Sir William 121
Leicester, Earl of *see* Dudley, Robert
Leigh, Samuel 317
Leigh's New Picture of London 317
Leith, Prue 379
Leland, John 1
Lely, Sir Peter 121, 122, 136, 172, 312
Lennox, Lord Henry Charles George Gordon 303
Lens, Bernard 272, *273*, 274, *274*
Leofric, Earl of Mercia 1
Leonard de Tibertis 4
Leslie, Charles Robert 250
Lessels, John *302*, 303, 305, *334*, 335
 fire precautions 335
 Great Gatehouse *40*, 304–5, *304*, *305*
 Horn Room 306
 lifting tackle 315
 Round Kitchen Court 306
 schoolhouse 332, *332*
 Wilderness House 337
 Wolsey Closet 316
levee 270
Levens Hall, Cumbria 229
Lewis, Pamela 376, 388
Lexington, Lord *see* Sutton, Robert
Lichfield, Bishop of 254
Lichfield, Lady 287
Lichfield and Coventry, Bishop of 269
Life in the English Country House (Girouard) 388
lighting 376
Lincoln, Earl of *see* Clinton
Lincoln's Inn Fields 289, *289*
Lindsay, Seymour 388
Lion Gate from the North in Georgian Times, The (Cox) 240
Lion Gates 240, *240*, *319*, 347, 350
Little Bedchamber 202, *203*, 204
Little Court 31–2
Little Dorrit (Dickens) 328
Little Oratory 247, 250
Lloyd, Christopher 388
lodgings
 courtiers 325, 327

 Wolsey 20–22, *21*, 27, *28*, 29–32
 see also Privy Lodgings; tower-lodgings
London, George 153, 229, 233, 235–6, 237
London Transport *318*
Long, Robert 131, 132, 207
Long Gallery
 Charles II 133, *138*, 141
 Henry VIII 44, 56
 influence 104
 stair 92
 Wolsey 22–4, *22*, *23*, 27, 31
Long Water 1, *156*, *226*, 229, 233, *354*, 355
Longford River 223–4, 227, 229, 240
Longley 386
Lorde, Robert 72, 73
Lorraine, Duke of 270, 274
Loudon, J. C. 347
Louis Philippe, King of France 312
Louis XII, King of France 105
Louis XIV, King of France
 Gobelins workshop 196
 prints of royal residences 342, *343*
 theatre 207–8
 trianon and Marly 188–9, *190*
 Versailles 172, 199, 204
 and William III 168, 205
Louisa (daughter of George II) 272
Louvre 152, 153, 156, *160*, *163*, *163*, *166*, 168, 170, 414n
Lovelace, Richard 122
Lovell, Sir Thomas 8, 9, 14
Lowe, George 343
Lower Orangery 231–2, *233*, 369
Lower Wilderness *242*, 341
Lowndes, Mr 327
Lowther, Sir John 187
Ludford, Colonel 119
Ludgator, Benjamin 285
Ludlow, Colonel Edmund 127
Lumley, Richard, second Earl of Scarborough 270
Lutterell, Narcissus 217
Lutyens, Edwin 319, 359, 361, *382*
Lyndhurst, Lady 339
Lysons, Daniel 290
Lyte, Sir Maxwell 361

Macartney, Mervyn 309
Macbeth (Shakespeare) 109
MacDonald, Crawford 386, 387, 388, 395, 397
McDonnell, Sir Schomberg 306
Machyn, Henry 81
Macky, John 163, 166, 213
MacQuoid, Percy 365, 366, 374
Maddox, Isaac 275
Madrid, château de 24, 105
Magalotti, Count Lorenzo 145, 225
Magdalen College, Oxford 35, 127
Magna Britannica (Cox) 341
Magnoni, Carlo 362
Maiano, Giovanni da 24, *25*, *26*, 303
Maidstone, John 127
Maine, Jonathan 177
Mallows, Charles Edward 307, *307*
Mansart, François 153, 156
Mansart, Jules Hardouin 188–9
Mansel, James 365

443

Mansions of England in Olden Times, The (Nash) 290
Mantegna, Andrea 114, 127, 146–7, 194, 199, 202, 245, 280, 313, 314, 365, 368, 369, 371, *372*
Manuel I, King of Portugal 105
Marillier, H. C. 358, 388–9
Markham, Gervase 111
Markye, John 97
Marlborough, Duke of *see* Churchill, John
Marlborough, Duchess of *see* Churchill, Sarah
Marlow, W. J. 350, 351
Marly 188–9, 190, *191*
Marney, Henry 99
Marot, Daniel 167, 173–4, *173*, *174*, *175*, 176, 179, *181*, 189, 193, 195, 198, 204, 208
 gardens 229, *230*, 236, *236*, 238–9
Marot, Jean 156, *160*, 163, *163*, *166*, 173
Marr, John 224
Marriott, James 129, 135, 136, 141, 184, 215
Marriott, Richard (father of James) 129
Marriott, Richard (son of James) 215, 219
Marshall, Richard 221, 267
Marten, David 72
Marvell, Andrew 126
Mary, Princess (daughter of George II) 272
Mary, Queen (wife of George V) 357, 359, 365, 366–7, *368*, 433n
Mary, Queen of Scots 83, 87, 147, 247
Mary I 29, 69, *69*, 70, 74, 80–81, 83, 101
Mary II 151–2, 416n
 bedchamber 251
 building collapse 171
 Cartoon Gallery 185
 Chapel Royal 206–7, 217
 embroidery *175*, 176
 gardens 223, 229, 231
 and Gibbons 176, 177
 new palace designs 152–3, *154*, *155*, 155, *156*, *156*, 157, *158*, *159*, *160*, 161, *162*, 163, *164*, *165*, 166–8, *166*
 paintings 199
 plays 207
 progress of work to 1694 182–3, 184
 start of work 168–70, *169*, *170*
 tapestries 194
 Water Gallery 171–2
Mary Magdalene (Titian) 114
Mary of Guise 80
Mary of Modena 137, 152
Mary of Orange (daughter of Charles I) 120, 123
Mascall, Eustace 44
masques 86, 108, 110, 111, 126, 358
Master Carpenter's Court 299, *300*, *301*, 302, *302*, 305
Maud de Wyke 4
Maude, Sir George Ashley 292
May, Adrian 225
May, Hugh *138*, 139, *139*, 140, 176, 177, 225, 412n
Maybank, Edward 227
Maynell, Mr 292
Maze 223, *228*, 240, *340*, *344*, 347, 351, *352*, 368
Meadow, James 63
Mehemet 255, 327
Melville, Sir James 87
Memoirs of the Life and Works of Christopher Wren (Elmes) 308
Mercier, Philippe 268, 277

Merton College, Oxford 35
Merton Priory 73
mews 85
Middle Gatehouse 25, *52*
Middlesex Guildhall 361, *362*
Middlesex Parishes (Lysons) 290
Mildmay, Anthony 125
Millar, Sir Oliver 374
Millenary Petition 108
Miller, Colonel John 381
Milton, John 225
Milton Abbey, Dorset 288, *288*
Ministry of Public Buildings and Works 357
Ministry of Works 357, 374
Mitchell, Elizabeth 8
Mitford, Bertram 303, 305, 306–7, 333
Mitford, Reverend John 294, 295
moat 5–6, 14, 79–80, 232
 bridge 60, *62*
 excavation 357, 359
 Henry VIII 45
 re-creation 306
 Wolsey 17, 24, 26
model yacht club 355
Molesey 8
Mollet, André 223, 225, *225*, 227, 229
Mollet, Gabriel 225
Monck, General George 127
Monconys, Monsieur de 145
Monnoyer, Jean-Baptiste 192–3, 199
Montacute, Somerset 104
Montagu, Charles, first Earl of Halifax 215, *215*, 216, 245, 246, 247, 347
Montagu, Lady Emily 317
Montagu, John, second Duke of Montagu 281
Montagu, Ralph, first Duke of Montagu 192, 194, 195, 196, 197, 281
Montagu, Sir Walter 112
Montagu House, London 192, 195, 199
Moor Hall, Harefield 6
Moor Park *139*, 140
Moore, Horatio 207
Moore, James 247–8, 281
Moore, Major General James 338
More, Edmund 63
More, Hannah 327
More, Philip 227
More, Sir Thomas 22
More, Thomas 141
More, The, Rickmansworth 16, 31, 35, 52
Moreland, Sir Samuel 171
Morians (tapestry) 127
Mornington, Lady 359
Morris, Robert 276
Morshead, Sir Owen 374
Mortier, David 219, 220
Mortlake 112, 196
Morton, John, Archbishop of Canterbury 14, 19, 20, 33, 41
Moulton, John 43, 66
Moundsmere House, Hampshire 309, *310*
Mount Garden 79, 89, 93, 95, 96, 97, 223
Much Wenlock Priory 20
Municipal Buildings, Leicester 308
murals 212–13, *212*, 369–70
Murray, John 309
Murray, John Fisher 299

music 217
Music Festival 387, 398
Music Party, The (Mercier) 268
Music Room 256, 270
 see also Public Dining Room; Queen's Guard Chamber
Mustapha 255, 327
Mytens, Daniel 247

Nadauld, Henri 172
Najera, Duke of 92
Nanfan, Sir Richard 15
Napier, Lord 328
Napier, Major 328
Nappen, Mr 284
Nash, John 290, 292, *292*, 298
Nash, Joseph 58
National Gallery, London 311, 312, 313, 317, 321, 358
National Library of Wales 369
National Physical Laboratory 352, 379
National Portrait Gallery 370
National Trust 373
Naylor, Mr 356, 378
Nedeham, James 43, 51, 54
Negretti, Tony 360
Negus, Colonel 267
Nero (roundel) 24, 302–3
Nesfield, William Eden 308
Nethaway, Mrs 225
Netherlands 167, 173
Neuburg, Prince of 149
New College, Oxford 35
New Hall, Essex 29, 43, 70, 124
Newcastle, Duke of *see* Cavendish, William
Newmarket 109, 110, 111, 136, 182
News of the World 383
'Next Paradise' 227
 Charles II 137–8, *139*, 140, 141, 143, 146
 William and Mary 168, 172
Nichols, Sutton 231
Nicholson, James 37
Nonsuch Palace 83, 290, 406n
 Henrietta Maria 110
 Henry VIII 52, 54, 63, 71, 72, 102
 Barbara Villiers 140
Norden, John 97
Norfolk, Duke of *see* Howard, Thomas
Norgate, Edward 120
Norris, Mr 146
Norris, John 186, 199
North, Frederick, second Earl of Guildford (Lord North) 327
North, Roger 208
Northumberland, Duke of 215
Norton, Colonel 124
Nortrage, Thomas 63
Nost, John 177, 191, 194, *202*, 235
Nottingham, Earl of *see* Finch, Daniel
Nottingham Castle 153, 415n
Nouveau Théâtre de la Grande Bretagne 220
Nurse, Richard 73
Nys, Daniel 114

oak 168
Oak Room 194, *195*, 380
oak trees 97

Oatlands, Surrey 17, 81, 107, 112, 140
 Henry VIII 54, 71, 72, 75, 102
Observations on English Architecture (Dallaway) 290
Ockwells, Berkshire 361
Office of the Greencloth 47
Office of Woods and Forests 294, 347, 349
Office of Works 79, 358
 Anne 211, 221
 Charles I 111, 112, 121
 Charles II 136, 140, 141, 149, 225
 gardens 96, 97, *239*, 240, 351, 379
 George I 245, 247, *254*, 260, 261, 265, 267
 George II 269, 277, 284, 285
 George III *130*, 287–8, 292
 grace and favour apartments 328–9, 336
 Great Hall restoration 361–2
 Henry VIII 41, 43–5, 71–2, 95–6, 99–100
 James I 108
 James II 145
 Jesse's restoration 296
 Lessels's restoration 305–7
 school 370
 tapestry restoration 389–90
 tourism 318
 Victoria 303, 313, 321, 322, 323
 William IV 294
 William and Mary 152, 167–8, 170, 172, 178, 188, 207, 229
 Wolsey Rooms 359
 see also Board of Works
Offley Shore, Mrs 329, *330*
Ogilvy, David George Coke Patrick, thirteenth Earl of Airlie 388, 398
Old and New Law (tapestry) 127
Oliver, John 171
Oram, William 288
Orangery 358, 359, 369
 Triumphs of Caesar 371, *372*, 373, *373*
 William and Mary 181, 182, 230–32, *233*
Oratory 250, 251, *252*, 271
orchards *19*, 26, 89, 95
Order of the Knights Hospitallers of St John of Jerusalem *see* Knights Hospitallers
organs
 Anne 218–19
 Charles I 120–21
 Charles II 133
 Cromwell 127, 128
 nineteenth century 330, 332
 twentieth century 365
 William and Mary 207
 Wolsey 37
Orkney, Lord *see* Hamilton, Lord George
Orpheus (sculpture) 235
Osgood, Richard 191
Otford, Kent 20, 41, 99
Otho (roundel) 24
Oursian, Nicholas 72
Outer Green Court 60, 272, *273*, 274
Oxburgh Hall, Norfolk 14, *14*

Padley, Mr 337
Pages' Chamber 392, *392*
paintings *see* picture hang
Palace Keeper 96, 102
pall-mall 224
Palladio 189, 260, 261, 275, 277, 282

Paradise 56, 87, 109, 137–8, 147
Parentalia (Wren) 163, 168
parks
 Anne 221, 238
 Capability Brown 345
 Charles I 117
 Charles II 147
 Commonwealth 124, 125
 George I and II 267
 James I 108, 117
 nineteenth and twentieth centuries *234*, 352, 354–5, 359, 379–82
 Restoration 225, 227
 Tudors 97
 William and Mary 153, *161*, 163, 188–9, 232, 233
Parliamentary Select Committees 317
parlours 22
Parr, Catherine 68, 75
parterres 225, *236*, 242
 see also Great Parterre
pastry house 47
Paton, Dorothy *318*
Paulet, William, first Marquis of Winchester 81–2, 86
Pavilion 190–91, *190*, 283–4, 337, 338–9, *338*, *339*
Pavilion Terrace 347
Pavilion Terrace Walk 351
Pawne, William 99
Peabody Estate, Cleverly, London 309, *310*
Peacock, Henry 227, 229
Pearce, Edward 167, 171
Pearce, Sir Edward Lovett 282
Peel, Lady Georgina 359, *360*
Peers, C. R. 357, 362
Pelham, Henry 275, 276
Pelletier, Jean 197–8, *197*
Pelletier brothers 174
Penkethman, William 261
Penne, Sybil 83
Pennington, Mr 327
Penshurst 295
Pepys, Samuel 57, *92*–3, 129, 131, 136, 411n
Percy, Algernon, tenth Earl of Northumberland 121
Percy, Elizabeth 325
Perrault, Claude 153, 163, *163*
Petrarch's Triumph (tapestry) 27
Petworth, Sussex 168, 189, 213, 427n
Pevsner, Nikolaus 358
Phelps, John 124, 125
Philip II, King of Spain 80, 81
Philip de Radynges 5
Phillips, Amyas 361
Phillips, Henry 138, 177
picture hang
 Caroline 271
 Charles I 113–14, 121, 123
 Charles II 146–7
 Commonwealth 125
 George I 245, 247, 253
 George II 272, 274, 279, *280*, 284
 George III 310–11, *366*
 George IV 311–12
 James II 147
 twentieth century 365, 366, 369, 371, *372*, 373–4, *373*, 374

Victoria 312–15, *314*, 316
 William IV 312
 William and Mary 172, 185–6, 198–9, 200, 202
Picture of London, The 317
Pierrepont, William, fourth Earl of Kingston 167
pigeon lofts 7, 225
Pinkerton, Godfrey 355
Pitkin Pictorials 358
Pitt-Rivers, Augustus 357
plague
 Charles I 110–11, 112, 410n
 Charles II 135–6
 Elizabeth I 83, 85, 86, 109
 James I 107, 108
Platter, Thomas 102
plays
 Charles I 111, 112, 409n
 Elizabeth I 86
 George I 261
 George II 274
 James I 107–8, 109
 William and Mary 207–8
Plukenet, Dr Leonard 231
Pocket Companion to the Royal Palaces 347
Pollnitz, Count Charles 269, 270
Poly-Olbion (Drayton) 276
Pomfrett, Countess of 271
Pond Garden 96, 227, 230, *232*
Pond Yard 89, 95, 223
 see also Glass Case Garden
Ponsonby, Lady Emily 299
Ponsonby, John William, fourth Earl of Bessborough and Viscount Duncannon 321
Ponsonby, Sir Spencer 316
Pope, Alexander 216
porcelain 173–4
Portland, first Earl of 152, 188–9, 194, 209, 253
 gardens 153, 163, 229, 232, 233, 235
Portland, Jane, Dowager Countess of 253
Portland stone 167, 182, 184, 218, 224
Portugal 105
Post Boy 219
Presence Chamber
 Charles I 111, 112, 114
 Charles II 141, 146
 Elizabeth I 82
 George II 271, 279
 George IV 312
 Henry VIII 52, 53, 59, 75, 104
 James I 108
 twentieth century 366, 374, 376
 William and Mary *176*, 177, 194, 196, *197*, 206
Presentation to Jupiter and Juno of the Liberal Sciences by Apollo, The (Honthorst) 279, *280*
Preston, John 118
Pretty, Colonel 123–4
Prince of Wales's Drawing Room 374, *375*
Princenhof, Bruges 91
Prinsep, Emily Rebecca *18*, 299
Prior, Matthew 188
Private Drawing Room 365
Privy Chamber *see* King's Privy Chamber; Queen's Privy Chamber
Privy Closet 49, 59–60, 63, 87
Privy Council
 Anne 211, 216–17
 Charles II 141, 143

445

Edward VI 80
Henry VIII 49, 104
James I 108
Whitehall 151
William and Mary 200
Privy Garden 223
　Anne 237, 238, 240, 242
　Charles I 224
　Charles II 227, 229
　Elizabeth I 87, 97
　George I 341
　George II 341, *342*
　George III *344*
　George IV 347
　Henry VIII 89, 90, 92, 96
　nineteenth century *348*, 351, *351*, 352, 355
　twentieth century 380, 395–7, *395*, *396*, *397*
　William and Mary 23, 89, 153, 168, 188, 229–30, *231*, 232, 233, 234, *235*, 236, *236*, 237
Privy Kitchen 78, 84–5, 102–3, 391
Privy Lodgings
　Charles I 114
　Charles II 140–41, *142*, 144
　Cromwell 127–8, *128*
　Elizabeth I 86–7, 92
　Henry VIII 44, 49–50, 55–7, 66, 68–9, 104
　James I 109
　James II 136–7, *137*, *138*, 140, 249
　see also King's Apartments; lodgings; Queen's Apartments
Privy Orchard 89, 95
Progers, Edward 215
Property Services Agency (PSA) 329, 357, 376, 378, 383, 385, 386, 391, 395
Public Dining Room 253, 270, 313, 365, 366
　see also Music Room
public lavatories 264–5, *264*, 320, 378
Pugin, A. C. 289–90, *289*, 292, 295, 303, *304*, 305, 402n
Pugin, A. W. N. 295, 296
putting green 378
Pyne, W. H. *198*, 200, 210, 218, 219, 247, 256, 283, 290, 292, *295*, 296, 315, 339

Queen Anne style 308, 366
Queen Elizabeth (paddle steamer) 320
Queen Elizabeth I (Gheeraerts) *88*, *94*
Queen Mary's Closet 204, 216, 365
Queen's Apartments
　George I 246–8, *246*, *247*, *248*, *249*, 250–51, *250*, *251*, *252*, 278
　George II 270, 271–2, 280–81
　James II 147
　twentieth century 366, *367*, 376
　Victoria 316–17
Queen's Audience Chamber 247, *248*, 313, 365
Queen's Bedchamber
　Caroline 250–51, *250*
　George I *244*, 246–7, *247*
　George II 270
　Henry VIII 68, 69, 70
　twentieth century 365
　William and Mary 177
Queen's Closet
　Anne 219
　George I 250
　William and Mary 177, *178*, *179*, *181*

Queen's Coachman 85
Queen's Drawing Room
　Anne 213, *214*, 216
　Charles II 227
　George I 247
　George II 280
　George IV 312
　twentieth century 366, *366*, *367*
　Victoria 316–17
Queen's Dressing Room 250
Queen's Gallery
　Charles II 67, 146
　chimney 177
　excavations 359
　George II 280–81, *283*
　George IV 312
　Henry VIII 68
　stags' heads 118
　Victoria 313
　William and Mary 202, *202*
　see also Green Gallery; Horn Gallery
Queen's Guard Chamber
　George I 247, 251, 255–6, *256*
　George II 271
　grace and favour apartment 337
　twentieth century 370–71, 376
Queen's Lodgings 104
　Anne Boleyn 55, 56–7
　Charles II 132, *133*
　Cromwell 127–8
　Jane Seymour 66, 69
Queen's Presence Chamber 251, 255–6, *257*, 312, 337
Queen's Private Bedchamber
　Caroline 250–51, *250*, 253
　twentieth century *394*, 395
　Victoria 315
Queen's Private Bedchamber (Leslie) *250*
Queen's Private Chamber 250, 253
Queen's Private Dining Room 250, 253, *253*
Queen's Privy Chamber
　George I 246, *246*, 247
Queen's Staircase 271, 277–9, *280*, *281*
Queen's Terrace 182, *182*
Quellin, Arnold 207
Quellingburgh, Hendrick 229
Quenington, Gloucestershire 7

racecourse 97
Railton, Henry *282*
railway station 318–19, *318*
Raleigh, Carew 123
Rammingen, Luitbert Freiherr von Pawel 337
Ranelagh, Earl of 189–90, 233
Rape of the Lock, The (Pope) 216
Raphael, *The Virgin and St Elizabeth with Jesus and the Infant St John the Baptist* 113
Raphael cartoons
　Anne 216, *217*
　Charles I 185–6
　George I 284
　George III 310–11, *311*
　twentieth century 390, *390*
　Victoria 312, 313–15, *314*, 317
　William III 199
Ratcliffe, Dr 187
Rathgeb, Jacob 102

Raumer, Frederick von 311
Rawlinson, Richard 139
Raynham Hall state bed 393
real (royal) tennis 53
Recolver, Richard 20, 27
Recruiting Office, The 274
Redgrave, Richard 312–13, 314
Redland 376
Redman, Henry 16, 43, 44
Reeve, R. *256*
Reigate stone 18
renaissance architecture 308–9
Reresby, Sir John 143
Reserve Picture Collection Gallery 374, 387
Restoration 129, 131
　see also Charles II
Rewley 95
Reynett, Lady 337–8
Reynett, Sir James 337
Reynolds, Gordon 365
Rhodes, Mr 219
Ricardi, Marquess 270
Ricci, Sebastiano 246, 366
Rice, Thomas 288
Rice, William 287, 288
Rich Bedchamber 128
Richard I 3
Richard II 113
Richard III 7
Richard de Meriton 4
Richmond, Duchess of 137, 143
Richmond Lodge 261, 282
Richmond Palace 29–30, 100, *101*, 102, 140, 290
　Caroline 341
　Commonwealth 129
　Elizabeth I 83, 104
　gardens 89, 223
　George II 270
　Henry VII 8, 43, 45, 51, 53
　Henry VIII 31, 43
　James I 109
Rickman, Thomas 298
Ridley, Nicholas 385
Rigaud, Jacques 343, *343*
Ripley, Thomas 267
Ripon, Geoffrey 395
roads 149, 266, 381–2
Robert de Gardino 5
Roberts, Sir Hugh 388
Roberts, Richard 256, 281
Roberts, Thomas 196, 202
Robertson, Bryan 373
Robethon, Baron 245
Robinson, John Charles 314–16, 339
Robinson, William 342
Rochester Priory 52
Rochfort, Lord 187
Rocque, John 341, *342*
Rogers, John 58
Romanelli 146
Romans 1
Ronjat, Dr 208
Roper, William 22
Rose, John 227, 229
Rossmore, Lady 359
Rougg, Garret 58, 63
Round Game Larder 292, 320

446

Round Kitchen Court 292, 305, *306*
roundels 24, *25*, *26*, 56, 58–9, 166, 302–3, 305, *307*
Rousseau, Jacques 199, 284
Rowe, John 16
Rowlandson, Thomas *347*
Royal Engineers *314*
Royal Heraldry (Willement) 296
Royal Horticultural Society 387
Royal Hospital, Chelsea 163, 219
Royal Institute of British Architects (RIBA) 358
Royal Mews 275
Royal Residences (Pyne) *198*, *200*, *210*, *218*, 219, *247*, *256*, *283*, *290*, *292*, *295*
Royal School of Needlework 371
Royal Slave, The (Cartwright) 112
Royal Stud *see* stud
Royal Water Closet 287
Royston, Hertfordshire 109
Ruddock and Sons 305
Rupert, Prince 133, 134, 141, 147, 198
Russell, John 54
Russell, Richard 16
Russell, William, fifth Earl and first Duke of Bedford 147
Rustat, Tobias 129, 141
Rutherford, F. J. 365, 366
Ryder, Dudley 248
Rydge, Richard 51, 58, 60
Ryley, Philip 171

Sabine de Dunolm 3
Saint-Germain-en-Laye, château of 51, 80, 131, 207–8
St James's Palace 388
 Anne 211–12, 217
 Augusta, Princess of Wales 282
 Caroline 270
 chapels 120
 Charles I 112
 clock 303
 Commonwealth 129
 engravings 220
 gardens 223, 227
 Henry VIII 68
 James I 109
 Vanbrugh's scheme 259–60, *261*
 William III 151
St James's Park 225
St Jerome (Titian) 114
St John Clerkenwell *34*, 35
St John's College, Cambridge 18
St Mary Woolnoth 190
St Paul (tapestry) 112
St Paul's cathedral 152, 167, 168, 171, 188, 317, 358
 dome 246–7
 Gibbons 177, *179*
St Stephen's Walbrook 251
St Valery, Annora 3
St Valery, Bernard (son of Reginald) 3
St Valery, Bernard (son of Walter) 2, 3
St Valery, Reginald 3
St Valery, Thomas 3
St Valery, Walter 2–3
Sakers, John 5, 6
Salvin, Anthony 290, 330
Sanderus, A. 89, *91*
Sandys, Sir William 99

sash windows 146, 208
Sassoon, Sir Philip 365–6
Satire of the Caesars (Julian the Apostate) 212
Saunders, Andrew 376
Savery, Thomas 239
Savorgnano, Mario, Count of Belgrade 29
Saxe-Weimar, Duke of 102
Saxony, King of 313
Sayer, Henry *348*
Scaramelli, Giovanni Carlo 102, 116
Scarborough, John 168
Scheffers, Nicholas 213
Schellinks, William 57, 131, 133, 227
Schön, Erhard *36*, *37*, 296
school 332, *332*, 370
Schreider, Christopher 219
Schulenberg, Melusine von der, Duchess of Kendal 245, 255, 265
Scientific American 352
sconces 204
Scott, James, Duke of Monmouth 136, *139*, 140
Scott, Sir Walter 295, 298
sculpture
 Anne 237
 Cromwell 127, 225
 George IV *347*
 nineteenth century *352*
 William and Mary 230, *235*
Seaton Delaval House, Northumberland 256
Sebastian, St 147
Second World War 234, 358, 368–70, *369*, 379–80, *379*, *380*
Secret Lodgings 66, 68, 92, 104
Seguier, William 311, 312, 317
Sellé, Dr William Christian 330
Seventeenth-Century Interior Decoration in England, France and Holland (Thornton) 388
sewage treatment 330
Seymour, Charles, sixth Duke of Somerset 325
Seymour, Edward, first Earl of Hertford and Duke of Somerset 79, 100, 105
Seymour, Francis, second Marquis of Hertford 287
Seymour, Sir George 299, 328
Seymour, Jane 65–6, 68–9, 70, 92, *296*
 arms *37*, 60, *60*, *307*
Shadforth, Mrs 339
Shaftesbury, Earl of *see* Cooper, Anthony Ashley
Shakespeare, William 107–8, 109
Shakespeare's Garden (Law) 380
Shaw, John 308
Shawfield House, Glasgow 261–2, *265*
Sheen 4
Sheffield Manor 22
Sheldonian Theatre, Oxford 170
Shepherd's Paradise, The (Montagu) 112
Shrewsbury, Duke of *see* Talbot, Charles
Shrewsbury, Earl of *see* Talbot, George; Talbot, Gilbert
Shynck, Robert 51, 56, *56*, 58–9, 60
Silvestre, Israel 163
Simmons, Henry 184
Simpson, Mr 141
Sissinghurst, Kent 361
Skelton, John 27, 33
skied galleries 104
Slade, George 292

Slaughter, Simon 310
smallpox 83, 102, 184
Smeton, Thomas 16
Smirke, Robert 292
Smith, Bernard 207
Smith, H. Clifford 366–7
Smith, Sir Thomas 100, 105
Smithsby, Thomas 125
Smithsby, William 113, 120, 121, 123, 125, 126, 129
Smout, John 218
Smythier, R. 204
Smythson, Robert 104
Snape, Andrew 135
Soane, Sir John 292, 337, 347
Battle of Solebay (tapestry) 248, 253, 366
Some Thought on Hampton Court Palace (Cole) 313
Somerset, Duke of *see* Seymour, Edward; Seymour, Charles
Somerset House 100, 105
 Anne of Denmark 110, 112, 113
 Catherine of Braganza 172
 chapel 120
 Elizabeth I 81, 83
 engravings 220
 gardens 223
 grace and favour apartments 327
 Henrietta Maria 113
 James I 109
 Queen's Chapel 217, 219
 sale of Charles I's goods 125
Sonning, Berkshire 63
South Gardens 347–8
South Kensington Museum 312, 313, 314–15, *314*, 316, 351–2, 371, 389
Specimens of Gothic Architecture (Pugin and Willson) 289–90, *289*, 303, *304*, 305
Spelthorne 2, 3
Spencer, Charles, third Earl of Sunderland 220, 254
Spencer House 388, 390
spicery 47, 135
Spyers, John
 Chapel Court *54*
 gardens *340*, *343*, *344*, *345*
 Home Park *345*, *346*
 Master Carpenter's Court 299, *300*, *301*, 302
stables
 Charles II 147
 George I 221, 266–7
 George II 283
 George III 338
 Henry VIII 85, *85*
 James I and Charles I 117
Stacey, William 295
Stadtholder's Garden at Honselaarsdijk (Florentius) 225
Stafford, Edward, third Duke of Buckingham 110, 117
Stafford, Henry, second Duke of Buckingham 29
stags' heads 117–18, *117*, 146, 410n
stained glass windows 295, 296, *296*, 362
staircases 51, 292
 see also King's Staircase; Queen's Staircase
Stanhope, Lady 123
Stanhope, James, first Earl Stanhope 245, 248, 254
Stanley, Sir John 186–7, 261, 325
Stansted Park, Sussex 309

State Apartments
 George I 247, 250, 261, 266, *266*
 George II 274, 283
 George III 287
 twentieth century 365–7, *366*, *367*, 374, 376, 383, 388–93
 Victoria 295, 315
 William and Mary 153, *155*, 156, *156*, *157*, *158*, *159*, 163, *164*, *165*, 166, 169–70, *169*, *170*, *171*, 199
statuary *see* sculpture
Steele, Sir Richard 217, 261, 266
Stephanoff, J. *198*, *200*
Stephenson, Benjamin 292, 294
Stettin Pomerania, Duke of 102
Stevens, Samuel 285
Stickells, Robert 109
Stockett, Lewis 84, 102
Stone, William Miles 288
stone 18, 167, 182, 184, 218, 224, 305
Stoop, Dirk *134*
Story of Abraham (tapestry) 52, 112, 196, 295, 316
Stranger's Guide to Hampton Court Palace, The (Grundy) 313, 317, 352
Stratton, Arthur 359, 361
Strawberry Hill House, Twickenham 277, 290, 295
Streeter, Robert 146, 196, 198, 278
Strickland, Walter 125
Strood, Kent 6, *6*
Stuart, Arbella 107, 109
Stuart, Frances, Duchess of Richmond 137, 143
Stuart, John, third Earl of Bute 287
Stubbs, Lawrence 16
stud
 Anne 221
 Charles II 147
 George I and II 267, 283
 George IV 292, 347
 twentieth century 380, 381
 Victoria 354, 355
Stud House 292, *292*
Sudeley Castle, Gloucestershire 17
Suffolk, Duchess of 133, 134
Suffolk Place, Southwark 99,110
Suffragette demonstrations 367
Summerly, Felix (Henry Cole) 320
Summer's Day at Hampton Court, A (Jesse) 294, *294*, 320
Sunderland, Earl of *see* Spencer, Charles
sundials 92, 111, 224
Surrey Comet 319
Survey of London 374
Sussex, Augustus Frederick, Duke of 287
Sutherland, T. *218*, *219*
Sutton, Robert, second Baron Lexington 187
Sutton Place, Surrey 24, *24*, 99
Swift, Jonathan 216, 217, 221
Swingfield, Kent 7, *7*
Switzer, Stephen 233, 238, 240
Sybil, A (Gentileschi) 113
Sydenham, William 125
Sydney, Henry, Viscount Sydney and Earl of Romney 207

Talbot, Charles, twelfth Earl and only Duke of Shrewsbury 186–7, 216, 246
Talbot, George, fourth Earl of Shrewsbury 22

Talbot, Gilbert, seventh Earl of Shrewsbury 107
Tallard, Count de 206
Talman, William 152, 163, 167–8, 173, 208, 255, 267
 Banqueting House and aviary 191–3, *193*
 Bowling Green Pavilion 190–91, *190*
 building collapse 171
 Chatsworth 251, 256, 310
 gardens 153, 227, *227*, 229, 233, 235–6
 King's Apartments 193–4
 Lower Orangery 231–2, *233*
 overdoor paintings 199
 trianon 187–9, *188*, *189*, 417n
tapestries
 Charles I 112, 114
 Charles II 131, 132, 141, 146
 Cromwell 125, 127
 George I 247, 248, 253
 George II 272, 280–81
 Henrietta Maria 119
 Henry VIII 52, 102
 James II 145
 restoration workshop 389
 twentieth century 366, 388–9, *390*
 Victoria 295, 313, 315–16
 William and Mary 194, 196, 204
 Wolsey 26–7
Taylor, Robert 288
Taylor, Zachary 118
Temple Balsall, West Midlands 6
Tennis Court
 Albert, Prince Consort 293
 Charles I 111
 Charles II 131–2, *131*, 136
 Edward VII 303
 George I 261
 George IV 292–3
 Henry VIII 19, 51, 53–4, *54*, 55, 404n
 James I 108
 post-war club 360, *361*
 William and Mary 207
Tennis Court Lane 332, *332*, 335, 342, 370
terracotta 19–20, 23–4, *23*, *24*, 168, 302–3, 402n
Textile Conservation Centre 371
Textile Conservation Studios 389
Thames 1, 10, 149, 330
Thames Conservancy Act 1867 330
Thames Ditton *188*, *189*, 189
Thames Gallery *see* Water Gallery
Thames Illustrated, The 296
theatre 207–8, 261, *262*, 288
Theobalds, Hertfordshire 103, 109, 111
Thomas, Prince of Savoy 113
Thomas, Lady Sophia (née Keppel) 327
Thompson, Major General Christopher 385, 386
Thompson, John 128, 171
Thoresby Hall, Nottinghamshire 167–8, *167*
Thornbury Castle 17, 20, 21, 29, 290, 302
Thorneycroft, the Hon. John 371, 374, *375*, 376, 388, 430n, 432n
Thornhill, Sir James
 Chapel Royal 218, 219, *219*, 297, *298*
 King's Staircase 212
 Princess Caroline's bedchamber *244*, 246–7
 Queen's Drawing Room 213
 Queen's Staircase 279
 Raphael cartoons 217, 284

Thornton, Peter 388
Thott, Thage 102
Three Clerks, The (Trollope) 319
throne canopies 112–13, 132, 197, *201*, 256, 366
Tiberius (roundel) 24, 302–3
Tijou, Jean 213, 229, *230*, 234, 235, 237, 238, 240, 278, 308, 341, 351–2, *353*, 380
Tildesley, Thomas 287
tiles 72, 173, *173*, 174
Tillières, Leverneur de 110
Tillotson, John 206
Tilson, Christopher 283
Tiltyard 95
Tiltyard Barracks 133
Tiltyard Gardens 229, 238, *348*, 356
 cafeteria 378–9, *379*
 recreation centre 378, *378*
Tiltyard towers *68*, 83–4, 95, 225, 378
timber 20, 63, 72, 168
Times, The 306, 307, 319, 365, 379
Tinney, John *192*, 343
Tintoretto 369
Tipping, H. Avray 307
Tite, Sir William 318–19, *318*
Titian 113, 114
Titus (roundel) 24
Tobias and the Angel (tapestry) 127, 247
Tod, Richard 83
topiary 92, 345
Tories 211, 246–7, *247*, 248
Toto del Nunziata 49
tourism 317–21
 gardens 347, 348, 355–6
 George II 284
 Raphael cartoons 311
 twentieth century 367–8, 374, 376, 378–9, 390–93, 395, 398
 Victoria 294–5
tournaments 83–4, 95
tower lodgings 44, 49–50, 52–3, 95, 104, 225
Tower of London 198, 220, 295, 296, 317, 385, 386, 388
Town and County 379
Townley, Nicholas 16
Townshend, Charles, second Viscount Townshend 245
Tradescant, John 113
Trajan (roundel) 24
tramway 319, *319*
Treaty of Amiens 32
Treaty of Hampton Court 32
Trevillion, John 383
trianon 187–9, *188*, *189*, 191, 193, 417n
Tribute to Sir Christopher Wren, A (Cockerell) 308, *309*
Trinity College, Oxford 219
Triumph of the Gods (tapestry) 127
Triumphs of Caesar (Mantegna) 114, 127, 146–7, 194, 199, 202, 245, 280, 313, 314, 365, 369, 371, *372*
Triumphs of Caesar (tapestry) 125, 127
Trollope, Anthony 319
Trophy Gate 60, 319, 320, 321, 356
trusses 170, *170*
Trusthouse Forte 378–9
Tudor architecture 289–90, 361
 see also gothic architecture

448

Tuke, Sir Brian 49
Tunstall, Archbishop Cuthbert 22
turnaround 232
Turner, J. M. W. *353*
Turner, Thackery 306
Turrell, Augustus 348, *355*
Twickenham 1, 3
Twickenham and Teddington Electric Supply Company 336
Two Songs at the Marriage of the Lord Fauconberg and the Lady Mary Cromwell (Marvell) 126
Tyler, William 338
Tyttenhanger, St Albans 16

Unwins, Thomas 312
Uppark House, Sussex 386
Upper Lodge, Bushy Park 215, *215*, 352, 354
Upper Orangery 230–31

Van Belcamp, Jan 123, 125
van de Velde, William 253, *253*
Van der Doort, Abraham 113
Van Dyck, Anthony 113, 121, 147, 199, 247
van Oosterwijk, Maria 199
van Somer, Paul 247
van Staden, Samuel 229
Van Vliet, Cornelius 231
van Wassenaer-Obdam, Agnes 151, 182
Vanbrugh, Sir John 240, 245, 267, 325
 gardens 341
 Queen's Apartments 255–6, *257*, 278
 rebuilding plan *258*, 259–60, *259*, *260*
 theatre 261
Vane, Sir Henry the elder 115
Vanoli, Dante 385
Vardy, John 269, 276, *278*
Venier, Marco Antonio 32
Venus (sculpture) 127, 225, 235
Venus (tapestry) 127
Venus and Adonis (sculpture) 225
Venus and Cupid (Bronzino) 114
Verelst, Simon 199
Verrio, Antonio 202, 208, 215, 246, 358, 419n
 Banqueting House 192, *193*
 gardens 227
 Great Bedchamber 204
 King's Staircase 199, 212–13, *212*, 287
 Queen's Drawing Room 213, *214*, 247, 253, 280, *366*
 Raphael cartoons 200
Versailles 386
 furnishings 198
 gallery 166
 grand laiterie 172
 Grand Trianon 184, *184*
 grotto 183
 menagerie 193
 as museum 312
 porcelain 174
 prints 342
 salle de comédie 208
 south front 153, 163
 Wren 414n
Vertue, George 246, 316
Vertue, William 16, 43
Victoria, Princess Royal 314
Victoria, Queen 303, 305, 366

grace and favour apartments 337, 338–9
Home Park 354–5
picture hang 312–15, *314*
tourism 295
Victoria and Albert Museum 312, 313, 314–15, *314*, 316, 351–2, 371, 389
Victoria County History for Middlesex 358
Vidler, John 288
Vignola, Signor 270
Villa Windsor, Paris 388
Villiers, Barbara, Countess of Castlemaine and Duchess of Cleveland 140–41, 143, 172, 215, 223, 227, 229
Villiers, Edward, first Earl of Jersey 204
Villiers, Henry 207
Vincent, David 81, 83
Vinckenbrinck, Albert Jansz 176
vine 227, 345, 349, 355–6, *355*, *356*, 368, 371
Vine House 356
Vine-Keeper's Cottage 337
Virgil 199
Virgin and St Elizabeth with Jesus and the Infant John the Baptist, The (Raphael) 113
Vision of the Twelve Goddesses, The (Daniel) 108
Vitellius (roundel) 24
Vitruvius Britannicus (Campbell) 220, 260, *260*, 265
Vliegenhardt, Adrain 388
Vos, Judocus de 280–81
Vrow Walk 378
Vulcan (tapestry) 127
Vulcan and Pan (sculpture) 235
Vyne, The, Hampshire 99

Wade, Robin 378
Waldstein, Baron 24, 102
wallpaper 365, 378, *379*
Walmoden, Amelia Sophia 279
Walpole, Horace 212, 213, 275, 277, 290, 295, 305, 327
Walpole, Sir Robert 245, 248, 262, 267, 270, 275, 276, 341
Walter de Wyke 4
Walton, Parry 185, 202
Ward, Misses 332
Warham, William, Archbishop of Canterbury 41
Warner, Sir Frank 365
Warwick Castle 153
Waryn, William 5, 6
Watching Chamber *see* Great Watching Chamber
Water Gallery
 Bronze Age finds 1
 Charles II 134, 140, 229
 Henry VIII 89, *92–3*, 95
 William and Mary 171–2, 173–4, *174*, 176, 188, 189, 190, 191, 208, 234
water supply 322–3
 Charles I 112, 223–4
 George II 285, *285*
 Henry VIII 73, *73*, 74, 95
 William and Mary 239, 240
Waterhouse, Ellis 212
Watson, Samuel 177, 208
Watson, W. 379
Waynflete, William 19
weapons 79, 80, 198, 295, *321*
Webb, Sir Aston 379
Webb, John 111, 128, 129, 139, 140, 170, 217, 220

Webb, Maurice 309, *310*
Webb, Sir William 124
Wedel, Leopold von 102
Welbeck Abbey, Nottinghamshire 190, 277
Wellesley, Arthur, first Duke of Wellington 313
Wellington, Duke of *see* Wellesley
Wellington College 308
Wemyss, Lady Isabella 338, 339
West, Colonel 124
West, Benjamin 311, 312, 317
West, Juliet 376
Westlake, N. H. J. 361
Westminster Abbey *8*, 63, 207, 317
Westminster Hall 51, 362
Westminster Palace 16, *34*, 35, 43
Weston, Sir Richard 99
Weston, Sir William 49
Wetherill, Robert 256
Wey, Francis 317
Whalley, Colonel Edward 121–2, 123
Whigs 211, 245, 246–7, 260–61, 265, 317
White, Fuller 285
White, Henry 174
White, John 374
Whitehall Palace 100–01
 Banqueting House 279, 386
 bowling alleys 95
 cellar 58
 chapel 120, 217, 219
 Charles I 119
 Charles II 129, 132, 136, 137, 225, 412n
 Cromwell 126, 128, 225
 Edward VI 79
 Elizabeth I 81, 83
 George I 260
 great hall 52
 guard chamber 198
 Henry VIII 54–5, 102
 Holbein Gate 24, 302
 James I 107, 109
 lodgings 20, 104
 Monmouth's lodgings 136
 oratory ceiling 251, *252*
 privy lodging 50
 tapestries 112
 tennis court 53
 throne canopy *98*
 William and Mary 151–2, 163, 176, 177, 186, 199, 207
 see also York Place
Whitelocke, Bulstrode 225
Why come ye not to Court? (Skelton) 27
Whynyard, John 109, 120
Wild, Charles *218*, 219, 295
Wilderness
 Anne 240, *242*
 Charles II 227, 229
 George I 341
 George III *340*, *344*, 347
 nineteenth century 347, *348*, 350–51
 tourism 378
 William and Mary 229, 233
Wilderness House 337, *337*, 341
Wilkes, John 310
Wilkins, Victor 309, *310*
Wilkins, William 317
Willement, Thomas 295, 296, *296*, 313

William III 151–2
 arrival of court 200, 202, 204–6
 Banqueting House and aviary 191–3
 bed 315, *315*, 365, 374
 building collapse 171
 Cartoon Gallery 184–6, *185*
 Chapel Royal 206–7, 217
 completion of King's Apartments 193–5, *195*
 courtier lodgings 325, *326*
 embroideries 176
 final months 207–9
 Fountain Court 89, 325
 furnishings 195–9, 365
 gardens *90*, 223, 229–32, *230*, *231*, *232*, 233–7, *233*, *235*, *236*, *237*, 238–9, *238*, 242, *243*, 341
 and Gibbons 177
 household apartments 186–7, *186*, *187*
 library at Het Loo 173
 new palace designs 152–3, *154*, 155, *155*, 156, *156*, *157*, *158*, *159*, 160, *161*, 162, 163, *164*, *165*, 166–8, *166*
 portraits 199, *201*, 217, 312
 Privy Garden 89
 progress of work to 1694 182–4
 Queen's Bedchamber 247
 start of work 168–70, *169*, *170*
 State Apartments 388
 Talman, Hawksmoor and the bowling green 189–91, *190*, *191*
 Talman and a *trianon* 187–9
 tennis court 207
 Verrio's mural 212
William III on Horseback (Kneller) 199, *201*, 312
William IV 292, 294, 312, 328, 337
William V, Prince of Orange 336–7
William of Wykeham 35
William the Conqueror 2
William Augustus, Duke of Cumberland (son of George II) 24, 272, 275, 302, 337
William Morris Tapestry Company 388–9
Williams, Henry 44, 72, 280, 281
Willson, E. J. 289–90, *289*, 303, *304*, 305
Wilson, Henry Riley 294
Wilson, John 44
Wilton House, Wiltshire 29, *30*, 128
Wimbledon House 223
Winchester, Marquis of *see* Paulet
Winchester Palace 152, 153, 156, 163, 166, 168
Windsor Castle 101
 Albert, Prince Consort 292
 Anne 211, 212
 chapel 120
 Charles I 111
 Charles II 141
 Commonwealth 129
 courtier lodgings 327
 Edward VI 79
 Elizabeth I 83
 engravings 220
 fire 386
 furnishings 102
 gardens 233
 gas 335
 George I and II 267
 George III 287, 288, 289, 310, 311
 George IV *236*
 Henry VIII 43
 James II 143
 Jesse 294, 295–6
 Langley's plans 276
 Lessels 303
 Queen Mary 366
 Round Tower 198
 St George's chapel 63
 tables 197, *197*
 tennis court 53
 William III 184
Windsor Castle (Hope) 358
Windsor Great Park 24, 302–3, 349
Wingfield, Charles Digman *290*, *291*, 311
Wingfield Manor, Lincolnshire 17, 20, 21
Winstanley, Henry 342
Wise, Henry 237, 242, 341
 Bowling Green Pavilions 283
 deer 221
 gardens 193, 207, 233, 235–6, 238, *242*
 maze 240
 and Verrio 215
Witham Park, Somerset 190
Withdrawing Chamber 52
Wode, John 7–8, 9, 14, 22, 401n
Wodehouse, Reverend 332
Woking 110
Wollaton Hall, Nottinghamshire 103–4
Wolseley, Lady 329, *331*
Wolsey, Cardinal Thomas 15–16, 43, 45, 49, 99, 100, 105
 badges and mottoes 29, *32*, 303, 305
 clocks 72
 first phase of work 17–24, *17*, 26–7
 gardens 89
 hat 290
 Henry Harris as Cardinal Wolsey 146, *146*
 in histories 339
 kitchens 12
 parks 97
 second phase of construction 27, *28*, 29–30, *31*
 start of building work 16
 swap of 1525 onwards 30–37, 41, 115
 tennis court 53
 Watching Chamber 58, *58*
 windows 295
Wolsey Closet *48*, 316, *316*
Wolsey Rooms 127, 359, *359*, *360*
Woodstock 52, 53, 111
Woolmer, Mr 125
Wootton Lodge, Staffordshire 104
Worksop Manor, Derbyshire 103, *103*
World War Two 234, 358, 368–70, *369*, 379–80, *379*, *380*

Wornum, R. N. 313
Wren, Sir Christopher 173, 277, 420n
 and Anne 211, 215
 bicentenary 358
 Bowling Green Pavilion 190
 building collapse 171
 Chapel Royal 217, 219
 Christ Church, Oxford 276
 Clock Court 294, *294*
 construction 168–70, *169*, *170*
 criticisms 305, 358, 425n
 gardens 229, 230, 233
 and George I 247, 259, 260
 and Gibbons 176–7
 and May 139–40
 new palace designs 151, 152–3, *154*, 155, *156*, *156*, *157*, *158*, 159, 162, 163, *164*, *165*, 166–8, *166*, 206, 207, 208, 260, 290, 325
 progress of work to 1694 183–4
 pugging 335
 revival 308–10, *309*
 Versailles 414n
 Whitehall Palace 37
 and William III 194
 Wolsey's gallery 23
 work restarts 184, 186, 187–8
Wren Society 358
Wright, John 51
Wright, Stephen 269, 287
Württemburg, Duke of 102
Wyatt, James 288, 289, 292, 294, 295
Wyatt, William Lewis 292
Wyatville, Jeffrey 294, 295–6, 310
Wyngaerde, Anthonis van den *19*, 20, *68*, *90*, *92*, *95*, 220
 Fountain Court 24, *26*, 60
 Greenwich Palace *101*

Xenia Alexandrovna, Grand Duchess 337

Yarnall, John 386
Yeates, Tobias 140, 141
Yexley, Harold 370–71, 376, 388
York Place 15, 16, *34*, 35, 43, 54–5
 ceiling 37
 gallery 22
 gardens 89
 hammerbeam roof 51
 privy lodging 50
 tapestries 26
 see also Whitehall Palace
Young, William 140, 215, 229

Zawadsky, John 115–16
Ziegler, H. B. *298*
Zinzerling, Justus 102
Zorgvliet, Netherlands 153, 229